D1093096

ULTIMATE NEW YORK DESIGN

teNeues

ULTIMATE
NEW YORK
DESIGN

Editor: Anja Llorella Oriol

Layout: Zahira Rodríguez Mediavilla

Translations: Nadja Leonard (English), Marion Westerhoff (French),
Christian Siegmund (German), Cristian Barbieri (Italian),
Empar Paredes, Ana Peco (Spanish)

Produced by Loft Publications
www.loftpublications.com

Published by teNeues Publishing Group

teNeues Publishing Company
16 West 22nd Street, New York, NY 10010, USA
Tel.: 001-212-627-9090, Fax: 001-212-627-9511

teNeues Verlag GmbH + Co. KG
Am Selder 37
47906 Kempen
Germany
Tel.: 0049-(0)2152 916 0, Fax: 0049-(0)2152 916 111

Press department: arehn@teneues.de

teNeues International Sales Division
Speditionstraße 17
40221 Düsseldorf, Germany
Tel.: 0049-(0)211-994597-0, Fax: 0049-(0)211-994597-40

teNeues Publishing UK Ltd.
P.O. Box 402
West Byfleet
KT14 7ZF, Great Britain
Tel.: 0044-1932-403509, Fax: 0044-1932-403514

teNeues France S.A.R.L.
4, rue de Valence
75005 Paris, France
Tel.: 0033-1-55 76 62 05, Fax: 0033-1-55 76 64 19

teNeues Ibérica S.L.
c/ Velázquez, 57 6.° izda.
28001 Madrid, Spain
Tel.: 0034-657-132133

teNeues Representative Office Italy
Via San Vittore 36/1
20123 Milano, Italy
Tel.: 0039-(0)347-76 40 551

www.teneues.com

ISBN-10: 3-8327-9107-8
ISBN-13: 978-3-8327-9107-0

© 2006 teNeues Verlag GmbH + Co. KG, Kempen

Printed in Spain

Bibliographic information published by
Die Deutsche Bibliothek. Die Deutsche Bibliothek lists
this publication in the Deutsche Nationalbibliografie;
detailed bibliographic data is available in the Internet
at http://dnb.ddb.de.

Contents

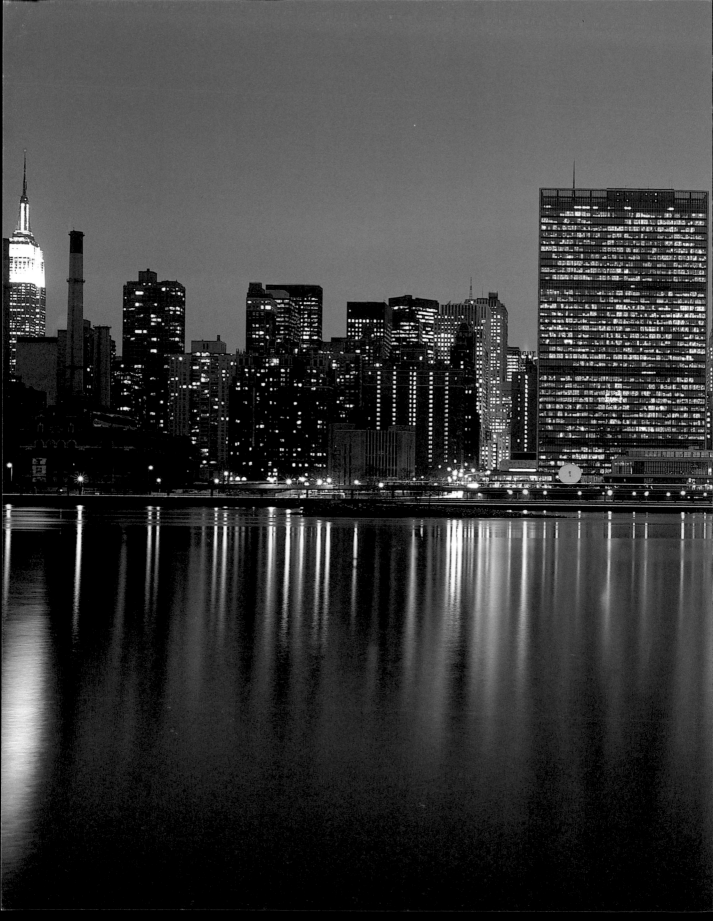

Introduction

Delicious New York

New York is considered the epitome of a metropolis. Since its establishment 400 years ago as the entry point to the American continent, the pulsating large city has developed into the financial and creative center of the world today. At the beginning of the 19th century, the city was growing faster than ever before and thus in 1811, the town planners decided to cover the entire island of Manhattan, only the southern portion of which was developed, with a grid-pattern street network, which, at the same time, forms the basis for the city's structure today. The only exception was then and still is: Broadway.

The first skyscrapers were built at the beginning of the 20th century. They became the symbol of the city, like the Woolworth Building and, above all later, the Empire State Building. The mean-spirited even say that this vibrant city has been living off of its cultural and architectonic legacy since the 1950s, such as, for example the Seagram Building, which was built based upon blueprints by the architect Mies van der Rohe or also the UN Headquarters, and that since then hardly any innovative, futuristic and daring projects have been realized.

In late summer 2001, New York experienced its darkest day, when the World Trade Center (WTC) was destroyed by terrorist attacks on September 11, 2001. In place of the WTC, now the Freedom Tower—based upon designs by the American-Polish architect Daniel Libeskind—is to be built. Clean-up work at Ground Zero was completed in May 2002 and the city began to look to the future once again with a multitude of extremely innovative projects such as the expansion of the MoMA.

This can also be seen upon closer inspection of New York's design scene, which is characterized by the overlap of various creative fields such as interior design, product design, fashion design, architecture, film and graphic arts.

New designers do not only want to be creators, but rather they transform themselves into independent producers. Thanks to computer science, they control the production process from the desk all the way to the finished product and are experimental and independent as a result. Also in terms of fashion, New York is both a mecca and a trendsetter. Famous designers such as Donna Karan and Calvin Klein have set trends around the world and a new squad of young designers presents its collections with substantial international resonance at New York's Fashion Week in Battery Park in Manhattan.

The examples gathered here show once again that New York really does not sleep but continues to set the trends of the international architecture and design industries.

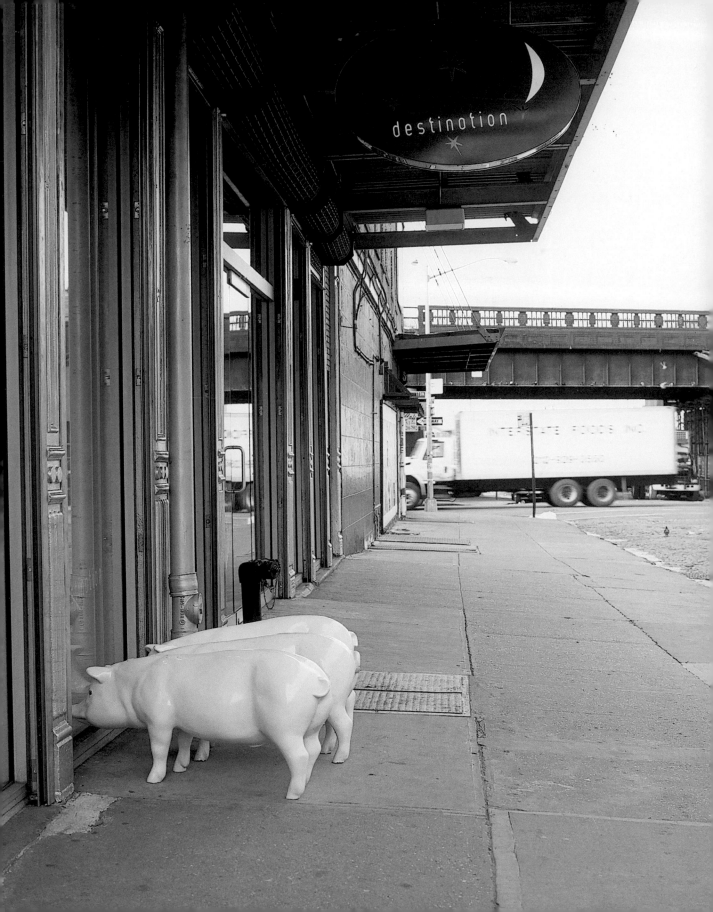

Einleitung

Delicious New York

New York gilt als die Metropole schlechthin. Als Eingangstor zum amerikanischen Kontinent entwickelte sich die pulsierende Großstadt seit ihrer Gründung vor 400 Jahren zum heutigen finanziellen und kreativen Zentrum der Welt. Zu Beginn des 19. Jahrhunderts wuchs die Stadt schneller als je zuvor und so beschlossen die Stadtplaner 1811, die ganze Insel Manhattan, von der nur die Südspitze bebaut war, mit einem rasterförmigen Straßennetz zu überziehen, das zugleich die Grundlage für die heutige Stadtstruktur bildet. Die einzige Ausnahme war und ist bis heute der Broadway.

Anfang des 20. Jahrhunderts entstanden die ersten Wolkenkratzer, die zum Sinnbild der Stadt wurden, wie das Woolworth Building und vor allem später das Empire State Building. Böse Zungen behaupten sogar, dass diese vibrierende Stadt seit den 50er Jahren von seinem kulturellen und architektonischen Erbe lebt, wie beispielsweise dem Seagram Building, das nach Plänen des Architekten Mies van der Rohe errichtet wurde, oder auch dem UN-Hauptquartier, und dass seitdem kaum innovative, futuristische und gewagte Projekt umgesetzt wurden.

Im Spätsommer 2001 erlebte New York seinen schwärzesten Tag, als das World Trade Center (WTC) bei den Terroranschlägen am 11. September 2001 zerstört wurde. An der Stelle des WTC soll nun der Freedom Tower – nach Vorlagen des amerikanisch-polnischen Architekten Daniel Libeskind – erbaut werden. Im Mai 2002 waren die Aufräumarbeiten auf Ground Zero beendet und die Stadt begann, mit einer Vielzahl überaus innovativer Projekte wie der Erweiterung des MoMA, wieder in die Zukunft zu blicken.

Dies lässt sich auch bei näherer Betrachtung der New Yorker Design-Szene feststellen, die zudem durch die Überschneidung der verschiedenen kreativen Bereiche wie Innenarchitektur, Produktdesign, Mode, Architektur, Film und Grafik charakterisiert ist.

Neue Designer wollen nicht nur Schöpfer sein, sondern sie verwandeln sich in eigenständige Produzenten. Dank der Informatik kontrollieren sie den Produktionsprozess vom Schreibtisch aus bis hin zum fertigen Produkt und sind dementsprechend experimentell und unabhängig. Auch in Sachen Mode ist New York sowohl Mekka als auch Trendsetter. Berühmte Designer wie Donna Karan und Calvin Klein haben weltweit Trends gesetzt und eine neue Riege junger Designer präsentiert mit großer internationaler Resonanz ihre Kollektionen auf der New Yorker Modewoche im Battery Park in Manhattan.

Die hier versammelten Beispiele zeigen einmal mehr, dass New York beileibe nicht schläft, sondern auch weiterhin Trendsetter der internationalen Architektur- und Designszene ist.

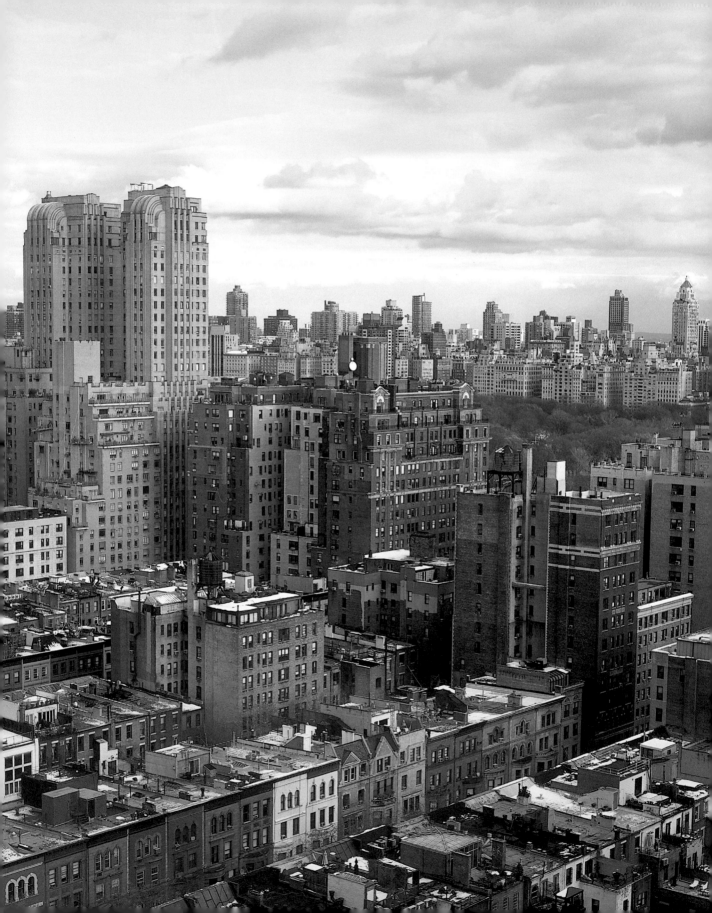

Introduction

Delicious New York

New York passe pour la métropole par excellence. Porte d'entrée pour le continent américain, mégapole bouillonnante de vie, elle est de nos jours, depuis sa fondation il y a 400 ans, le centre du monde des finances et de la création. A l'aube du XIXe siècle, l'essor de la ville s'accentue plus que jamais. Par conséquent, en 1811, alors que seule la pointe sud est construite, les urbanistes décident de quadriller toute l'île de Manhattan d'un réseau de rues, base de la structure actuelle. Broadway étant la seule exception, hier comme aujourd'hui.

Au début du XXe siècle, les premiers gratte-ciels qui surgissent à l'horizon, s'érigent en symbole de la ville, à l'image du Woolworth Building et, plus tard, de l'Empire State Building. Certaines mauvaises langues vont même jusqu'à dire que cette ville palpitante, se repose, depuis les années cinquante, sur son héritage architectural et culturel, à l'instar du Seagram Building, érigé d'après les plans de l'architecte Mies van der Rohe, ou du quartier général de l'ONU. Depuis lors, presque aucun projet innovant, futuriste ou audacieux n'aurait vu le jour.

A la fin de l'été 2001, New York vit son jour le plus sombre, lors de la destruction du World Trade Center (WTC), par les attentats terroristes du 11 septembre 2001. Le WTC va être désormais remplacé par la Freedom Tower – érigé d'après les plans de Daniel Libeskind, architecte américain d'origine polonaise. En Mai 2002, les derniers travaux de déblayage de Ground Zero se terminent et la ville, forte d'un grand nombre de projets extrêmement innovants, comme l'extension du MoMA, recommence à tourner ses regards vers l'avenir.

C'est également ce que l'on peut observer sur la scène du design new-yorkais, qui égraine un chapelet de créations diverses, déclinant design d'intérieur, design de produit, mode, architecture, cinéma et art graphiques.

Les nouveaux designers ne se contentent pas d'être uniquement créateurs, mais veulent être aussi producteurs autonomes. Grâce à l'informatique, ils contrôlent le processus de production depuis leur bureau jusqu'au produit fini, gagnant ainsi en expérience et indépendance. New York, devenu également la Mecque de la mode, donne le ton à l'échelon mondial, en matière de tendances, avec les grands noms du design, à l'instar de Donna Karan et Calvin Klein. Une nouvelle équipe de jeunes designers fait déjà parler d'elle sur la scène internationale, avec la présentation de sa collection lors de la semaine de la mode de New York dans le Battery Park de Manhattan.

Les exemples réunis dans cet ouvrage, montrent, une fois de plus, que New York n'est vraiment pas « la Belle au Bois dormant », mais reste le protagoniste des nouvelles tendances sur la scène internationale du design et de l'architecture.

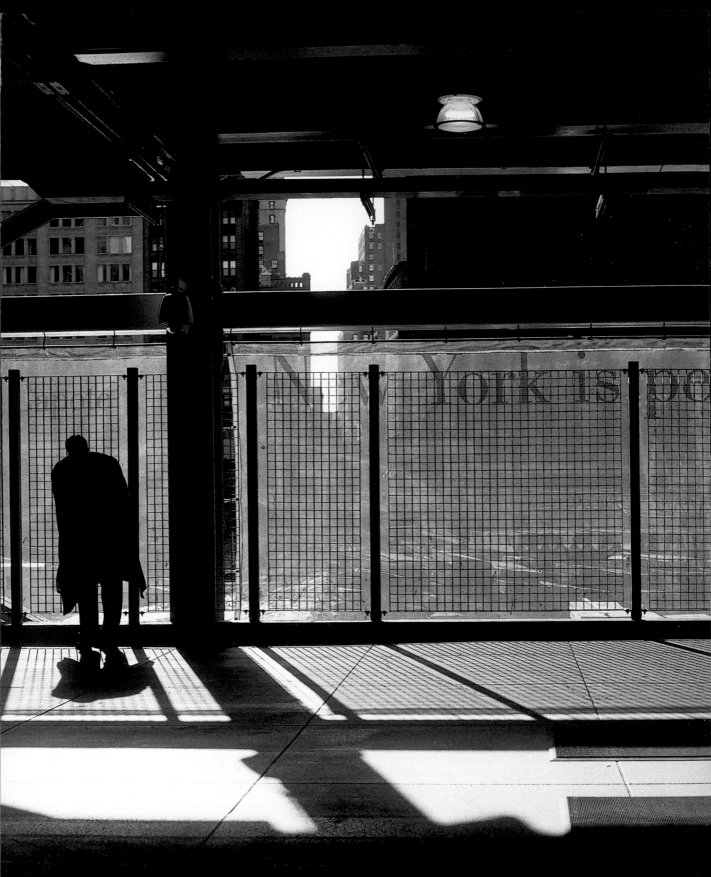

Introducción

Delicious New York

Nueva York es la metrópoli por excelencia. Como puerta de entrada al continente americano, esta gran ciudad de ritmo trepidante no ha cesado de evolucionar desde su fundación hace 400 años hasta convertirse en el centro financiero y creativo del mundo. A principios del s. XIX la ciudad creció con una velocidad hasta entonces nunca vista, de forma que los responsables de urbanismo decidieron en 1811 cubrir la isla de Manhattan, de la que solo estaba edificada el extremo sur, con una cuadrícula de calles que constituye la base de la estructura actual de la ciudad. La única excepción fue, y sigue siendo, Broadway. A principios del s. XX se construyeron los primeros rascacielos que se convirtieron en el símbolo de la ciudad, como el Woolworth Building y más adelante el Empire State Building. Las malas lenguas afirman incluso que esta ciudad vibrante vive de la herencia cultural y arquitectónica de la década de los 50, como por ejemplo el Seagram Building, erigido según los planos del arquitecto Mies van der Rohe, o la sede central de la ONU, y que desde entonces ya no se ha visto ningún proyecto innovador, futurista y arriesgado.

A finales del verano del 2001, Nueva York vivió el día más negro de su historia, cuando los atentados terroristas del 11 de septiembre de 2001 destruyeron el World Trade Center (WTC). En su lugar, se construirá la Torre de la Libertad (Freedom Tower), proyectada por el arquitecto estadounidense de origen polaco Daniel Libeskind. En mayo de 2002 finalizaron los trabajos de desescombro de la Zona Cero y la ciudad empezó a mirar de nuevo hacia el futuro con un gran número de proyectos innovadores, como la ampliación del MoMA.

Este giro también se constata cuando se observa de cerca los círculos neoyorquinos del diseño, que además se caracterizan por la intersección de distintas áreas creativas como el diseño interior, el diseño industrial, la moda, la arquitectura, la producción audiovisual y las artes gráficas.

Los nuevos diseñadores no solo quieren ser creadores, sino que se convierten en productores independientes. Gracias a la informática, controlan desde su escritorio la cadena de producción hasta el producto final y consiguen así experimentar y ser autónomos. También en cuestión de moda, Nueva York es punto de obligada referencia y marca tendencias. Diseñadores de renombre como Donna Karan y Calvin Klein han marcado tendencias en todo el mundo y una nueva hornada de jóvenes diseñadores presenta sus colecciones en la semana de la moda neoyorquina que se celebrada en el Battery Park de Manhattan con gran eco internacional.

Los ejemplos que se reúnen en esta obra muestran una vez más que Nueva York realmente nunca duerme, sino que sigue marcando tendencias en el panorama internacional de la arquitectura y del diseño.

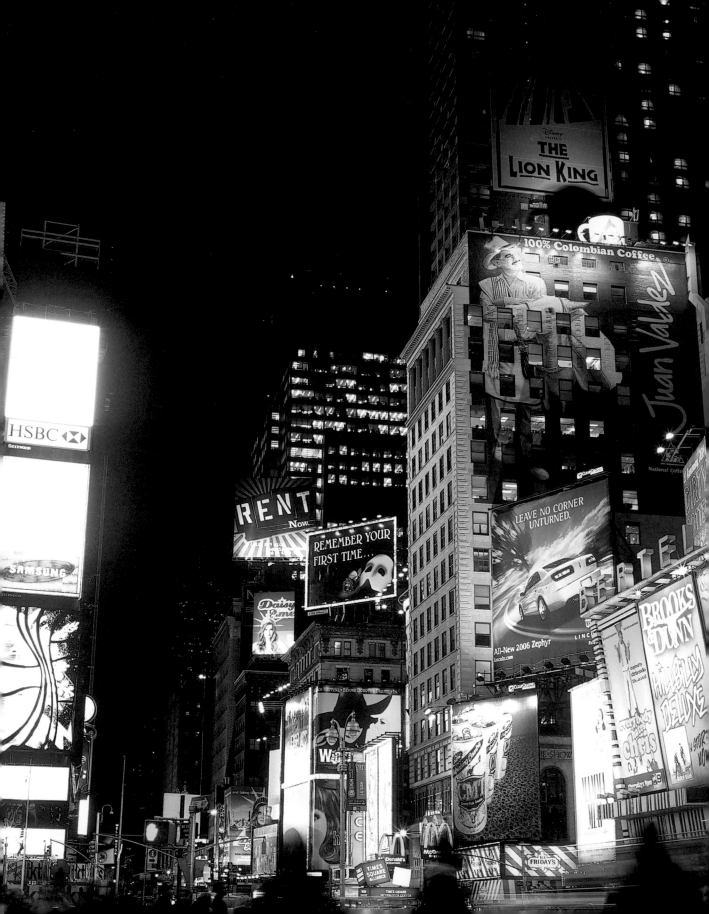

Introduzione

Delicious New York

New York è di per se il simbolo di una metropoli. Da porta di entrata del continente americano, questa città vitale si è trasformata a partire dalla sua fondazione 400 anni fa nell'attuale centro del mondo finanziario e creativo. All'inizio del XIX secolo la città è cresciuta come mai fino ad allora e per questo motivo gli ingegneri civili hanno deciso nel 1811 di dotare l'intera isola di Manhattan, di cui sino ad allora soltanto la punta meridionale era coperta di edifici, di una rete di strade in una struttura a griglia, che è diventata poi la base del disegno urbano attuale. L'unica eccezione era ed è ancora la via Broadway. All'inizio del XX secolo sono sorti i primi grattacieli, che sono poi diventati un simbolo della città, come quello della Woolworth e soprattutto in seguito l'Empire State Building. Cattive lingue sostengono tra l'altro che questa città piena di vita, a partire dagli anni '50 avrebbe continuato a vivere della sua eredità culturale e architettonica, come ad esempio il Seagram Building, costruito su progetto dell'architetto Mies van der Rohe, o anche il quartiere generale dell'ONU e che da allora siano stati portati a termine ben pochi progetti innovativi, futuristici e coraggiosi.

Verso la fine dell'estate del 2001 New York visse il suo giorno più nero, quando il World Trade Center (WTC) fu distrutto dagli attacchi terroristici dell'11 settembre 2001. Al posto del WTC dovrebbe ora essere costruita la Freedom Tower, sulla base dell'architetto americano-polacco Daniel Libeskind. Nel Maggio del 2002 i lavori di eliminazione delle macerie a Ground Zero sono terminati e la città ha nuovamente iniziato a guardare al futuro con un gran numero di progetti innovativi come l'ampliamento del MoMA.

Ciò è deducibile anche da un'osservazione più attenta dell'ambiente del design di New York, che è caratterizzato dalla sovrapposizione di diversi ambienti creativi come l'architettura di interno, il design di produzione, la moda, l'architettura, il cinema e la grafica.

I nuovi designer non sono semplicemente creatori, ma si occupano anche della produzione. Grazie all'informatica, essi sono in grado di controllare il processo di produzione dalla loro scrivania fino al prodotto finito e sono quindi indipendenti e aperti a nuove esperienze. Anche nel settore della moda New York è sia una Mecca, sia un luogo di creazione. Designer famosi come Donna Karan o Calvin Klein hanno imposto il loro marchio nel mondo intero e una nuova generazione di giovani designer presentano con grande risonanza le proprie collezioni durante la settimana dedicata alla moda nel Battery Park di Manhattan.

Gli esempi qui raccolti ci mostrano una volta di più, che non solo New York non sta dormendo, ma che continua anche ad essere un luogo di creazione di trend di architetti e designer internazionali.

Architecture

Steven Holl Architects

Polshek Partnership Architects

Taniguchi and Associates

Tod Williams Billie Tsien & Associates

1100 Architect

FXFOWLE Architects

Archi-Tectonics

Richard Meier & Partners Architects

LOT-EK

SOM – Skidmore, Owings & Merrill

Rafael Viñoly Architects

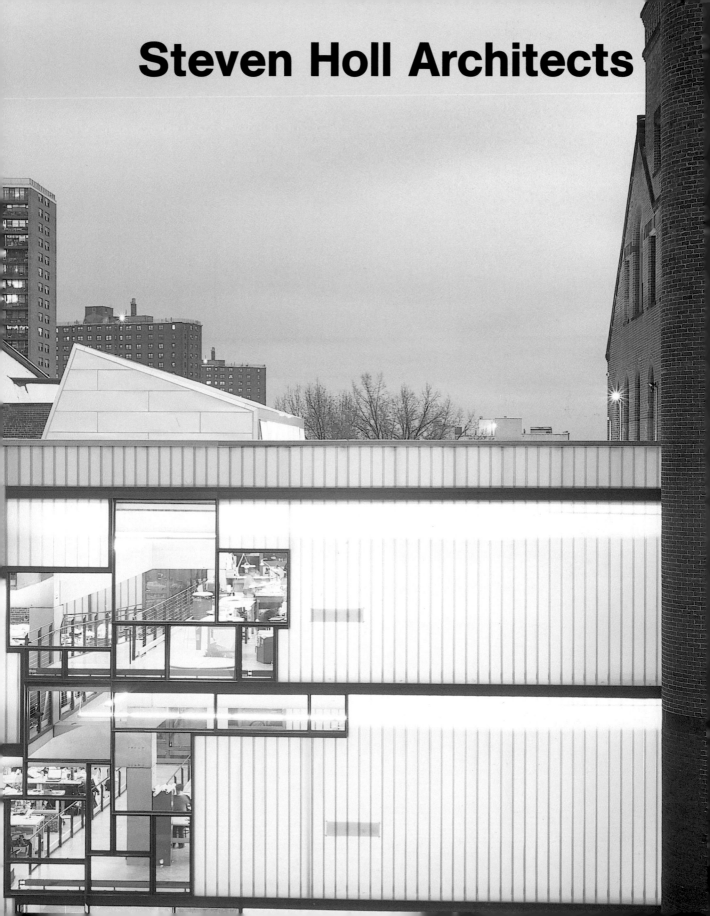

Steven Holl Architects

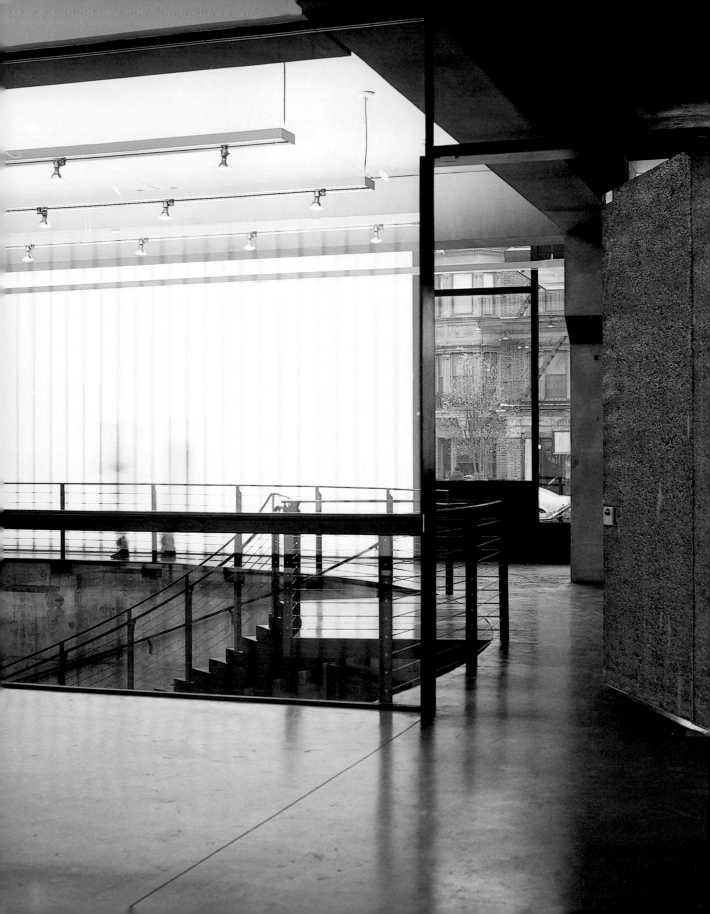

Steven Holl Architects

450 West 31st Street, 11th Floor, New York, NY 10001, USA

+1 212 629 7262

+1 212 629 7312

www.stevenholl.com

mail@stevenholl.com

Steven Holl

Steven Holl was born 1947 in Bremerton and completed his studies in 1970 at the University of Washington. In 1976, he opened his office in New York. Holl became famous for the Kiasma Museum of Contemporary Art in Helsinki as well as the student dormitory, Simmons Hall at the Massachusetts Institute of Technology.

Steven Holl wurde 1947 in Bremerton geboren und schloss sein Studium 1970 an der University of Washington ab. 1976 eröffnete er sein Büro in New York. Bekannt wurde Holl vor allem durch das Museum of Contemporary Art Kiasma in Helsinki sowie das Studentenwohnheim Simmons Hall am Massachusetts Institute of Technology.

Steven Holl, né en 1947 à Bremerton, termine ses études en 1970 à l'université de Washington. En 1976, il ouvre son bureau à New York. Holl s'est fait connaître surtout par le Museum of Contemporary Art Kiasma à Helsinki ainsi que par la cité universitaire de Simmons Hall à l'Institute of Technology de Massachusetts.

Steven Holl nació en Bremerton en el año 1947 y finalizó sus estudios en la University of Washington en 1970. El año 1976 abrió su oficina en Nueva York. Alcanzó la popularidad, en especial, por el Museum of Contemporary Art Kiasma de Helsinki, así como la residencia estudiantil Simmons Hall en el Massachusetts Institute of Technology.

Steven Holl nacque nel 1947 a Bremerton e terminò i suoi studi nel 1970 all'Università di Washington. Nel 1976 aprì il suo ufficio a New York. Holl diventò famoso soprattutto grazie al Museum of Contemporary Art Kiasma di Helsinki e alla residenza studentesca Simmons Hall del Massachusetts Institute of Technology.

1947
Born in Bremerton, Washington, USA

1970
Graduated from the University of Washington, USA

1976
Established his office Steven Holl Architects in New York, USA

Since 1981
Professor at Columbia University's Graduate School of Architecture and Planning, New York, USA

1998
Alvar Aalto Medal, The Kiasma Museum of Contemporary Art in Helsinki, Finland
Chrysler Award for Innovation in Design

2002
National Design Award in Architecture from the Cooper Hewitt National Design Museum

2003
Simmons Hall at Massachusetts Institute of Technology, Cambridge, USA
Honorary Fellow of the Royal Institute of British Architects, UK

Interview | Steven Holl
Architects

What do you consider the most work of your career? All are equally important.

In what ways does New York inspire your work? While other cities seem to sit on the ground, New York City is vertical, much more of a city in section than a city in plan. Urban planners never seem to engage the sectional energetic possibilities of New York City.

Does a typical New York style exist, and if so, how does it show in your work? Now we are building Beijing Linked Hybrid. The eight 22 story towers will be linked with a zigzag bridges connecting public programs on the upper levels. New York City in my future vision would have a great variety of sectional inventions and new urban experiences.

How do you imagine New York in the future? The dense pack metropolis of New York City requires public space at the top, on different levels above the street in sectional space, in order to further evolve the potential of a 21st century metropolitan city.

Was halten Sie für die wichtigste Arbeit in Ihrer Karriere? Sie sind alle gleich wichtig.

Auf welche Weise inspiriert New York Ihre Arbeit? Während andere Städte geradezu am Erdboden kleben, ist New York City vertikal konzipiert: mehr in Auf- als in Grundrissen gegliedert. Städteplaner vernachlässigen oft diese nach Sektionen ausgerichteten dynamischen Möglichkeiten von New York City.

Gibt es einen typischen New Yorker Stil und wenn ja, wie zeigt sich das in Ihrer Arbeit? Derzeit bauen wir den Beijing Linked Hybrid. Die acht 22-stöckigen Türme des Gebäudekomplexes werden durch zickzackartige Brücken verlinkt und verbinden auf diese Weise die oberen Stockwerke. In meiner Zukunftsvision von New York sehe ich viele verschiedene, nach Sektionen unterteilte Neugestaltungen und neue urbane Erfahrungswerte.

Wie stellen Sie sich New York in der Zukunft vor? Die dicht gedrängte Metropole New York muss sich öffentlichen Raum über den Dächern schaffen. Auf verschiedenen, sektionsweise ausgerichteten Ebenen. Nur so kann sie als Weltstadt des 21sten Jahrhunderts ihr volles Potential ausschöpfen.

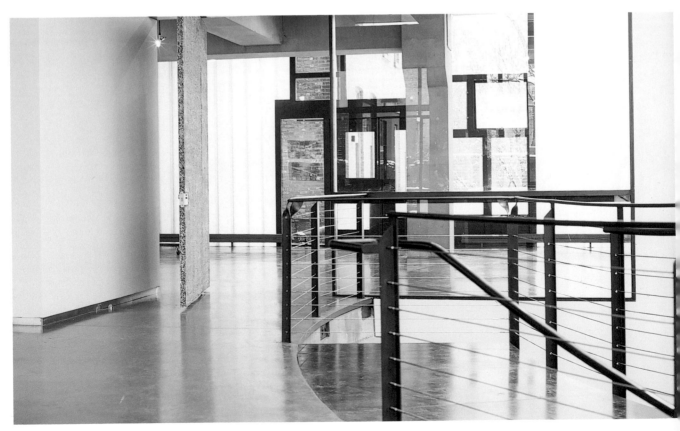

Quelle est l'œuvre la plus importante de votre carrière ? Elles ont toutes la même importance.

Dans quelle mesure la ville de New York inspire-t-elle votre œuvre ? Alors que d'autres cités semblent rester au ras de la terre, la ville de New York s'élance vers le ciel. C'est davantage une cité perpendiculaire qu'une ville linéaire. Toutefois, les urbanistes ne semblent pas exploiter à fond toutes le potentiel de construction verticale de la ville de New York.

Peut-on parler d'un style typiquement new-yorkais, et si oui, comment se manifeste-t-il dans votre œuvre ? Actuellement nous construisons le Linked Hybrid de Pékin. Les huit tours de 22 étages seront reliées par des ponts en zigzag pour rejoindre les programmes publics des niveaux supérieurs. J'imagine la ville de New York de demain forte d'une grande diversité de réalisations verticales et de nouvelles expériences sur le plan urbanistique.

Comment imaginez-vous le New York de demain ? La ville de New York City est une métropole dont la densité exige de créer des espaces publics en hauteur, sur différents niveaux au-dessus des rues, à la verticale, afin d'optimiser le potentiel qu'offre une métropole du XXIe siècle.

¿Cuál es el trabajo que considera más importante en su carrera? Todos tienen igual importancia.

¿De qué manera Nueva York supone una inspiración en su trabajo? Mientras que otras ciudades parecen asentarse sobre el suelo, la ciudad do Nuova York oc vortical, una ciudad más en la sección que en el plano. Los urbanistas no parecen captar las posibilidades energéticas seccionales de la ciudad de Nueva York.

¿Existe un estilo típico neoyorquino y, si es así, cómo se revela en su obra? Actualmente estamos construyendo el Linked Hybrid en Pekín. Las ocho torres de 22 plantas estarán unidas mediante puentes en zigzag que conectan programas públicos en los niveles superiores. En mi visión futura, la ciudad de Nueva York tendría una gran variedad de invenciones seccionales y nuevas experiencias urbanas.

¿Cómo se imagina Nueva York en el futuro? La densa metrópolis de la ciudad de Nueva York requiere espacio público a nivel superior, a distintos niveles sobre la calle en espacio seccional, para poder desarrollar el potencial de una ciudad metropolitana del siglo XXI.

Cosa pensa che sia il lavoro più importante della sua carriera? Sono tutti ugualmente importanti.

In che modo New York influenza il Suo lavoro? Mentre altre città sembrano poste appoggiate al suolo, New York è verticale; rappresentabile molto di più con plastico in rilievo di una città, che una piantina di carta. I pianificatori urbani di New York sembrano non volere intaccare mai le caratteristiche di sezione di questa città.

Esiste uno stile tipico a New York? Se sì, come influenza il Suo lavoro? Ora stiamo costruendo il Beijing Linked Hybrid di Pechino. Le otto torri di 22 piani saranno collegate da una serie di ponti a zigzag, per la connessione di uffici pubblici ai piani superiori. New York City nella mia visione futura avrà moltissime sezioni inventive e una nuova esperienza urbana.

Come si immagina New York in futuro? La densa metropoli urbana di New York ha bisogno di spazi pubblici alla sua sommità, a diversi livelli sopra le strade e nello spazio sezionale, per poter evolvere le potenzialità di una città metropolitana del 21 secolo.

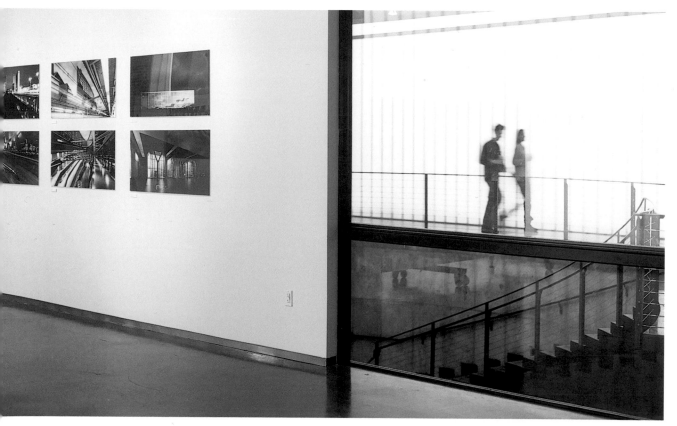

Steven Holl Architects 23

Higgins Hall Center Section at Pratt Institute

Year: 2005

Photographs: © Gogortza & Llorella, Mark Heitoff (portrait)

The new Higgins Hall Center Section was inserted between two already existing buildings at Pratt Institute and thereby connects the north and south wings of the architecture faculty for the first time. In order to match the different heights of the adjacent buildings in this new section, asymmetrical zones in the center were created, which appear on the transparent external façade and are compensated on the inside by ramps.

Die neue Higgins Hall Center Section wurde zwischen zwei bereits bestehenden Gebäuden des Pratt Institute eingefügt und verbindet so zum ersten Mal den Nord- und Südflügel der Architekturfakultät. Um die unterschiedlichen Höhen der angrenzenden Gebäude in diesem neuen Abschnitt anzugleichen, wurden asymmetrische Zonen im Zentrum geschaffen, die sich auf der transparenten Außenfassade abzeichnen und im Inneren durch Rampen kompensiert werden.

La nouvelle Higgins Hall Center Section s'insère entre deux édifices préexistants du Pratt Institute, reliant ainsi pour la première fois les ailes nord et sud de la faculté d'architecture. L'adaptation des différents niveaux des bâtiments côtoyant cette nouvelle partie est réalisée par le biais de zones asymétriques au centre, qui se dessinent sur les façades extérieures et sont compensées à l'intérieur par des rampes.

La nueva Higgins Hall Center Section se integró entre dos edificios ya existentes del instituto Pratt y comunica por primera vez el ala norte y sur de la facultad de arquitectura. Para igualar las diferentes alturas de los edificios colindantes, se crearon zonas asimétricas en el centro, que se perfilan en la fachada exterior transparente y se compensan en el interior con rampas.

La nuova Higgins Hall Center Section è stata inserita tra i due edifici già esistenti del Pratt Institute e riunisce per la prima volta l'ala sud e l'ala nord della facoltà di architettura. Per controbilanciare la differenza di altezza degli immobili confinati in questo nuovo settore sono state create in centro delle zone asimmetriche, che si profilano sulle facciate esterne trasparenti è che sono compensate internamente dalle rampe.

Steven Holl Architects

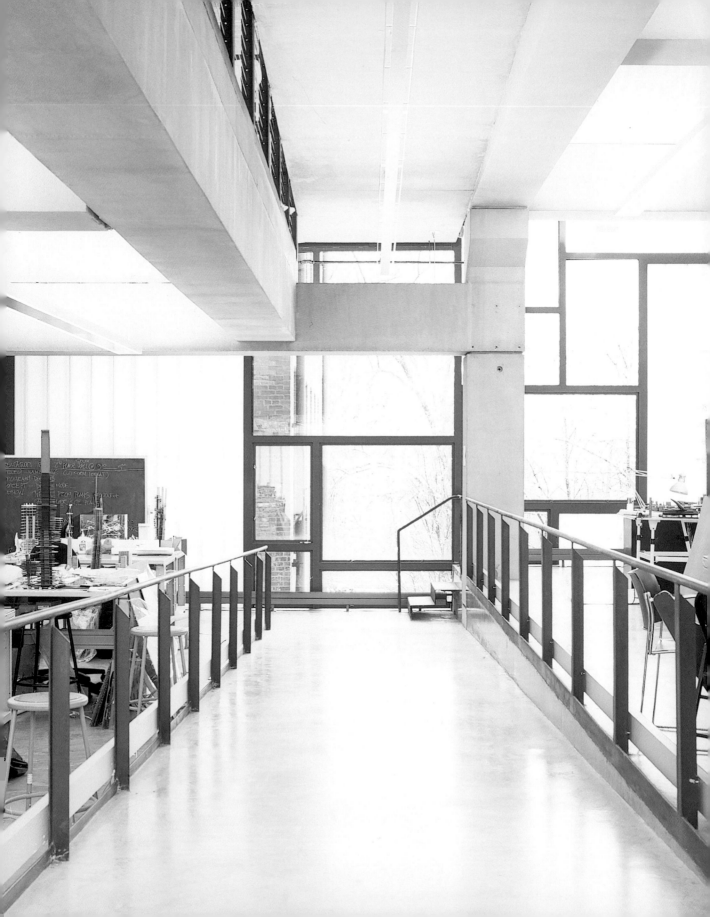

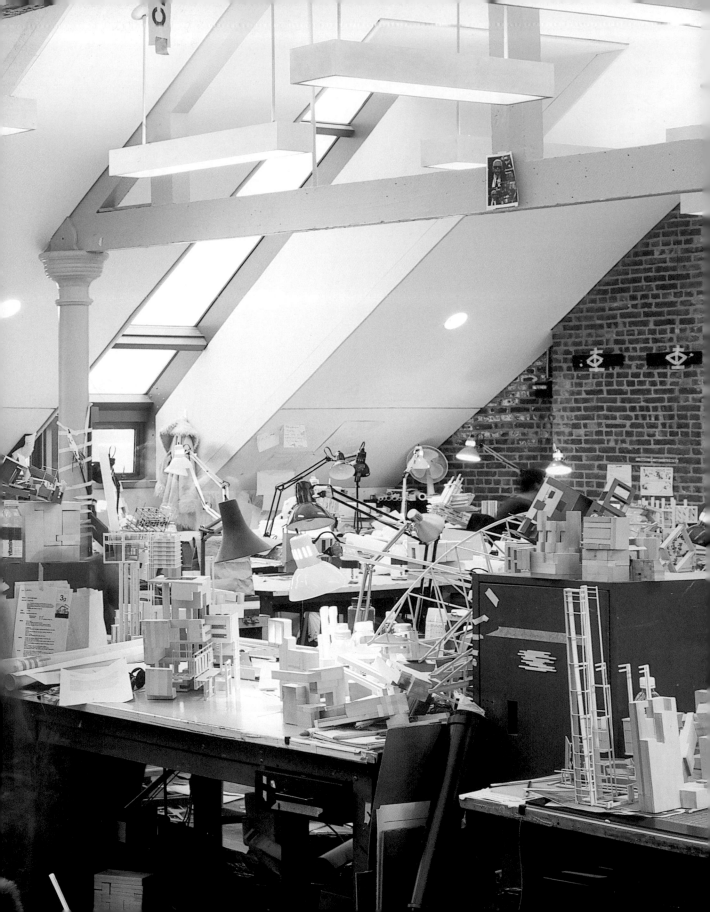

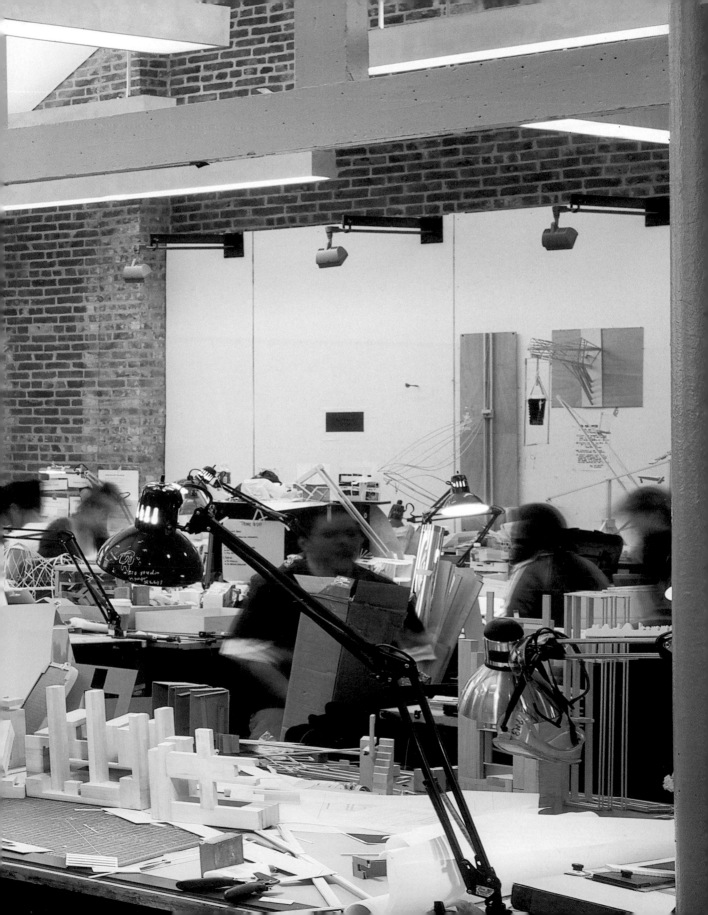

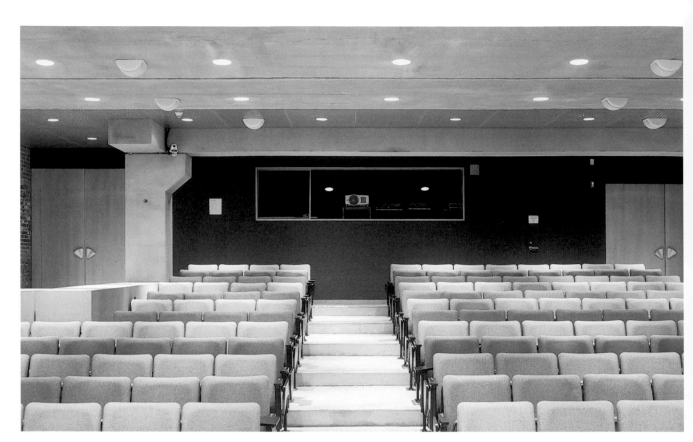

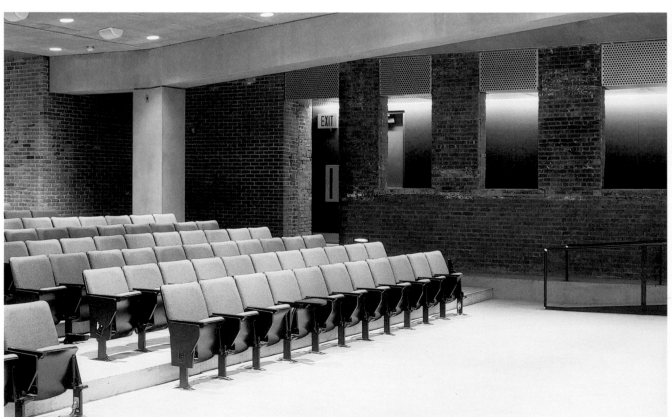

Steven Holl Architects

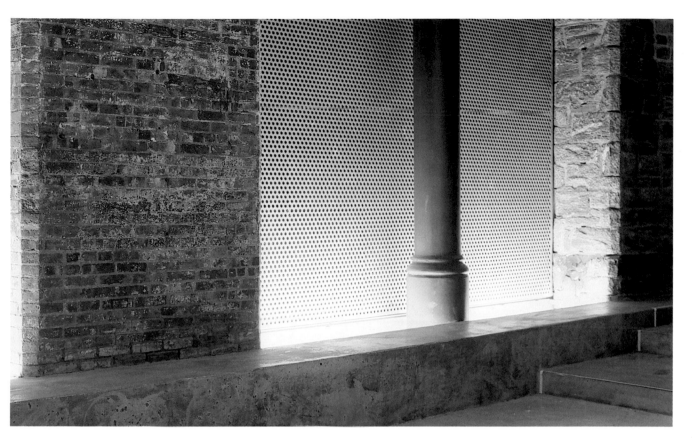

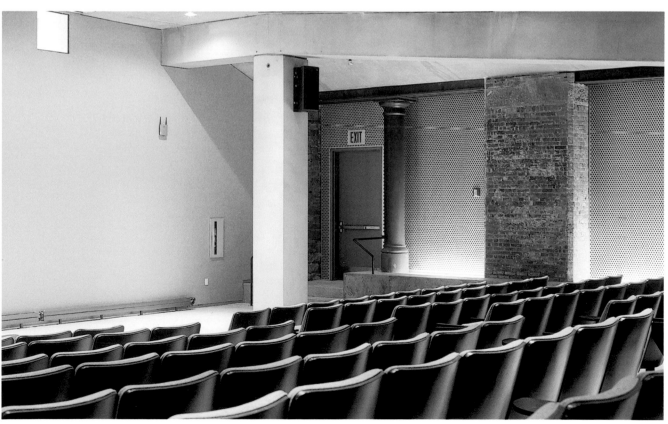

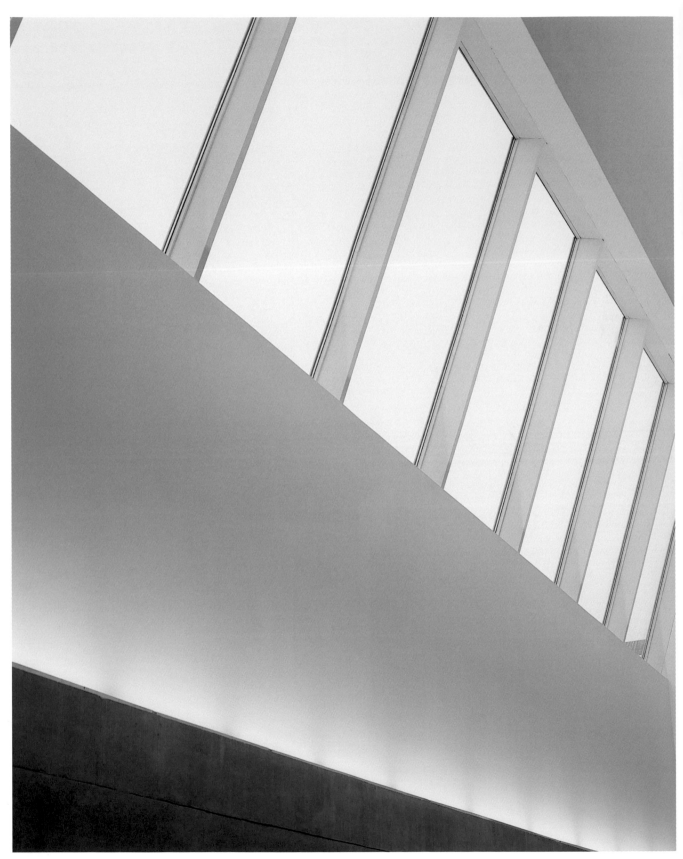

Steven Holl Architects

Ground floor

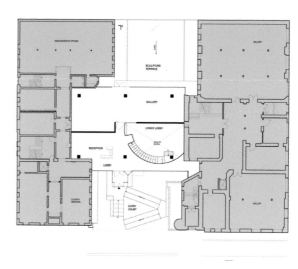

First floor

Second floor

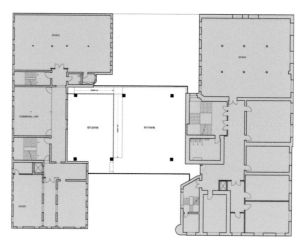

Third floor

Fourth floor

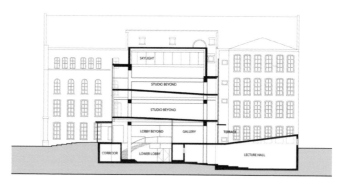

Section

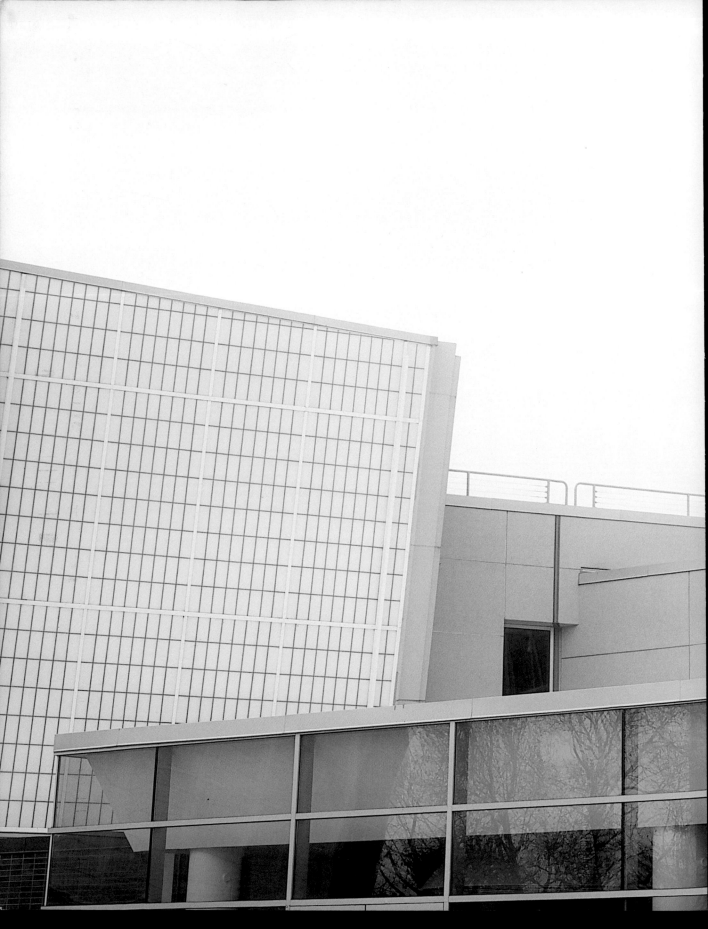

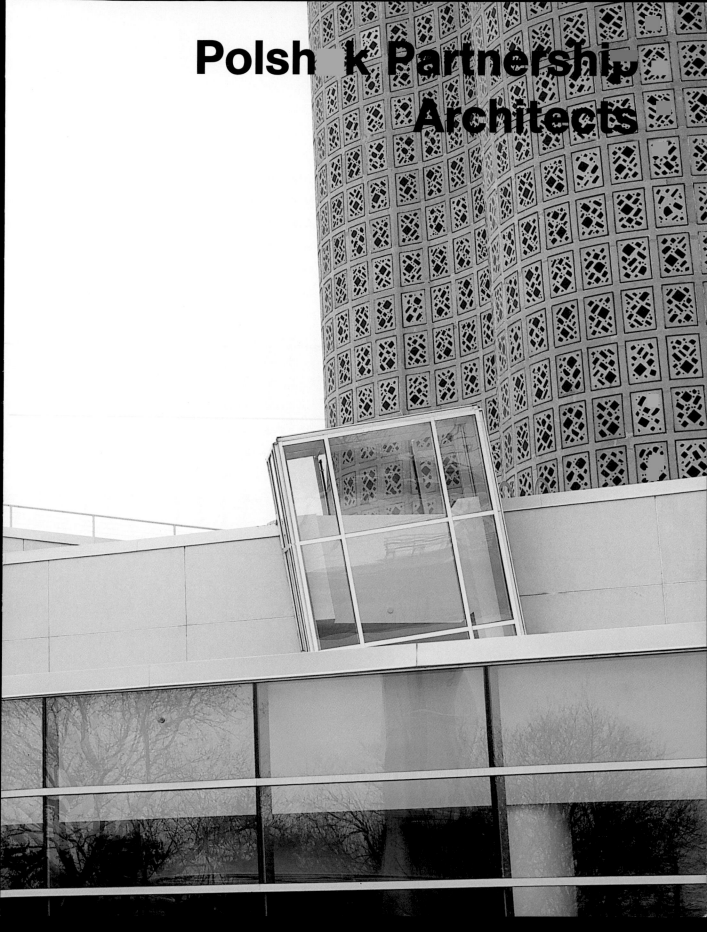

Polshek Partnership Architects

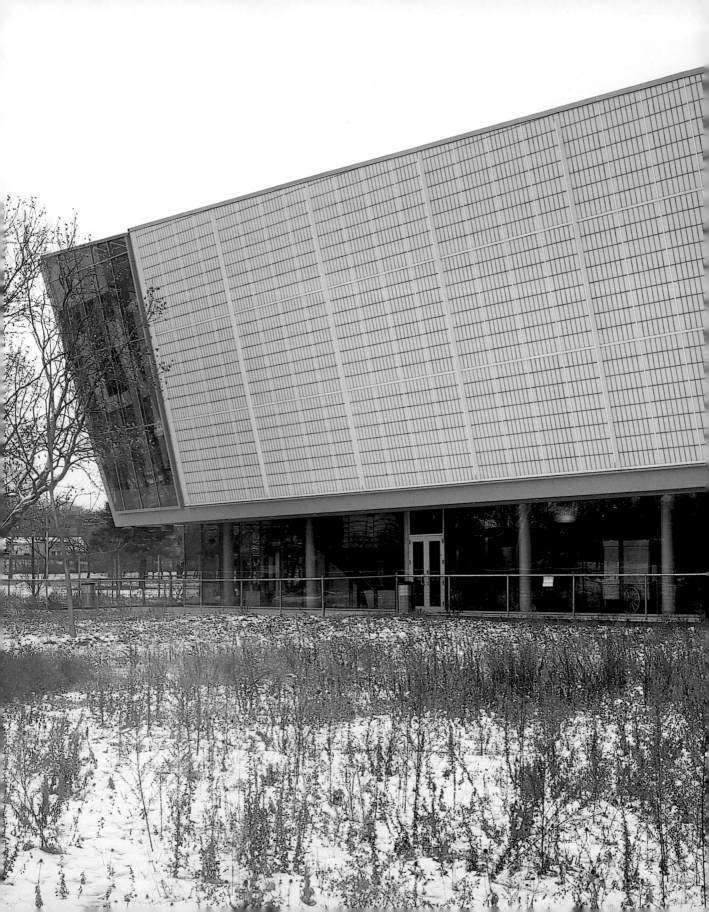

Polshek Partnership Architects

320 West 13th Street, New York, NY 10014, USA

+1 212 807 7171

+1 212 807 5917

www.polshek.com

info@polshek.com

Todd H. Schliemann

Since its founding in 1963, Polshek Partnership Architects has carried out a broad spectrum of designs, particularly in public and cultural buildings as well as education and science buildings. Using a team-oriented practice, the company and its 150 employees is known for finding architectural solutions, which are topical both technically and socially and which are designed for the long-term in their functions and in their integration into the environment.

Seit ihrer Gründung 1963 haben Polshek Partnership Architects ein breites Spektrum an Entwürfen vor allem von öffentlichen und kulturellen Gebäuden sowie Bildungs- und Wissenschaftsbauten verwirklicht. Das Unternehmen und seine 150 Mitarbeiter ist dafür bekannt, in einem gemeinschaftlichen Prozess architektonische Lösungen zu finden, die technisch und sozial zeitgemäß sind und die in ihren Funktionen und der Einbettung in die Umgebung auf Langfristigkeit angelegt sind.

Depuis sa fondation en 1963, le groupe Polshek Partnership Architects a réalisé un large éventail de projets allant des édifices publics et culturels aux bâtiments dans le secteur de l'enseignement et des sciences. L'entreprise et ses 150 collaborateurs sont réputés pour leur engagement dans un processus commun à la recherche de solutions architecturales, adaptées à la société et aux techniques actuelles, dotées de fonctions et de capacité d'intégration dans l'environnement, à long terme.

Desde su fundación en 1963, Polshek Partnership Architects ha llevado a cabo un amplio abanico de proyectos de edificios públicos y culturales, así como obras con fines educativos o científicos. La empresa y sus 150 empleados son conocidos por encontrar, en un proceso común, soluciones arquitectónicas de actualidad técnica y social y pensadas a largo plazo, tanto por su funcionalidad como por su integración en el entorno.

Sin dalla loro fondazione nel 1963 gli architetti di Polshek Partnership Architects hanno sviluppato un ampio spettro di progetti per edifici pubblici, culturali, legati all'ambiente scolastico e scientifico. L'impresa con i suoi 150 dipendenti è conosciuta per trovare soluzioni in un processo architettonico comune, che dal punto di vista tecnico e sociale si adeguino ai tempi attuali e che nelle loro funzioni siano collocate in un ambito di lunga durata.

1963
Foundation of Polshek Architects, New York, USA

1998
The Santa Fe Opera Theater, Santa Fe, Mexico

2000
Rose Center for Earth and Space, expansion of the American Museum of Natural History in New York, USA

2001
Expansion of Smithsonian Institution at Cooper-Hewitt National Design Museum, New York, USA
Scandinavia House: The Nordic Center in America, New York, USA

2003
AIA/New York Chapter President's Medal
Carnegie Hall, Judy and Arthur Zankel Hall, New York, USA

2004
Master plan, renovation and expansion of Brooklyn Museum, New York, USA
New York Hall of Science, New York, USA

Interview | Polshek Partnership Architects

What do you consider the most important work of your career? Rose Center for Earth and Space, American Museum of Natural History.

In what ways does New York inspire your work? New York's energy fuels my passion for exploration and discovery.

Does a typical New York style exist and if so, how does it show in your work? There is no typical New York style because the city is constantly changing and sponsoring invention.

How do you imagine New York in the future? The pressures to ignore responsible growth are great. New York architects must, at the same time, respond to the inevitability of development while perpetuating the energy of optimism and change.

Was halten Sie für die wichtigste Arbeit in Ihrer Karriere? Das Rose Center for Earth and Space am American Museum of Natural History.

Auf welche Weise inspiriert Sie New York? Die Energie dieser Stadt schürt meine Leidenschaft, Neues zu entdecken und zu erforschen.

Gibt es einen typischen New Yorker Stil, und wenn ja, wie zeigt sich das in Ihrer Arbeit? Einen typischen New Yorker Stil gibt es nicht, weil sich die Stadt ständig verändert und neue Ideen unterstützt.

Wie stellen Sie sich New York in der Zukunft vor? Der Druck ist groß, Verantwortung beim städtebaulichen Wachstum einfach zu ignorieren. New Yorker Architekten stehen vor der Frage, wie die unvermeidlich fortschreitende Entwicklung mit einer anhaltenden Energie von Optimismus und Veränderung in Einklang zu bringen ist.

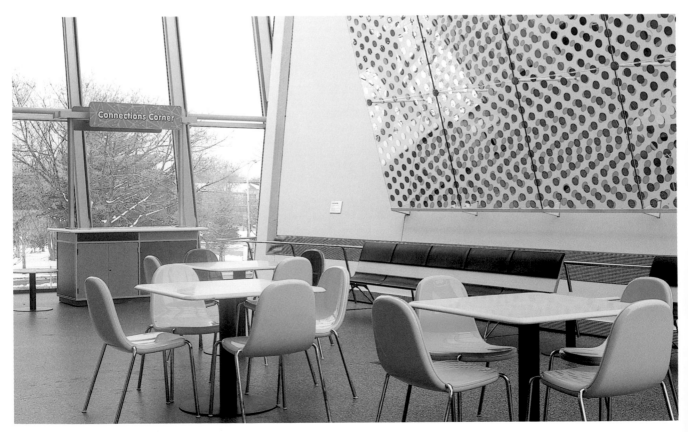

Quelle est l'œuvre la plus importante de votre carrière ? Le Rose Center for Earth and Space dans le American Museum of Natural History.

Dans quelle mesure la ville de New York inspire-t-elle votre œuvre ? L'énergie de la ville de New York alimente ma passion pour l'exploration ot la dóoouvcrtc.

Peut-on parler d'un style typiquement new-yorkais, et si oui, comment se manifeste-t-il dans votre œuvre ? Il n'y a pas de style new-yorkais à proprement parler par ce que la ville évolue constamment, et ne cesse d'encourager l'esprit d'invention.

Comment imaginez-vous le New York de demain ? Les tentations d'ignorer sa croissance réelle sont énormes. Les architectes de New York doivent, à la fois, répondre au développement inéluctable tout en perpétuant le dynamisme et l'optimisme liés à l'évolution.

¿Cuál es el trabajo que considera más importante en su carrera? El Rose Center for Earth and Space en el American Museum of Natural History.

¿De qué manera Nueva York supone una inspiración en su trabajo? La energía de Nueva York alimenta mi pasión por la exploración y el descubrimiento.

¿Existe un estilo típico neoyorquino y, si es así, cómo se revela en su obra? No existe un estilo neoyorquino típico ya que la ciudad está cambiando y auspiciando la invención constantemente.

¿Cómo se imagina Nueva York en el futuro? Las presiones para ignorar el crecimiento responsable son considerables. Al mismo tiempo, los arquitectos neoyorquinos deben dar respuesta a la inevitabilidad del desarrollo a la par que perpetúan la energía del optimismo y el cambio.

Qual è secondo Lei il progetto più importante della Sua carriera? Il Rose Center for Earth and Space in American Museum of Natural History.

In che modo la città di New York ispira il Suo lavoro? L'energia di New York accende la mia passione per l'esplorazione e la scoperta.

È possibile parlare di uno stile tipico per New York, e, se questo stile esiste, in che modo si manifesta nei Suoi lavori? No, non credo esista uno "stile tipico New York"; la città non finisce mai di cambiare e di stimolare nuove invenzioni.

Come si immagina la New York del futuro? Le pressioni che spingono a ignorare una crescita responsabile sono molto forti. Gli architetti di New York devono, allo stesso tempo, fornire risposte adeguate alla necessità della crescita, lasciando libera l'energia dell'ottimismo e della voglia di cambiamento.

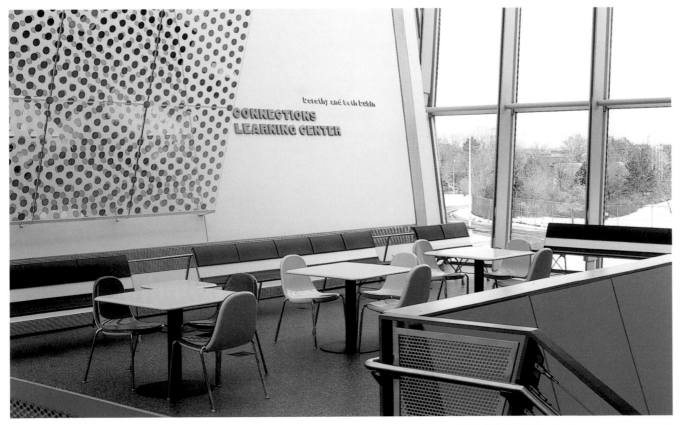

New York Hall of Science

Year: 2004
Photographs: © Gogortza & Llorella

The New York Hall of Science is the expansion of the Great Hall, originally built for the 1964 World Expo. By using transparency and a long, rectangular shape for the new building, the architects created a contrast point to the Great Hall's vertically emphasized cement structure ornamented with cobalt-blue glass panes. The rooms were spaciously designed and should also provide a significant degree of flexibility in the future.

Die New York Hall of Science ist die Erweiterung der ursprünglich für die Weltausstellung 1964 konstruierten Great Hall. Dabei schufen die Architekten durch die Transparenz und die rechteckige, lang gezogene Form des neuen Gebäudes einen Kontrapunkt zu der vertikal betonten, mit kobaltblauen Glasscherben geschmückten Zementstruktur der Great Hall. Die Räume wurden großzügig angelegt und sollen auch künftig ein großes Maß an Flexibilität ermöglichen.

La New York Hall of Science est en fait l'extension du Great Hall construit à l'origine pour l'exposition universelle de 1964. Par le biais de la transparence et de la forme carrée tout en longueur du nouvel édifice, les architectes sont parvenus à créer un contrepoint à la structure verticale en ciment recouverte de débris de verre bleu cobalt du Great Hall. Les pièces, très spacieuses, sont modulables en espaces très flexibles.

La New York Hall of Science es la ampliación de la Great Hall construida en 1964 con motivo de la exposición universal. Sirviéndose de la transparencia y de la forma rectangular y alargada del nuevo edificio, los arquitectos crearon un contrapunto de la Great Hall, con su estructura de cemento marcadamente vertical y adornada con fragmentos de vidrio azul cobalto. Los espacios son generosos y pretenden proporcionar grandes dosis de flexibilidad también en el futuro.

La New York Hall of Science è l'ampliamento del Great Hall, originariamente costruito per l'esposizione universale del 1964. Approfittando della trasparenza, della geometricità e delle forme allungate del nuovo stabile, gli architetti crearono un contrasto con la struttura del Great Hall, disegnando una struttura verticale e ornata con frammenti di vetro di colore blu cobalto. Le stanze sono state impostate generosamente e permetteranno anche in futuro una grande flessibilità.

Polshek Partnership Architects

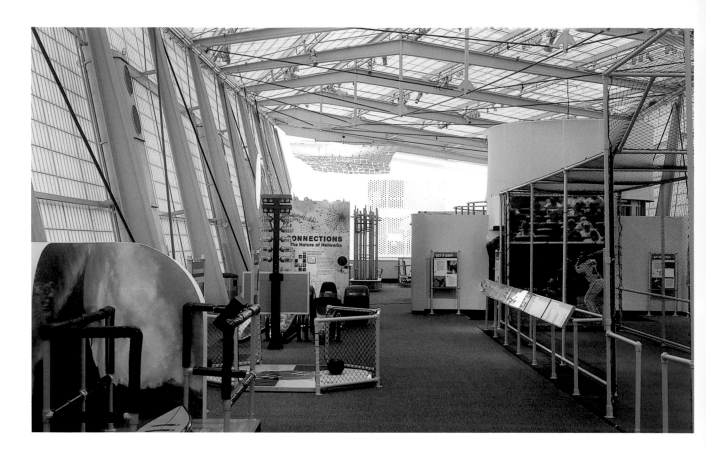

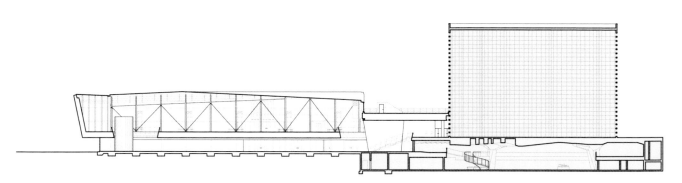

Longitudinal section

Polshek Partnership Architects

Site plan

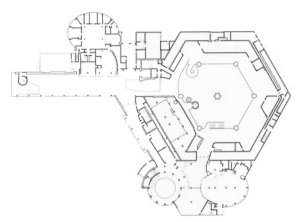

First floor

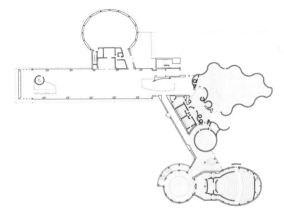

Second floor

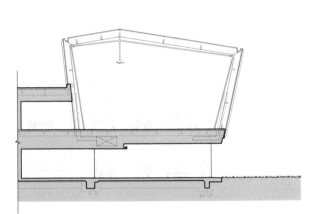

Section

Axonometric view

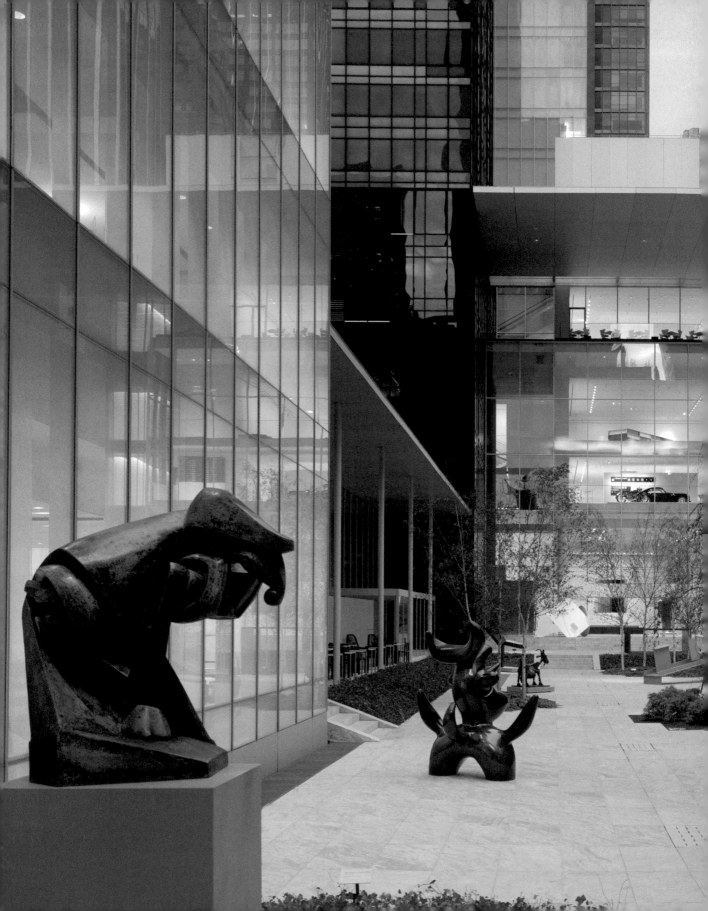

Taniguchi and Associates

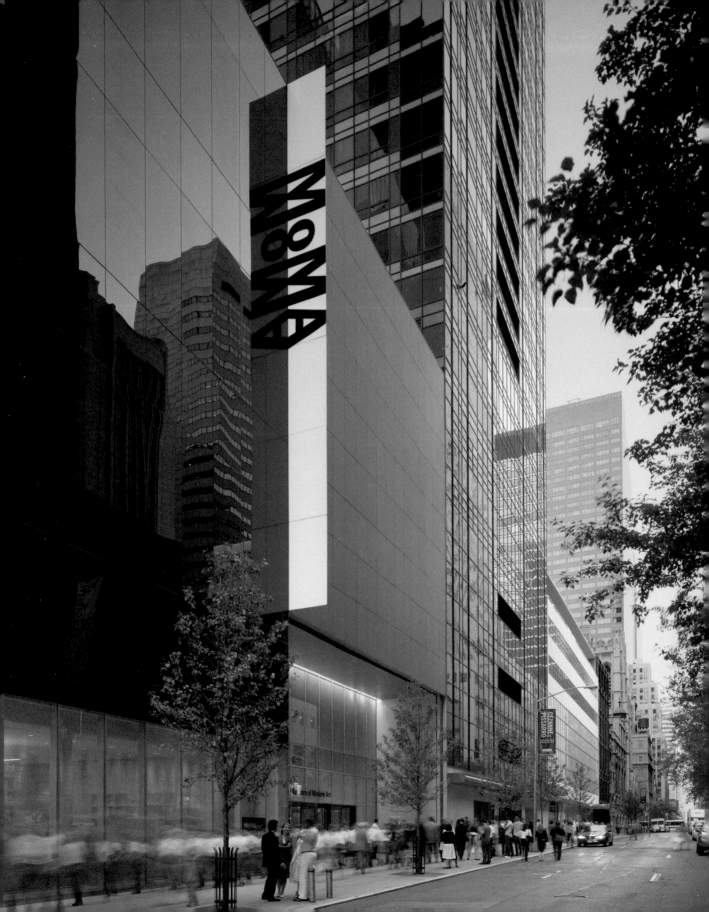

Taniguchi and Associates

4-1-40 Toranomon, to-ku, Tokyo 105-0001, Japan

+81 3 3438 1506

+81 3 3438 1248

Before establishing his office in Tokyo, the Japanese architect Yoshio Taniguchi had the opportunity to work with important people such as Walter Gropius and Kenzo Tange. Since then, he has designed and built a multitude of buildings, above all museums. In 1997, Yoshio Taniguchi received international acclaim for winning and converting the MoMA (Museum of Modern Art) in New York.

Vor der Gründung seines Büros in Tokyo konnte der japanische Architekt Yoshio Taniguchi mit so bedeutenden Persönlichkeiten wie Walter Gropius und Kenzo Tange zusammen arbeiten. Seitdem hat er eine Vielzahl von Bauwerken, vor allem Museen, verwirklicht. 1997 erlangte Yoshio Taniguchi internationale Anerkennung, als er den für das MoMA (Museum of Modern Art) in New York ausgeschriebenen Wettbewerb gewann und umsetzte.

Avant la création de son cabinet d'architecture de Tokyo, l'architecte japonais Yoshio Taniguchi collabore avec les grands noms de l'architecture, comme Walter Gropius et Kenzo Tange. Depuis lors, il a réalisé un grand nombre d'édifices, surtout des musées. En 1997, sélectionné lauréat du concours pour la modernisation du MoMA (Museum of Modern Art) à New York, et commanditaire du projet, Yoshio Taniguchi acquit alors une renommée internationale.

Antes de fundar su estudio en Tokyo, el arquitecto japonés Yoshio Taniguchi tuvo ocasión de trabajar con personalidades de tal calibre como Walter Gropius y Kenzo Tange. Desde entonces, ha llevado a cabo un gran número de obras, sobre todo museos. En 1997, Yoshio Taniguchi recibió el reconocimiento internacional al ganar y llevar a término el concurso para el MoMA (Museum of Modern Art) en Nueva York.

Prima dell'apertura del suo studio a Tokyo, l'architetto giapponese Yoshio Taniguchi a potuto lavorare insieme a personalità di rilievo come Walter Gropius e Kenzo Tange. Da allora ha realizzato un gran numero di edifici, soprattutto musei. Nel 1997 Yoshio Taniguchi ottenne riconoscimento internazionale partecipando e vincendo il concorso indetto per il MoMA (Museum of Modern Art) di New York.

Yoshio Taniguchi

1937
Born in Tokyo, Japan

1964
Master in Architecture, Harvard University, Cambridge, Massachusetts

1979
President of Taniguchi and Associates, Tokyo, Japan

1990
Higashiyama Kaii Gallery, Nagano City, Japan

1991
Marugame Genichiro-Inokuma Museum of Contemporary Art and Marugame City Library, Marugame, Japan

1995
Toyota Municipal Museum of Art, Toyota City, Japan

1999
The Gallery of Horyuji Treasures, Tokyo National Museum, Tokyo, Japan

2004
Museum of Modern Art (MoMA) in New York, USA

Interview | Taniguchi and Associates

Which do you consider the most important work of your career? Hopefully my next project will be the most important project of my career.

In what ways does New York inspire your work? For MoMA, I drew inspiration from New York, a city which I love. I had also worked with many interesting people, all of whom enriched my project in many ways.

Does a typical New York style exist, and if so, how does it show in your work? The diverse architecture within the city constitutes an overall cityscape. In MoMA, architectural openings were strategically placed to frame the cityscape, to remind the visitors that they are viewing the artworks not just in any city—but in New York.

How do you imagine New York in the future? The grid system in New York will be fully implemented when all the available blocks are developed. The street system could be extended within the blocks, to expand the boundaries of public realm. This idea was also implemented in MoMA's lobby.

Was halten Sie für die wichtigste Arbeit in Ihrer Karriere? Hoffentlich wird mein nächstes Projekt das wichtigste meiner Karriere.

Auf welche Weise inspiriert New York Ihre Arbeit? Für das MoMa habe ich mich direkt an New York inspiriert; eine Stadt die ich liebe. Aber ich habe auch mit vielen interessanten Leuten gearbeitet, die mein Projekt jeweils auf verschiedene Art und Weise bereichert haben.

Gibt es einen typischen New Yorker Stil, und wenn ja, wie zeigt sich das in Ihrer Arbeit? Die unterschiedliche Architektur innerhalb der Stadt sorgt für eine umfassende Stadtlandschaft. Die architektonischen Öffnungen im Gebäude des MoMA wurden strategisch gewählt, um der Stadtlandschaft einen Rahmen zu geben und dem Besucher vor Auge zu führen, dass er die Kunstwerke nicht in einer x-beliebigen Stadt besichtigt, sondern in New York.

Wie stellen Sie sich New York in der Zukunft vor? Die Gitterstruktur New Yorks wird erst vollends umgesetzt werden, wenn die vorhandenen Straßenblöcke vollständig ausgebaut sind. Man könnte ebenso das Straßensystem innerhalb der Blocks ausweiten, um die Grenzen des öffentlichen Raums auszudehnen. Diese Idee wurde auch in der Lobby des MoMA umgesetzt.

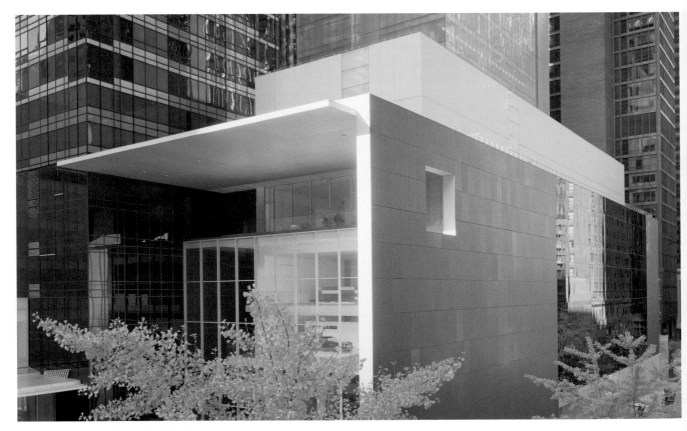

Quelle est l'œuvre la plus importante de votre carrière ? J'espère que ma prochaine réalisation sera l'œuvre la plus importante de ma carrière.

Dans quelle mesure la ville de New York inspire-t-elle votre œuvre ? Pour le MoMA, j'ai tiré mon inspiration de New York, une ville que j'aime. J'ai aussi travaillé avec une foule de gens intéressants, qui ont tous enrichi mon projet de façons multiples.

Peut-on parler d'un style typiquement new-yorkais, et si oui, comment se manifeste-t-il dans votre œuvre ? La diversité de l'architecture au sein de la ville constitue son paysage urbain. Au MoMA, les ouvertures architecturales ont été placées de manière stratégique pour encadrer le paysage urbain, afin de rappeler aux visiteurs qu'ils ne sont pas en train de contempler les oeuvres d'art dans n'importe qu'elle ville– mais bien à New York.

Comment imaginez-vous le New York de demain ? La structure urbaine en grille de New York sera entièrement utilisée lorsque tous les blocs disponibles auront été développés. Le système de voirie pourrait être développé à l'intérieur des blocs, pour élargir les limites du domaine public. C'est l'idée qui a été également développée dans le lobby du MoMA.

¿Cuál es el trabajo que considera más importante en su carrera? Espero que mi próximo proyecto sea el más importante de mi carrera.

¿De qué manera Nueva York supone una inspiración en su trabajo? Para el MoMA, tomé mi inspiración de Nueva York, una ciudad a la que adoro. También había trabajado con mucha gente interesante; todos ellos enriquecieron mi proyecto de numerosas formas.

¿Existe un estilo típico neoyorquino, y si es así, cómo se revela en su obra? La diversidad de la arquitectura de la ciudad determina un paisaje urbano general. En el MoMA, las aperturas arquitectónicas se situaron estratégicamente para enmarcar el paisaje urbano, para recordar a los visitantes que están viendo obras de arte no en cualquier ciudad, sino en Nueva York.

¿Cómo se imagina Nueva York en el futuro? El sistema de cuadrícula de Nueva York estará totalmente implantado cuando se hayan construido todas las manzanas disponibles. El sistema de calles podría ampliarse dentro de las manzanas, para expandir los límites del dominio público. Esta idea también se implantó en el vestíbulo del MoMA.

Cosa pensa che sia la cosa più importante della Sua carriera? Speriamo che il mio prossimo progetto sarà il più importante della mia carriera.

In che modo New York influenza il Suo lavoro? Per il MoMA, ho preso l'ispirazione da New York, una città che amo molto. Ho anche lavorato con molta gente interessante, e tutti loro hanno arricchito in vari modi il mio progetto.

Esiste uno stile tipico a New York? Se sì, come influenza il Suo lavoro? La diversità architettonica all'interno della città costituisce una fisionomia urbana complessiva. Nel MoMA le aperture architettoniche sono state posizionate in modo strategico per inquadrare la città, per ricordare al visitatore che sta vedendo le opere d'arte non in una città qualsiasi, ma a New York.

Come si immagina New York in futuro? La struttura a griglia di New York sarà definitivamente realizzata quando tutti i blocchi disponibili saranno sviluppati. Il sistema delle strade potrebbe svilupparsi all'interno dei blocchi per espandere i limiti della sfera pubblica. Quest'idea è stata anche implementata nell'atrio del MoMA.

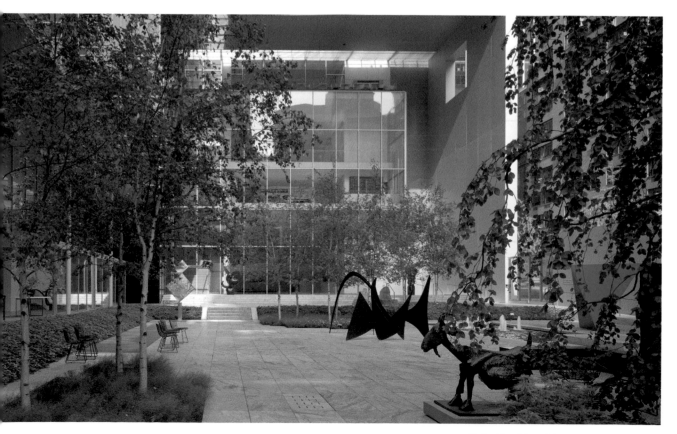

Museum of Modern Art

Year: 2005
Photographs: © Tim Hursley

In the modernization of the MoMA, Yoshio Taniguchi created an elegant structure with substantial natural light and combined materials such as glass, granite and aluminum. Through the glass façade in the generously appointed reception hall, one has a direct view of the Abby Aldrich Rockefeller Sculpture Garden. By using high ceilings and a spacious room design, an ideal context to exhibit artwork was created.

Bei der Modernisierung des MoMA erschuf Yoshio Taniguchi eine elegante Struktur mit viel natürlichem Licht und kombinierte Materialien wie Glas, Granit und Aluminium. Von der großzügig angelegten Empfangshalle blickt man durch die verglasten Fronten direkt auf den Abby Aldrich Rockefeller-Skulpturengarten. Durch die hohen Decken und eine großzügigere Raumaufteilung wurde ein idealer Rahmen für die Darbietung der Kunstwerke geschaffen.

Lors de la modernisation du MoMA, Yoshio Taniguchi réalise une structure toute en élégance, inondée de lumière naturelle, dans une alliance de verre, granite et aluminium. Depuis le hall de réception aux proportions généreuses et au travers des façades vitrées, les regards vont directement vers le jardin de sculptures de Abby Aldrich Rockefeller. Grâce à la hauteur de plafond et la distribution très généreuse de l'espace, l'architecte a su créer un cadre idéal pour exposer les œuvres d'art à grande échelle.

Para la modernización del MoMA, Yoshio Taniguchi creó una elegante estructura con mucha luz y combinó materiales como el vidrio, granito y aluminio. Desde el amplio vestíbulo puede verse a través de las cristaleras el jardín de esculturas Abby Aldrich Rockefeller. Gracias a los altos techos y a una generosa distribución de los espacios, se creó un marco ideal para la presentación de las obras de arte.

Per il rimodernamento del MoMA Yoshio Taniguchi riuscì a creare una struttura elegante con molta luce naturale e materiali combinati come vetro, granito e alluminio. Dall'ampio atrio si può ammirare attraverso la facciata in vetro direttamente il giardino con le sculture Abby Aldrich Rockefeller. Grazie ai soffitti alti e alla suddivisione generosa della stanze, è stato creato un contesto straordinario per la presentazione delle opere d'arte.

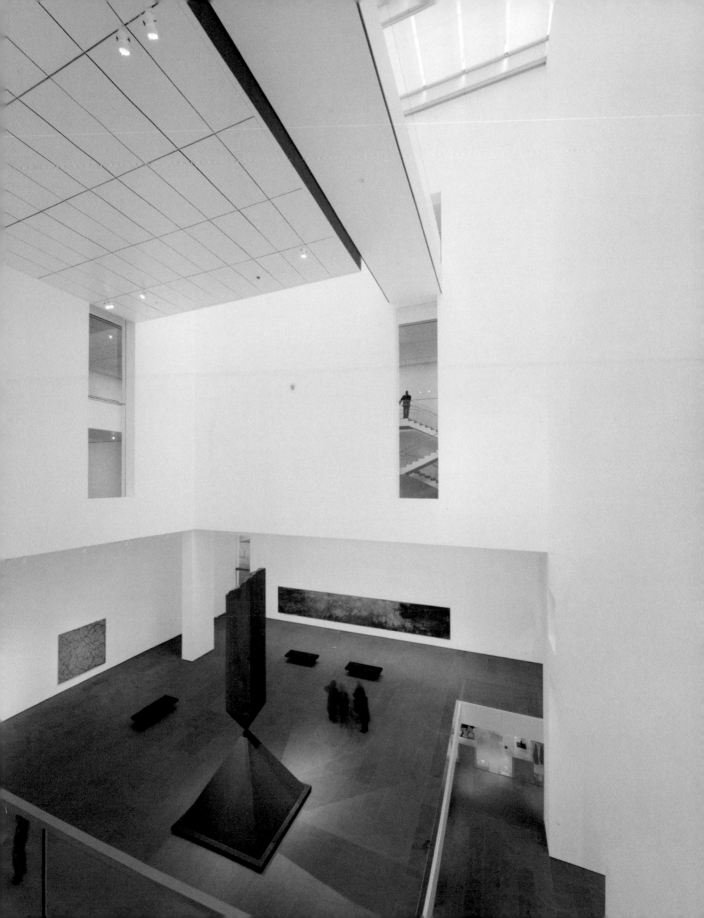

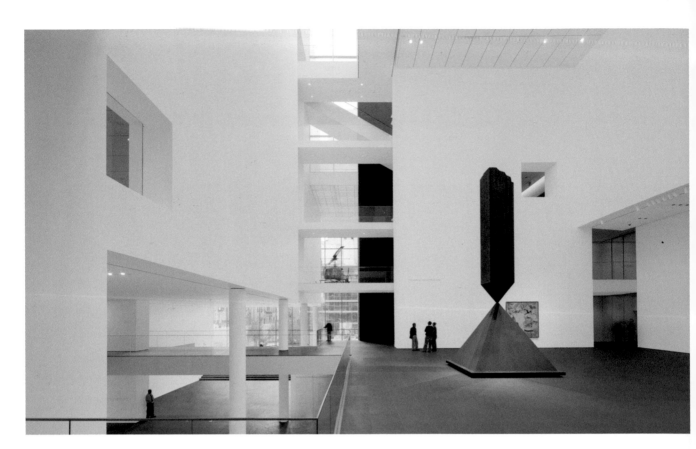

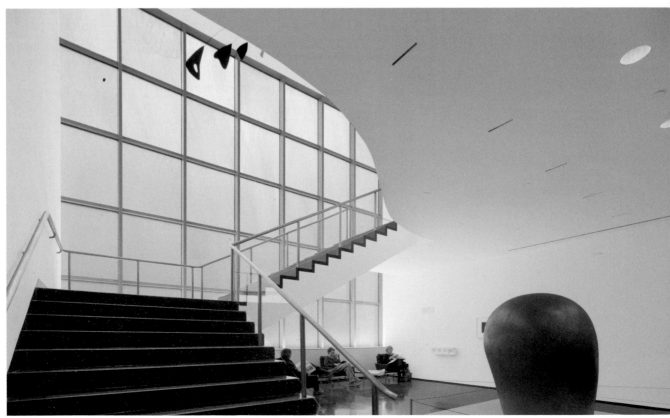

Taniguchi and Associates

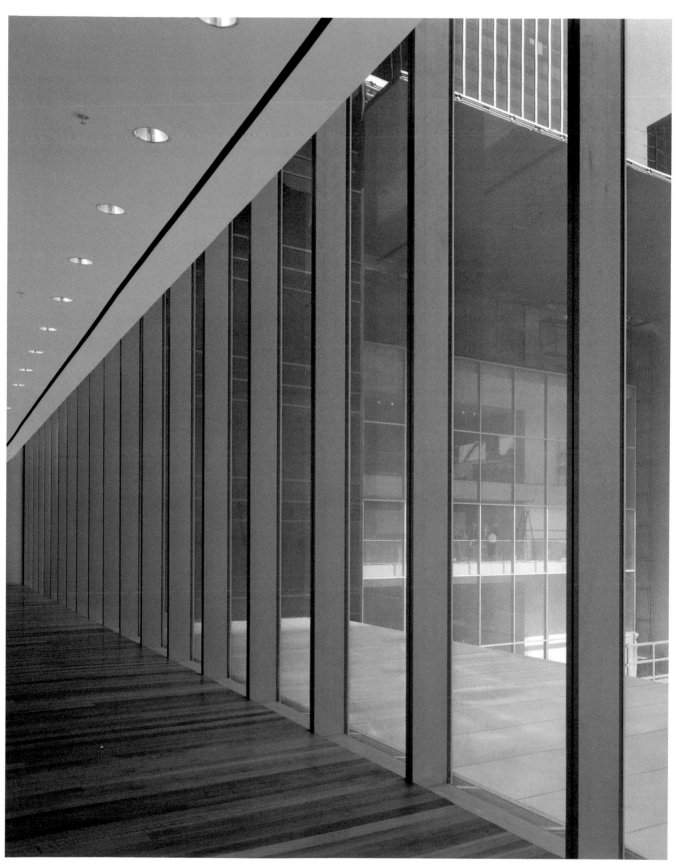

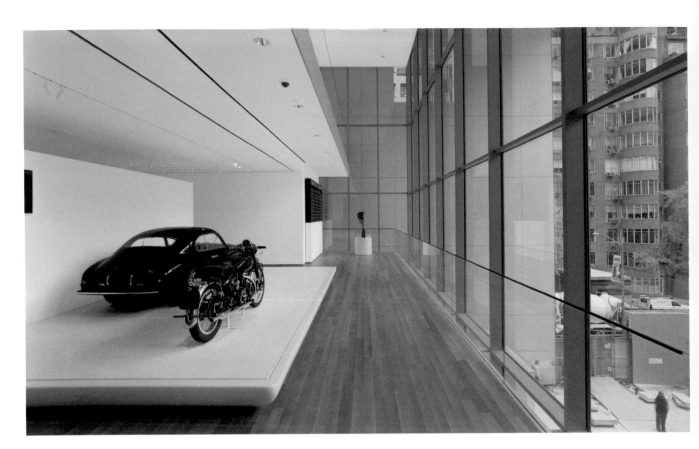

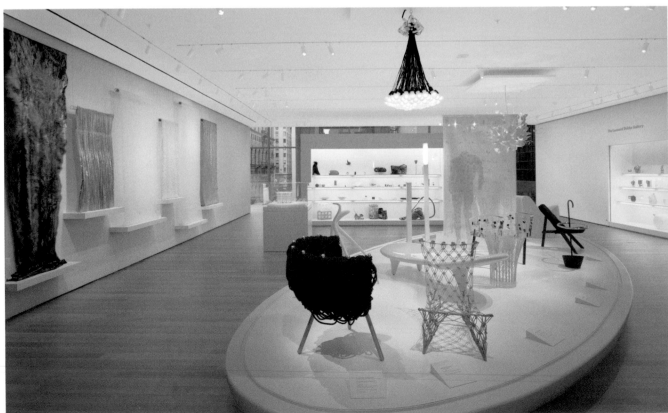

Taniguchi and Associates

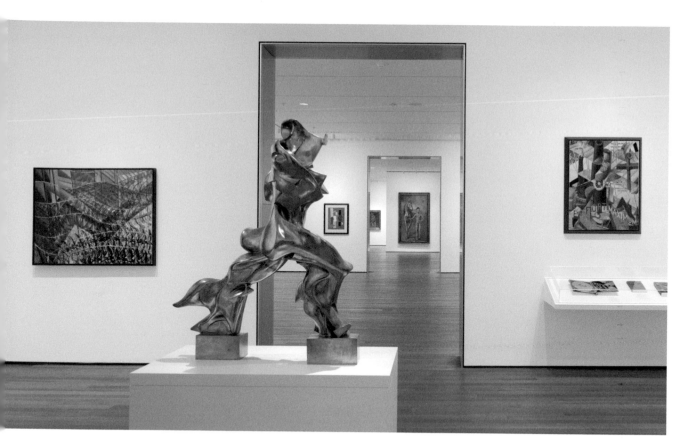

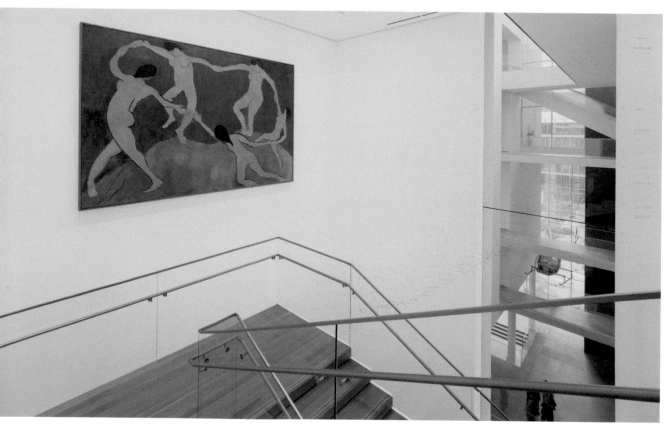

Tod Williams Billie Tsien & Associates

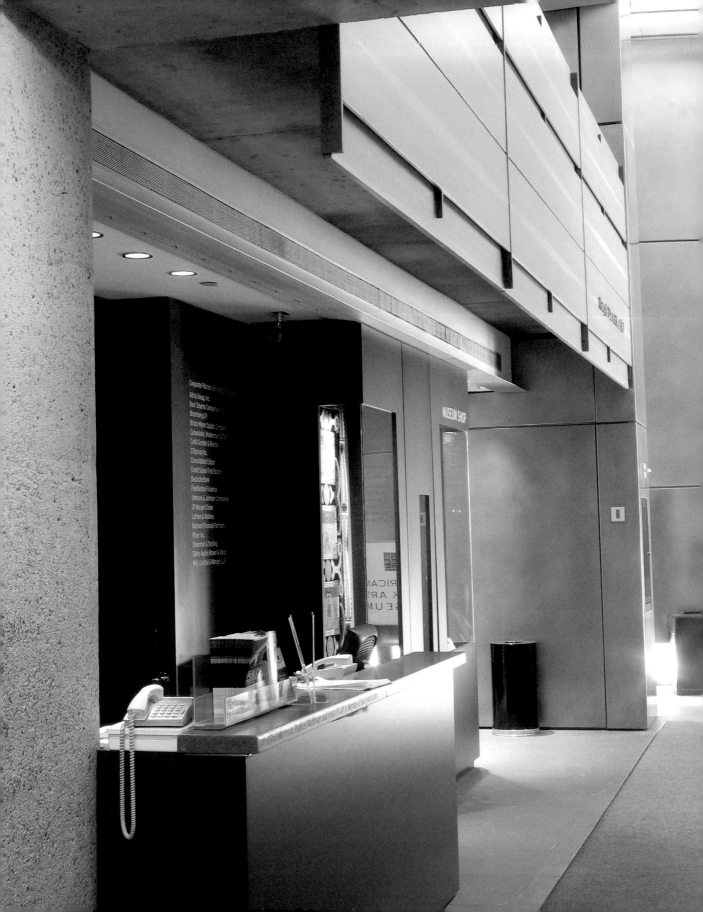

Tod Williams Billie Tsien & Associates

222 Central Park South, New York, NY 10019, USA

+1 212 582 2385

+1 212 245 1984

www.twbta.com

mail@twbta.com

Tod Williams and Billie Tsien

Based upon their interdisciplinary training, the two founders of TWBTA, Tod Williams and Billie Tsien are very interested in design concepts, which, on the one hand, connect art and architecture and, on the other hand, link practice and theory. They show a special feeling for materiality with their sometimes minimalistic work. Their work is always perfectly thought through, from the overall context down to the smallest detail.

Aufgrund ihrer interdisziplinären Ausbildung sind die beiden Gründer von TWBTA, Tod Williams und Billie Tsien sehr an Entwürfen interessiert, die zum einen Kunst und Architektur und zum anderen Praxis und Theorie miteinander verbinden. Dabei zeigen sie bei ihren tendenziell minimalistischen Arbeiten ein besonderes Gespür für Materialität. Ihre Arbeiten sind stets perfekt durchdacht, vom großen Kontext bis hin zum kleinsten Detail.

Fort de leur formation interdisciplinaire, les deux fondateurs de TWBTA, Tod Williams et Billie Tsien s'intéressent à des projets, qui d'un côté fusionnent l'art et l'architecture et de l'autre unissent la pratique à la théorie. De ce fait, on trouve dans leurs travaux à tendance minimaliste, une certaine sensibilité pour la matière. Leurs œuvres sont toujours parfaitement étudiées, des plus grands complexes aux plus petits des détails.

Debido a su formación interdisciplinaria, los fundadores de TWBTA, Tod Williams y Billie Tsien, se interesan por proyectos que unen, de un lado, arte y arquitectura, y, de otro, teoría y práctica. En esta línea, en sus trabajos más bien minimalistas, denotan un especial sentido por la materialidad. Sus trabajos están siempre pensados a la perfección, desde el contexto amplio hasta el detalle más pequeño.

In seguito alla loro formazione interdisciplinare i due fondatori di TWBTA Tod Williams e Billie Tsien sono interessati a progetti che collegano vicendevolmente da una parte arte e architettura e dall'altra teoria e pratica. Nei loro lavori tendenzialmente minimalisti sono riusciti a mostrare una sensibilità particolare verso la materialità. I loro lavori sono sempre perfetti, dal contesto maggiore fino al più piccolo dettaglio.

1977
Foundation of Tod Williams Billie Tsien and Associates in New York, USA

1994
University of Virginia Extension, Charlottesville, USA

1996
Neurosciences Institute, Scripps Research Institute, San Diego-La Jolla, USA
Extension of the Phoenix Art Museum, USA

1999
Williams Natatorium, Cranbrook School, Michigan, USA

2001
American Folk Art Museum, New York, USA
AIA National Honor Award for Long Island Residence and Williams Natatorium

2002
World Architecture Award, American Folk Art Museum

2003
Cooper Hewitt National Design Award
AIA National Honor Award, American Folk Art Museum

Interview | Tod Williams Billie Tsien & Associates

What do you consider the most work of your career? I suppose the most visible project so far is the American Folk Art Museum in New York City. Architects are optimists, so the most optimistic thing to say is that our next project will be our most important project.

In what ways does New York inspire your work? New York is full of large and small surprises just around the corner. It is a city where it is very difficult to build new buildings. Your eyes must be open, but your backbone needs to be strong!

Does a typical New York style exist, and if so, how does it show in your work? There is no New York Style and that shows in our work because we do not want to have a particular style. Style is a prison.

How do you imagine New York in the future? Pockets are always changing, but the basic plan—the grid stays the same. In terms of its people—we have always been a city of immigrants—so that too will be the same—just that the people will be coming from different countries.

Was halten Sie für die wichtigste Arbeit in Ihrer Karriere? Das auffallendste Projekt war bisher sicherlich das American Folk Museum in New York City. Architekten sind Optimisten dann ist es wohl das Optimistischste zu sagen, dass unser nächstes Projekt unser wichtigstes Projekt sein wird.

Auf welche Weise inspiriert New York Ihre Arbeit? New York City steckt voller großer und kleiner Überraschungen, hinter jeder Ecke. Es ist aber auch eine Stadt, in der es sehr schwierig ist, neue Gebäude zu errichten. Du musst die Augen offen halten, aber dein Rückgrat muss stark sein!

Gibt es einen typischen New Yorker Stil, und wenn ja, wie zeigt sich das in Ihrer Arbeit? Es gibt keinen New Yorker Stil und das zeigt sich in unserer Arbeit, denn wir wollen keinen speziellen Stil haben. Stil ist ein Gefängnis.

Wie stellen Sie sich New York in der Zukunft vor? Das Raster als Gesamtkonzept bleibt - nur seine Zwischenräume ändern sich. Was die Leute betrifft, so waren wir immer eine Einwandererstadt - und das wird sicher auch so bleiben - nur werden die Menschen wohl aus anderen Ländern kommen.

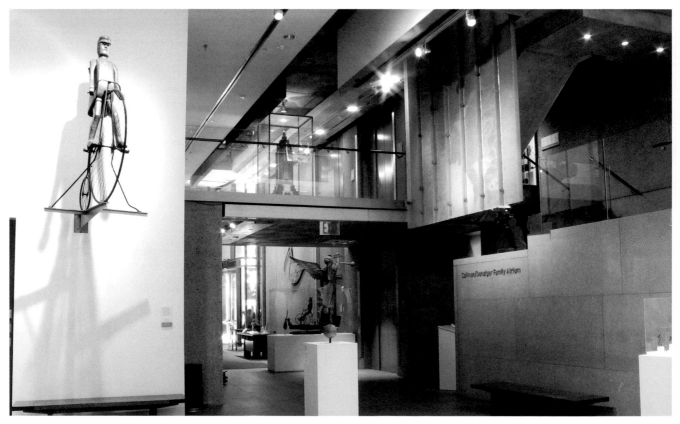

Quelle est l'œuvre la plus importante de votre carrière ? Je pense que le projet phare est le American Folk Art Museum à New York City. Les architectes sont optimistes, alors dans cette optique positive, je dirai que le projet suivant sera le plus important.

Dans quelle mesure la ville de New York inspire-t-elle votre œuvre ? New York est une ville danslaquelle il y a toujouro unc foule de peti-tes ou grandes surprises qui vous attendent au coin de la rue. C'est une ville où il est difficile de construire de nouveaux bâtiments. Vous devez à la fois gardez les yeux ouverts et avoir les reins solides!

Peut-on parler d'un style typiquement new-yorkais, et si oui, comment se manifeste-t-il dans votre œuvre ? Il n'y a pas de style new-yorkais. Cela transparaît dans notre œuvre, car nous ne voulons pas afficher un style particulier car pour nous style est synonyme de prison.

Comment imaginez-vous le New York de demain ? Il y a des niches qui changent toujours, mais le plan de base – le système de grille reste le même. Pour ce qui est des gens – nous avons toujours été une ville d'émigrants – et cela aussi ne changera pas – à la différence que les gens viendront d'autres pays.

¿Cuál es el trabajo que considera más importante en su carrera? Supongo que el proyecto más visible hasta ahora es el Museo de arte folk americano de Nueva York. Los arquitectos son optimistas, de modo que lo más optimista que se puede decir es que nuestro próximo proyecto será el más importante.

¿De qué manera Nueva York supone una insplración en su trabajo? Nueva York está llena de pequeñas y grandes sorpresas a la vuelta de la esquina. Se trata de una ciudad donde es muy difícil construir edificios nuevos. ¡Debes tener los ojos abiertos, pero es necesario tener buena fibra!

¿Existe un estilo típico neoyorquino, y si es así, cómo se revela en su obra? No existe tal cosa como un estilo neoyorquino y eso se ve en nuestro trabajo puesto que no queremos tener un estilo en particular. Un estilo es como una cárcel.

¿Cómo se imagina Nueva York en el futuro? Los pequeños lugares siempre cambian, pero el plan de base, la cuadrícula, permanece inalterada. En cuanto a la gente, siempre hemos sido una ciudad de inmigrantes, de modo que seguirá siendo lo mismo, sólo que la gente vendrá de países diferentes.

Cosa pensa che sia la cosa più importante della Sua carriera? Credo che il nostro progetto più visibile finora sia stato l'American Folk Art Museum di New York City. Noi architetti siamo ottimisti, perciò la cosa più ottimista da dire è che il nostro prossimo progetto sarà il più importante.

In che modo New York influenza il Suo lavoro? New York è piena di grandi e piccole sorprese proprio dietro l'angolo. È una città in cui è molto difficile costruire nuovi edifici. Qui devi avere gli occhi aperti, ma devi anche avere una spina dorsale forte!

Esiste uno stile tipico a New York? Se sì, come influenza il Suo lavoro? Non esiste uno stile New York, e questo si vede nel nostro lavoro, noi non vogliamo avere uno stile particolare. Lo stile è una prigione.

Come si immagina New York in futuro? I suoi spazi interni cambiano sempre, ma il piano di base, la griglia, resta la stessa. Per quanto riguarda la popolazione, siamo sempre stati una città di immigranti, la gente continuerà a venire da paesi diversi.

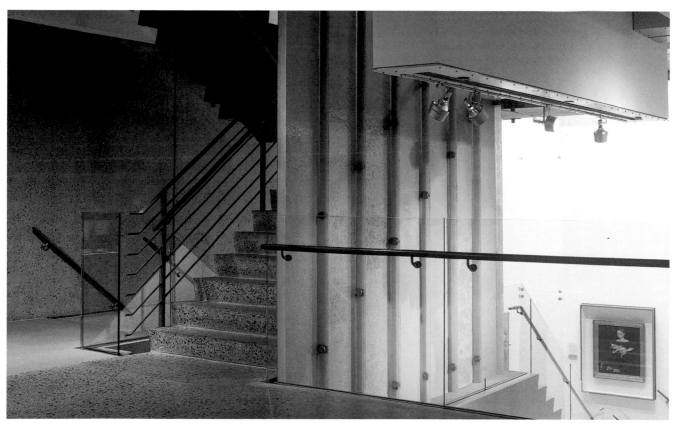

Tod Williams Billie Tsien & Associates

American Folk Art Museum

Year: 2001

Photographs: © Roger Casas

Contrary to the frequently used glass façades, the façade of the American Folk Art Museum captivates thanks to its shiny metallic stone cladding of tombasile, a hand-finished bronze alloy. The architects' goal was to create a museum in which visitors could explore art in an unexpected, informal setting. The museum receives natural light by means of a skylight. Wood flooring and many niches create a warm atmosphere.

Im Gegensatz zu den häufig anzutreffenden Glasfronten besticht die Fassade des American Folk Art Museum durch seine metallisch glänzende Steinverkleidung aus Tombasil, einer handgefertigten Bronzelegierung. Ziel der Architekten war es, ein Museum zu schaffen, in dem die Besucher Kunst in unerwarteten zwanglosen Szenarien erkunden können. Natürliche Beleuchtung erhält das Museum durch ein Oberlicht. Holzböden und viele Nischen schaffen eine warme Atmosphäre.

Contrairement aux traditionnelles parois de verre, la façade de l'American Folk Art Museum frappe par son revêtement de pierre, brillant comme le métal en Tombasil, un alliage de bronze travaillé à la main. Le but des architectes est de créer un musée où le visiteur puisse aller appréhender l'art selon des concepts inattendus et sans aucune contrainte. La lumière naturelle du musée est dispensée par un puits de lumière. Parquets et nombreuses niches façonnent une atmosphère chaleureuse.

En contraposición a las numerosas frentes de vidrio, la fachada del American Folk Art Museum destaca por el brillo de su revestimiento metálico de Tombasil, una aleación del bronce elaborada a mano. El objetivo de los arquitectos era crear un museo en el que el visitante pudiera descubrir el arte en ambientes inesperados y sin compromisos. A través de un tragaluz, el museo recibe iluminación natural. Los suelos de madera y muchos rincones crean una atmósfera cálida.

Anziché i diffusi frontali in vetro, la facciata dell'American Folk Art Museum possiede un rivestimento in pietrame luccicante composto da Tombasil, una intelligente lega del bronzo. Lo scopo degli architetti era di creare un museo in cui il visitatore avrebbe avuto accesso ad opere artistiche circondate da scenari inusuali. Il museo gode di illuminazione naturale grazie ad un lucernario. Il pavimento in legno insieme a diverse nicchie fornisce una calda atmosfera.

Tod Williams Billie Tsien & Associates

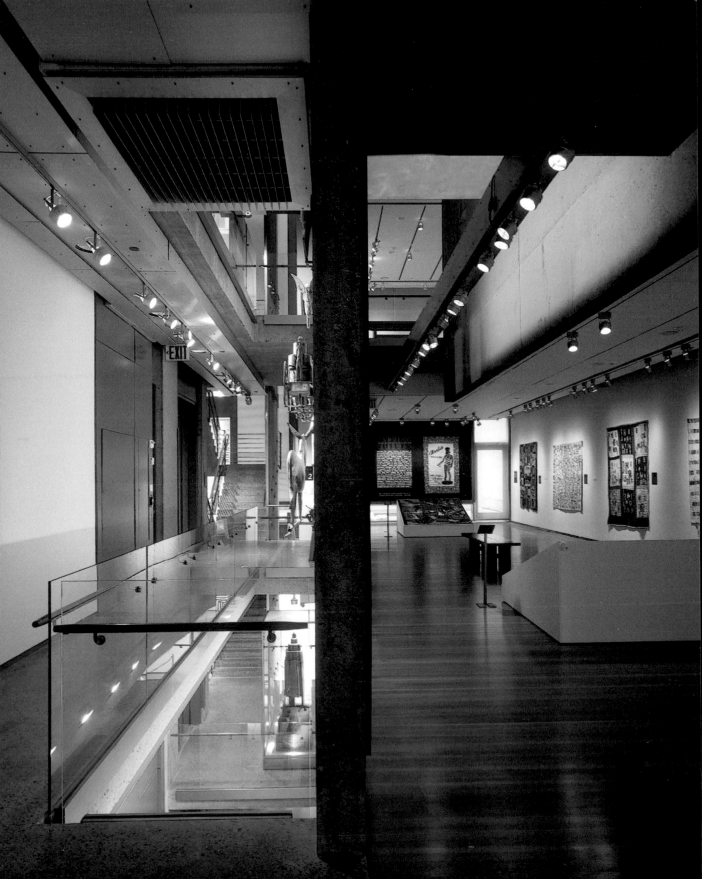

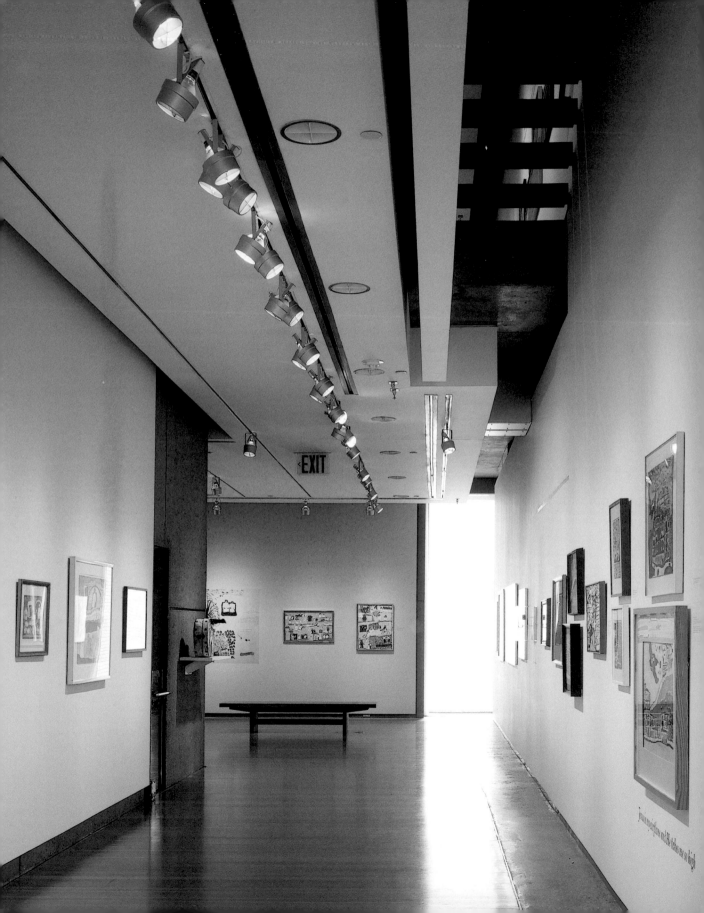

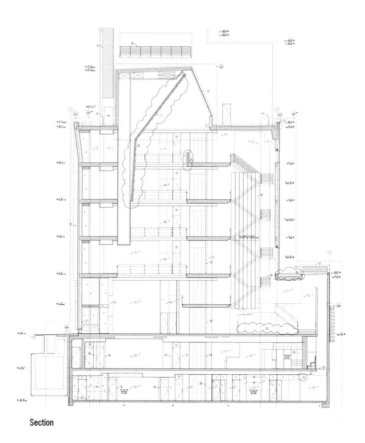

Section

Tod Williams Billie Tsien & Associates

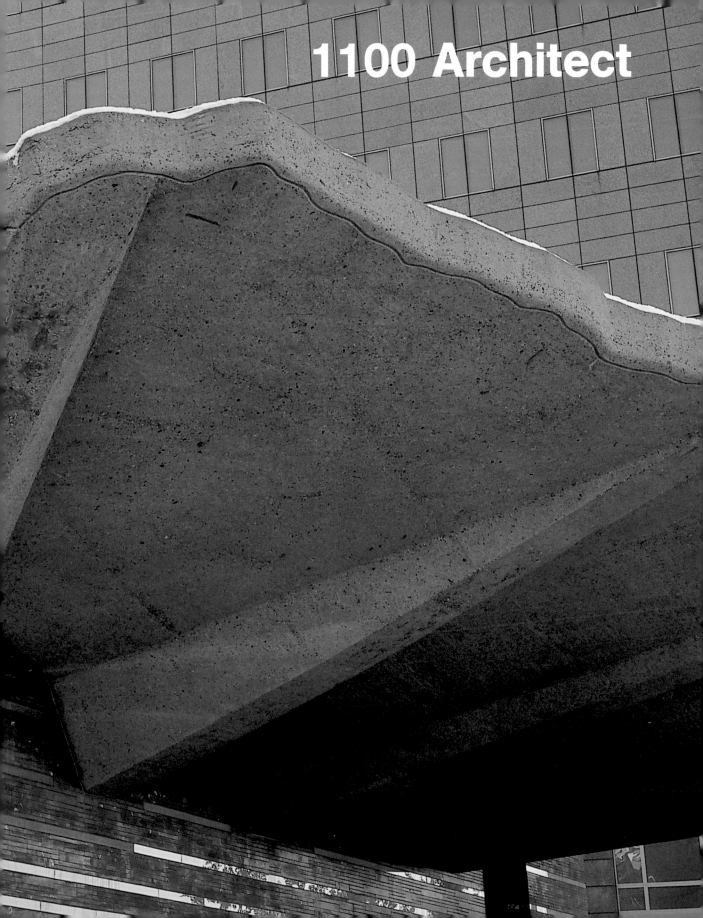

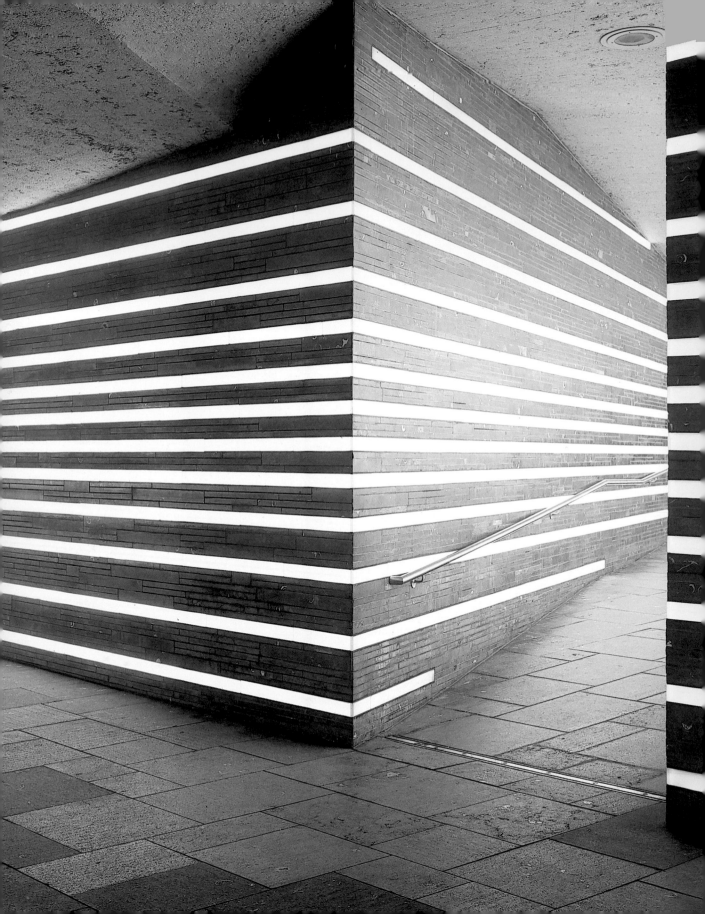

1100 Architect

475 10th Avenue 10th Floor, New York, NY 10018, USA

+1 212 645 1011

+1 212 645 4670

www.1100architect.com

contact@1100architect.com

David Piscuskas and Jürgen Riehm

1100 Architect is a company founded in 1983 by David Piscuskas and Jürgen Riehm and based in New York and Frankfurt. Their residential, commercial and public buildings are characterized by transparent architecture, in which luxury is combined with sensual restraint. Their particular field of interest lies in the interaction between art and space.

1100 Architect ist ein in New York und Frankfurt ansässiges Unternehmen, das 1983 von David Piscuskas und Jürgen Riehm gegründet wurde. Ihre Wohn-, Geschäfts- und öffentlichen Bauten zeichnen sich durch transparente Architektur aus, bei der Luxus mit einer sinnlichen Zurückhaltung kombiniert wird. Dabei liegt ihr besonderes Interesse in der Wechselwirkung zwischen Kunst und Raum.

1100 Architect est une entreprise fondée en 1983 par David Piscuskas et Jürgen Riehm dont le siège est à New York et Francfort. Leurs constructions – habitations, magasins et bâtiments publics – affichent une architecture transparente, où le luxe est mâtiné d'une retenue sensuelle, et qui met surtout l'accent sur l'interaction entre art et espace.

1100 Architect es una empresa con oficinas en Nueva York y Francfort, fundada en 1983 por David Piscuskas y Jürgen Riehm. Los edificios de viviendas y de oficinas y los edificios públicos se caracterizan por una arquitectura transparente en la que se combina el lujo con una sensual discreción. Presta especial interés en la interacción entre arte y espacio.

1100 Architect è uno studio basato a New York e a Francoforte, creato nel 1983 da David Piscuskas e Jürgen Riehm. I loro immobili abitativi, commerciali e pubblici sono caratterizzati da un'architettura trasparente nella quale il lusso è combinato con una riservatezza dei sensi. Nel loro caso è posto un interesse particolare agli effetti combinati dell'arte e dello spazio.

1983
Foundation of 1100 Architects, New York, USA

2000
Winner of AIA New York Chapter Architecture Award Design Awards Program for the Little Red School House

2001
Winner of AIA New York Chapter Award of Merit for the Little Red School House

2001
Winner of Irish Hunger Memorial Competition, Battery Park City Authority with Brian Tolle, artist and Gail Wittwer, landscape architect, New York, USA

2002
International Association of Lighting Designers Award of Merit, MoMA Design Store SoHo, New York, USA

2003
AIA Interior Architecture Award, Carriage House

Interview | 1100 Architect

What do you consider the most important work of your career? Public work such as Irish Hunger Memorial, Little Red School House, and currently the Queens Borough Public Library. They have affected a positive transformation in the communities for which they were built.

In what ways does New York inspire your work? The influences, aspirations and art forms of so many cultures mixed here continuously.

Does a typical New York Style exist, and if so, how does it show in your work? No formulaic style but a New York attitude toward new opportunity, which we share. We strive for a sense of clarity in our work, persistently honing our larger aspiration for architectural space, our vision for its unifying idea and its layers of meaning.

How do you imagine New York in the future? New York is an evolving, living organism. During our 25-year practice, New York has constantly transformed and shown tremendous resilience.

Was halten Sie für die wichtigste Arbeit in Ihrer Karriere? Öffentliche Projekte wie das Irish Hunger Memorial, das Little Red School House und gegenwärtig die Queens Borough Public Library. Sie haben ihre Zielgruppen inspiriert und positiv beeinflusst.

Auf welche Weise inspiriert Sie New York? Durch die Einflüsse, Ambitionen und Kunstformen so vieler Kulturen, die hier verschmelzen.

Gibt es einen typischen New Yorker Stil, und wenn ja, wie zeigt sich das in Ihrer Arbeit? Es gibt eher eine Art positiver New York Attitüde hinsichtlich neuer Möglichkeiten. Wir streben kontinuierlich nach einem Sinn für Klarheit und suchen den architektonischen Raum, die Vision von dessen verbindender Idee und Bedeutungsvielfalt.

Wie stellen Sie sich New York in der Zukunft vor? New York ist ein lebendiger, sich entwickelnder Organismus. Während unserer 25-jährigen Praxis hat sich New York stets weiterentwickelt und eine ungeheure Unverwüstlichkeit an den Tag gelegt.

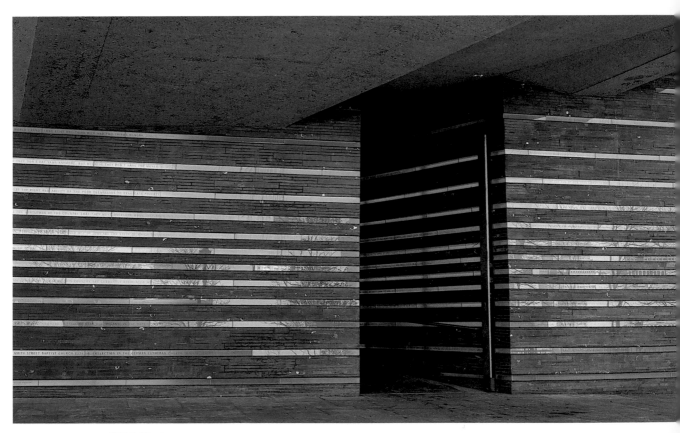

Quelle est l'œuvre la plus importante de votre carrière ? Mes réalisations de bâtiments publics, à l'instar du Irish Hunger Memorial, Little Red School House, et actuellement la Queens Borough Public Library, ont en impact positif sur la communauté pour laquelle ils ont été construits.

Dans quelle mesure la ville de New York inspire-t-elle votre œuvre ? Le brassage d'influences, d'aspirations et de formes artistiques multiculturelles permanent.

Peut-on parler d'un style typiquement new-yorkais, et si oui, comment se manifeste-t-il dans votre œuvre ? Il n'y pas de style typiquement new-yorkais, mais nous partageons approche positive aux nouvelles opportunités. Nous sommes constamment en quête de clarté dans notre travail, peaufinant sans cesse nos aspirations générales quant à l'espace architectural, notre vision d'unité qui lui est lié et ses multiples facettes.

Comment imaginez-vous le New York de demain ? New York est un organisme vivant et en constante évolution. Pendant mes 25 ans d'expérience professionnelle, New York s'est constamment transformé, déployant une force évolutive étonnante.

¿Cuál es el trabajo que considera más importante en su carrera? Trabajos de carácter público como el Irish Hunger Memorial, la escuela Little Red School House, y actualmente la biblioteca pública de Queens. Estas obras han contribuido a una transformación positiva en las comunidades para las que se construyeron.

¿De qué manera Nueva York supone una inspiración en su trabajo? Mediante las influencias, las aspiraciones y las formas artísticas de tantas culturas quo se mezclan aquí continuamente.

¿Existe un estilo típico neoyorquino y, si es así, cómo se revela en su obra? No un estilo como tal, sino más bien una actitud neoyorquina hacia las nuevas oportunidades, la cual compartimos. Nos esforzamos por alcanzar una sensación de claridad en nuestro trabajo puliendo una y otra vez nuestra más amplia aspiración de espacio arquitectónico, nuestra visión de su idea unificadora y sus interpretaciones.

¿Cómo ve Nueva York en el futuro? Nueva York es un ente vivo en constante evolución. Durante nuestros 25 años de trayectoria, Nueva York se ha transformado sin descanso y ha mostrado una enorme elasticidad.

Qual è secondo Lei il progetto più importante della Sua carriera? Sono realizzazioni di interesse pubblico come lo Irish Hunger Memorial, la Little Red School House o, al momento, la Queens Borough Public Library – opere che hanno trasformato positivamente le comunità per cui sono state costruite.

In che modo la città di New York ispira il Suo lavoro? Gli influssi, le aspirazioni e le forme artistiche di una miriade di culture chi si mescolano qui di continuo.

È possibile parlare di uno stile tipico per New York, e, se questo stile esiste, in che modo si manifesta nei Suoi lavori? Non proprio uno "stile New York" definibile concretamente ma, direi, un "atteggiamento New York": un atteggiamento di apertura nei confronti delle nuove opportunità che ci vengono offerte. Noi cerchiamo di raggiungere un senso di chiarezza, di trasparenza, affinando senza sosta un nostro spazio architettonico ideale, la nostra visione di una sua idea unificante, la sua stratificazione di senso.

Come si immagina la New York del futuro? New York è un organismo vivo, in continua evoluzione. Nei miei 25 anni di attività New York si è continuamente trasformata, dimostrando una fortissima resilienza.

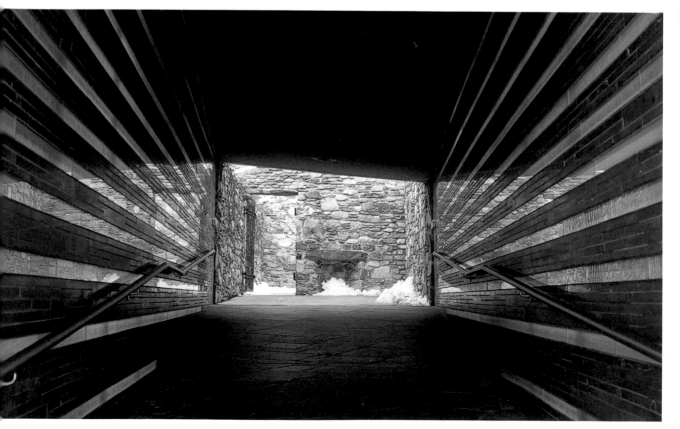

Irish Hunger Memorial

Artist: Brian Tolle, Landscape Architect: Gail Wittwer-Laird, History: Maureen O'Rourke-Murpy, Irish Cultural Liaison: Adrian P. Flannelly

Year: 2002

Photographs: © Gogortza & Llorella

One enters the Irish Hunger Memorial by means of an inclined passageway, which opens up to a stone surface area, which symbolizes the stark Irish landscape and the abandoned potato fields. To achieve this, stones from 32 Irish counties were collected. The surrounding stone field rests upon a structure made up of smooth stones, which are integrated with illuminated glass strips, which describe the history of Ireland's great hunger crisis.

Das Irish Hunger Memorial betritt man über einen ansteigenden Durchgang, der sich zu einer Steinfläche hin öffnet, die die schroffe, irische Landschaft und die verwaisten Kartoffelacker symbolisiert. Hierfür wurden Steine aus 32 irischen Grafschaften gesammelt. Das Steinfeld wiederum ruht auf einer Struktur aus glatten Steinen, die mit beleuchteten Glasstreifen durchzogen sind, in denen die Geschichte der Großen Hungersnot in Irland beschrieben ist.

L'accès au Irish Hunger Memorial se fait par un passage incliné qui s'ouvre sur une surface dallée, symbolisant le paysage irlandais et les champs de pommes de terre abandonnés. A cet effet, des pierres provenant de 32 comtés irlandais ont été rassemblées. Ce champ minéral repose à son tour sur une structure de dalles lisses, traversées par des bandes de verre lumineuses, où s'inscrit l'histoire de la grande famine qui a dévasté l'Irlande.

El acceso al Irish Hunger Memorial se realiza a través de un pasillo ascendente que desemboca ante una superficie de piedra que simboliza el abrupto paisaje irlandés y los campos de patatas abandonados. Para la construcción, se recogieron piedras procedentes de 32 condados irlandeses. A su vez, la piedra descansa sobre una estructura de ladrillos lisos, atravesados por franjas de vidrio iluminadas, en los que se describe la historia de las grandes hambrunas irlandesas.

L'Irish Hunger Memorial è accessibile attraverso un corridoio in salita, dal quale si apre una superficie in pietra che rappresenta i campi scoscesi irlandesi e i campi di patate abbandonati. A questo fine sono state raccolte delle pietre da 32 contee irlandesi. Il campo di pietre è invece formato da una struttura a pietre lisce, sulle quali si allungano strisce luminose, allo scopo di ricordare i gravi problemi legati alla fame nella storia del paese.

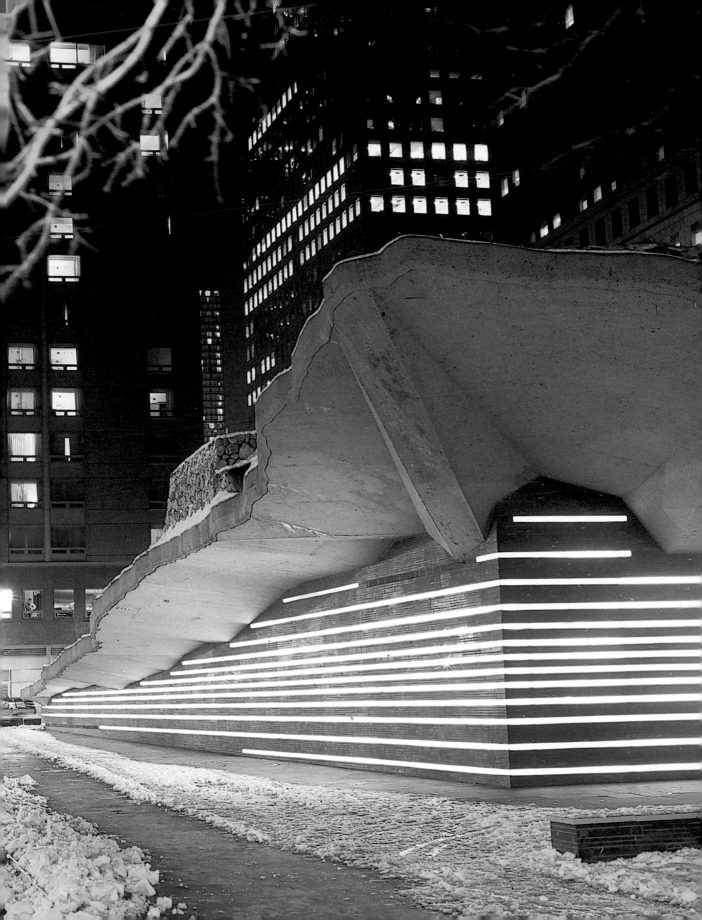

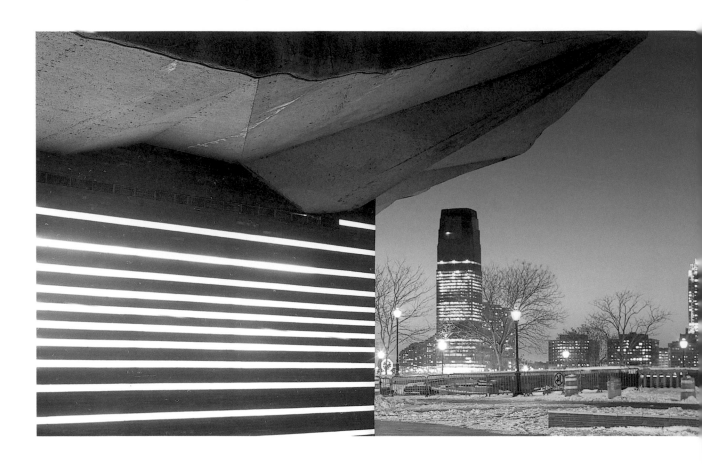

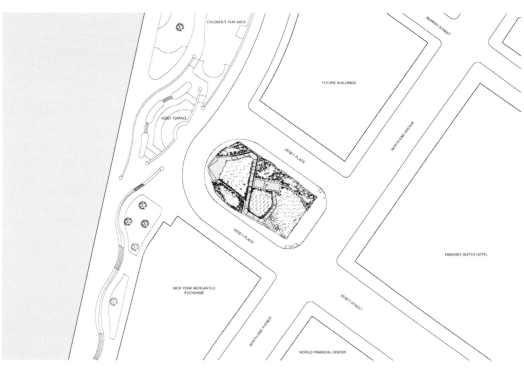

Site plan

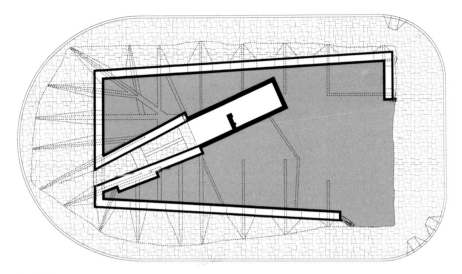

Lower level

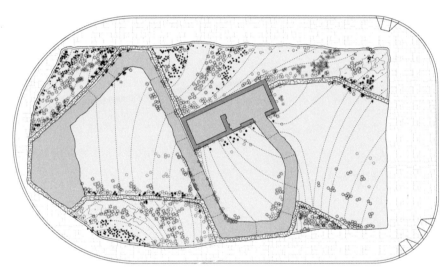

Upper level

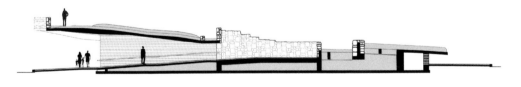

Longitudinal section

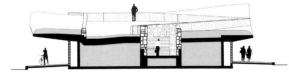

Cross section

1100 Architect 75

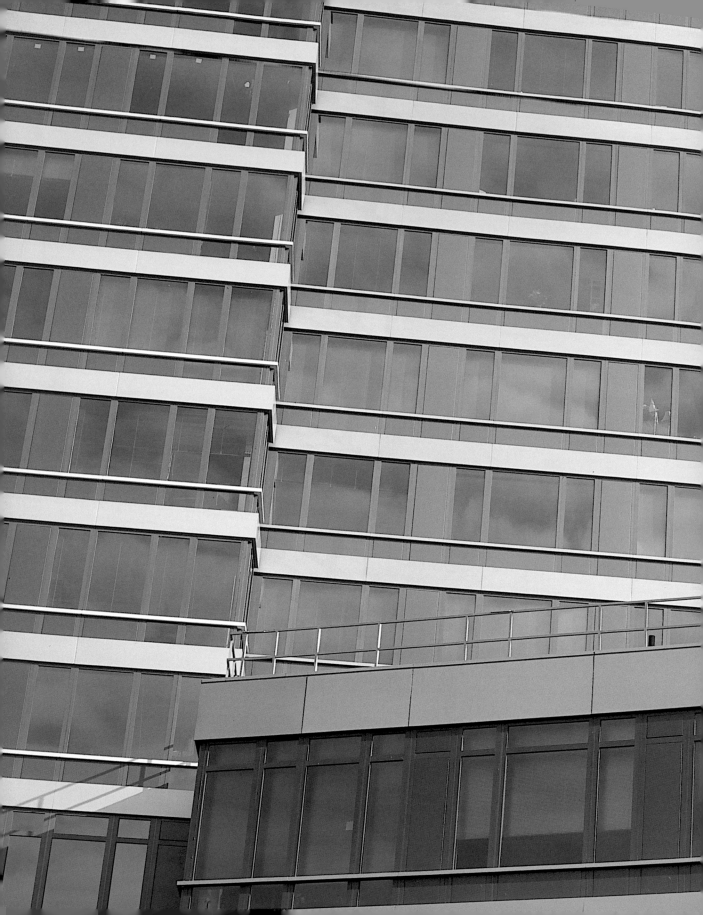

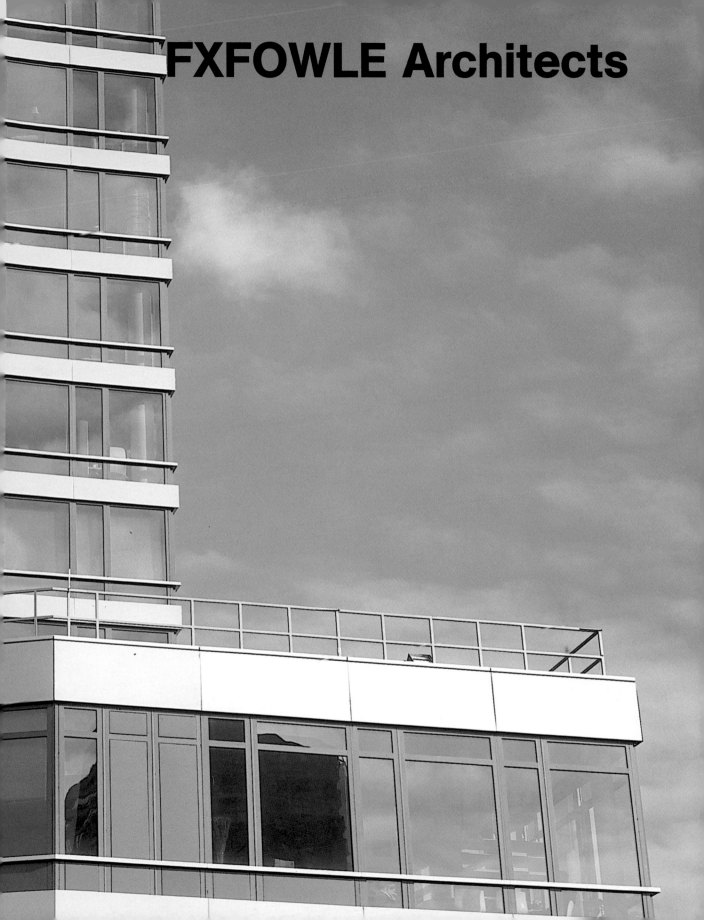

FXFOWLE Architects

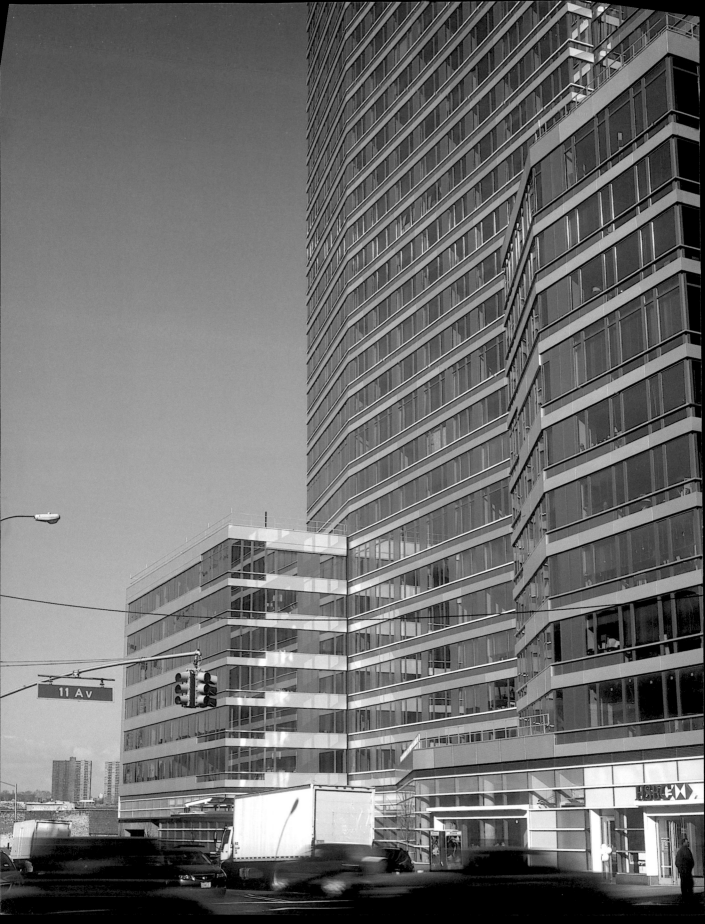

FXFOWLE Architects

22 West 19 Street, New York, NY 10011, USA

+1 212 627 1700

+1 212 463 8716

www.fxfowle.com

info@fxfowle.com

FXFOWLE Architects

In their New York office, FXFOWLE Architects has developed projects in the areas of urban construction, architecture and interior design. The office is organized into five independent design studios, which are supported by an internal network of specialists. The basis of their work is a holistic approach, which results in rigorous study of the site and its function as well as form-giving processes in order to develop environmentally and socially-conscious projects.

Die Architekten von FXFOWLE entwickeln in ihrem New Yorker Büro Projekte im Bereich Städtebau, Architektur und Innendesign. Dabei ist das Büro in fünf unabhängige Designstudios gegliedert, die durch ein internes Netz aus Fachleuten unterstützt werden. Die Grundlage ihrer Arbeit ist ein holistischer Ansatz, bei dem eine rigorose Erforschung des Ortes und seiner Funktion sowie der formbildenden Prozesse erfolgt, sowie umwelt- und sozialverträgliche Projekte entwickelt werden.

Dans leur bureau new-yorkais, l'équipe d'architectes FXFOWLE développe des projets d'urbanisme, d'architecture et de design intérieur. Le bureau est divisé en cinq studios de design autonomes, secondés par un réseau interne d'experts. Leur travail est fondé sur une approche holistique, entraînant une étude rigoureuse du lieu, de sa fonction et des processus formels, et sur le développement de projets écologiques et sociaux.

Los arquitectos de FXFOWLE desarrollan en sus oficinas neoyorquinas proyectos urbanísticos, arquitectónicos y de diseño interior. Las oficinas están divididas en cinco estudios de diseño independientes, que reciben el apoyo de una red interna de especialistas. La base de su trabajo es una aproximación holística, para la que se lleva a cabo una rigurosa investigación sobre el lugar y su función, así como de los procesos morfógenos; asimismo se desarrollan proyectos sostenibles social y medioambientalmente.

Gli architetti FXFOWLE hanno creato nel loro ufficio di New York progetti nel settore dell'urbanistica, dell'architettura e dell'arredamento di interni. Il loro ufficio è suddiviso in 5 studi di design indipendenti, accompagnati da una rete di specialisti. Il loro lavoro parte da un concetto olistico, che richiede un'analisi attenta del luogo e delle sue funzioni, oltre che dei processi di costituzione della forma. Allo stesso modo sono sviluppati progetti ambientali e socialmente sostenibili.

FXFOWLE Architects

1979
Foundation of FOX & FOWLE Architects, New York, USA

1999
The Condé Nast Building at Four Times Square, New York, USA

2000
AIA New York Chapter Medal of Honor for distinguished work and the highest professional standing

2001
The Reuters Building, New York, USA
AIA National Honor Award for The Condé Nast Building at Four Times Square, New York, USA

2005
AIA Green Affordable Housing Award for the Helena Apartment Building

Interview | FXFOWLE

Which do you consider the most important work of your career? My next project! What do I consider my most important work so far? Collaborating with Renzo Piano on the New York Times Building.

In what ways does New York inspire your work? New York is a famously energetic and diverse metropolis. Reflecting and extending the city's vibrancy is the goal of our work.

Does a typical New York style exist, and if so, how does it show in your work? New York has a very strong set of pressures–including zoning, financial, schedule, and labor concerns. Also New York City's grid and density tends to suppress the presence of any single building. As a result, the buildings become "serialized"–experienced, and often treated, in a fragmented way.

How do you imagine New York in the future? In the future, New York will (re)discover its high roofs, sky-bridges and aeries for public, recreational and green spaces.

Was halten Sie für die wichtigste Arbeit in Ihrer Karriere? Mein nächstes Projekt! Was ich bisher als wichtigste Arbeit betrachte? Die Zusammenarbeit mit Renzo Piano am New York Times Building.

Auf welche Weise inspiriert New York Ihre Arbeit? New York ist berühmt als energiegeladene und verschiedenartige Metropole. Unser Ziel ist es, die Dynamik dieser Stadt zu reflektieren und auszuweiten.

Gibt es einen typischen New Yorker Stil, und wenn ja, wie zeigt sich das in Ihrer Arbeit? In New York bekommt man von allen Seiten Druck – auch was Flächenbegrenzung, Finanzielles, Planung und Ausführung betrifft. Auch verdrängt die Gitterstruktur und Dichte von New York City die Präsenz eines einzelnen Gebäudes. Folge davon ist, dass die Gebäude „serienmäßig" werden – und oft nur als Fragment wahrgenommen und behandelt werden.

Wie stellen Sie sich New York in der Zukunft vor? In der Zukunft wird New York den Raum auf seinen hohen Dächern, Luftbrücken und -nestern mehr für die Öffentlichkeit, für Freizeitgestaltung und Grünflächen (wieder)entdecken.

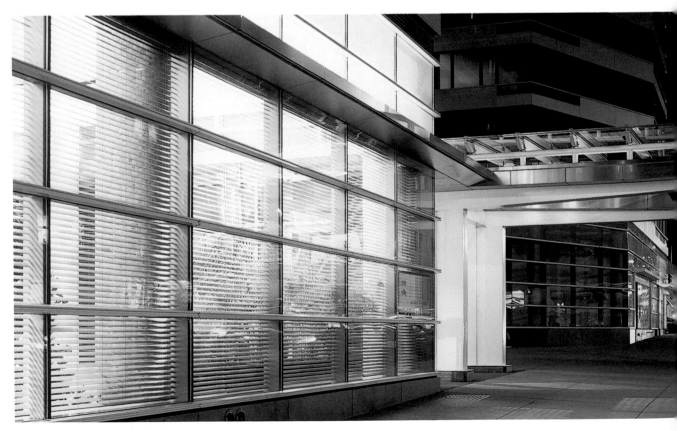

Quelle est l'œuvre la plus importante de votre carrière ? Mon prochain projet ! Quelle est l'œuvre la plus importante de ma carrière ? Ma collaboration avec Renzo Piano sur le New York Times Building.

Dans quelle mesure la ville de New York inspire-t-elle votre œuvre ? New York est une métropole célèbre pour son dynamisme et sa diversité. Notre but est de reproduire le rayonnement et les vibrations de cette ville.

Peut-on parler d'un style typiquement new-yorkais, et si oui, comment se manifeste-t-il dans votre œuvre ? New York est soumis à de fortes pressions – problèmes de zones, financiers, d'emploi du temps et de travail. De surcroît, le quadrillage urbain de New York et sa densité ont tendance à supprimer la présence de tout édifice isolé. On obtient alors des édifices « en série » – ressentis et traités de manière fragmentée.

Comment imaginez-vous le New York de demain ? A l'avenir, New York « re » découvrira ses toits élevés, ponts aériens et espaces publics, espaces verts et de loisirs.

¿Cuál es el trabajo que considera más importante en su carrera? ¡Mi próximo proyecto! ¿Cuál considero el trabajo más importante hasta ahora? La colaboración con Renzo Piano en el edificio del New York Times.

¿De qué manera Nueva York supone una inspiración en su trabajo? Nueva York es una metrópolis divinamente energética y diversa. El reflejo y la ampliación del dinamismo de la ciudad es el objetivo de nuestro trabajo.

¿Existe un estilo típico neoyorquino y, si es así, cómo se revela en su obra? Nueva York posee un conjunto muy fuerte de presiones, entre las que se encuentran las cuestiones de división en zonas, financieras, de programación y de mano de obra. Asimismo, la cuadrícula y la densidad neoyorquina tienden a suprimir la presencia de un edificio individual. A consecuencia de ello, los edificios se convierten en elementos de una serie, experimentados y, con frecuencia, considerados de forma fragmentaria.

¿Cómo se imagina Nueva York en el futuro? En el futuro, Nueva York (re)descubrirá sus tejados altos, los puentes y pasos elevados para espacios públicos, recreativos y verdes.

Cosa pensa che sia la cosa più importante della Sua carriera? Il mio nuovo progetto! Che cosa considero come essere la cosa più importante fino ad ora? Aver collaborato con Renzo Piano per il New York Times Building.

In che modo New York influenza il Suo lavoro? New York è una metropoli notevolmente energica e diversa. L'obiettivo per il nostro futuro è di riflettere e di estendere le vibrazioni di questa città.

Esiste uno stile tipico a New York? Se sì, come influenza il Suo lavoro? A New York si sente sempre una certa pressione, a riguardo del piano urbanistico, dei finanziamenti, del calendario degli appuntamenti e dei problemi di lavoro. Le reti e la densità di New York tendono a sopprimere la presenza dei singoli edifici. Come risultato di ciò gli edifici diventano esperienze "di serie" e sono spesso considerati in modo frammentato.

Come si immagina New York in futuro? In futuro, New York (ri)scoprirà i suoi alti tetti, le passerelle tra i grattacieli, le zone ricreative e gli spazi verdi.

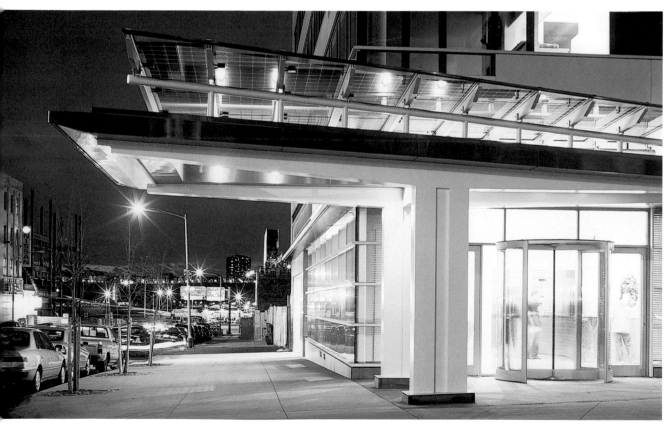

The Helena Apartment Building

Year: 2005

Photographs: © Gogortza & Llorella

The 37-story Helena House is based upon the interpretation of the classic New York residential typology, with floor-to-ceiling windows and spacious interiors. The concrete structure is modernized by means of metal cladding, which loosens the sleek façade. For its high quality in terms of environmental compatibility, the project received the Green Housing Award from the AIA American Institute of Architects in 2005.

Das 37-stöckige Helena Wohnhaus basiert auf der Interpretation der klassischen New Yorker Wohntypologie, bei der die Fenster vom Boden bis zur Decke reichen und die Innenräume großzügig gestaltet sind. Modernisiert wird die Betonstruktur durch Metallverkleidungen, die so die glatte Fassade auflockern. Das Projekt erhielt für seine hohe Qualität im Bereich Umweltverträglichkeit 2005 den Green Affordable Housing Award des AIA American Institute of Architects.

L'immeuble Helena de 37 étages reprend l'interprétation de la typologie d'habitation new-yorkaise classique, avec baies vitrées du sol au plafond et intérieurs spacieux. La structure en béton est modernisée par un habillage en métal, égayant ainsi la façade lisse. Pour la grande qualité écologique de la construction, le projet a reçu en 2005 le Green Affordable Housing Award de l'AIA, American Institute of Architects.

El edificio de viviendas Helena de 37 plantas se basa en una interpretación de la tipología clásica de vivienda neoyorquina, donde los ventanales van desde el suelo hasta el techo y los espacios interiores se distribuyen con generosidad. Los revestimientos de metal dan el toque moderno a la estructura de hormigón, dando ligereza a la fachada lisa. Por su excelencia en compatibilidad medioambiental, el proyecto recibió en el año 2005 el Green Affordable Housing Award del AIA American Institute of Architects.

L'immobile abitativa di 37 piani Helena si basa sull'interpretazione della tipologia abitativa classica newyorchese: con le finestre a vetrate dal pavimento fino al soffitto e con i ricchi interni. La struttura in cemento armato è stata modernizzata con un rivestimento in metallo, per rendere la facciata meno imponente. Grazie alla sua alta qualità in materia di sostenibilità ambientale, il progetto ha ottenuto nel 2005 il Green Affordable Housing Award dell'AIA American Institute of Architects.

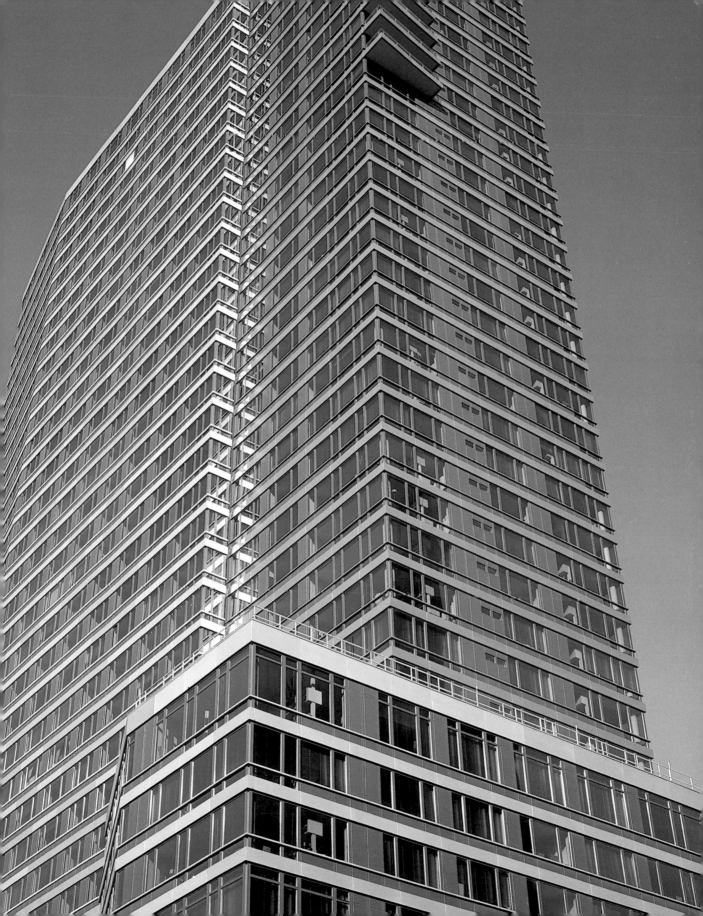

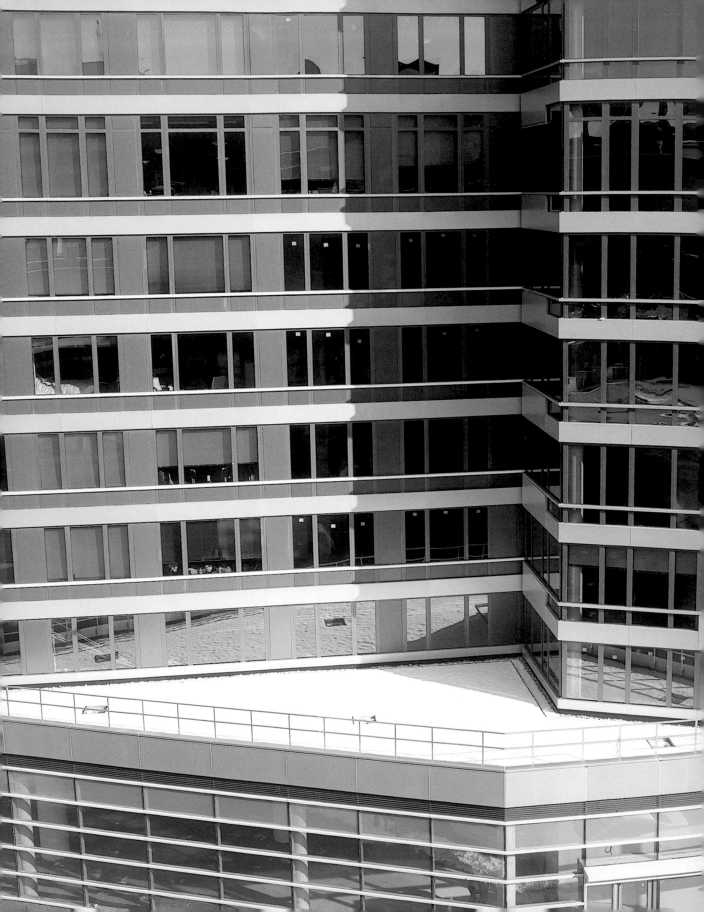

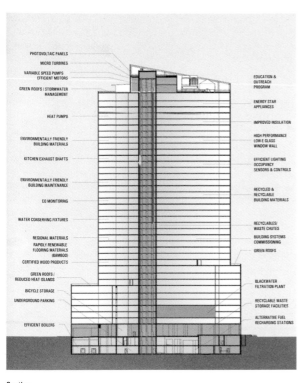

PHOTOVOLTAIC PANELS
MICRO TURBINES
VARIABLE SPEED PUMPS / EFFICIENT MOTORS
GREEN ROOFS / STORMWATER MANAGEMENT

HEAT PUMPS

ENVIRONMENTALLY FRIENDLY BUILDING MATERIALS

KITCHEN EXHAUST SHAFTS

ENVIRONMENTALLY FRIENDLY BUILDING MAINTENANCE

CO MONITORING

WATER CONSERVING FIXTURES

REGIONAL MATERIALS
RAPIDLY RENEWABLE FLOORING MATERIALS (BAMBOO)
CERTIFIED WOOD PRODUCTS

GREEN ROOFS / REDUCED HEAT ISLANDS

BICYCLE STORAGE

UNDERGROUND PARKING

EFFICIENT BOILERS

EDUCATION & OUTREACH PROGRAM

ENERGY STAR APPLIANCES

IMPROVED INSULATION

HIGH PERFORMANCE LOW-E GLASS WINDOW WALL

EFFICIENT LIGHTING OCCUPANCY SENSORS & CONTROLS

RECYCLED & RECYCLABLE BUILDING MATERIALS

RECYCLABLES/ WASTE CHUTES
BUILDING SYSTEMS COMMISSIONING
GREEN ROOFS

BLACKWATER FILTRATION PLANT

RECYCLABLE WASTE STORAGE FACILITIES

ALTERNATIVE FUEL RECHARGING STATIONS

Section

ELEVENTH AVENUE

WEST 57th STREET

Floor plan

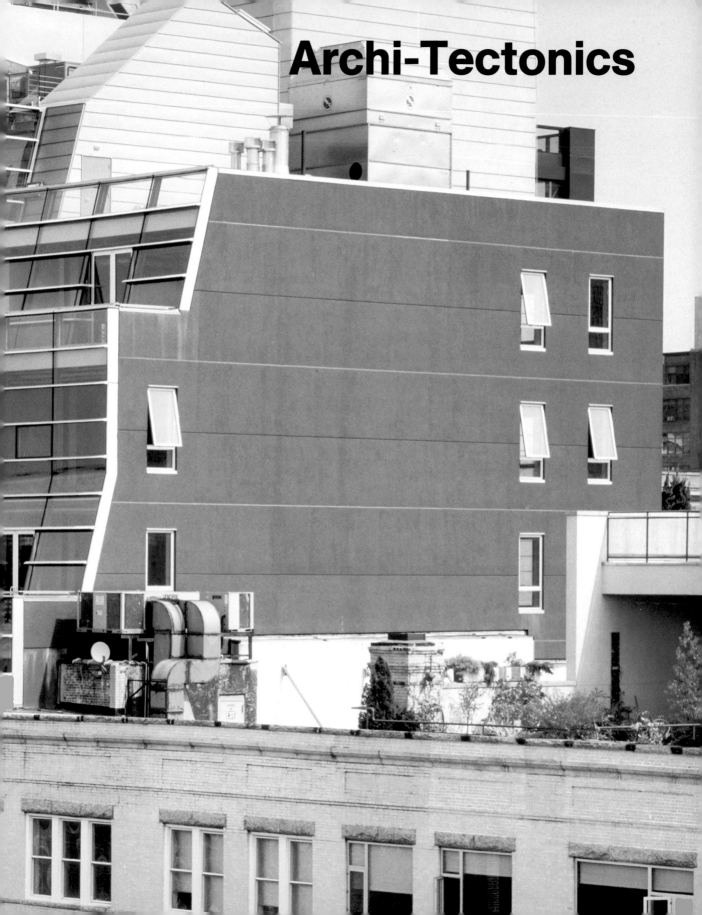

Archi-Tectonics

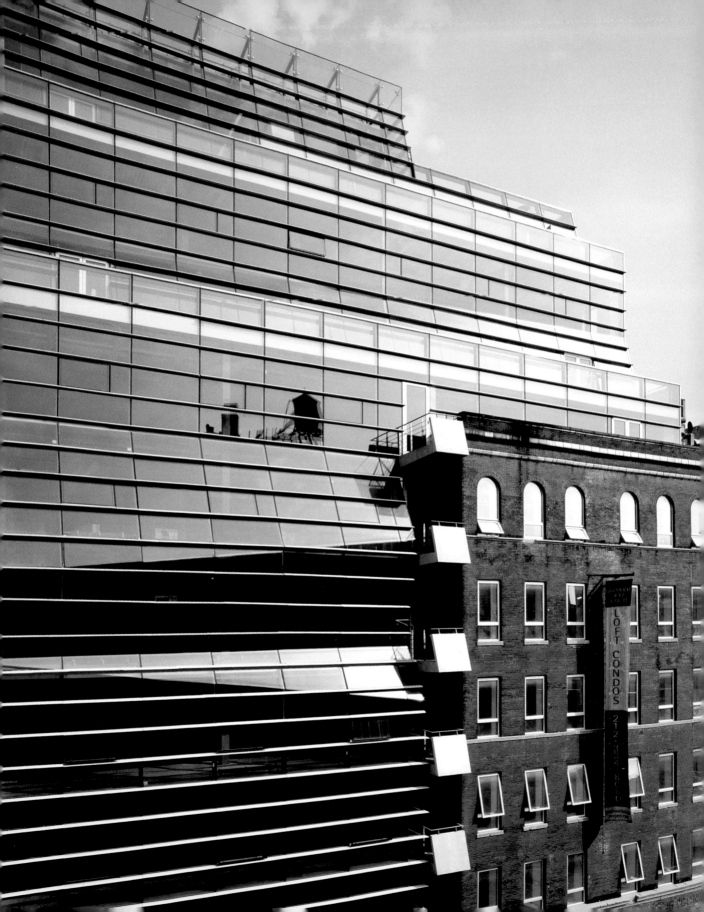

Archi-Tectonics

200 Varick Street, Suite 507B, New York, NY 10014, USA

+1 212 226 0303

+1 212 206 0920

www.archi-tectonics.com

office@archi-tectonics.com

Winkka Dubbeldam

After ending her architecture study in 1990 in Rotterdam in the Netherlands, Winkka Dubbeldam moved to the United States. Before opening her own architecture firm, Archi-Tectonics, she worked with architects such as Steven Holl, Bernard Tschumi and Peter Eisenman. In her studio, known for its innovative work, the computer is considered a crucial tool, not only for the research process but also as an independent form generator.

Nach dem Abschluss ihres Architekturstudiums 1990 in Rotterdam in den Niederlanden zog Winkka Dubbeldam in die Vereinigten Staaten. Bevor sie ihr eigenes Büro Archi-Tectonics eröffnete, arbeitete sie mit Architekten wie Steven Holl, Bernard Tschumi und Peter Eisenman. In ihrem für seine innovativen Arbeiten bekannten Studio betrachtet man den Computer als ein entscheidendes Werkzeug; nicht nur im Forschungsprozess, sondern auch als einen eigenständigen Formgenerator.

A l'issue de ses études d'architecture en 1990, à Rotterdam, au Pays-Bas, Winkka Dubbeldam s'installe aux Etats-Unis. Avant d'ouvrir son propre cabinet d'architecture Archi-Tectonics, elle travaille avec divers architectes tels que Steven Holl, Bernard Tschumi et Peter Eisenman. Dans son cabinet, réputé pour le caractère innovant de ses travaux, l'ordinateur est un des principaux outils de travail, non seulement dans le processus d'étude, mais également en tant que créateur de formes à part entière.

Tras finalizar sus estudios de arquitectura en 1990 en Rotterdam, Winkka Dubbeldam se trasladó de los Países Bajos a Estados Unidos. Antes de abrir su propio estudio Archi-Tectonics, trabajó con arquitectos como Steven Holl, Bernard Tschumi y Peter Eisenman. En su estudio, conocido por sus innovadores trabajos, el ordenador se considera una herramienta decisiva; no solo en el proceso de investigación, sino también como generador de formas autónomo.

Dopo aver terminato i suoi studi in architettura nel 1990 a Rotterdam, nei Paesi Bassi, Winkka Dubbeldam andò a vivere negli Stati Uniti. Prima di aprire il proprio studio Archi-Tectonics, ella lavorò con architetti come Steven Holl, Bernard Tschumi e Peter Eisenman. Il questo studio conosciuto per il suo modo di lavorare innovativo, il computer è considerato come strumento di lavoro essenziale; non soltanto nel processo di ricerca, ma anche in quanto creatore di forme.

1990
Graduation of the Faculty of Architecture, Rotterdam, Netherlands

1990
Worked with Rem Koolhaas' "Office for Metropolitan Architecture" (OMA/BOA), Rotterdam, Holland

1991-1992
Master Degree, Columbia University, New York, USA

1994
Foundation of "Archi-Tectonics", architecture office and art gallery
Mixed-Media Art "Cristine Rose Gallery", New York, USA

2000
Aida Hair & Beauty Salon, Upper east side, New York, USA
Architecture Triennial, Sofia "Best Urban Design Proposal" for Moscow
"Emerging Voices", The Architectural League of New York

2002
Greenwich Street Building, New York, USA

Interview | Archi-Tectonics

Which do you consider the most important work of your career? The Greenwich building in NYC, we were able to make the building an innovative structure with a folded glass wall, an energy-efficient system and provide open lofts with very high ceiling spaces.

In what ways does New York inspire your work? NY has great energy and creates an inspiring environment for any creative person. I really appreciate the Academic world here; for my work it is crucial to combine the academic with a practice. As the director of the Post-Professional Program at UPenn, I can combine both.

Does a typical New York style exist, and if so, how does it show in your work? I do not think "a typical NY style" exists, the great thing abut NYC is that it is so international.

How do you imagine New York in the future? Fast and furious...hopefully! The implementation of new technologies are necessary to keep this huge dense machine running.

Was halten Sie für die wichtigste Arbeit in Ihrer Karriere? Das Greenwich Building in New York City. Es ist uns gelungen, dem Gebäude eine innovative Fassade aus einer energiesparenden, gefalteten Glasstruktur zu geben und dort offene Lofts mit hohen Decken zu schaffen.

Auf welche Weise inspiriert New York Ihre Arbeit? New York besitzt eine unglaubliche Energie und bietet jeder kreativen Person ein inspirierendes Ambiente. Was ich hier besonders schätze ist die akademische Welt. Für meine Arbeit ist es ausschlaggebend, das Akademische mit dem Praktischen zu verbinden. Als Direktor des Master-Studiengangs an der University of Pennsylvania kann ich beides miteinander verbinden.

Gibt es einen typischen New Yorker Stil, und wenn ja, wie zeigt sich das in Ihrer Arbeit? Ich glaube nicht, dass es einen typischen New Yorker Stil gibt. Das Grandiose an New York ist ja, dass es so international ist.

Wie stellen Sie sich New York in der Zukunft vor? Schnell und stürmisch ... hoffen wir mal! Man wird neue Technologien einsetzen müssen, um das dichte Räderwerk dieser riesigen Maschine in Gang zu halten.

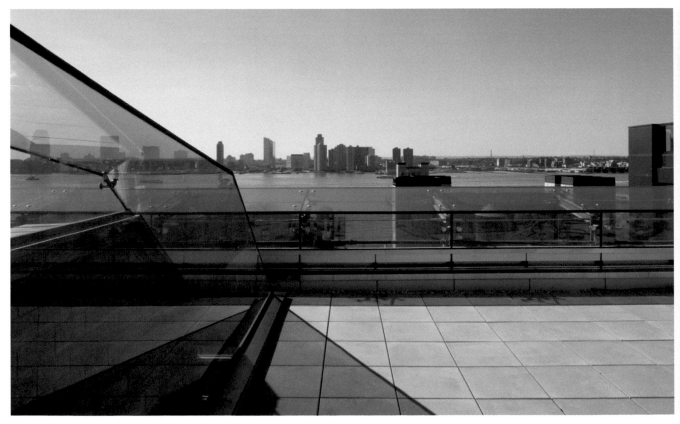

Quelle est l'œuvre la plus importante de votre carrière ? Le Greenwich building à NYC où nous avons pu réaliser une structure innovante avec une paroi de verrée pliée, un système d'énergie efficace, des lofts ouverts dotés d'espaces pourvus de très hauts plafonds.

Dans quelle mesure la ville de New York inspire-t-elle votre œuvre ? New York dégage une grande énergie et crée un environnement, source d'inspiration pour tout créateur. J'apprécie beaucoup le travail académique qui se fait ici. Dans mon œuvre, il est essentiel de combiner le travail académique et la pratique. En tant que directeur du Programme Post Professionnel à l'UPenn, je combine les deux.

Peut-on parler d'un style typiquement new-yorkais, et si oui, comment se manifeste-t-il dans votre œuvre ? Je ne crois pas qu'il y ait « un style typiquement new-yorkais ». Ce qu'il y a de formidable à New York, c'est son caractère hautement international.

Comment imaginez-vous le New York de demain ? Rapide et fougueux... je l'espère! Il faut utiliser les nouvelles technologies pour garder cette énorme machine en marche.

¿Cuál es el trabajo que considera más importante en su carrera? El edificio Greenwich en Nueva York. Pudimos dotar al edificio de una innovadora estructura con una pared de cristal plegado, un sistema de ahorro de energía y así proporcionar lofts abiertos con espacios de techo muy altos.

¿De qué manera Nueva York supone una inspiración en su trabajo? Nueva York tiene una enorme energía y supone un entorno inspirador para cualquier persona creativa. El mundo académico aquí es de un gran valor; en mi trabajo es crucial combinar la teoría con la práctica. Como director del programa postprofesional de la Universidad de Pennsylvania, puedo combinar ambas.

¿Existe un estilo típico neoyorquino, y si es así, cómo se revela en su obra? No creo que exista un "estilo típico neoyorquino", lo grande de Nueva York es que es tan internacional.

¿Cómo se imagina Nueva York en el futuro? "A todo gas"... ¡espero! La implantación de nuevas tecnologías es necesaria para mantener en marcha esta máquina enormemente densa.

Cosa pensa che sia la cosa più importante della Sua carriera? Il Greenwich building di NYC, siamo riusciti a fare dell'edificio una struttura innovativa con una parete di vetro piegata e con un sistema energetico efficace, e a realizzare dei loft aperti con soffitti molto alti.

In che modo New York influenza il Suo lavoro? NY ha molta energia e produce un ambiente ispirativo per ogni persona creativa. Apprezzo molto il mondo accademico qui; combinare l'accademia con la pratica è decisivo per il mio lavoro. Come direttore del programma post-professionale presso la UPenn (University of Pennsylvania) posso combinare entrambi.

Esiste uno stile tipico New York? Se sì, come influenza il Suo lavoro? Non credo che esiste uno "stile tipico New York", la cosa bella di New York è che è così internazionale.

Come si immagina New York in futuro? Veloce e furiosa... Lo spero! L'implementazione di nuove tecnologie è indispensabile per tenere in movimento questa densa e gigantesca macchina.

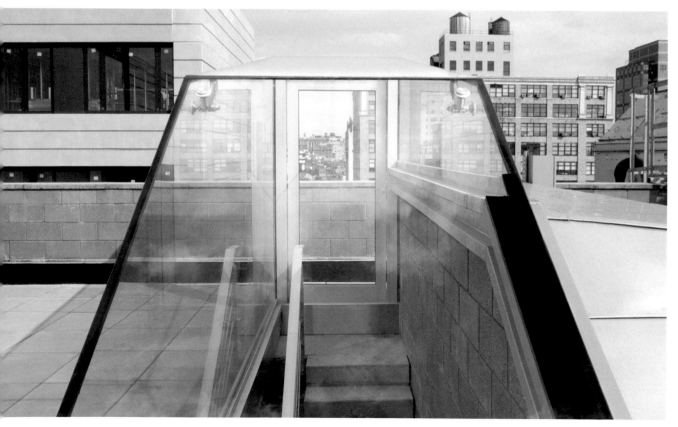

Greenwich Street Project

Year: 2003
Photographs: © Floto & Warner Studio

The design of the eleven-story apartment house in Greenwich was a reconversion of an original six-story storage space. A connection between the new and the existing was created by means of the unique glass façade which falls over the building like a cascade. The structure of the loft-designed interiors was built upon a steel frame in which concrete floors were set. The back concrete façade serves as a closure.

Beim Entwurf des elfstöckigen Apartmenthauses in Greenwich handelt es sich um die Umgestaltung eines ursprünglich sechsstöckigen Warenlagers. Eine Verbindung zwischen Neuem und Bestehendem wurde durch die ungewöhnliche Glasfassade erreicht, die sich wie ein Wasserfall über das Gebäude stülpt. Die Struktur der als Loft angelegten Innenräume wurde aus einem Stahlrahmen errichtet, in den die Betonböden eingesetzt wurden. Als Abschluss dient die rückseitige Betonfassade.

Un ancien entrepôt de six étages a été revisité pour créer un immeuble de onze étages à Greenwich. Le trait d'union entre le nouveau et l'ancien bâtiment prend la forme d'une façade de verre des plus originales, qui s'épanche sur l'édifice à l'instar d'une cascade. La structure, qui accueille un intérieur du style loft, est composée de cadres d'acier où sont coulés les sols en béton. La façade arrière en béton parachève l'ensemble.

Este proyecto para un edificio de apartamentos de once plantas en Greenwich consiste en la remodelación de un almacén, originariamente de seis plantas. La conexión entre lo nuevo y la parte original, se consiguió gracias a la insólita fachada de vidrio que cubre el edificio como una cascada. La estructura de los espacios interiores, distribuidos en lofts, se construyó mediante un armazón de acero en el que se colocaron los suelos de hormigón. El conjunto lo cierra la fachada de hormigón trasera.

Il progetto di un immobile residenziale di undici piani a Greenwich è stato realizzato partendo dalla trasformazione di un magazzino merci di sei piani. Il collegamento tra l'immobile nuovo e quello già esistente è stato realizzato attraverso una inusuale facciata in vetro che si rovescia sullo stabile come una cascata. La struttura a loft degli spazi interni è stata costruita partendo da uno scheletro in acciaio in cui sono state inserite le pareti in cemento armato. La chiusura è composta dalla facciata in cemento armato del retro.

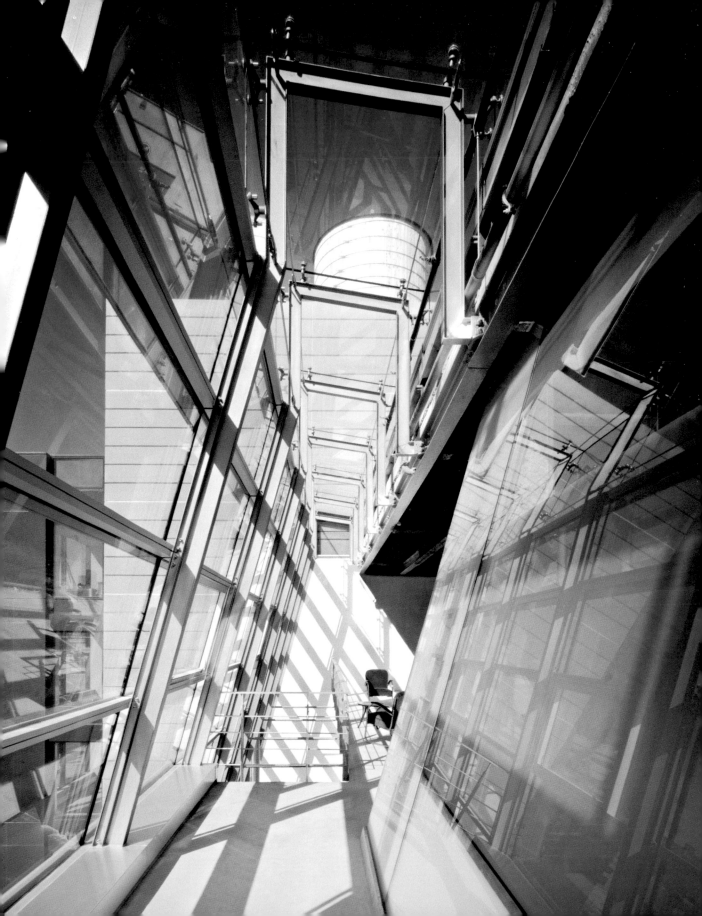

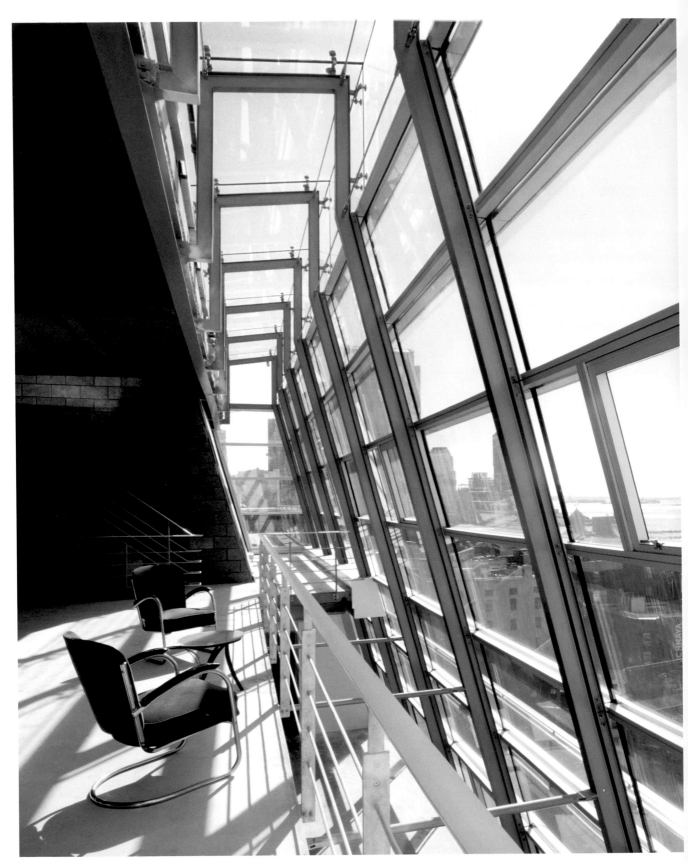

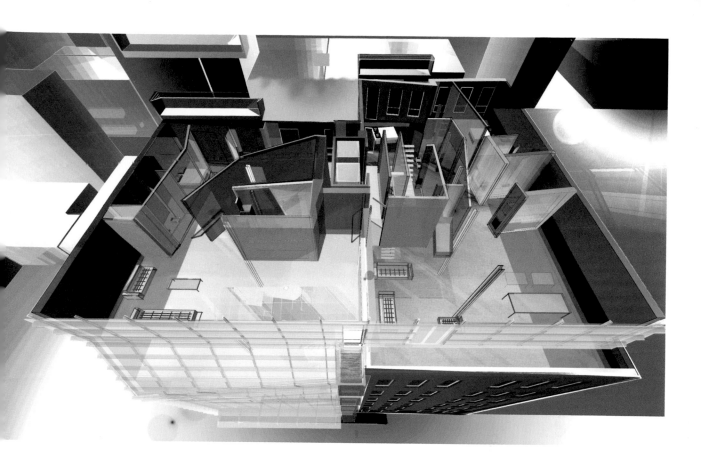

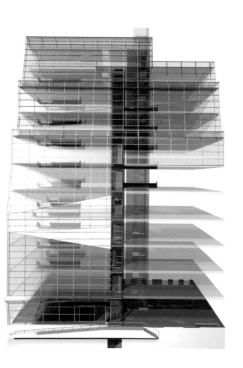

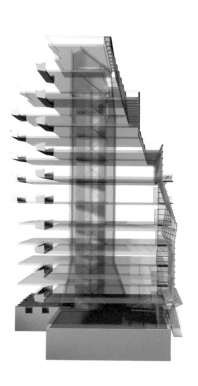

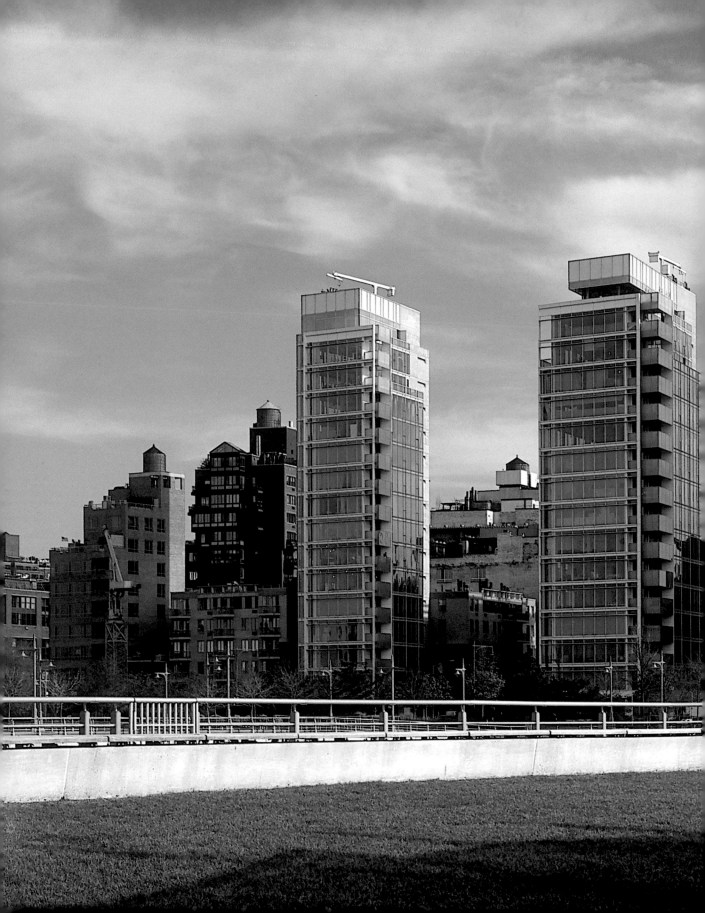

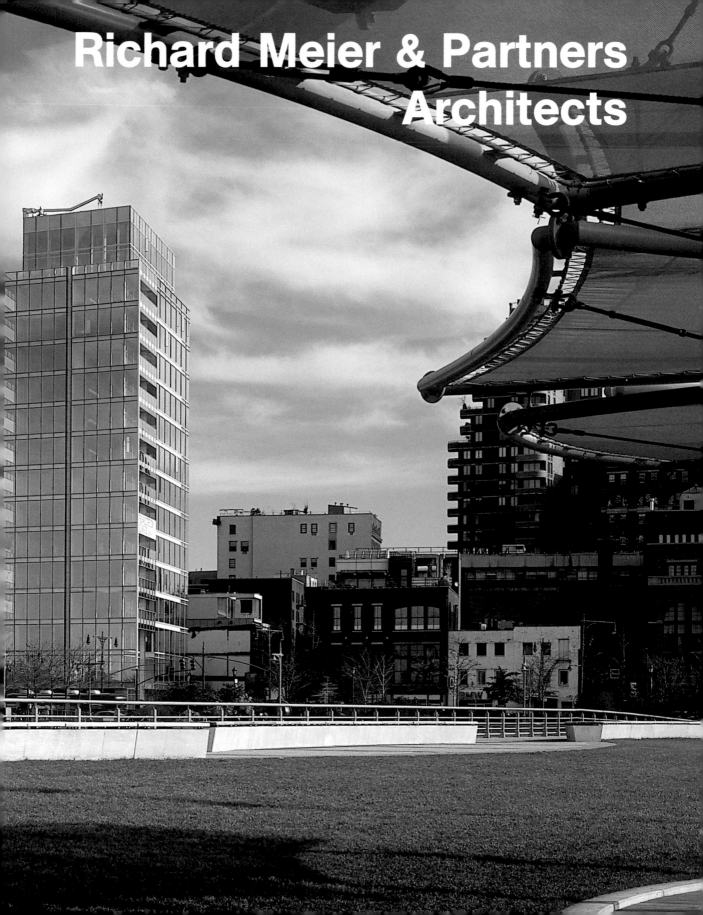

Richard Meier & Partners
Architects

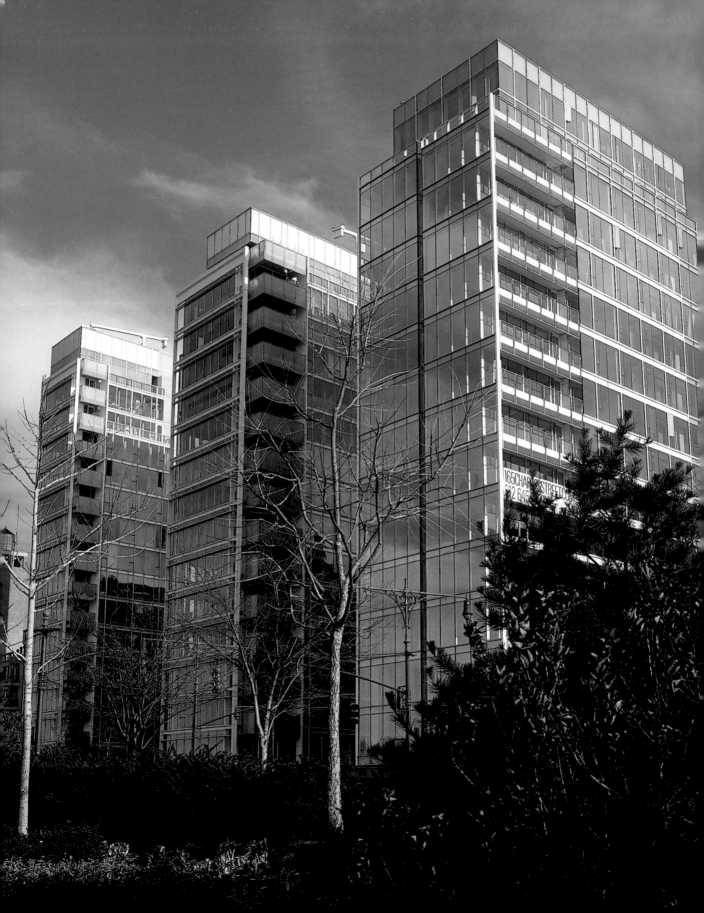

Richard Meier & Partners Architects

475 Tenth Avenue, 6th Floor, New York, NY 10018, USA

+1 212 967 6060

+1 212 967 3207

www.richardmeier.com

mail@richardmeier.com

Richard Meier

1934
Born in Newark, New Jersey, USA

1957
Graduated from the Cornell University in Ithaca,
New York, USA

1963
Established his office Richard Meier & Partners
Architects in New York, USA

1984-1997
The Getty Center, Los Angeles, California

1986-1995
Hague City Hall and Central Library,
Netherlands

1987-1995
Barcelona Museum of Contemporary Art,
Barcelona, Spain

1998
Awarded with the Pritzker Architecture Prize

1996-2003
Jubilee Church, Rome, Italy

For over four decades Richard Meier has been creating timeless and unique buildings around the world, above all with his public buildings, such as, for example, the Getty Center or the MACBA in Barcelona. His white and flexible designs, frequently combined with enameled cladding and glass, enriched the architectonic landscape of the 1980s. In 1998, he was honored for his work as the youngest winner of the Pritzker Prize at the time.

Seit mehr als vier Jahrzehnten erschafft Richard Meier weltweit, vor allem mit seinen öffentlichen Bauten, wie zum Beispiel dem Getty Center oder dem MACBA in Barcelona, zeitlose Gebäude, die Zeichen setzen. Seine weißen und plastischen Entwürfe, oft kombiniert mit emaillierten Verkleidungen und Glas, bereicherten die architektonische Landschaft der 80er Jahre. Aufgrund seiner Arbeit wurde er als damals jüngster Preisträger 1998 mit dem Pritzker Preis geehrt.

Depuis plus de quarante ans, Richard Meier crée à l'échelle mondiale, surtout dans le secteur des bâtiments publics, à l'instar du Getty Center ou du MACBA à Barcelone, des édifices intemporels, qui laissent des traces. Ses projets et conceptions plastiques blanches, combinés aux habillages en émaillages et verre, ont enrichi le paysage architectural des années 80. Il est le plus jeune lauréat à être récompensé pour son travail, en 1998, par le prix Pritzker.

Desde hace más de cuatro décadas, Richard Meier crea en todo el mundo, especialmente con sus obras públicas, como por ejemplo el Getty Center o el MACBA en Barcelona, edificios atemporales que marcan estilo. Sus diseños blancos y plásticos, a menudo combinados con revestimientos esmaltados y de vidrio, enriquecieron el panorama arquitectónico de los 80. Por su trabajo recibió, en 1998, el precio Pritzker, siendo el galardonado más joven hasta entonces.

Da oltre quattro decenni Richard Meier riesce con i suoi edifici senza tempo, come il Getty Center o il MACBA di Barcellona a lasciare un segno. I suoi progetti bianchi e plastici, spesso combinati con rivestimenti in smalto e in vetro arricchiscono il panorama architettonico degli anni 80. In merito al suo lavoro è già stato nel 1998 il più giovane premiato con il premio Pritzker.

Interview | Richard Meier & Partners Architects

What do you consider the most important work of your career? The Getty Center, due to its scale if nothing else.

In what ways does New York inspire your work? New York has been a city in which I have lived and worked, but rarely built. I have gathered inspiration from the city in rather indirect ways, for instance, from the remarkable creative energy of the artists and architects I have known over the years.

Does a typical New York style exist, and if so, how does it show in your work? If there is a New York style, it is most powerfully expressed in the city's energy found in the dynamism of the streets of midtown, in the light and views along the Hudson River, in any surprising combination of elements that make the city unique.

How do you imagine New York in the future? I sense real opportunity for good architecture to be realized in New York on a large scale. Over the past five years the city's skyline has seen its profile enriched by a number of projects with genuine presence.

Was halten Sie für die wichtigste Arbeit in Ihrer Karriere? Das Getty Center, allein schon wegen seiner Ausmaße.

Auf welche Weise inspiriert Sie New York? Ich habe in New York gelebt und gearbeitet, aber nur selten dort gebaut. Daher hat mich die Stadt eher auf indirekte Art inspiriert, z.B. durch die bemerkenswerte kreative Energie der Künstler und Architekten, die ich hier kennen gelernt habe.

Gibt es einen typischen New Yorker Stil, und wenn ja, wie zeigt sich das in Ihrer Arbeit? Wenn es einen New Yorker Stil gibt, so kommt er besonders deutlich in der Energie der Stadt zum Ausdruck, in der Bewegung und Dynamik der Straßen in Midtown, dem unglaublichen Licht und der Aussicht entlang des Hudson River und in jeder der überraschenden Verbindungen verschiedener Elemente, die diese Stadt so einzigartig machen.

Wie sehen Sie die Zukunft New Yorks? Ich spüre in New York erstmals eine wirkliche Chance für die Umsetzung guter Architektur in größerem Stil. In den letzten fünf Jahren wurde die Skyline der Stadt durch eine Anzahl verschiedener Projekte bereichert, die alle eine authentische Präsenz zeigen.

Quelle est l'œuvre la plus importante de votre carrière ? Le Getty Center, surtout pour son ampleur, entre autres.

Dans quelle mesure la ville de New York inspire-t-elle votre œuvre ? New York était la ville où j'ai vécu et travaillé, mais rarement construit. J'ai recevilli mon inspiration de la ville de manière plutôt indirecte, par exemple à travers de l'énergie créative remarquable des artistes ou architectes que j'ai rencontré au cours des années.

Peut-on parler d'un style typiquement new-yorkais, et si oui, comment se manifeste-t-il dans votre œuvre ? S'il y a vraiment un style new-yorkais, il s'exprime par l'énergie qui se dégage de la ville. Elle se manifeste à divers endroits, dans le mouvement et le dynamisme des rues de la Midtown, dans l'incroyable lumière et les vues extraordinaires le long de la Hudson River, dans les alliances étonnantes de tous ces éléments qui rendent la ville unique en son genre.

Comment imaginez-vous le New York de demain ? Je sens une réelle possibilité de faire de la bonne architecture à New York, sur une grande échelle. Au cours des cinq dernières années, le profil de la ville s'est enrichi d'un grand nombre de projets d'une réelle valeur.

¿Cuál es el trabajo que considera más importante en su carrera? El Getty Center, debido sobre todo a su magnitud.

¿De qué manera Nueva York supone una inspiración en su trabajo? Nueva York ha sido la ciudad en la que he vivido y trabajado, pero en la que casi nunca he construido. La ciudad ha supuesto para mí una fuente de inspiración de forma bastante indirecta, por ejemplo, me ha inspirado la sorprendente energía creativa de los artistas y arquitectos que he conocido a lo largo de los años.

¿Existe un estilo típico neoyorquino y, si es así, cómo se revela en su obra? Si existe un estilo neoyorquino, éste se expresa más plenamente en la energía de la ciudad, que radica en el dinamismo de las calles en torno al centro, en la luz y las vistas a lo largo del río Hudson, en cualquier sorprendente combinación de elementos que hacen única la ciudad.

¿Cómo se imagina Nueva York en el futuro? Percibo una verdadera oportunidad de realizar buena arquitectura en Nueva York a gran escala. En los últimos cinco años, la línea de horizonte de la ciudad ha visto enriquecido su perfil gracias a una serie de proyectos de genuina presencia.

Qual è secondo Lei il progetto più importante della Sua carriera? Il Getty Center perché, per la sua scala, si tratta di un progetto unico.

In che modo la città di New York ispira il Suo lavoro? New York è stata la città in cui ho vissuto e lavorato, ma in cui molto di rado ho costruito. Ho tratto ispirazione dalla città in modo "indiretto", per esempio dalla straordinaria energia creativa di artisti e architetti conosciuti nel corso degli anni.

È possibile parlare di uno stile tipico per New York, e, se questo stile esiste, in che modo si manifesta nei Suoi lavori? Se esiste uno "stile tipico New York" esso si manifesta certamente al meglio nell'energia della città, nel dinamismo delle strade della mid-town, nelle luci e vedute lungo lo Hudson River, e in ogni sorprendente combinazione di elementi che rendono questa città unica al mondo.

Come si immagina la New York del futuro? Credo ci siano concrete possibilità per la realizzazione di buone costruzioni architettoniche su larga scala a New York. Lo skyline della città è stato arricchito negli ultimi cinque anni circa attraverso numerosi progetti di indubbia qualità.

Berry Place Loft Conversion

Year: 2003

Photographs: © Gogortza & Llorella, Richard Phibbs (portrait)

These apartment buildings are the first Richard Meier designs in Manhattan. The 16-story residential building is located on the north-south side of Perry Street with a fantastic view overlooking the Hudson. To maximize the panorama, the concrete structure was oriented to the east. The floor structure of the building is emphasized by the interruption of the transparent, minimalistic glass cladding with white metal panels.

Diese Apartmentgebäude sind der erste Entwurf Richard Meiers in Manhattan. Die 16-stöckigen Wohngebäude befinden sich auf der Nord-Süd-Seite der Perry Street mit einem fantastischen Blick über den Hudson. Um dieses Panorama nicht zu beeinträchtigen, wurde die Betonstruktur nach Osten ausgerichtet. Die Etagenstruktur des Gebäudes wird durch die Unterbrechung der transparenten, minimalistischen Glasverkleidung mit weißen Metallpaneelen hervorgehoben.

Cet immeuble d'appartements est le premier projet de Richard Meier à Manhattan. L'immeuble de 16 étages se trouve sur le côté nord-sud de la Perry Street, avec une vue fantastique sur l'Hudson. Pour ne pas gêner ce panorama, la structure en béton est orientée vers l'est. La structure en étages de l'édifice est sublimée par l'interruption du revêtement en verre transparent et minimaliste, encadré de panneaux de métal blanc.

Estos edificios de apartamentos son el primer proyecto de Richard Meier en Manhattan. Los edificios de viviendas de 16 plantas están situados en el lado Norte-Sur de la calle Perry, con unas vistas fabulosas sobre el río Hudson. Para no interferir sobre el panorama, la estructura de hormigón se orientó hacia el Este. Los paneles de metal blancos que interrumpen el revestimiento de vidrio minimalista y transparente realzan la estructura de pisos del edificio.

Questi immobili residenziali corrispondono al primo progetto di Richard Meier a Manhattan. L'immobile a 16 piani si trova sul lato nord-sud della Perry Street, con una fantastica vista sul fiume Hudson. Per non impoverire questo panorama, la struttura in cemento armato è stata orientata verso est. La struttura a piani dell'edificio è evidenziata dall'interruzione del rivestimento in vetro minimo con pannelli metallici bianchi.

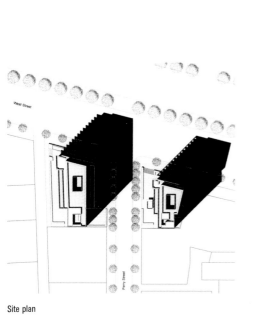

Site plan

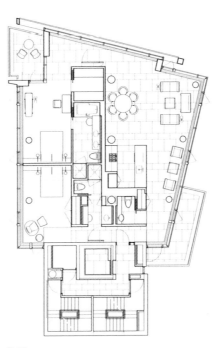

First floor

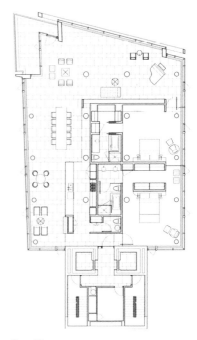

Second floor

LOT-EK

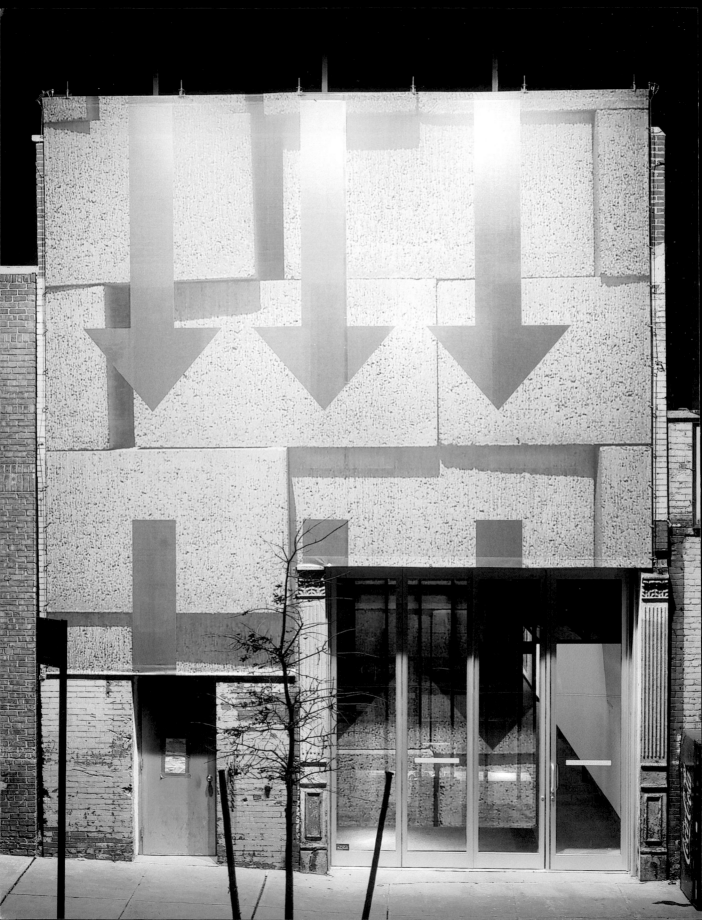

LOT-EK

55 Little West 12th Street, New York, NY 10014, USA

+1 212 255 9326

+1 212 255 2988

www.lot-ek.com

info@lot-ek.com

LOT-EK

1993
LOT-EK founded by Ada Tolla and Giuseppe Lignano in New York, USA

1998
TV-TANK, television lounging tube, Deitch Projects, New York, USA

1999
Morton Duplex, residence, West Village, New York, USA
Emerging Voices, Architectural League, New York, USA

2000
Boon, clothing store, Seoul, Korea
Students Pavilion, multifunctional space, University of Washington Campus, Seattle, USA
The Bohen Foundation, Meat District, New York, USA

2001
National Design Award, Finalist, Cooper-Hewitt National Design Museum

2005
Cynthia Broan Gallery, New York, USA

Ada Tolla and Giuseppe Lignano studied architecture together in Naples, before continuing their training in New York and creating 1993 LOT-EK. Their design portfolio ranges from residential buildings to commercial and public projects to exhibit design and installations. Their ever-innovative approach to space and materials, as well as their work with concepts such as mobility and transformation are hallmarks of their designs.

Ada Tolla und Giuseppe Lignano studierten gemeinsam Architektur in Neapel und New York, bevor sie 1993 LOT-EK gründeten. Ihre Entwurfspalette reicht von Wohnbauten über kommerzielle und öffentliche Projekte bis zu Ausstellungsdesign und Installationen. Charakteristisch ist die innovative Annäherung an den Raum und an Materialien, sowie ihre Beschäftigung mit Konzepten wie Mobilität und Transformierung.

Ada Tolla et Giuseppe Lignano font ensemble leurs études d'architecture à Naples, avant de continuer leur formation à New York et de fonder, en 1993, le cabinet LOT-EK. L'éventail de leurs réalisations va des constructions d'immeubles d'habitations jusqu'aux installations et design d'expositions en passant par des projets commerciaux et publics. Leurs projets affichent une approche de l'espace et des matériaux toujours innovatrice, et s'attachent à réaliser des concepts flexibles et modulables.

Ada Tolla y Giuseppe Lignano estudiaron juntos arquitectura en Nápoles antes de continuar su formación en Nueva York y de fundar, en 1993, LOT-EK. Su abanico de proyectos va desde los edificios residenciales hasta el diseño de exposiciones e instalaciones, pasando por los edificios comerciales y públicos. Los proyectos se caracterizan por una aproximación siempre innovadora al espacio y los materiales, así como por la reflexión sobre conceptos como la movilidad y la transformación.

Ada Tolla e Giuseppe Lignano hanno studiato insieme architettura a Napoli, prima di proseguire la loro formazione a New York, fondando nel 1993 LOT-EK. I loro progetti variano da immobili abitativi, passando per progetti commerciali e pubblici, fino al design di esposizioni e installazioni. La caratteristica principale dei loro progetti e l'avvicinamento innovativo continuo allo spazio e ai materiali, così come il trattamento di concetti come la mobilità e la trasformazione.

Interview | LOT-EK

Which do you consider the most important work of your career? We are very excited right now about our entry for the competition for the new Jalisco library in Guadalajara, Mexico.

In what way does New York inspire your work? New York City is the best example of the urban situations that we look at: it is a completely artificial nature, with layers and layers of objects, cultures, and lifestyles. Existing objects are adjusted and reformatted to integrate new technologies. Everything and everyone moves around each other, creating a dense physical and social infrastructure.

Does a typical New York style exist, and if so, how does it show in your work? Not a style but a personality, a careless, proud and layered personality as described above.

How do you imagine New York in the future? More layers. The new will layer over the existing, people and objects will come and go.

Was halten Sie für die wichtigste Arbeit in Ihrer Karriere? Bei uns herrscht im Moment große Aufregung wegen unseres Beitrags am Wettbewerb für die neue Jalisco Bibliothek in Guadalajara, Mexiko.

Auf welche Weise inspiriert New York Ihre Arbeit? New York City ist doch das beste Beispiel für urbane Situationen: es besitzt eine komplett künstliche Natur mit unzähligen Schichten von Objekten, Kulturen und unterschiedlichem Lifestyle. Bereits bestehende Objekte werden umgestaltet und neu formatiert, um neue Technologien zu integrieren. Alles und jeder kreist um einander herum: Das erzeugt eine dichte physische und soziale Infrastruktur.

Gibt es einen typischen New Yorker Stil, und wenn ja, wie zeigt sich das in Ihrer Arbeit? Es gibt zwar keinen solchen Stil, aber eine Persönlichkeit, eine leichtfertige, stolze und vielschichtige Persönlichkeit wie zuvor beschrieben.

Wie stellen Sie sich New York in der Zukunft vor? Vielschichtig. Die neuen Schichten werden sich über die bestehenden legen, Menschen und Objekte werden kommen und gehen.

Quelle est l'œuvre la plus importante de votre carrière ? Nous sommes actuellement enthousiasmés par notre participation au concours pour la création de la nouvelle bibliothèque Jalisco de Guadalajara à Mexico.

Dans quelle mesure la ville de New York inspire-t-elle votre œuvre ? La ville de New York est l'exemple parfait de l'urbanisme que nous recherchons : sa nature entièrement artificielle est faite de diverses couches d'objets, cultures et styles de vie. Les objets existants sont réadaptés et revisités pour intégrer de nouvelles technologies. Dans ce maelström de gens et de choses, l'infrastructure sociale et physique devient très dense.

Peut-on parler d'un style typiquement new-yorkais, et si oui, comment se manifeste-t-il dans votre œuvre ? On ne peut pas parler d'un style mais d'une personnalité, insouciante, fière, aux multiples facettes, telle que je l'ai décrite plus haut.

Comment imaginez-vous le New York de demain ? Des couches qui s'ajoutent les unes aux autres. Le nouveau recouvrira ce qui existe, dans un va et vient de gens et de choses qui naîtront et disparaîtront.

¿Cuál es el trabajo que considera más importante en su carrera? Ahora mismo estamos muy ilusionados con nuestra participación en el concurso para la nueva biblioteca de Jalisco en Guadalajara, Méjico.

¿De qué manera Nueva York supone una inspiración en su trabajo? La ciudad de Nueva York es el mejor ejemplo de las situaciones urbanas que consideramos: se trata de una naturaleza totalmente artificial, con capas y capas de objetos, culturas y estilos de vida. Los objetos existentes se ajustan y reformatean para integrar las nuevas tecnologías. Todo y todos se mueven unos en torno a otros, creando una densa infraestructura física y social.

¿Existe un estilo típico neoyorquino y, si es así, cómo se revela en su obra? No un estilo sino una personalidad, una descuidada, orgullosa y estratificada personalidad según se ha descrito con anterioridad.

¿Cómo se imagina Nueva York en el futuro? Más estratificada aún. Lo nuevo se superpondrá a lo existente, la gente y los objetos irán y vendrán.

Cosa pensa che sia la cosa più importante della Sua carriera? Siamo eccitatissimi per aver potuto in questo momento partecipare alla gara di appalto per la biblioteca Jalisco a Guadalajara, in Messico.

In che modo New York influenza il Suo lavoro? New York City è l'esempio migliore della situazione urbana a cui facciamo riferimento: è una natura completamente artificiale, con diversi strati di oggetti, culture e stili di vita. Gli oggetti esistenti devono essere modificati e riformattati per integrare nuove tecnologie. Tutto e tutti si muovono intorno reciprocamente, creando una densità fisica e una infrastruttura sociale.

Esiste uno stile tipico a New York? Se sì, come influenza il Suo lavoro? Non uno stile ma una personalità, una personalità senza pensieri, fiera e multipla come descritto sopra.

Come si immagina New York in futuro? Con ancora più strati. I nuovi strati si stenderanno sopra a quelli presenti: gente ed oggetti verranno e ripartiranno.

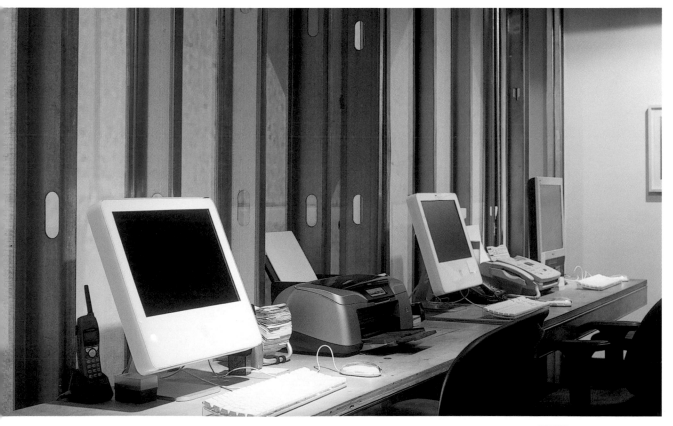

Cynthia Broan Gallery

Year: 2005
Photographs: © Gogortza & Llorella

The Cynthia Broan Gallery represents the conversion of an auto bodyshop into an art gallery. The classic exhibit space is replaced here with walls which are mounted on steel rails, which allows each exhibit to look new. Also the office can be made smaller or larger as needed. The transformation idea is visualized in the brick façade since the latter is clad with a bolt-stamped vinyl foil.

Bei der Cynthia Broan Gallery handelt es sich um den Umbau einer Autowerkstatt in eine Kunstgalerie. Der klassische Ausstellungsraum wird hier durch Wände ersetzt, die auf Stahlschienen montiert sind und so jede Ausstellung neu aussehen lassen. Auch das Büro lässt sich nach Bedarf verkleinern oder vergrößern. Die Idee der Transformierung wird zudem in der Backsteinfassade visualisiert, denn diese wurde mit einer mit Pfeilen bedruckten Vinylfolie überzogen.

La Cynthia Broan Gallery est un projet de réhabilitation d'un garage en galerie d'art. L'espace d'exposition classique se présente ici sous la forme de quatre murs montés sur des rails en métal conférant à chaque exposition un caractère unique. Il est aussi possible d'agrandir ou de diminuer l'espace du bureau au gré des besoins. L'idée même de transformation visuelle s'affiche également sur la façade de briques, recouverte d'une feuille de vinyle imprimée de flèches.

Para la Cynthia Broan Gallery se remodeló un taller de reparación de automóviles, convirtiéndolo en una galería de arte. La sala de exposiciones clásica se sustituye aquí por paredes montadas sobre guías de acero que permiten cambiar el aspecto de cada exposición. La oficina también se puede ampliar o reducir según las necesidades. La idea de la transformación también se visualiza en la fachada de ladrillos, que se cubrió con una lámina de vinilo con flechas impresas.

La Cynthia Broan Gallery è nata dalla trasformazione di un'autofficina in una galleria artistica. La sala delle esposizioni classica è qui sostituita da pareti montate su rotaie di acciaio e che possono quindi essere disposte diversamente per ogni esposizione. Anche l'ufficio può essere allargato o ristretto a seconda delle necessità. L'idea della trasformazione è inoltre visualizzabile nella facciata in laterizi, coperta da una lamina di vinile su cui sono state stampate delle frecce.

SOM – Skidmore, Owings & Merrill

SOM – Skidmore, Owings & Merrill

14 Wall Street, 24th Floor, New York, NY 10005, USA

+1 212 298 93 00

+1 212 298 95 00

www.som.com

somnewyork@som.com

Roger Duffy

SOM is one of the leading architectural firms in the world. Since its founding in 1936 by Louis Skidmore, Nathaniel Owings and John Merrill, the firm has carried out over 10,000 architecture and interior design projects in more than 50 countries. From the outset, a great deal of value was placed upon teamwork and individual responsibility by the employees. Since its establishment, these efforts have been honored with over 800 awards.

SOM ist eine der weltweit führenden Architekturfirmen. Seit ihrer Gründung 1936 durch Louis Skidmore, Nathaniel Owings und John Merrill verwirklichte sie über 10 000 Architektur- und Innendesignprojekte in mehr als 50 Ländern. Von Anfang an wurde dabei sehr viel Wert auf Teamwork und Eigenverantwortung der Mitarbeiter Wert gelegt. Diese Bemühungen wurden seit der Gründung mit über 800 Auszeichnungen prämiert.

SOM est l'un des cabinets d'architecture les plus reconnus au monde. Formé en 1936 par Louis Skidmore, Nathaniel Owings et John Merrill, ils ont depuis lors réalisé plus de 10 000 projets d'architecture et de design d'intérieur – dans plus de 50 pays. Dès le départ, l'accent est mis sur l'importance du travail d'équipe et la responsabilité personnelle des collaborateurs. Depuis la fondation du groupe, ils se sont vus décerner plus de 800 distinctions.

SOM es una de las firmas de arquitectura líderes del mundo. Desde su fundación en 1936 por Louis Skidmore, Nathaniel Owings y John Merrill, ha llevado a cabo más de 10 000 proyectos de arquitectura y diseño interior en más de 50 países. Desde el principio se dio gran importancia al trabajo en equipo y a la responsabilidad personal de los empleados. Y desde la fundación, estos esfuerzos se han visto premiados con más de 800 distinciones.

SOM è una delle società di architetti dominanti a livello mondiale. A partire dalla sua fondazione nel 1936 da parte di Louis Skidmore, Nathaniel Owings e John Merrill sono stati sviluppati più di 10 000 progetti architettonici e di arredamento interno in oltre 50 paesi. Sin dall'inizio è stata data una grande importanza al lavoro di gruppo e alla responsabilità personale di ogni collaboratore. Questi sforzi sono stati premiati dal ricevimento a partire dalla fondazione di oltre 800 premi.

1939
Foundation of Skidmore, Owings & Merrill,

1952
Lever House

1961
Awarded with Firm Award, American Institute of Architects

1970
John Hancock Tower, Chicago, Illinois, USA

1974-76
Sears Tower, Chicago, Illinois, USA

1996
Awarded with Firm Award, American Institute of Architects

2002
Partner of Skidmore, Owings & Merrill (Ben Gurion International Airport, Logan International Airport, Tribeca Bridge, Deerfield Academy, Hilton Resort Kuwait, Brunswick School, Arc de Seine, George's Quay, Skyscraper Museum)

2003
AOL Time Warner Center, New York, USA

Interview | SOM – Skidmore, Owens & Merrill

Which do you consider the most important work of your career? Greenwich Academy Upper School (Greenwich, Connecticut) was a breakthrough building for us. Its success set the course for the studio's practice.

In what ways does New York inspire your work? I've traveled all over the world and New York remains for me the greatest city. New York continues to attract the most talented and creative people. The work of SOM New York is contingent on access to those people.

Does a typical New York style exist, and if so, how does it show in your work? New York is a place of many constraints. The challenge is to be creative within the constraints.

How do you imagine New York in the future? I see New York becoming even more vital and interesting. There will be a price to pay in terms of the demands placed on the infrastructure. Increasing density will strain the public-private divide and create new challenges for designers and policy makers.

Was halten Sie für die wichtigste Arbeit in Ihrer Karriere? Die Greenwich Academy Upper School (Greenwich, Connecticut) war für uns ein bahnbrechendes Gebäude. Sein Erfolg hat die Kursrichtung für unser Studio vorgegeben.

Auf welche Weise inspiriert New York Ihre Arbeit? Ich habe die gesamte Welt bereist und New York bleibt für mich einfach die großartigste Stadt. New York zieht unaufhörlich die talentiertesten und kreativsten Menschen an. Der Zugang zu diesen Menschen bestimmt die Arbeit von SOM New York.

Gibt es einen typischen New Yorker Stil, und wenn ja, wie zeigt sich das in Ihrer Arbeit? New York ist in vielerlei Hinsicht ein Ort der Begrenzungen. Die Herausforderung liegt darin, mit diesen Einschränkungen kreativ umzugehen.

Wie stellen Sie sich New York in der Zukunft vor? New York wird meines Erachtens immer lebendiger und interessanter. Was die Nachfrage an Infrastruktur betrifft, so wird sicherlich ein hoher Preis gezahlt werden müssen. Die zunehmende Dichte wird den Graben zwischen Öffentlichem und Privatem erweitern und neue Herausforderungen für Designer und politische Entscheidungsträger schaffen.

Quelle est l'œuvre la plus importante de votre carrière ? La Greenwich Academy Upper School (Greenwich, Connecticut) nous a rendus célèbres. Cette réussite a déterminé le cours de notre agence d'architecture.

Dans quelle mesure la ville de New York inspire-t-elle votre œuvre ? Après avoir parcouru le monde entier, je pense que New York reste encore la plus grande ville du monde. New York continue d'attirer les gens les plus talentueux et créatifs. L'œuvre de SOM New York est influencée par tous ces talents.

Peut-on parler d'un style typiquement new-yorkais, et si oui, comment se manifeste-t-il dans votre œuvre ? New York est un lieu aux contraintes multiples. Le défi à relever est de savoir créer en tenant compte de toutes les contraintes inhérentes à New York.

Comment imaginez-vous le New York de demain ? Je pense que New York sera une ville de plus en plus importante et intéressante. Il y aura certainement un prix à payer au niveau des impératifs infrastructurels. La densité croissante réduira la séparation entre sphère publique et privée, posant de nouveaux défis aux concepteurs et décideurs politiques.

¿Cuál es el trabajo que considera más importante en su carrera? La escuela superior Greenwich Academy (Greenwich, Connecticut) fue un edificio que supuso un paso adelante para nosotros. Su éxito trazó el rumbo en la práctica del estudio.

¿De qué manera Nueva York supone una inspiración en su trabajo? He viajado por todo el mundo y para mí Nueva York sigue siendo la ciudad más estupenda. Nueva York sigue atrayendo a las personas con mayor talento y creatividad. El trabajo de SOM en Nueva York está supeditado al acceso a dichas personas.

¿Existe un estilo típico neoyorquino y, si es así, cómo se revela en su obra? Nueva York es un lugar de numerosas limitaciones. El reto consiste en ser creativo dentro de las limitaciones.

¿Cómo se imagina Nueva York en el futuro? Veo Nueva York convirtiéndose en una ciudad cada vez más vital e interesante. Se pagará un precio en términos de la demanda sobre la infraestructura. La densidad en aumento someterá a una presión excesiva la separación entre público-privado y generará nuevos desafíos para diseñadores y responsables políticos.

Cosa pensa che sia la cosa più importante della Sua carriera? L'edificio della scuola Greenwich Academy Upper School (Greenwich, Connecticut) ha rappresentato per noi una svolta. Il suo successo ha posto le basi di lavoro per il nostro studio.

In che modo New York influenza il Suo lavoro? Ho viaggiato in tutto il mondo e New York rimane per me la grande città per eccellenza. New York continua ad attirare gente creativa e piena di talento. Il lavoro di SOM New York è in un qualche modo contingente a questa gente.

Esiste uno stile tipico a New York? Se sì, come influenza il Suo lavoro? New York è un luogo dai molti vincoli. La sfida è di riuscire a essere creativo all'interno delle costrizioni.

Come si immagina New York in futuro? Vedo New York diventare sempre più vitale ed interessante. Ci sarà un prezzo da pagare nei termini della domanda nei confronti dell'infrastruttura. L'incremento della densità aumenterà la divisione tra il pubblico e il privato, creando nuove sfide per i designer e gli autori politici.

The Skyscraper Museum

Year: 2004

Photographs: © Roger Casas

The Skyscraper Museum is located on the ground floor of a building complex, which is also home to the Ritz Carlton Hotel and the Condominium Tower. Due to the limited available space, the architects decided to construct a mezzanine level. Ramps connect the book shop with the showroom on the main level. Moreover, they give the impression of an endless vertical space by using flooring and a ceiling clad in mirrors.

Das Skyscraper Museum befindet sich im Erdgeschoss eines Gebäudekomplexes, der auch das Ritz Carlton Hotel und den Condominium Tower beherbergt. Aufgrund des begrenzt zur Verfügung stehenden Raumes entschieden sich die Architekten für die Konstruktion eines Zwischengeschosses. Rampen verbinden den Buchladen mit dem Ausstellungsraum in der Hauptetage. Des Weiteren vermitteln die mit Spiegeln verkleideten Fußböden und Decken den Eindruck eines unendlich vertikalen Raumes.

Le Skyscraper Museum est situé au rez-de-chaussée d'un complexe de bâtiments, qui abrite aussi le Ritz Carlton hôtel et la Condominium Tower. Vu le manque de place disponible, les architectes ont décidé de construire un entresol. Des rampes relient la librairie aux salles d'expositions du premier étage. En outre, les sols et les plafonds, habillés de miroir, transmettent la sensation d'une pièce infiniment verticale.

El Skyscraper Museum está ubicado en la planta baja de un complejo de edificios que también acoge al hotel Ritz Carlton y la Condominium Tower. Debido a las limitaciones del espacio disponible, los arquitectos se decidieron por la construcción de una planta intermedia. Las rampas unen la librería con la sala de exposiciones en la planta principal. Además, los suelos y techos cubiertos de espejos dan la sensación de un espacio vertical infinito.

Il museo Skyscraper si trova al piano terra di un complesso immobiliare che comprende anche il Ritz Carlton Hotel e la Condominium Tower. In seguito allo spazio limitato a loro disposizione, gli architetti si decisero per la costruzione di un mezzanino. Delle rampe di scale collegano la libreria con la sala delle esposizioni al piano principale. Il pavimento e il soffitto a specchi danno poi l'idea di una stanza verticalmente infinita.

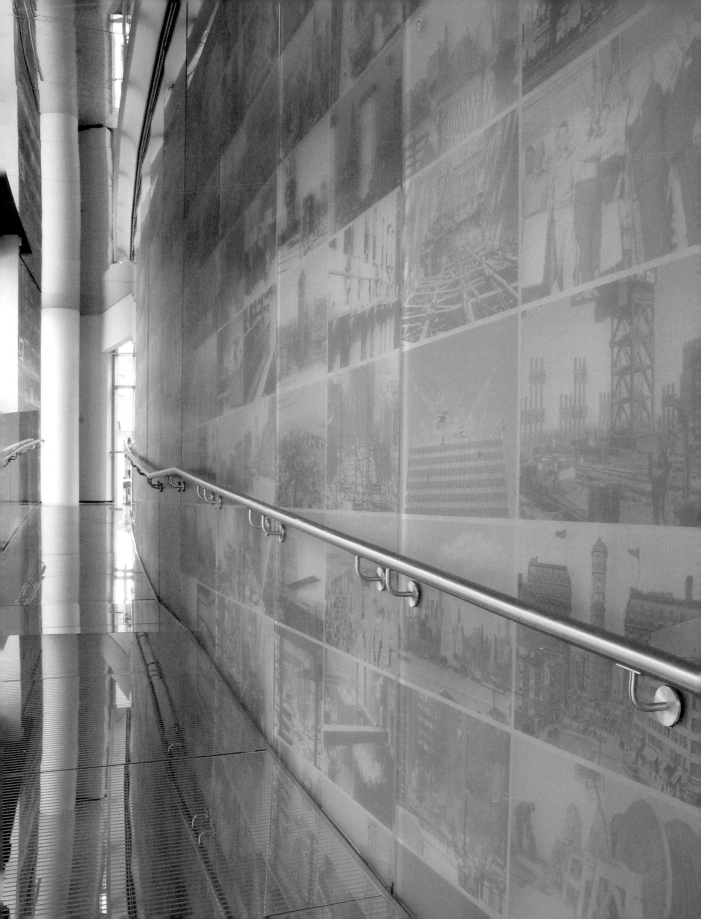

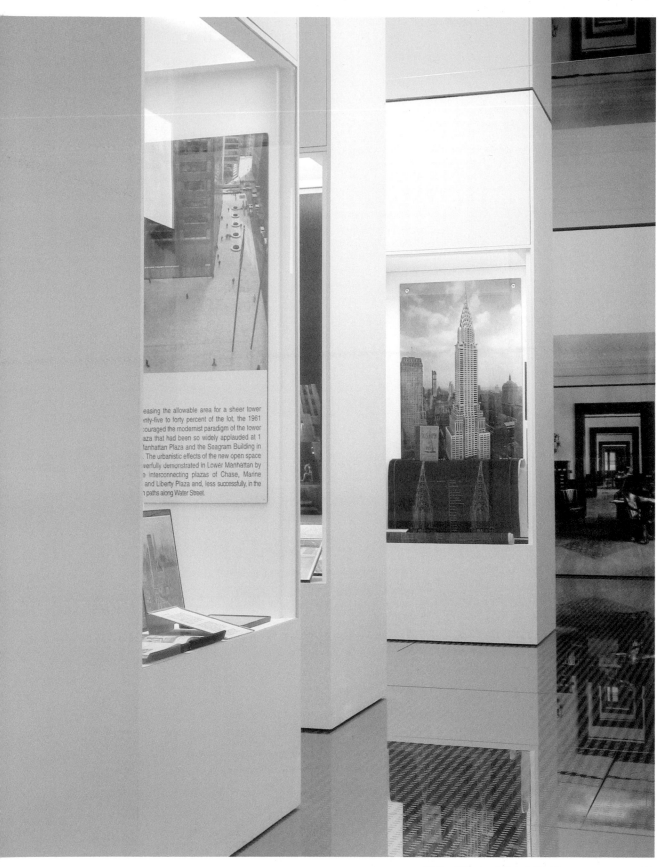

easing the allowable area for a sheer tower
...nty-five to forty percent of the lot, the 1961
...couraged the modernist paradigm of the tower
...aza that had been so widely applauded at 1
...anhattan Plaza and the Seagram Building in
... The urbanistic effects of the new open space
...werfully demonstrated in Lower Manhattan by
... interconnecting plazas of Chase, Marine
... and Liberty Plaza and, less successfully, in the
... paths along Water Street.

SOM – Skidmore, Owings & Merrill

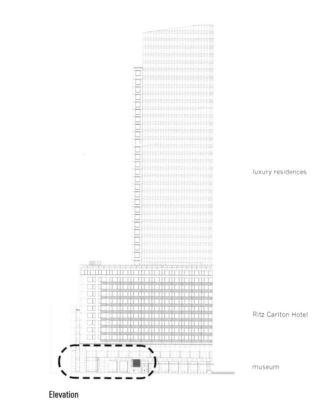

luxury residences

Ritz Carlton Hotel

museum

Elevation

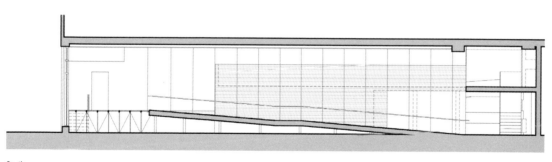

Section

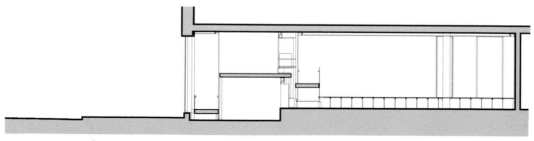

Section

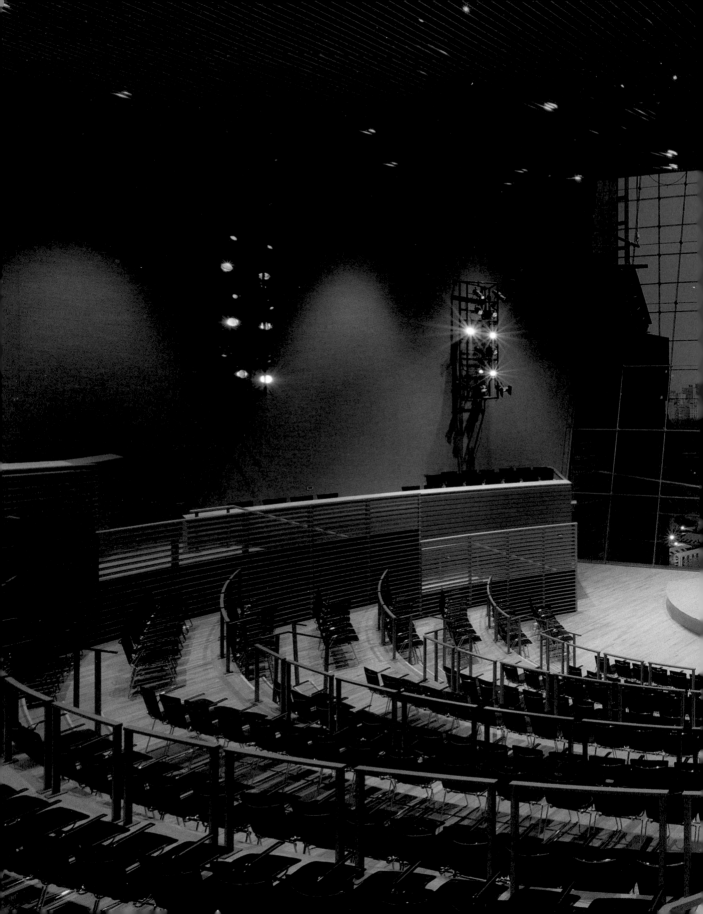

Rafael Viñoly Architects

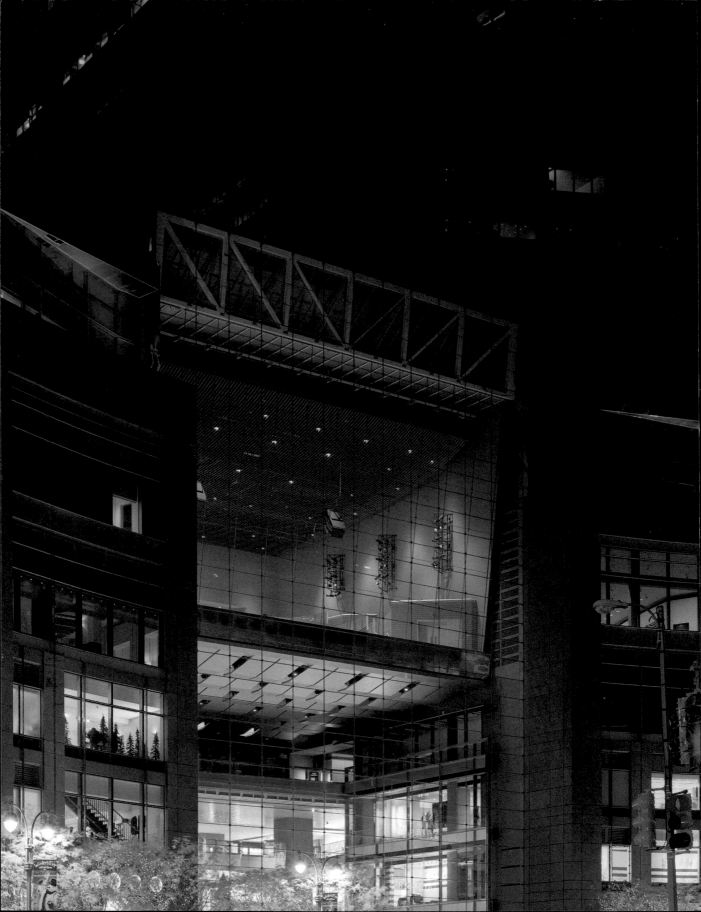

Rafael Viñoly Architects

50 Vandam Street, New York, NY 10013, USA

+1 212 924 5060

+1 212 924 5858

www.rvapc.com

info@rvapc.com

Rafael Viñoly

1944
Born in Montevideo, Uruguay

1968
Graduated from the University of Buenos Aires

1982
Foundation of Rafael Viñoly Architects in New York, USA

1996
Tokio International Forum

2001
Kimmel Center for the Performing Arts, Philadelphia, Pennsylvania, USA

2003
Information Sciences and Technology Building, Pennsylvania State University, Pennsylvania, USA
David L. Lawrence Convention Center, Pittsburgh, Pennsylvania, USA

2004
Jazz at Lincoln Center, New York, USA
Boston Convention and Exhibition Center, Boston, Massachusetts, USA

Before establishing his New York architecture office, Rafael Viñoly had already realized a multitude of trendsetting projects in his Estudio de Arquitectura, one of the largest design studios in Latin America. He achieved substantial international prominence for the creativity and rigorousness of his designs of the Tokyo International Forum competition project and the Kimmel Center for Performing Arts in Philadelphia.

Vor der Gründung seines New Yorker Architekturbüros hatte Rafael Viñoly bereits schon mit seinem Estudio de Arquitectura, einem der größten Designstudios Lateinamerikas, eine Vielzahl von richtungweisenden Projekten verwirklicht. Große internationale Anerkennung für die Kreativität und Rigorosität seiner Entwürfe erlangte er mit dem Wettbewerbsprojekt Tokyo International Forum und dem Kimmel Center for Performing Arts in Philadelphia.

Avant la fondation de son bureau d'architecte à New York, Rafael Viñoly avait déjà avec son Estudio de Arquitectura, un des plus grands studios de design de toute l'Amérique latine, et développé un grand nombre de projets phares. Il acquiert une grande notoriété internationale pour la créativité et le rigorisme de ses œuvres lors du concours du Tokyo International Forum et du Kimmel Center for Performing Arts à Philadelphie.

Antes de fundar su estudio de arquitectura neoyorquino, Rafael Viñoly ya había llevado a cabo con su Estudio de Arquitectura, uno de los estudios de diseño más importantes de Latinoamérica, un gran número de proyectos que han creado escuela. Obtuvo un amplio reconocimiento internacional por la creatividad y rigurosidad de los diseños presentados en el concurso del Tokyo International Forum y el Kimmel Center for Performing Arts de Philadelphia.

Già prima dell'apertura del suo studio di architetti a New York, Rafael Viñoly aveva già sviluppato col suo Estudio de Arquitectura uno dei più grandi uffici di design dell'America Latina, un gran numero di progetti faro. Un grande riconoscimento internazionale per la creatività e la rigorosità dei suoi disegni li ha ottenuti col progetto competitivo Tokyo International Forum e con il Kimmel Center for Performing Arts di Filadelfia.

Interview | Rafael Viñoly Architects

Which do you consider the most important work of your career? I always feel that the most important job of my career is the one I am presently working on.

In what ways does New York inspire your work? New York is a melting pot of people, talent and resources. There is a plurality and a democracy while retaining a sense of individualism. The overall effect is that we all participate in the New York project.

Does a typical New York style exist, and if so, how does it show in your work? I don't think there is a New York style anymore. What does exist is a New York "style of thinking", one that is based on an extraordinary sense of pragmatism, that rejects the nonsense, but that is as daring as it is non-hierarchical.

How do you imagine New York in the future? Manhattan is exceptionally integrated, its verticality allowing the perceptions of scale to shift towards the very large. I hope this does not alter. I also hope that within this system we retain the sense of village and common identity that bound all who live here.

Was halten Sie für die wichtigste Arbeit in Ihrer Karriere? Ich denke stets, dass das Projekt, an dem ich gerade arbeite, die wichtigste Arbeit meiner Karriere ist.

Auf welche Weise inspiriert New York Ihre Arbeit? New York ist ein Schmelztiegel von Menschen, Talenten und Ressourcen. Es herrscht Pluralität und Demokratie und gleichzeitig wird der Sinn für Individualismus beibehalten. Der Gesamteffekt ist der, dass wir alle am Projekt New York mitarbeiten.

Gibt es einen typischen New Yorker Stil, und wenn ja, wie zeigt sich das in Ihrer Arbeit? Ich glaube nicht, dass es noch einen New Yorker Stil gibt. Was es allerdings gibt, ist ein New Yorker „Style of Thinking". Dieser beruht auf einem ausgeprägten Sinn für Pragmatismus, der zwar den Nonsens ablehnt, aber sowohl wagemutig als auch nicht-hierarchisch ist.

Wie stellen Sie sich New York in der Zukunft vor? Manhattan ist außergewöhnlich einheitlich. Durch seine Vertikalität sind der Vorstellung nach oben hin keine Grenzen gesetzt. Ich hoffe, dass sich da nichts ändert. Ich hoffe auch, dass wir innerhalb dieses Systems denn Sinn für Gemeinschaft und gemeinsame Identität behalten, was alle, die hier leben, verbindet.

Quelle est l'œuvre la plus importante de votre carrière ? J'ai toujours l'impression que l'œuvre la plus importante de ma carrière est celle du moment.

Dans quelle mesure la ville de New York inspire-t-elle votre œuvre ? New York est un creuset de personnes, talents et ressources. Pluralité et démocratie côtoient un certain individualisme. Au bout du compte, nous participons tous au projet de New York.

Peut-on parler d'un style typiquement new-yorkais, et si oui, comment se manifeste-t-il dans votre œuvre ? A mon avis, il n'y a plus de style typiquement new-yorkais. Mais davantage un « style de pensée » new-yorkais, fondé sur un sens extraordinaire du pragmatisme qui rejette le non-sens, et qui, aussi étonnant que cela puisse paraître, défie toute hiérarchie.

Comment imaginez-vous le New York de demain ? L'intégration de Manhattan est exceptionnelle, sa verticalité permettant d'atteindre une très grande échelle. Je souhaite que cette faculté demeure. J'espère aussi, qu'au sein de ce système, nous ne perdions pas l'idée de village et de l'identité commune qui nous unit tous ici.

¿Cuál es el trabajo que considera más importante en su carrera? Siempre tengo la sensación de que el trabajo más importante de mi carrera es aquel en el que estoy trabajando en ese momento.

¿De qué manera Nueva York supone una inspiración en su trabajo? Nueva York es un crisol de gente, talento y recursos. Existe una pluralidad y una democracia, al tiempo que se mantiene una sensación de individualismo. El efecto general es que todos participamos en el proyecto de Nueva York.

¿Existe un estilo típico neoyorquino, y si es así, cómo se revela en su obra? Ya no creo que haya un estilo neoyorquino. Lo que sí existe es un "estilo de pensar" neoyorquino, uno que se basa en un extraordinario sentido de pragmatismo, que rechaza la estupidez, pero que es tan atrevido como no jerárquico.

¿Cómo se imagina Nueva York en el futuro? Manhattan está excepcionalmente integrada, su verticalidad permite que las percepciones de tamaño cambien hacia lo muy grande. Espero que esto no cambie. También espero que en este sistema mantengamos la sensación de ciudad y la identidad común que vincula a todos los que viven aquí.

Cosa pensa che sia la cosa più importante della Sua carriera? Ho l'abitudine di pensare che il lavoro più importante della mia carriera sia sempre quello a cui sto lavorando in un particolare momento.

In che modo New York ispira il Suo lavoro? New York è un crogiolo di gente, talenti e risorse. C'è un senso di pluralità e di democrazia, mentre si ritiene un certo senso di individualismo. L'effetto globale è che noi tutti partecipiamo al progetto di New York.

Esiste uno stile tipico a New York? Se sì, come influenza il Suo lavoro? Non penso che esista più uno stile newyorchese. Quello che esiste è un "modo di pensare" newyorchese, basato su uno straordinario senso pragmatico, che rigetta le assurdità, ma che è coraggioso perchè non è gerarchizzato.

Come si immagina New York in futuro? Manhattan è stata integrata in modo eccezionale: la sua verticalità permette la percezione scalare di passare al livello massimo. Spero che ciò non cambi. Spero anche che all'interno di questo sistema si mantenga il senso del villaggio e dell'identità comune che collega tutti coloro che vivono qui.

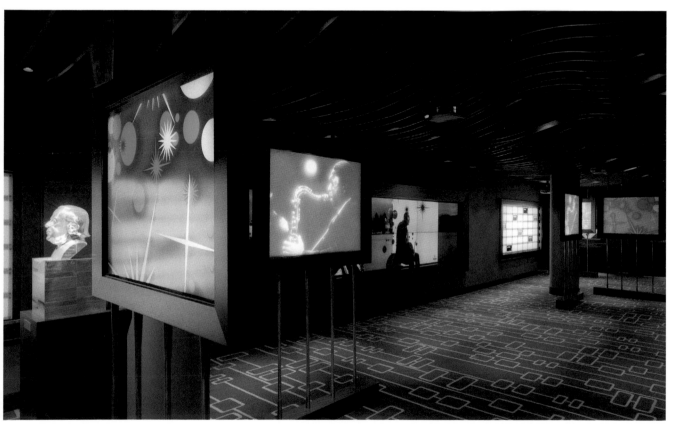

Jazz at Lincoln Center

Year: 2004
Photographs: © Brad Feinknopf

"Jazz at Lincoln Center" is the world's largest non-profit organization for the promotion of the jazz music. Rafael Viñoly designed its new building as a combination of highly flexible and changeable rooms, which can be adapted to the different concert and meeting configurations. The core is the 1,200-seat Rose Hall. Thanks to movable furniture, this hall can also be used for opera and dance performances.

„Jazz at Lincoln Center" ist die weltweit größte gemeinnützige Organisation zur Förderung der Jazzmusik. Rafael Viñoly entwarf ihr neues Gebäude als eine Kombination hoch flexibler und wandelbarer Räume, die sich an die unterschiedlichen Konzert- und Veranstaltungssituationen anpassen lassen. Das Herzstück ist die für 1200 Sitze veranschlagte Rose Hall. Aufgrund des beweglichen Mobiliars kann dieser Saal auch für Oper und Tanzveranstaltungen genutzt werden.

« Jazz at Lincoln Center » est la plus grande organisation mondiale d'utilité publique pour le développement de la musique Jazz. Rafael Viñoly a conçu son nouveau bâtiment comme une combinaison de pièces modulables et flexibles, s'adaptant facilement aux divers concerts et manifestations ou représentations. La cerise sur le gâteau est la Rose Hall conçue pour 1200 places. Un mobilier modulable permet à cette salle d'être utilisée aussi comme salle d'opéra ou de danse.

El "Jazz at Lincoln Center" es la mayor organización mundial sin ánimo de lucro para la promoción de la música jazz. Rafael Viñoly diseñó el nuevo edificio como combinación de espacios muy flexibles y versátiles que se adaptan a los conciertos o actos de distinta índole. El centro lo constituye la Rose Hall con espacio para 1200 butacas. Gracias al mobiliario móvil, la sala también se puede utilizar para ópera o baile.

"Jazz at Lincoln Center" è la più grande organizzazione ad interesse collettivo mondiale per il sostegno della musica Jazz. Rafael Viñoly ne ha progettato il nuovo studio come una combinazione di stanze altamente flessibili e mutevoli, che si adattano alle più diverse situazioni di concerti e manifestazioni. Il pezzo forte è rappresentato dalla Rose Hall con i suoi 1200 posti. Grazie alla mobilità dell'arredamento questa sala può essere utilizzata anche per serate di Opera e di Danza.

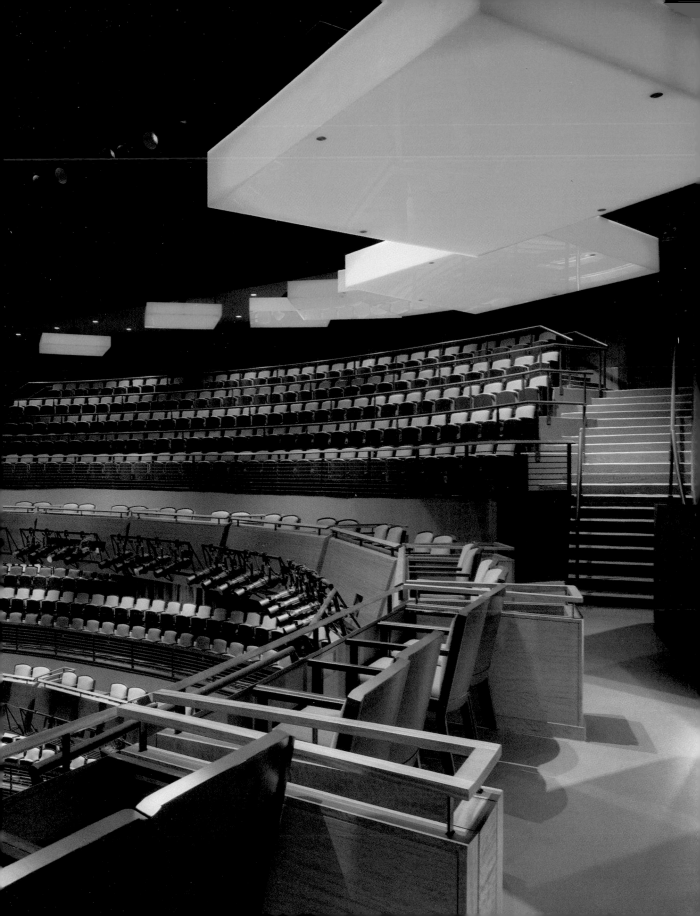

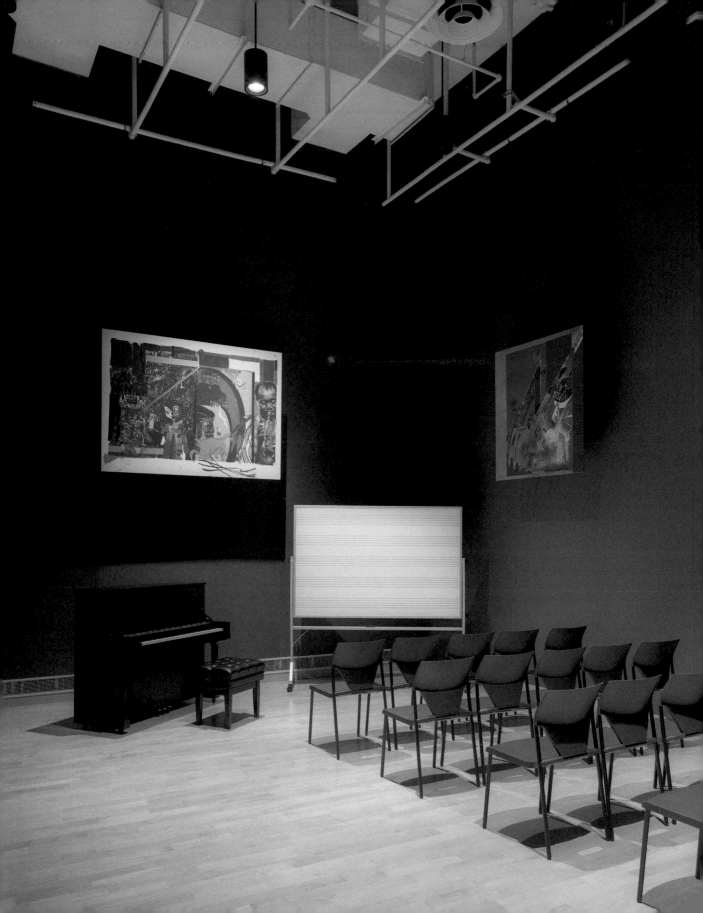

Floor plan

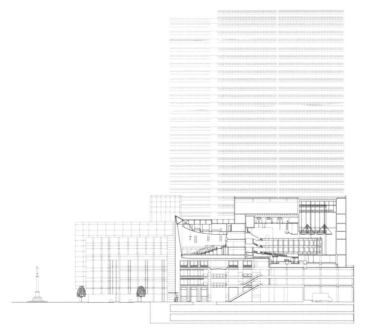

Section

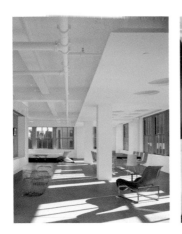 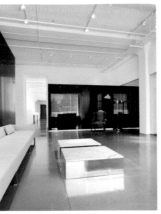 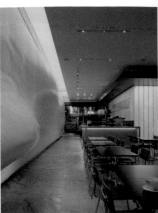

Interior Design

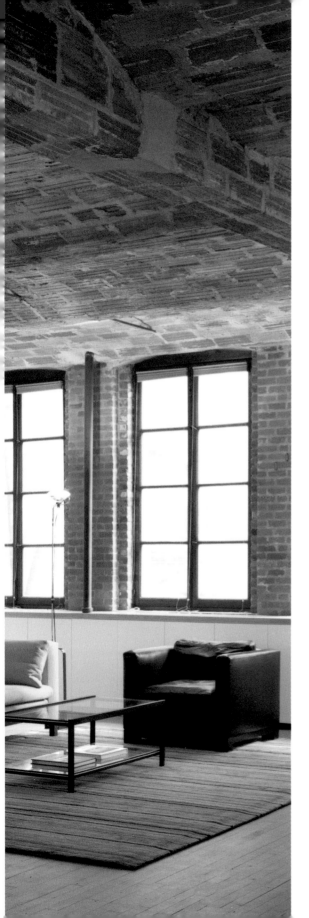

Hariri & Hariri Architecture

Roy Design

Marcel Wanders Studio

Lewis.Tsurumaki.Lewis

Lynch / Eisinger / Design

konyk

Workshop For Architecture

SHoP Architects

Leven Betts Studio

bonetti kozerski studio

Desai/Chia Architecture

nARCHITECTS

EOA – Elmslie Osler Architect

tang kawasaki studio

Messana O'Rorke Architects

AvroKO

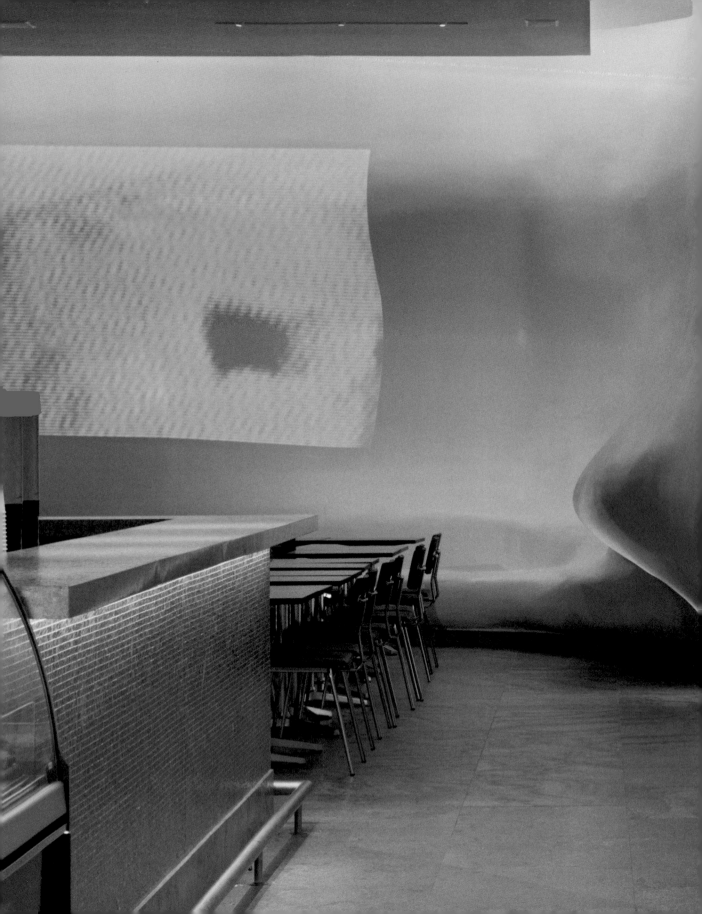

Hariri & Hariri Architecture

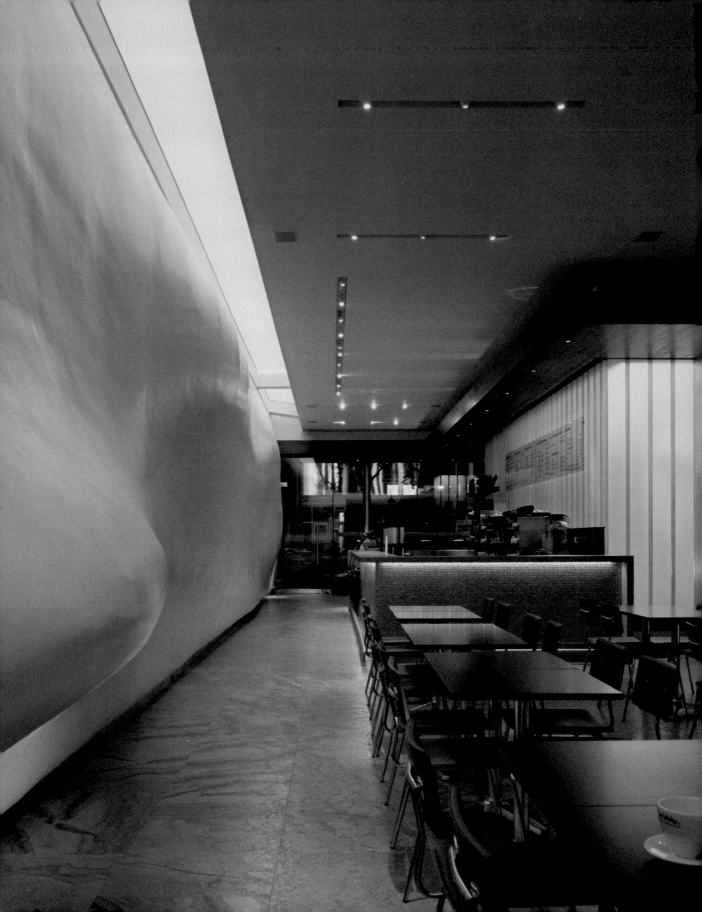

Hariri & Hariri Architecture

39 West 29th Street, 12th Floor, New York, NY 10001, USA

+1 212 727 0338

+1 212 727 0479

www.haririandhariri.com

info@haririandhariri.com

Gisue and Mojgan Hariri

Born in Iran and raised in the USA, the siblings Gisue and Mojgan Hariri founded their own office Hariri & Hariri in 1986, after studying architecture at Cornell University in New York. The integration of digital technology with a feeling for space and light, combined with an innovative use of materials and the exploration of globalized culture, creates futuristic projects and prototypes.

Die im Iran geborenen und in den USA aufgewachsenen Geschwister Gisue und Mojgan Hariri gründeten 1986 ihr eigenes Büro Hariri & Hariri, nachdem sie beide an der Cornell Universität in New York Architektur studiert hatten. Durch die Integration digitaler Technologie mit einem Gespür für Raum und Licht, verbunden mit der innovativen Verwendung von Materialien und der Erkundung der globalisierten Kultur, erschaffen sie futuristische Projekte und Prototypen.

Nées en Iran, les sœurs Gisue und Mojgan Hariri grandissent aux Etats-Unis et fondent en 1986 leur propre cabinet Hariri & Hariri, après avoir étudié l'architecture à l'Université de Cornell à New York. L'association de la technologie digitale et du sens de l'espace et de la lumière, conjuguée à l'emploi innovateur de matériaux et l'exploration de la mondialisation, donne naissance à des projets et prototypes futuristes.

Las hermanas Gisue y Mojgan Hariri, nacidas en Irán y criadas en EE.UU., fundaron en 1986 su propio estudio Hariri & Hariri, después de haber estudiado arquitectura en la universidad Cornell de Nueva York. La integración de la tecnología digital con un especial sentido por el espacio y la luz, unida al uso innovador de materiales y a la exploración de la cultura globalizada, crea proyectos y prototipos futuristas.

Le sorelle Gisue e Mojgan Hariri, nati in Iran e cresciuti negli Stati Uniti fondarono nel 1986 il proprio studio Hariri & Hariri, dopo aver studiato entrambi architettura all'Università Cornell di New York. L'integrazione delle tecnologie digitali, con una certa sensibilità per lo spazio e per la luce, uniti all'uso innovativo dei materiali e alla scoperta della cultura globale hanno dato luce a progetti futuristici e a prototipi.

1986
Foundation of Hariri & Hariri, New York, USA

1991
JSM Music Studios, New York, USA

1995
The Architectural League of New York,
Emerging Voice Award

1998
Greenwich House, Greenwich, Connecticut, USA

1990
The Architectural League of New York, Young
Architects Forum, Award

2001
Tui Pranich Showroom, Miami, Florida, USA
Unified Field Office, New York, USA

2002
Perry Street Loft, New York, USA
Belmont House, Belmont, California, USA

2004
Juan Valdez Flagship, New York, USA
The AD 100 – The World's Top Designers and
Architects Award

Interview | Hariri & Hariri Architecture

What do you consider the most important work of your career? All of our work is important to us, but in terms of groundbreaking ideas our DIGITAL-HOUSE prototype, our vision of homes and living conditions in the 21st century, is one of the most important.

In what ways does New York inspire your work? The density of New York City makes you aware of your environment. It is the dynamic, engaging, and visionary qualities of New York City that inspires our work.

Does a typical New York style exist, and if so, how does it show in your work? We never look at style in architecture. We find issues related or relevant to New York City and express them in our work.

How do you imagine New York in the future? New York City is becoming the 21st century city. We will have buildings that communicate with one another and towers that constantly evolve, making New York more organic, alive and unforgettable.

Was halten Sie für die wichtigste Arbeit in Ihrer Karriere? Im Sinne von bahnbrechenden Ideen sicherlich unseren DIGITAL-HOUSE-Prototyp, unsere Vision von zeitgemäßem Eigenheim und Lebensbedingungen im 21. Jahrhundert.

Auf welche Weise inspiriert New York Ihre Arbeit? Die Dichte von New York erzeugt ein Bewusstsein für die eigene Umgebung. Die dynamischen, abwechslungsreichen und visionären Eigenschaften der Stadt beeinflussen unsere Arbeit.

Gibt es einen typischen New Yorker Stil, und wenn ja, wie zeigt sich das in Ihrer Arbeit? Wir betrachten Architektur niemals unter dem Gesichtspunkt des Stils. Sicherlich kommen auch Fragen, die New York City betreffen, in unserer Arbeit zum Ausdruck.

Wie stellen Sie sich New York in der Zukunft vor? New York City wird zum Inbegriff der Stadt des 21. Jh. werden. Es wird Gebäude geben, die miteinander kommunizieren und Türme, die sich fortwährend weiter entwickeln, Dinge, die New York noch organischer, lebendiger und einzigartiger machen.

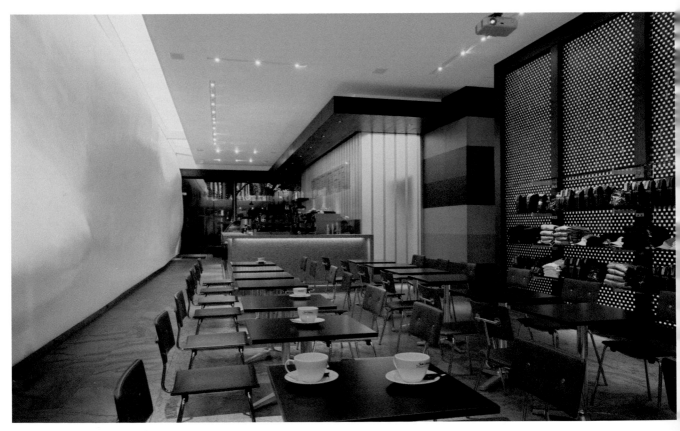

quelle est l'œuvre la plus importante de otre carrière ? Vous savez, pour nous, toutes s œuvres ont leur importance ! Mais en terme idées architecturales révolutionnaires, notre rototype DIGITAL-HOUSE, notre vision de l'habi-t et des conditions de vie au XXIe siècle, en st une des plus importantes.

ans quelle mesure la ville de New York spire-t-elle votre œuvre ? La densité de la le de New York vous fait prendre conscience e l'environnement. Nos œuvres sont inspirées ar le dynamisme, l'engagement et les idées sionnaires de la ville de New York.

eut-on parler d'un style typiquement ew-yorkais, et si oui, comment se mani-este-t-il dans votre œuvre ? En architecture, n ne s'occupe jamais de style. Nous trouvons es idées liées ou inhérentes à la ville de New ork et les exprimons dans notre travail.

omment imaginez-vous le New York de emain ? La ville de New York entre dans le XIe siècle. Nous avons des édifices qui commu-iquent entre eux et des tours en constante utation, rendant New York plus que jamais rganique, vivant et inoubliable.

¿Cuál es el trabajo que considera más importante en su carrera? Toda nuestra obra tiene importancia para nosotros, pero en térmi-nos de ideas innovadoras, nuestro prototipo de CASA DIGITAL, nuestra visión de las viviendas y las condiciones de habitabilidad en el siglo XXI, es uno de los más importantes.

¿De qué manera Nueva York supone una inspiración en su trabajo? La densidad de Nueva York hace que adquieras conciencia de tu entorno. Las cualidades dinámicas, atractivas y visionarias de la ciudad son la fuente de inspira-ción de nuestro trabajo.

¿Existe un estilo típico neoyorquino y, si es así, cómo se revela en su obra? Nunca consideramos el estilo en arquitectura. Buscamos cuestiones relevantes o relativas a la ciudad de Nueva York y las expresamos en nuestro trabajo.

¿Cómo se imagina Nueva York en el futu-ro? Nueva York se está convirtiendo en la ciudad del siglo XXI. Tendremos edificios que se comuni-carán con otros y torres en constante evolución, que convertirán a Nueva York en una ciudad más orgánica, viva e inolvidable.

Qual è secondo Lei il progetto più impor-tante della Sua carriera? Tutti i nostri progetti sono per noi molto importanti, ma in termini di innovazione, il prototipo della DIGITAL HOUSE – la nostra concezione della casa e dell'abitare nel 21esimo secolo – è certo fra i più importanti.

In che modo la città di New York ispira il Suo lavoro? La densità di New York ti fa pren-dere coscienza dell'ambiente in cui vivi. New York è dinamica, coinvolgente, visionaria: sono queste qualità della città a ispirare il nostro lavo-ro.

È possibile parlare di uno stile tipico per New York, e, se questo stile esiste, in che modo si manifesta nei Suoi lavori? In archi-tettura non si guarda a uno stile. Dobbiamo tro-vare dei temi di rilievo collegati alla città e cer-care di esprimerli nel nostro lavoro.

Come si immagina la New York del futuro? New York sta diventando la città del 21esimo secolo. In futuro avremo edifici che comunicano fra di loro e torri che cambiano di continuo e che faranno di New York una città ancor più organica, viva e indimenticabile.

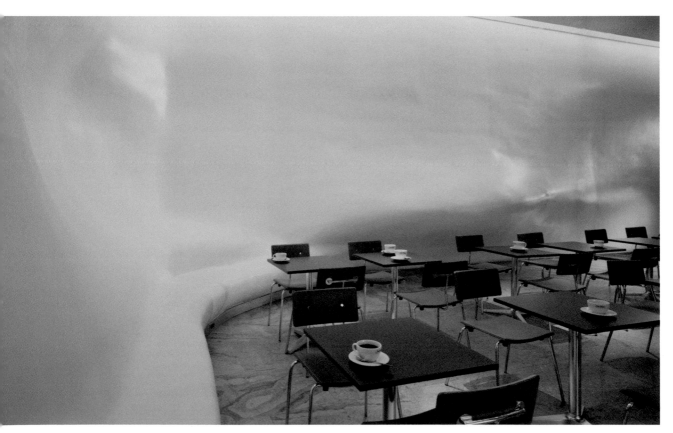

Juan Valdez Flagship Café

Year: 2004
Photographs: © Paul Warchol

For the Juan Valdez Flagship Café, Hariri & Hariri created a 21st century cafe. The façade was clad with an image of the fictional character, Juan Valdez, who is considered a symbol of Colombian coffee around the world. The entrance was designed in teak wood in the shape of a coffee bean. Coffee also inspired the architects in the design of the walls in the interiors. The amorphous surfaces are designed continuously in places to serve as seating areas.

Für das Juan Valdez Flagship Café erschufen Hariri & Hariri ein Caféhaus des 21. Jahrhunderts. Die Fassade wurde mit dem Abbild von Juan Valdez überzogen, jenem fiktiven Charakter, der weltweit als Synonym für Kaffee aus Kolumbien gilt. Der Eingang wurde in Form einer Kaffeebohne in Teakholz konstruiert und auch für die Wände im Innenraum ließen sich die Architekten von fertigem Kaffee inspirieren. Übergangslos sind die amorphen Flächen stellenweise zu Sitzflächen ausgestülpt.

Pour le Juan Valdez Flagship Café, Hariri & Hariri a réalisé un Café du XXIe siècle. Les façades sont recouvertes du portrait de Juan Valdez, caractère fictif, synonyme dans le monde entier du café de Colombie. L'entrée est construite à l'image d'un grain de café en bois de teck, de même, pour les murs intérieurs, les architectes se sont inspirés du café fini. Sans transition et par endroit, les surfaces amorphes se métamorphosent en sièges.

Para el Juan Valdez Flagship Café, Hariri & Hariri crearon un café del s. XXI. La fachada se cubrió con la imagen de Juan Valdez, ese personaje ficticio conocido en todo el mundo como sinónimo del café de Colombia. La entrada se construyó en forma de grano de café en madera de teca, y para las paredes del interior las arquitectas se dejaron inspirar por este brebaje. Sin transiciones, las superficies amorfas se convierten aquí y allí en asientos.

Per il Juan Valdez Flagship Café, Hariri & Hariri hanno creato il caffè del XXI secolo. La facciata è stata rivestita da un'immagine di Juan Valdez, il personaggio fittizio che in tutto il mondo rappresenta il simbolo del caffé colombiano. L'entrata è stata costruita in legno tek in forma di un chicco di caffé e anche per le pareti delle stanze interne gli architetti si sono fatti ispirare da caffé da bere. Le superfici amorfe si trasformano in alcuni punti e senza un vero e proprio passaggio in sorte di divanetti.

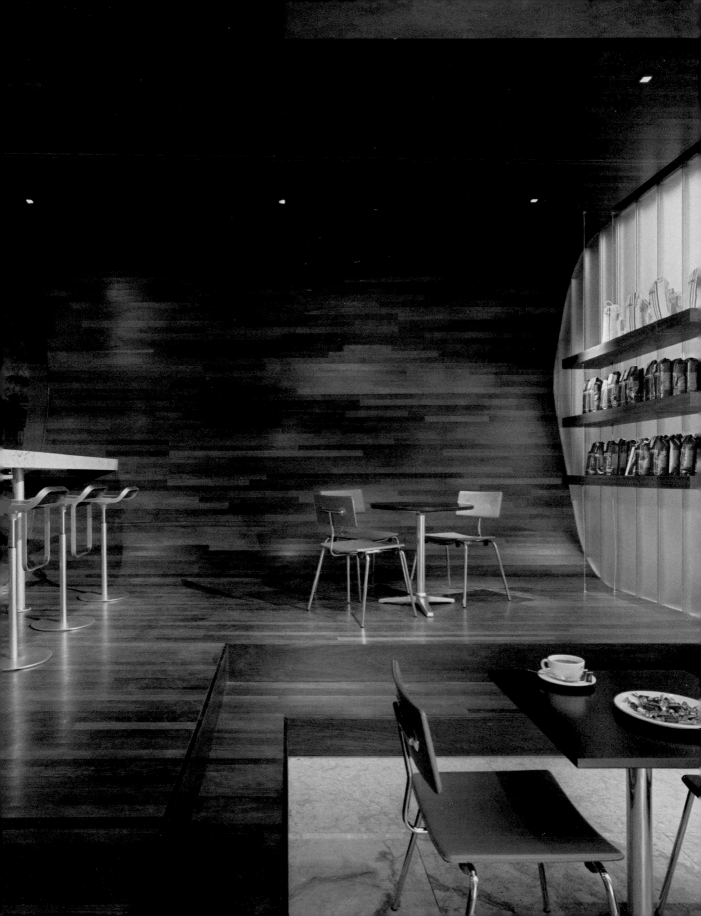

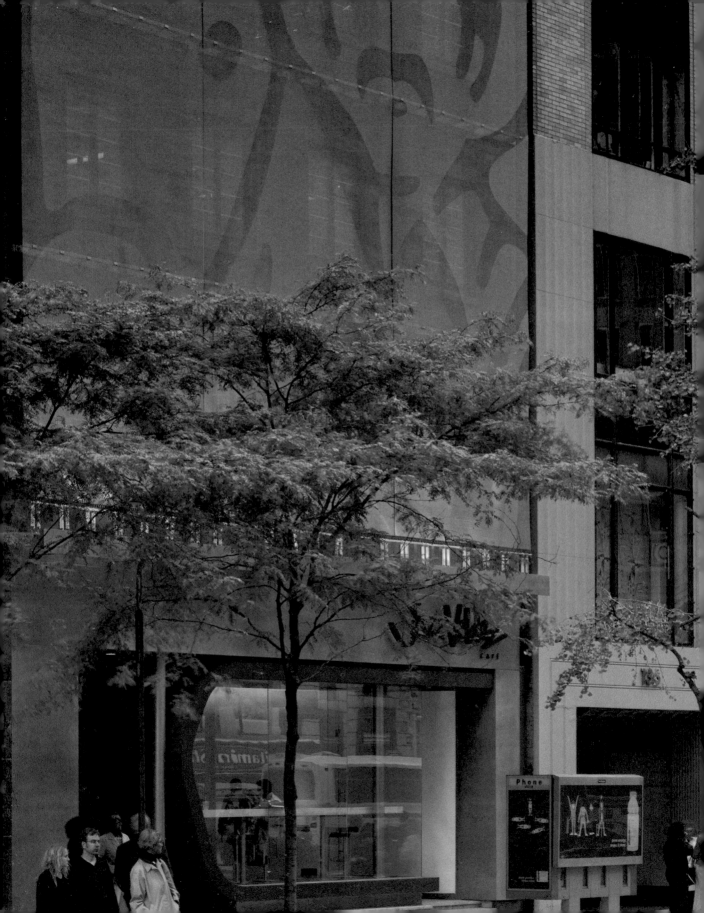

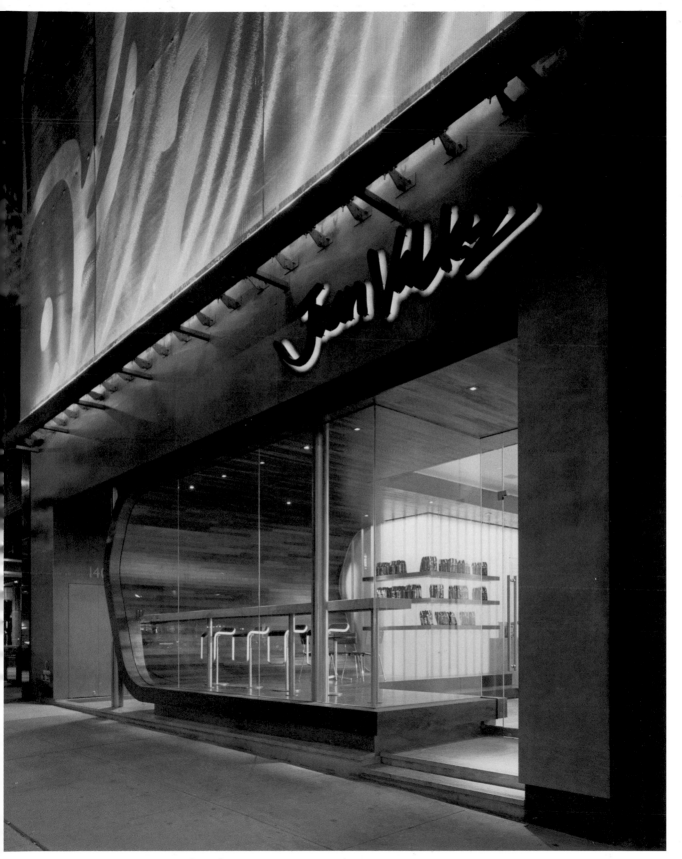

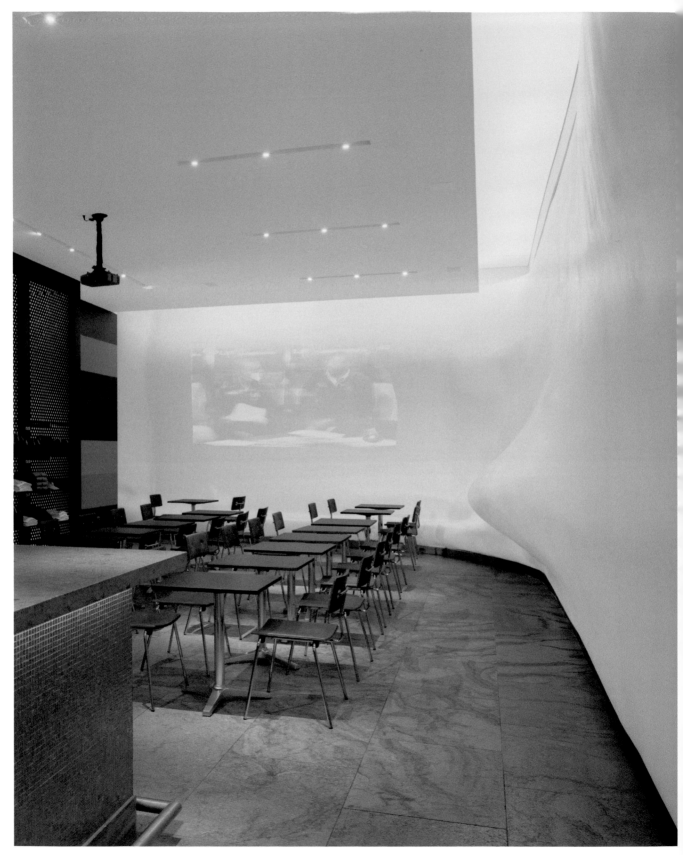

Floor plan

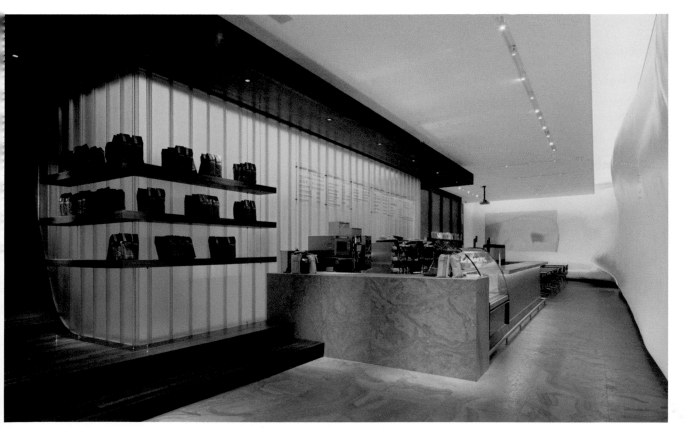

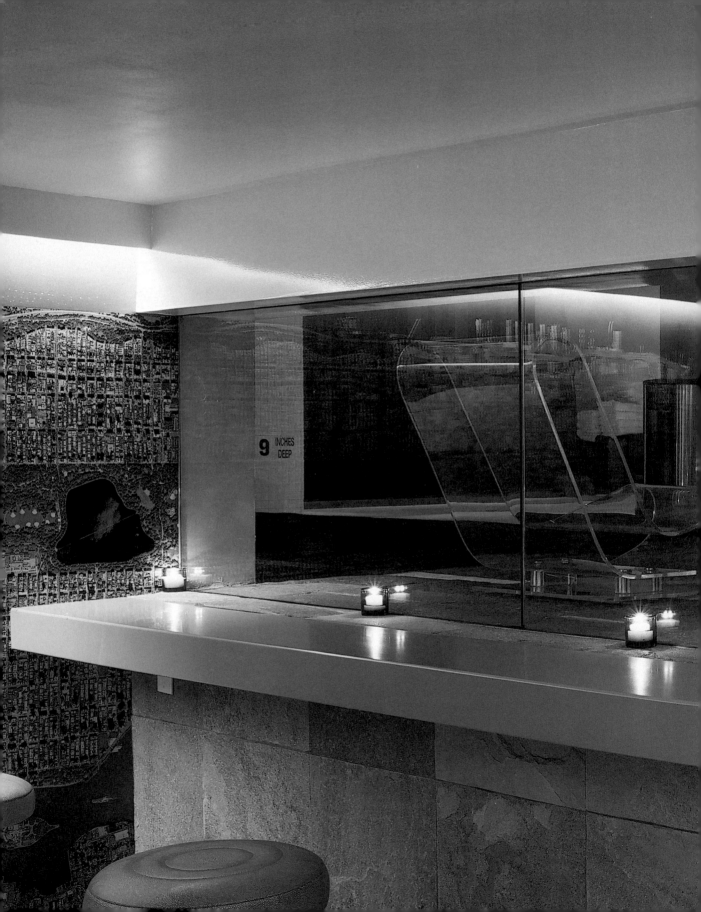

9 INCHES DEEP

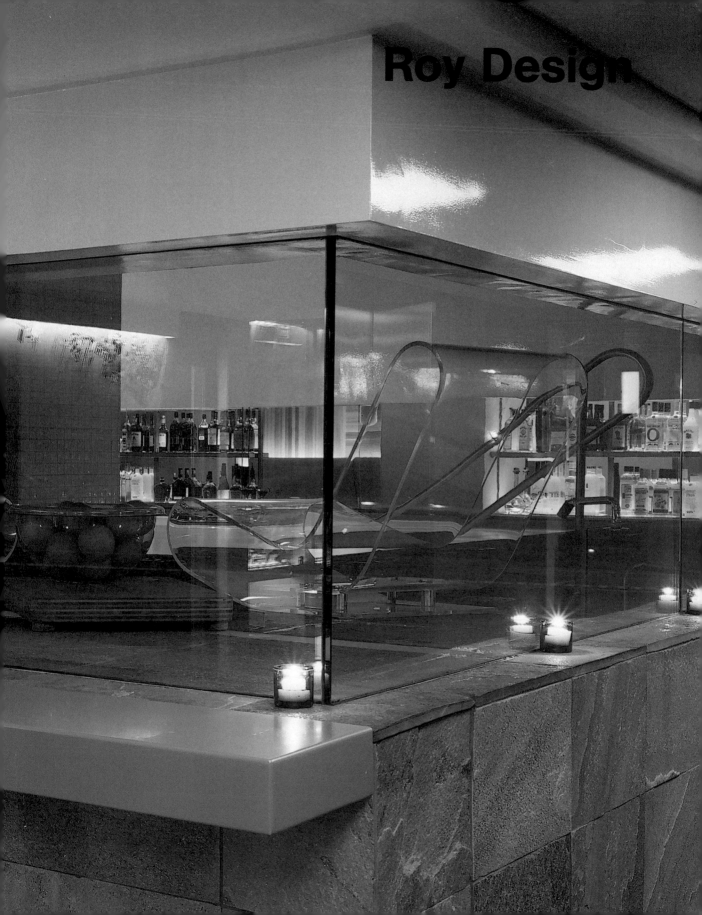

Roy Design

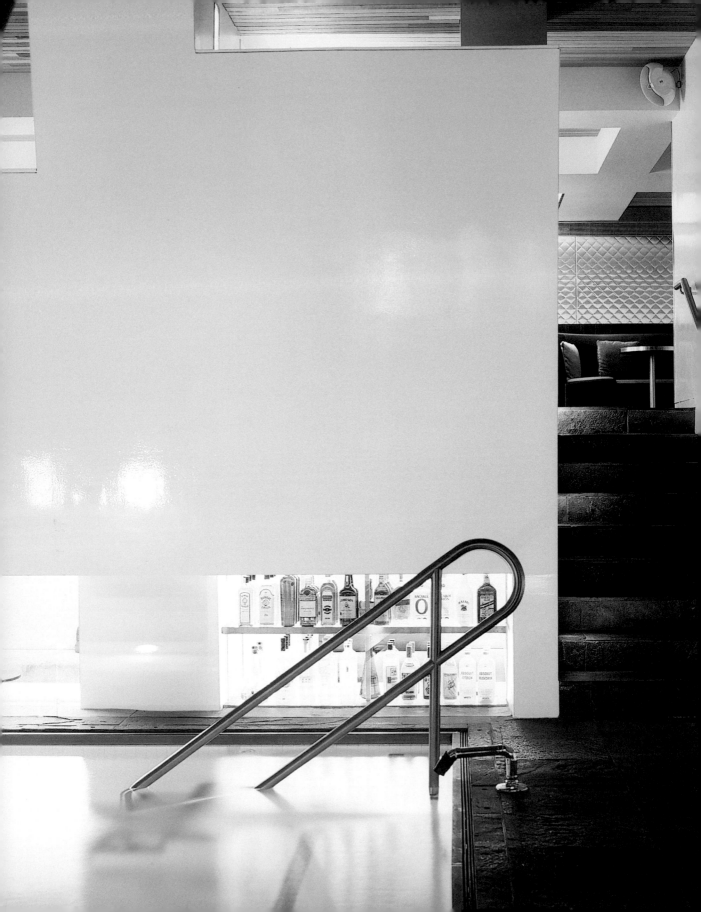

Roy Design

71 Gansevoort Street, Suite 2c, New York, NY 10014, USA

+1 212 627 4816

+1 212 627 5570

www.roydesign.com

info@roydesign.com

Linda Roy

Before opening her own office in the year 2000, Linda Roy had already gained experience with the architect Peter Eisenman. The designs for residential buildings, shops and hotels, developed in her studio, are acknowledged by critics and curators for their analytic and conceptual approach and are already part of the permanent collections of the Museum of Modern Art in New York and San Francisco.

Bevor Linda Roy im Jahr 2000 ihr eigenes Büro eröffnete, konnte sie bereits Erfahrungen bei dem Architekten Peter Eisenman sammeln. Die in ihrem Studio entwickelten Entwürfe für Wohngebäude, Geschäfte und Hotels werden von Kritikern und Kuratoren für ihren analytischen und konzeptuellen Ansatz geschätzt und sind bereits Teil der ständigen Sammlungen des Museum of Modern Art New York und des San Francisco Museum of Modern Art.

Avant d'ouvrir son propre cabinet en 2000, Linda Roy a déjà accumulé de l'expérience chez l'architecte Peter Eisenman. Les projets d'immeubles d'habitation, de magasins et d'hôtels conçus dans son cabinet, sont fort appréciés des critiques et administrateurs de musée pour son approche analytique et conceptuelle. Ils font d'ailleurs déjà partie des collections permanentes du Museum of Modern Art de New York et du Museum of Modern Art de San Francisco.

Antes de que Linda Roy abriera su propio estudio en el año 2000, había ganado experiencia con el arquitecto Peter Eisenman. Los proyectos desarrollados en su estudio para edificios de viviendas, comercios y hoteles son apreciados, tanto por la crítica como por los conservadores, por su aproximación analítica y conceptual y ya forman parte del fondo permanente del Museum of Modern Art de Nueva York y del San Francisco Museum of Modern Art.

Prima che Linda Roy aprisse il suo studio nell'anno 2000, ella poté già acquisire una certa esperienza lavorando con l'architetto Peter Eisenman. I progetti sviluppati nel suo studio per immobili residenziali, negozi e hotel sono apprezzati da critici e curatori per il loro spirito analitico e concettuale e fanno già parte della collezione permanente del Museum of Modern Art di New York e del San Francisco Museum of Modern Art.

1963
Born in Cape Town, South Africa

1985
Bachelor Degree, University of Cape Town, South Africa

1990
Master Degree, Columbia University, New York, USA

2000
Foundation of Roy Co., New York, USA

2001
Subwave, MoMA/P.S.1 Young Architects, The Museum of Modern Art, New York, USA

2002
Vitra Headquarter, Meatpacking District, New York

2004
L'Oreal Paris, Beverly Center, Farmington, Connecticut, USA

2005
Hotel QT, New York, USA

Interview | Roy Design

Which do you consider the most important work of your career? Always the next project.

In what ways does New York inspire your work? That no one here ever asks that question.

Does a typical New York style exist, and if so, how does it show in your work? No.

How do you imagine New York in the future? Still here.

Was halten Sie für die wichtigste Arbeit in Ihrer Karriere? Immer das nächste Projekt.

Auf welche Weise inspiriert New York Ihre Arbeit? Dass mir niemand hier diese Frage stellt.

Gibt es einen typischen New Yorker Stil, und wenn ja, wie zeigt sich das in Ihrer Arbeit? Nein.

Wie stellen Sie sich New York in der Zukunft vor? Es steht noch.

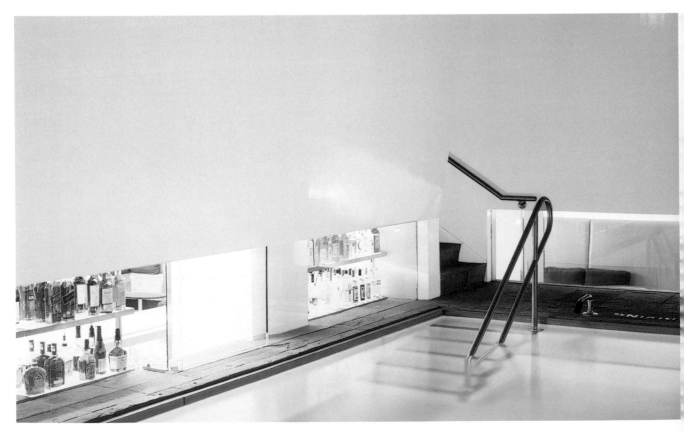

Quelle est l'œuvre la plus importante de votre carrière ? C'est toujours le projet à venir.

Dans quelle mesure la ville de New York inspire-t-elle votre œuvre ? Personne ne pose cette question ici.

Peut-on parler d'un style typiquement new-yorkais, et si oui, comment se manifeste-t-il dans votre œuvre ? Non.

Comment imaginez-vous le New York de demain ? Il sera encore là!

¿Cuál es el trabajo que considera más importante en su carrera? Siempre el siguiente proyecto.

¿De qué manera Nueva York supone una inspiración en su trabajo? Que nunca nadie aquí me hace esa pregunta.

¿Existe un estilo típico neoyorquino, y si es así, cómo se revela en su obra? No.

¿Cómo se imagina Nueva York en el futuro? Pues aún aquí.

Cosa pensa che sia la cosa più importante della Sua carriera? Sempre il prossimo progetto.

In che modo New York influenza il Suo lavoro? Il fatto che nessuno mai mi ha posto questa domanda.

Esiste uno stile tipico a New York? Se sì, come influenza il Suo lavoro? No.

Come si immagina New York in futuro? Ancora qui.

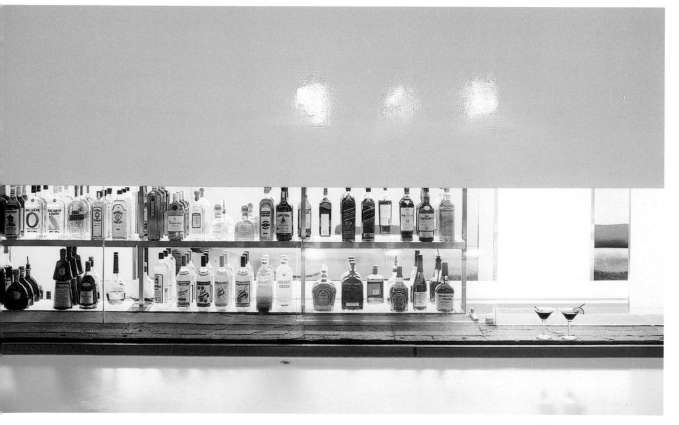

Hotel QT

Year: 2005

Photographs: © Gogortza & Llorella

The QT, a hotel located in Times Square, was created from the conversion of a 15-story office building. The project's focal point is the pool, complete with underwater music, located in the reception hall. Crystal panes create the even connection between the pool's edge made of quartzite and the hotel bar. Additional features include the steam room, showers and sauna, which are located behind amber-colored curtains. The furniture of the rooms was custom-designed for the QT.

Das QT, ein am Times Square gelegenes Hotel, entstand aus dem Umbau eines 15-stöckigen Bürogebäudes. Blickfang des Projektes ist der in der Empfangshalle gelegene Pool mit Unterwasser-Musik. Kristallscheiben schaffen die ebene Verbindung zwischen dem Poolrand aus Quarzitstein und der Hotelbar. Ein zusätzliches Plus sind Dampfbad, Duschen und Sauna, die sich hinter bernsteinfarbenen Vorhängen befinden. Das Mobiliar der Räume wurde speziell für das QT entworfen.

Le QT, hôtel situé au Times Square, est né de la rénovation d'un ensemble de bureaux de 15 étages. La piscine agrémentée de musique sous l'eau, située au cœur du hall de réception, est le point de mire du projet. Des parois de verre créent un lien au sol entre le bord de la piscine en quartzite et le bar de l'hôtel. Nec plus ultra, les bains de vapeur, douches et sauna sont installés derrière des rideaux couleur d'ambre. Le mobilier intérieur a été spécialement conçu pour le QT.

El QT, un hotel próximo a Times Square, nació de la remodelación de un edificio de oficinas de 15 plantas. El blanco de todas las miradas es la piscina situada en el vestíbulo con música subacuática. Las planchas de cristal crean la unión entre el borde de la piscina de cuarcita y el bar del hotel. Otros extras son un baño turco, las duchas y la sauna, que se encuentran detrás de las cortinas de color ámbar. El mobiliario de las estancias se diseñó especialmente para el QT.

Il QT è un hotel situato nella Times Square, sorto dalle modifiche apportate ad un edificio ad uso uffici di 15 piani. L'attrazione principale di questo progetto è la piscina situata nell'atrio dotata di musica proveniente da sotto l'acqua. Delle lastre di cristallo formano il collegamento tra le estremità in quarzite della piscina e il bar dell'hotel. Un ulteriore ornamento è formato dai bagni turchi, dalle docce e dalla sauna che appaiono dietro a tende color ambra. L'arredamento delle stanze è stato studiato specificamente per QT.

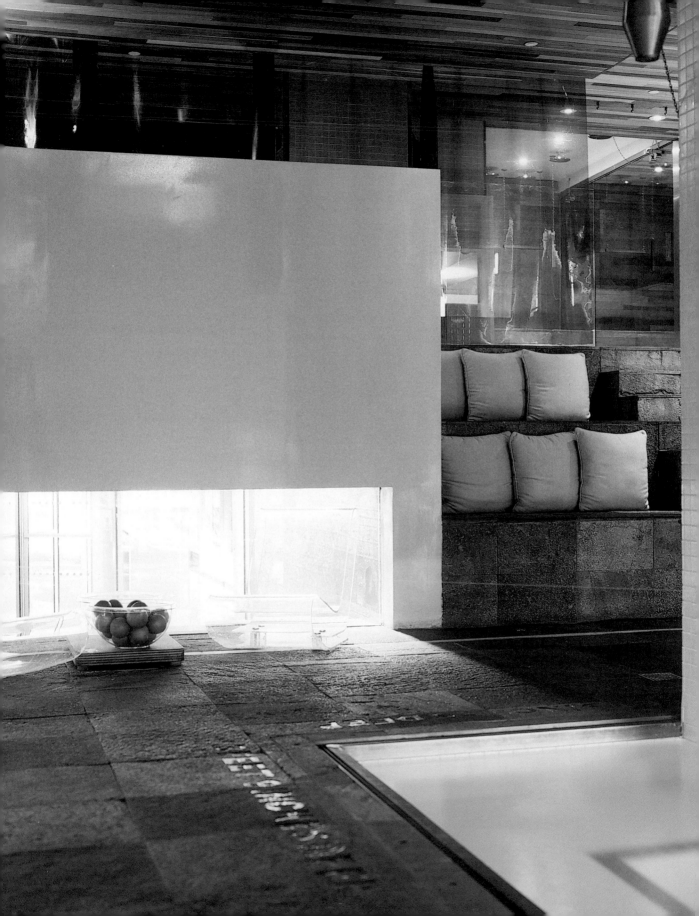

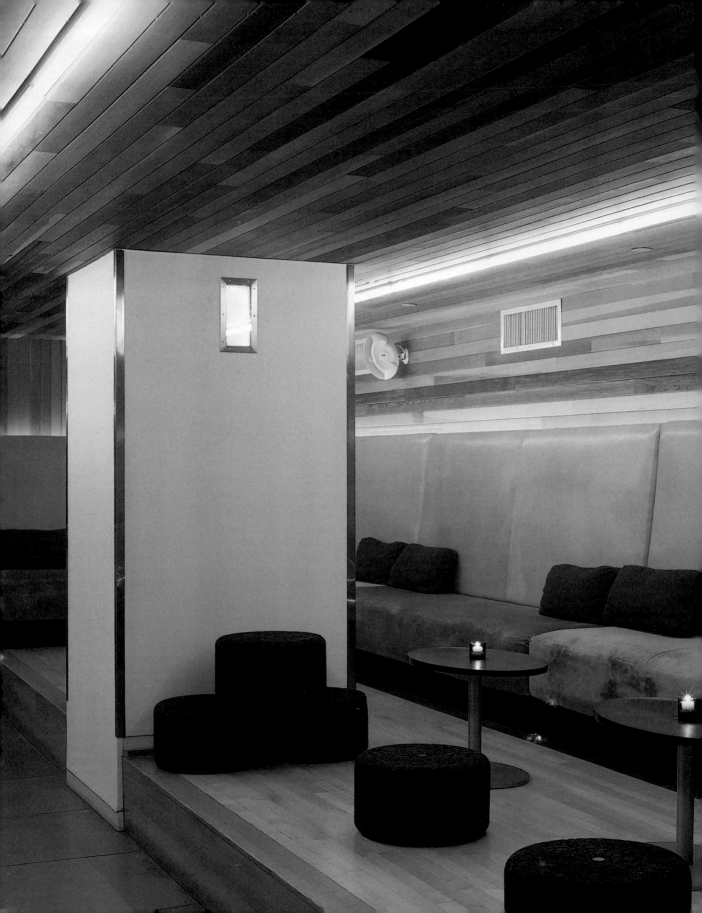

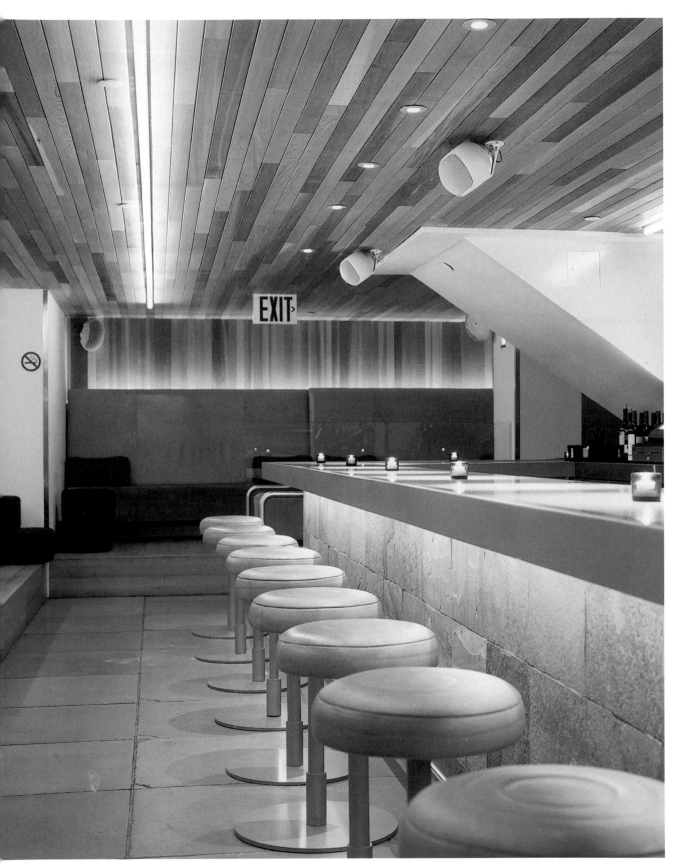

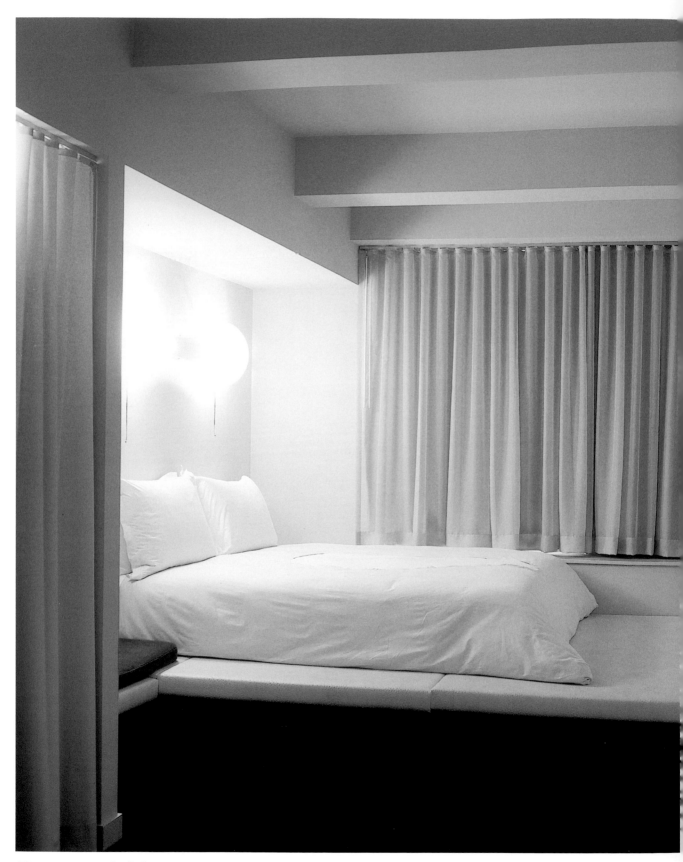

Roy Design

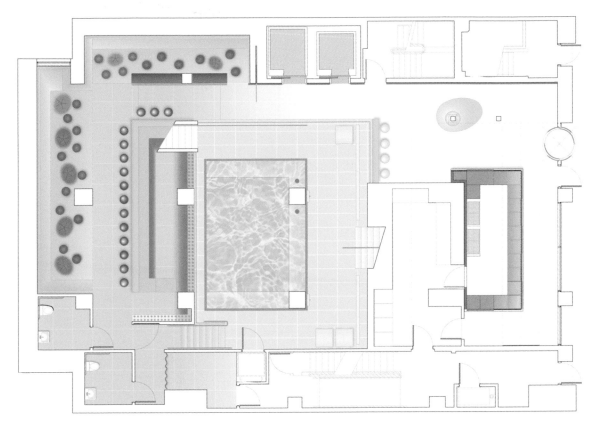

Lobby ground floor

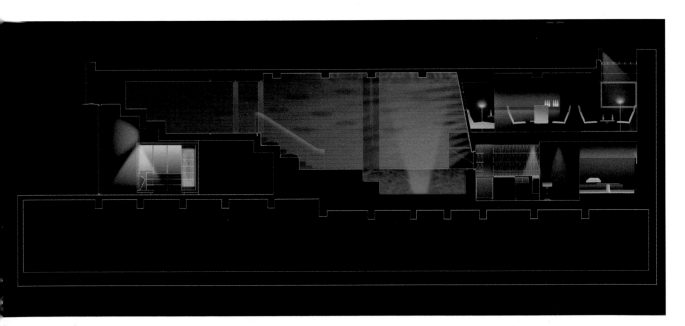

Pool section

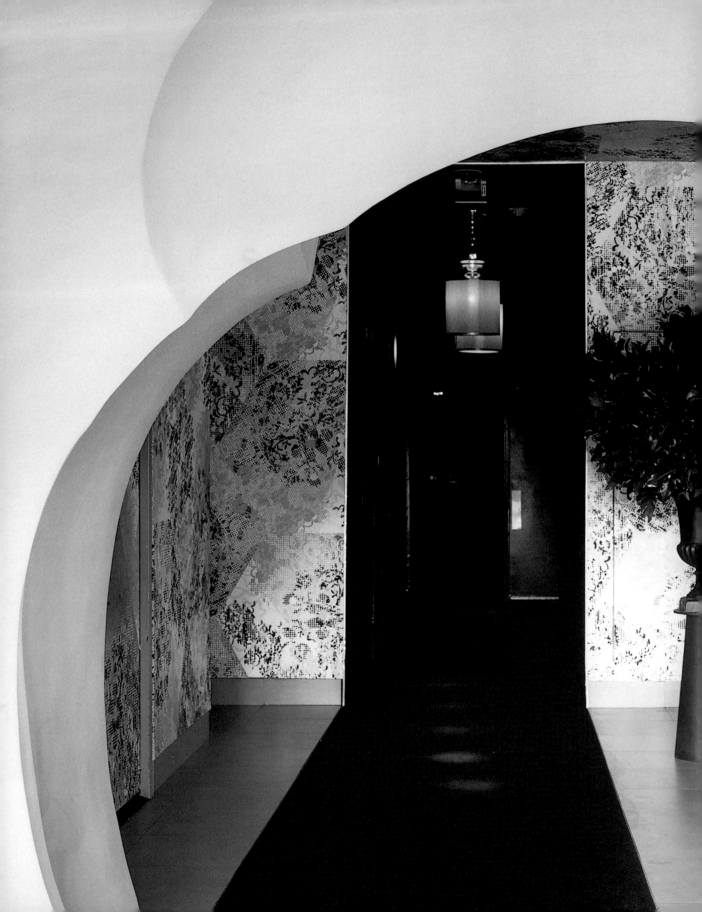

Marcel Wanders Studio

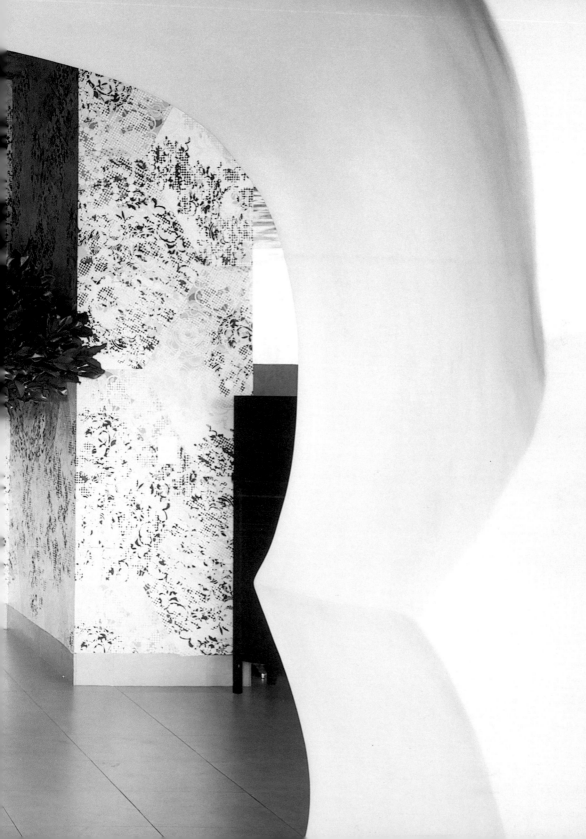

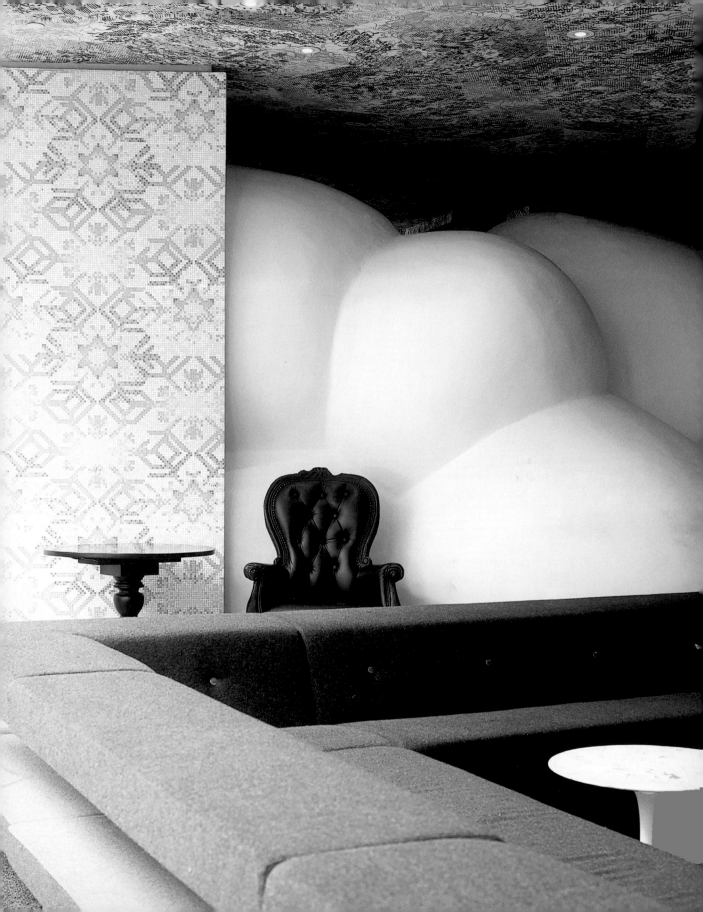

Marcel Wanders Studio

Jacob Catskade 35, 1052 BT Amsterdam, The Netherlands

+31 20 422 1339

+31 20 681 5056

www.marcelwanders.com

joy@marcelwanders.com

Marcel Wanders

Marcel Wanders was born in 1963 in Boxtel in the Netherlands and studied at the Academy of Arts in Arnhem. Before establishing his office, in which he develops product and interior design, he worked as a freelance designer for the Netherlands design agency, WAACS. His works, such as the Knotted Chair which is on display at the Museum of Modern Art in New York, have achieved international acclaim.

Marcel Wanders wurde 1963 in Boxtel in den Niederlanden geboren und studierte an der Kunstakademie in Arnhem. Vor der Gründung seines Büros, in dem er Produkt- und Innendesignentwürfe entwickelt, arbeitete er als freier Designer für die niederländische Designagentur WAACS. International geschätzt werden seine Entwürfe wie beispielsweise der Knotted Chair, den das Museum of Modern Art in New York präsentiert.

Marcel Wanders, né en 1963 à Boxtel, aux Pays-Bas, fait ses études à l'Académie des beaux-arts de Arnhem. Avant de fonder son cabinet, où il conçoit des produits et développe des projets de design d'intérieur, il est designer indépendant chez WAACS, agence de design néerlandaise. Ses concepts sont reconnus sur la scène internationale, à l'instar de la Knotted Chair, présentée au Museum of Modern Art de New York.

Marcel Wanders nació en 1963 en la localidad holandesa de Boxtel y estudió en la Academia de Arte de Arnhem. Antes de fundar su estudio, en el que desarrolla diseños de productos y de interiores, trabajó de diseñador autónomo para la agencia de diseño holandesa WAACS. Sus trabajos se aprecian internacionalmente, como por ejemplo la Knotted Chair, que presenta el Museum of Modern Art de Nueva York.

Marcel Wanders nacque nel 1963 a Boxtel, nei Paesi Bassi e studiò all'Accademia dell'arte di Arnhem. Prima della fondazione del suo studio, dove sono realizzati progetti relativi a prodotti e a design di interni, egli lavorò come disegnatore indipendente per l'agenzia di design olandese WAACS. I suoi progetti sono ammirati a livello internazionale, come ad esempio la Knotted Chair, presentata al Museum of Modern Art di New York.

1963
Born in Boxtel, The Netherlands

1988
Graduation from School of Arts Arnhem, The Netherlands

1995
Foundation of Marcel Wanders Studio, Amsterdam, The Netherlands

1996
Design of Knotted Chair

1997
Design of Egg Vase

1999
Double nomination Rotterdam Design Prize

2000
Alterpoint Design Award, Milan, Italy

2005
Interior design "Hotel On Rivington" and restaurant "Thor", New York, USA
Design for:
Moooi, Cappellini, Bisazza, Moroso, Poliform, Droog Design, Flos, Mandarina Duck, B&B Italia, Vitra, Kartell, Cassina, Boffi

Interview | Marcel Wanders Studio

Which do you consider the most important work of your career? The "design" of Moooi.

In what ways does New York inspire your work? New York is my New Amsterdam, whatever I believe is true in Amsterdam I feel challenged in New Amsterdam, what ever I dream of in Amsterdam I will realize in New Amsterdam.

Does a typical New York style exist, and if so, how does it show in your work? Only the insecure try to fix what is in motion.

How do you imagine New York in the future? I hope New York, now being the big apple, will open up and grow to be the big international inspired fruit bowl.

Was halten Sie für die wichtigste Arbeit in Ihrer Karriere? Das Design für Moooi.

Auf welche Weise inspiriert New York Ihre Arbeit? New York ist mein neues Amsterdam. Alles, was für mich in Amsterdam Tatsache ist, stellt New Amsterdam in Frage; Alles, wovon ich in Amsterdam träume, werde ich in New Amsterdam in die Tat umsetzen.

Gibt es einen typischen New Yorker Stil, und wenn ja, wie zeigt sich das in Ihrer Arbeit? Nur der ungewisse Versuch, zu fixieren, was in Bewegung ist.

Wie stellen Sie sich New York in der Zukunft vor? Ich hoffe, dass New York – im Moment nur „Big Applo" sich öffnet und eines Tages zum großen, international inspirierten Fruchtcocktail wird.

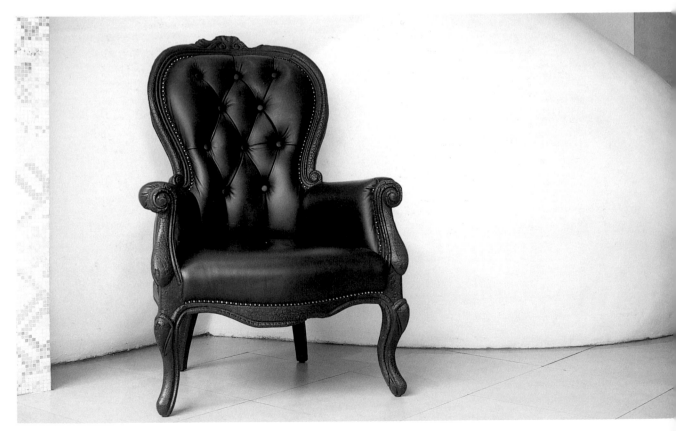

Quelle est l'oeuvre la plus importante de votre carrière ? Le « design » de Moooi

Dans quelle mesure la ville de New York inspire-t-elle votre œuvre ? New York est mon New Amsterdam, tout ce qui me semble vrai à Amsterdam se transforme en défi à New Amsterdam, tout ce dont je rêve à Amsterdam, je le réaliserai à New Amsterdam.

Peut-on parler d'un style typiquement new-yorkais, et si oui, comment se manifeste-t-il dans votre œuvre ? Il n'y a que l'insécurité qui essaie de fixer ce qui est en mouvement.

Comment imaginez-vous le New York de demain ? J'espère que New York, actuellement la « Grosse Pomme » s'ouvre et devienne une belle corne d'abondance, débordante d'inspiration.

¿Cuál es el trabajo que considera más importante en su carrera? El "diseño" de Moooi.

¿De qué manera Nueva York supone una inspiración en su trabajo? Nueva York es mi Nueva Ámsterdam, cualquier cosa que crea cierta en Ámsterdam se convierte en un desafío en Nueva Ámsterdam, cualquier cosa que sueñe en Ámsterdam se convertirá en realidad en Nueva Ámsterdam.

¿Existe un estilo típico neoyorquino, y si es así, cómo se revela en su obra? Sólo los inseguros intentan fijar algo que está en movimiento.

¿Cómo se imagina Nueva York en el futuro? Espero que Nueva York, ahora la Gran Manzana, se abra y crezca para convertirse en una Gran fuente de fruta con inspiración internacional.

Cosa pensa che sia la cosa più importante della Sua carriera? Il "design" di Moooi.

In che modo New York influenza il Suo lavoro? New York è la mia Nuova Amsterdam, tutto ciò che io credo essere vero ad Amsterdam, a Nuova Amsterdam lo sento essere messo in forse, tutto ciò che sogno ad Amsterdam, a Nuova Amsterdam lo realizzo.

Esiste uno stile tipico a New York? Se sì, come influenza il Suo lavoro? Soltanto il tentativo insicuro di fissare qualcosa che è in movimento.

Come si immagina New York in futuro? Spero che New York non resterà la Grande Mela, ma si aprirà e crescerà fino ad essere la grande fruttiera internazionale.

Thor Restaurant

Year: 2005

Photographs: © Gogortza & Llorella

For the Hotel on Rivington, Marcel Wanders designed the reception hall as well as the restaurant. The entrance area is a focal point, in which cloud-shaped forms float and bubble around in the room. These unusual shapes are enriched by the differently patterned black and white mosaic cladding. The reduction of the color palette to three colors: white, red and black harmonizes the high-contrast and lively design.

Für das Hotel on Rivington entwarf Marcel Wanders den Empfang sowie das Restaurant. Als Blickfang wirkt der Eingangsbereich, in dem wolkenartige Formen in den Raum sprudeln. Diese ungewöhnlichen Formen werden zusätzlich durch die unterschiedlich gemusterten schwarz-weißen Mosaikverkleidungen bereichert. Die Reduktion der Farbpalette auf die drei Farben Weiß, Rot und Schwarz bringt Harmonie in den in seiner Form kontrastreichen und lebendigen Entwurf.

Marcel Wanders a conçu, pour l'Hotel on Rivington, la réception et le restaurant. L'espace d'accueil accroche le regard avec ses formes de nuages jaillissantes. Ces formes originales sont exaltées par le revêtement en mosaïques aux différents motifs noir et blanc. La palette de couleurs, réduite aux couleurs blanc, rouge et noire, crée l'harmonie dans ce projet aux formes vivantes et riche en contrastes.

Marcel Wanders diseñó la recepción y el restaurante para el Hotel on Rivington. La zona de entrada es el blanco de las miradas con sus líneas en forma de nube que brotan en el espacio. Estas formas inusuales se enriquecen con los distintos estampados de mosaico en blanco y negro. La reducción de la gama cromática a los tres colores blanco, rojo y negro armoniza este diseño vivo y lleno de contrastes.

Per l'Hotel on Rivington Marcel Wanders ha progettato la hall di entrata e il ristorante. L'attenzione è attirata dall'entrata dell'edificio, dove elementi a forma di nuvola zampillano nella stanza. Questi elementi inusuali sono inoltre arricchiti da un rivestimento a mosaico bianco e nero dalle forme diverse. La riduzione all'uso di tre colori – bianco, rosso e nero –, armonizza il design di questo progetto vivo e pieno di contrasti.

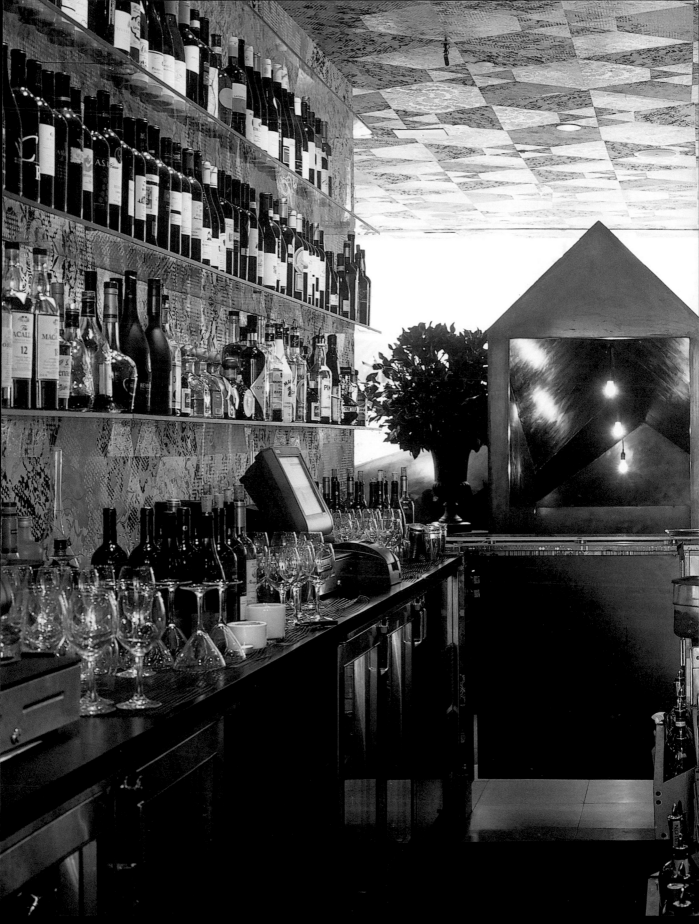

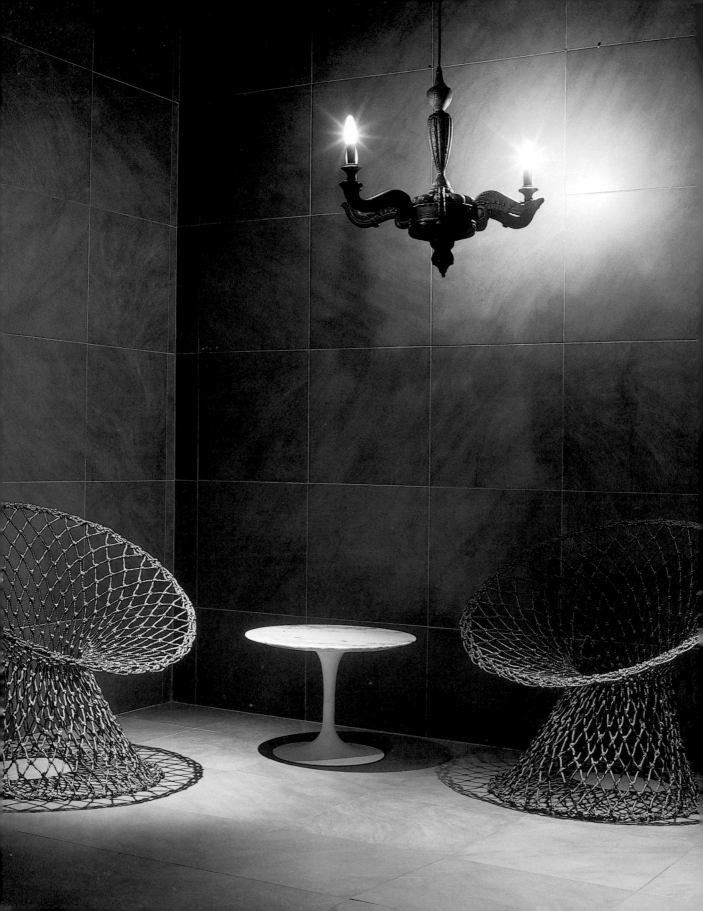

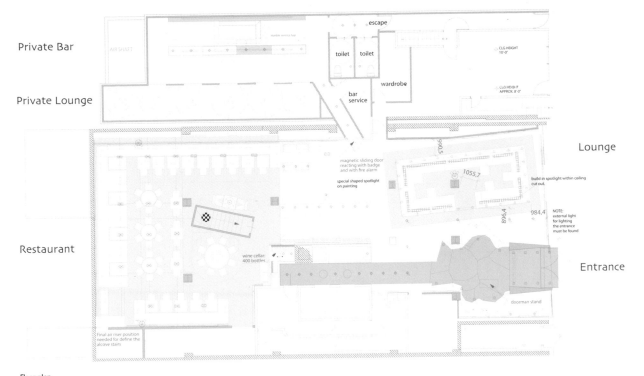

Private Bar

Private Lounge

Restaurant

Lounge

Entrance

Floor plan

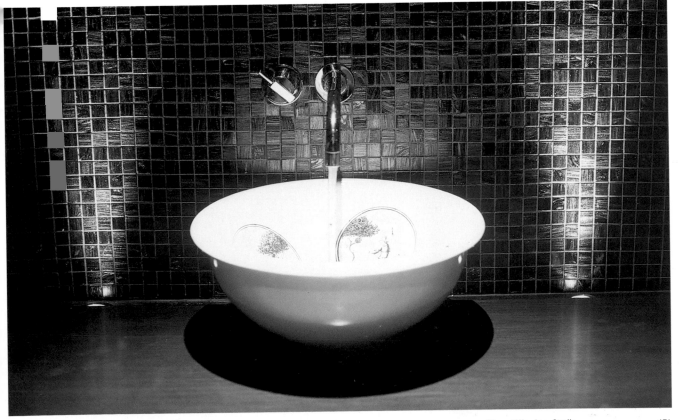

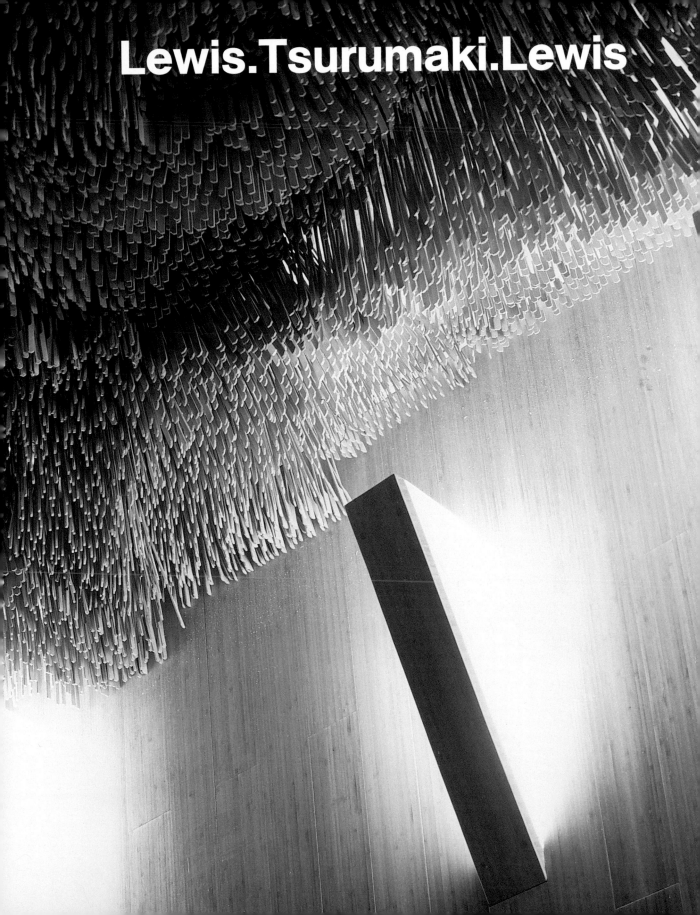

Lewis.Tsurumaki.Lewis

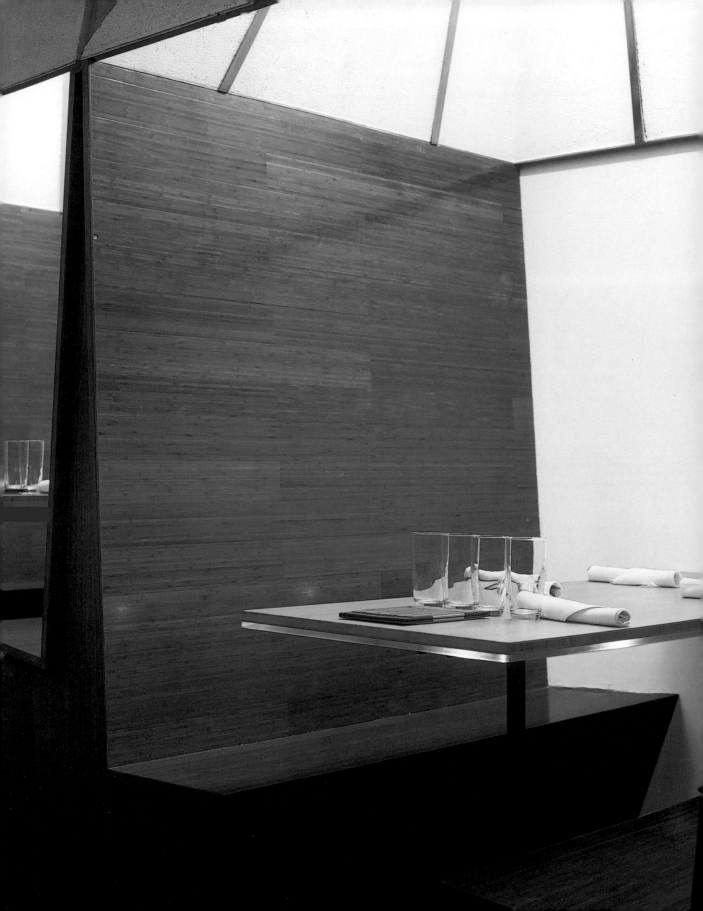

Lewis.Tsurumaki.Lewis

147 Essex Street, New York, NY 10002, USA

+1 212 505 5955

+1 212 505 1648

www.ltlarchitects.com

office@ltlarchitects.com

Lewis.Tsurumaki.Lewis

Lewis.Tsurumaki.Lewis, briefly LTL, was founded in 1993 by Paul Lewis, Treber Tsurumaki and David J. Lewis in New York. The studio realizes architecture and interior design projects in which the architects address design challenges by using creative and innovative solutions. In addition to a plethora of designs for restaurants, their design portfolio also includes residential, exhibit as well as commercial projects.

Lewis.Tsurumaki.Lewis, kurz LTL, wurde 1993 durch Paul Lewis, Treber Tsurumaki und David J. Lewis in New York gegründet. Das Studio realisiert Architektur- und Innendesignprojekte, bei denen die Architekten Problemstellungen auf kreative, innovative und unkonventionelle Art lösen. Neben einer Vielzahl von Entwürfen für Restaurants umfasst ihre Entwurfspalette auch Wohn-, Ausstellungs- sowie Geschäftsprojekte.

Lewis.Tsurumaki.Lewis, LTL en abrégé, est fondée en 1993, à New York, par Paul Lewis, Treber Tsurumaki et David J. Lewis. Le cabinet réalise des projets d'architecture et de design d'intérieur, avec des architectes montrant un esprit créatif et innovant pour résoudre certains problèmes de manière non conventionnelle. Aux côtés d'une kyrielle de réalisations de restaurants, leur gamme de projet décline habitations, salles d'expositions et magasins.

Lewis.Tsurumaki.Lewis, abreviado LTL, se fundó en 1993 por Paul Lewis, Treber Tsurumaki y David J. Lewis en Nueva York. El estudio lleva a cabo proyectos de arquitectura y diseño interior en los que los arquitectos solucionan los problemas con respuestas innovadoras y creativas. Además de un gran número de proyectos para restaurantes, su trabajo incluye proyectos para viviendas, exposiciones y comercios.

Lewis.Tsurumaki.Lewis, in breve LTL, fu fondato nel 1993 da Paul Lewis, Treber Tsurumaki e David J. Lewis a New York. Lo studio realizza progetti di architettura e design per interni, nei quali gli architetti risolvono in modo non convenzionale dei problemi progettuali tramite soluzioni creative ed innovative. Oltre a numerosi progetti per ristoranti, il loro "campionario" comprende anche abitazioni, esposizioni e negozi.

Lewis.Tsurumaki.Lewis

1993
Foundation of Lewis.Tsurumaki.Lewis in New York, USA

2002
Lozoo restaurant, New York, USA
Selectected architect for the "Emerging Voices" lecture series, The Architectural League of New York, USA

2003
Ohio House, Wooster, Ohio, USA

2004
Bornhuetter Hall, The College of Wooster, Ohio, USA
Fluff Bakery, New York, USA
Ini Ani Coffee Shop, New York, USA

2005
Tides restaurant, New York, USA, (honorable mention by AR/ Architecture Review Awards for Emerging Architecture)
DASH dogs restaurant, New York, USA
Xing restaurant, New York, USA, Winner of the AIA New York Chapter, Design Merit Award, Interior Architecture

Interview |
Lewis.Tsurumaki.Lewis

What do you consider the most important work of your career? The trajectory of ideas and experiments that evolves from project to project is more crucial than any single work. Therefore, the next project is always the most important work.

In what ways does New York inspire your work? In New York, the accidental incident and unexpected encounter is the norm challenging routine habits and patterns.

Does a typical New York style exist, and if so, how does it show in your work? Perhaps, but if it can be identified, than that would be precisely what we would wish to not manifest in our work.

How do you imagine New York in the future? The beauty of New York is that it always exceeds the imagination of one person, and as such is perpetually outside of expectation.

Was halten Sie für die wichtigste Arbeit in Ihrer Karriere? Der Prozess, in dem sich die verschiedenen Ideen und Experimente von Projekt zu Projekt entwickeln, ist weit ausschlaggebender als jede Einzelarbeit. Infolgedessen ist stets das anstehende Projekt die wichtigste Arbeit.

Auf welche Weise inspiriert New York Ihre Arbeit? In New York sind unvorhergesehene Ereignisse und unerwartete Begegnungen die Norm, wodurch Routine und Gewohnheit in Frage gestellt werden.

Gibt es einen typischen New Yorker Stil, und wenn ja, wie zeigt sich das in Ihrer Arbeit? Vielleicht, aber wenn ein solcher feststellbar ist, wäre es genau das, wovon wir uns wünschen würden, dass es nicht in unserer Arbeit zum Ausdruck kommt.

Wie stellen Sie sich New York in der Zukunft vor? Die Schönheit New Yorks liegt darin, dass sie stets die Vorstellungskraft einer einzelnen Person übersteigt und als solches ist sie immer jenseits irgendeiner Erwartungshaltung

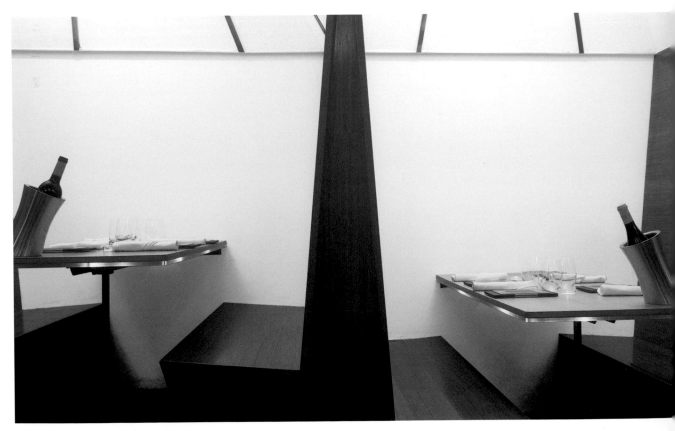

Quelle est l'œuvre la plus importante de votre carrière ? Le cheminement des idées et expériences qui se fait au fil des projets est plus important que le project en particulier. Donc, le projet suivant est toujours le plus important.

Dans quelle mesure la ville de New York inspire-t-elle votre œuvre ? A New York, l'incident dû au hasard et la rencontre inattendue sont la norme qui fait la nique à la routine et aux sentiers battus.

Peut-on parler d'un style typiquement new-yorkais, et si oui, comment se manifeste-t-il dans votre œuvre ? Oui, peut-être, mais s'il est identifiable, c'est justement ce que nous éviterons de montrer dans notre œuvre.

Comment imaginez-vous le New York de demain ? La beauté de New York réside dans le fait qu'elle dépasse toujours l'imagination d'un individu, et ceci dit, est constamment en dehors de toute attente.

¿Cuál es el trabajo que considera más importante en su carrera? La trayectoria de ideas y experimentos que evoluciona de proyecto a proyecto es más decisiva que cualquier trabajo individual. Por tanto, el siguiente proyecto es siempre el trabajo más importante.

¿De qué manera Nueva York supone una inspiración en su trabajo? En Nueva York, el incidente accidental y el encuentro inesperado son la norma, desafiando los hábitos y patrones cotidianos.

¿Existe un estilo típico neoyorquino y, si es así, cómo se revela en su obra? Quizá, pero si es posible identificarlo, entonces sería precisamente lo que desearíamos no manifestar en nuestro trabajo

¿Cómo se imagina Nueva York en el futuro? La belleza de Nueva York es aquella que siempre supera la imaginación de una persona, y como tal, está eternamente fuera de cualquier expectativa.

Qual è secondo Lei il progetto più importante della Sua carriera? Il percorso delle idee e degli esperimenti tra un progetto e l'altro è più importante di ogni singolo lavoro. Per questo motivo il progetto di prossima realizzazione è sempre quello più importante.

In che modo la città di New York ispira il Suo lavoro? A New York l'avvenimento fortuito o l'incontro casuale costituiscono una sfida a cui sono sottoposte continuamente le proprie abitudini e i propri stili di vita consolidati.

È possibile parlare di uno stile tipico per New York, e, se questo stile esiste, in che modo si manifesta nei Suoi lavori? Forse sì, ma se questo stile potesse essere identificato, sarebbe proprio lo stile che non vorremmo esprimere nei nostri lavori.

Come si immagina la New York del futuro? La bellezza di New York consiste proprio nel fatto di andare sempre al di là dell'immaginazione di una singola persona. In questo New York si pone sempre al di là di ogni aspettativa.

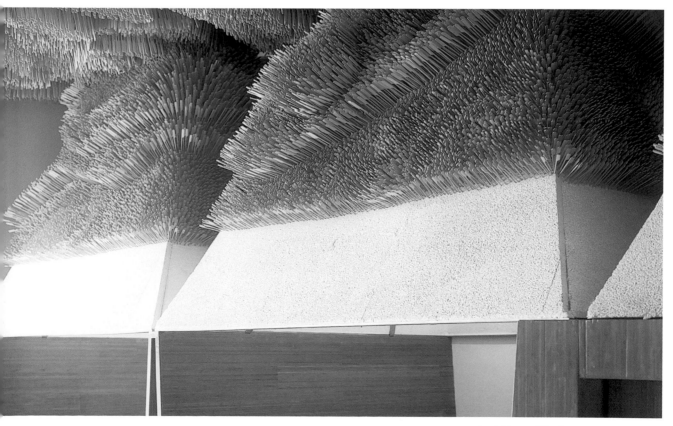

Tides Restaurant

Year: 2005
Photographs: © Gogortza & Llorella

In this small and at the same time spacious restaurant, the architects worked with various combinations of bamboo woods. In this way, the ceiling was created from 120,000 bamboo sticks, which are illuminated from the rear, studded in a soundproof ceiling plate to create a three-dimensional, wave shaped landscape. Various types of bamboo characterize the booths, tables and chairs animate the design while creating a cozy feeling at the same time.

In diesem kleinen und zugleich geräumigen Restaurant arbeiteten die Architekten mit diversen Kombinationen von Bambushölzern. So wurde die Decke aus 120 000 Bambusspießen geschaffen, die von hinten beleuchtet, in eine lärmgeschützte Deckenplatte gespickt wurden und so eine dreidimensionale, wellenförmige Landschaft kreieren. Unterschiedliche Bambussorten kennzeichnen die Separees, Tische und Stühle beleben den Entwurf und schaffen zugleich ein gemütliches Flair.

Dans ce restaurant petit et spacieux à la fois, les architectes travaillent avec des mélanges de bois de bambou. Le plafond est réalisé à partir de 120 000 bouts de bambous, éclairés par derrière, piqués dans un socle insonorisé pour créer un paysage tridimensionnel, en forme de vagues. Diverses sortes de bambou différencient les espaces, tables et sièges égayent le projet tout en créant une atmosphère douillette.

En este pequeño pero amplio restaurante, los arquitectos trabajaron con diversas combinaciones de madera de bambú. Por ejemplo, el techo se creó con 120 000 bastones de bambú, iluminados por detrás, clavados en un plafón del techo antirruido formando un paisaje ondulado tridimensional. Los distintos tipos de bambú para los reservados, las mesas y las sillas realzan el diseño y crean al mismo tiempo una atmósfera agradable.

In questo piccolo ed allo stesso tempo spazioso ristorante gli architetti hanno lavorato con diverse combinazioni di bambù. Il soffitto è costituito da 120 000 spiedini di bambù retroilluminati, integrati in una lastra fonoassorbente, che creano così un paesaggio ondulato tridimensionale. Diversi tipi di bambù diversificano i separé, tavoli e sedie ravvivano il progetto ed allo stesso tempo creano una piacevole atmosfera.

Lewis.Tsurumaki.Lewis

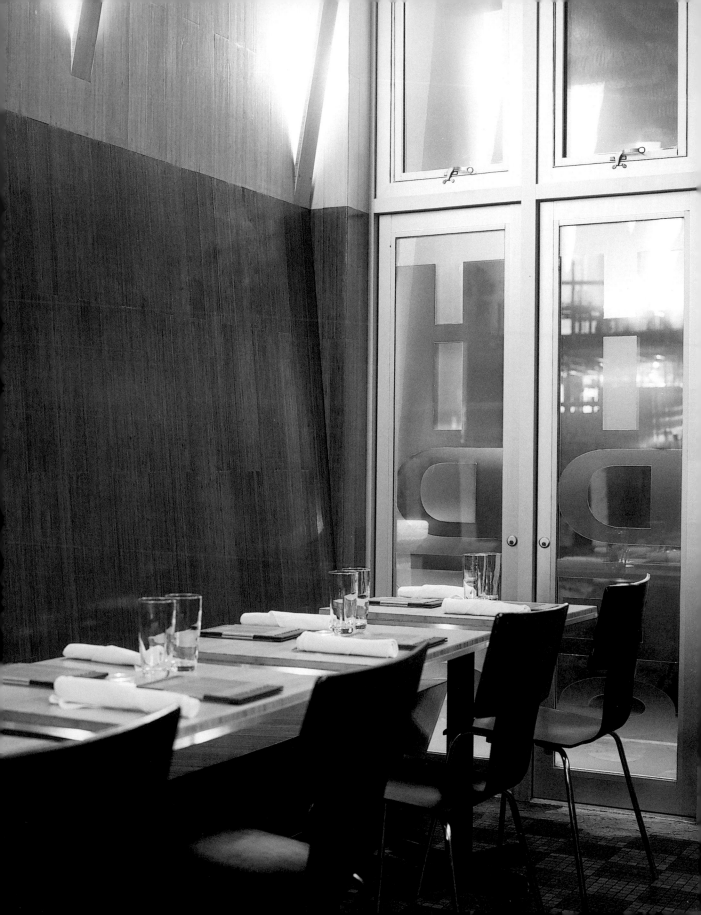

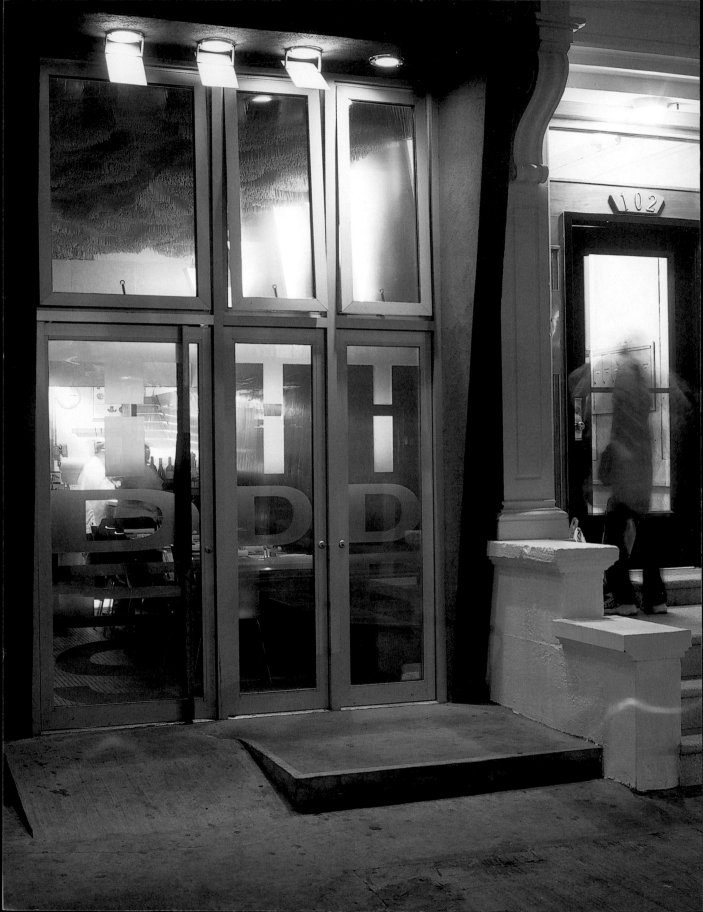

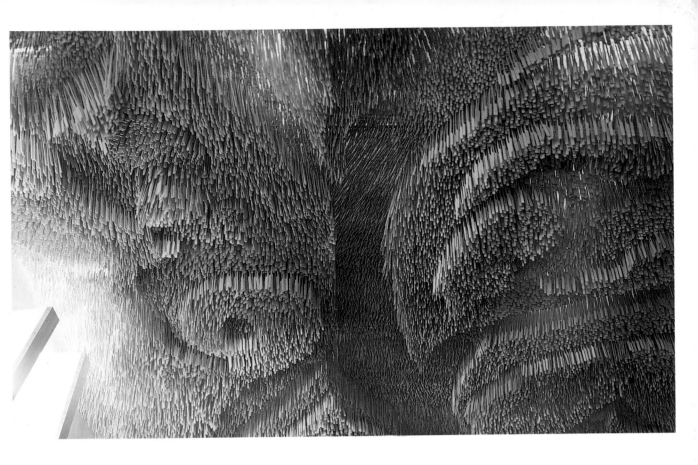

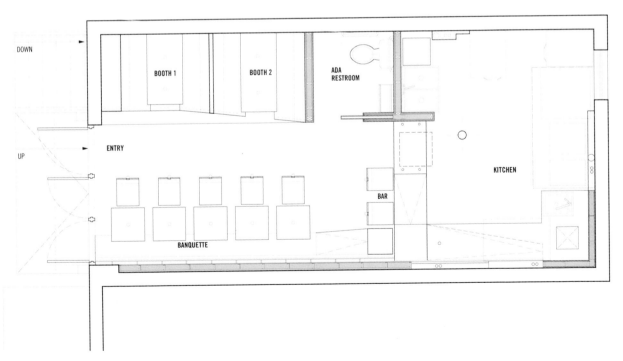

DOWN ▶

UP ▶

ENTRY ▶

BOOTH 1

BOOTH 2

ADA
RESTROOM

KITCHEN

BAR

BANQUETTE

Floor plan

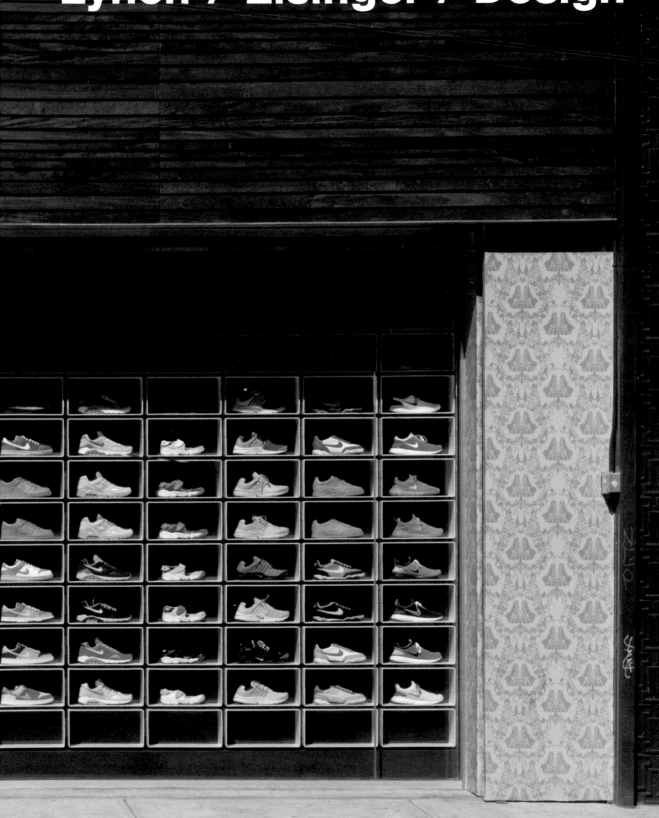

Lynch / Eisinger / Design

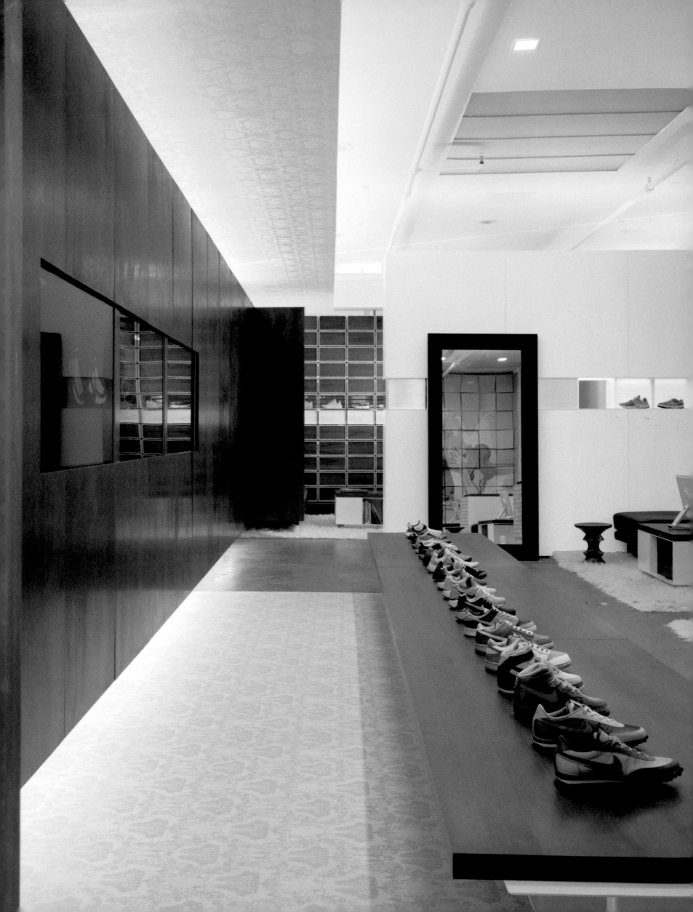

Lynch / Eisinger / Design

224 Centre Street, 5th Floor, New York, NY 10013, USA

+1 212 219 6377

+1 212 219 6378

www.lyncheisingerdesign.com

studio@lyncheisingerdesign.com

Christian Lynch and Simon Eisinger met while studying architecture at Columbia University and in 1999, they established their office in Manhattan. Their design offering includes architecture and interior design as well as product design projects. In their designs, they consider the built environment to be a cultural and social landscape, which must be integrated into the design. This is why the designers place a great deal of significance on contextual analysis.

Christian Lynch und Simon Eisinger lernten sich bei ihrem Architekturstudium an der Columbia University kennen und gründeten 1999 ihr Büro in Manhattan. Ihre Entwurfspalette umfasst Architektur und Innenarchitektur sowie Produktdesignprojekte. Bei ihren Entwürfen betrachten sie die bebaute Umwelt als eine kulturelle und soziale Landschaft, die es in den Entwurf zu integrieren gilt. Deshalb legen die Gestalter großen Wert auf die kontextuelle Analyse.

Christian Lynch et Simon Eisinger qui se sont rencontrés en faisant leurs études d'architecture à la Columbia University, fondent leur cabinet à Manhattan, en 1999. La gamme de leurs projets decline architecture et architcoture d'intérieur ainsi que les créations de design de produits. La conception de leurs projets prend en compte et intègre l'environnement construit en tant que paysage culturel et social. Ce qui explique l'importance que les concepteurs attachent à l'analyse du contexte.

Christian Lynch y Simon Eisinger se conocieron durante sus estudios de arquitectura en la universidad Columbia y fundaron su estudio en Manhattan en 1999. Sus trabajos abarcan la arquitectura y el interiorismo, así como los proyectos de diseño industrial. En sus diseños, contemplan el entorno edificado como un paisaje cultural y social que debe integrarse en el proyecto. Por tanto, estos creadores otorgan gran importancia al análisis contextual.

Christian Lynch e Simon Eisinger si sono conosciuti durante i loro studi di architettura alla Columbia University e hanno fondato nel 1999 il loro studio a Manhattan. La loro area di azione riguarda l'architettura e gli arredamenti di interno, così come la progettazione del design di prodotti. Nei loro disegni considerano lo spazio urbano come essere una superficie culturale e sociale che deve essere integrata nel progetto. Di conseguenza questi creatori danno un grande valore all'analisi contestuale.

Simon Eisinger

1990
Bachelor of Science in Architecture, Massachusetts Institute of Technology, Cambridge, Massachusetts, USA

1994
Master of Architecture, Columbia University, New York, USA

Christian Benavides Lynch

1990
Bachelor of Arts in Architecture, University of California, Berkeley, California, USA

1994
Master of Architecture, Columbia University, New York, USA

1999
Foundation of Lynch / Eisinger / Design, New York, USA

2005
Nike ID Flagship, New York, USA

2004
Nike "Genealogy of Speed", Exhibition, New York, USA
Brenner Residence

Interview | Lynch / Eisinger / Design

Which do you consider the most important work of your career? We try to learn new things from every project and each one that we are working on feels important. Ask us again in a few years, when we can look back with more perspective!

In what ways does New York inspire your work? New York has the highest density and variety of human interaction of any place I know. That means tremendous intellectual and creative exchange, but also means we have to look for some calm in order to process all that input. New York teaches us to edit.

Does a typical New York style exist, and if so, how does it show in your work? There is no New York style, but there is a New York way of doing things. For us it means striving to be practical while refusing to give in to the mundane.

How do you imagine New York in the future? We look forward to New York being used as proof that cities are not just culturally efficient, but efficient in their use of resources too.

Was halten Sie für die wichtigste Arbeit in Ihrer Karriere? Wir versuchen, von jedem neuen Projekt etwas zu lernen und jedes einzelne, an dem wir arbeiten, erscheint uns wichtig. Stellen Sie uns diese Frage in ein paar Jahren noch mal, wenn wir mit mehr Erfahrung zurückschauen können!

Auf welche Weise inspiriert New York Ihre Arbeit? Von allen Städten, die ich kenne, besitzt New York die größte Dichte und Vielfalt an menschlicher Interaktion. Das sorgt für einen ungeheuren intellektuellen und kreativen Austausch, bedeutet aber auch, dass wir nach einer gewissen Ruhe suchen müssen, um diesen ganzen Input zu verdauen. New York lehrt uns, wie man Dinge verarbeitet.

Gibt es einen typischen New Yorker Stil, und wenn ja, wie zeigt sich das in Ihrer Arbeit? Es gibt zwar keinen New Yorker Stil, wohl aber eine New Yorker Art und Weise, Dinge zu tun. Für uns bedeutet das, nach dem Praktischen zu streben und gleichzeitig das Banale abzulehnen.

Wie stellen Sie sich New York in der Zukunft vor? Wir hoffen, dass New York ein lebendiger Beweis dafür wird, dass Städte nicht nur kulturell effizient sind, sondern auch bei der Nutzung ihrer Ressourcen.

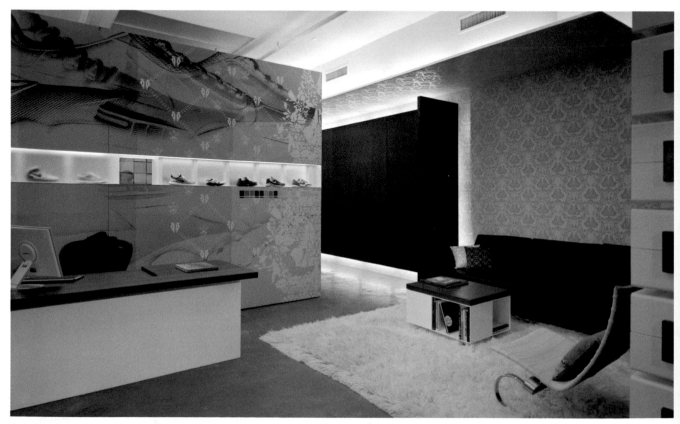

Quelle est l'œuvre la plus importante de votre carrière ? Chaque projet nous apprend quelque chose de nouveau et dans ce sens tous sont importants. Reposez-nous cette question, quand nous aurons plus de recul!

Dans quelle mesure la ville de New York inspire-t-elle votre œuvre ? New York est le seul endroit que je connaisse qui dispose d'une telle densité et diversité humaine déployant une si grande interaction. Il en découle un intense échange intellectuel et créatif. Il est néanmoins essentiel de trouver le calme nécessaire pour transformer toute cette richesse. New York nous apprend à être productif.

Peut-on parler d'un style typiquement new-yorkais, et si oui, comment se manifeste-t-il dans votre œuvre ? Il n'y a pas de style new-yorkais à proprement parler, mais davantage une façon new-yorkaise de voir et faire les choses. Quant à nous, nous nous efforçons de garder un sens pratique. Nous refusons de tomber dans les mondanités.

Comment imaginez-vous le New York de demain ? On souhaite ardemment que New York puisse prouver que les villes ne sont pas uniquement efficaces sur le plan culturel, mais également dans l'utilisation des ressources.

¿Cuál es el trabajo que considera más importante en su carrera? Intentamos aprender algo nuevo de todos los proyectos y cada uno en el que trabajamos nos parece importante. ¡Pregúntenos de nuevo en unos años, cuando podamos mirar atrás con mayor perspectiva!

¿De qué manera Nueva York supone una inspiración en su trabajo? Nueva York tiene la mayor densidad y variedad de interacción humana de cualquier lugar que yo conozca. Esto significa un tremendo intercambio intelectual y creativo, pero también significa que tenemos que buscar cierta calma para procesar toda esa información. Nueva York nos enseña a editar.

¿Existe un estilo típico neoyorquino, y si es así, cómo se revela en su obra? No hay estilo neoyorquino, pero sí hay una forma neoyorquina de hacer las cosas. Para nosotros significa esforzarnos por ser prácticos al tiempo que rechazamos abandonarnos a lo mundano.

¿Cómo se imagina Nueva York en el futuro? Deseamos que Nueva York sea la prueba de que las ciudades no son eficaces sólo culturalmente sino también en el uso que hacen de los recursos.

Cosa pensa che sia la cosa più importante della Sua carriera? Cerchiamo di imparare cose nuove da ogni progetto e ogni progetto sul quale stiamo lavorando ci sembra importante. Torni a chiederci fra qualche anno quando potremmo guardare indietro con maggiore prospettiva!

In che modo New York influenza il Suo lavoro? New York possiede le più alte densità e varietà di interazioni umane di qualunque altro posto che io conosco. Questo significa uno scambio intellettuale e creativo immenso, ma significa anche che dobbiamo cercare la calma per essere capaci di elaborare tutto questo input. New York ci insegna ad editare.

Esiste uno stile tipico a New York? Se sì, come influenza il Suo lavoro? Non esiste uno stile newyorchese, ma esiste un modo newyorchese di fare le cose. Per noi, questo significa forzarci ad essere pratici, mentre ci rifiutiamo di cadere nel mondano.

Come si immagina New York in futuro? Noi speriamo in una New York capace di provare che una città non è efficace soltanto culturalmente, ma anche nel suo utilizzo delle risorse.

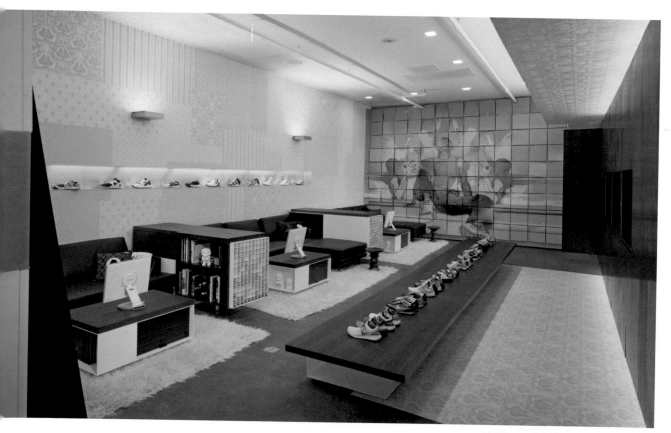

Nike ID Flagship

Year: 2005
Photographs: © Paul Warchol

In this Nike design center, one can design one's own sneaker under the guidance of experts. The personalized character was also interpreted in the interior design. In this way, the architects designed the furniture, fittings and décor with a great love of detail. Only upon closer inspection does one discover that the Victorian wall motif is not made up of flowers, but of sneakers and baseballs.

In diesem Nike Designzentrum kann man unter Anleitung von Experten seine Turnschuhe selbst entwerfen. Der individuelle Charakter wurde auch in der Innenarchitektur umgesetzt. So wurde das Mobiliar und die Dekoration von den Architekten individuell für dieses Projekt mit viel Liebe zum Detail entworfen. Erst beim näheren Hinsehen entdeckt man, dass sich das viktorianische Wandmotiv nicht aus Blumen, sondern aus Turnschuhen und Basebällen zusammensetzt.

Dans ce centre de design Nike, l'acheteur peut concevoir lui-même ses chaussures de sport avec les conseils d'experts. Cette conception individuelle se dégage également dans l'architecture d'intérieur. En effet, c'est avec un soin particulier, accompagné d'un amour profond du détail, que les architectes ont conçu le mobilier et la décoration. Ce n'est que de très près que l'on découvre que le motif mural Victorien n'est pas composé de fleurs, mais de chaussures de sport et de balles de baseball.

En este centro de diseño Nike, con la ayuda de expertos el cliente puede crear sus propias zapatillas deportivas. El carácter individual también se plasmó en la arquitectura interior. Los arquitectos diseñaron el mobiliario y la decoración en exclusiva para este proyecto, con pasión por el detalle. Hasta que no lo mira de cerca, el visitante no descubre que el estampado victoriano de las paredes no está formado por flores, sino por zapatillas y gorras.

In questo centro di design della Nike è possibile creare le proprie scarpe da ginnastica dietro la guida di esperti. Il carattere individuale è stato anche trasformato nell'architettura di interni. Per questo motivo l'arredamento e la decorazione sono stati studiati individualmente dagli architetti per questo progetto, con amore per il dettaglio. Solo osservando attentamente ci si rende conto che il motivo vittoriano delle pareti non è rappresentato da fiori, ma bensì da scarpe da ginnastica e da palle da Baseball.

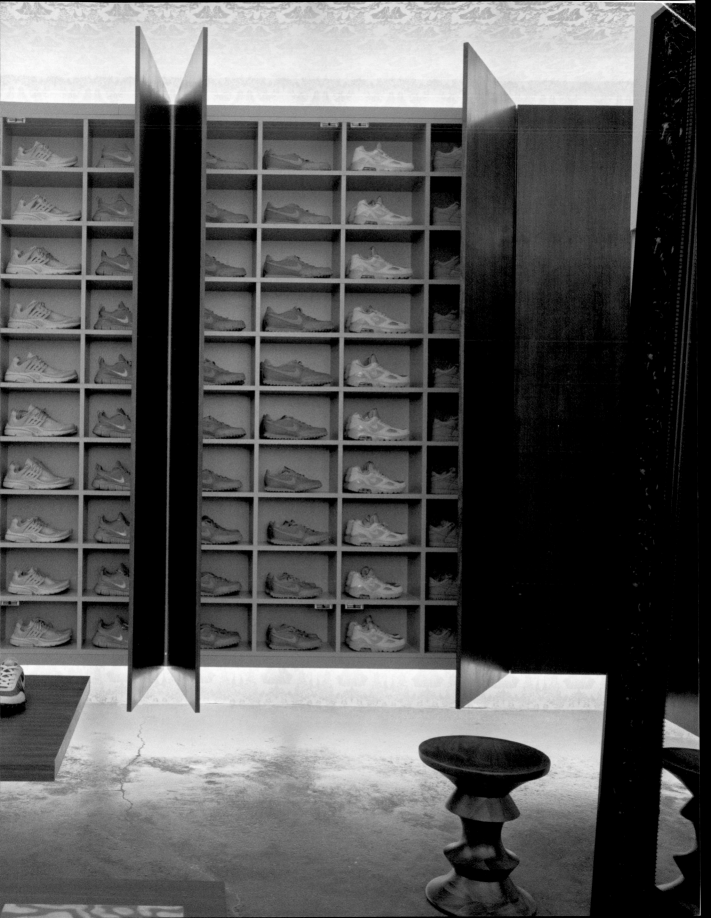

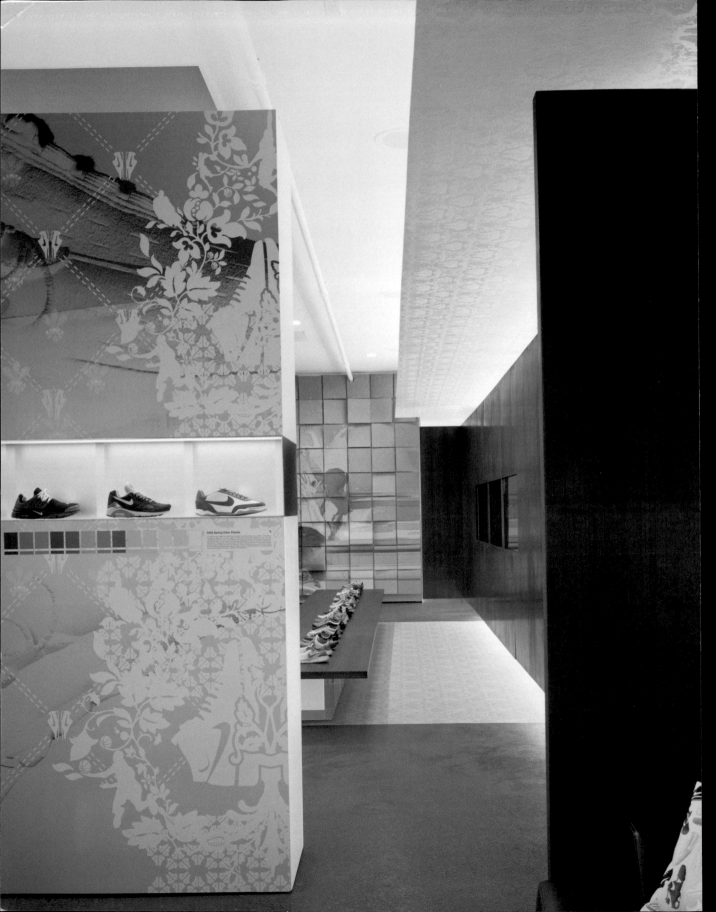

Floor plan

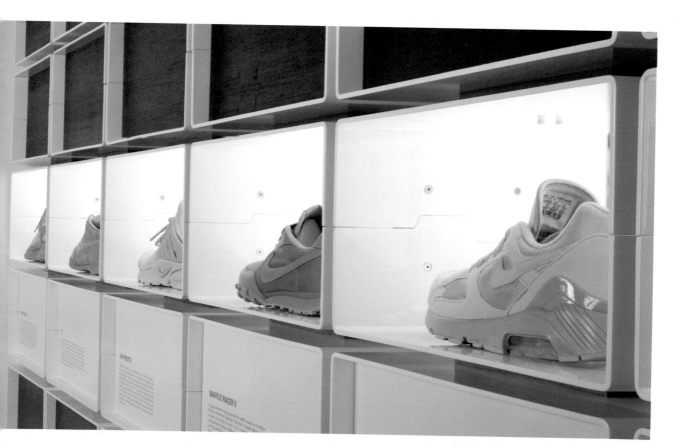

Lynch / Eisinger / Design

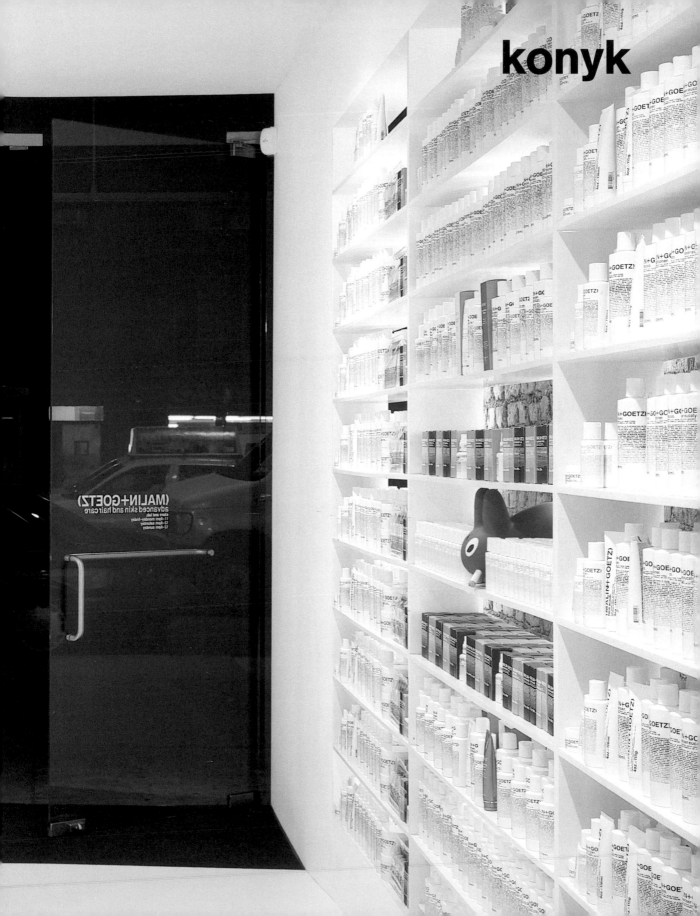

konyk

konyk

61 Pearl Street, #509 (dumbo), Brooklyn, NY 11201-8339, USA

+1 718 852 5381

+1 718 852 1890

www.konyk.net

konyk@konyk.net

Craig Konyk

Craig Konyk combines his work in his studio, konyk, created in 1989 in Brooklyn with his teaching activity at Columbia University in New York. His design portfolio is very diverse and ranges from retail to office and residential projects to cultural facilities. For his innovative solutions, he has been honored with various awards, such as, for example, the AIA New York Chapter Award or the ID Magazine Design Prize.

Craig Konyk kombiniert seine Tätigkeit im 1989 in Brooklyn gegründeten Studio konyk mit seiner Lehrtätigkeit an der Columbia University in New York. Seine Entwurfspalette ist sehr vielfältig und reicht von Geschäfts- über Büro- und Wohnprojekte bis hin zu Kulturbauten. Für seine innovativen Lösungen wurde er mit verschiedenen Preisen geehrt wie beispielsweise dem AIA New York Chapter Award oder dem ID Magazine Design Preis.

Craig Konyk conjugue architecture dans son Studio konyk, fondé à Brooklyn, en 1989, et enseignement à l'université de Columbia à New York. Sa gamme de projets, très variée, va de la réalisation de magasins, à la construction d'édifices culturels, en passant par celle de bureaux et d'habitations. Ses solutions innovatrices lui ont valu d'être récompensé par divers prix, à l'instar du AIA New York Chapter Award ou ID Magazine Design Price.

Craig Konyk combina su trabajo en el estudio konyk fundado en 1989 en Brooklyn con sus funciones como profesor en la universidad Columbia de Nueva York. Sus trabajos son muy variados y van desde proyectos para viviendas, comercios y oficinas, hasta obras culturales. Por sus soluciones innovadoras ha sido merecedor de diversos galardones, como por ejemplo el AIA New York Chapter Award o el premio ID Magazine Design.

Craig Konyk combinò l'attività del suo studio konyk fondato nel 1989 a Brooklyn con il suo impegno di insegnante alla Columbia University di New York. I suoi progetti sono molto variegati e spaziano da immobili commerciali, abitativi o dediti ad uffici, fino ad edifici culturali. In merito alle sue soluzioni innovative è stato ricompensato con diversi premi, come ad esempio l'AIA New York Chapter Award o il premio ID Magazine Design.

1989
Foundation of konyk by Craig Konyk

1991
Selectected architect for the "Emerging Voices" lecture series, The Architectural League of New York

1995
Selectected architect for the "Young Architects Forum," The Architectural League of New York

2003
Up! House, prefabricated home design, mobile

2004
Malin + Goetz Shop, New York, USA
Glad Tidings Church Tower, New York, USA

2006
Tuttle Street ONE Miami showroom, Miami, Florida, USA

Interview | konyk

Which do you consider the most important work of your career? I think at the moment, the GLAD! project. A tower project in Manhattan is fraught with tingles.

In what ways does New York inspire your work? I think the density of New York is most inspiring. Every square centimeter is pulsing with creative energy. Lou Reed used to write lyrics to his songs by walking down the street. I think that's kind of it.

Does a typical New York style exist, and if so, how does it show in your work? Invention. No looking back. These might summarize a "New York Style" if indeed one exists.

How do you imagine New York in the future? I worry that New York will become a city of only glass. Or maybe it will disappear completely and only exist in our memories and old websites. Or maybe it will become a rich person's paradise, a high-tech petting zoo where you can only take children to visit on field trips.

Was halten Sie für die wichtigste Arbeit in Ihrer Karriere? Ich denke, im Moment das GLAD!-Projekt. Ein Turmbauprojekt in Manhattan ist ein spannendes Unterfangen.

Auf welche Weise inspiriert New York Ihre Arbeit? Ich denke, die Dichte New Yorks ist überaus inspirierend. Jeder Quadratzentimeter pulsiert vor positiver Energie. Lou Reed schrieb Liedtexte während er einfach die Straße entlang ging. Ich denke, das ist es in etwa.

Gibt es einen typischen New Yorker Stil, und wenn ja, wie zeigt sich das in Ihrer Arbeit? Phantasie. Niemals zurückschauen. Das könnte vielleicht einen „New York Style" umreißen, sollte es ihn überhaupt geben.

Wie stellen Sie sich New York in der Zukunft vor? Ich fürchte, New York wird eine Stadt ganz aus Glas werden. Oder vielleicht wird es gänzlich verschwinden und nur noch in unseren Erinnerungen und auf alten Webseiten existieren. Vielleicht wird es aber auch zum Paradies eines reichen Menschen: ein Hightech-Streichelzoo, wo Kinder nur noch auf Klassenfahrt hinkommen.

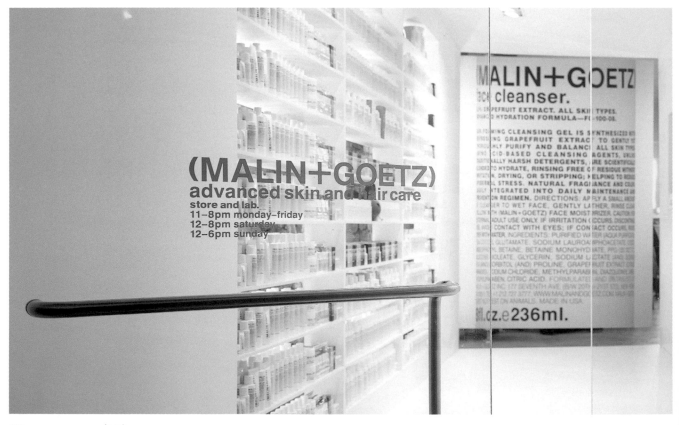

(MALIN+GOETZ)
advanced skin and hair care
store and lab.
11–8pm monday–friday
12–8pm saturday
12–6pm sunday

MALIN+GOETZ
cleanser.

Quelle est l'œuvre la plus importante de votre carrière ? Pour l'instant, le projet GLAD! Un projet de tour à Manhattan exaltant qui fait frissonner de joie.

Dans quelle mesure la ville de New York inspire-t-elle votre œuvre ? La source d'inspiration essentielle vient de la densité de New York. Chaque centimètre carré est bouillonnant d'énergie créatrice. Lou Reed écrivait l'accompagnement lyrique de ses chansons en marchant dans la rue. Voilà, c'est un peu comme ça que New York nous inspire.

Peut-on parler d'un style typiquement new-yorkais, et si oui, comment se manifeste-t-il dans votre œuvre ? Inventer. Ne pas regarder en arrière. Oui, en résumé, c'est peut-être çà « un style new-yorkais » pour autant qu'il existe vraiment.

Comment imaginez-vous le New York de demain ? J'ai peur que New York devienne uniquement une cité de verre. Il est possible aussi qu'elle disparaisse complètement et n'existe que sur d'anciennes pages web ou dans nos souvenirs. Ou alors, elle sera le paradis d'une seule personne extrêmement riche, un zoo animal très high-tech où l'on emmènera les enfants faire une sortie.

¿Cuál es el trabajo que considera más importante en su carrera? Creo que en este momento el proyecto GLAD! El proyecto de una torre en Manhattan está cargado de inquietudes.

¿De qué manera Nueva York supone una inspiración en su trabajo? Creo que lo más inspirador es la densidad de Nueva York. Cada centímetro cuadrado late con energía creativa. Lou Reed solía escribir las letras de sus canciones caminando por la calle. Creo que es algo así.

¿Existe un estilo típico neoyorquino, y si es así, cómo se revela en su obra? La invención. No mirar atrás. Esto podría resumir un "estilo neoyorquino", si es que de verdad existe alguno.

¿Cómo se imagina Nueva York en el futuro? Me preocupa que Nueva York se convierta en una ciudad sólo de cristal. O quizá desaparezca totalmente y sólo exista en nuestros recuerdos y viejos sitios web. Quizá también se convierta en un paraíso para los ricos, un zoo de mascotas donde sólo se pueda llevar a los niños de visita en excursiones.

Cosa pensa che sia la cosa più importante della Sua carriera? Credo che fino ad ora sia stato il progetto GLAD! Il progetto di una torre a Manhattan provoca sempre qualche brivido.

In che modo New York influenza il Suo lavoro? Penso che sia la densità di New York ad ispirarmi maggiormente. Ogni centimetro quadrato pulseggia di energia creativa. Lou Reed scriveva le parole delle sue canzoni camminando per strada; penso che sia un poco così.

Esiste uno stile tipico a New York? Se si, come influenza il Suo lavoro? L'inventiva. Senza guardarsi indietro. Ciò potrebbe riassumere lo "Stile di New York", sempre ammesso che ne esista uno.

Come si immagina la New York del futuro? Ho paura che New York possa diventare una città di solo vetro. O forse potrà addirittura scomparire completamente, continuando ad esistere solo nella memoria e in vecchi siti web. O forse diventerà un paradiso per una persona ricca, uno zoo dell'alta tecnologia per animali domestici, dove si possono solo prendere bambini per visite sul luogo.

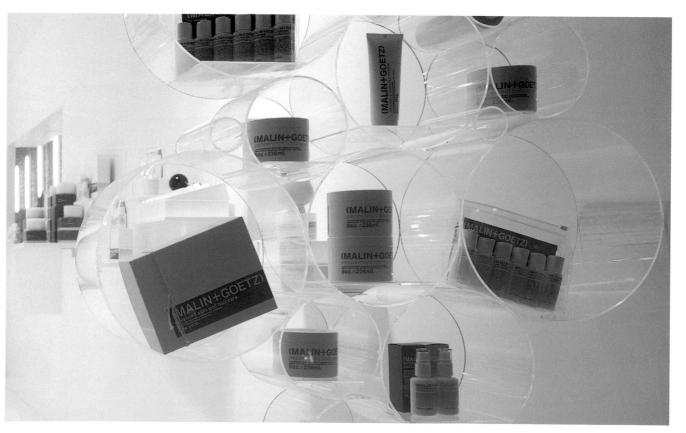

Malin+Goetz Shop

Year: 2004
Photographs: © Gogortza & Llorella

In the design of the Malin+Goetz cosmetic store, a roofed passage between two buildings was used to arrange a product warehouse and a sales room. The existing clinker stone walls were uncovered and restored. Additionally, in the front part of the store, a white Corian box was built, in order to create a neutral presentation surface to better showcase attractive products through its packaging design.

Für den Entwurf des Malin+Goetz Kosmetikgeschäftes wurde ein überdachter Durchgang zwischen zwei Gebäuden ausgenutzt, um ein Warenlager und einen Verkaufsraum zu gestalten. Die vorhandenen Klinkersteinwände wurden freigelegt und restauriert. Zusätzlich wurde im vorderen Teil des Geschäfts eine weiße Box aus Corian eingebaut, um eine neutrale Präsentationsfläche zu erzielen, die die attraktiven Produkte noch besser zur Geltung bringt.

Dans la conception du magasin de produits cosmétiques Malin+Goetz, l'architecte a tiré parti d'un passage couvert entre deux édifices pour créer un entrepôt de marchandises et un espace vente. Les murs de briques préexistants ont été mis à nu et restaurés. A cela s'ajoute, dans la partie frontale, une boite blanche en Corian, créée pour avoir une surface d'exposition neutre, qui met mieux en valeur les produits attrayants.

Para el diseño de la tienda de cosméticos Malin+Goetz se aprovechó una entrada con tejadillo entre dos edificios para crear un almacén y una tienda. Las paredes de ladrillos existentes se pusieron al descubierto y se restauraron. Adicionalmente, en la entrada se construyó una estructura blanca de Corian en forma de caja para obtener una superficie de presentación neutra que resalta aún más los atractivos productos.

Per il progetto dello studio cosmetico Malin+Goetz è stato utilizzato un passaggio coperto tra due immobili per realizzare un magazzino merci e uno spazio vendite. Le pareti esistenti in clinker sono state portate alla superficie e restaurate. Nella parte anteriore del negozio è stata inserita una scatola bianca di Corian per poter predisporre una superficie di presentazione neutrale, che attraverso il design doni ancora più valore a prodotti attrattivi.

(MALIN+GOETZ)
face cleanser.

6.5% GRAPEFRUIT EXTRACT. ALL SKIN TYPES.
ADVANCED HYDRATION FORMULA—FC·100·08.

OUR FOAMING CLEANSING GEL IS SYNTHESIZED WITH
REFRESHING GRAPEFRUIT EXTRACT TO GENTLY YET
THOROUGHLY PURIFY AND BALANCE ALL SKIN TYPES.
AMINO ACID·BASED CLEANSING AGENTS, UNLIKE
TRADITIONALLY HARSH DETERGENTS, ARE SCIENTIFICALLY
BLENDED TO HYDRATE, RINSING FREE OF RESIDUE WITHOUT
IRRITATION, DRYING, OR STRIPPING; HELPING TO REDUCE
EPIDERMAL STRESS. NATURAL FRAGRANCE AND COLOR.
EASILY INTEGRATED INTO DAILY MAINTENANCE AND
PREVENTION REGIMEN. DIRECTIONS: APPLY A SMALL AMOUNT
OF CLEANSER TO WET FACE, GENTLY LATHER, RINSE CLEAN.
FOLLOW WITH (MALIN+GOETZ) FACE MOISTURIZER. CAUTION: FOR
EXTERNAL, ADULT USE ONLY. IF IRRITATION OCCURS, DISCONTINUE
USE. AVOID CONTACT WITH EYES; IF CONTACT OCCURS, RINSE
EYES WITH WATER. INGREDIENTS: PURIFIED WATER (AQUA PURIFICATA)
DEA·COCOYL GLUTAMATE, SODIUM LAUROAMPHOACETATE COCO-
AMIDOPROPYL BETAINE, BETAINE MONOHYDRATE, PPG·120 METHYL
GLUCOSE DIOLEATE, GLYCERIN, SODIUM LACTATE (AND) SODIUM
PCA (AND) SORBITOL (AND) PROLINE, GRAPEFRUIT EXTRACT (CITRUS
GRANDISI), SODIUM CHLORIDE, METHYLPARABEN, DIAZOLIDINYL UREA,
PROPYLPARABEN, CITRIC ACID. FORMULATED AND DISTRIBUTED BY
PRODUCE INC. 177 SEVENTH AVE (@ W. 20TH + 21ST STS, NEW YORK,
NY10011. TEL +1 212 727 3777, WWW.MALINANDGOETZ.COM. MALIN+GOETZ
DOES NOT TEST ON ANIMALS. MADE IN USA.

8fl.oz.℮236ml.

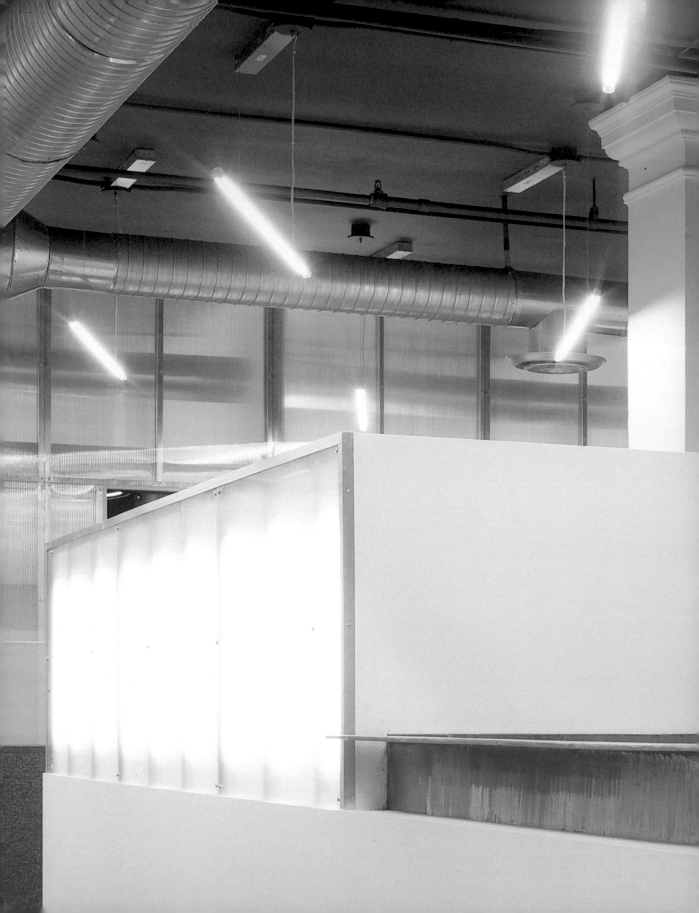

Workshop For Architecture

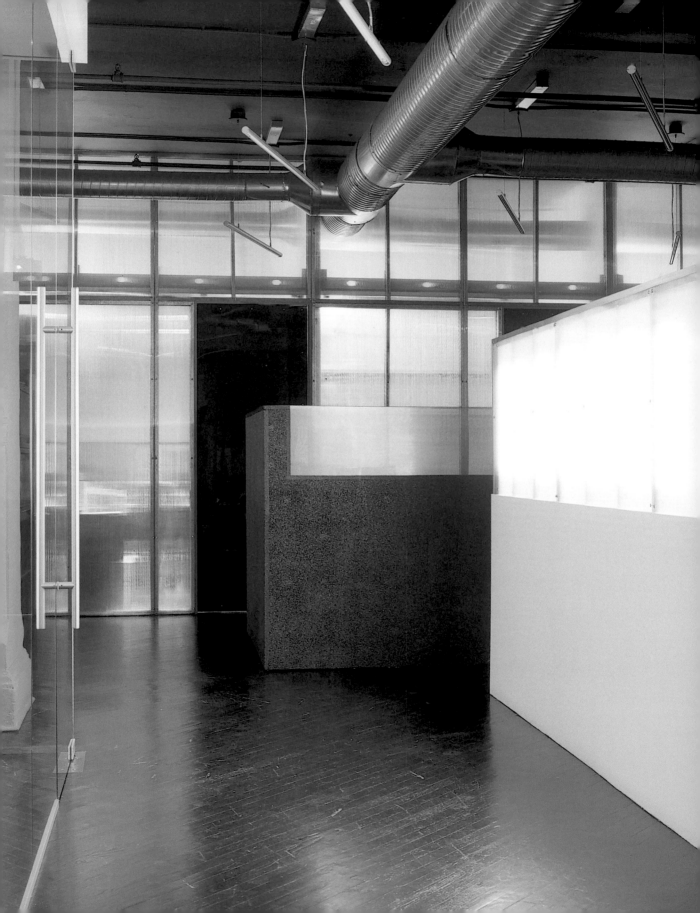

Workshop For Architecture

195 Chrystie Street, Suite 603F, New York, NY 10002, USA

+1 212 674 3400

+1 212 674 0400

www.wfora.com

info@wfora.com

John H. Lee

John Lee has been working as an architect in New York for over 16 years and has worked with offices such as HLW International and Kohn Pederson & Fox. In 2003, he established his own architectural firm, Workshop For Architecture, in which he can transfer his experience gained in numerous urban designs and interior design projects to smaller-scale and more personal designs.

John Lee ist seit über 16 Jahren in New York als Architekt tätig und arbeitete mit Büros wie HLW International und Kohn Pederson & Fox. 2003 gründete er sein eigenes Architekturbüro Workshop For Architecture, in dem er seine bei ausgedehnten Städtebauentwürfen sowie Innenarchitekturprojekten gesammelten Erfahrungen auf reduziertere und persönlichere Entwürfe übertragen kann.

John Lee exerce la fonction d'architecte à New York, depuis plus de 16 ans. Il travaille avec les cabinets tels que HLW International et Kohn Pederson & Fox. En 2003, il fonde son propre cabinet d'architecture Workshop For Architecture. Là, il peut appliquer à des projets plus petits et personnels, l'expérience accumulée dans ses nombreux travaux d'urbanisme et d'architecture d'intérieur.

John Lee lleva más de 16 años dedicado a la arquitectura en Nueva York y ha trabajado en estudios como HLW International y Kohn Pederson & Fox. En 2003 fundó su propio estudio Workshop For Architecture, en el que puede verter su experiencia en amplios proyectos urbanísticos y de arquitectura interior en diseños más reducidos y personales.

John Lee da oltre 16 anni lavora come architetto a New York, dove ha collaborato con studi quali HLW International e Kohn Pederson & Fox. Nel 2003 fondò il suo proprio studio di architettura Workshop For Architecture, dove ebbe la possibilità di trasferire sui suoi progetti personali le esperienze raccolte nei progetti urbanistici su piccola scala e nel design di interni.

1985
Bachelor of Arts, Franklin & Marshall College, Lancaster, Pennsylvania, USA

1984
One-year Undergraduate program, Institute of Architecture and Urban Studies, New York, USA

1989
Master of Architecture, Harvard University Graduate School of Design, Boston, Massachusetts, USA

2003
Foundation of Workshop for Architecture by John H. Lee, New York, USA
Office Interiors Maritime Intelligence Group, Washington, USA

2004
Ball Construction Office, New York, USA

Interview | Workshop For Architecture

What do you consider the most important work of your career? We're not there yet.

In what ways does New York inspire your work? Each project has its own set of inspirational moments, and New York provides you with so many sources for inspiration. Currently, we are interested in the installation art world of New York.

Does a typical New York style exist, and if so, how does it show in your work? I don't believe there is. Certain material choices lead to stylistic discussions, but there are more meaningful issues to address.

How do you imagine New York in the future? In terms of architecture, hopefully, we will be catching up to the sophistication of building designs in cities like Paris, Barcelona, Tokyo and even Beijing. There is a new cultural spotlight on architecture here, and architects should respond intelligently.

Was halten Sie für die wichtigste Arbeit in Ihrer Karriere? Soweit sind wir noch nicht.

Auf welche Weise inspiriert New York Ihre Arbeit? Jedes Projekt hat seine ganz eigene Fülle inspirierender Momente und New York selbst liefert einem ja so viele Inspirationsquellen. Im Augenblick interessieren wir uns für New Yorks Installationskunst-Szene.

Gibt es einen typischen New Yorker Stil, und wenn ja, wie zeigt sich das in Ihrer Arbeit? Ich glaube nicht, dass es den gibt. Bestimmte Materialfragen führen zu stilistischen Diskussionen, aber man kann sich bedeutungsvolleren Fragen widmen.

Wie stellen Sie sich New York in der Zukunft vor? Was die Architektur anbelangt, so werden wir hoffentlich in Eleganz und Komplexität mit dem Gebäudedesign von Paris, Barcelona, Tokio und auch Peking mithalten können. In kultureller Hinsicht wird verstärkt ein Augenmerk auf die hiesige Architektur gerichtet, und die Architekten sollten darauf intelligent reagieren.

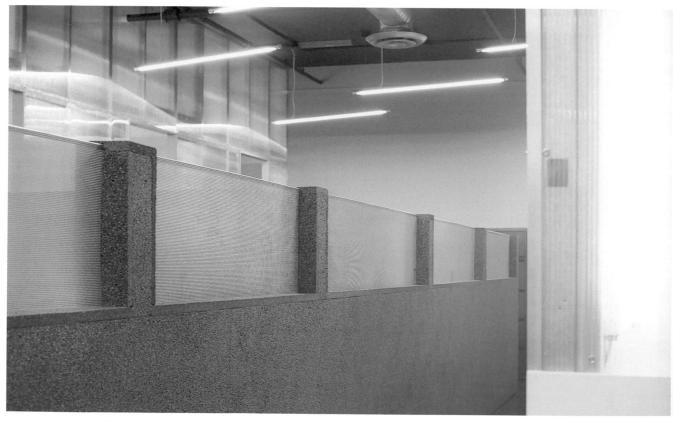

Quelle est l'œuvre la plus importante de votre carrière ? On n'en est pas encore là !

Dans quelle mesure la ville de New York inspire-t-elle votre œuvre ? Chaque projet à ses propres moments d'inspiration, et New York en offre tant. Actuellement, nous nous intéressons aux installations artistiques exposées à New York.

Peut-on parler d'un style typiquement new-yorkais, et si oui, comment se manifeste-t-il dans votre œuvre ? Je ne pense pas qu'il y en ait un. Certains choix de matériaux mènent à des discussions de style, mais il y a des questions plus vitales.

Comment imaginez-vous le New York de demain ? En termes d'architecture, j'espère que nous allons rattraper le degré de sophistication le design architectural de villes comme Paris, Barcelone, Tokyo et même Pékin. Ici, l'architecture est à nouveau sous les feux des projecteurs et je souhaite que les architectes prennent le train en marche dans le bon sens.

¿Cuál es el trabajo que considera más importante en su carrera? Aún no hemos llegado ahí.

¿De qué manera Nueva York supone una inspiración en su trabajo? Cada proyecto tiene su propia colección de momentos inspiradores y Nueva York puede ofrecer tantas fuentes de inspiración. En la actualidad, estamos interesados en el mundo artístico de la instalación de Nueva York.

¿Existe un estilo típico neoyorquino y, si es así, cómo se revela en su obra? No creo que exista. Determinadas elecciones de material conducen a discusiones estilísticas, pero hay cuestiones más significativas que tratar.

¿Cómo se imagina Nueva York en el futuro? En términos de arquitectura, espero que llegaremos a la sofisticación en los diseños de edificios de ciudades como París, Barcelona, Tokio e incluso Pekín. Hay un nuevo centro de atención cultural en la arquitectura aquí, y los arquitectos deben responder con inteligencia.

Qual è secondo Lei il progetto più importante della Sua carriera? Non ci siamo ancora arrivati.

In che modo la città di New York ispira il Suo lavoro? Ogni progetto si basa su una serie di momenti di ispirazione e New York dispone di un'infinita varietà di fonti di ispirazione. Al momento ci stiamo concentrando sul mondo dell'istallazione artistica.

È possibile parlare di uno stile tipico per New York, e, se questo stile esiste, in che modo si manifesta nei Suoi lavori? Non credo ce ne sia uno. Determinate scelte pratiche danno avvio a discussioni di natura stilistica, ma ci sono certo numerosi altri motivi significativi di cui si potrebbe tener conto.

Come si immagina la New York del futuro? Per quel che riguarda l'architettura, spero sarà possibile tener testa all'alto grado di sofisticazione raggiunto nella progettazione di edifici in altre città come Parigi, Barcellona, Tokyo o addirittura Pechino. Nuovi interessi culturali investono i progetti architettonici realizzati in queste città e gli architetti devono tenerne conto e rispondere con intelligenza a queste nuove sfide.

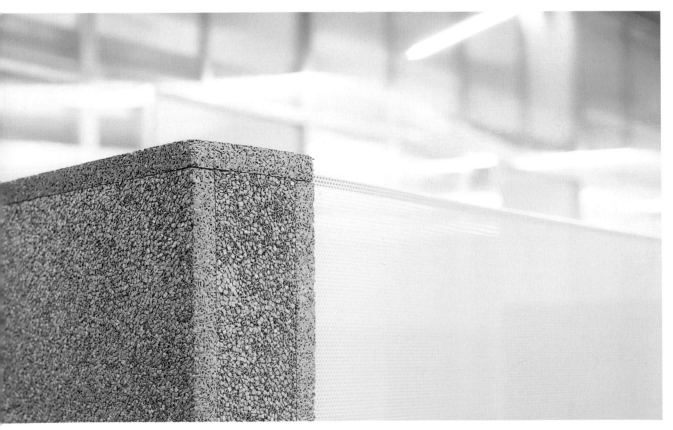

Ball Construction Offices

Year: 2004

Photographs: © Gogortza & Llorella

In this office design, John Lee placed a great deal of emphasis on a harmonious overall impression as well as special attention to the details. This is why the reception and work spaces were clad in foamed polypropylene, for its absorption function. To compensate for sparse natural light, the dark blue flooring was covered in a shiny coating which reflects the light of the lighting tubes floating in the room.

Bei diesem Büroentwurf legte John Lee sehr viel Wert auf einen harmonischen Gesamteindruck sowie auf besondere Gestaltung der Details. So wurden der Empfang und die Arbeitsplätze mit geschäumtem Polypropylen verkleidet, der eine Dämmfunktion besitzt und als Pinnwand dient. Um das fehlende natürliche Licht zu kompensieren, wurde der dunkelblaue Boden mit einem seidenglänzenden Anstrich überzogen, der das Licht der im Raum schwebenden Leuchtröhren reflektiert.

Dans ce projet de bureau, John Lee attache une grande importance à une vue d'ensemble harmonieuse et à une réalisation particulière des détails. La réception et les emplacements de travail sont revêtus de mousse de Polypropylène, permettant à la fois d'isoler et d'y mettre des punaises. Pour compenser la carence en lumière naturelle, le sol bleu foncé est verni, reflétant ainsi la lumière des néons qui flottent dans l'espace.

En estas oficinas, John Lee otorgó gran importancia a la creación de una impresión global armoniosa y a dar una especial presentación de los detalles. Como ejemplo, la recepción y los puestos de trabajo se revistieron con polipropileno espumado, que además de su función aislante, sirve para fijar notas. Para compensar la falta de luz natural, el suelo azul oscuro se cubrió con una pintura satinada que refleja la luz de tubos fluorescentes suspendidos en el espacio.

In questo progetto per uffici John Lee diede la massima importanza ad un effetto d'insieme armonico e ad un particolare lavoro sui dettagli. La reception e le postazioni di lavoro furono rivestite di schiuma di polipropilene, materiale che oltre al suo potere isolante permette anche di fungere da pannello per affissione. Per compensare la mancanza di luce naturale il pavimento blu scuro è stato rivestito con una vernice semilucida che riflette la luce dei tubi fluorescenti appesi al soffitto.

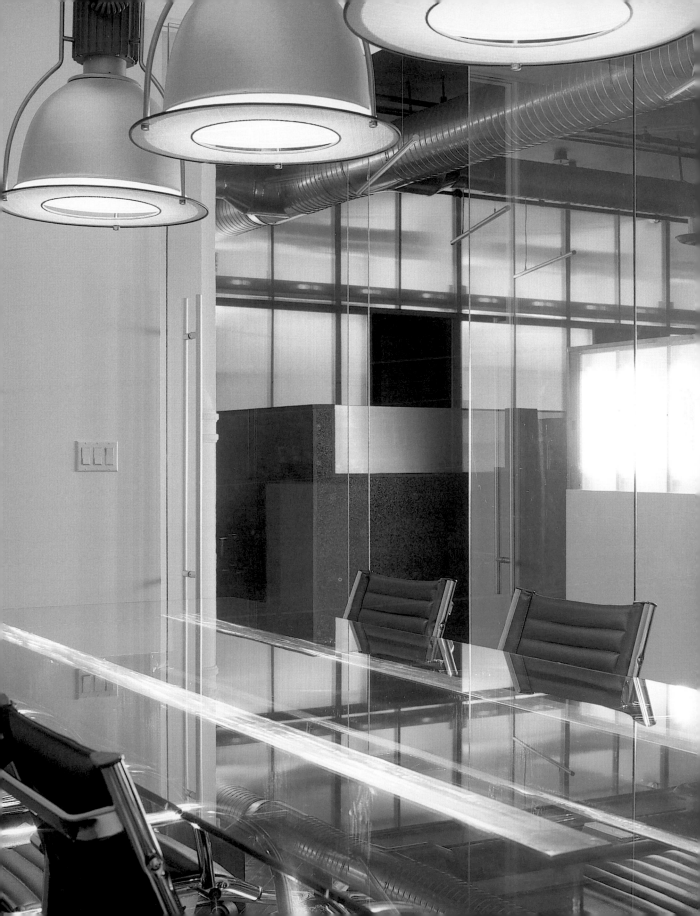

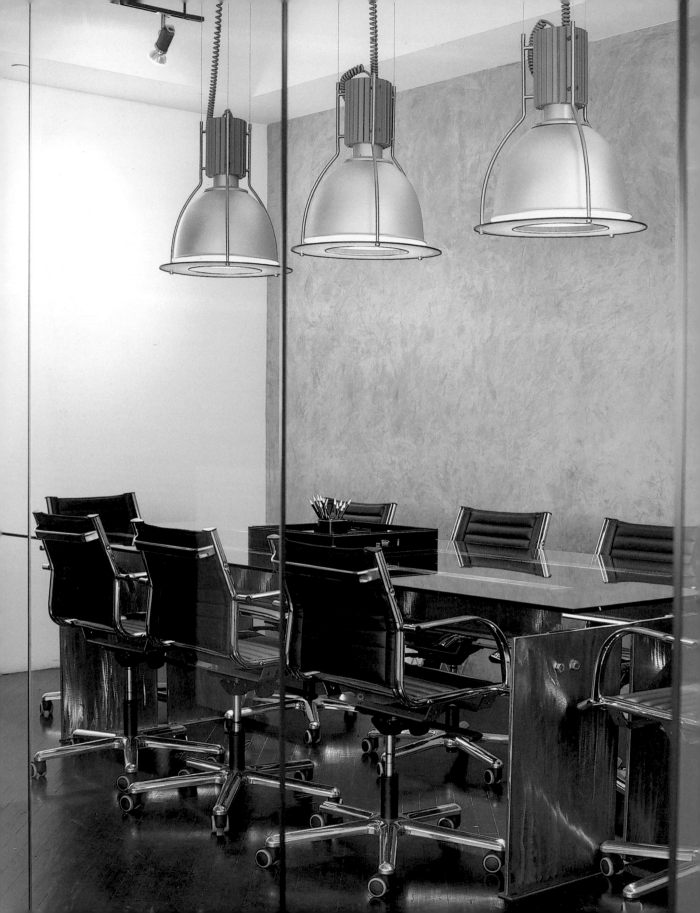

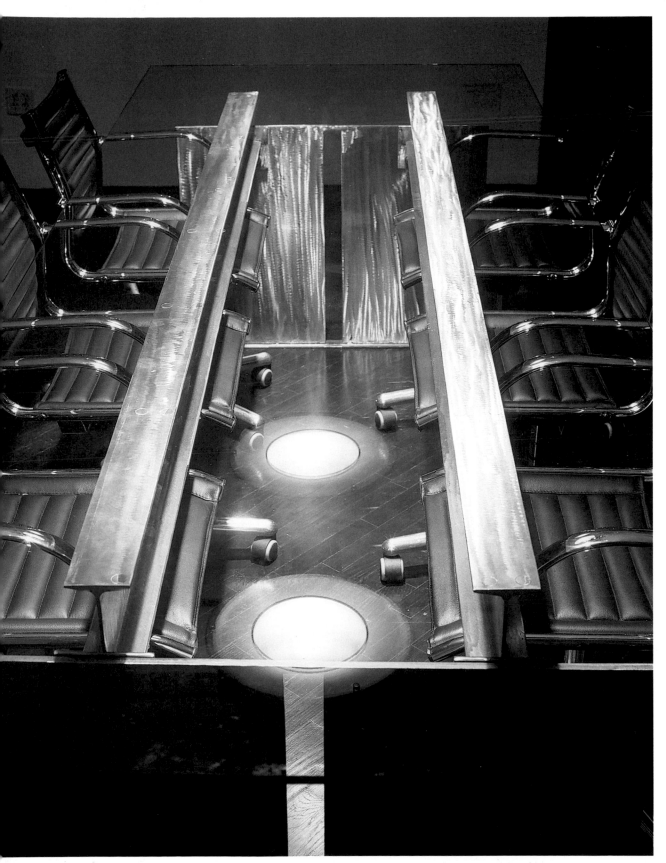

Floor plan

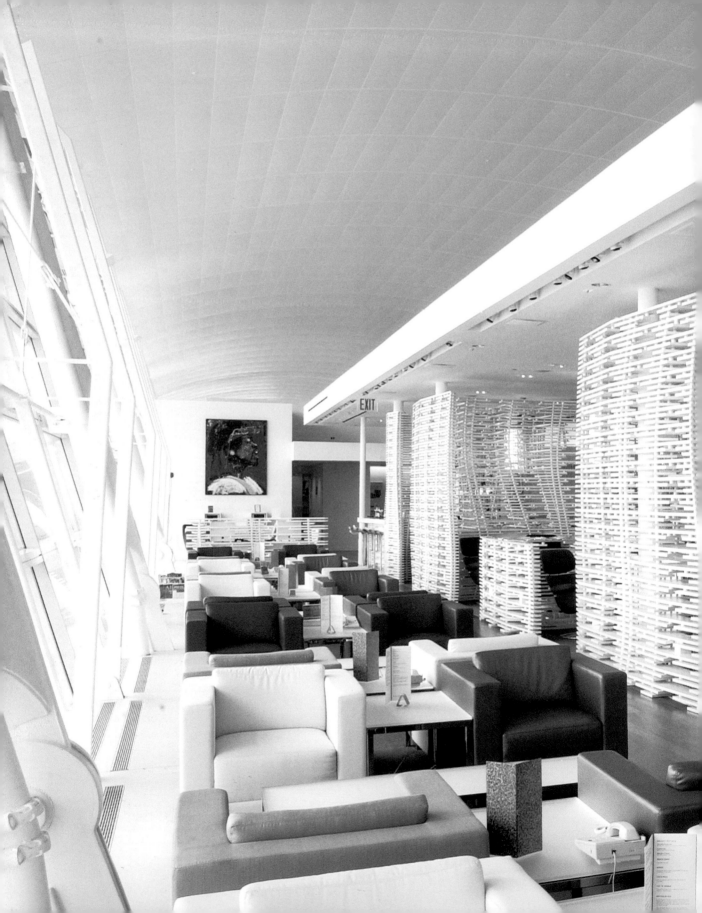

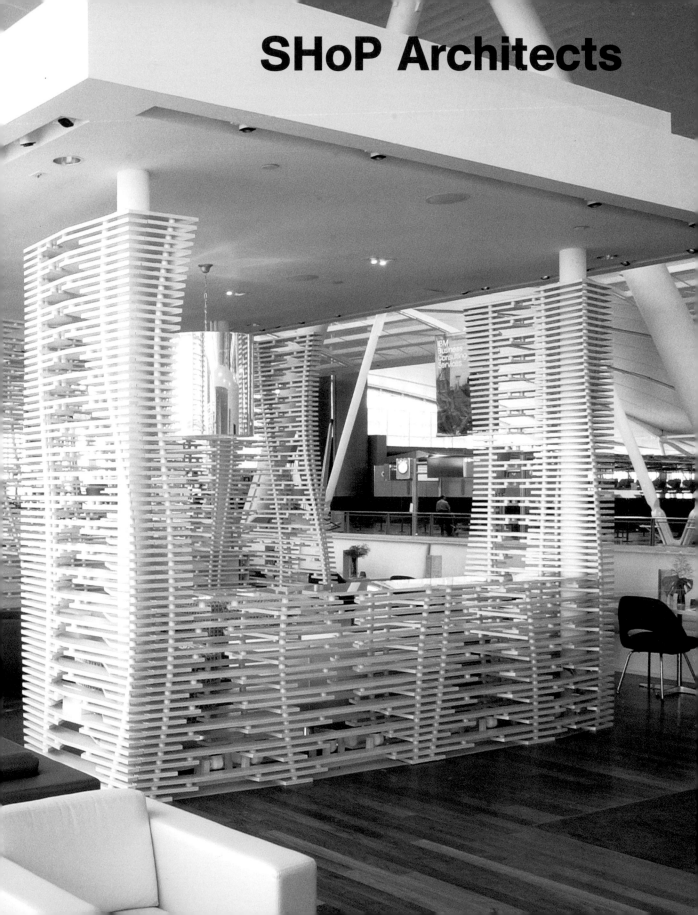

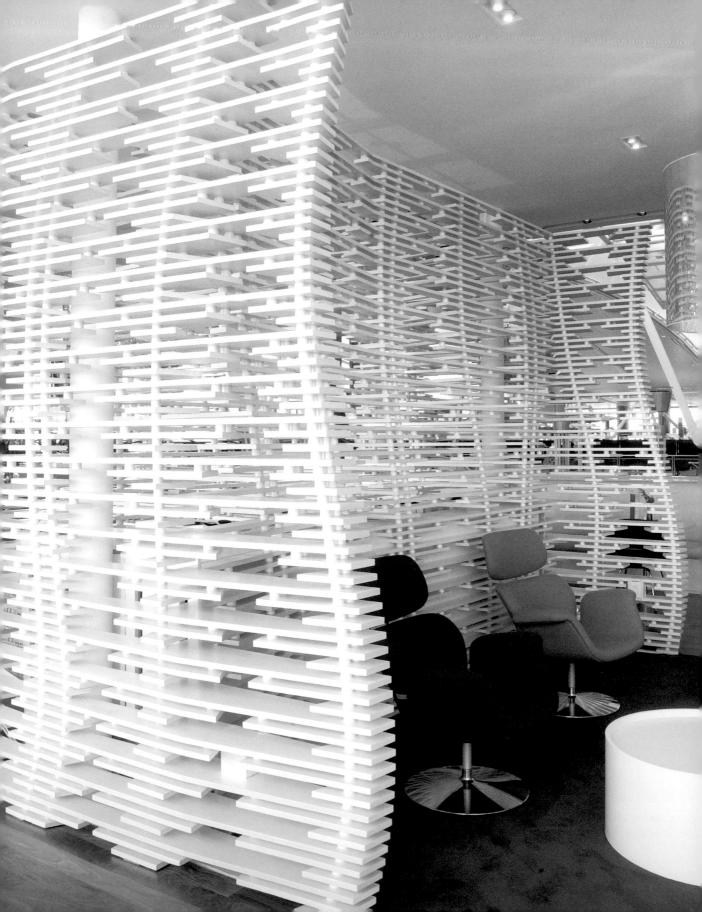

SHoP Architects

11 Park Place, Penthouse, New York, NY 10007, USA

+1 212 889 9005

+1 212 889 3686

www.shoparc.com

studio@shoparc.com

SHoP Architects

The architecture firm SHoP Architects, which currently has 38 employees, was founded in New York in 1996 by five partners: Christopher, William and Coren Sharples and Kimberly Holden and Gregg Pasquarelli. The various studies and work experience which the partners bring to the design process lead to designs that combine avant-garde concepts and theories with practical design and construction solutions.

Das mittlerweile 38 Mitarbeiter zählende Architekturbüro SHoP Architects wurde 1996 von den fünf Partnern Christopher, William und Coren Sharples sowie Kimberly Holden und Gregg Pasquarelli in New York gegründet. Die unterschiedlichen Studien- und Arbeitserfahrungen, die die Partner in den Designprozess einbringen, führen zu Entwürfen, die avantgardistische Konzepte und Theorien mit pragmatischen Design- und Konstruktionsansätzen kombinieren.

Le cabinet d'architecture SHoP Architects, qui compte actuellement 38 collaborateurs, est fondé en 1996, à New York, par cinq partenaires, Christopher, William et Coren Sharples, Kimberly Holden et Gregg Pasquarelli. Les diverses expériences d'études et de conception, intégrées par les partenaires dans le processus de design, mènent à des projets qui marient théories et concepts les plus avant-gardistes à des approches pragmatiques d'architecture et de design.

El estudio SHoP Architects, que cuenta ya con 38 empleados, se fundó en Nueva York el año 1996 por cinco socios: Christopher, William y Coren Sharples, Kimberly Holden y Gregg Pasquarelli. El diverso bagaje formativo y profesional que aportan los socios al proceso de diseño se traduce en proyectos que combinan conceptos y teorías vanguardistas con aproximaciones pragmáticas al diseño y la construcción.

Lo studio di architettura SHoP Architects, che ormai conta ben 38 collaboratori, fu fondato a New York nel 1996 dai cinque soci Christopher, William e Coren Sharples e da Kimberly Holden e Gregg Pasquarelli. Le diversificate esperienze di studio e di lavoro che i soci integrano nel processo creativo hanno avuto come risultato dei progetti che combinano concetti e teorie avanguardistiche con elementi costruttivi e progettuali pragmatici.

SHoP Architects

1996
SHoP founded in New York, USA

2000
"Dunescape" installation, Winner, MoMA/P.S.1 Young Architects, The Museum of Modern Art, New York, USA

2001
Finalist, Architecture Design Award, Cooper-Hewitt National Design Awards Program

2002
Rector Street Bridge, New York, USA

2003
Porter House, Manhattan, New York, USA

2004
Virgin Atlantic Clubhouse at JFK, New York, USA
Heyri Art Complex, Seoul, South Korea

2005
Mitchell Park, Greenport, New York, USA
108 Arch Street, Philadelphia, Pennsylvania, USA
East River Waterfront Comprehensive Study, New York, USA

Interview | SHoP Architects

Which do you consider the most important work of your career? The kind of practice we have developed makes this office a laboratory where the practice of architecture is constantly evolving. SHoP is not about a single image or building.

In what ways does New York inspire your work? New York's dynamic interaction of competing and collaborating forces inspires SHoP Architects to think of design as a living negotiating organism, one that must continually reinvent itself to remain vibrant and optimistic.

Does a typical New York style exist, and if so, how does it show in your work? There is no typical New York style. The city's infrastructure operates as a framework for experimentation and cross-pollenization.

How do you imagine New York in the future? Its position as the city that causes the least harm to the environment will only drive its prominence in the coming century. New York's best days are yet to come.

Was halten Sie für die wichtigste Arbeit in Ihrer Karriere? Die von uns entwickelte Praxis macht unser Studio zu einem Laboratorium, in dem die Verfahren der Architektur ständig weiterentwickelt werden. ShoP geht es nicht um ein einzelnes Image oder Gebäude.

Auf welche Weise inspiriert New York Ihre Arbeit? Die dynamische Interaktion der konkurrierenden und kooperierenden Kräfte dieser Stadt inspirieren die Architekten von ShoP dazu, das Design als eine Art lebendigen, interaktiven Organismus zu betrachten, der sich stets neu definiert, um dynamisch und optimistisch zu bleiben.

Gibt es einen typischen New Yorker Stil, und wenn ja, wie zeigt sich das in Ihrer Arbeit? Es gibt keinen typischen New Yorker Stil. Die Infrastruktur der Stadt bietet einen idealen Rahmen für Experimente und gegenseitige Befruchtung.

Wie stellen Sie sich New York in der Zukunft vor? Den Rang als umweltfreundlichste Stadt wird New Yorks Beliebtheit wohl erst im kommenden Jahrhundert steigern. New Yorks beste Tage stehen uns also erst noch bevor.

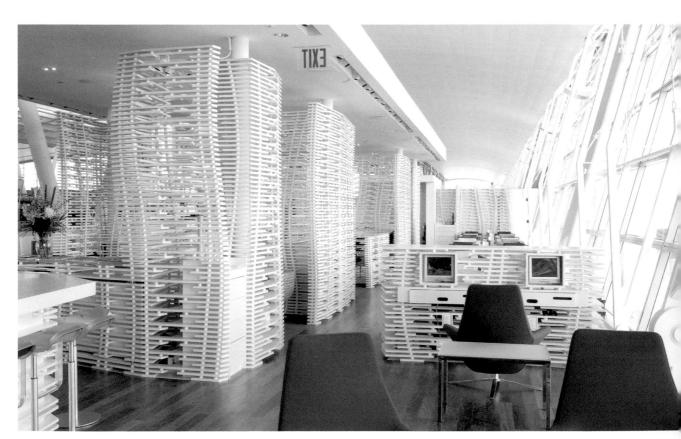

Quelle est l'œuvre la plus importante de otre carrière ? Le type d'expérience que nous vons développé transforme ce bureau en labora-ire où la pratique de l'architecture est en nstante évolution. SHoP ne produit pas d'image u d'édifice uniques.

ans quelle mesure la ville de New York spire-t-elle votre œuvre ? A New York, le namisme interactif des forces, se faisant ncurrence ou collaborant, influence le bureau études SHoP Architects dans sa conception de esign : un organisme vivant, qui doit sans cesse e réinventer pour rester vibrant d'émotion et timiste.

eut-on parler d'un style typiquement ew-yorkais, et si oui, comment se mani-este-t-il dans votre œuvre ? Il n'y a pas de tyle typiquement new-yorkais. L'infrastructure de ville fonctionne comme un cadre expérimental t de pollinisation croisée.

omment imaginez-vous le new York de emain ? Ce n'est qu'au prochain siècle que ew York jouera son rôle de ville causant le oins de mal sur l'environnement. Pour New ork, les jours meilleurs se profilent à l'horizon 'une ère prochaine.

¿Cuál es el trabajo que considera más importante en su carrera? La forma de traba-jar que hemos desarrollado convierte a esta ofici-na en un laboratorio donde el ejercicio de la arquitectura está en constante evolución. SHoP no se trata de una única imagen o edificio.

¿De qué manera Nueva York supone una inspiración en su trabajo? La interacción dinámica que se da en Nueva York entre las fuer-zas de colaboración y de competencia inspira a los arquitectos de SHoP para considerar el diseño como un organismo de negociación vivo, uno que debe reinventarse a sí mismo continuamente para permanecer vibrante y optimista.

¿Existe un estilo típico neoyorquino, y si es así, cómo se revela en su obra? No exis-te un estilo típico neoyorquino como tal. La infra-estructura de la ciudad sirve de marco para la experimentación y la polinización cruzada.

¿Cómo se imagina Nueva York en el futu-ro? Su posición como la ciudad que provoca el menor perjuicio al medio ambiente sólo servirá para impulsar su prominencia en el próximo siglo. Los mejores tiempos para Nueva York aún están por venir.

Cosa pensa che sia la cosa più importante della Sua carriera? Il tipo di pratica sviluppato da noi fa di questo studio un laboratorio in cui la pratica dell'architettura si trova in continua evo-luzione. ShoP non riguarda una sola immagine e un singolo edificio.

In che modo New York influenza il Suo lavoro? L'interazione dinamica di forze in com-petizione e in collaborazione qui a New York ispi-ra gli architetti di ShoP, nel senso di concepire il design come un organismo vivo e negoziabile che si deve continuamente reinventare per rimanere ottimista e in vibrazione.

Esiste uno stile tipico a New York? Se sì, come influenza il Suo lavoro? Non esiste uno stile tipico di New York. Le infrastrutture della città agiscono da cornice per la sperimenta-zione e l'impollinazione incrociata.

Come si immagina New York in futuro? La sua posizione come la città che causa meno danno ambientale aumenterà il suo vantaggio ancora di più nel prossimo secolo. I giorni miglio-ri di New York devono ancora venire.

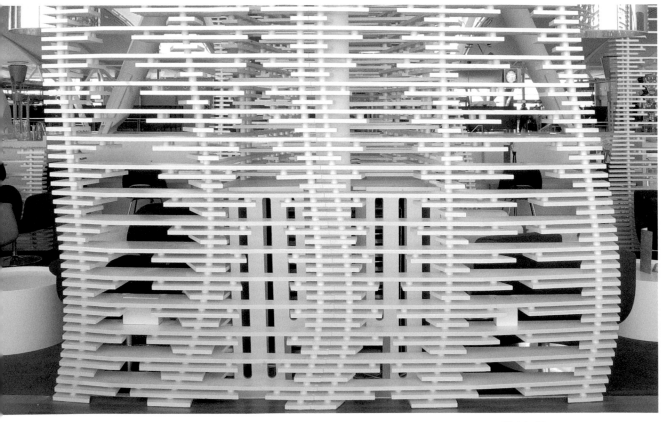

Virgin Atlantic Clubhouse

Year: 2004

Photographs: © Seong Kwon, Jay Bierach (portrait)

For the design of the Virgin Atlantic Lounge at John F. Kennedy Airport, the architects used innovative digital design technologies to create an urban and artificial landscape. As a focal point of the lounge, mother-of-pearl colored and wave-shaped structures made of MDF plates serve as translucent separators for the comfortable booths. The shimmery effect of the cladding is further intensified by the flexible lighting design.

Für das Design der Virgin Atlantic Lounge des John F. Kennedy Airports nutzen die Architekten innovative digitale Entwurfstechnologien, um eine urbane und artifizielle Landschaft zu kreieren. Als lichtdurchlässige Begrenzung für die komfortablen Separees, den Blickfang der Lounge, fungieren perlmuttfarbene und wellenförmige Strukturen aus MDF-Platten. Der schimmernde Effekt der Verkleidungen wird zudem durch das wandelbare Lichtdesign intensiviert.

Pour le design du Virgin Atlantic Lounge de l'aéroport John F. Kennedy, les architectes utilisent les technologies de conceptions digitales innovatrices, pour créer un paysage urbain et artificiel. Des structures nacrées en forme de vagues, réalisées à base de plaques MDF, sont le point de mire du Lounge et façonnent un écran laissant passer la lumière pour séparer les espaces confortables. L'effet brillant du revêtement est exalté par les modulations du design lumineux.

Para el diseño del Virgin Atlantic Lounge en el aeropuerto John F. Kennedy, los arquitectos utilizan innovadoras tecnologías de diseño digital para crear un paisaje urbano y artificial. Los acogedores reservados están formados por estructuras onduladas a base de placas MDF de color nácar que, además de ser el blanco de las miradas, dejan pasar la luz. El brillo de los revestimientos se intensiva por el cambiante diseño de luces.

Per il progetto della Virgin Atlantic Lounge nell'aeroporto John F. Kennedy gli architetti si sono avvalsi di tecnologie progettuali innovative per creare un paesaggio urbano ed artificiale. Strutture ondulate color madreperla composte da lastre di MDF fungono da divisori – che permettono il passaggio della luce – per i confortevoli separé, che costituiscono il richiamo visivo della sala d'attesa. L'effetto luccicante dei rivestimenti viene amplificato dall'illuminazione modificabile.

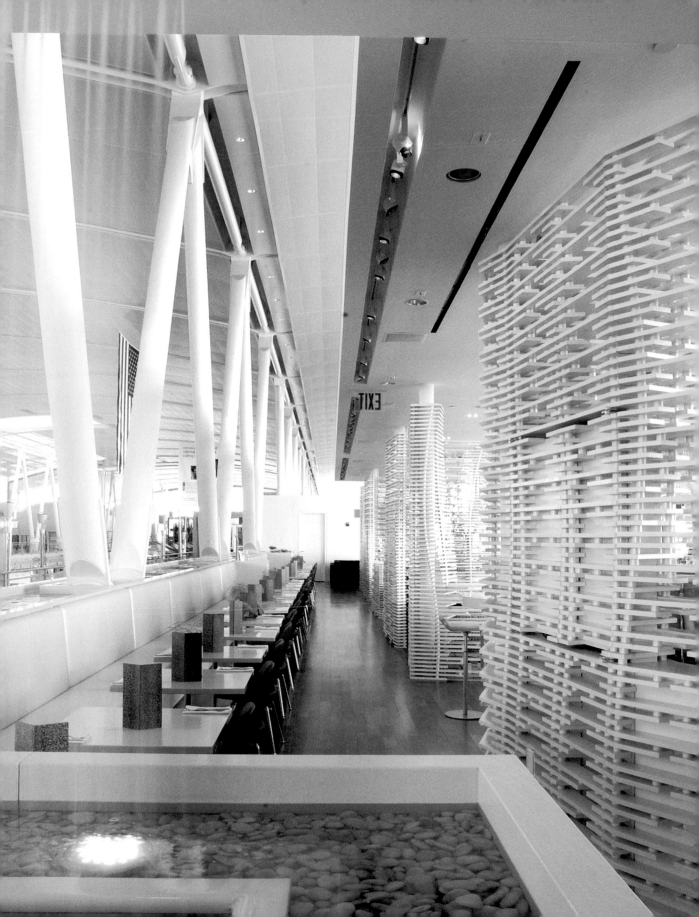

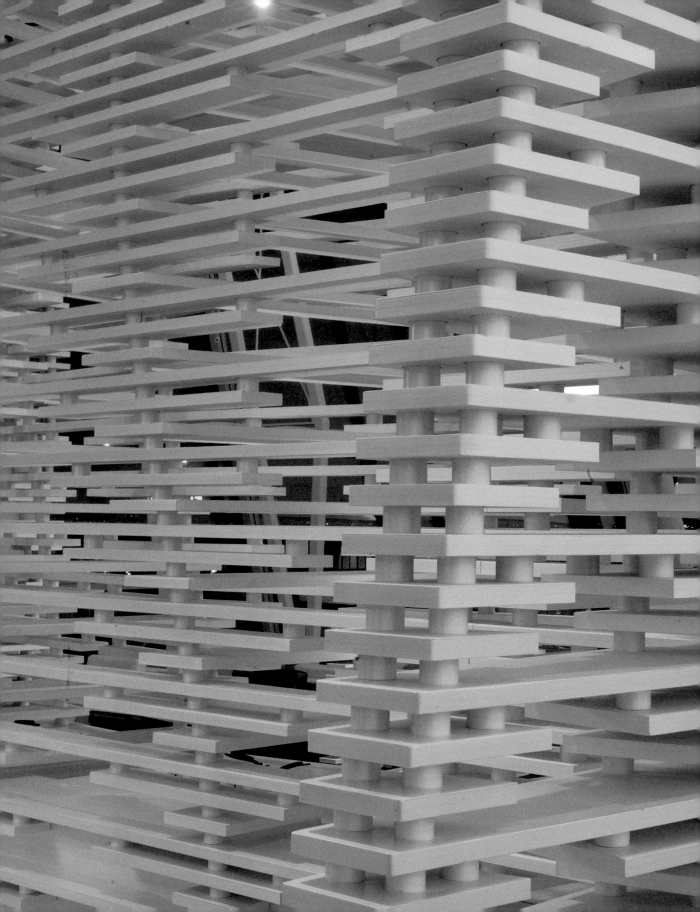

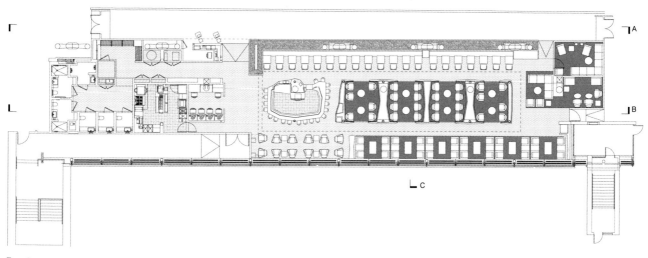

Floor plan

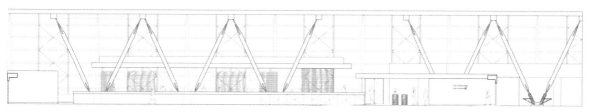

Section

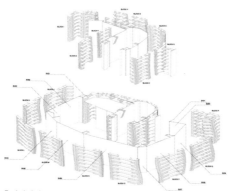

Exploded view

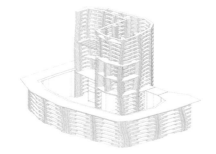

Assembly

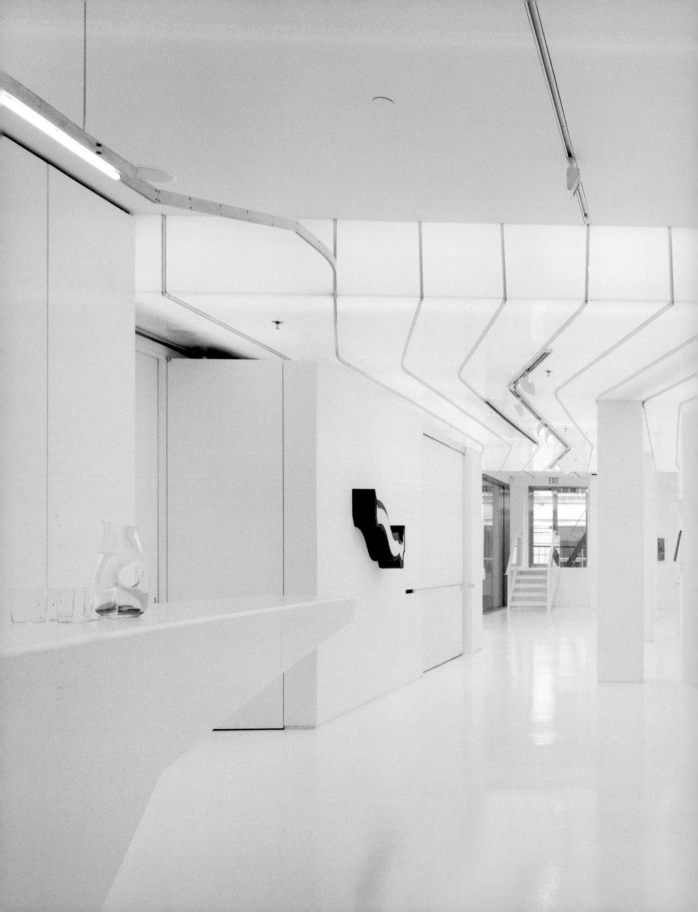

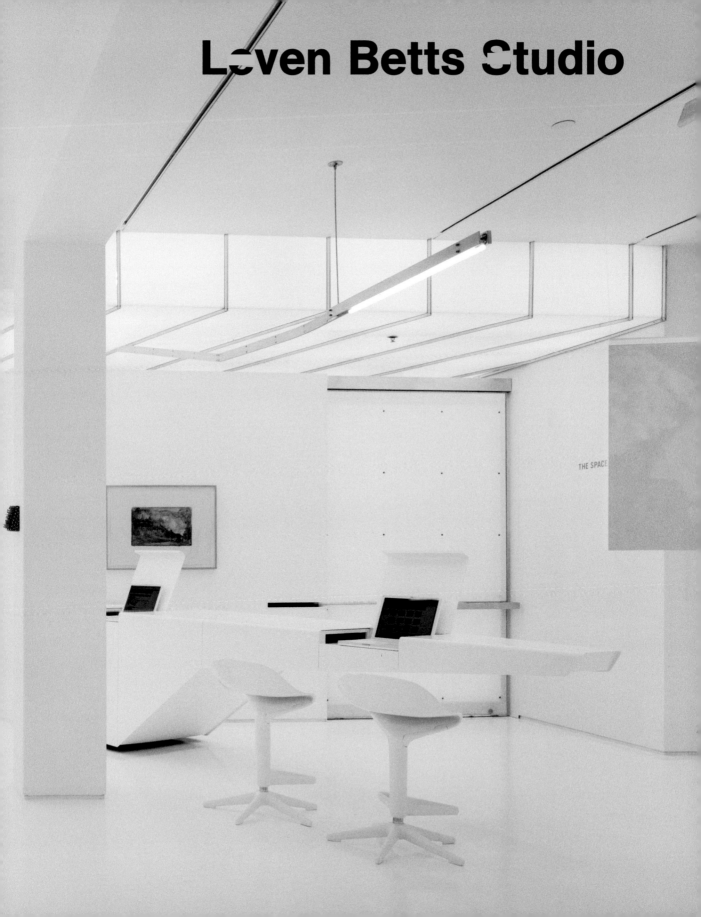

Leven Betts Studio

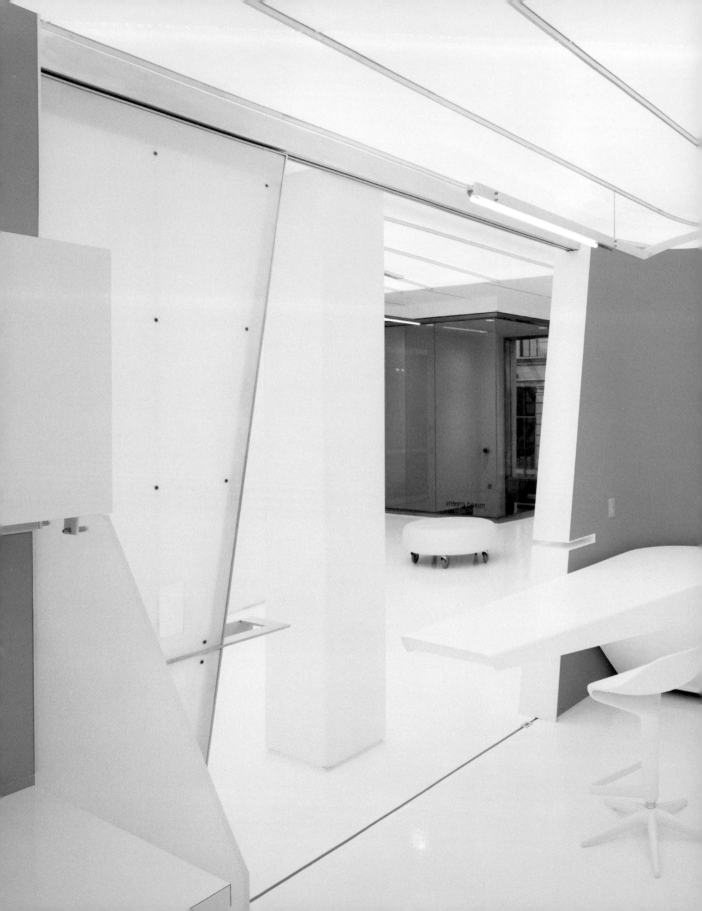

Leven Betts Studio

511 West 25th Street 808, New York, NY 10001, USA

+1 212 620 9792

+1 212 620 3235

www.levenbetts.com

info@levenbetts.com

David Leven and Stella Betts opened their architecture studio in 1997 in New York–the city in which they also create the majority of their designs. In addition to a strong education and work experience, which they pass on as professors, they enrich their projects through originality in architecture and design, for example by custom-designing furnishings for the project at hand.

David Leven und Stella Betts eröffneten ihr Architekturstudio 1997 in New York, dem Ort, an dem sie auch die Mehrzahl ihrer Entwürfe umsetzen. Neben einer fundierten Ausbildung und ihrer Arbeitserfahrung, die sie als Professoren weitergeben, bereichern sie Ihre Projekte durch Originalität in Architektur und Design, beispielsweise indem sie Mobiliar speziell für das jeweilige Projekt neu entwerfen.

David Leven et Stella Betts inaugurent leur studio d'architecture en 1997 à New York, lieu où ils réalisent la plupart de leurs projets. A côté d'une bonne formation et d'une intense expérience professionnelle, qu'ils transmettent en tant que professeurs, ils enrichissent leurs projets avec une architecture et un design ponctué d'originalité, à l'instar du mobilier qu'ils conçoivent spécialement pour ce projet.

David Leven y Stella Betts abrieron su estudio de arquitectura en 1997 en Nueva York, el lugar en el que realizan la mayor parte de sus proyectos. Junto a una sólida formación y experiencia profesional, que transmiten en sus respectivas cátedras, sus proyectos se enriquecen con la originalidad en la arquitectura y el diseño, creando por ejemplo el mobiliario para cada proyecto.

David Leven e Stella Betts aprirono il loro studio di architetti nel 1997 a New York, il luogo in cui realizzano anche la maggior parte dei loro progetti. Oltre ad una formazione consistente e alla grande esperienza di lavoro che trasmettono come professori, i due arricchiscono i loro progetti con un'originalità particolare in architettura e nel design, che li porta ad esempio a disegnare un arredamento specifico per ogni nuovo progetto.

David Leven

1986
Bachelor of Arts, Colgate University, Hamilton, New York, USA

1991
Master of Architecture, Yale University School of Architecture, New Haven, Connecticut, USA

Stella Betts

1988
Bachelor of Arts, Connecticut College, New London Connecticut, USA

1994
Master of Architecture, Harvard University Graduate School of Design, Cambridge, Massachusetts, USA

1997
Foundation of Leven Betts Studio, New York, USA

2004
106 Greenwich Street Apartments, AIA New York Chapter Design Award

2005
Mixed Greens Gallery, New York, USA

Interview | Leven Betts Studio

What do you consider to be the most important work of your career? The most important work of our career is fast approaching.

In what ways does New York inspire your work? New York is multi-centered, connected by infrastructure and constantly in flux. We are inspired by the inevitability of seeing places and buildings we have never seen before, by the infrastructural networks and by all of these things as they change.

Does a typical New York style exist and if so, how does it show in your work? New York City's style is fast and constantly moving. Our work aspires to capture these stylistic attributes.

How do you imagine New York in the future? New York is constantly passing into its future and as a result embodies a state of flux. But, as it is New York, its shifting form always contains an element of disrepair. New York in the future will be highly technologized, hopefully green and in need of maintenance.

Was halten Sie für die wichtigste Arbeit in Ihrer Karriere? Von der wichtigsten Arbeit unserer Karriere sind wir nur einen Katzensprung entfernt.

Auf welche Weise inspiriert New York Ihre Arbeit? New York besitzt mehrere Zentren, die über die Infrastruktur miteinander verbunden sind und sich in einem kontinuierlichen Fluss befinden. Uns inspirieren die stets neuen Plätze und Gebäude, mit denen wir unweigerlich konfrontiert sind, das Ausmaß infrastruktureller Netzwerke, die Gesamtheit dieser Dinge in ihrem Wandel.

Gibt es einen typischen New Yorker Stil, und wenn ja, wie zeigt sich das in Ihrer Arbeit? Der Stil von New York City befindet sich in ständiger, schneller Bewegung. Ziel unserer Arbeit ist es, diese stilistischen Attribute einzufangen.

Wie stellen Sie sich New York in der Zukunft vor? New York gleitet ständig in die eigene Zukunft hinüber und verkörpert folglich diesen fließenden Zustand. Aber da New York nun mal so ist, geht dieser Zustand stets mit dem Element der Baufälligkeit einher. New York wird in der Zukunft höchst technologisiert sein, hoffentlich grün, aber auch wartungsbedürftig.

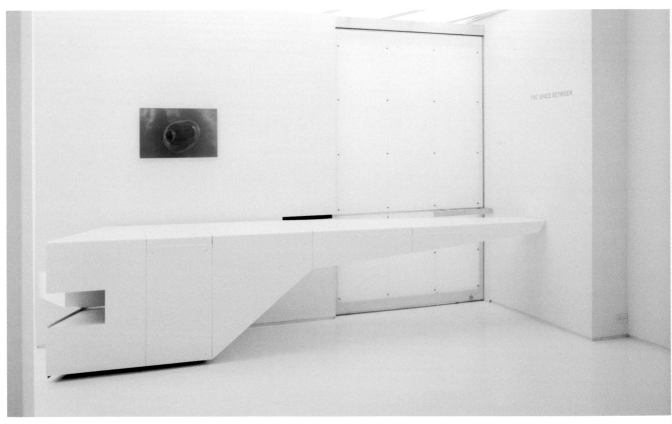

Quelle est l'œuvre la plus importante de votre carrière ? La plus importante œuvre de notre carrière est toute proche.

Dans quelle mesure la ville de New York inspire-t-elle votre œuvre artistique ? New York a plusieurs centres, reliés par une infrastructure et en mutation constante. Notre inspiration naît de l'incontournable vision de lieux et de bâtiments jamais vus auparavant, des réseaux d'infrastructures et de l'évolution constante de tous ces éléments.

Peut-on parler d'un style typiquement new-yorkais, et si oui, comment se manifeste-t-il dans votre œuvre ? Le style de la ville de New York passe vite car il est constamment en mutation. Notre travail aspire à capturer ces qualités stylistiques.

Comment imaginez-vous le New York de demain ? New York est sans cesse en marche vers l'avenir et dans ce sens incarne un état de fluctuation permanente. Mais, la ville de New York étant ce qu'elle est, sa mutation s'accompagne d'un élément de délabrement. New York sera à l'avenir une ville à la pointe de la technologie, verte dans la mesure du possible et qui aura besoin d'être entretenue.

¿Cuál es el trabajo que considera como el más importante en su carrera? El trabajo más importante de nuestra carrera está muy cerca.

¿De qué manera Nueva York supone una inspiración en su trabajo? Nueva York es una ciudad con numerosos focos de atención, conectados mediante infraestructura y en constante estado de cambio. Nos inspira la inevitabilidad de ver lugares y edificios que nunca hemos visto antes, las redes de infraestructura y todas estas cosas a medida que cambian.

¿Existe un estilo típico neoyorquino y, si es así, cómo se revela en su obra? El estilo de Nueva York es rápido y está en constante movimiento. Nuestro trabajo aspira a capturar estos atributos estilísticos.

¿Cómo se imagina Nueva York en el futuro? Nueva York está constantemente dando pasos hacia su futuro y, por ende, personifica un estado de cambio. Pero, como se trata de Nueva York, su forma cambiante contiene un elemento de deterioro. En el futuro, Nueva York será una ciudad presa de la tecnología, esperemos que verde y con necesidad de mantenimiento.

Qual è secondo Lei il progetto più importante della Sua carriera? Il progetto più importante della nostra carriera non è lontano...

In che modo la città di New York ispira il Suo lavoro? New York è una città con molti centri, collegata da infrastrutture e in una condizione di fluttuazione costante. È l'inevitabile paesaggio di posti e edifici che non abbiamo mai visto che ci ispira, le reti infrastrutturali e il mutuare continuo di tutto questo.

È possibile parlare di uno stile tipico per New York, e, se questo stile esiste, in che modo si manifesta nei Suoi lavori? Lo stile di New York è uno stile veloce e in continuo movimento. I nostri lavori si propongono di catturare proprio questi elementi stilistici.

Come si immagina la New York del futuro? New York si traduce costantemente nel suo futuro e questo determina la sua condizione di fluttuazione. Ma New York è sempre New York: il suo essere così instabile ha anche sempre un elemento di decadenza e rovina. La New York del futuro sarà altamente tecnologizzata, verde, mi auguro, e con un forte bisogno di manutenzione.

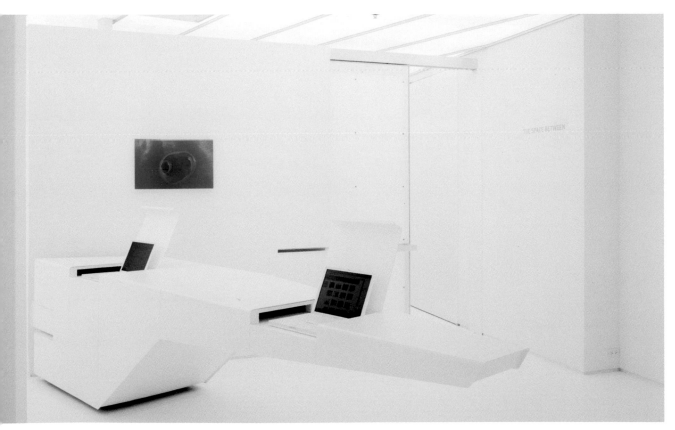

Mixed Greens Gallery

Interior Designer: Ghislaine Vinas
Year: 2005
Photographs: © Moranstudio

In the case of this gallery in Chelsea of more than 10,700 sq. feet, the client wanted a combination of the most diverse functional areas, such as, for example exhibit and conference rooms. To define the different ranges, the architects used the existing structure made of beams and columns and placed the office in the center, thereby separating the more public front from the rear areas. The bar and reception table were custom-designed for the gallery.

Bei dieser 1000 m² großen Galerie in Chelsea wünschte sich der Auftraggeber die Kombination verschiedenster Funktionsbereiche, wie beispielsweise Ausstellungs- und Konferenzraum. Um die verschiedenen Bereiche zu definieren, nutzten die Architekten die vorhandene Struktur aus Balken und Säulen und setzten das Büro in das Zentrum, um so den öffentlicheren, vorderen vom hinteren Bereich zu trennen. Bar- und Empfangstisch wurden speziell für die Galerie entworfen.

Dans cette grande galerie de Chelsea, forte de 1000 m², les clients souhaitaient combiner différents espaces fonctionnels, comme par exemple la salle d'exposition et de conférence. Pour définir les différents domaines, les architectes ont utilisé la structure existante faite de poutres et de piliers pour placer le bureau au centre, séparant ainsi, à l'avant, la sphère publique de la zone arrière. Le bar et la table de réception sont spécialement conçus pour la galerie.

En esta galería de Chelsea de 1000 m², el cliente deseaba combinar distintas áreas funcionales, como la sala de exposiciones o la sala de reuniones. Para definirlas, los arquitectos utilizaron la estructura existente de vigas y columnas y dispusieron el despacho en el centro para separar así la zona delantera pública de la parte trasera. La barra y el mostrador de recepción se diseñaron especialmente para la galería.

In questa galleria di 1000 m² a Chelsea, il committente desiderava una combinazione tra settori funzionali differenti, come per esempio uno spazio espositivo e una sala da conferenze. Per definire i diversi settori, gli architetti utilizzarono la struttura esistente di travi e colonne e posizionarono l'ufficio nel centro, per separare così il settore anteriore, più ufficiale, dalla parte posteriore. Il bancone bar / ricevimento è stato disegnato appositamente per la galleria.

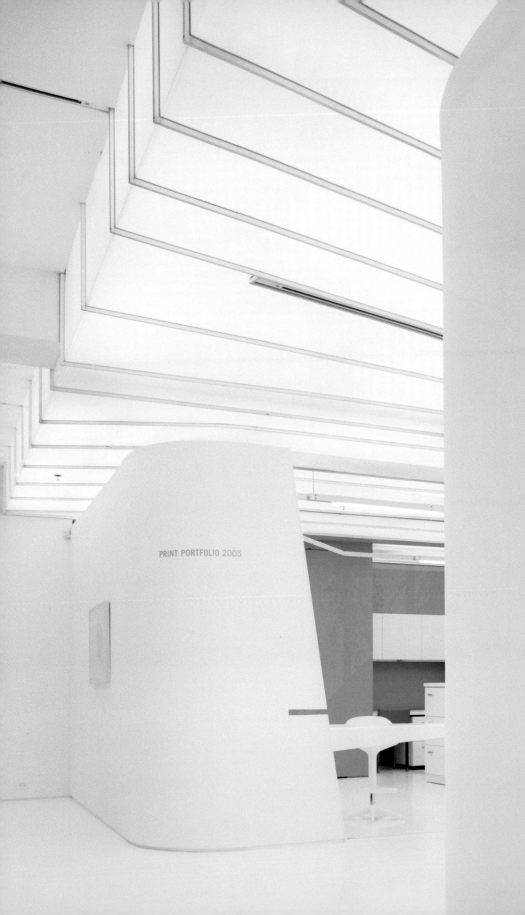

PRINT PORTFOLIO 2005

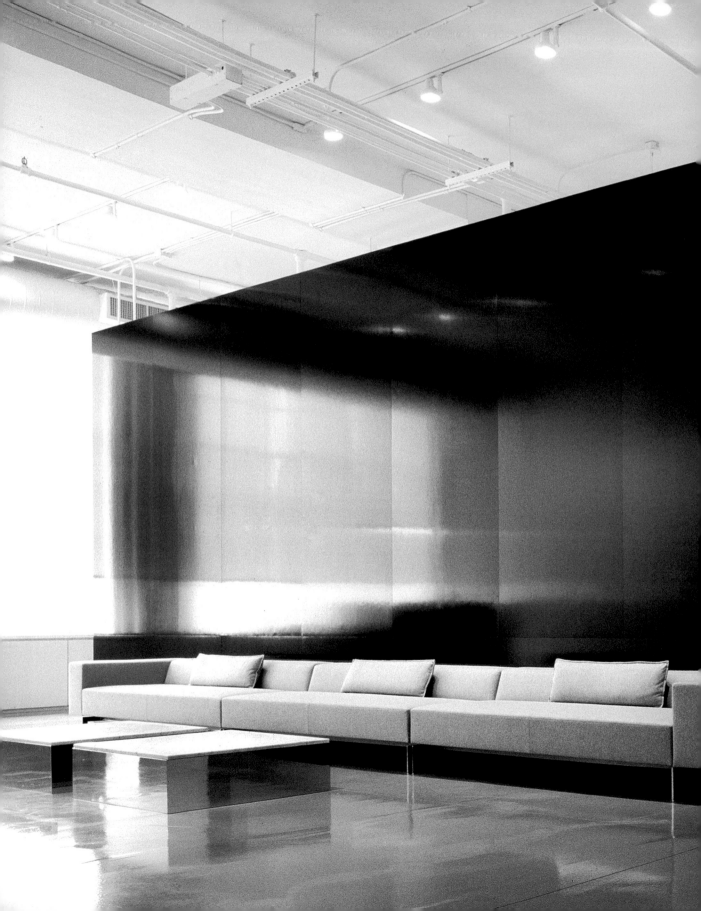

bonetti kozerski studio

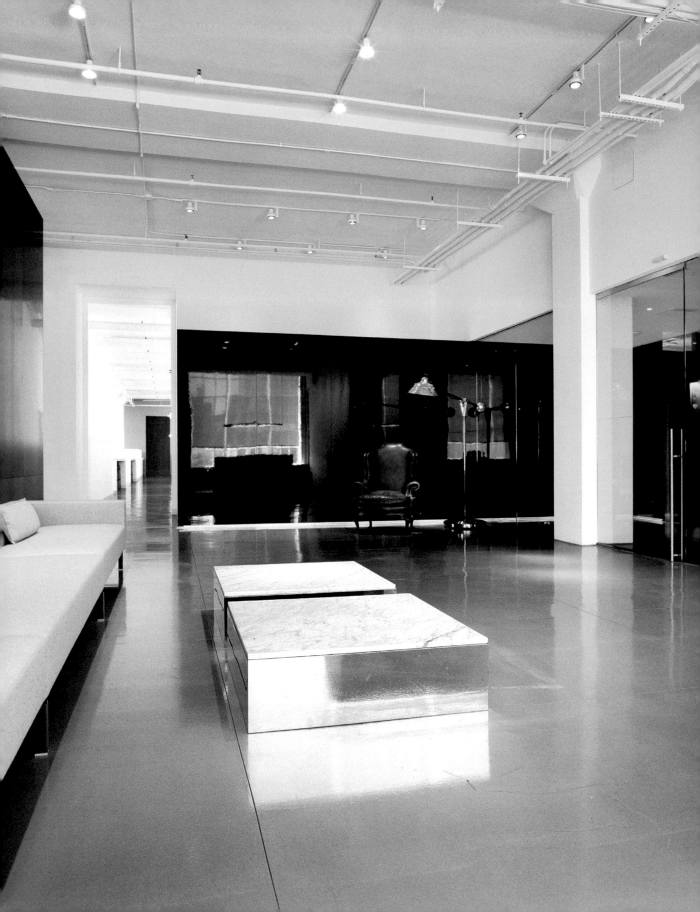

bonetti kozerski studio

270 Lafayette Street, Suite 906, New York, NY 10012, USA

+1 212 343 9898

+1 212 343 8042

www.bonettikozerski.com

info@bonettikozerski.com

Enrico Bonetti and Dominic Kozerski

Despite its brief existence, the office of the designers Enrico Bonetti and Dominic Kozerski, originally from Italy as well as England, already has a plethora of projects, primarily design stores for designers such as Donna Karan, Diane von Fürstenberg and Cynthia Steffe. The designers trained in Europe not only create the concept for the interior design, but also design the furnishings.

Trotz seines kurzen Bestehens hat das Büro der ursprünglich aus Italien sowie England stammenden Designer Enrico Bonetti und Dominic Kozerski schon eine Vielzahl von Projekten, vor allem Modegeschäfte für Designer wie Donna Karan, Diane von Fürstenberg und Cynthia Steffe, entworfen. Dabei entwickeln die in Europa ausgebildeten Designer nicht nur das Konzept für das Innendesign, sondern entwerfen auch das Mobiliar.

Malgré une courte existence, le cabinet des designers Enrico Bonetti et Dominic Kozerski, respectivement originaires d'Italie et d'Angleterre, a déjà réalisé une multitude de projets, notamment des magasins de mode pour les stylistes tels que Donna Karan, Diane von Fürstenberg et Cynthia Steffe. Ces designers, formés en Europe ne se sont pas limités à projeter le design intérieur mais ont également conçu le mobilier.

A pesar de su corta existencia, el estudio de los diseñadores de origen italiano e inglés Enrico Bonetti y Dominic Kozerski ha realizado ya un gran número de proyectos, en especial tiendas de moda, para diseñadores como Donna Karan, Diane von Fürstenberg y Cynthia Steffe. Estos diseñadores formados en Europa, no solo desarrollan el concepto del diseño interior, sino también el mobiliario.

Nel breve tempo dalla sua fondazione lo studio dei due designer Enrico Bonetti e Dominic Kozerski, di origine rispettivamente italiana e inglese, ha già realizzato una moltitudine di progetti, soprattutto dei negozi di moda per stilisti come Donna Karan, Diane von Fürstenberg e Cynthia Steffe. In questi progetti, i due designer di formazione europea non progettano soltanto il disegni degli interni, ma anche l'arredamento.

2000
Foundation of bonetti kozerski studio by Enrico Bonetti, Dominic Kozerski

2001
Donna Karen Collection Store, New York, USA

2002
DK Residence, New York, USA
DK Spa House, East Hampton, New York, USA

2003
Donna Karen Collection Store, Tokyo, Japan

2004
Laird+Partners Offices, New York

2005
TWC Apartment New York, USA
CPW Duplex Apartment, New York, USA
Tods Flagship, New York, USA
DKNY Starhill, Kuala Lumpur, Malaysia
Rover Viver Store, New York, USA

Interview | bonetti kozerski studio

What do you consider the most important work of your career? The most important job has yet to come.

In what ways does New York inspire your work? We are inspired by its cultural diversity.

Does a typical New York style exist, and if so, how does it show in your work? We believe that what most characterizes New York design is the absence of a specific style.

How do you imagine New York in the future? The continued real estate fueled gentrification of Manhattan could end up destroying its originality.

Was halten Sie für die wichtigste Arbeit in Ihrer Karriere? Der wichtigste Job muss erst noch kommen.

Auf welche Weise inspiriert New York Ihre Arbeit? Wir lassen uns durch seine kulturelle Vielfalt inspirieren.

Gibt es einen typischen New Yorker Stil, und wenn ja, wie zeigt sich das in Ihrer Arbeit? Unserer Meinung nach ist gerade die Abwesenheit eines spezifischen Stils das charakteristische Merkmal für New Yorker Design.

Wie stellen Sie sich New York in der Zukunft vor? Die kontinuierliche, durch den Immobilienmarkt vorangetriebene Gentrification Manhattans, d.h. die Aufwertung innenstadtnaher Wohngebiete, könnte letzten Endes deren Originalität zerstören

Quelle est l'œuvre la plus importante de votre carrière ? Le travail le plus important est encore sur la liste d'attente.

Dans quelle mesure la ville de New York inspire-t-elle votre œuvre ? Nous nous inspirons de sa diversité culturelle.

Peut-on parler d'un style typiquement new-yorkais, et si oui, comment se manifeste-t-il dans votre œuvre ? A notre avis, ce qui définit surtout le design de New York, c'est qu'il n'a pas de style particulier.

Comment imaginez-vous le New York de demain ? La gentrification constante de différents quartiers à Manhattan pourrait finir par tuer son originalité.

¿Cuál es el trabajo que considera más importante en su carrera? El trabajo más importante aún está por llegar.

¿De qué manera Nueva York supone una inspiración en su trabajo? Nos inspira su diversidad cultural.

¿Existe un estilo típico neoyorquino y, si es así, cómo se revela en su obra? Creemos que lo más característico del diseño de Nueva York es la ausencia de un estilo específico.

¿Cómo se imagina Nueva York en el futuro? El continuado aburguesamiento de Manhattan estimulado por el sector inmobiliario podría acabar destruyendo su originalidad.

Qual è secondo Lei il progetto più importante della Sua carriera? Il lavoro più importante sta per arrivare.

In che modo la città di New York ispira il Suo lavoro? A ispirarci è la sua molteplicità culturale.

È possibile parlare di uno stile tipico per New York, e, se questo stile esiste, in che modo si manifesta nei Suoi lavori? Credo che quello che caratterizza il design di New York sia proprio l'assenza di uno stile specifico.

Come si immagina la New York del futuro? Credo che il continuo innalzamento qualitativo del mercato immobiliare di Manhattan finirà con il distruggere la sua originalità.

Laird+Partners

Year: 2003

Photographs: © Matteo Piazza

As one enters the offices of the advertising agency, Laird+Partners, through the blue-lacquered reception area, one's eye is directed to the monolithic volume of black bakelite. In this space, a loft like area for a conference and campaign presentation room was created. The library—closed off with glass and lacquered sliding doors—and the management office border on the black box.

Betritt man das Büro der Werbeagentur Laird+Partners durch den blau lackierten Empfangsbereich, fällt der Blick auf ein monolithisches Volumen aus schwarzem Bakelit. Durch diesen Körper wurde in dem loftähnlichen Bereich Platz für einen Konferenz- und Präsentationsraum geschaffen, in dem die Kampagnen vorgestellt werden. An die schwarze Box grenzt die mit Glas- und lackierten Schiebetüren abgeschlossene Bibliothek sowie das Büro der Geschäftsführung.

En entrant dans les bureaux de l'agence de publicité Laird+Partners par la zone de réception toute de bleu laquée, on est frappé par un volume monolithique en bakélite noire. Ce corps, inséré au cœur de cet espace style loft, permet de créer une pièce de conférence et de présentation des campagnes de publicité. Attenante à la boite noire, on découvre la bibliothèque et le bureau de la direction derrière les portes coulissantes en verre et bois laqué.

Al entrar en la oficina de la agencia publicitaria Laird+Partners a través del vestíbulo pintado de azul, la mirada se centra en un volumen monolítico de baquelita negra. Con él, se creó en este espacio de estilo loft una sala de reuniones y presentaciones en el que se presentan las campañas. La biblioteca, con puertas correderas de vidrio y lacadas, y el despacho de la dirección lindan con esta caja negra.

Entrando nell'ufficio dell'agenzia pubblicitaria Laird+Partners attraverso l'atrio laccato in blu, lo sguardo si posa su un volume monolitico in bachelite nero. Grazie a questo corpo all'interno dello spazio simile ad un loft, è stato creato un luogo per conferenze e presentazioni di campagne pubblicitarie. Annessi al box nero si trovano la biblioteca chiusa da porte scorrevoli di vetro e laccate e l'ufficio del manager.

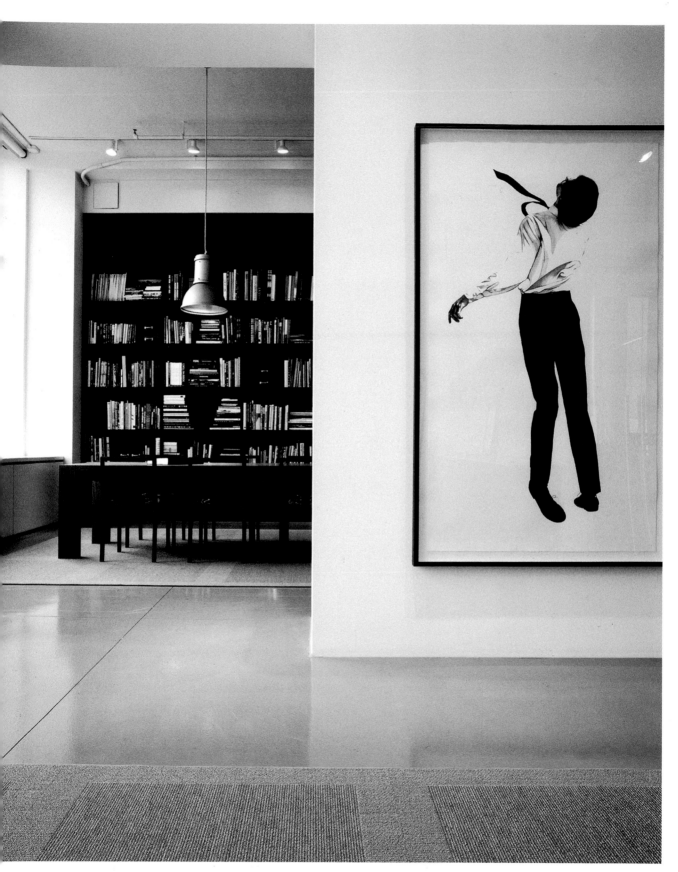

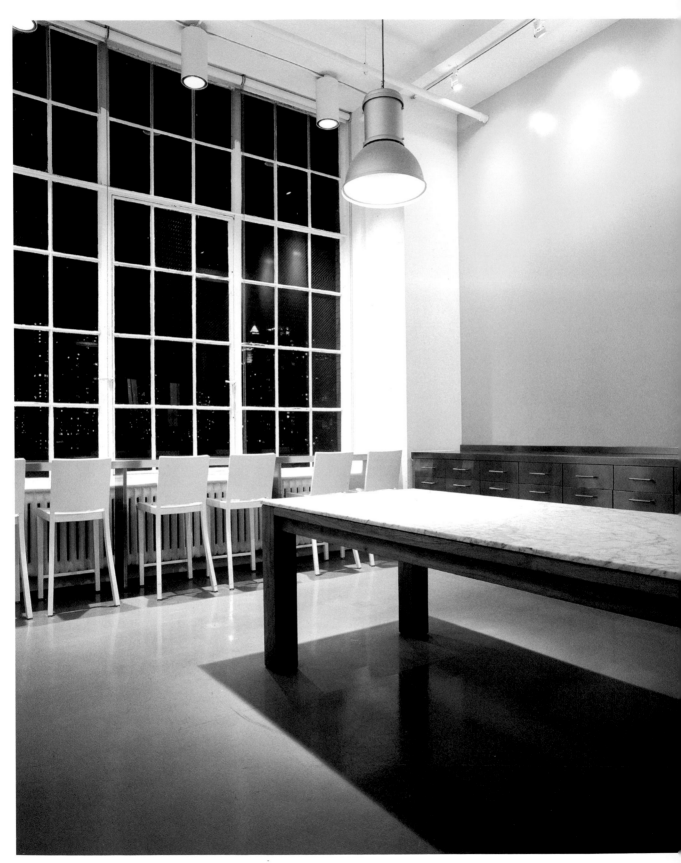

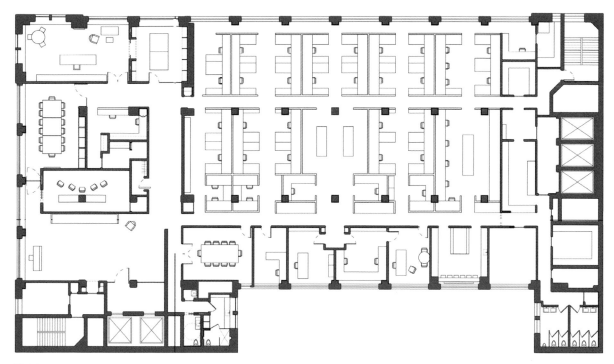

Floor plan

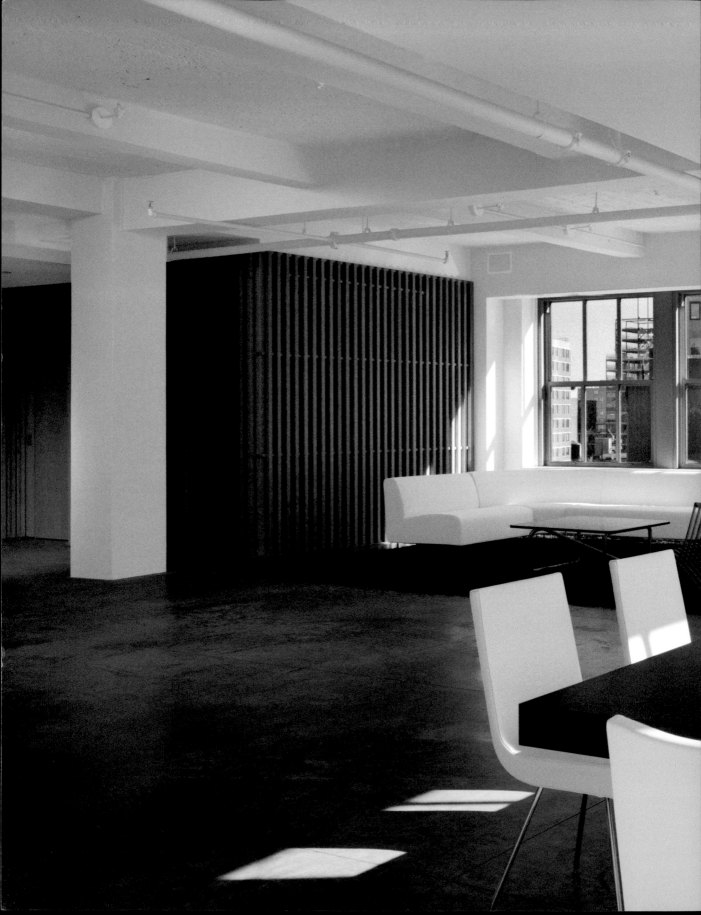

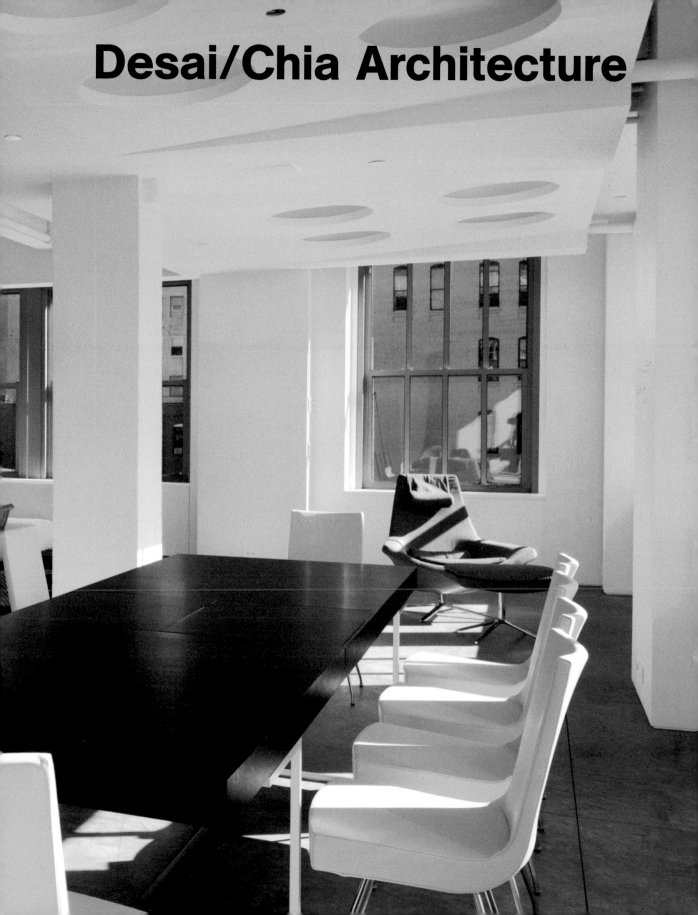

Desai/Chia Architecture

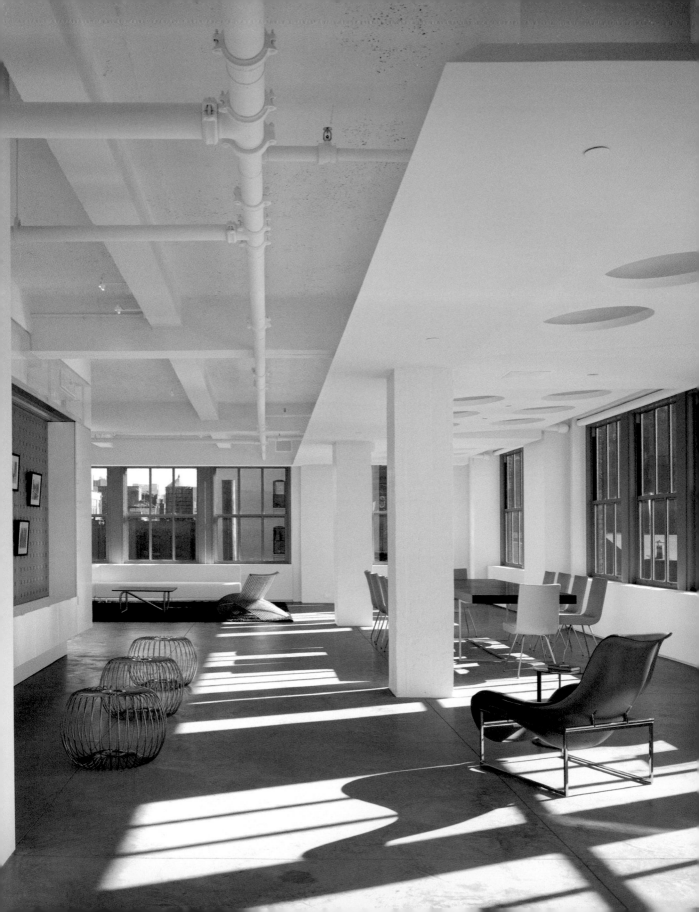

Desai/Chia Architecture

54 West 21st Street, 7th Floor, New York, NY 10010, USA

+1 212 366 9630

+1 212 366 9278

www.desaichia.com

info@desaichia.com

Katherine Chia

Desai/Chia Architecture was established by Katherine Chia and Arjun Desai in New York. With their work specialized in interior design for private homes, they place particular value on interdisciplinary solutions, in which the selection and combination of innovative materials play a major role. In order to reach the highest level of quality in the execution of their designs, they cultivate a close co-operation with their project team.

Desai/Chia Architecture wurde von Katherine Chia und Arjun Desai in New York gegründet. Bei Ihren auf Innenarchitekturentwürfe für Privathäuser spezialisierten Arbeiten legen sie besonderen Wert auf interdisziplinäre Lösungen, bei denen die Auswahl und Kombination innovativer Materialien eine große Rolle spielt. Um ein Höchstmaß an Qualität in den Ausführungen ihrer Entwürfe zu erreichen, pflegen sie eine intensive Zusammenarbeit mit ihren Projektmitarbeitern.

Desai/Chia Architecture a été fondé à New York par Katherine Chia et Arjun Desai. Dans leurs réalisations spécialisées sur l'architecture d'intérieur pour maisons individuelles, ils attachent une importance toute particulière à des solutions interdisciplinaires, où le choix et l'association de matériaux innovants jouent un rôle prépondérant. Pour réaliser ces projets d'une extrême qualité, une intense collaboration avec les partenaires est de mise.

Desai/Chia Architecture fue fundada en Nueva York por Katherine Chia y Arjun Desai. En sus trabajos, especializados en diseños de interiorismo para casas particulares, dan especial valor a las soluciones interdisciplinarias, en las que juegan un papel importante la elección y combinación de materiales innovadores. Para alcanzar los máximos niveles de calidad en la realización de sus diseños, trabajan estrechamente con sus colaboradores.

Desai/Chia Architecture è stato fondato da Katherine Chia e Arjun Desai a New York. Nei loro progetti specializzati in architettura per interni di case private si è sempre tenuto molto alle soluzioni interdisciplinari, un grande ruolo giocava in ciò la selezione e la combinazione di materiali innovativi. Per giungere ad un massimo di qualità nella realizzazione dei loro disegni, i due architetti curano una collaborazione particolarmente intensa con i loro collaboratori.

1996
Foundation of Desai/Chia Architecture, New York, USA
Tribeca Loft, New York, USA

1997
Forest Retreat House, Bedford, New York, USA

1998
SoundandVision Loft, New York, USA

1999
Pied a Terre Apartment, New York, USA

2001
Flower District Loft, New York, USA

2004
Cooper Square Loft, New York, USA, Winner AIA New York Chapter Design Award

2005
Cooper Square Loft, American Architecture Award

Interview | Desai/Chia Architecture

Which do you consider the most important work of your career? Each project is unique and important; each one becomes an investigative research vehicle for our design philosophy.

In what ways does New York inspire your work? New York is an incubator of extreme urban conditions. We are inspired by the vibrant energy inherent in seemingly incompatible adjacencies and relationships within the city fabric.

Does a typical New York style exist, and if so, how does it show in your work? Our style is based on a rigorous approach to the crafting of space and place. We are not trying to fit into a particular style; instead we focus on the innovations that occur from an evolving process of refinement and architectonic discourse.

How do you imagine New York in the future? New York's dynamic nature is so hard to predict. However, I think that links (both physical and virtual) in the form of information, circulation, and media/communication will continue to grow and define new spines of infrastructure.

Was halten Sie für die wichtigste Arbeit in Ihrer Karriere? Jedes Projekt ist einzigartig und wichtig. Jede Arbeit wird zum Forschungsprojekt für unsere Design-Philosophie.

Auf welche Weise inspiriert New York Ihre Arbeit? Die extremen urbanen Bedingungen in New York wirken wie ein Brutkasten. Wir lassen uns von der dynamischen Energie inspirieren, die in der scheinbar unvereinbaren Verflechtung und Dichte der Stadtstruktur steckt.

Gibt es einen typischen New Yorker Stil, und wenn ja, wie zeigt sich das in Ihrer Arbeit? Unser Stil basiert auf einem rigorosen Ansatz des Raum- und Platzschaffens. Wir versuchen nicht, in einen besonderen Stil hineinzupassen. Wir konzentrieren uns eher auf die Innovationen, die bei dem Prozess der Veredelung und der architektonischen Auseinandersetzung herauskommen.

Wie stellen Sie sich New York in der Zukunft vor? Bei New Yorks dynamischem Charakter ist das schwer vorauszusagen. Jedoch denke ich, dass Verbindungen (sowohl physische als auch virtuelle) in Form von Information, Zirkulation und Medien-Kommunikation wachsen werden und so die Infrastruktur grundlegend verändern.

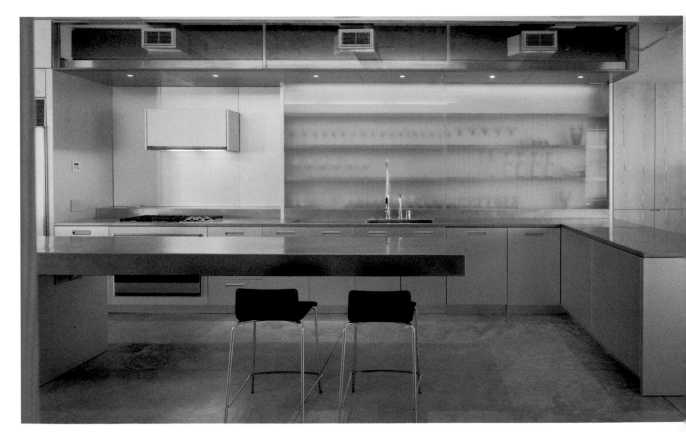

Quelle est l'œuvre la plus importante de votre carrière ? Chaque projet est unique et important : chacun est le fruit d'une recherche qui façonne la philosophie de notre design.

Dans quelle mesure la ville de New York inspire-t-elle votre œuvre ? New York est un incubateur de conditions urbaines extrêmes. Ce qui nous inspire, c'est l'énergie vibrante inhérente à des relations et rapprochements apparemment incompatibles, au sein du tissu urbain.

Peut-on parler d'un style typiquement new-yorkais, et si oui, comment se manifeste-t-il dans votre œuvre ? Notre style repose sur une approche rigoureuse de la figuration de l'espace et des lieux. Nous n'essayons par de nous mouler dans un style particulier mais de nous orienter davantage vers les innovations issues du processus évolutif, fruits d'une approche architecturale subtile.

Comment imaginez-vous le New York de demain ? Le dynamisme de New York ne permet pas de prédire l'avenir. Toutefois, je pense que les liens (à la fois physiques et virtuels) sous forme d'informations, circulation, et communication médiatique vont s'amplifier et définiront de nouvelles lignes infrastructurelles.

¿Cuál es el trabajo que considera más importante en su carrera? Cada proyecto es único e importante; cada uno se convierte en un vehículo de investigación para nuestra filosofía de diseño.

¿De qué manera Nueva York supone una inspiración en su trabajo? Nueva York es una incubadora de condiciones urbanas extremas. Nos inspira la vibrante energía inherente en las posiciones aparentemente incompatibles y las relaciones dentro del tejido urbano.

¿Existe un estilo típico neoyorquino y, si es así, cómo se revela en su obra? Nuestro estilo se basa en un enfoque riguroso de la construcción del espacio y el lugar. No intentamos encajar en un estilo en particular; en su lugar nos centramos en las innovaciones que surgen de un proceso en curso de refinamiento y discurso arquitectónico.

¿Cómo se imagina Nueva York en el futuro? La naturaleza dinámica de Nueva York es tan difícil de predecir. No obstante, creo que los vínculos (tanto físicos como virtuales) en la forma de información, circulación y medios/comunicación continuarán creciendo y definiendo los nuevos pilares de infraestructura.

Cosa pensa che sia la cosa più importante della Sua carriera? Ogni progetto è unico e importante; ognuno di essi diventa una ricerca investigativa; un veicolo per la nostra filosofia di design.

In che modo New York influenza il Suo lavoro? New York è un'incubatrice di condizioni urbane estreme. Siamo ispirati dalla sua vibrante energia interna, dalle apparenti incompatibilità adiacenti e dalle sue relazioni con la fabbricazione cittadina.

Esiste uno stile tipico a New York? Se sì, come influenza il Suo lavoro? Il nostro stile si basa su un approccio rigoroso della forza della spazio e del luogo. Non stiamo cercando di appartenere ad uno stile particolare, ma ci concentriamo invece sulle evoluzioni che avvengono in un processo evolutivo di redefinizione e del discorso architettonico.

Come si immagina New York in futuro? La natura dinamica di New York non mi permette di fare una previsione di questo tipo. Penso tuttavia a dei collegamenti (sia reali che virtuali) sotto forma di informazione, circolazione e media/comunicazione continuerà ad accrescere e definirà nuovi modelli di infrastruttura.

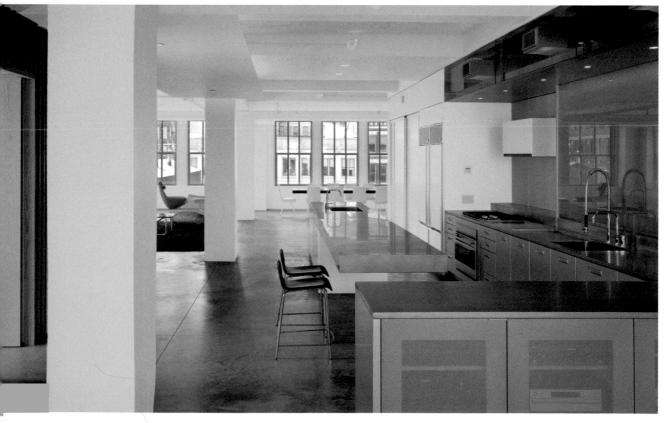

Cooper Square Loft

Year: 2004

Photographs: © Paul Warchol

In the case of the Cooper Square Loft, a loft originally used as a commercial space, was converted into the new home for a three-member family. It was important for the architects to maintain the open character of the L-shaped space while outfitting it with private areas. This is why wood-clad, sun-filtering bedrooms were set up in the center of the loft. The anodized aluminum serves as a light reflector in the kitchen.

Beim Cooper Square Loft wurde ein ursprünglich gewerblich genutzter Loft in das neue Zuhause einer dreiköpfigen Familie verwandelt. Dabei war es den Architekten wichtig, den offenen Charakter des L-förmigen Raumes beizubehalten und zugleich mit privaten Bereichen zu versorgen. Daher wurden im Zentrum des Lofts holzverkleidete und das Sonnenlicht filternde Schlafräume installiert. Wie ein Lichtreflektor wirkt das in der Küche verwendete eloxierte Aluminium.

Le Cooper Square Loft, à l'origine un loft industriel, est restauré pour devenir le nouveau logis d'une famille de trois personnes. Les architectes tenaient à tout prix à conserver l'espace ouvert en L, tout en lui ajoutant des zones privées. A cet effet, les chambres lambrissées, tamisant la lumière du soleil, sont installées au centre du loft. L'aluminium oxydé utilisé dans la cuisine réfléchi la lumière.

En el caso del Cooper Square Loft, se convirtió un loft que había sido usado originariamente con fines comerciales en el hogar de una familia de tres miembros. Para los arquitectos, era prioritario mantener el carácter abierto del espacio en forma de L y a la vez crear zonas privadas. Por tanto se instalaron en el centro del loft los dormitorios revestidos de madera que a su vez filtraban la luz del sol. El aluminio anodizado que se empleó en la cocina actúa de reflector de la luz.

Nel caso del Cooper Square Loft, un loft usato originalmente per scopi commerciali è stato trasformato nella una nuova casa di una familia di tre persone. Gli architetti mirarono particolarmente a conservare il carattere aperto dello spazio a "L" inserendovi tuttavia anche dei settori privati. Per questo motivo al centro del loft sono state installate delle camere da letto con delle pareti in legno in grado di filtrare la luce solare. L'alluminio anodizzato utilizzato in cucina risulta essere un riflettore della luce.

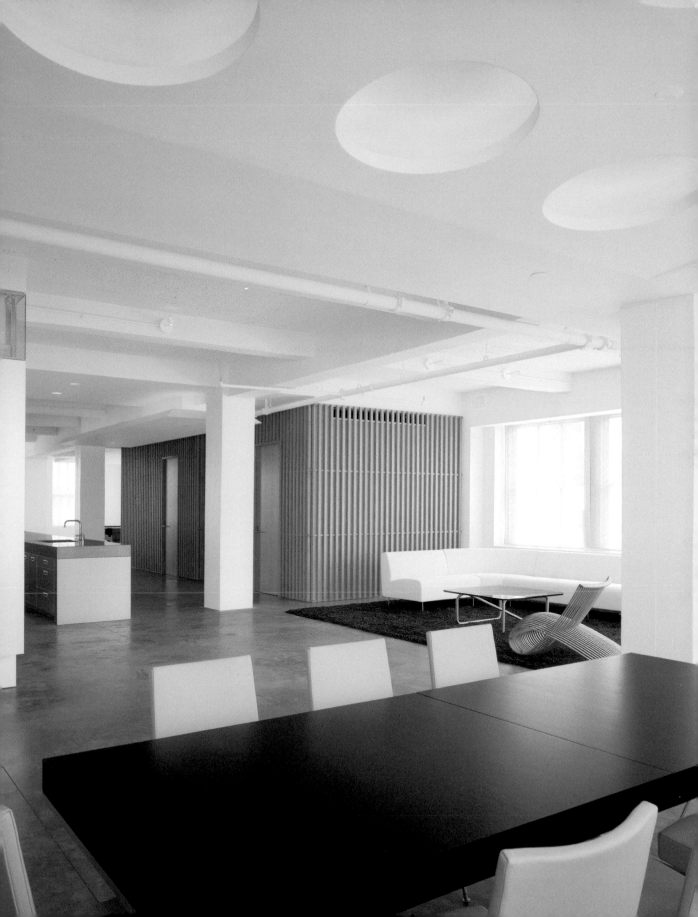

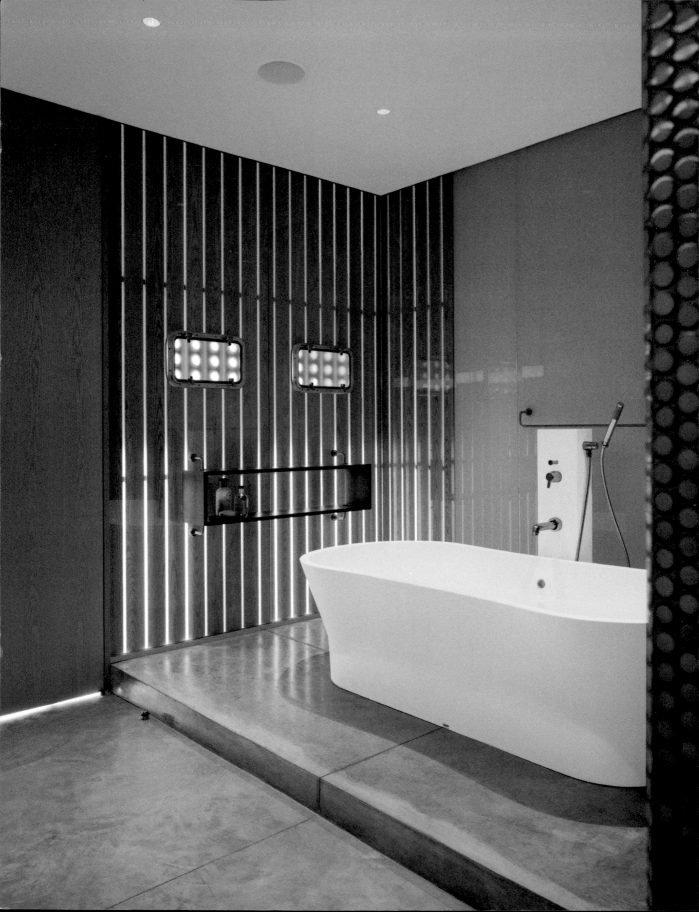

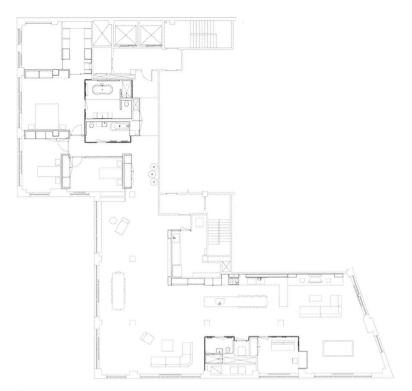

Floor plan

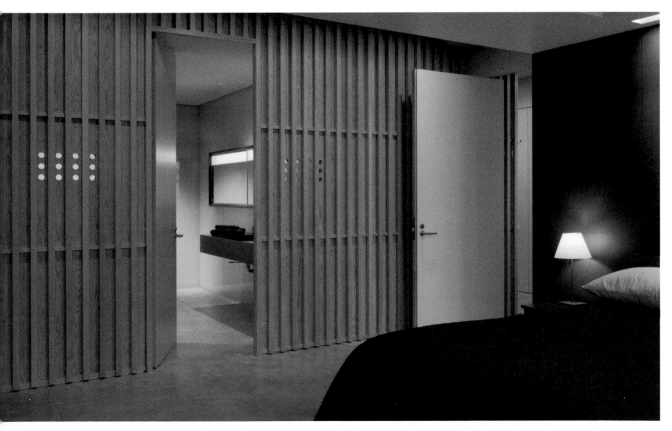

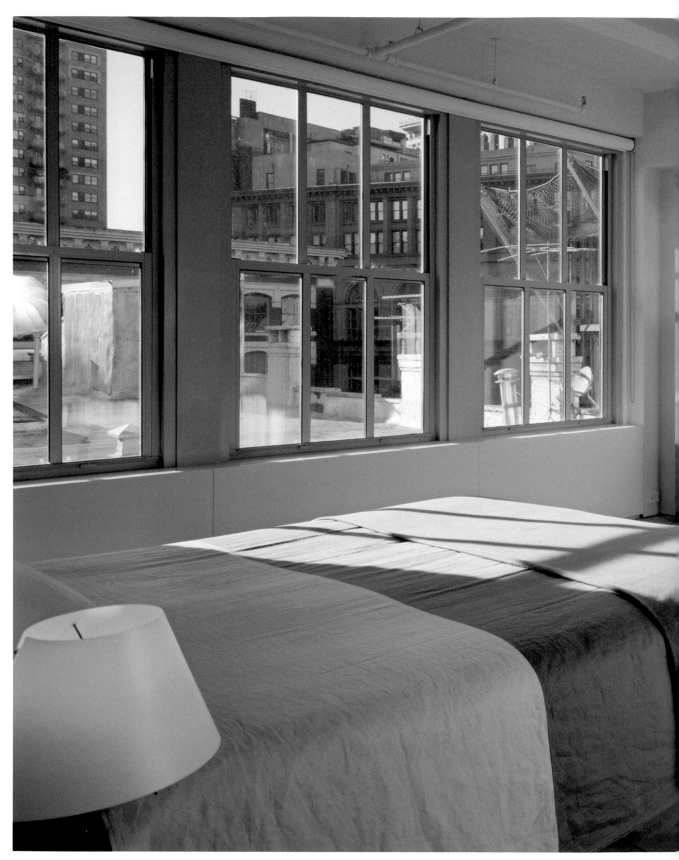

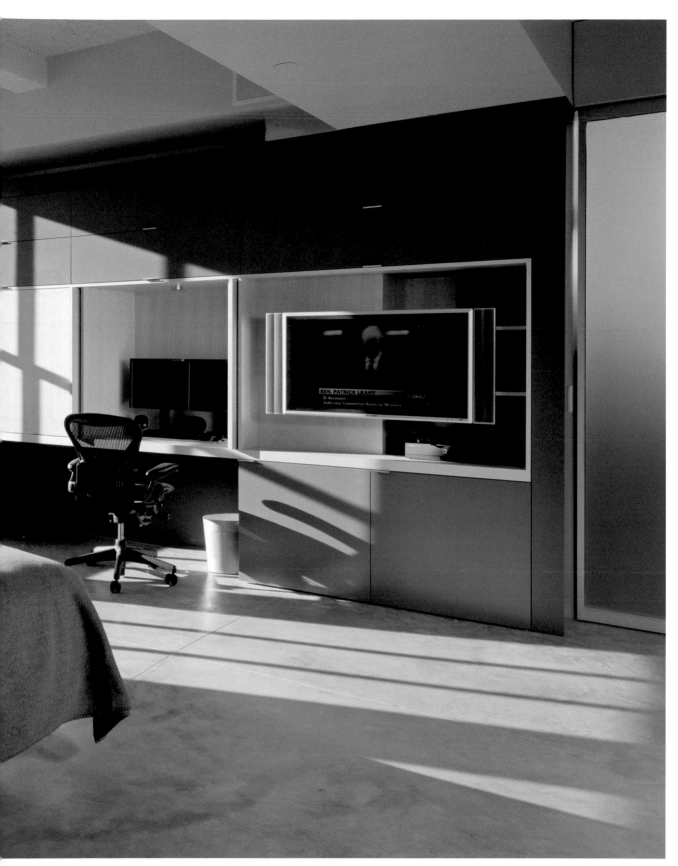

nARCHITECTS

nARCHITECTS

147 Essex Street, New York, NY 10002, USA

+1 212 253 2853

+1 212 844 9070

www.narchitects.com

n@narchitects.com

N symbolizes a numeric value with an endless number of possibilities. The founders of nAR-CHITECTS, Eric Bunge and Mimi Hoang, decided on this name, in order to express their flexible design approach. Since its creation in 1999, their tasks range from designs of buildings, installations, exhibitions and interiors. Their temporary exhibit, "Canopy" aroused particular attention as part of MoMA's annual P.S. 1 project.

N symbolisiert einen numerischen Wert mit einer endlosen Anzahl von Möglichkeiten. Die Gründer von nARCHITECTS, Eric Bunge und Mimi Hoang, entschieden sich für diesen Namen, um ihren flexiblen Designansatz zum Ausdruck zu bringen. Seit der Gründung 1999 umfasst ihr Aufgabenfeld Entwürfe von Gebäuden, Installationen, Ausstellungen und Inneneinrichtungen. Besondere Aufmerksamkeit erregte ihre temporäre Ausstellung "Canopy" für das jährliche P.S. 1 Projekt des MoMA.

N symbolise une valeur numérique ayant un nombre infini de possibilités. Les fondateurs de nARCHITECTS, Eric Bunge et Mimi Hoang, ont choisi ce nom pour souligner la flexibilité de leur approche du design. Depuis sa création en 1999, ce bureau comprend des projets de bâtiments, d'installations, d'expositions et d'aménagement intérieur. Leur exposition temporaire « Canopy » pour le projet P.S. 1 du MoMA, a suscité un grand intérêt.

N es el símbolo de valor numérico con infinitas posibilidades. Eric Bunge y Mimi Hoang, los fundadores de nARCHITECTS, se decidieron por este nombre para expresar su planteamiento flexible del diseño. Desde su fundación en 1999, el abanico de tareas abarca la proyección de edificios, instalaciones, exposiciones y diseños interiores. Especial interés despertó la exposición temporal "Canopy" para el proyecto anual P.S. 1 del MoMA.

N simbolizza un valore numerico con una quantità infinita di possibilità. I fondatori di nARCHITECTS, Eric Bunge e Mimi Hoang hanno scelto questo nome per poter bene esprimere il loro approccio flessibile nei confronti del design. A partire dalla fondazione del loro studio nel 1999 il loro approccio si concentra sulla progettazione di immobili, istalazzioni, esposizioni e arredamenti di interni. Un interesse particolare è stato risvegliato dall'esposizione provvisoria "Canopy" per il progetto annuale P.S. 1 del MoMA.

nARCHITECTS

1999
Foundation of nARCHITECTS, New York, USA

2002-2003
Installation New Hotels for Global Nomads, Cooper-Hewitt National Design Museum, New York, USA

2004
nARCHITECTS is selected by Architectural Record as one of eleven "Design Vanguard" firms
1st Prize: MoMA/P.S. 1 Young Architects Program for "Canopy"
Renovation of "The Kitchen" theater
Renovation of a 2 story penthouse on Broadway, New York City, USA

2005
AIA New York Chapter Design Honor Award for "Canopy"
Canadian Professional Rome Prize

2005
"Ply Loft" apartment

Under Construction
Switch Building

Interview | nARCHITECTS

Which do you consider the most important work of your career? Canopy (for MoMA) and Switch Building have been important for us, as they represent a rare sort of commission in New York: public space and reestanding buildings.

In what ways does New York inspire your work? New York is an environment of simultaneous extremes: pragmatic and fantastical. Our work often takes inspiration from reconciling or inverting this opposition.

Does a typical New York style exist, and if so, how does it show in your work? If we see style, we run in the opposite direction! Our projects are different from each other, perhaps because we try to approach each one as a unique situation.

How do you imagine New York in the future? As a 19th century grid with successive overlays of 20th and 21st century culture and technology, New York functions well. Its continued vibrancy will however depend on external economic and environmental factors: water, pollution, diminishing financial status.

Was halten Sie für die wichtigste Arbeit in Ihrer Karriere? Canopy (für das MoMA) und das Switch Building waren sehr wichtig für uns, weil es Projekte wie diese in New York nur sehr selten gibt: Freistehende Gebäude und öffentlicher Raum.

Auf welche Weise inspiriert New York Ihre Arbeit? New York ist man zugleich von verschiedenen Extremen umgeben: dem Pragmatischen und dem Bizarren. Inspiration für unsere Arbeit ist die Aufgabe, diese Gegensätze in Einklang zu bringen oder umzukehren.

Gibt es einen typischen New Yorker Stil, und wenn ja, wie zeigt sich das in Ihrer Arbeit? Sobald wir einen Stil erkennen, rennen wir in die entgegengesetzte Richtung! Unsere Projekte unterscheiden sich wohl deshalb so voneinander, weil wir bereits im Ansatz die Einzigartigkeit eines Projektes berücksichtigen.

Wie stellen Sie sich New York in der Zukunft vor? Als Stadt mit Gitterstruktur aus dem 19. Jahrhundert und sukzessiver kultureller und technologischer Überlagerung des 20. und 21. Jahrhunderts funktioniert New York gut. Die Zukunft dieser Dynamik hängt stark von externen ökonomischen und ökologischen Faktoren ab: Wasser, Umweltverschmutzung, der Rückgang als Finanzstandort.

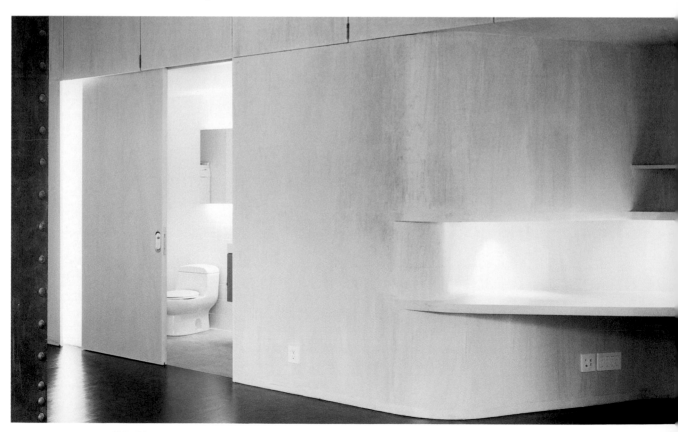

Quelle est l'œuvre la plus importante de votre carrière ? Canopy (pour le MoMA) et Switch Building sont des oeuvres importantes, car elles représentent un modèle de réalisation assez rare à New York : l'alliance d'espaces publics et d'édifices individuels isolés.

Dans quelle mesure la ville de New York inspire-t-elle votre œuvre ? New York c'est un environnement qui offre en même temps tous les extrêmes : pragmatiques et fantastiques. Nous puisons notre inspiration en unissant ou en inversant cette opposition.

Peut-on parler d'un style typiquement new-yorkais, et si oui, comment se manifeste-t-il dans votre œuvre ? Dés que nous sentons qu'il y a du style dans l'air, nous prenons la direction opposée! Tous nos projets sont différents! Notre optique est d'essayer des les aborder de façon unique.

Comment imaginez-vous le New York de demain ? Avec sa grille urbaine du XIXe siècle sur lequel se greffent la culture et la technologie des XXe et XXIe siècles, New York fonctionne très bien. Cette constante effervescence dépendra de facteurs économiques et environnementaux : eau, pollution, baisse du statut financier.

¿Cuál es el trabajo que considera más importante en su carrera? La cubierta (para el MoMA) y el edificio Switch han sido importantes para nosotros ya que representan proyectos muy poco comunes en Nueva York: espacio público y edificios independientes.

¿De qué manera Nueva York supone una inspiración en su trabajo? Nueva York es un entorno de extremos simultáneos: pragmático y fantástico. Con frecuencia nuestro trabajo se inspira en la reconciliación o inversión de esta oposición.

¿Existe un estilo típico neoyorquino, y si es así, cómo se revela en su obra? Si vemos estilo, ¡corremos en dirección contraria! Nuestros proyectos son distintos entre sí, quizá porque intentamos enfocar cada uno como una situación única.

¿Cómo se imagina Nueva York en el futuro? Para ser una cuadrícula decimonónica con sucesivas capas de cultura y tecnología de los siglos XX y XXI, Nueva York funciona bien. Que esta vitalidad continúe dependerá de factores externos económicos y medio ambientales: el agua, la contaminación, una situación financiera limitante.

Cosa pensa che sia la cosa più importante della Sua carriera? Canopy (per il MoMA) e Switch Building sono state le opere più importanti per noi, perché rappresentano delle commissioni abbastanza rare per New York: spazio pubblico e edifici isolati.

In che modo New York influenza il Suo lavoro? New York è un ambiente con due estremi simultanei: pragmatico e miracoloso. Il nostro lavoro spesso prende ispirazione dalla riconciliazione o dall'inversione di questa opposizione.

Esiste uno stile tipico a New York? Se sì, come influenza il Suo lavoro? Se intravediamo uno stile, corriamo nella direzione opposta! I nostri progetti sono diversi uno dall'altro, forse perché stiamo cercando di avvicinare ciascuno come una situazione unica.

Come si immagina New York in futuro? Con una griglia del 19esimo secolo e successivi strati del 20esimo e del 21esimo New York sta funzionando bene. La sua irradiazione in futuro dipenderà comunque da fattori economici ed ambientali esterni: acqua, inquinamento, stato economio in diminuzione.

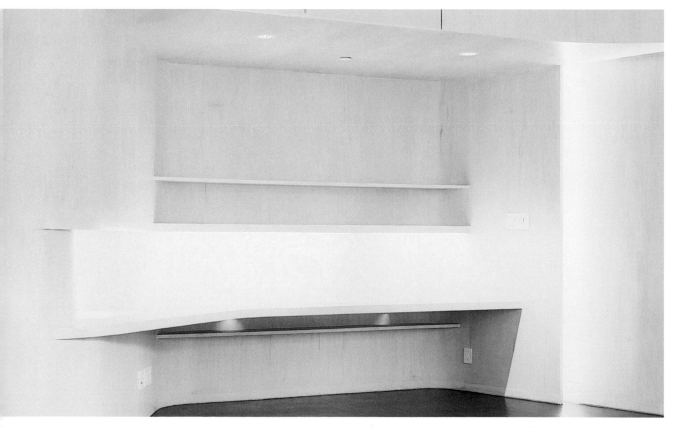

Ply Loft

Year: 2005

Photographs: © Gogortza & Llorella

The Ply Loft in Tribeca was designed for two artists to both live and work. A uniform and at the same time comfortable atmosphere was created by cladding the walls with curved wooden plates, which configure the kitchenette at the same time. The curved doors, also made of wood, not only close the openings with style, but also serve to regulate light and as a projection surface for video projects by the artists.

Der Ply Loft in Tribeca wurde für zwei Künstler zum Wohnen und Arbeiten entworfen. Eine uniforme und gleichzeitig komfortable Atmosphäre wurde durch die Verkleidung der Wände mit gebogenen Holzplatten erreicht, die gleichzeitig die Küchenzeile bestimmen. Die gebogenen Türen, ebenfalls aus Holz, schließen die Öffnungen nicht nur stilgerecht ab, sondern dienen gleichzeitig zur Regulierung des Lichts und als Projektionsfläche für die Videoarbeiten der Künstler.

Le Ply Loft, à Tribeca, est conçu comme lieu de vie et de travail de deux artistes. Une atmosphère à la fois homogène et confortable se dégage de l'habillage des murs avec des lattes de bois incurvées, configurant en même temps la cuisine intégrée. Les portes incurvées, en bois également, ne sont pas que des fermetures stylées, mais font également office de régulateur de lumière et de surface de projection pour les travaux de vidéo des artistes.

El Ply Loft en Tribeca se diseñó como vivienda y estudio para dos artistas. Se consiguió un ambiente uniforme y a la vez confortable gracias a los revestimientos de las paredes con tablones de madera curvados que, al mismo tiempo, configuran la cocina. Las puertas curvas, también de madera, no solo cierran los espacios conservando el estilo del conjunto, sino que además regulan la luz y sirven de superficie para proyectar los trabajos audiovisuales de los artistas.

Il Ply Loft a Tribeca è stato studiato per essere atelier di lavoro e abitazione per due artisti. Si tratta di un ambiente uniforme e allo stesso tempo confortevole, creato ricoprendo le pareti con tavole di legno arcuate, che allo stesso tempo configurano il blocco cucina. Le porte arcuate, anche loro in legno, non soltanto chiudono le aperture con stile, ma servono bensì anche per la regolazione della luce e come superficie di proiezione dei lavori video degli artisti.

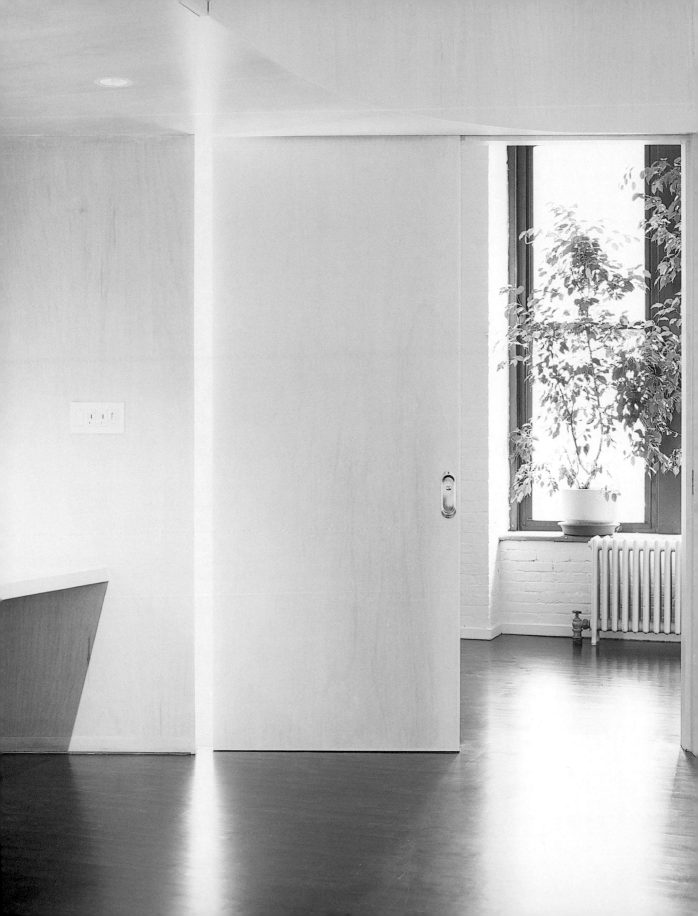

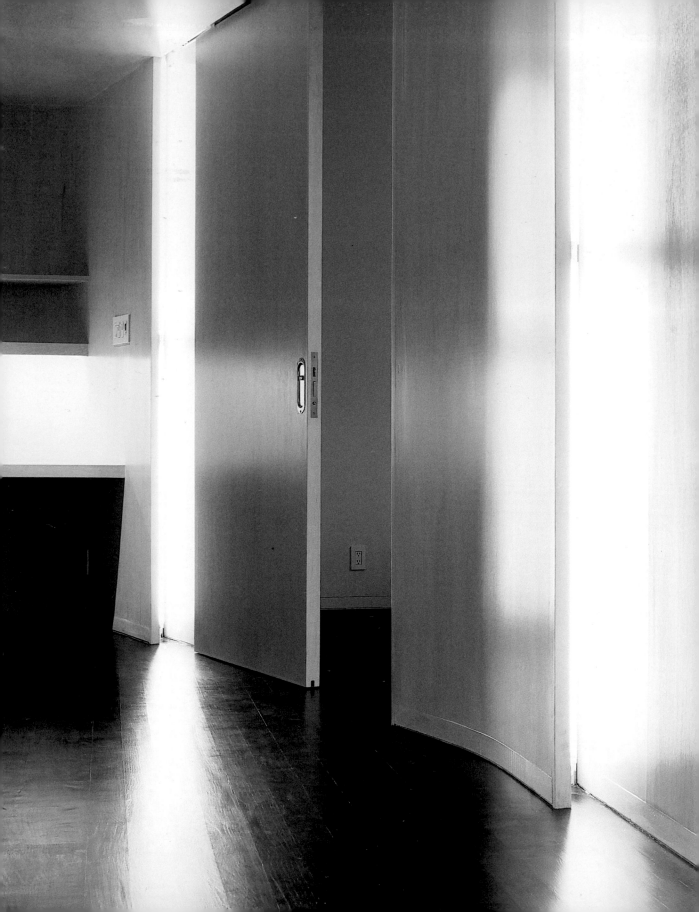

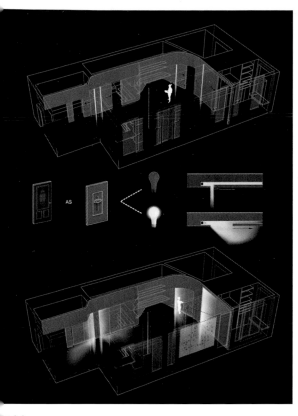

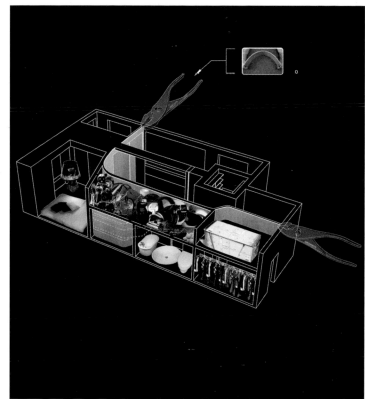

enderings

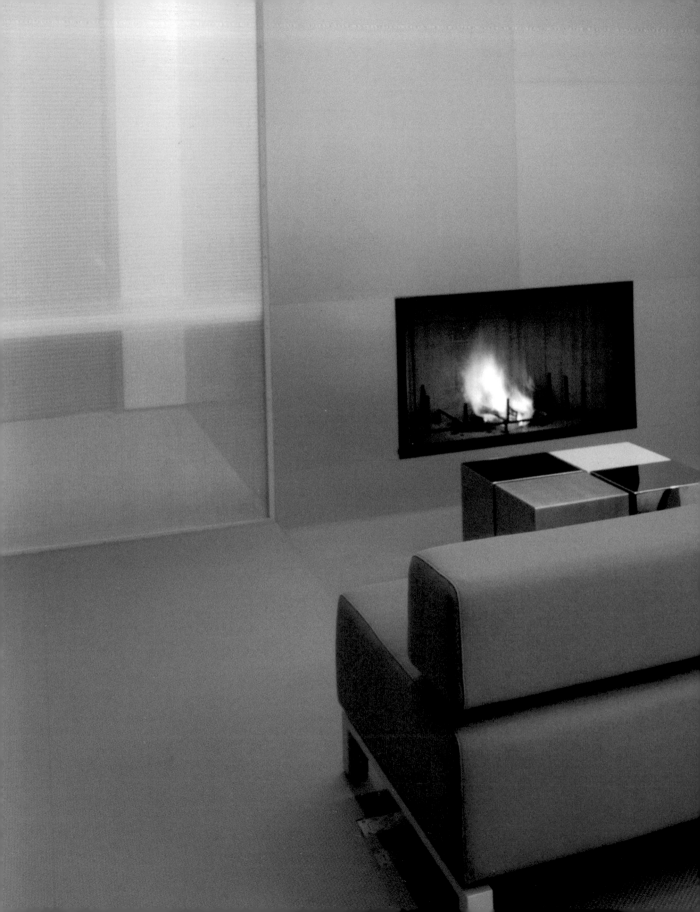

EOA – Elmslie Osler Architect

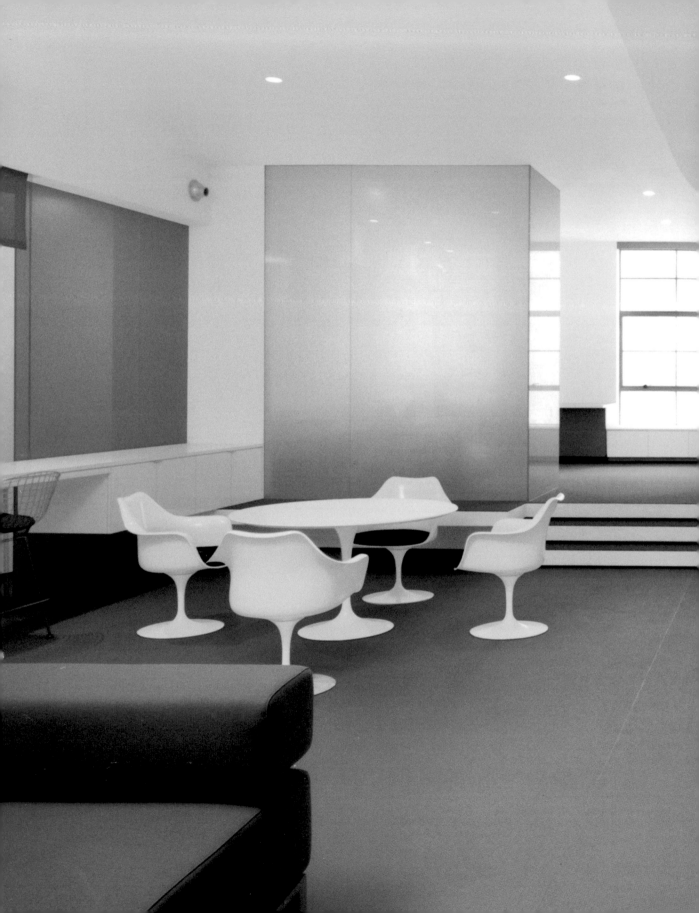

EOA – Elmslie Osler Architect

526 West 26th Street, Suite 514, New York, NY 10001, USA

+1 212 989 0652

+1 212 366 0762

www.eoarch.com

mail@eoarch.com

Growing up in an architect family, Robin Elmslie Osler studied architecture in Virginia and Yale before opening her own studio, EOA – Elmslie Osler Architect in 1996. In her designs, she places a great deal of importance on the intense exchange with the client as well as on the selection of materials and lighting design. In this way, she develops solutions which highlight the sensory experience.

In einer Architektenfamilie aufgewachsen, studierte Robin Elmslie Osler Architektur in Virginia und Yale, bevor sie 1996 ihr eigenes Studio EOA – Elmslie Osler Architect gründete. In ihren Entwürfen legt sie sehr viel Wert auf einen intensiven Austausch mit dem Auftraggeber sowie auf die Auswahl der Materialen und die Gestaltung des Lichts. Dabei entwickelt sie Lösungen, bei denen das sinnliche Erleben des Raums im Vordergrund steht.

Elevée dans une famille d'architecte, Robin Elmslie Osler suit des études d'architecture à Virginia et Yale avant de fonder en 1996 son propre cabinet EOA – Elmslie Osler Architect. Dans son approche conceptuelle, elle met l'accent sur les échanges intenses avec le client, le choix des matériaux et la mise en scène de la lumière. Les solutions qu'elle développe mettent au premier plan la perception sensorielle de l'espace.

Criada en el seno de una familia de arquitectos, Robin Elmslie Osler estudió arquitectura en Virginia y Yale antes de fundar su propio estudio EOA – Elmslie Osler Architect en 1996. En sus proyectos, prioriza un intenso diálogo con el cliente, así como la elección de los materiales y la distribución de la luz. Desarrolla soluciones en las que prevalece la experiencia sensorial del espacio.

Cresciuta in una famiglia di architetti, Robin Elmslie Osler ha studiato architettura in Virginia ed a Yale prima di fondare il suo studio EOA – Elmslie Osler Architect nel 1996. Nei suoi progetti dà molto valore ad un intenso scambio con il committente, alla scelta dei materiali ed alla progettazione della luce. Durante questo processo sviluppa delle soluzioni che pongono in primo piano l'esperienza sensoriale dello spazio.

Elmslie Osler

1987
Bachelor of Science in Architecture, University of Virginia, Charlottesville, Virginia, USA

1990
Master of Architecture, Yale School of Architecture, New Haven, Connecticut, USA

1996
Foundation of EOA - Elmslie Osler Architect by Robin Elmslie Osler, New York, USA

1999
DNA Model Management Office, New York, USA

2001
Gillett/Klinkowstein Residence, New York, USA
Alexander Residence, Southampton, New York, USA

2004
Schreiber Residence, Islesboro, Maine, USA

2005
B8 Couture Retail Store, New York, USA

2006
Kurkova Residence, New York, USA

Interview | EOA – Elmslie Osler Architect

Which do you consider the most important work of your career? I haven't built it yet. The DNA project, however, gave birth to the idea of manipulating perception through materiality. I am now working on several different ways of playing with this idea on a grand scale.

In what ways does New York inspire your work? The city is an inspired con game. People come to recreate themselves into something new and the city reflects these invented images back, creating a potent stew. The juxtaposition of potential dreams and nightmares makes it a very interesting place to be.

Does a typical New York style exist, and if so, how does it show in your work? Everything can exist here—to the extent that budgets, absurd building codes and litigious personalities allow it. I hope that my work reflects the ambiguity and desire that is inherent to this city.

How do you imagine New York in the future? Because it is an island, it really has no choice but to become anything other than contained intense chaos.

Was halten Sie für die wichtigste Arbeit in Ihrer Karriere? Soweit bin ich noch nicht. Das DNA Projekt war allerdings ausschlaggebend für die Idee, die Wahrnehmung durch Materialität zu manipulieren. Im Moment arbeite ich an verschiedenen Möglichkeiten, diese Idee in größerem Maßstab umzusetzen.

Auf welche Weise inspiriert New York Ihre Arbeit? Diese Stadt ist ein genialer Schwindel. Die Menschen versuchen, sich hier neu zu erschaffen und die Stadt spiegelt diese ausgedachten Bilder wider. Daraus entsteht ein leistungsfähiger Mix. Das Nebeneinander von potentiellen Träumen und Alpträumen macht New York so interessant.

Gibt es einen typischen New Yorker Stil, und wenn ja, wie zeigt sich das in Ihrer Arbeit? Hier ist alles möglich – soweit Budgets, absurde Bauvorschriften und Persönlichkeiten grünes Licht geben. Ich hoffe, dass sich in meiner Arbeit die Ambiguität und die Sehnsüchte widerspiegeln, die diese Stadt ausmachen.

Wie stellen Sie sich New York in der Zukunft vor? Da New York eine Insel ist, kann innerhalb seiner Grenzen nichts anderes sein als intensives Chaos.

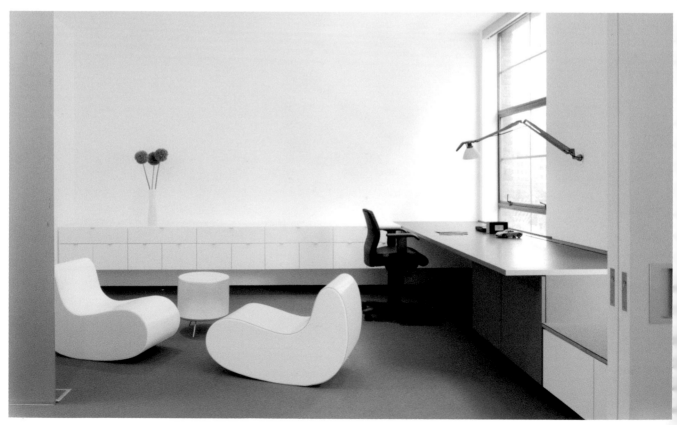

Quelle est l'œuvre la plus importante de votre carrière ? Je ne l'ai pas encore construite. Toutefois, le projet DNA a donné naissance à l'idée de manipuler la perception par le biais de la matière. Je travaille actuellement sur les différentes manières de jouer avec cette idée à grande échelle.

Dans quelle mesure la ville de New York inspire-t-elle votre œuvre ? La ville est un jeu inspiré de contrastes. Les gens viennent se ressourcer dans quelque chose de nouveau et la cité renvoie ses images inventées, créant un bouillon de culture formidable. La juxtaposition de rêves potentiels et de cauchemars en fait un lieu de vie extrêmement intéressant.

Peut-on parler d'un style typiquement new-yorkais, et si oui, comment se manifeste-t-il dans votre œuvre ? Il y a de tout ici – pour autant que les budgets, les codes de constructions absurdes et les personnalités douteuses le permettent. Je souhaite que mon œuvre reflète l'ambiguïté et le désir inhérents à cette ville.

Comment imaginez-vous le new York de demain ? New York étant une île, cette ville ne peut pas être vraiment autre chose qu'un chaos intense.

¿Cuál es el trabajo que considera más importante en su carrera? Aún no lo he construido. No obstante, el proyecto DNA, dio origen a la idea de manipular la percepción mediante la materialidad. Ahora trabajo en varias formas distintas de jugar con esta idea a gran escala.

¿De qué manera Nueva York supone una inspiración en su trabajo? La ciudad es un truco genial. La gente viene a recrearse en algo nuevo y la ciudad refleja estas imágenes inventadas, dando lugar a una potente elaboración. La yuxtaposición de los sueños y las pesadillas potenciales la convierte en un sitio interesante en el que estar.

¿Existe un estilo típico neoyorquino, y si es así, cómo se revela en su obra? Cualquier cosa puede existir aquí, hasta el punto en que los presupuestos, los absurdos códigos de edificación y las personalidades litigiosas lo permitan. Espero que mi trabajo refleje la ambigüedad y el deseo inherentes a esta ciudad.

¿Cómo se imagina Nueva York en el futuro? Puesto que se trata de una isla, realmente no hay otra opción más que convertirse en un intenso caos contenido.

Cosa pensa che sia la cosa più importante della Sua carriera? Non l'ho ancora realizzato. Il progetto DNA ha comunque dato origine all'idea di manipolare la percezione attraverso la materialità. Sto elaborando diversi modi per giocare con questa idea a scala grande.

In che modo New York influenza il Suo lavoro? La città è un gioco ispirato all'imbroglio. La gente viene per ricreare se stessa in qualcosa di nuovo e la città riflette queste immagini inventate, ne crea un potente minestrone. La giustapposizione di sogni virtuali e di incubi fa di questa città un posto molto interessante.

Esiste uno stile tipico a New York? Se sì, come influenza il Suo lavoro? Qui tutto può esistere – nella misura in cui finanze, regolamenti di edilizia assurdi e personaggi litigiosi lo permettono. Spero che il mio lavoro rifletta l'ambiguità e il desiderio inerenti a questa città.

Come si immagina New York in futuro? Per il fatto che è un'isola, in effetti non ha altra scelta che diventare un caos contenuto e intenso. Forse si espanderà oltre i propri limiti e stenderà tentacoli inabitabili sopra i fiumi.

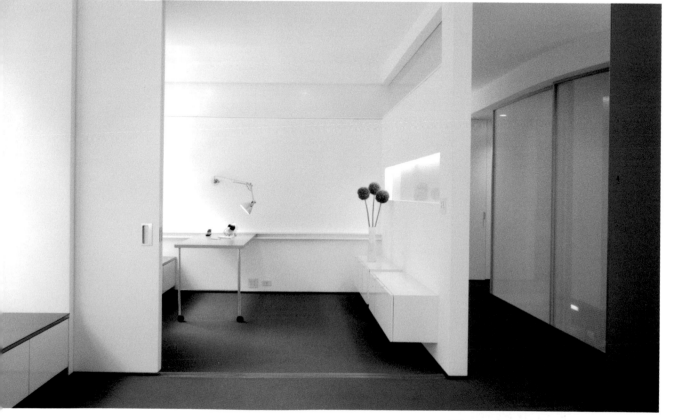

Gillet/Klinkowstein Residence

Year: 2000
Photographs: © Gregory Goode, John Hall

During the reconversion of a rubber factory into the new home of a fashion designer and media consultant, their opposite interests and tastes had to be harmonized. Inspired by Stanley Kubrick's film "2001: A Space Odyssey", the architect created a minimalistic loft which always reflects the light differently by means of lumasite wall cladding and opaque glass surfaces.

Bei der Umgestaltung einer Gummifabrik in das neue Zuhause einer Modedesignerin und eines Media Consultant galt es, deren gegensätzliche Interessen und Geschmäcker in Einklang zu bringen. Inspiriert von Stanley Kubricks Film „2001: Odyssee im Weltraum" kreierte die Architektin einen minimalistischen Loft, der durch die Lumasite-Wandverkleidungen und opaken Glasflächen das Licht immer wieder neu im Raum reflektiert.

La réhabilitation d'une usine à caoutchouc en nouvelle demeure d'une styliste et d'un consultant en médias met en avant l'harmonisation d'intérêts et de goûts différents. S'inspirant du film de Stanley Kubricks, « 2001, l'odyssée de l'espace », l'architecte a réalisé un loft minimaliste, qui, grâce au revêtement mural en lumasite et aux parois vitrées opaques, met en scène une gamme de reflets lumineux dont la versatilité module l'espace.

En la reconversión de una fábrica de goma en el nuevo hogar de una diseñadora de modas y un Media Consultant, el reto consistía en armonizar los gustos e intereses opuestos de los propietarios. Inspirada en la película de Stanley Kubrick "2001: Una odisea del espacio", la arquitecta creó un loft minimalista en el que, gracias a los revestimientos de las paredes de Lumasite y a las superficies de vidrio opaco, la luz se refleja una y otra vez en el espacio.

Nel processo di trasformazione di una fabbrica di gomma in nuova abitazione per una stilista di moda ed un media consultant, il traguardo era di riuscire a porre in armonia i loro interessi e gusti contrastanti. Traendo ispirazione dal film "2001: Odissea nello Spazio" di Stanley Kubrick l'architetto ha creato un loft minimalista, che per mezzo del rivestimento delle pareti in Lumasite e le superfici di vetro opaco riflette nello spazio una luce sempre nuova.

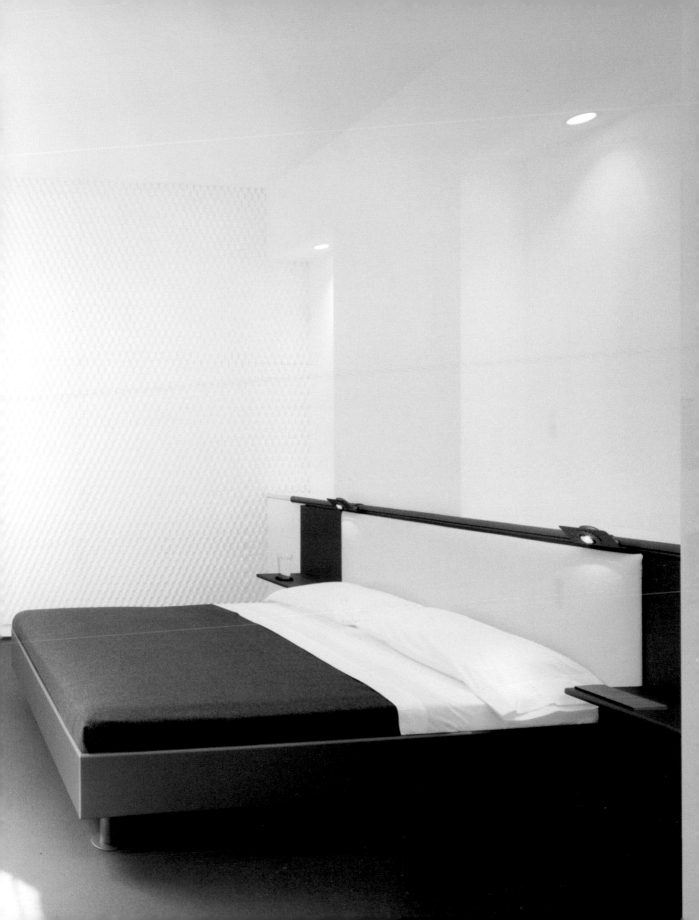

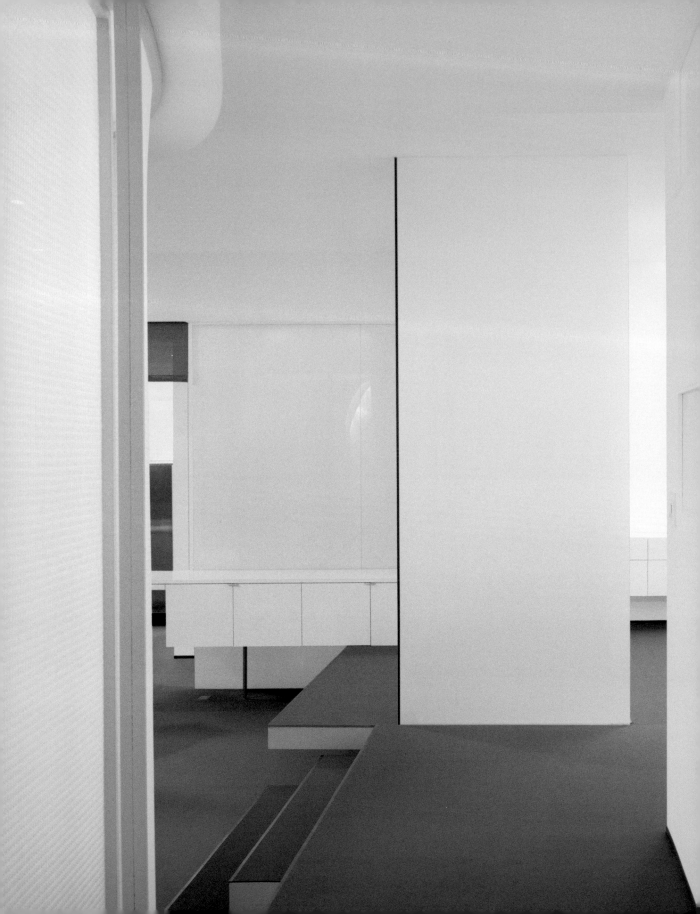

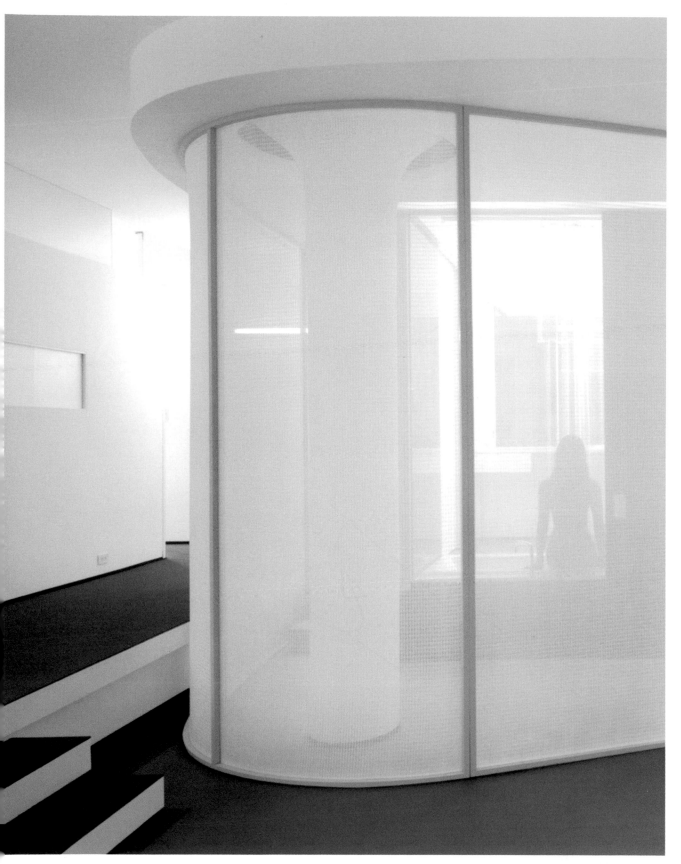

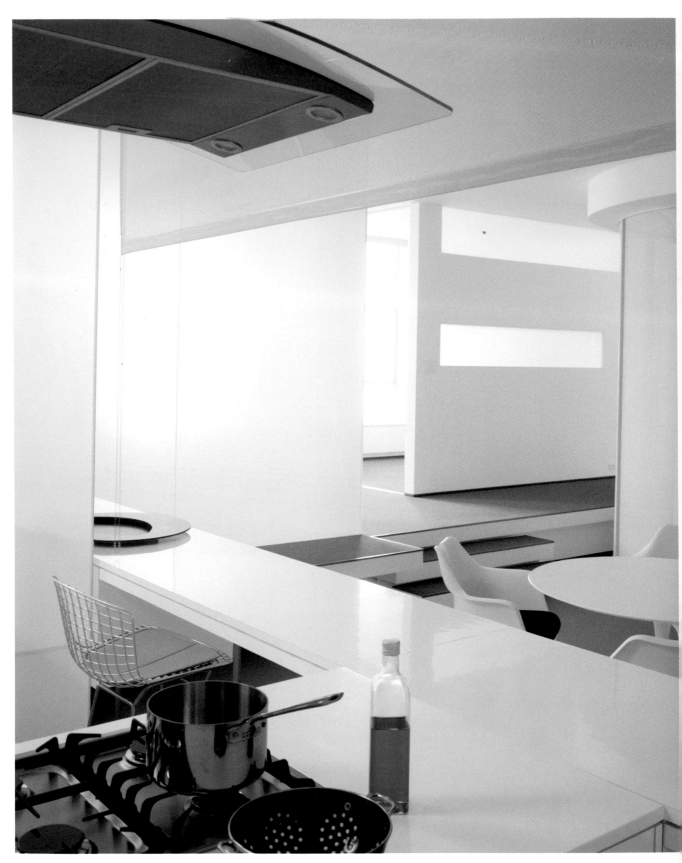

EOA – Elmslie Osler Architect

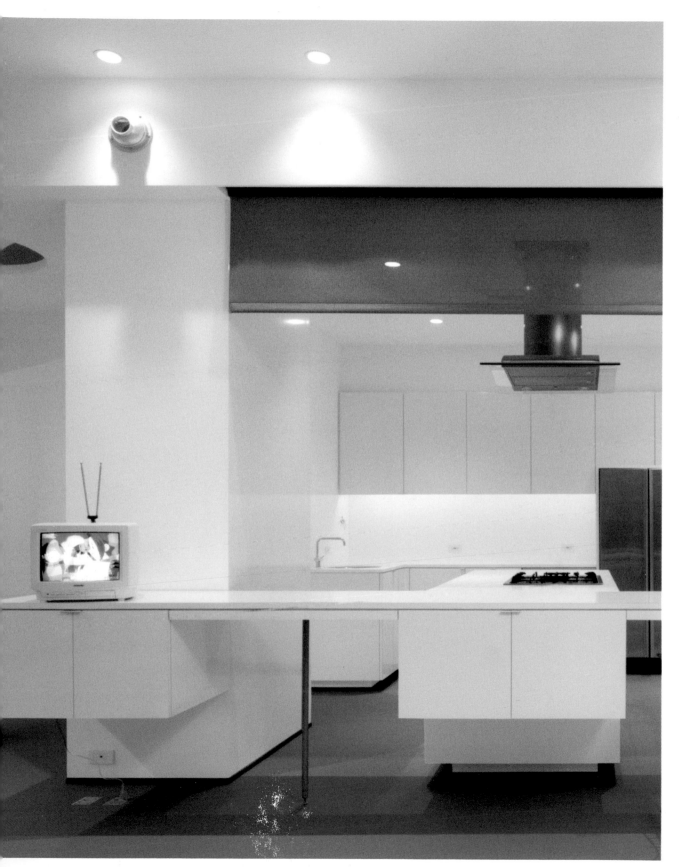

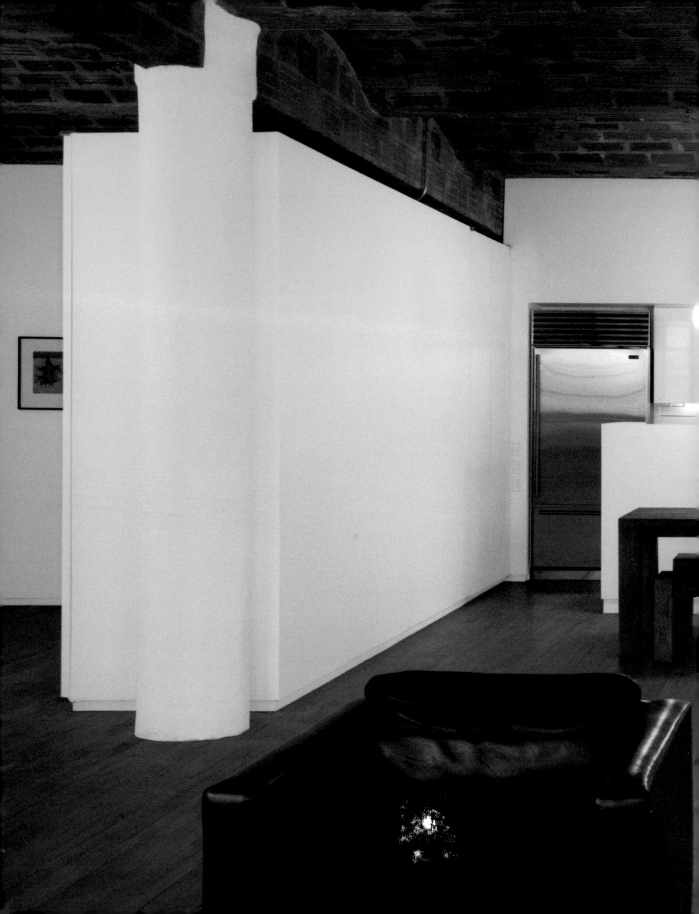

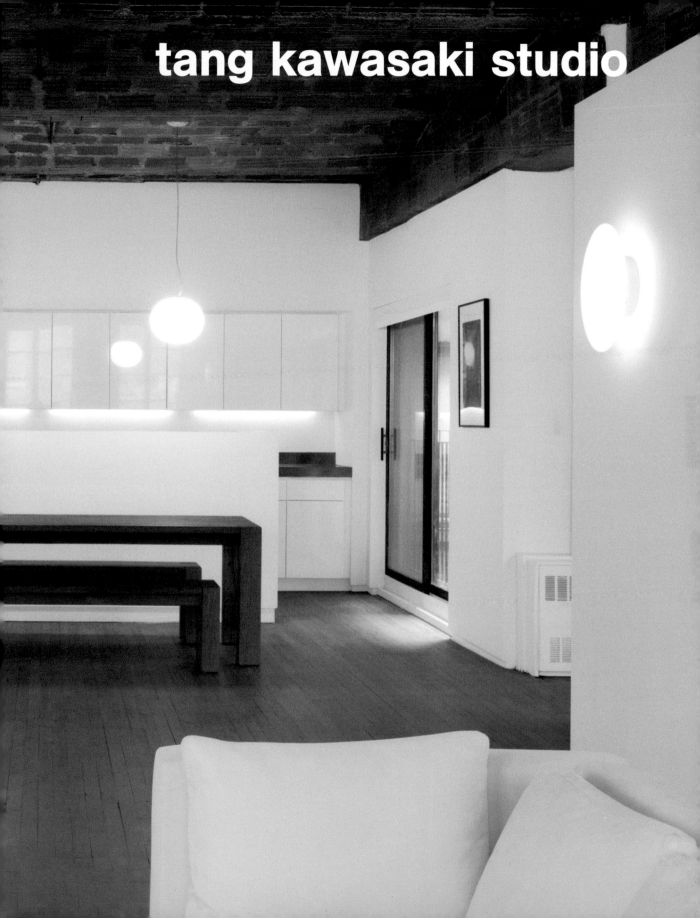

tang kawasaki studio

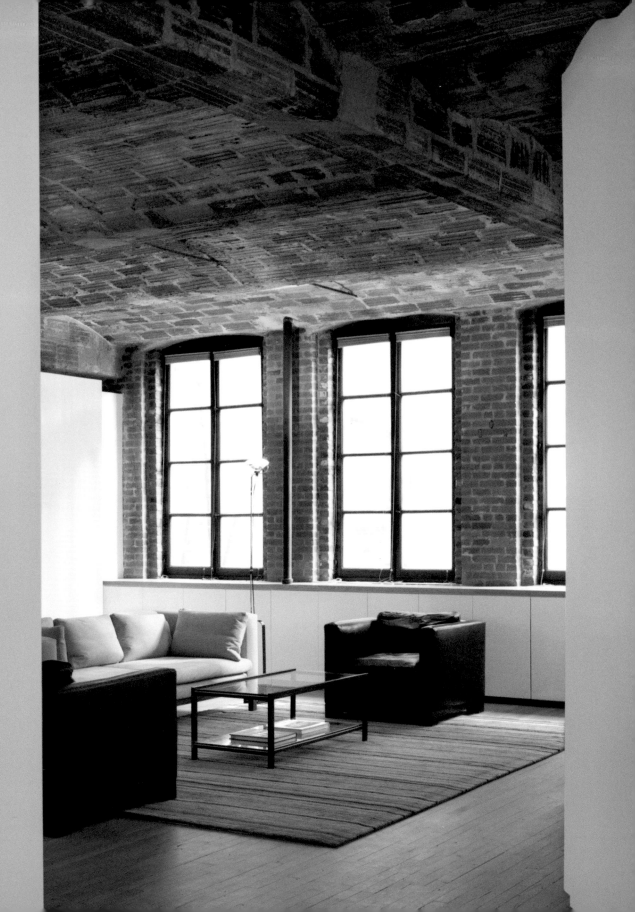

tang kawasaki studio

338 East 5th Street #19, New York, NY 10003, USA

+1 212 614 9594

+1 212 614 9594

www.tangkawasaki.com

jason@tangkawasaki.com

maki@tangkawasaki.com

Jason Tang and Maki Kawasaki met while studying architecture in New York and decided, upon completion of their studies, to open the tang kawasaki studio in which they carry out interior design and architecture projects and design furniture. Before they decided to work together, they gathered experiences with architects such as Calvert Wright, Ike Kligerman Barkley, Lewis Tsurumaki Lewis and Patkau Architects.

Jason Tang und Maki Kawasaki lernten sich während ihres Architekturstudiums in New York kennen und entschieden sich nach Beendigung ihres Studiums, das tang kawasaki studio zu eröffnen, in dem sie Interior-Design- und Architekturprojekte realisieren und Mobiliar entwerfen. Bevor sie sich für eine gemeinsame Zusammenarbeit entschieden, sammelten sie Erfahrungen mit Architekten wie Calvert Wright, Ike Kligerman Barkley, Lewis Tsurumaki Lewis und Patkau Architects.

Jason Tang et Maki Kawasaki se sont rencontrés à New York, lors de leurs études d'architecture. A la fin de leurs études, ils décident de fonder le tang kawasaki studio, où ils réalisent des projets de design d'intérieur et d'architecture. Ils conçoivent également des meubles. Avant de travailler ensemble, ils acquièrent de l'expérience avec les architectes tels que Calvert Wright, Ike Kligerman Barkley, Lewis Tsurumaki Lewis et Patkau Architects.

Jason Tang y Maki Kawasaki se conocieron durante sus estudios de arquitectura en Nueva York y decidieron, al finalizar, abrir el tang kawasaki studio, en el que llevan a cabo proyectos de diseño interior y arquitectura y diseñan muebles. Antes de lanzarse al trabajo en común, reunieron experiencias con arquitectos como Calvert Wright, Ike Kligerman Barkley, Lewis Tsurumaki Lewis y Patkau Architects.

Jason Tang e Maki Kawasaki si conobbero a New York quando studiavano architettura, ed una volta terminata l'università decisero di aprire lo studio tang kawasaki, dove realizzano progetti di design per interni e di architettura e disegnano oggetti di arredamento. Prima di decidere di lavorare insieme, fecero diverse esperienze lavorando con architetti come Calvert Wright, Ike Kligerman Barkley, Lewis Tsurumaki Lewis e Patkau Architects.

Jason Tang

1977
Born in Vancouver, Canada

1995-2000
Cornell University, Ithaca, New York, USA

Maki Kawasaki

1977
Born in Kobe, Japan

1995-2000
Cornell University, Ithaca, New York, USA

2001
Foundation of tang kawasaki studio, New York, USA

2004
Nelson Residence, New York, USA

2005
Morgan Residence, New York, USA
Dimuro Residence, New York, USA

Interview | tang kawasaki studio

Which do you consider the most important work of your career? Designing for children. We've always found ourselves gravitate towards this theme or it has sometimes come and found us. From our first project in the city, a children's shop in the west village, to our furniture company, to our ongoing study of Isamu Noguchi's work, a curiosity of how children perceive their environment motivates us daily.

In what ways does New York inspire your work? New York is anything and everything all mashed together in a beautifully gridded mess. Its residents, our clients and collaborators, inspire us in many ways for better and worse, but above all, afford us the luxury of exploring new ideas to their fullest extent.

Does a typical New York style exist, and if so, how does it show in your work? We have yet to find anything definitively "typical" in New York.

How do you imagine New York in the future? Denser, greener, and full with flying cars.

Was halten Sie für die wichtigste Arbeit in Ihrer Karriere? Design für Kinder. Das zieht sich wie ein roter Faden durch unsere Arbeit: Von unserem ersten Projekt an, einer Kinderboutique im West Village, bis hin zu unserer Möbelfabrik oder unserem aktuellen Projekt, einer Studie zum Werk Isami Noguchis. Wir wollen verstehen, wie Kinder ihre Umgebung wahrnehmen und das motiviert uns Tag für Tag.

Auf welche Weise inspiriert New York Ihre Arbeit? In New York ist alles auf engstem Raum zusammengepfercht: ein gigantisches Wirrwarr. New Yorks Einwohner, unsere Klienten und Mitarbeiter, inspirieren uns bereits auf verschiedene Weise, vor allem aber ermöglichen sie uns den Luxus, mit neuen Ideen zu experimentieren.

Gibt es einen typischen New Yorker Stil, und wenn ja, wie zeigt sich das in Ihrer Arbeit? Was wirklich „typisch" für New York sein soll, muss wohl erst noch gefunden werden.

Wie stellen Sie sich New York in der Zukunft vor? Dichter, grüner, und überall fliegende Autos.

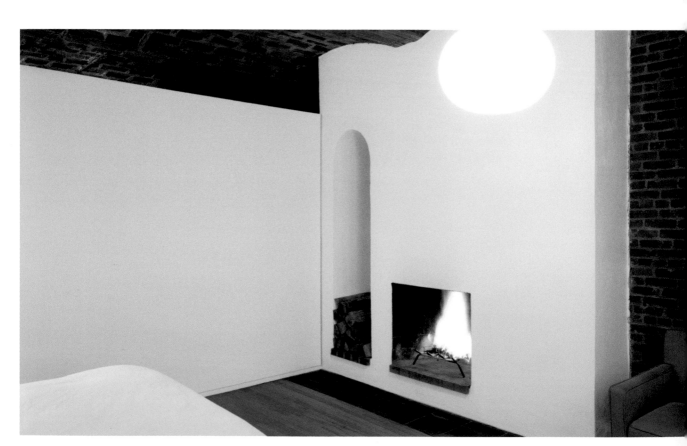

Quelle est l'œuvre la plus importante de votre carrière ? Faire du design pour les enfants. Notre travail a toujours tourné autour de ce thème ou alors c'est lui qui est venu nous chercher. Ce qui nous intéresse, c'est de comprendre la façon dont les enfants perçoivent leur environnement. Cette approche nous motive au quotidien et se reflète dans tous nos projets, que ce soit le tout premier, un magasin pour enfants dans le West Village, notre compagnie de meubles, ou notre étude actuelle de l'œuvre de Isamu Noguchi.

Dans quelle mesure la ville de New York inspire-t-elle votre œuvre ? New York est un mélange de rien et de tout à la fois qui se fond dans un chaos merveilleusement articulé. Ses résidents, nos clients et collaborateurs nous inspirent de mille et une façons pour le pire et le meilleur, en nous offrant surtout le luxe d'exploiter à fond de nouvelles idées.

Peut-on parler d'un style typiquement new-yorkais, et si oui, comment se manifeste-t-il dans votre œuvre ? Nous n'avons pas encore trouver quelque chose de vraiment typiquement » new-yorkais.

Comment imaginez-vous le New York de demain ? Plus dense, plus vert, avec des voitures volantes partout.

¿Cuál es el trabajo que considera más importante en su carrera? Diseñar para los niños. De un modo u otro siempre nos hemos sentido atraídos por este tema o quizá, a veces, haya sido él quien ha venido a nuestro encuentro. Desde nuestro primer proyecto en la ciudad, una tienda infantil en el "west village", hasta nuestra empresa de mobiliario o nuestro estudio en curso del trabajo de Isamu Noguchi, la curiosidad por saber cómo los niños perciben su entorno nos motiva diariamente.

¿De qué manera Nueva York supone una inspiración en su trabajo? Nueva York es cada cosa y todas a la vez envueltas en un revoltijo deliciosamente cuadriculado. Sus habitantes, nuestros clientes y colaboradores nos inspiran de numerosas formas para mejor y peor, pero sobre todo, nos permiten el lujo de explorar nuevas ideas hasta su máximo alcance.

¿Existe un estilo típico neoyorquino y, si es así, cómo se revela en su obra? Aún está por encontrarse algo definitivamente "típico" en Nueva York.

¿Cómo se imagina Nueva York en el futuro? Más densa, más verde y llena de vehículos voladores.

Cosa pensa che sia la cosa più importante della Sua carriera? Il design per i bambini. Abbiamo sempre gravitato attorno a questo tema, che è come se avesse trovato qualcosa in noi. A partire dal mio primo progetto in città: un negozio per bambini nel West Village, fino alla nostra ditta di mobili e al nostro studio in corso delle opere di Isamu Noguchi; una curiosità sul modo in cui i bambini percepiscono il loro ambiente, che ci motiva ogni giorno.

In che modo New York influenza il Suo lavoro? New York è tutto e niente allo stesso tempo: tutto è mescolato insieme in una fantastica confusione. I suoi residenti, nostri clienti e collaboratori ci ispirano in vari modi nel meglio e nel peggio e soprattutto ci concedono il lusso di esplorare nuove idee al loro meglio.

Esiste uno stile tipico di New York? Se sì, come influenza il Suo lavoro? Non abbiamo ancora trovato niente che si possa definire "tipico" di New York.

Come si immagina New York in futuro? Più densa, più verde e piena di automobili volanti.

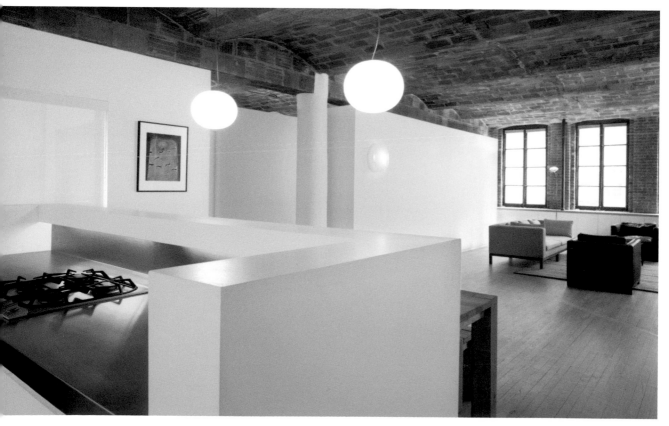

tang kawasaki studio 283

Morgan Residence

Year: 2005
Photographs: © Björg Magnea

This 7,200 sq feet apartment in Greenwich Village is a conversion of a commercial building. To keep the industrial character while modernizing it at the same time, the brick ceiling was restored and the floor was made of bleached American white oak. The apartment obtains its contemporary character from the sleek white cabinets. A half-height kitchenette structures and separates the kitchen from the living room.

Bei diesem 670 m² großen Apartment in Greenwich Village handelt es sich um den Umbau eines Geschäftsgebäudes. Um den industriellen Charakter zu bewahren und gleichzeitig zu modernisieren, wurde die Backsteindecke restauriert und ein Boden aus gebleichter Amerikanischer Weißeiche verlegt. Einen zeitgemäßen Charakter erhält das Apartment durch die schlichten weißen Einbauschränke. Eine halbhohe Küchenzeile strukturiert und trennt die Küche optisch vom Wohnraum.

Ce grand appartement de 670 m² à Greenwich Village est le résultat d'un projet de restructuration d'un immeuble commercial. Pour préserver son caractère industriel tout en le modernisant, les architectes ont restauré le plafond en briques et blanchi le parquet en chêne blanc d'Amérique. Les armoires intégrées blanches, sobres et épurées, confèrent une note contemporaine à cet appartement. Une cuisine intégrée à mi hauteur structure la cuisine tout en instaurant une séparation visuelle avec le séjour.

En este apartamento de 670 m² de Greenwich Village se remodeló un local comercial. Para conservar el carácter industrial y al mismo tiempo modernizarlo, se restauró el techo de ladrillos y se decoloró el suelo de roble blanco americano. Los sencillos armarios empotrados de color blanco dan al apartamento un carácter actual. La barra americana separa visualmente la cocina de la zona de estar.

Questo appartamento di 670 m² nel Greenwich Village è il frutto della trasformazione di un edificio commerciale. Per mantenere il carattere industriale ed allo stesso tempo dargli un aspetto moderno, è stato restaurato il soffitto di laterizi e decolorato il pavimento in quercia bianca americana. L'appartamento ottiene il suo carattere moderno grazie ai sobri armadi a muro bianchi. Un blocco cucina di media altezza dà forma alla cucina e la divide visivamente dal soggiorno.

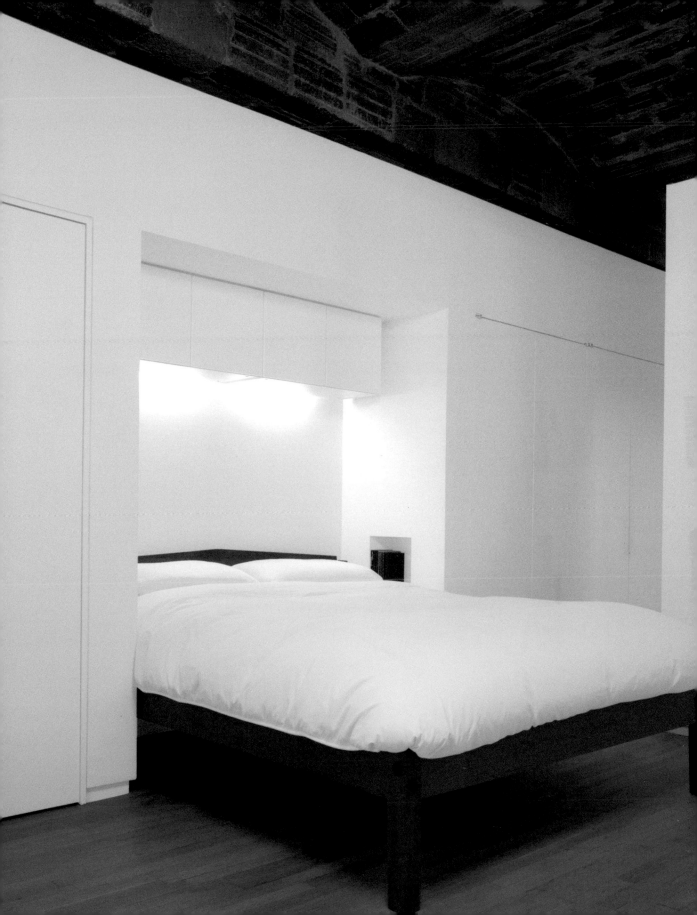

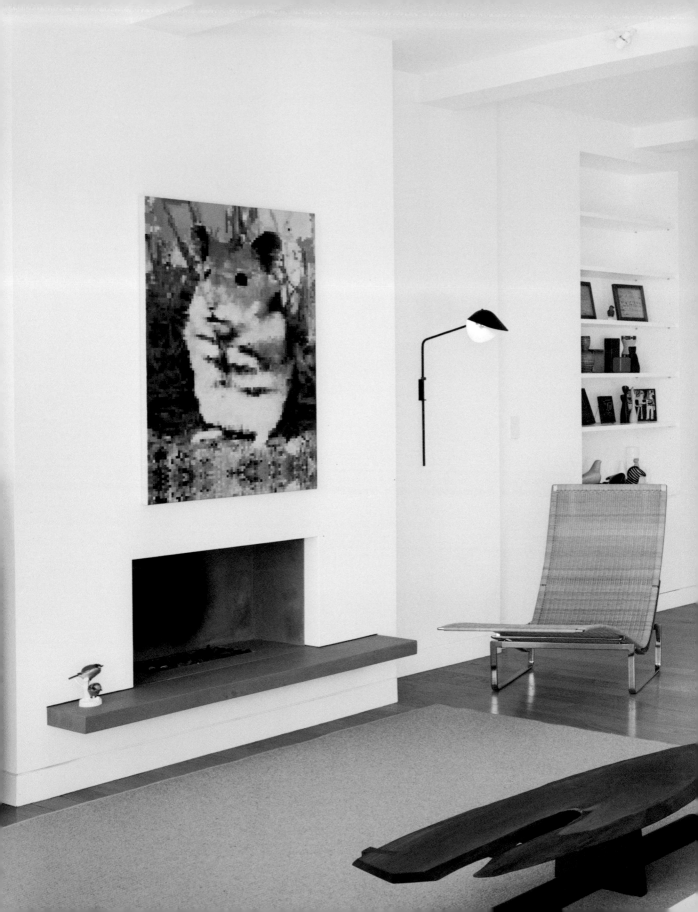

Messana O'Rorke
Architects

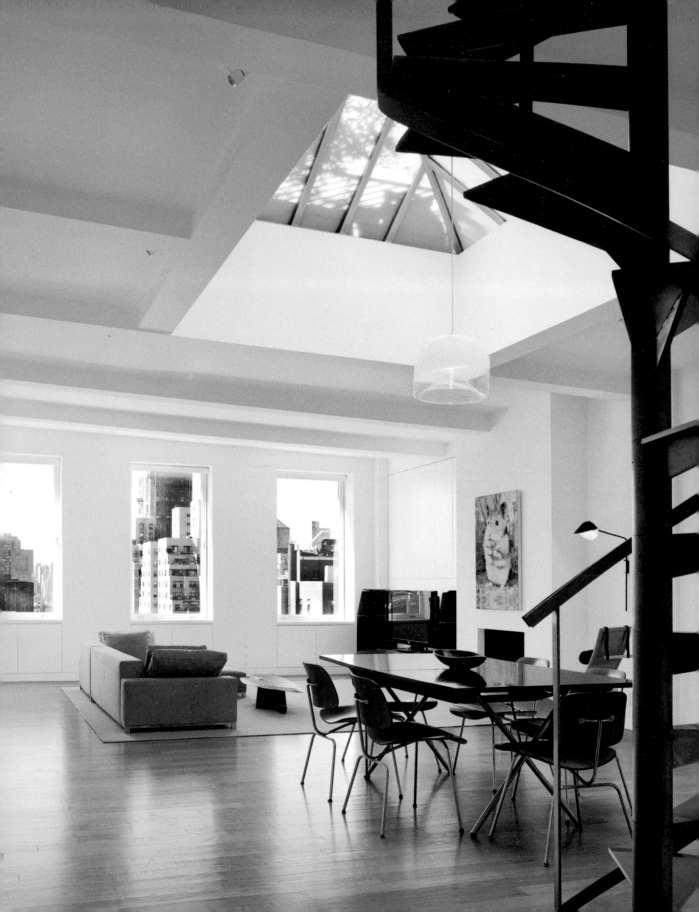

Messana O'Rorke Architects

118 West 22nd Street, 9th Floor, New York, NY 10011, USA

+1 212 807 1960

+1 212 807 1966

www.messanaororke.com

brian@messanaororke.com

Brian Messana and Toby O'Rorke

When Brian Messana and Toby O'Rorke created the office of Messana O'Rorke Architects in 1996, they already had seven years of experience working together. In their designs, Messana O'Rorke Architects combine architecture and interior design with graphics, product and furniture design, thereby creating customized and well thought-out solutions. To achieve this, teamwork in the design process is very important to them.

Als Brian Messana und Toby O'Rorke das Büro Messana O'Rorke Architects 1996 gründeten, konnten sie schon auf eine siebenjährige Zusammenarbeit zurück blicken. Messana O'Rorke Architects kombinieren in ihren Entwürfen Architektur und Innenarchitektur mit Grafik-, Produkt- und Möbeldesign und schaffen so individuelle und durchdachte Lösungen. Dabei ist ihnen die Zusammenarbeit der am Entwurfsprozess beteiligten Experten sehr wichtig.

Lors de la création de leur cabinet, Messana O'Rorke Architects, en 1996, Brian Messana et Toby O'Rorke ont déjà derrière eux sept années de collaboration fructueuse. Messana O'Rorke Architects conjuguent leurs projets d'architecture et design d'intérieur au graphisme, design de produits et de mobilier, créant ainsi des solutions individuelles bien étudiées. Dans ce travail, la collaboration avec les experts participant à la conception est primordiale.

Cuando en 1996 Brian Messana y Toby O'Rorke fundaron el estudio Messana O'Rorke Architects, contaban ya con la experiencia de siete años de colaboración. Messana O'Rorke Architects combina en sus proyectos arquitectura y diseño interior con las artes gráficas, el diseño industrial y el diseño de muebles, con lo que consiguen soluciones individuales y pensadas hasta el último detalle. Al mismo tiempo, otorgan gran importancia a la colaboración con los expertos participantes en el proceso de creación.

Nel 1996, quando Brian Messana e Toby O'Rorke fondarono lo studio Messana O'Rorke Architects, avevano alle spalle già sette anni di collaborazione. Messana O'Rorke Architects riuniscono nei loro progetti l'architettura e il disegno per interni con la grafica, il disegno di prodotti e di arredamento e creano così delle soluzioni studiate individualmente. In ciò danno particolare attenzione alla collaborazione degli specialisti coinvolti nel processo di progettazione.

1996
Foundation of Messana O'Rorke Architects by Brian Messana and Toby O'Rorke

1998
Axis Theatre, New York, USA

1999
Skin Care Lab, New York, USA, Interior Architecture Award, The AIA New York Chapter Design Award

2001
Dorsinville Loft, New York, USA
The AIA New York State Chapter 2001 Award of Merit for Skin Care Lab

2002
The Pent Tank House, New York, USA
The AIA New York State Chapter 2002 Award of Citation for the project Axis Theatre

Interview | Messana O'Rorke Architects

What do you consider the most important work of your career? Skin Care lab, Axis Theatre, Savage House, and Ten Broeck Cottage.

In what ways does New York inspire your work? The humanity of the street life, the skyline from Central Park, where the city meets the rivers especially traveling along the Franklin D. Roosevelt Drive, under the United Nations.

Does a typical New York style exist, and if so, how does it show in your work? It is a city of individuals, where you are free to express your own style, there is no conformity, so you follow your own instinct.

How do you imagine New York in the future? Continued growth as the Capital of the World, continued diversity, creativity and struggle.

Was halten Sie für die wichtigste Arbeit in Ihrer Karriere? Das Skin Care Lab, das Axis Theatre, das Savage House sowie das Ten Broeck Cottage.

Auf welche Weise inspiriert New York Ihre Arbeit? Die Menschen auf den Straßen, die Skyline vom Central Park aus gesehen, wo die Stadt und ihre Flüsse zusammentreffen, besonders entlang des Franklin D. Roosevelt Drives unterhalb der Vereinten Nationen.

Gibt es einen typischen New Yorker Stil, und wenn ja, wie zeigt sich das in Ihrer Arbeit? New York ist eine Stadt der Individuen, in der jeder die Freiheit hat, seinen ganz eigenen Stil zum Ausdruck zu bringen. Gleichförmigkeit gibt es nicht, also folgt man dem eigenen Instinkt.

Wie stellen Sie sich New York in der Zukunft vor? Weiterhin Entwicklung zur Welthauptstadt, kontinuierliche Vielfalt, Kreativität und Kampf.

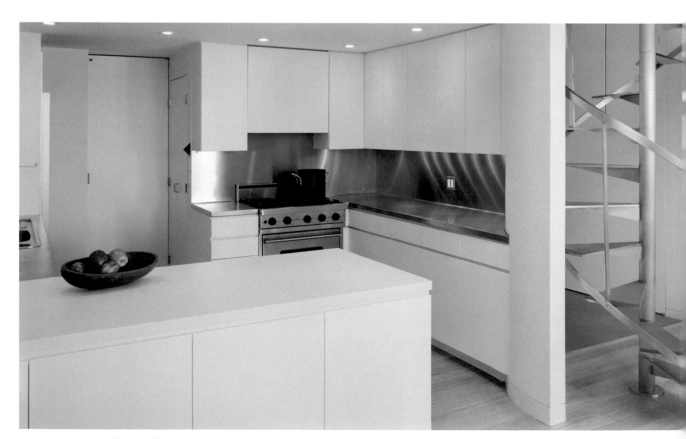

Quelle est l'œuvre la plus importante de votre carrière ? Skin Care lab, Axis Theatre, Savage House et Ten Broeck Cottage.

Dans quelle mesure la ville de New York inspire-t-elle votre œuvre ? Le côté humain de la vie dans les rues, la skyline depuis Central Park, où la ville rencontre la rivière, surtout en longeant la Franklin D. Roosevelt Drive, sous les Nations Unies.

Peut-on parler d'un style typiquement new-yorkais, et si oui, comment se manifeste-t-il dans votre œuvre ? C'est une ville d'individualistes, où vous pouvez exprimer librement votre propre style, il n'y a pas de conformisme, vous pouvez suivre votre instinct.

Comment imaginez-vous le New York de demain ? Capitale du monde du fait de sa croissance, diversité, créativité et de son côté battant.

¿Cuál es el trabajo que considera más importante en su carrera? El laboratorio de Skin Care, el teatro Axis, la casa Savage y la casita Ten Broeck.

¿De qué manera Nueva York supone una inspiración en su trabajo? La humanidad de la vida de la calle, la línea de horizonte desde Central Park, donde la ciudad se encuentra con los ríos, especialmente viajando por el Franklin D. Roosevelt Drive bajo las Naciones Unidas.

¿Existe un estilo típico neoyorquino y, si es así, cómo se revela en su obra? Es una ciudad de individuos, donde eres libre de expresar tu propio estilo, no hay conformidad, de modo que sigues tu propio instinto.

¿Cómo se imagina Nueva York en el futuro? En un continuo crecimiento como la Capital del mundo, en una continua diversidad, creatividad y lucha.

Qual è secondo Lei il progetto più importante della Sua carriera? Lo Skin Care lab, l'Axis Theatre, la Savage House e il Ten Broeck Cottage.

In che modo la città di New York ispira il Suo lavoro? Lo ispira con la vivacità e vitalità delle sue strade, con lo skyline dal Central Park, dove la città si incontra con i fiumi, in particolar modo lungo il Franklin D. Roosevelt Drive, sotto alle Nazioni Unite.

È possibile parlare di uno stile tipico per New York, e, se questo stile esiste, in che modo si manifesta nei Suoi lavori? New York è una città di individui singoli in cui ognuno è libero di esprimere il proprio stile. Non esistono standard, ognuno può quindi seguire il proprio istinto.

Come si immagina la New York del futuro? La immagino in continua crescita, come Capitale del Mondo, con la sua molteplicità, creatività e competizione infinita.

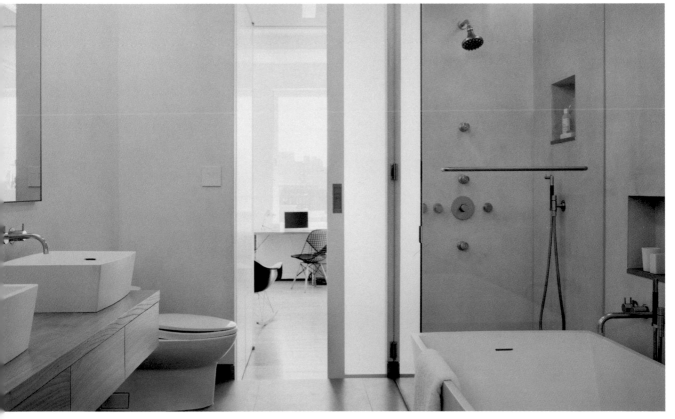

The Pent Tank House

Year: 2002

Photographs: © Elizabeth Felicella

During the modernization of this loft, a crucial design approach was to develop the pedestrian-friendly and newly planted rooftop. In addition to the spiral staircase especially created for the project, this was achieved by means of the skylight which provides the room with natural light. The apartment's open structure was maintained, however the bathroom and bedroom were equipped and expanded with individual entrances.

Bei der Modernisierung dieses Lofts bestand ein entscheidender Ansatz des Entwurfs darin, das begehbare und neu bepflanzte Dach optisch zu erschließen. Dies wurde neben einer speziell für dieses Projekt angefertigten Wendeltreppe auch über das Oberlicht erreicht, das den Wohnraum mit natürlichem Licht versorgt. Die offene Struktur des Apartments wurde beibehalten, allerdings wurde das Bad- und Schlafzimmer mit individuellen Zugängen ausgestattet und vergrößert.

Dans ce loft revisité, l'approche conceptuelle met principalement l'accent sur l'intégration visuelle du toit accessible dont la plantation a été repensée. Ceci est possible grâce à un escalier en colimaçon conçu spécialement pour le projet et par un puits de lumière qui inonde le séjour de lumière naturelle. L'appartement conserve sa structure ouverte initiale, par contre salle de bains et chambre à coucher sont élargies, avec à la clé un accès individuel respectif.

Para la modernización de este loft, un principio decisivo del proyecto consistía en integrar visualmente el tejado transitable y recién ajardinado. Esto se consiguió, además de con la escalera de caracol creada especialmente para este proyecto, mediante el tragaluz que riega de luz natural la zona de estar. La estructura abierta del apartamento se conservó, si bien se crearon accesos individuales para el cuarto de baño y el dormitorio y se ampliaron.

Nella modernizzazione di questo loft uno degli approcci base del progetto prevedeva la valorizzazione visiva del tetto praticabile nuovamente ricoperto di erba. Questo presupposto è stato realizzato grazie alla scala a chiocciola appositamente costruita e al lucernario che alimenta il soggiorno con luce naturale. La struttura aperta dell'appartamento è stata mantenuta, ma il bagno e la camera da letto sono stati attrezzati con accessi individuali e ingranditi.

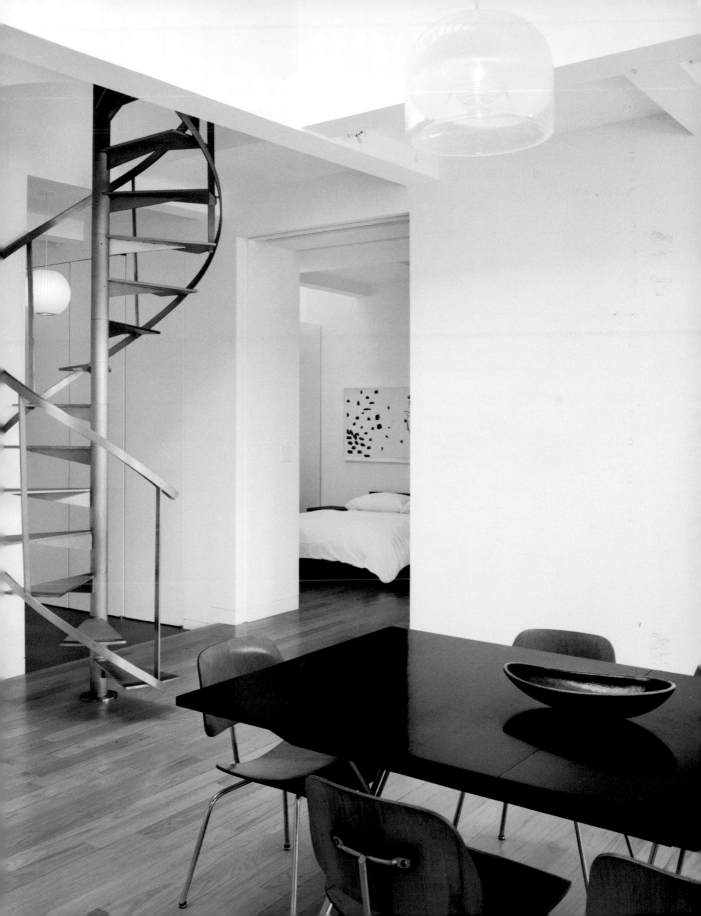

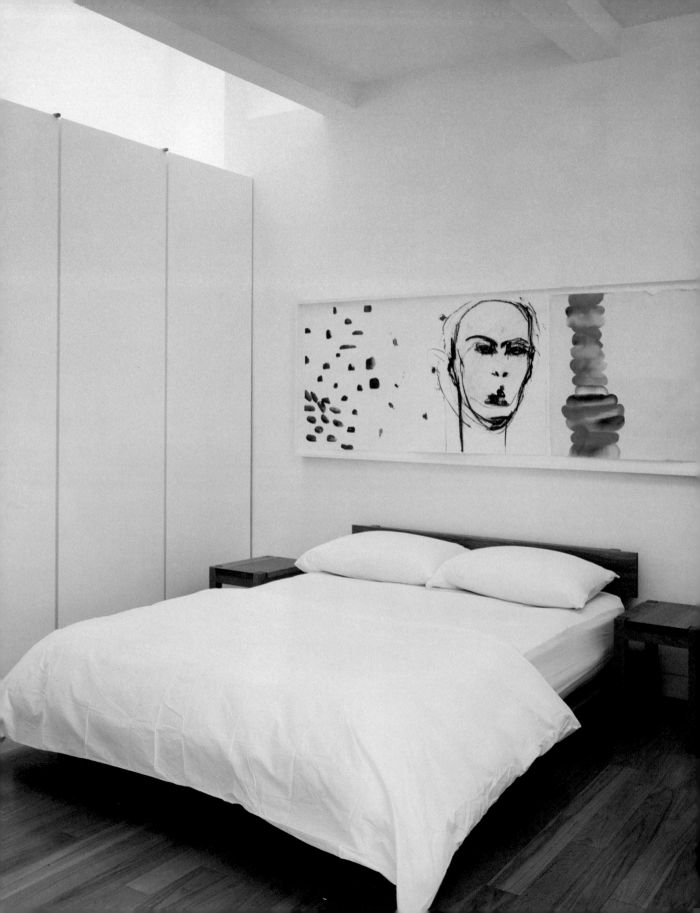

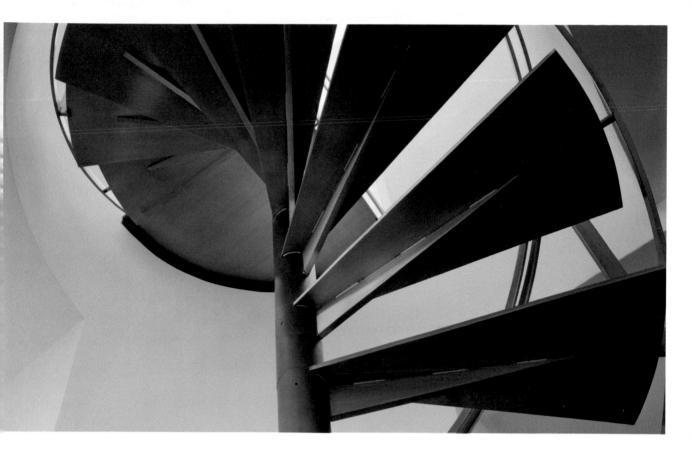

Floor plan

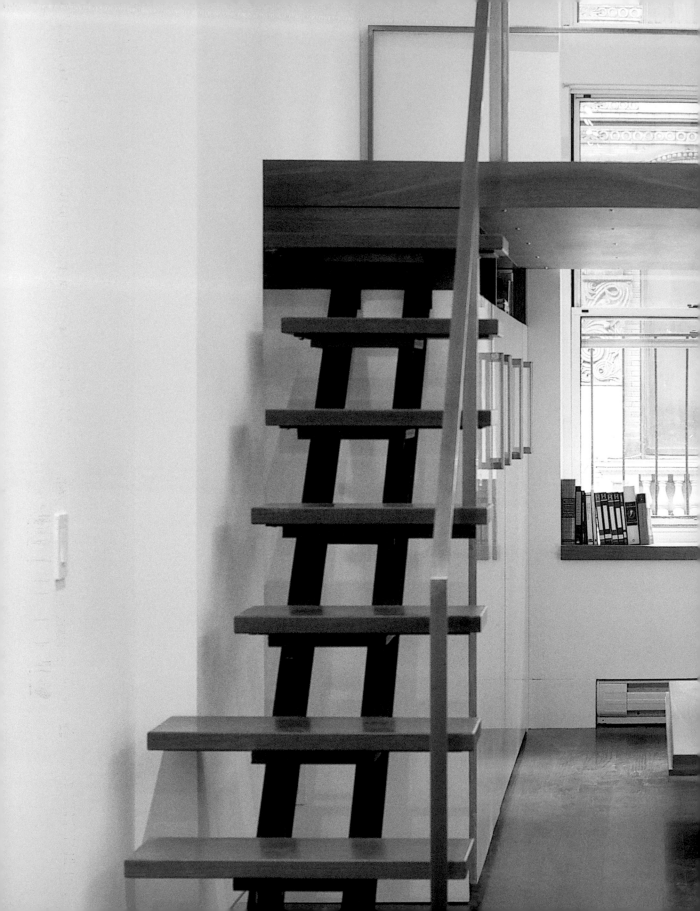

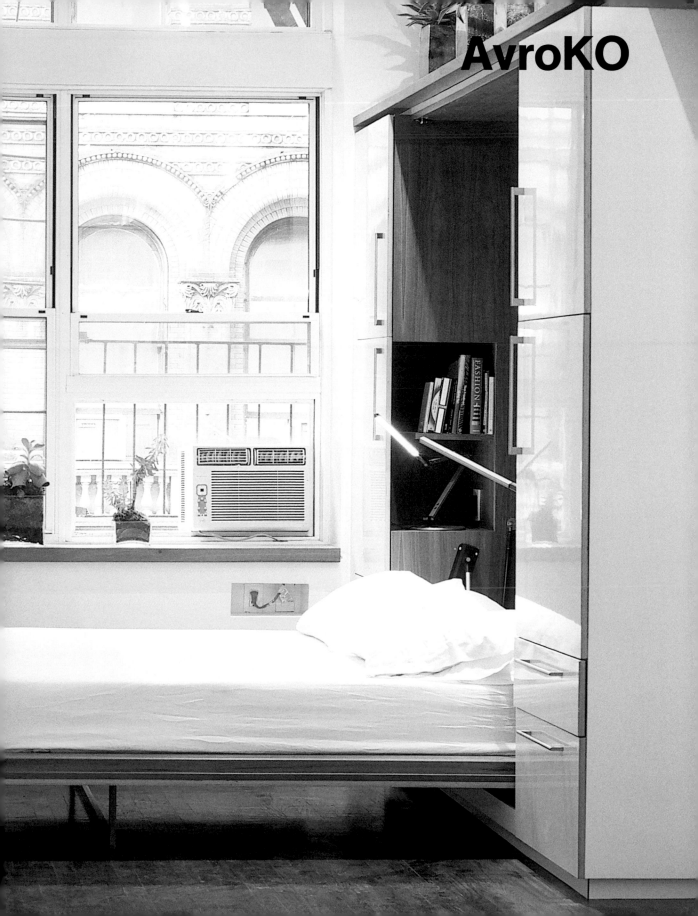

AvroKO

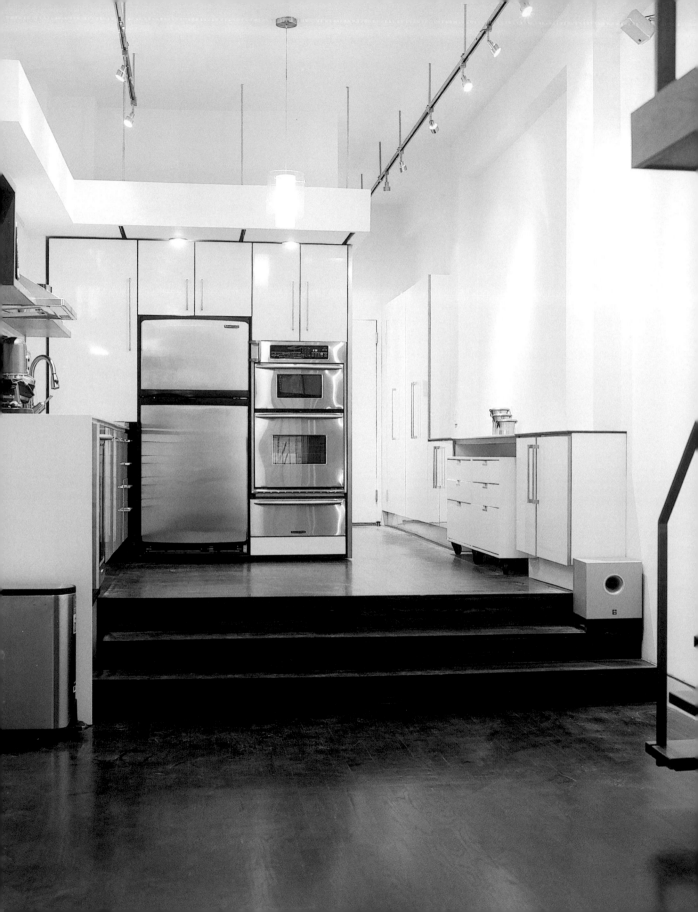

AvroKO

210 Elizabeth Street, 3rd Floor, New York, NY 10012, USA

+1 212 343 7024

www.avroko.com

info@avroko.com

AvroKO was created by 4 high school friends, who, despite diverse specializations, shared a common taste for innovative design. The name of the company, headed by Adam Farmerie, Kristina O'Neal, William Harris and Greg Bradshaw, comes from the airplane, Avro 512, a highly complex machine which symbolizes AvroKO's design origin as idea machine.

AvroKO wurde von vier Hochschulfreunden gegründet, die trotz unterschiedlicher Spezialisierungen ihr gemeinsamer Geschmack für innovatives Design verbindet. Den Namen verdankt die Firma von Adam Farmerie, Kristina O'Neal, William Harris und Greg Bradshaw, dem Flugzeug Avro 512, einer hochkomplexen Maschine, die den Designansatz AvroKOs als Ideenmaschine symbolisiert.

AvroKO a été fondé par quatre camarades d'université, qui, malgré des spécialisations différentes, sont unis par le même goût du design innovant. L'entreprise d'Adam Farmerie, Kristina O'Neal, William Harris et Greg Bradshaw doit son nom à l'avion Avro 512, une machine d'une complexité extrême, symbolisant la conception du design d'AvroKO, en tant que machine à idées.

AvroKO fue fundada por cuatro amigos de la universidad unidos, a pesar de sus distintas especialidades, por un gusto común por el diseño innovador. El nombre de la empresa de Adam Farmerie, Kristina O'Neal, William Harris y Greg Bradshaw se debe al avión Avro 512, una máquina de gran complejidad que simboliza el planteamiento de AvroKO como máquina de ideas.

AvroKO è stato creato da quattro amici universitari i quali, pur avendo scelto specializzazioni diverse, condividevano lo stesso gusto per il design innovativo. Il nome di questa ditta da Adam Farmerie, Kristina O'Neal, William Harris e Greg Bradshaw è basato sull'aereo Avro 512, macchina fortemente complessa che rispecchia il principio creativo di AvroKO visto come macchina da idee.

AvroKO

2000
Foundation of AvroKO, New York, USA

2004
James Beard Foundation Outstanding Restaurant Design Award for "PUBLIC"

2005
"Smart. Space" residential project, New York, USA

2005
Launch of furniture collection "Transport Series"

Interview | AvroKO

What do you consider the most important work of your career? We designed, own and operate PUBLIC restaurant. For us, PUBLIC was an opportunity to showcase our design process and it established our integrated design philosophy to some degree as well.

In what ways does New York inspire your work? New York is a very competitive city, which can be an excellent motivator. There is so much talent concentrated here that it really encourages us to move a little faster, and push our ideas a little farther.

Does a typical New York style exist, and if so, how does it show in your work? The very essence of New York is about diversity and creativity and change—the only typical aspect of New York style is that nothing ever stays the same.

How do you imagine New York in the future? There are some exciting architectural projects in the works—the High Line, Lincoln Center, Ground Zero, etc. We think these types of projects will help re-position New York at the forefront of groundbreaking architecture.

Was halten Sie für die wichtigste Arbeit in Ihrer Karriere? Aus unserem Entwurf stammt das PUBLIC Restaurant, das wir besitzen und auch betreiben. Das PUBLIC gab uns die Möglichkeit, unsere Designentwicklung öffentlich vorzustellen und die Philosophie unseres integrierten Designs unter Beweis zu stellen.

Auf welche Weise inspiriert New York Ihre Arbeit? New York ist eine wettbewerbsorientierte Stadt, was eine ausgezeichnete Motivation sein kann. Die Konzentration an Talenten ist hoch und das ermutigt uns, schneller voranzugehen und unsere Ideen weiterzutreiben.

Gibt es einen typischen New Yorker Stil, und wenn ja, wie zeigt sich das in Ihrer Arbeit? Das Wesentliche an New York sind seine Vielfältigkeit, seine Kreativität und seine Veränderbarkeit – das einzig Typische am New Yorker Stil ist, dass niemals etwas gleich bleibt.

Wie stellen Sie sich New York in der Zukunft vor? Einige interessante Architekturprojekte sind zur Zeit im Gange – die High Line, das Lincoln Center, Ground Zero, usw. Wir denken, dass diese Projekte dazu beitragen werden, New York wieder an die Spitze der wegweisenden Architektur zu bringen.

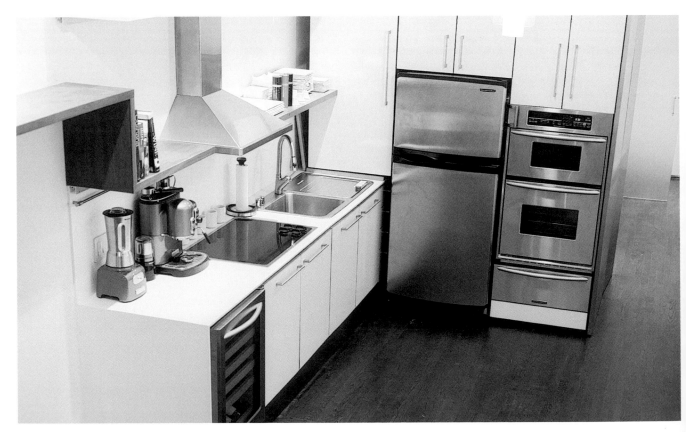

Quelle est l'œuvre la plus importante de votre carrière ? Le restaurant PUBLIC est le fruit de notre conception, nous en sommes propriétaires et nous le gérons. Pour nous, PUBLIC nous a offert l'occasion de faire connaître notre processus de design et en même temps de traduire la démarche conceptuelle qui le définit.

Dans quelle mesure la ville de New York inspire-t-elle votre œuvre ? New York est une ville où la concurrence est dure, ce qui, par ailleurs, peut être extrêmement motivant. Il y a une telle concentration de talents ici, que cela nous incite à avancer plus vite, et à pousser nos idées encore plus loin.

Peut-on parler d'un style typiquement new-yorkais, et si oui, comment se manifeste-t-il dans votre œuvre ? L'essence même de New York est imprégnée de diversité, créativité et changement – le seul aspect typique du style new-yorkais est que rien ne reste jamais identique.

Comment imaginez-vous le New York de demain ? Il y a quelques projets architecturaux très intéressants en vue – le High Line, Lincoln Center, Ground Zero, etc. Nous pensons que grâce à ce genre de projets, New York pourra redevenir la ville phare de l'architecture d'avant-garde.

¿Cuál es el trabajo que considera más importante en su carrera? Diseñamos, somos propietarios y regentamos el restaurante PUBLIC. Para nosotros, PUBLIC fue la oportunidad de exhibir nuestro proceso de diseño y, hasta cierto punto, también determinó nuestra filosofía de diseño integrada.

¿De qué manera Nueva York supone una inspiración en su trabajo? Nueva York es una ciudad de una enorme competitividad, lo cual puede ser una excelente motivación. Hay tanto talento concentrado aquí que realmente nos estimula para movernos un poco más deprisa y para llevar nuestras ideas un poco más lejos.

¿Existe un estilo típico neoyorquino y, si es así, cómo se revela en su obra? La propia esencia de Nueva York se basa en la diversidad, la creatividad y el cambio; el único aspecto típico de Nueva York es que nada permanece inalterado.

¿Cómo se imagina Nueva York en el futuro? Hay algunos proyectos arquitectónicos fascinantes en construcción: el viaducto High Line, el Lincoln Center, la Zona Cero, etc. Creemos que esta clase de proyectos contribuirá a situar a Nueva York en primera línea de la arquitectura innovadora.

Qual è secondo Lei il progetto più importante della Sua carriera? Abbiamo progettato, acquistato e gestito il ristorante PUBLIC. PUBLIC ha costituito una sorta di vetrina in cui esporre i nuovi sviluppi del nostro design e ha altresì contribuito a rafforzare la nostra filosofia del design integrato.

In che modo la città di New York ispira il Suo lavoro? New York è una città molto competitiva e questo è per noi fonte di forte motivazione. La presenza in poco spazio di così tanti talenti stimola sicuramente a andare sempre più veloce, ci stimola a spingere le nostre idee sempre un po' più in là.

È possibile parlare di uno stile tipico per New York, e, se questo stile esiste, in che modo si manifesta nei Suoi lavori? Diversità, creatività e cambiamento costituiscono l'essenza di New York – nello stile di New York "tipico" è solo il fatto che niente rimane com'è.

Come si immagina la New York del futuro? Progetti architettonici molto interessanti stanno per essere realizzati a New York – lo High Line, il Lincoln Center, Ground Zero, etc. Credo che questi progetti ci aiuteranno a riportare New York al primo posto per quel che riguarda l'architettura d'avanguardia.

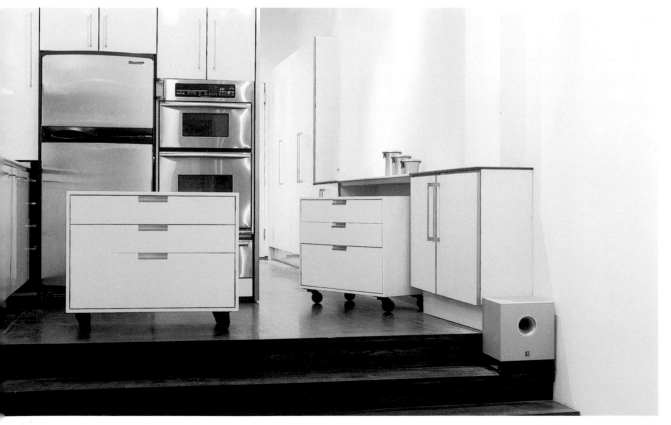

Waverly Mews: Smart. Space Project

Year: 2005
Photographs: © Gogortza & Llorella

During the redesign of two apartments in Greenwich Village, the designers solved the problem of limited available space by means of a flexible interior design which included furniture designed by the architects. With the push of a button, individual elements are moved and completely new functional areas are created. In this way, the high-tech kitchenette makes space for a guest bed upholstered in leather and the main bed disappears into the cabinet by day.

Bei der Neugestaltung zweier Apartments in Greenwich Village lösten die Designer das Problem des geringen verfügbaren Platzes durch eine flexible Innengestaltung, bei der auch das Mobiliar von den Architekten entworfen wurde. Per Knopfdruck lassen sich einzelne Elemente verschieben und es entstehen ganz neue Funktionsbereiche. So macht die High-Tech-Küchenzeile bei Bedarf einem mit Leder bezogenen Gästebett Platz und auch das Hauptbett verschwindet tagsüber im Schrank.

Dans la rénovation de deux appartements de Greenwich Village, les designers ont résolu le problème du manque de place disponible par un aménagement intérieur flexible, avec un mobilier conçu par les architectes. Une simple pression sur un bouton déplace chaque élément pour laisser la place à de nouvelles zones de fonctions. C'est ainsi que la cuisine intégrée High-Tech cède le pas, si besoin est, à un lit d'amis recouvert de cuir, et dans la journée, le lit des maîtres disparaît également dans un placard.

Para la remodelación de dos apartamentos en Greenwich Village, los diseñadores solucionaron el problema del reducido espacio disponible con una distribución interior flexible, en la que también los muebles son obra de los arquitectos. Con solo pulsar un botón se pueden desplazar los distintos elementos dando paso a nuevas áreas funcionales. Así, en caso necesario, la cocina de alta tecnología deja espacio para una cama de invitados tapizada en cuero, o la cama principal desaparece de día en el armario.

Al momento del rinnovamento di due appartamenti nel Greenwich Village i designer hanno risolto il problema dello spazio limitato a disposizione grazie ad una realizzazione flessibile degli interni, dove anche i mobili sono stati studiati dall'architetto. Premendo un pulsante è possibile spostare i singoli elementi, mettendo a disposizione nuove aree funzionali. In questo modo il blocco cucina altamente tecnologico si trasforma in caso di necessità in un letto degli ospiti rivestito in pelle e anche il letto principale è nascosto durante il giorno nell'armadio.

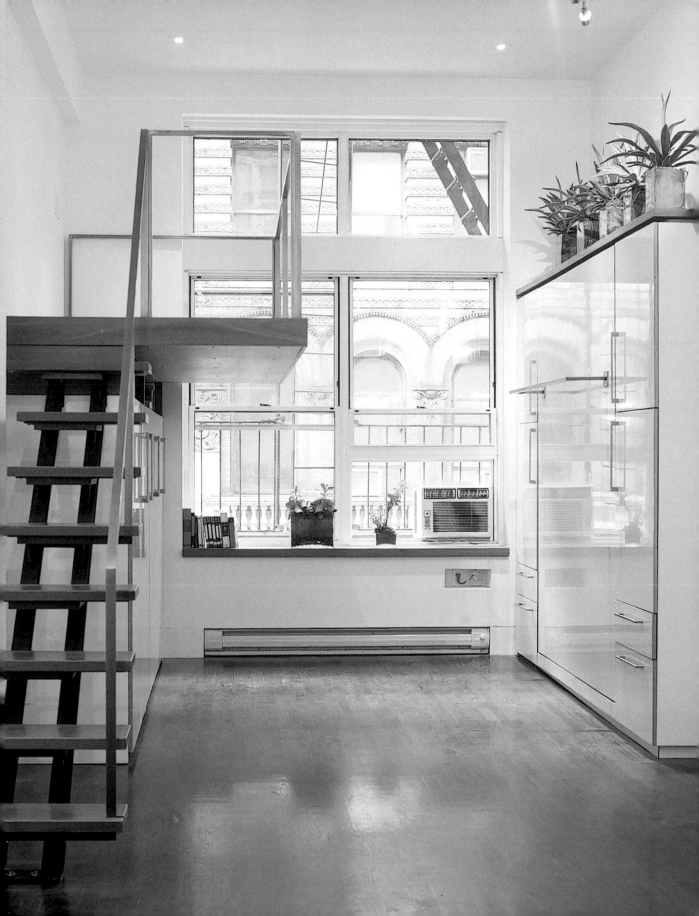

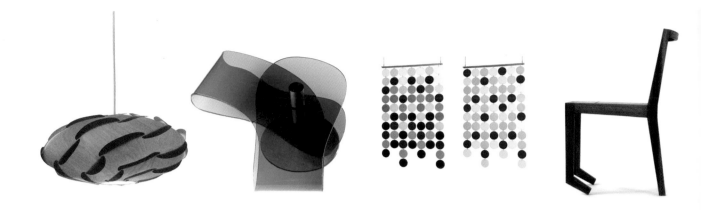

Product Design

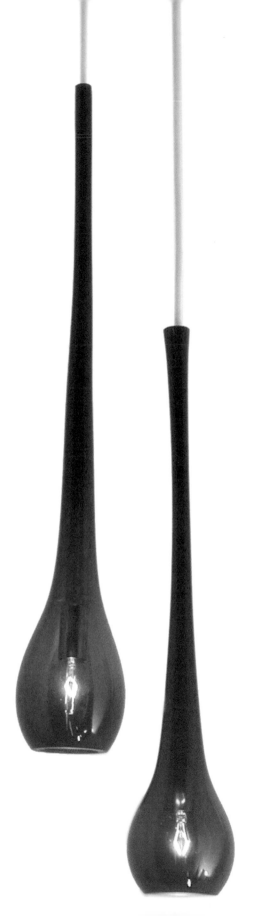

Karim Rashid

Third Eye Studios

Kabalab

Brave Space

David Weeks Studio

54Dean

Studio Dror

Iglooplay by Lisa Albin Design

dform

521 Design

Designfenzider Studio

ducduc

Zia-Priven Design

J Schatz

hivemindesign

jGoodDesign

Karim Rashid

Karim Rashid

357 West 17th Street, New York, NY 10011, USA

+1 212 929 8657

+1 212 929 0247

www.karimrashid.com

office@karimrashid.com

Karim Rashid

Born in Cairo and raised in Canada, Karim Rashid is a member of the design elite with his peppy designs. Like so many young talents, he went to New York, where he opened his own studio in 1993. The breakthrough came in the mid-1990s with the design of the Garbo trash can for the Canadian firm, Umbra. Since then, his prize-winning designs have been shown around the world in over 14 museums and in numerous galleries.

In Kairo geboren und in Kanada aufgewachsen, zählt Karim Rashid mit seinen poppigen Entwürfen zur Designelite. Wie so viele junge Talente ging er nach New York, wo er 1993 sein eigenes Studio eröffnete. Der Durchbruch kam Mitte der neunziger Jahre mit dem Entwurf des Mülleimers Garbo für die kanadische Firma Umbra. Seit dem werden seine preisgekrönten Entwürfe weltweit in über 14 Museen und einer Vielzahl von Galerien ausgestellt.

Né au Caire et élevé au Canada, Karim Rashid, fort de ses concepts Pop, fait partie de l'élite du design. A l'image de nombreux jeunes talents, il part à New York, où il crée en 1993 son propre studio. Il connaît le succès au milieu des années quatre-vingt dix grâce à son concept de poubelle Garbo pour l'entreprise canadienne Umbra. Depuis lors, ses projets primés dans le monde entier sont exposés dans 14 musées et bon nombre de galeries d'art.

Karim Rashid nació en El Cairo y se crió en Canadá. Sus diseños pop le han llevado a ser considerado uno de los grandes diseñadores actuales. Como muchos jóvenes talentos, se trasladó a Nueva York donde inauguró su propio estudio en 1993. El éxito le llegó a mitad de los años noventa con el diseño del cubo de basura Garbo para la firma canadiense Umbra. Desde entonces sus proyectos han recibido numerosos premios y se exponen en más de 14 museos y multitud de galerías del mundo entero.

Nato al Cairo e cresciuto in Canada, Karim Rashid fa parte dell'elite del design grazie alle sue creazioni "pop". Come molti altri giovani talenti, si trasferì a New York, dove aprì il suo studio nel 1993. Il successo giunse a metà degli anni novanta con la creazione della pattumiera Garbo per la ditta canadese Umbra. Da quel momento i suoi oggetti pluripremiati furono esposti in 14 musei ed innumerevoli gallerie in tutto il mondo.

1960
Born in Cairo, Egypt

1982
Bachelor of Industrial Design degree from Carleton University, Ottawa, Ontario, Canada

1993
Foundation of Karim Rashid Studio, New York, USA

2001
Editor, International Design Yearbook 18

2002
ID Magazine Annual Design Review Award, Best of Packaging Category

2005
Sleep 05 European Hotel Design Award for Best Interior Design Public Spaces for Semiramis Hotel

2006
IDSA Industrial Design Excellence Award, Bronze

Interview | Karim Rashid

What do you consider the most important work of your career? My work is incredibly diverse and includes furniture, cosmetics, clothes, jewelry, interior design, and much more. I am always obsessed with the latest work so once objects see the world (one of every 50 things I design), I am onto something completely new and try to not think of the past.

In what ways does New York inspire your work? The size and energy of Manhattan feed me constantly. New York City is forever changing, evolving, and never the same one day to the next—it is the most dynamic city in the world. It is also a true global melting, its diversities and globalism are really inspiring.

Does a typical New York style exist, and if so, how does it show in your work? The style that exists is quite eclectic and I would say it is more prominent and visible in the art world. There is no real design "style" emanating from New York and the art and design are quite different.

Was halten Sie für die wichtigste Arbeit in Ihrer Karriere? Meine Arbeit ist unglaublich abwechslungsreich und umfasst Design für Möbel, Kosmetik, Kleidung, Schmuck, Innenein-richtung sowie vieles mehr. Ich bin immerzu besessen vom aktuellen Projekt, sodass ich mich nachdem ein Objekt in die Tat umgesetzt ist (etwa jedes 50. Objekt, das ich designe), sofort auf etwas komplett Neues stürze und versuche, nicht an die Vergangenheit zu denken.

Auf welche Weise inspiriert New York Ihre Arbeit? Die Größe und Energie von Manhattan geben mir stetig neuen Input. New York City ändert und entwickelt sich in einem fort, Tag für Tag ist es eine andere Stadt – es ist die dyna-mischste Stadt der Welt. Aber sie ist auch ein globaler Schmelztiegel, dessen Vielfalt und Glo-balismus wirklich inspirierend sind.

Gibt es einen typischen New Yorker Stil, und wenn ja, wie zeigt sich das in Ihrer Arbeit? Es gibt einen Stil, und der ist ziemlich eklektisch. Ich würde sagen, dass man ihn eher in der Kunstwelt vorfindet. Einen richtigen New Yorker „Designstil" gibt es allerdings nicht, Kuns und Designwelt sind da ziemlich verschieden.

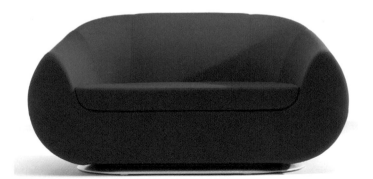 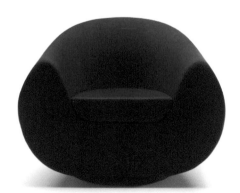

uelle est l'œuvre la plus importante de otre carrière ? Mon œuvre, extrêmement iverse, englobe meubles, cosmétiques, habits, ijoux, design d'intérieur, et beaucoup plus en ore. Je suis toujours obsédé par la dernière euvre, donc dès que mes objets sont créés (un ur 50 de mes designs), je suis déjà en train de oncevoir quelque chose de totalement différent, n essayant de ne pas regarder en arrière.

ans quelle mesure la ville de New York ispire-t-elle votre œuvre ? La taille et le ynamisme de Manhattan sont ma nourriture per tuelle. New York est sans cesse en change ent, en mutation, et n'est jamais pareil d'un ur à l'autre – c'est la ville la plus dynamique du onde. C'est un véritable creuset de cultures, s diversités et son globalisme sont de réelles urces d'inspirations.

eut-on parler d'un style typiquement ew-yorkais, et si oui, comment se mani ste-t-il dans votre œuvre ? Si il y a un yle, il est très éclectique et je pense qu'il est us important et visible dans le monde de l'art. n'y a pas de vrai « style » de design issu de w York et l'art et le design sont assez diffé nts.

¿Cuál es el trabajo que considera más importante en su carrera? Mi trabajo es increíblemente diverso e incluye mobiliario, cosmética, ropa, joyería, diseño de interior y mucho más. Siempre me obsesiona el trabajo más reciente, de forma que una vez que los objetos han visto la luz (una de cada 50 cosas que diseño), estoy en algo completamente nuevo y intento no pensar en el pasado.

¿De qué manera Nueva York supone una inspiración en su trabajo? El tamaño y la energía de Manhattan me estimulan constantemente. La ciudad de Nueva York está en eterno cambio, nunca es lo mismo de un día para otro, es la ciudad más dinámica del mundo. También se trata de un verdadero crisol, sus diversidades y globalismo son verdaderamente inspiradores.

¿Existe un estilo típico neoyorquino y, si es así, cómo se revela en su obra? El estilo que existe es bastante ecléctico y diría que es más prominente y visible en el mundo artístico. No hay un "estilo" de diseño real que emane de Nueva York y el arte y el diseño son bastante distintos.

Qual è secondo Lei il progetto più importante della Sua carriera? I miei progetti sono incredibilmente vari e riguardano l'arredamento, prodotti cosmetici, abbigliamento, gioielli, design da interni e molto altro. Il progetto più recente diventa per me quasi un'ossessione e così, quando un mio disegno viene realizzato (circa un oggetto su 50 che disegno viene poi realizzato) sono già completamente preso da qualcos'altro e mi sforzo di non pensare al passato.

In che modo la città di New York ispira il Suo lavoro? Le dimensioni e l'energia di Manhattan sono per me fonte di costante nutrimento. New York City è in continua mutazione, in costante evoluzione, non è mai la stessa, è giorno dopo giorno diversa – è la città più dinamica del mondo. È veramente un crogiuolo di culture, la sua diversità e il suo carattere globale sono vere fonti di ispirazione.

È possibile parlare di uno stile tipico per New York, e, se questo stile esiste, in che modo si manifesta nei Suoi lavori? Lo stile esistente è molto eclettico e, direi, è certo più visibile nel mondo dell'arte. Non c'è un vero stile nel design che riassuma New York, e i mondi dell'arte e del design sono piuttosto diversi.

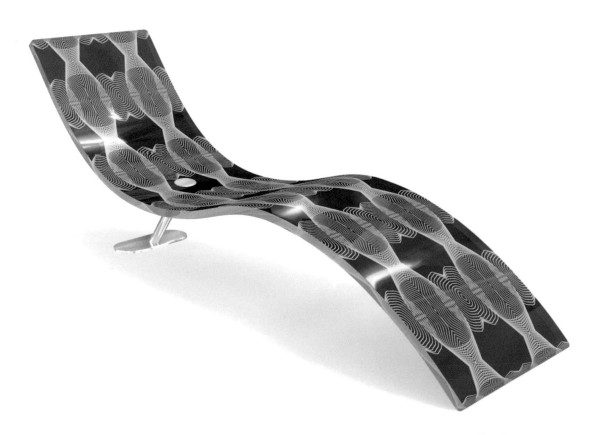

Karim Rashid 311

Collection

Kurl Shelf 2004, Kink Table 2005, Dragonfly 2005, Kloud 2Seater and chair 2006, KX 2005, Skwarim 2006, Um Chair 2005, Topograph 2005, Orikami 2005, Koho 2005

Photographs: © Courtesy of Karim Rashid Inc.

More than 2,000 of his designs have been realized to date. Designs for furniture, clothes, shoes, disposable lighters and carpets make up his portfolio along with hotels and lofts. With his dynamic, striking and colorful shapes and material vocabulary, he has been an international design trendsetter for years. In his designs, the borders between art and design flow freely and he himself calls his designs "Sensual Minimalism".

Mehr als 2000 seiner Entwürfe wurden bis heute umgesetzt. Designs für Möbel, Kleidung, Schuhe, Einwegfeuerzeuge und Teppiche zählen genauso zu seinem Repertoire wie Hotels und Lofts. Mit seiner bewegten, plakativen und farbenfrohen Formen- und Materialsprache ist er seit Jahren ein Trendsetter des internationalen Designs. Bei seinen Entwürfen sind die Grenzen zwischen Kunst und Design fließend und er selbst definiert seine Entwürfe als „Sensual Minimalism".

Plus de 2000 de ses projets ont été réalisés jusqu'à ce jour. Designs de meubles, vêtements, chaussures, briquets jetables et tapis font partie de son répertoire au même titre qu'hôtels et lofts. Avec son langage aux formes et matières mouvantes, dotées de couleurs voyantes et gaies, il est, depuis des années, le gourou du design et des nouvelles tendances sur la scène internationale. Dans ses projets, les frontières entre art et design fusionnent et il caractérise lui-même ses œuvres de « Sensual Minimalism ».

Hasta la fecha ha vendido más de 2.000 diseños propios. Su portfolio incluye tanto proyectos para muebles, ropa, zapatos, mecheros y alfombras como para hoteles y lofts. Con un lenguaje dinámico, llamativo y multicolor de formas y materiales es, desde hace años, un referente que marca tendencias en el diseño internacional. En sus trabajos, que él mismo define como "Sensual Minimalism", se confunden los límites entre el arte y el diseño.

Più di 2000 progetti sono stati realizzati fino ad oggi. Design di mobili, vestiti, scarpe, accendini monouso e tappeti fanno parte del suo repertorio alla pari di alberghi e loft. Con il suo linguaggio dinamico di forme e materiali, figurativo e colorato, è da anni un trend-setter del design internazionale. Nei suoi progetti i confini tra arte e design svaniscono ed egli stesso definisce le sue creazioni "sensual minimalism".

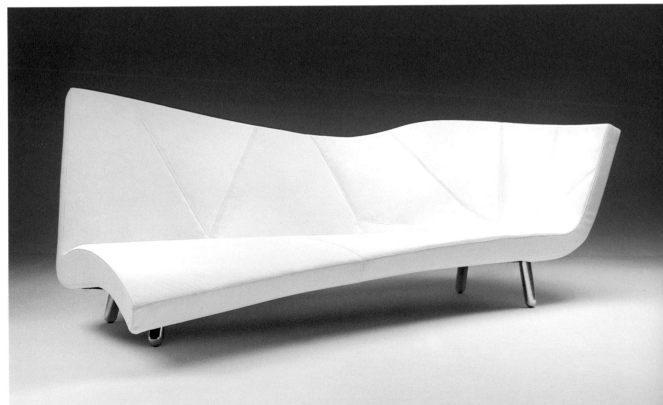

Karim Rashid

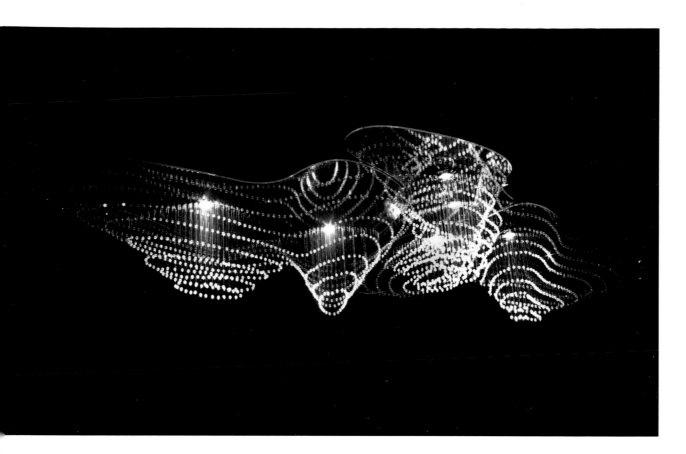

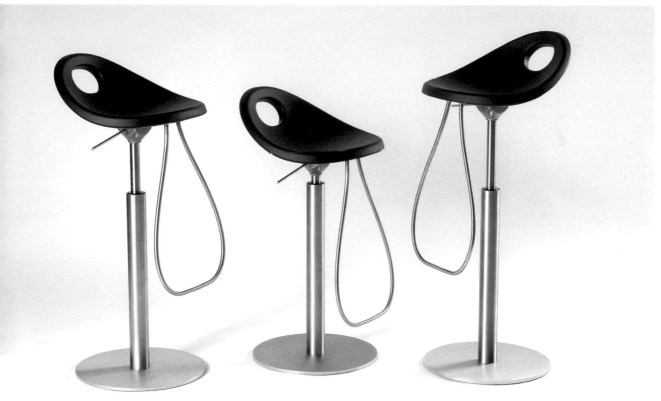

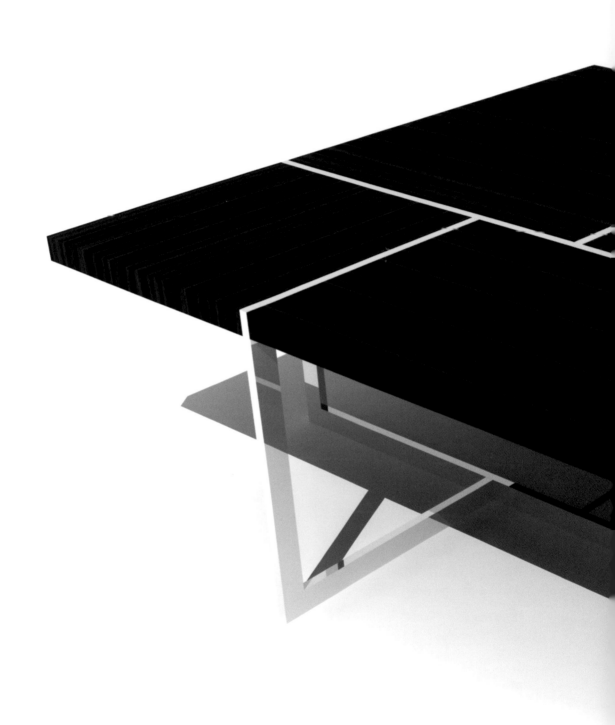

Third Eye Studios

Third Eye Studios

419 Lafayette Street, New York, NY 10003, USA

+1 917 513 9312

+1 212 228 3547

www.3estudios.net

info@ 3estudios.net

The interdisciplinary training of Marc Thorpe, who studied both industrial design and graphic design as well as architecture, can be seen in his pluralistic design approach. His company, Third Eye Studio, established in 2001 is less of a design studio and more like a collective which brings together independent architects, designers and artists, to design products together, which combine art and design with daily life.

Die interdisziplinäre Ausbildung von Marc Thorpe, der sowohl Industrie- und Grafikdesign als auch Architektur studierte, zeigt sich auch bei dem pluralistischen Ansatz seiner Entwürfe. Seine 2001 gegründete Firma Third Eye Studio ist weniger als Designstudio als vielmehr als Kollektiv zu verstehen, das unabhängige Architekten, Designer und Künstler zusammenführt, um gemeinsam Produkte zu entwerfen, die Kunst und Design mit dem alltäglichen Leben verbinden.

La formation interdisciplinaire de Marc Thorpe qui a étudié à la fois le design graphique et industriel et l'architecture, se retrouve aussi dans l'approche pluraliste des ses créations. Son entreprise, Third Eye Studio, fondée en 2001, plus qu'un studio de design est davantage un groupe, qui réunit des architectes, designers et artistes indépendants pour concevoir des projets communs alliant l'art et le design à la vie quotidienne.

Marc Thorpe estudió diseño gráfico e industrial así como también arquitectura, en el enfoque pluralista de sus proyectos se deja ver esta formación interdisciplinar. Third Eye Studio, la firma que fundó en 2001, podría definirse como un estudio de diseño, aunque más bien debería entenderse como un colectivo que reúne a arquitectos, diseñadores y artistas independientes para diseñar conjuntamente productos que combinan el arte y el diseño con la vida cotidiana.

La formazione interdisciplinare di Marc Thorpe, che ha studiato sia design industriale e grafica, che architettura, si mostra anche nell'approccio pluralistico dei suoi progetti. La sua ditta Third Eye Studio, fondata nel 2001, non è tanto uno studio di design, quanto piuttosto un collettivo che riunisce architetti, designer ed artisti indipendenti, allo scopo di creare nuovi prodotti che uniscano l'arte ed il design alla la vita quotidiana.

Marc Thorpe

1978
Marc Andreas Thorpe born in Maryland, USA

2000
Bachelor Degree in Industrial and Graphic Design, University of Maryland, USA

1998
Director of Design, DSA Associates, Washington, USA

2001
Foundation of Third Eye Studios NYC, New York, USA

2004
Master Degree in Architecture, Parsons School of Design, New York, USA

2005
Edge Table

Interview | Third Eye Studios

Which do you consider the most important work of your career? When Enzo Ferrari was asked what his favorite Ferrari was he said, "the one designed tomorrow." I completely agree with this notion.

In what ways does New York inspire your work? For me the most inspirational thing about New York City is the act of reformulation. The city is consistently evolving in front of our eyes. It is representative of the process of life and its holistic properties. It is an abstracted reflection of the inner connected nature of everyone and everything.

Does a typical New York style exist? No, to define something as a particular style is to limit it. New York brings the world together to create a new mutation of hybrid of cultures and influences. It is ever changing and in a constant state of flux. With respect to this condition, it does not allow us to define it.

How do you imagine New York in the future? I would like to imagine New York in the future as the one place in the world everyone can call home.

Was halten Sie für die wichtigste Arbeit in Ihrer Karriere? Als Enzo Ferrari gefragt wurde, was sein Lieblings-Ferrari sei, sagte er: „der, der morgen entworfen wird". Dem schließe ich mich an.

Auf welche Weise inspiriert New York Ihre Arbeit? Das Inspirierendste an New York City ist für mich das Gesetz der dauernden Erneuerung. Die Stadt entwickelt sich stets weiter, vor unseren Augen. Das ist repräsentativ für den Lebensprozess sowie dessen ganzheitliche Eigenschaften. Abstrakt gesehen spiegelt sich darin die innere Verbundenheit von allem und jedem wider.

Gibt es einen typischen New Yorker Stil, und wenn ja, wie zeigt sich das in Ihrer Arbeit? Nein. Wenn man etwas als einen bestimmten Stil bezeichnet, so grenzt man es ein. New York bringt die ganze Welt an einem Ort zusammen, um aus den verschiedenen Kulturen und Einflüssen eine neue hybride Variante zu erschaffen. Die Stadt verändert sich stets aufs Neue und ist fortwährend in Bewegung. Der Respekt gegenüber diesem Zustand erlaubt uns keine Festlegung.

Wie stellen Sie sich New York in der Zukunft vor? Ich fände es schön, wenn New York in der Zukunft derjenige Ort wäre, den jeder auf der Welt ein Zuhause nennen kann.

Quelle est l'œuvre la plus importante de votre carrière ? Lorsqu'on a demandé à Enzo Ferrari de nommer sa Ferrari préférée, il a répondu, « celle que je concevrai demain.» Je partage entièrement cette opinion.

Dans quelle mesure la ville de New York inspire-t-elle votre œuvre ? Je pense que c'est l'action de reformuler les choses qui m'inspire le plus à New York. La ville évolue constamment sous vos yeux. Elle incarne le processus vital et ses caractéristiques holistiques. C'est le reflet abstrait de la nature intrinsèque des gens et des choses.

Peut-on parler d'un style typiquement new-yorkais ? Non, si on définit un style particulier on lui fixe des limites. New York réunit tout le monde pour créer une nouvelle mutation de cultures et influences hybrides. Elle est dans un état permanent de changement et de flux constant. Si on respecte cet état d'esprit, on ne peut le définir.

Comment imaginez-vous le New York de demain ? Je souhaiterai que le New York de demain reste le seul endroit au monde où chacun se sente chez soi.

¿Cuál es el trabajo que considera más importante en su carrera? Cuando preguntaron a Enzo Ferrari cuál era su Ferrari favorito él contesto, "el que se va a diseñar mañana". Estoy totalmente de acuerdo con esta idea.

¿De qué manera Nueva York supone una inspiración en su trabajo? Para mí, lo más inspirador de la ciudad de Nueva York es el acto de la reformulación. La ciudad está evolucionando de forma constante delante de tus ojos. Es una representación del proceso de la vida y de sus propiedades holísticas. Es una reflexión abstraída de la naturaleza interior conectada de todos y todo.

¿Existe un estilo típico neoyorquino? No, definir algo como un estilo particular es limitarlo. Nueva York es un puente de unión internacional que crea una nueva mutación de la mezcla de culturas e influencias. Está en un constante estado de cambio y fluctuación. El respeto a esta condición no nos permite definirla.

¿Cómo se imagina Nueva York en el futuro? Me gustaría imaginar Nueva York en el futuro como el único lugar del mundo que todos puedan llamar hogar.

Cosa pensa che sia la cosa più importante della Sua carriera? Quando chiesero a Enzo Ferrari quale era la sua Ferrari preferita, egli rispose: "quella che disegneremo domani." Sono completamente d'accordo con questa visione.

In che modo New York inspira il Suo lavoro? L'ispirazione maggiore che traggo da New York City è la continua riformulazione. La città continua ad evolvere davanti ai propri occhi. È una rappresentazione del processo vitale e delle sue proprietà olistiche. É una riflessione astratta della natura profondamente connessa di tutto e di tutti.

Esiste uno stile tipico di New York? No, definire qualcosa come stile particolare significa porgli dei limiti. New York riunisce il mondo per creare una nuova mutazione di culture e influenze ibride. La città cambia continuamente e si trova in un flusso di modifiche incessanti. Nel rispetto di questa condizione non è possibile darci una definizione.

Come si immagina New York in futuro? Mi immagino la New York del futuro come un posto che tutti potranno chiamare casa.

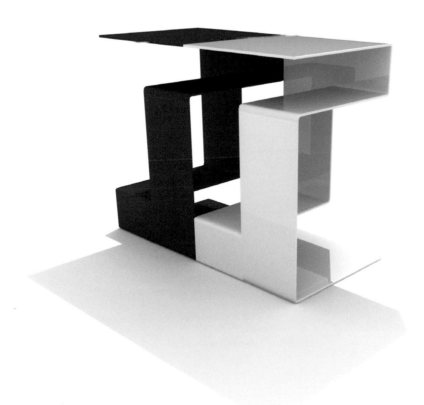

Collection

Edge Table 2005, L7 Loung Chair 2006, Rift Unit 2004, Revo Unit 2006, JamesT 2006, Poof Table 2006, TEK armchair 2006
Photographs: © Greg Hess

Marc Thorpe's comprehensive and interdisciplinary training forms the basis of his designs. For the design of the Edge Table, Mark Thorpe worked hard on the idea of the invisible. Inspired by camouflage tactics used on battleships during World War II, he developed a dynamic shape out of glass plates. This diagonal structure was then joined together with a special adhesive which hardens extremely quickly under UV light.

Die umfassende und interdisziplinäre Ausbildung von Marc Thorpe bildet die Grundlage seiner Entwürfe. Für das Design des Edge Table beschäftigte sich Marc Thorpe intensiv mit der Idee des Unsichtbaren. Inspiriert von den Taktiken der Tarnung der Schlachtschiffe während des Zweiten Weltkrieges entwickelte er eine dynamische Form aus Glasplatten. Diese diagonale Struktur wurde dann mit einem Spezialkleber zusammengefügt, der sehr schnell unter UV Licht härtet.

La formation complète et interdisciplinaire de Marc Thorpe se reflète dans ses créations. Dans le design de la Edge Table, Marc Thorpe explore intensément l'idée de l'invisible. S'inspirant de la tactique de camouflage des navires de combats lors de la Seconde Guerre Mondiale, il conçoit une forme dynamique à base de plaques de verre. Cette structure en diagonale est ensuite assemblée avec une colle spéciale qui durcit rapidement sous l'action des UV.

La base de los proyectos de Marc Thorpe viene marcada por su amplia formación interdisciplinar. Para el diseño de la Edge Table se centró intensamente en la idea de lo invisible. Inspirado en las tácticas de camuflaje empleadas por los buques acorazados durante la Segunda Guerra Mundial, desarrolló un modelo dinámico hecho a partir de placas de vidrio. Esta estructura diagonal se unió con un pegamento especial que se endurece rápidamente con luz ultravioleta.

L'ampia formazione interdisciplinare di Marc Thorpe costituisce la base delle sue creazioni. Per il progetto della Edge Table Marc Thorpe ha a lungo approfondito l'idea dell'invisibile. Ispirato dalle tattiche di mimetizzazione delle navi da guerra durante la seconda guerra mondiale, sviluppò una forma dinamica di lastre di vetro. Questa struttura diagonale venne successivamente unita con una colla speciale ad indurimento ultrarapido sotto l'effetto dei raggi UV.

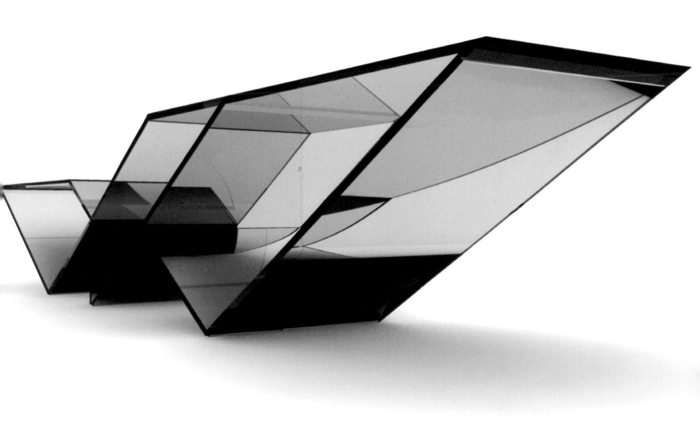

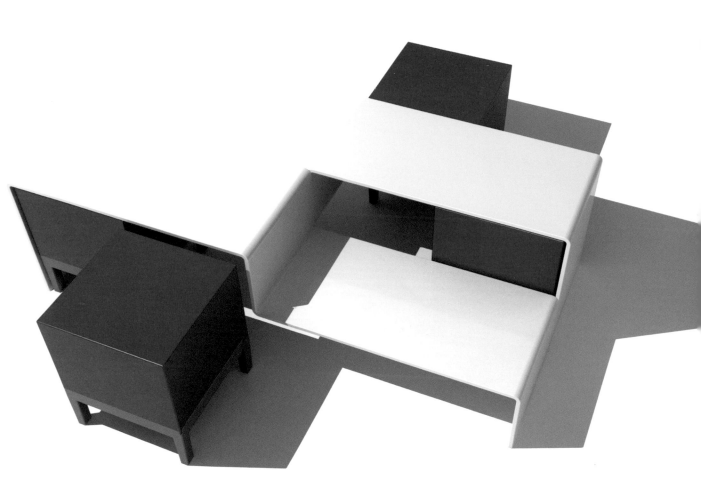

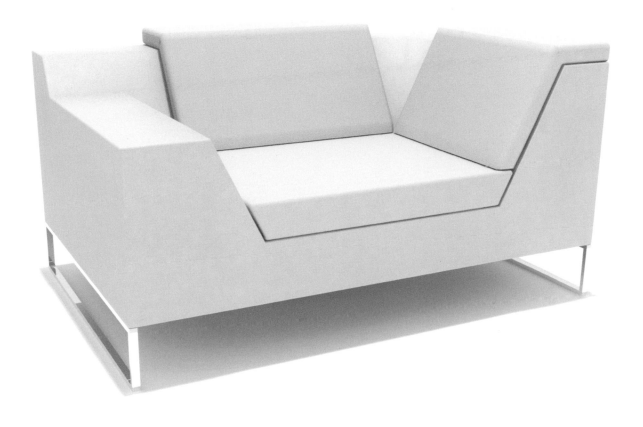

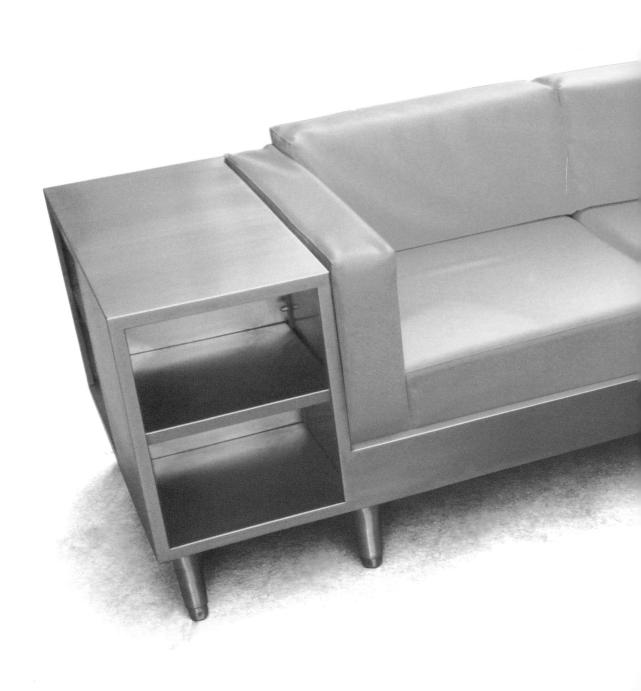

Kabalab

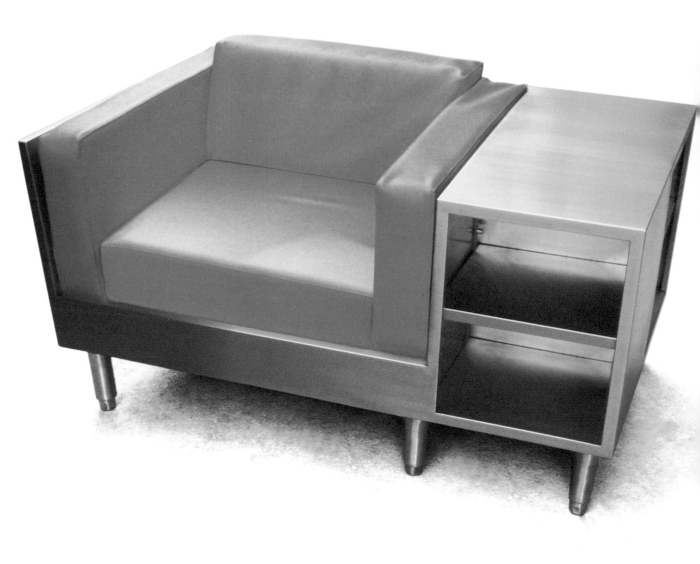

Kabalab

Kabalab

311 Baltic Street, Suite 1A, Brooklyn, NY 11201, USA

+1 718 666 5683

+1 718 935 4080

www.kabalab.com

info@kabalab.com

In their studio, Kabalab in Brooklyn, the German-born designers Karlheinz Schempp and Barbara Kohler not only design furnishings and products, but they also develop graphic design solutions. Their minimalist and unique works, which have a holistic basis, won the IDSA Award for the best product design of the year and are also featured in the design store of the Museum of Modern Art (MoMA).

In ihrem Studio Kabalab in Brooklyn entwerfen die in Deutschland geborenen Designer Karlheinz Schempp und Barbara Kohler nicht nur Mobiliar und Produkte, sondern entwickeln auch Grafik-Design-Lösungen. Ihre minimalistischen und originellen Arbeiten, denen ein holistischer Designansatz zu Grunde liegt, gewannen den IDSA Award für das beste Produktdesign des Jahres und werden auch im Designgeschäft des Museum of Modern Art (MoMA) geführt.

Les designers Karlheinz Schempp et Barbara Kohler, nés en Allemagne, conçoivent dans leur Studio Kabalab de Brooklyn, du mobilier et des produits, mais aussi des propositions de design graphique. Leurs œuvres minimalistes et originales, dotées d'une approche de design holistique, ont obtenu le IDSA Award pour le meilleur design de produit de l'année et seront exposés dans la boutique de design du Museum of Modern Art (MoMA).

En su estudio Kabalab de Brooklyn, los diseñadores de origen alemán Karlheinz Schempp y Barbara Kohler no solo crean muebles y productos, sino que también desarrollan soluciones de diseño gráfico. Sus trabajos minimalistas y originales, con una aproximación holística, han sido premiados con el IDSA Award para el mejor producto del año y también se encuentran en la tienda de diseño del Museum of Modern Art (MoMA).

Nel loro studio Kabalab a Brooklyn i designer tedeschi Karlheinz Schempp e Barbara Kohler non progettano solo mobili e oggetti, ma si occupano anche di soluzioni di graphic design. I loro originali lavori minimalistici, che si basano su un approccio olistico, vinsero l'IDSA Award per il miglior design dell'anno e sono in vendita anche nel negozio di design del Museum of Modern Art (MoMA).

Barbara Kohler

1969
Born in Kempten, Germany

1997
BA Design, Hochschule für Gestaltung, Schwäbisch Gmünd, Germany

Karlheinz Schempp

1968
Born in Kempten, Germany

1997
BA Design, Hochschule für Gestaltung, Schwäbisch Gmünd, Germany

2001
Foundation of Kabalab, New York, USA

2002
Kabafurniture
Kabaclip

2003
Kabaclip, Industrial Design Excellence Award for best product of year

2003
Kabacase

Interview | Kabalab

Which do you consider your most important work in your career? For a designer every new project should be the most important in the career. But reviewing our products the contact lens case KABACLIP stands out.

In what ways does New York inspire your work? New York is a city of extremes. In such a place—where cultures meet, inspire, mate, and reproduce—life, unsuspectingly, turns into design.

Does a typical New York style exist, and if so, how does it show in your work? It is hard to define a New York style. However there seems to exist the urge for uncluttered, lean and clean solutions that are very powerful and emotionally appealing.

How do you imagine New York in the future? New York is home to a blazing concentration of smart and adventurous people who want to change the world. Combine this with their built-in optimism and the outcome will always be something new—again and again and again...

Was halten Sie für die wichtigste Arbeit in Ihrer Karriere? Für einen Designer sollte jedes neuo Projekt das wichtigste der Karriere sein. Aber wenn ich unsere Arbeiten Revue passieren lasse, so sticht der Kontaktlinsenbehälter KABACLIP heraus.

Auf welche Weise inspiriert New York Ihre Arbeit? New York ist eine Stadt der Extreme. An solch einem Ort – wo Kulturen aufeinander treffen, sich inspirieren, paaren und fortpflanzen – da wird kurzerhand das Leben selbst zum Design.

Gibt es einen typischen New Yorker Stil, und wenn ja, wie zeigt sich das in Ihrer Arbeit? Es ist schwierig, einen New Yorker Stil zu definieren. Es existiert jedoch scheinbar ein Drang nach ordentlichen, knappen und sauberen Lösungen, in denen viel Kraft steckt und die emotional ansprechend sind.

Wie stellen Sie sich New York in der Zukunft vor? New York heheimatet viele smarte und abenteuerlustige Menschen, die die Welt verändern wollen. In Kombination mit dem ihnen angeborenen Optimismus wird als Ergebnis immer etwas gänzlich Neues herauskommen – immer und immer wieder ...

Quelle est l'œuvre la plus importante de votre carrière ? Pour un designer tout nouveau projet doit être le plus important de sa carrière. Mais si je passe en revue tous nos produits, je pense que l'étui de lentilles de contact KABACLIP est le projet phare.

Dans quelle mesure la ville de New York inspire-t-elle votre œuvre ? New York est une ville d'extrêmes. Dans un tel lieu–où les cultures se rencontrent, s'inspirent les unes de autres, s'accouplent et se mêlent–la vie, sans crier garde, devient design.

Peut-on parler d'un style typiquement new-yorkais, et si oui, comment se manifeste-t-il dans votre œuvre ? Il est difficile de définir un style new-yorkais. En tout cas, il y a un désir apparent de trouver des solutions simples, claires et nettes, durables et d'une grande portée émotionnelle.

Comment imaginez-vous le New York de demain ? New York est la terre d'accueil d'une forte concentration de gens intelligents et aventureux qui veulent changer le monde. Si vous combinez cela à leur optimisme intrinsèque, vous aurez toujours quelque chose de nouveau–encore et encore...

¿Cuál es el trabajo que considera más importante en su carrera? Para un diseñador, cada nuevo proyecto debe ser el más importante de su carrera. No obstante, si echamos un vistazo a nuestros productos destaca la caja para lentes de contacto KABACLIP.

¿De qué manera Nueva York supone una inspiración en su trabajo? Nueva York es una ciudad de extremos. En un lugar así, donde las culturas se encuentran, inspiran, emparejan y reproducen, la vida se convierte en diseño, sin siquiera saberlo.

¿Existe un estilo típico neoyorquino, y si es así, cómo se revela en su obra? Es difícil definir un estilo neoyorquino. No obstante, parece existir la necesidad de soluciones no recargadas, enjutas y limpias con un enorme potencial y atractivo emocional.

¿Cómo se imagina Nueva York en el futuro? Nueva York es el hogar de una brillante concentración de gente inteligente y aventurera que quiere cambiar el mundo. La combinación de esto con su optimismo inherente siempre dará como resultado algo nuevo, una y otra vez...

Cosa pensa che sia la cosa più importante della Sua carriera? Per uno stilista ogni nuovo progetto dovrebbe essere quello più importante della sua carriera. Ma se guardiamo ai nostri prodotti, risalta la custodia per lenti a contatto KABACLIP.

In che modo New York influenza il Suo lavoro? New York è una citta degli estremi. In un luogo come questo, dove le culture si incontrano, si inspirano, si mischiano e si riproducono, la vita ingenuamente diventa design.

Esiste uno stile tipico a New York? Se sì, come influenza il Suo lavoro? È difficile definire uno stile per New York. Comunque, sembra che esista un impulso verso le soluzioni effettive, scabre e nette che sono allo stesso tempo molto potenti e emozionalmente attraenti.

Come si immagina New York in futuro? New York è la patria di una vistosa massa di gente abile ed avventurosa che vuole cambiare il mondo. Combinando questo con il loro innato ottimismo, ciò che verrà fuori sarà sempre qualcosa di nuovo – sempre e sempre di nuovo...

Kabafurniture

Year: 2003
Photographs: © Erich Dapunt

The experiences of the two designers of Kabalab are as varied as their designs. For the Kabafurniture collection, they drew inspiration from the construction materials from New York's industrial quarters. Simple steel furniture is not only designed for the home, but also for the office, thereby providing versatile use. In order to follow production down to the detail, the designs are realized by local companies.

Die Erfahrungen der beiden Designer von Kabalab sind so vielfältig wie ihre Entwürfe. Für die Kollektion Kabafurniture ließen sie sich von den Konstruktionsmaterialien der industriellen Viertel New Yorks inspirieren. Die schlichten Stahlmöbel sind dabei nicht nur für zu Hause, sondern zugleich auch für das Büro konzipiert und ermöglichen so eine vielfältige Nutzung. Um die Produktion bis ins Detail verfolgen zu können, werden die Designs von lokalen Firmen umgesetzt.

L'expérience des designers de Kabalab est aussi variée que leurs projets. Pour la collection Kabafurniture, ils se sont inspirés des matériaux de construction des quartiers industriels de New York. Les meubles en acier aux formes épurées, conçus à la fois pour la maison et pour le bureau, sont donc multifonctionnels. Pour suivre la production jusque dans les moindres détails, les designs sont réalisés par des entreprises locales.

Las experiencias de los dos diseñadores de Kabalab son tan variadas como sus trabajos. Para la colección Kabafurniture se inspiraron en los materiales de la construcción del barrio industrial de Nueva York. Los sobrios muebles de metal no están concebidos únicamente para le hogar, sino también para la oficina, y permiten así un uso versátil. Para poder hacer un estrecho seguimiento de la producción, los diseños se fabrican en empresas locales.

Le esperienze dei designer di Kabalab sono molteplici almeno quanto i loro progetti. Per la collezione Kabafurniture presero l'ispirazione dai materiali da costruzione dei quartieri industriali di New York. I sobri mobili di acciaio non sono pensati solo per l'abitazione, ma sono concepiti anche per l'ufficio e permettono un uso molteplice. Per poter seguire tutta la produzione fino al minimo dettaglio, i progetti vengono fatti realizzare da ditte locali.

Brave Space

Brave Space

Brave Space

449 Troutman Street, Studio 2a, Brooklyn, NY 11237, USA

+1 646 831 2470

+1 718 417 3180

www.bravespacedesign.com

info@bravespacedesign.com

The studio was founded in Brooklyn in 2002. Their experience in the modernization of apartments in New York gave the designers the motivation to design modular and multifunctional furniture, which makes optimal use of available space and can be used in a flexible manner. In addition to the quality of the materials used, they placed special importance on their environmental compatibility.

Das Studio wurde 2002 in Brooklyn gegründet. Erfahrungen bei der Modernisierung von Apartments in New York gaben den Designern die Anregung, modulare und multifunktionale Möbel zu entwerfen, die den verfügbaren Platz optimal ausnutzen und vielseitig verwendbar sind. Neben der Qualität der verwendeten Materialien wird besonders Wert auf deren Umweltverträglichkeit gelegt.

Le studio de design est fondé en 2002, à Brooklyn. Suite à leurs divers projets de modernisation d'appartements, à New York, les designers ont l'idée de concevoir des meubles modulables, multifonctionnels et polyvalents pour maximaliser l'espace disponible. Outre la qualité des matériaux employés, ils réservent, dans leur démarche conceptuelle, une grande place au respect de l'environnement.

El estudio se fundó en Brooklyn en el año 2002. La experiencia acumulada en la modernización de apartamentos neoyorquinos sirvió de estímulo para diseñar muebles modulares y multifuncionales que aprovechan de forma óptima el espacio disponible y pueden cumplir múltiples usos. Junto de la calidad de los materiales utilizados, en sus diseños otorgan especial importancia a la compatibilidad con el medio ambiente.

Lo studio fu fondato a Brooklyn nel 2002. La loro esperienza nella ristrutturazione di appartamenti a New York diede a questi designer l'impulso per progettare mobili modulari e multifunzionali, che sfruttano al meglio lo spazio a disposizione e possono essere impiegati in diversi modi. Accanto alla qualità dei materiali utilizzabili danno particolare valore alla sostenibilità ambientale.

Brave Space

2002
Foundation of Brave Space by Sam Kragiel, Nikki Frazier and Jesse James Arnold, New York, USA

2004
Tetris Shelving

2005
Bamboo Slide
Bamboo Stagger

2006
Tetris Flat
Hollow Table & Endtable
Folded Shelves

Interview | Brave Space

Which do you consider the most important work of your career? That would be allowing sustainable materials to be an effortless facet in our design process. These materials not only become an instinctive choice, but a reliable and complimentary aspect of our work.

In what ways does New York inspire your work? NY is a pillar of strength in adaptability, a natural progression in the city gives way for movements and the creation of new ideas.

Does a typical New York style exist, and if so, how does it show in your work? The style of New York reflects the people and diversity of the city. The design world grows and changes along with the city and the people who inhabit it. That will always be shown in current design work

How do you imagine New York in the future? We imagine NY taking part in the growing movement towards sustainability and the opportunities to procure green materials to be incorporated into the continued evolution of design.

Was halten Sie für die wichtigste Arbeit in Ihrer Karriere? Unsere wichtigste Arbeit ist der Versuch, bei unseren Designprozessen umweltverträgliche Materialien auf problemlose Weise zu integrieren. Diese Materialien sind bei unserer Arbeit nicht nur eine instinktive Wahl, sondern haben sich auch als zuverlässig und empfehlenswürdig erwiesen.

Auf welche Weise inspiriert New York Ihre Arbeit? New York ist eine extrem anpassungsfähige Stadt, deren Eigenart stets für neue Strömungen und kreativen Ideenreichtum sorgt.

Gibt es einen typischen New Yorker Stil, und wenn ja, wie zeigt sich das in Ihrer Arbeit? Im New Yorker Stil spiegeln sich die Menschen und die Vielfalt dieser Stadt wider. Die Designerwelt wächst und verändert sich mit der Stadt und ihren Einwohnern. Das wird sich immer auch Im Design bemerkbar machen.

Wie stellen Sie sich New York in der Zukunft vor? Unserer Meinung nach wird auch in New York das weltweit anwachsende Umweltbewusstsein Einzug halten und die Integration umweltverträglicher Materialien wird so zum festen Bestandteil in der Designentwicklung werden.

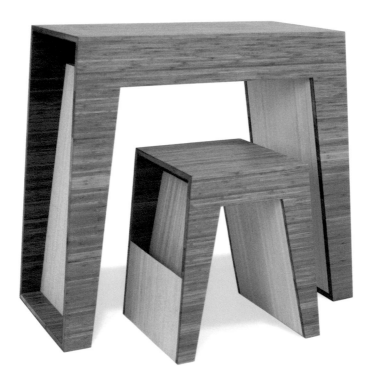

Quelle est l'œuvre la plus importante de votre carrière ? Ce serait faire des matières durables une vaine facette de notre processus conceptuel. Ces matériaux sont non seulement devenus un choix instinctif, mais un aspect complémentaire, inhérent à notre oeuvre.

Dans quelle mesure la ville de New York inspire-t-elle votre œuvre ? New York étant la reine de l'adaptabilité, la ville développe une tendance naturelle pour les courants et les créations de nouvelles idées.

Peut-on parler d'un style typiquement new-yorkais, et si oui, comment se manifeste-t-il dans votre œuvre ? Le style de New York reflète les gens et la diversité de la ville. Le monde du design se développe et change au rythme de la ville et des gens qui y vivent. Cela apparaîtra toujours en filigrane dans notre design.

Comment imaginez-vous le New York de demain ? Nous imaginons New York comme partie intégrante du mouvement croissant en faveur du développement durable et de la création de moyens d'incorporer la végétation dans l'essor continu du design.

¿Cuál es el trabajo que considera más importante en su carrera? Sería permitir que los materiales sostenibles fueran una faceta natural en nuestro proceso de diseño. Estos materiales no sólo se convierten en una elección instintiva, sino en un aspecto fiable y elogioso de nuestro trabajo.

¿De qué manera Nueva York supone una inspiración en su trabajo? Nueva York es un pilar de fortaleza en adaptabilidad, una progresión natural en la ciudad da paso a los movimientos y la creación de nuevas ideas.

¿Existe un estilo típico neoyorquino, y si es así, cómo se revela en su obra? El estilo de Nueva York refleja la gente y la diversidad de la ciudad. El mundo del diseño crece y cambia con la ciudad y la gente que vive en ella. Eso siempre se mostrará en el trabajo de diseño actual.

¿Cómo se imagina Nueva York en el futuro? Nos imaginamos Nueva York formando parte del movimiento en auge hacia la sostenibilidad y las oportunidades para obtener materiales ecológicos que se incorporen a la evolución continuada del diseño.

Cosa pensa che sia la cosa più importante della Sua carriera? Sarebbe come ammettere che dei materiali sostenibili non sono che sfaccettature prive di sforzo all'interno del nostro processo stilistico. Questi materiali non solo diventano una scelta instintiva, ma anche un aspetto attendibile e complementare del nostro lavoro.

In che modo New York influenza il Suo lavoro? NY è una forza in quanto all'adattabilità, l'evoluzione naturale della città da spazio ai movimenti e alla creazione di nuove idee.

Esiste uno stile tipico a New York? Se sì, come influenza il Suo lavoro? Lo stile di New York riflette gente e diversità della città. Il mondo del design cresce e cambia insieme alla città e insieme alla gente che vi abita. Nei lavori di design attuali questo sarà sempre presente.

Come si immagina New York in futuro? Ci immaginiamo una NY che faccia parte del movimento crescente verso l'ecocompatibilità e ci immaginiamo le opportunità offerte dai materiali verdi quando sono coinvolte nell'evoluzione continua del design.

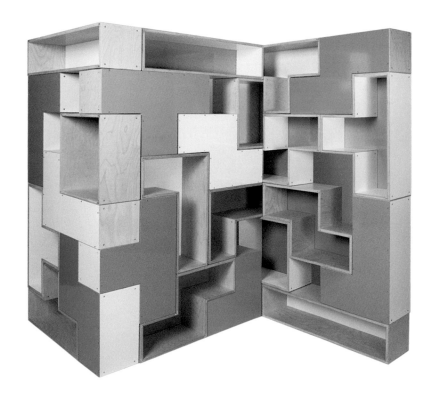

Collection

Bamboo Slide 2005, Bamboo Stagger 2005, Hollow Table and Hollow End Table 2006, Tetris Flat 2006, Tetris Shelving 2004

Photographs: © Nikki Frazier, Sean Hemmerly

Brave Space's designs are modular and can be used in a multifunctional manner. Inspired by video games, for example, the Tetris shelf is made up of a multitude of basic modules, which can easily be combined as desired and which can be expanded as needed. The highly versatile table, Bamboo Slide was specially designed for small kitchens. In addition to swing-out work surfaces and supplemental storage space, a wine shelf was integrated as an added bonus.

Die Designs von Brave Space sind modular und multifunktional einsetzbar. Inspiriert von Videospielen, besteht beispielsweise das Regal Tetris aus einer Vielzahl von Grundmodulen, die sich beliebig und spielerisch zusammensetzen und bei Bedarf erweitern lassen. Der vielseitig verwendbare Tisch Bamboo Slide wurde speziell für kleine Küchen entworfen. Neben ausklappbaren Arbeitsflächen und zusätzlichem Stauraum wurde als Clou ein Weinregal integriert.

Les designs de Brave Space sont modulables et multifonctionnels. S'inspirant de jeux vidéos, l'étagère Tetris est composée de plusieurs modules de base, dont le montage, à l'instar d'un jeu d'enfant, se fait au gré des désirs, avec la possibilité d'en moduler la taille à souhait. La table polyvalente Bamboo Slide est spécialement conçue pour la cuisine de petite taille. A côté de plans de travail pliables et de possibilités de rangements supplémentaires, elle intègre aussi, cerise sur le gâteau, l'étagère à vins.

Los diseños de Brave Space son modulares y multifuncionales. Por ejemplo, la estantería Tetris, inspirada en el videojuego, consta de un gran número de módulos básicos que se pueden combinar a discreción y ampliar en caso necesario. La mesa Bamboo Slide, especialmente versátil, se desarrolló para cocinas pequeñas. Además de las superficies de trabajo desplegables y del espacio adicional de almacenaje, otra de las claves fue la integración de un botellero.

Gli oggetti di design di Brave Space sono utilizzabili in maniera modulare e multifunzionale. Lo scaffale Tetris, per esempio, che si ispira all'omonimo videogioco, è composto da numerosi moduli di base, che possono essere composti ed abbinati giocosamente in infinite combinazioni, ed in caso di necessità possono essere ampliati. Il tavolo Bamboo Slide dai molteplici usi è stato progettato appositamente per le cucine di piccole dimensioni. Oltre ai ripiani da lavoro estraibili ed all'ulteriore spazio portaoggetti, come colpo di scena vi è stato addirittura integrato uno scaffale per i vini.

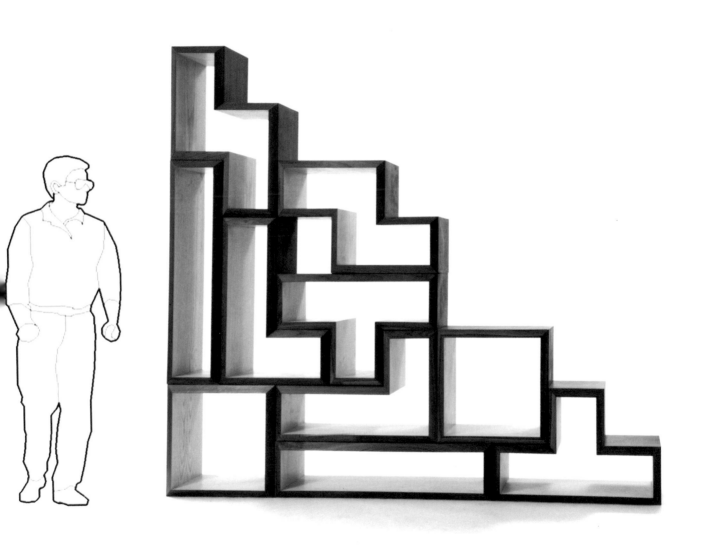

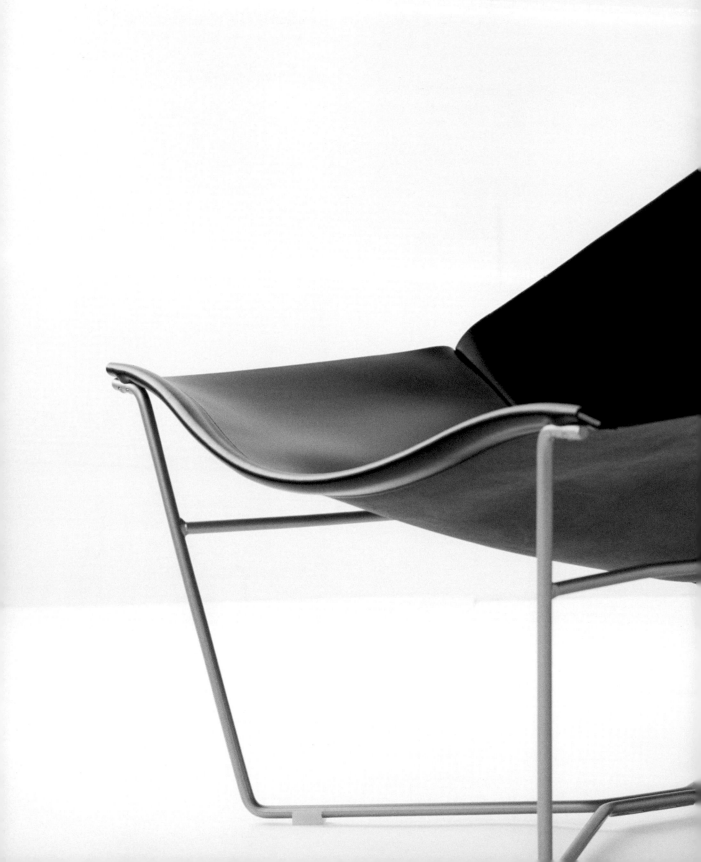

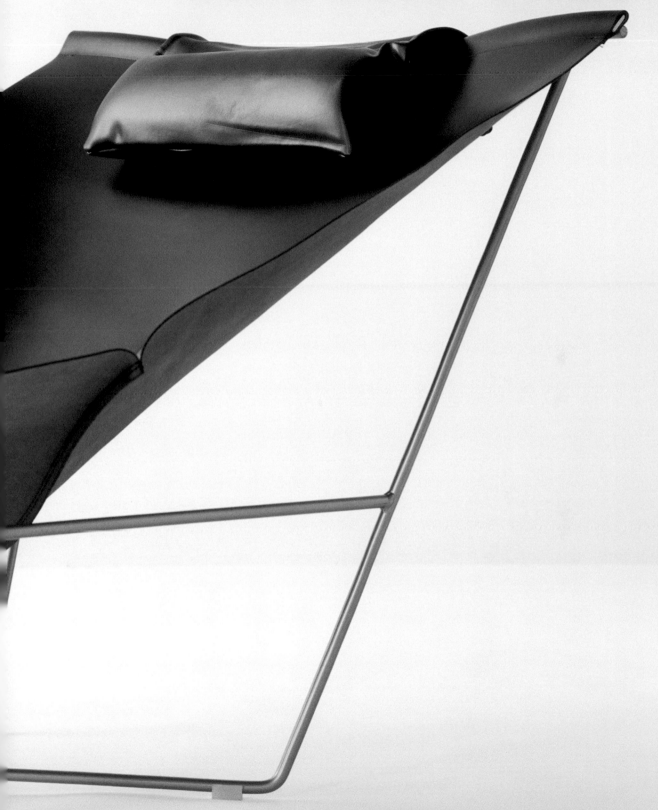

David Weeks Studio

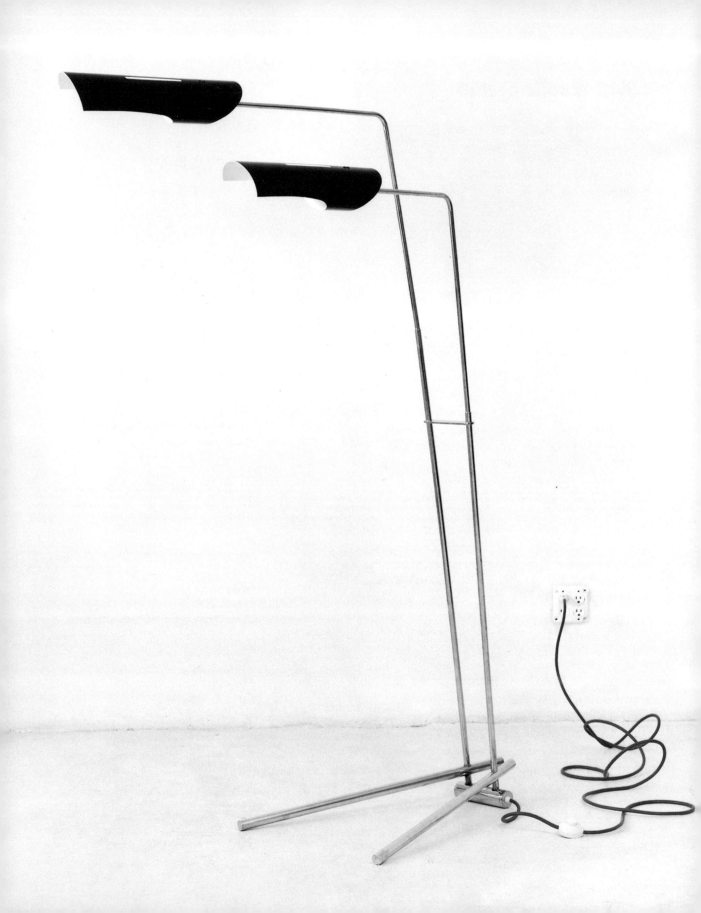

David Weeks Studio

61 Pearl Street, No 612A, Brooklyn, NY 11201, USA

+1 718 596 7945

+1 718 596 7914

www.davidweeksstudio.com

dw@davidweeksstudio.com

David Weeks

After studying painting and sculpture, David Weeks first worked with the jeweler, Ted Muehling, before creating his own studio in Brooklyn in 1996. He not only designs his products himself, but he also finishes them by hand in the adjacent workshop. His particular interest is in the design of lamps for which he was awarded the Editors Choice Award at the International Furniture Fair in 1999.

Nach seinem Studium der Malerei und Bildhauerei arbeitete David Weeks zunächst mit dem Juwelier Ted Muehling zusammen, bevor er 1996 sein eigenes Studio in Brooklyn gründete. Seine Produkte entwirft er nicht nur selbst, sondern fertigt sie auch per Hand in der angrenzenden Werkstatt an. Dabei gilt sein spezielles Interesse dem Design von Leuchten, für die er 1999 mit dem Editors Choice Award der International Furniture Fair ausgezeichnet wurde.

Après ses études de peinture et de sculpture David Weeks travaille d'abord avec le joaillier Ted Muehling, avant de créer en 1996 son propre studio à Brooklyn. En plus de concevoir lui-même ses produits, il les réalise à la main dans l'atelier attenant. Il s'intéresse surtout au design de luminaires, et se voit décerner en 1999 le Editors Choice Award de l'International Furniture Fair.

Después de estudiar pintura y escultura David Weeks colaboró con el joyero Ted Muehling antes de abrir su propio estudio en Brooklyn. No solo diseña él mismo sus proyectos, sino que también los elabora a mano en los talleres colindantes. Se ha centrado especialmente en el diseño de lámparas, por el que fue galardonado en 1999 con el Editors Choice Award de la feria International Furniture Fair.

Dopo gli studi di pittura e scultura, David Weeks collaborò in un primo tempo con il gioielliere Ted Muehling per fondare nel 1996 il suo proprio studio a Brooklyn. Egli disegna tutti i suoi prodotti e li fabbrica poi manualmente nell'officina annessa. Il suo interesse si rivolge particolarmente al disegno di luminari, per i quali nel 1999 è stato premiato con il Editors Choice Award della International Furniture Fair (Fiera internazionale del mobile).

1968
David Weeks born in Athens, Georgia, USA

1990
Bachelor of Fine Arts at Rhode Island School of Design, Providence, Rhode Island, USA

1996
Foundation of David Weeks Studio, New York, USA

1997
Two-arm Sconce with Bottle Shade

1999
Semana Chair
Editors Choice Award, International Furniture Fair

2000
Gorilla Ashtray

2003
Boi Sconce and Tri-Boi Chandelier

2004
Bucket Light
Woven Chair and Woven Couch

2005
Torroja Cross Chandelier and Torroja Standing Lamp

Interview | David Weeks Studio

Which do you consider the most important work of your career? I guess the original Mobile design. I've always seen my designs as a body of work. Commenting on each other. Educating future decisions. I hope to do my best work 10 to 20 years from now.

In what ways does New York inspire your work? If I left New York my focus and output would be cut in half. The street life and hundreds of strangers you see everyday is also crucial.

Does a typical New York style exist, and if so, how does it show in your work? A client once classified my work as not American, not European, but very New York. New York design is exactly what it should be; no bells and whistles, no fussiness, just bang on.

How do you imagine New York in the future? I'm concerned. Much of the subculture has been destroyed by higher rents. New York is becoming a cleaner, safer, less interesting place. Which is disappointing. I've always been inspired by the fringe element.

Was halten Sie für die wichtigste Arbeit in Ihrer Karriere? Das ursprüngliche Mobile Design. Ich habe meine verschiedenen Designarbeiten immer als Teil eines Ganzen angesehen. Sie spielen aufeinander an und bilden Grundlagen für neue Entscheidungen. Ich hoffe, dass meine besten Arbeiten erst in 10 bis 20 Jahren entstehen.

Auf welche Weise inspiriert New York Ihre Arbeit? Wenn ich aus New York wegginge, würden sich meine Konzentration und Produktivität halbieren. Das Leben auf den Straßen und die hunderte von Fremden, die man jeden Tag sieht, sind ebenso äußerst wichtig.

Gibt es einen typischen New Yorker Stil, und wenn ja, wie zeigt sich das in Ihrer Arbeit? Einer meiner Kunden hat meine Arbeit einmal als weder amerikanisch noch europäisch, sondern als sehr „New Yorkisch" bezeichnet. New Yorker Design ist genau das, was es sein sollte: ohne viel Tand und Schnickschnack, genau richtig.

Wie stellen Sie sich New York in der Zukunft vor? Da mache ich mir Sorgen. Die hohen Mieten haben große Teile der Subkultur verdrängt. New York wird enttäuschenderweise immer sauberer, sicherer und uninteressanter. Das Klima der Extreme finde ich viel inspirierender.

quelle est l'œuvre la plus importante de votre carrière ? Je pense que c'est le design original de Mobile. J'ai toujours considéré mes designs comme faisant partie d'un tout. En discuter. Former de nouvelles décisions. Je pense réaliser ma plus belle oeuvre dans 10 à 20 ans.

ans quelle mesure la ville de New York nspire-t-elle votre œuvre ? Si je quittais ew York, ma vision et ma production seraient duites de moitié. La vie de la rue et les cen-ines d'étrangers que vous voyez tous les jours nt aussi une importante cruciale.

eut-on parler d'un style typiquement ew-yorkais, et si oui, comment se mani-este-t-il dans votre œuvre ? Un jour, un lient a qualifié mon oeuvre de non américaine, on européenne, mais comme étant très new-rkaise. Le design de New York est exactement e qu'il doit être: sans tambours, ni trompettes, ans chichis, simplement génial.

omment imaginez-vous le new York de emain ? Cela m'inquiète. Un grand nombre de us cultures a été détruit par l'augmentation roissante des loyers. A mon grand dam, New ork devient plus propre, plus sûr et moins inté-ssant. C'est très décevant. J'ai toujours été spiré par l'élément marginal.

¿Cuál es el trabajo que considera más importante en su carrera? Creo que el diseño original de Mobile. Siempre he considerado mis diseños como un todo. Donde unos trabajos comentan con otros. Sirven de base para deci-siones futuras. Espero hacer mi mejor trabajo dentro de 10 ó 20 años a partir de ahora.

¿De qué manera Nueva York supone una inspiración en su trabajo? Si abandonara Nueva York mi enfoque y mi producción se verían cercenados por la mitad. La vida de la calle y los cientos de extraños que ves cada día también son fundamentales.

¿Existe un estilo típico neoyorquino, y si es así, cómo se revela en su obra? Una vez un cliente clasificó mi trabajo como ni america-no, ni europeo, sino muy neoyorquino. El diseño de Nueva York es exactamente lo que debería ser; sin campanas ni silbatos, sin elaboración, simplemente pega.

¿Cómo se imagina Nueva York en el futu-ro? Me preocupa. Gran parte de la subcultura ha sido destruida por los alquileres elevados. Nueva York se está convirtiendo en un lugar más limpio, más seguro y menos interesante. Lo cual es decepcionante. Siempre me ha inspirado el ele-mento marginal.

Cosa pensa che sia la cosa più importante della Sua carriera? Credo il design originale Mobile. Ho sempre visto i miei design come parte di un insieme di lavori che si commentano a vicenda per preparare decisioni future. Spero che realizzerò il mio lavoro migliore fra 10 o 20 anni.

In che modo New York influenza il Suo lavoro? Se io me ne andassi da New York, la mia concentrazione e il mio output rimarrebbero dimezzati. La vita nelle strade e i centinaia di stranieri che vedi ogni giorno sono altrettanto importanti.

Esiste uno stile tipico a New York? Se sì, come influenza il Suo lavoro? Tempo fa, un cliente qualificava il mio lavoro come non ameri-cano, non europeo, ma molto newyorchese. Il design di New York è esattamente ciò che dovrebbe essere; niente flauti e campanelli, nes-suna formalizzazione, suvvia! colpisci.

Come si immagina New York in futuro? Mi preoccupa. Gran parte della subcultura è stata distrutta per causa di affitti troppo alti. New York sta diventando un posto più pulito, più sicuro e meno interessante. Questo fatto è deludente: sono sempre stato ispirato dall'elemento margi-nale.

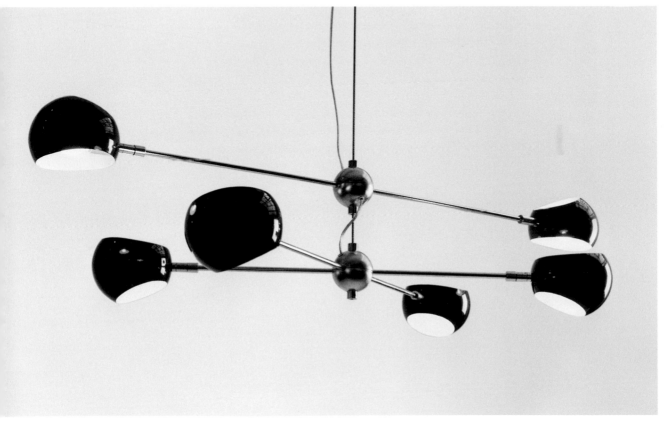

Collection

Semana Chair 1999, Torroja Standing Lamp 2005, Boi Sconce and Tri-Boi Chandelier 2003, Bucket Light 2004, Woven Couch and Woven Chair 2004, Gorilla Ashtray 2000
Photographs: © Robert Bean, Antoine Bootz, Björn Wallander (portrait)

Already with the metal sculpture designs for the jeweler, Ted Muehling, Weeks showed his interest in industrial materials. He gives organic shape to this hard material. In so doing, he places particular importance on the design of the lamps, for which he is inspired by style directions such as, for example, European Modernism, Industrial Age design and kinetic sculptures.

Schon bei den Metallskulptur-Entwürfen für den Juwelier Ted Muehling zeigte sich Weeks' Interesse für industrielle Materialien. Er bringt dieses harte Material in organische Formen. Dabei legt er einen besonderen Wert auf die Gestaltung der Leuchten, für die er sich von verschiedenen Stilrichtungen, wie beispielsweise der europäischen Moderne, dem Design des Industriezeitalters und kinetischen Skulpturen inspirieren lässt.

Déjà dans les créations de sculpture en métal pour le bijoutier Ted Muehling, Week montre sa prédilection pour les matériaux industriels. Il façonne ce matériau dur en formes organiques. La conception de luminaires lui tient particulièrement à cœur, tirant son inspiration de tendances de styles éclectiques, à l'instar du modernisme européen, du design de l'ère industrielle et de sculptures cinétiques.

En sus proyectos de escultura en metal para el joyero Ted Muehling ya se podía entrever el interés de Weeks por los materiales industriales. Consigue que este duro material adquiera formas orgánicas. Al mismo tiempo le da mucha importancia a la creación de lámparas y se ha dejado inspirar por estilos como el modernismo europeo, el diseño de la era industrial y las esculturas dinámicas.

Già nei progetti per sculture in metallo eseguite per il gioielliere Ted Muehling si è rivelato l'interesse di Week per i materiali industriali: egli dona forme organiche a questi materiali duri. Si concentra particolarmente sul design di luminari per i quali si ispira a stili come il modernismo europeo, il design dell'era industriale e la scultura cinetica.

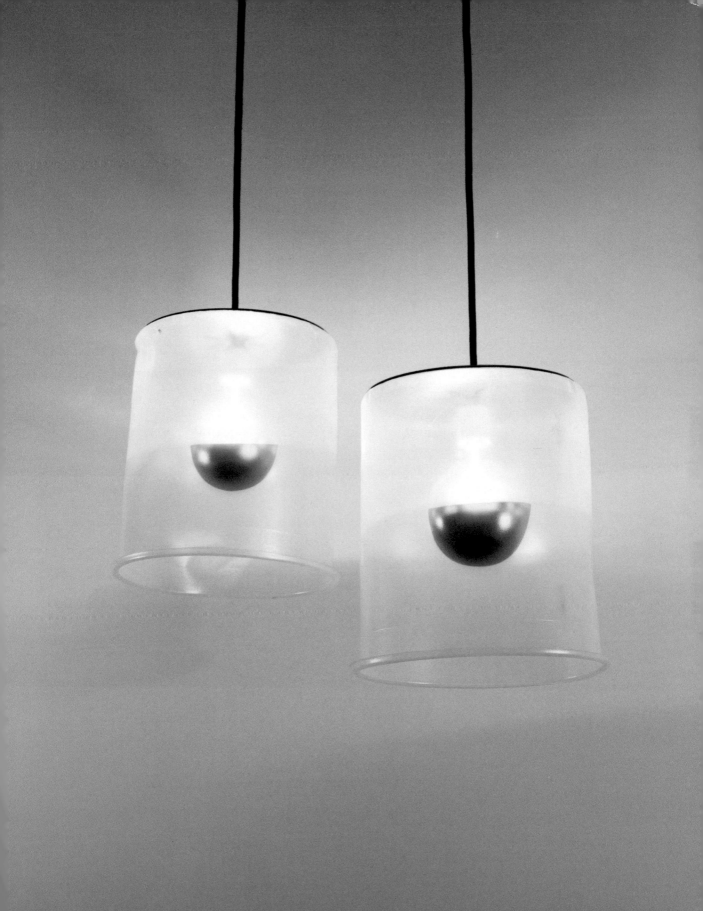

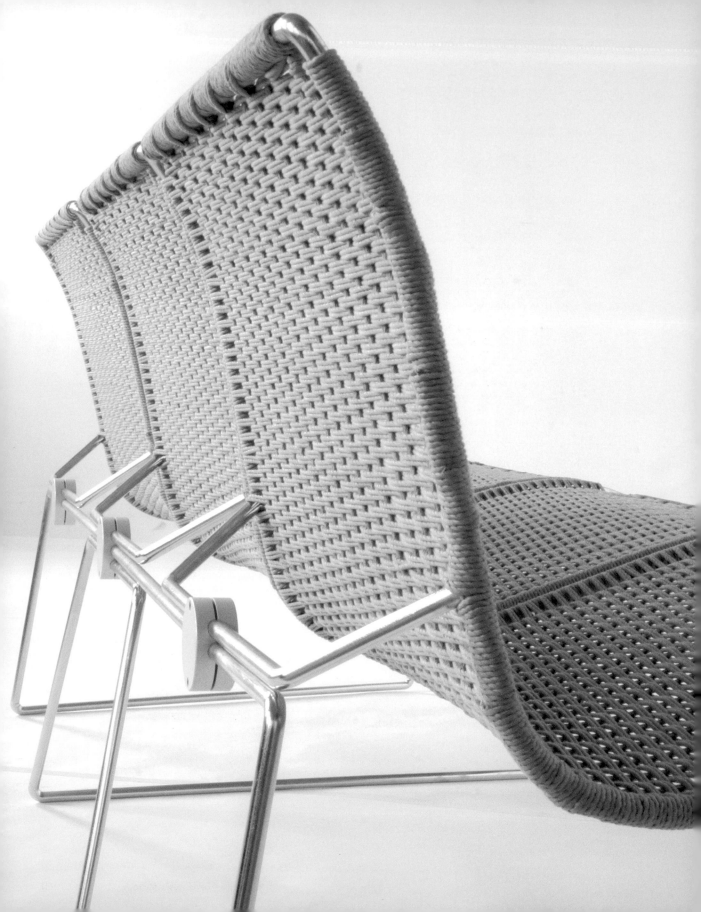

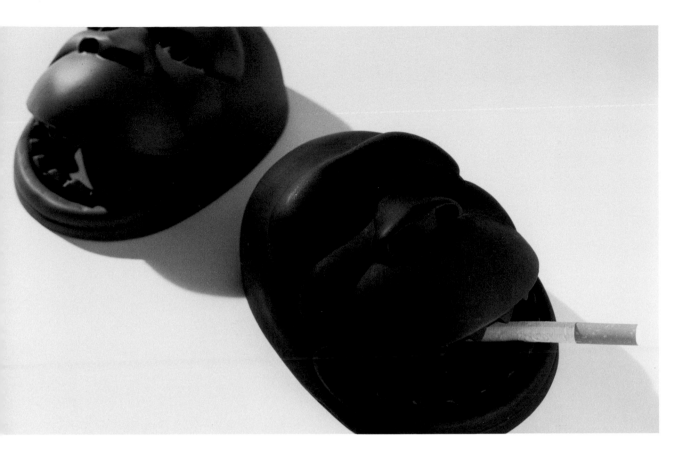

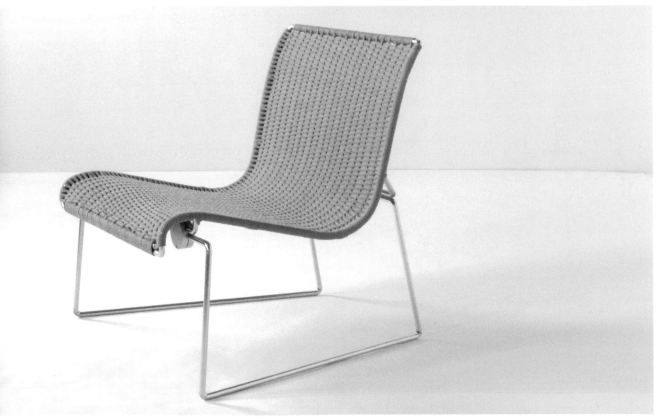

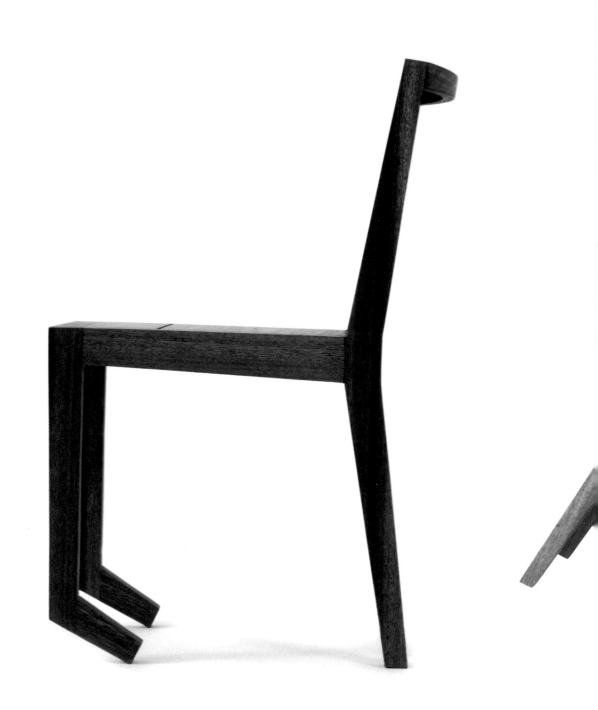

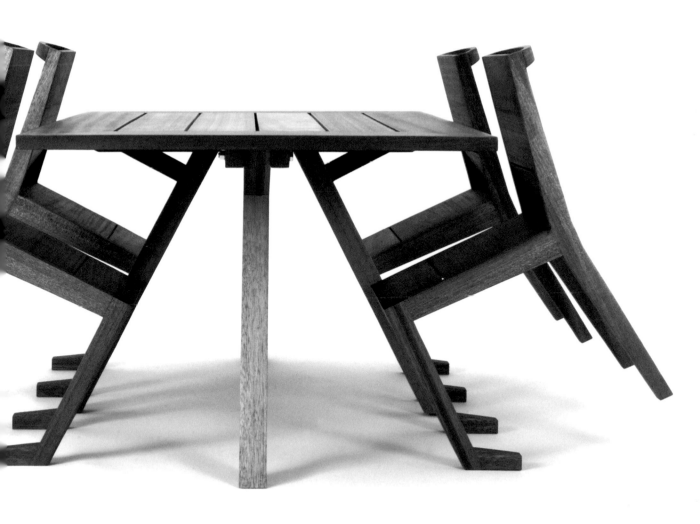

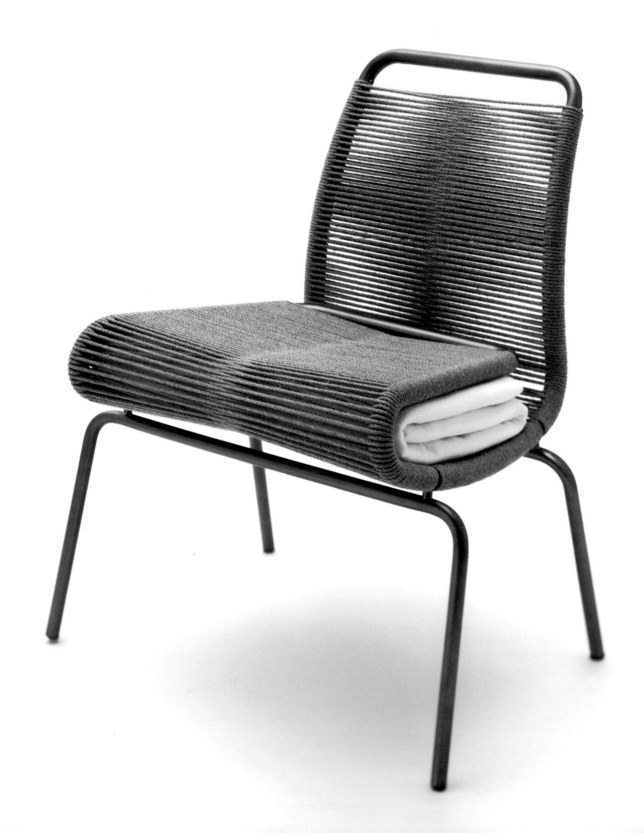

54Dean

24 Creamer Street, Suite 7, Brooklyn, NY 11231, USA

+1 718 596 3353

+1 718 596 3353

www.54dean.com

info@54dean.com

Paul Galli and Todd Seidman founded their studio, 54Dean in New York in 2004. The designers met at Pratt Institute in New York. Both 54Dean founders have long-term experience in creative fields. Todd Seidman worked as a film and television set designer for 10 years and Paul Galli was creative director for AGENCY.COM, an interactive design company.

Paul Galli und Todd Seidman gründeten 2004 in New York ihr Studio 54Dean. Kennen gelernt haben sich die Designer am Pratt Institute in New York. Die beiden Gründer von 54Dean blicken auf langjährige Erfahrungen im kreativen Bereich zurück: Todd Seidman arbeitete zehn Jahre lang als Set-Designer für Film und Fernsehen und Paul Galli als Kreativdirektor für AGENCY.COM, eine Firma für interaktives Design.

Paul Galli et Todd Seidman fondent en 2004 à New York leur studio 54Dean. Les designers se sont rencontrés au Pratt Institute de New York. Les deux initiateurs de 54Dean ont derrière eux une longue expérience dans le domaine de la création : Todd Seidman travaille 10 ans en tant que scénographe pour le cinéma et la télévision et Paul Galli comme directeur de création pour AGENCY.COM, une entreprise de design interactif.

Paul Galli y Todd Seidman fundaron Studio 54Dean en el año 2004, en Nueva York Se conocieron en el Pratt Instituto dc Nueva York. Los dos fundadores de 54Dean poseen años de experiencia en el sector creativo: Todd Seidman trabajó durante 10 años como diseñador de decorados para el cine y la televisión y Paul Galli como director creativo en AGENCY.COM, una empresa de diseño interactivo.

Nel 2004 Paul Galli e Todd Seidman hanno fondato a New York il loro Studio 54Dean. I due stilisti si sono conosciuti al Pratt Institute di New York. Entrambi i fondatori di 54Dean avevano alle spalle lunghi anni di esperienze nell'ambito creativo: Todd Seidman aveva lavorato per dieci anni come scenografo e set designer per film e televisione, mentre Paul Galli era stato direttore creativo di AGENCY.COM, una ditta specializzata nel disegno interattivo.

Paul Galli

2003
Scandinavian Furniture Design, Denmark's Design School, Copenhagen, Denmark

2000
Career Discovery Program, Landscape Architecture, Harvard University Graduate School of Design, Cambridge, Massachusetts, USA

2004
Master of Industrial Design, Pratt Institute, New York, USA

Todd Seidman

2003
Scandinavian Furniture Design, Denmark's Design School, Copenhagen, Denmark

2004
Master of Industrial Design, Pratt Institute, New York, USA

2004
Foundation of 54Dean, New York, USA
Watershed Outdoor Furniture Set
Georgie table

Interview | 54Dean

What do you consider the most important work of your career? Always the next one. Why not try your next idea? That's the fun in it after all.

In what ways does New York inspire your work? New York is full of astonishing beauty and ugliness. Being part of a city with a vibrant street life presents you with all these wonderful and uncalculated juxtapositions. For us, in terms of inspiration, New York creates its own weather.

Does a typical New York style exist, and if so, how does it show in your work? No. In fact, what we think what differentiates design in New York is the lack of that singular, signature style. There is such a bounty of potential influences that it becomes about editing and synthesizing. It takes great discipline to choose correctly.

How do you imagine New York in the future? New York is in the process of re-imagining itself as a waterfront city. Parkland is being developed along waterfronts in all boroughs. Spatially, this opens everything up. We are curious to see how this new openness manifests itself in all disciplines of design.

Was halten Sie für die wichtigste Arbeit in Ihrer Karriere? Immer die anstehende. Warum nicht gleich die nächste Idee angehen? Das ist es doch, was überhaupt erst Spaß macht.

Auf welche Weise inspiriert New York Ihre Arbeit? New York ist voller Schönheit und Hässlichkeit. Als Teil einer Stadt, die ein derart dynamisches Straßenleben hat, wird man mit wundervollen und unberechenbaren Dingen konfrontiert, die nebeneinander existieren. New York erzeugt sein eigenes Klima der Inspiration.

Gibt es einen typischen New Yorker Stil, und wenn ja, wie zeigt sich das in Ihrer Arbeit? Nein. Unserer Meinung nach ist es genau das Fehlen eines singulären, identifizierbaren Stils, was das New Yorker Design so einzigartig macht. Die Fülle potentieller Einflüsse ist dermaßen groß, dass man immer neu arrangieren und kombinieren muss. Es erfordert große Disziplin, richtig auszuwählen.

Wie stellen Sie sich New York in der Zukunft vor? New York sieht sich wieder als Küstenstadt, die in der Lage ist ein offenes Raumgefühl zu vermitteln. Wir sind gespannt, inwiefern sich diese Offenheit in den verschiedenen Designrichtungen manifestieren wird.

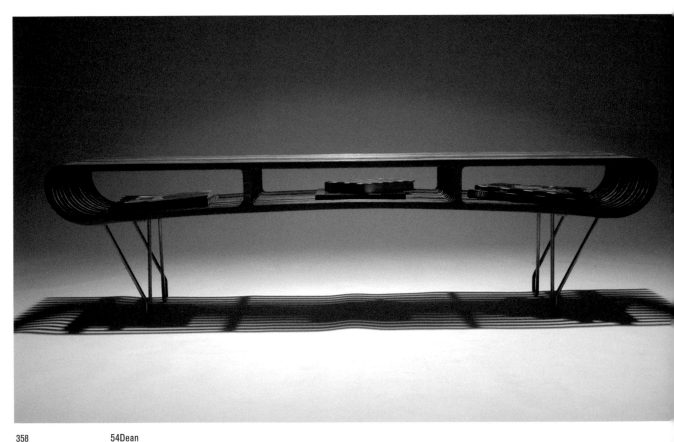

uelle est l'œuvre la plus importante de tre carrière ? C'est toujours la suivante. urquoi ne pas essayer la prochaine idée ? C'est le vrai plaisir, non?

ans quelle mesure la ville de New York spire-t-elle votre œuvre ? La ville de New rk est emplie de beautés et laideurs éton- ntes. Appartenir à une ville, où la vie des rues t si palpitante, vous place devant de tels ntrastes tour à tour merveilleux et imprévus. ant à nous, sur le plan de l'inspiration, New rk fait la pluie et le beau temps.

ut-on parler d'un style typiquement ew-yorkais, et si oui, comment se mani- ste-t-il dans votre œuvre ? Non. A notre s, ce qui différencie le design new-yorkais, st l'absence de ce style unique. Il y a une le foison d'influences potentielles, qu'il faut rvenir à trier et faire la synthèse. Il faut être s discipliné pour faire le bon choix.

mment imaginez-vous le New York de main ? New York est en train de revisiter son age en tant que ville côtière. Sur le plan spa- , cela crée une ouverture totale. Nous mmes curieux de voir comment cette nouvelle verture va se traduire dans toutes les disci- es du design.

¿Cuál es el trabajo que considera más importante en su carrera? Siempre el siguiente. ¿Por qué no probar tu siguiente idea? Después de todo, eso es lo divertido.

¿De qué manera Nueva York supone una inspiración en su trabajo? Nueva York des- borda de sorprendente belleza y fealdad. Formar parte de una ciudad con una vibrante vida de la calle te permite presenciar estas yuxtaposiciones maravillosas y no planeadas. Para nosotros, en términos de inspiración, Nueva York crea su pro- pio clima.

¿Existe un estilo típico neoyorquino y, si es así, cómo se revela en su obra? No, de hecho, lo que creemos que diferencia el diseño en Nueva York es la ausencia de ese estilo de firma singular. Hay tal prodigalidad de influencias que hay que editar y sintetizar. Hace falta una gran disciplina para elegir correctamente.

¿Cómo se imagina Nueva York en el futu- ro? Nueva York vive un proceso de reimaginarse a sí misma como una ciudad a orillas del río. Espacialmente, esto supone una abertura gene- ral. Sentimos curiosidad por ver cómo ésta se manifiesta en todas las disciplinas del diseño.

Qual è secondo Lei il progetto più impor- tante della Sua carriera? È sempre quello che sta per arrivare. Perché non lasciarsi coinvol- gere dal prossimo esperimento? Dopo tutto è proprio quello che ci stimola nel nostro lavoro...

In che modo la città di New York ispira il Suo lavoro? A New York coesistono luoghi di straordinaria bellezza e luoghi orribili. Essere parte di una città con delle strade così piene di vita significa essere posti di continuo di fronte a contrasti meravigliosi e inaspettati. In termini di ispirazione, New York è capace per noi di formare la propria storia.

È possibile parlare di uno stile tipico per New York, e, se questo stile esiste, in che modo si manifesta nei Suoi lavori? No. La mancanza di uno stile determinato, di uno stile specifico è proprio quello che contraddistingue il design di New York. C'è una tale abbondanza di possibili influssi che lo stile diventa una sorta di montaggio, di sintesi. Non è facile scegliere cor- rettamente...

Come si immagina la New York del futuro? New York si sta ripensando come fronte del porto. Questo riapre certo l'intera topografia. Sarà da vedere come questa nuova apertura farà sentire la sua presenza in tutte le discipline del design.

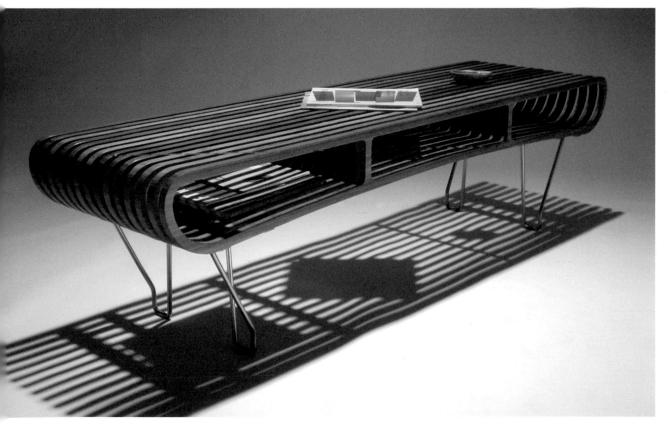

Collection

Watershed Outdoor Furniture Set 2004, Copenhagen Chair 2003, Georgie Table 2003, BreakForm 2005
Photographs: © Mia Barker, John Curry

54Dean's simple designs combine a practical approach with aesthetic feeling and humor. The designers work with a variety of materials and shapes. For their garden furniture collection, they were inspired by the habit of leaning chairs against the table in bad weather to protect them from the rain. The Watershed Outdoor Furniture collection pays homage to this act by means of an unusual and simultaneously functional form.

Die schlichten Entwürfe von 54Dean kombinieren einen praktischen Ansatz mit ästhetischem Gespür und Humor. Die Designer arbeiten mit den verschiedensten Materialien und Formen. Für ihre Gartenmöbelkollektion ließen sie sich von der Angewohnheit inspirieren, Stühle bei schlechtem Wetter an den Tisch zu lehnen, um sie vor Regen zu schützen. Die Kollektion Watershed Outdoor Furniture huldigt diesem Umstand durch eine ungewöhnliche und zugleich funktionale Form.

Les créations épurées de 54Dean conjuguent approche pratique et sens de l'esthétique mâtiné d'un zeste d'humour. Les designers travaillent sur les matières et formes les plus diverses. Pour créer leur collection de meubles de jardins, ils se sont inspirés de l'habitude d'incliner les sièges contre la table par mauvais temps, pour les protéger de la pluie. La collection Watershed Outdoor Furniture fait honneur à ce détail en créant une forme inhabituelle et fonctionnelle à la fois.

Los diseños sencillos de 54Dean combinan un enfoque práctico con humor y sentido estético. Trabajan con las formas y materiales más diversos. Para su colección de muebles de jardín se dejaron inspirar por la costumbre, así las sillas reposan apoyadas en la mesa cuando hace mal tiempo para protegerse de la lluvia. La colección Watershed Outdoor Furniture recoge esta particularidad con unas formas poco comunes a la vez que funcionales.

I disegni semplici di 54Dean combinano un'impostazione pratica con una sensibilità estetica e con dell'umorismo. I due stilisti lavorano con materiali e forme svariatissimi. Per la loro collezione di mobili da giardino si sono ispirati all'usanza di appoggiare le sedie al tavolo quando fa mal tempo, per proteggerle dalla pioggia. La collezione Watershed Outdoor Furniture traspone questo dato di fatto nella forma insolita e contemporaneamente funzionale.

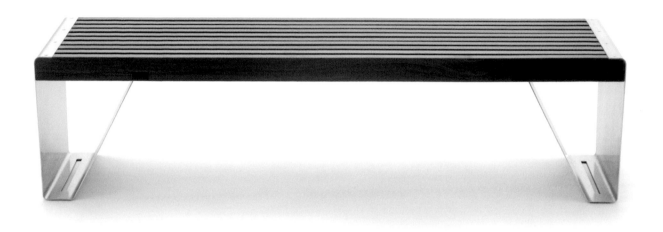

Studio Dror

Studio Dror

225 West 39th Street, 6th Floor, New York, NY10018, USA

+1 212 929 2196

+1 212 929 2196

www.studiodror.com

info@studiodror.com

Dror Benshetrit

Dror Benshetrit, born in 1977 in Tel Aviv, attended the Eindhoven Design Academy and the Center for Art Education at the Tel Aviv Museum of Art, before creating his Studio Dror in New York in 2002. With his unique design style, he designed products for Rosenthal, Puma, Kiehl's, Material Connexion and his design, Vase of Phases is on display at the National Museum for Applied Art in Munich and the Eretz Israel Museum in Tel Aviv.

Der 1977 in Tel Aviv geborene Dror Benshetrit besuchte die Design Academy Eindhoven und das Center for Art Education am Tel Aviv Museum of Art, bevor er 2002 sein Studio Dror in New York gründete. Mit seinem einzigartigen Designstil entwickelt er Produkte für Rosenthal, Puma, Kiehl's und Material Connexion, und sein Design Vase of Phases ist Teil der Ausstellung des Staatlichen Museums für Angewandte Kunst, München und des Eretz Israel Museums in Tel Aviv.

Dror Benshetrit, né en 1977 à Tel Aviv, suit les cours de la Design Academy Eindhoven et du Center for Art Education au Tel Aviv Museum of Art, avant de fonder, en 2002, son Studio Dror à New York. Fort d'un style de design unique, il réalise des produits pour Rosenthal, Puma et Kiehl's, ainsi que Material Connexion. Son Design Vase of Phases fait partie de l'exposition du Staatliches Museum für Angewandte Kunst de Munich et du Eretz Israel Museum de Tel Aviv.

Dror Benshetrit, nacido en 1977 en Tel Aviv, acudió a la Design Academy Eindhoven y al Center for Art Education en el Tel Aviv Museum of Art, antes de fundar su Studio Dror en Nueva York el año 2002. Con su estilo único, desarrolla productos para Rosenthal, Puma, Kiehl's o Material Connexion, y su obra Vase of Phases se expone en el Staatliches Museum für Angewandte Kunst de Munich y en el Eretz Israel Museum de Tel Aviv.

Nato nel 1977 a Tel Aviv, Dror Benshetrit studiò alla Design Academy Eindhoven ed al Center for Art Education del Tel Aviv Museum of Art, prima di fondare il suo Studio Dror a New York nel 2002. Con il suo stile unico sviluppa prodotti per Rosenthal, Puma, Kiehl's e Material Connexion, e la sua creazione Vase of Phases fa parte della mostra permanente dello Staatliches Museum für Angewandte Kunst, di Monaco di Baviera e dell'Eretz Israel Museum di Tel Aviv.

1977
Born in Tel Aviv, Israel

1991
Tel Aviv Museum of Art, Centre for Art Education, Fine Arts Studies, Israel

2002
Design Academy Eindhoven, The Netherlands, Bachelor of Arts in Design

2002
Foundation of Studio Dror, New York, USA

2001
Herb Pot

2002
Pick Chair for Gruppo Sintesi

2004
Vase of Phases for Rosenthal

2005
Champagne Glass produced by Rosenthal made for Surface

2006
Folding Table for Gruppo Sintesi,
Broken Martini, Martini glass for Rosenthal

Interview | Studio Dror

What do you consider the most important work of your career? Please ask me this question in 30 years. Within 30 years I will have created significant work, which I will be able to call important.

In what ways does New York inspire your work? As a designer who loves playing with movement and transformation New York offers a source of great inspiration. Transformation, duality and opposites stems from the constant exchange of information and energies and the diversity of all the types and cultures.

Does a typical New York style exist, and if so, how does it show in your work? There are different New York styles, however it is more the lifestyle of New York that influences my work to some degree.

How do you imagine New York in the future? As New York evolves, so too does the diversity and energy of each neighborhood which transforms the city. This multicultural flow and transformation will always be a part of New York, just as the idea of transformation and movement will be a part of my work.

Was halten Sie für die wichtigste Arbeit in Ihrer Karriere? Bitte stellen Sie mir diese Frage in 30 Jahren. In 30 Jahren werde ich wohl grundlegende Arbeiten geschaffen haben, die ich dann wichtig nennen kann.

Auf welche Weise inspiriert New York Ihre Arbeit? Ich spiele gern mit Bewegung und Verwandlung und da bietet New York eine großartige Inspirationsquelle. Verwandlung und Gegensätze entstehen durch den Austausch von Information und Energie sowie die Verschiedenartigkeit aller Typen und Kulturen.

Gibt es einen typischen New Yorker Stil, und wenn ja, wie zeigt sich das in Ihrer Arbeit? Es gibt verschiedene New Yorker Stile, jedoch ist es wohl eher der Lifestyle New Yorks, der meine Arbeit beeinflusst.

Wie stellen Sie sich New York in der Zukunft vor? Mit der ständigen Entwicklung New Yorks geht die Entwicklung der Vielfalt und Energie jedes einzelnen Stadtviertels einher und das verändert die gesamte Stadt. Dieser multikulturelle Strom und dessen Wandel werden stets Teil New Yorks sein, ebenso werden der Gedanke von Wandel und Bewegung fester Bestandteil meiner Arbeit sein.

Quelle est l'œuvre la plus importante de votre carrière ? Reposez-moi cette question dans 30 ans ! D'ici là, j'aurai eu le temps de créer une œuvre conséquente, que je pourrai alors qualifier d'importante.

Dans quelle mesure la ville de New York inspire-t-elle votre œuvre ? Pour un designer comme moi, qui aime jouer avec le mouvement et la transformation, New York est une véritable source d'inspiration. Transformation, dualité et contrastes naissent de l'échange constant d'informations, d'énergies et de diversités en tout genre et de toutes cultures.

Peut-on parler d'un style typiquement new-yorkais, et si oui, comment se manifeste-t-il dans votre œuvre ? Il y a différents styles new-yorkais, mais c'est surtout dans le style de vie de New York que je puise en quelque sorte mon inspiration.

Comment imaginez-vous le New York de demain ? New York évolue en fonction de la diversité et de l'énergie de chaque quartier qui transforme la ville. Ce flux multiculturel et cette transformation seront toujours inhérents à New York, comme l'idée de mutation et de mouvement era toujours partie de mon œuvre.

¿Cuál es el trabajo que considera más importante en su carrera? Pregúnteme eso dentro de 30 años. Dentro de 30 años habré creado un trabajo significativo, al que podré denominar "importante".

¿De qué manera Nueva York supone una inspiración en su trabajo? Como un diseñador que disfruta jugando con el movimiento y la transformación, Nueva York supone una enorme fuente de inspiración. La transformación, la dualidad y los opuestos derivan del intercambio constante de información y energías y la diversidad de todos los tipos y culturas.

¿Existe un estilo típico neoyorquino y, si es así, cómo se revela en su obra? Hay distintos estilos neoyorquinos, no obstante, es más el estilo de vida de Nueva York lo que hasta cierto punto influye en mi trabajo.

¿Cómo se imagina Nueva York en el futuro? A medida que evoluciona Nueva York, también lo hacen la diversidad y la energía de cada barrio que transforma la ciudad. Este flujo multicultural y la transformación siempre formarán parte de Nueva York, al igual que la idea de transformación y movimiento formarán parte de mi trabajo.

Qual è secondo Lei il progetto più importante della Sua carriera? Dovrebbe chiedermelo fra 30 anni. Nei prossimi 30 anni, credo, compirò alcuni progetti che potrò forse definire "importanti".

In che modo la città di New York ispira il Suo lavoro? New York è una grande fonte di ispirazione per un designer che ami il gioco con il movimento e la trasformazione continui. Trasformazione, dualità e opposizioni si basano sullo scambio costante di informazioni e energie, sulla mescolanza dei tipi e delle culture.

È possibile parlare di uno stile tipico per New York, e, se questo stile esiste, in che modo si manifesta nei Suoi lavori? Ci sono diversi "stili New York", ma è più lo stile di vita proprio di New York a influenzare i miei progetti.

Come si immagina la New York del futuro? Allo stesso modo in cui si evolve New York cambiano anche la diversità e le energie dei quartieri che trasformano la città. Questo flusso ininterrotto di culture con le loro trasformazioni faranno sempre parte di New York, come l'idea della trasformazione e del movimento saranno sempre presenti nei miei lavori.

Collection

Vase of Phases 2005, Pick Chair 2002, Champagne Glass 2005, Herb Pot 2001
Photographs: © Ernst van ter Beek, Studio Dror, Andrew Zuckerman (portrait)

In order to understand Dror Benshetrits work, one must consider its logic and take a closer look at the thought process, which is the basis for his style. The innovation in his work comes from intense work with new types of materials, techniques and shapes combined with work focusing on the origin of movement. In this way, his design, Vase of Phases, in which the object goes through several development phases, symbolizes the experience of the transformation of life.

Um Dror Benshetrits Arbeiten zu verstehen, muss man die Logik und den Denkprozess näher betrachten, die seinem Stil zugrunde liegen. Die Innovation in seinen Arbeiten entsteht aus der intensiven Beschäftigung mit neuartigen Materialien, Techniken und Formen, wobei er sich zudem mit dem Ursprung von Bewegung beschäftigt. So symbolisiert sein Entwurf Vase of Phases, bei dem das Objekt mehrere Entwicklungsabschnitte durchläuft, die Erfahrung der Transformation des Lebens.

Pour comprendre les œuvres de Dror Benshetrit, il faut se pencher sur la logique et le processus de pensée, bases de son style. Le caractère innovant de ses œuvres repose sur son étude approfondie de nouveaux matériaux, techniques et formes, tout en s'intéressant en même temps à l'origine du mouvement. Son œuvre, Vase of Phases, symbolise l'expérience des différentes étapes de la vie, ce qu'il traduit en faisant passer son objet par diverses phases de création.

Para entender los trabajos de Dror Benshetrit hay que observar de cerca la lógica y los procesos cognitivos que hay detrás de su estilo. La innovación en sus trabajos surge de una intensa reflexión sobre materiales, técnicas y formas novedosas, además de su preocupación por el origen del movimiento. Su diseño Vase of Phases, en el que el objeto recorre varias fases de desarrollo, simboliza la experiencia de la transformación vital.

Per meglio comprendere i lavori di Dror Benshetrit si devono approfondire la logica ed i ragionamenti sui quali è fondato il suo stile. Il carattere innovativo dei suoi lavori scaturisce dall'intenso confrontarsi con nuovi materiali, tecniche e forme, e dallo studio dell'origine del movimento. Il suo progetto Vase of Phases, dove l'oggetto in questione attraversa varie fasi di sviluppo, simboleggia l'esperienza della trasformazione della vita.

Iglooplay
by Lisa Albin Design

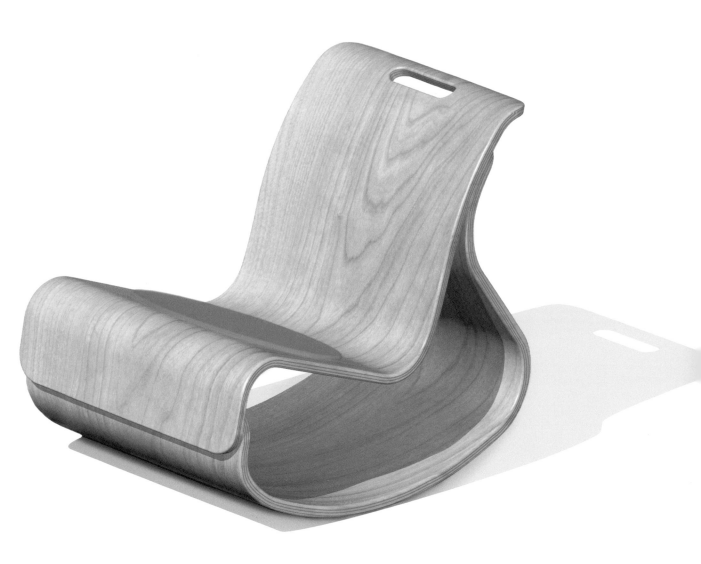

Iglooplay by Lisa Albin Design

123 Seventh Avenue, Brooklyn, NY 11215, USA

+1 718 622 0047

+1 718 288 9647

www.iglookids.com

info@lisaalbin.com

Lisa Albin

1967
Lisa Albin born in Baltimore, Maryland, USA

1990
Bachelor of Architecture from The Rhode Island
School of Design, Rhode Island, USA

1990-2005
Work in interior design and film design

2005
Launch of Iglooplay, New York, USA
Launch of the Igloo furniture collection, New
York, USA
Good Design Award from The Chicago
Athenaeum/Museum of Architecture and
Design in the category of best children's
products
Mod Rocker & Mod Topper
Tea Pods
Lima Tables

2006
Honorable Mention for Mod Rocker by I.D.
Magazine's 2006 Annual Design Review
Show Blocks

After studying architecture, Lisa Albin first worked for the landscape architect Alexandre Chemetoff as well as the artist Vito Acconci. In addition, she worked as an interior designer and set designer. Inspired by the birth of her child and following a seminar at the Haystack Mountain School of Crafts in Maine, Lisa Albin introduced the children's furniture collection, Iglooplay in 2005, for which she received the 2005 Good Design Award.

Nach ihrem Architekturstudium arbeitete Lisa Albin zunächst für den Landschaftsarchitekten Alexandre Chemetoff sowie den Künstler Vito Acconci. In Ergänzung dazu arbeitete sie als Innenarchitektin und Set-Designerin. Inspiriert durch die Geburt ihres Kindes und nach einem Seminar an der Haystack Mountain School of Crafts in Main präsentierte Lisa Albin 2005 die Kindermöbelkollektion Iglooplay, für die sie 2005 den Good Design Award erhielt.

Après ses études d'architecture, Lisa Albin travaille dans un premier temps pour l'architecte paysagiste Alexandre Chemetoff ainsi que pour l'artiste Vito Acconci. A cela s'ajoute son activité d'architecture d'intérieur et de design scénique. La naissance de son enfant est une nouvelle source d'inspiration qu'elle intensifie par un séminaire à la Haystack Mountain School of Crafts de Main, où Lisa Albin présente en 2005 la collection de meubles d'enfants Iglooplay, couronnée par Good Design Award, prix qui lui est décerné la même année.

Al finalizar sus estudios de arquitectura, Lisa Albin trabajó para el arquitecto paisajista Alexandre Chemetoff y para el artista Vito Acconci. Además realizó trabajos como arquitecta de interiores y diseñadora de decorados. El nacimiento de su hijo le sirvió como fuente de inspiración y, tras un seminario en la Haystack Mountain School of Crafts de Main, Lisa Albin presentó en 2005 la colección de mobiliario infantil Iglooplay, por la que obtuvo el Good Design Award de 2005.

Dopo gli studi di architettura Lisa Albin lavorò per l'architetto paesaggista Alexandre Chemetoff e per l'artista Vito Acconci. Inoltre lavorò come architetto di interni e come set designer. Inspirata dalla nascita del suo bambino e dopo avere partecipato a uno stage alla Haystack Mountain School of Crafts nel Main, Lisa Albin presentò nel 2005 la sua collezione di mobili per l'infanzia Iglooplay, per la quale ricevette nel 2005 il Good Design Award.

Interview | Lisa Albin

Which do you consider the most important work of your career? My RISD thesis of a childcare center and garden made me committed to the social basis of design (...). My furniture combines the two: designing to promote qualities which children naturally posses in their play.

In what ways does New York inspire your work? For a child, observation, random experiences and personal narrative commingle with raw creativity as a way of negotiating NY–that unadulterated perspective inspires my work.

Does a typical New York style exist, and if so, how does it show in your work? No. But limited space in NY often leads to multi-purpose design. If something is to perform only one function, it should be singular and sculptural.

How do you imagine New York in the future? As artists are pushed to the city's edges, we have to depend on tele-commuting to create a connected production space that will continue to support collaborative, complex design for the built environment.

Was halten Sie für die wichtigste Arbeit in Ihrer Karriere? Bereits in meiner Diplomarbeit an der Rhode Island School of Design – ein Kinderbetreuungs-Zentrum und Garten (...) – habe ich mich einem sozialen Grundgedanken des Designs verpflichtet gefühlt. In meinem Möbelentwurf wird das kombiniert: Mein Design will die Eigenschaften fördern, die Kinder naturgemäß beim Spielen besitzen.

Auf welche Weise inspiriert New York Ihre Arbeit? Kinder loten New York auf ihre ganz eigene Weise aus: Durch Beobachtung, zufällige Erlebnisse, persönliche Erzählung sowie ihre ungebremste Kreativität. Diese unverfälschte Sichtweise inspiriert meine Arbeit.

Gibt es einen typischen New Yorker Stil, und wenn ja, wie zeigt sich das in Ihrer Arbeit? Nein. Aber der begrenzte Raum führt oftmals zu multifunktionalem Design. Wenn etwas nur eine einzige Funktion hat, so sollte es auch singulär und plastisch sein.

Wie stellen Sie sich New York in der Zukunft vor? Da viele Künstler an den Stadtrand gedrängt werden, wird es nur über Telekommunikation möglich sein, ein produktives Netzwerk aufzubauen, das weiterhin gemeinschaftliches komplexes Design für die bebaute Umwelt fördern kann.

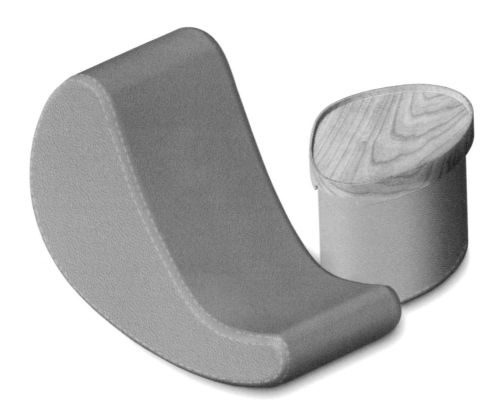

Quelle est l'œuvre la plus importante de votre carrière ? Ma thèse RISD du centre d'enfants et jardin m'a fait intégrer l'aspect social du design (...). Mes meubles associent les deux : concevoir pour promouvoir les qualités que les enfants possèdent naturellement en jouant.

Dans quelle mesure la ville de New York inspire-t-elle votre œuvre ? Chez l'enfant, l'observation, les expériences imprévues et personnelles se mélangent à la créativité pure et sont une façon d'appréhender NY: cette perspective spontanée inspire mon oeuvre.

Peut-on parler d'un style typiquement new-yorkais, et si oui, comment se manifeste-t-il dans votre œuvre ? Non. Mais l'espace limité à NY aboutit souvent à un design multifonctionnel. Si un objet doit avoir une seule fonction, il devra être unique et sculptural.

Comment imaginez-vous le New York de demain ? Comme les artistes sont repoussés aux confins de la ville, nous dépendrons de la communication à distance pour créer un espace de production en ligne qui continuera à encourager un design complexe en faveur de l'environnement architectural.

¿Cuál es el trabajo que considera más importante en su carrera? Mi tesis de la escuela de diseño RISD para un centro y jardín de infancia me hizo comprometerme con la base social del diseño (...). Mi mobiliario combina ambos: diseñando para fomentar cualidades que los niños poseen de forma natural en su juego.

¿De qué manera Nueva York supone una inspiración en su trabajo? Para un niño, la observación, las experiencias aleatorias y la narrativa personal se mezclan con la creatividad bruta como una forma de gestionar Nueva York. Esa perspectiva sin adulterar inspira mi trabajo.

¿Existe un estilo típico neoyorquino y, si es así, cómo se revela en su obra? No. Pero la limitación de espacio en Nueva York con frecuencia da lugar a un diseño multifuncional. Si algo va a realizar una única función, debe ser singular y escultural.

¿Cómo se imagina Nueva York en el futuro? A medida que los artistas se vean empujados hacia la periferia de la ciudad, tendremos que depender del trabajo a distancia para crear un espacio de producción conectado que continúe siendo un apoyo para el complejo diseño colaborativo del entorno construido.

Cosa pensa che sia la cosa più importante della Sua carriera? La mia tesi RISD su un centro di assistenza infantile corredato da un giardino mi ha portato a concentrarmi sulle basi sociali del design (...). I miei arredamenti mettono insieme le due cose: un tipo di design per promuovere le qualità che appartengono solitamente ai bambini nei loro giochi.

In che modo New York influenza il Suo lavoro? Per un bambino, l'osservazione, l'esperienza casuale e la narrativa personale corrispondono ad una creatività grezza, ad un modo di negoziare NY. Sono queste perspettive intatte ad ispirare il mio lavoro.

Esiste uno stile tipico a New York? Se sì, come influenza il Suo lavoro? No, ma esiste dello spazio limitato. NY spesso induce a creare un design multiuso. Se qualcosa deve essere creato per solo una funzione, dovrebbe essere singolare e scultorea.

Come si immagina New York in futuro? Siccome gli artisti sono spinti ai limiti della città, dipenderà dalla mobilità e dalla telecomunicazione il creare una connessione di spazi produttivi che continuino a essere collaborare; un design complesso per costruire l'ambiente.

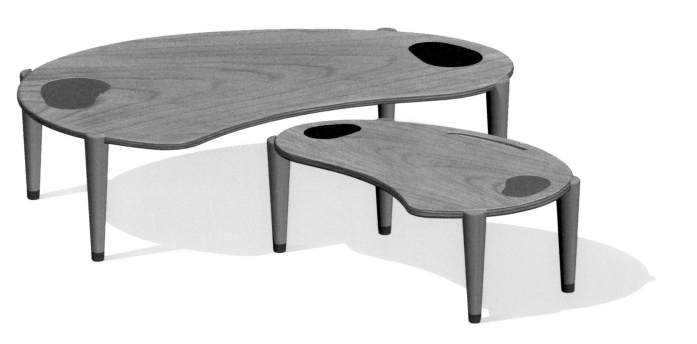

Iglooplay by Lisa Albin Design 375

Collection

Tea Pods, Mod Rocker, Lima Tables, Mod Topper
Year: 2005
Photographs: © Michelle Ocampo

In her children's furniture designs, Lisa Albin places particular importance on organic and ergonomic shapes which motivate children to learn by playing. For this reason, in addition to natural materials such as wood and foam material, freedom of movement and combination options of the individual parts are of primary importance. Accordingly, the Tea Pod can be used as a chair, table, ottoman or simply as a toy and swing object.

Bei ihren Kindermöbelentwürfen legt Lisa Albin besonderen Wert auf organische und ergonomische Formen, die Kinder zum spielerischen Lernen anregen. Daher stehen neben natürlichen Materialien, wie Holz und Schaumstoff, Bewegungsfreiheit und Kombinationsmöglichkeiten der einzelnen Teile im Vordergrund. Dementsprechend kann der Tea Pod als Stuhl, Tisch, Ottomane oder einfach als Spiel- und Schaukelobjekt genutzt werden.

En concevant ses meubles d'enfant, Lisa Albin privilégie les formes organiques et ergonomiques qui incitent les enfants à un apprentissage ludique. D'où sa prédilection pour les matériaux naturels comme le bois et la mousse, la liberté de mouvement et la possibilité de combiner les éléments entre eux. Dans cette ligne de pensée, le Tea Pod peut être utilisé tour à tour comme siège, table, ottomane ou tout simplement pour se balancer ou jouer.

En sus diseños de mobiliario infantil, Lisa Albin le da una importancia especial a las formas orgánicas y ergonómicas que estimulan a los niños a aprender jugando. Por este motivo, junto a materiales naturales como madera y espuma, da prioridad a la libertad de movimiento y a las posibilidades de combinación de cada una de las piezas. Así, por ejemplo, el Tea Pod puede utilizarse como silla, mesa, sofá o simplemente como juguete o mecedora.

Nel suo progetto per mobili per l'infanzia Lisa Albin tiene in particolare a forme organiche ed ergonomiche che devono ispirare i bambini all'apprendimento giocoso. Albin affianca a materiali naturali come legno e gomma piuma l'idea della libertà di movimento e delle possibilità combinatorie delle singole parti. Secondo questo concetto, il Tea Pod è utilizzabile come sedia, tavolo, ottomana oppure semplicemente come oggetto da gioco e da dondolo.

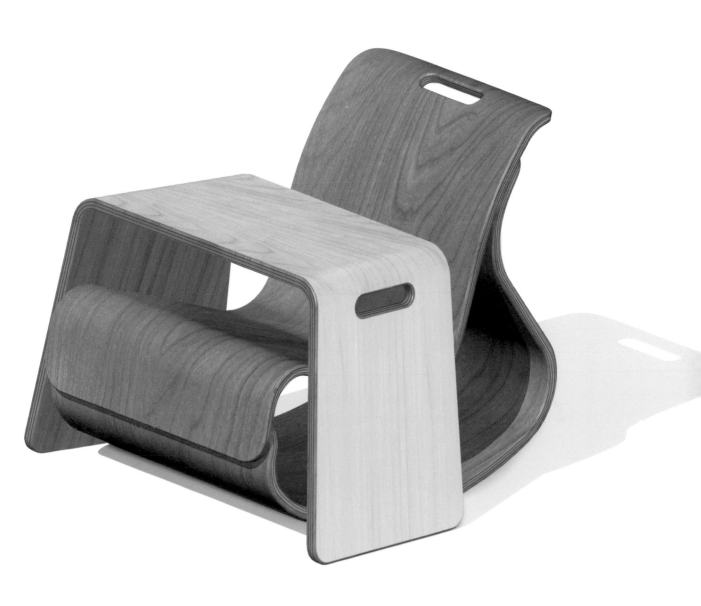

Iglooplay by Lisa Albin Design

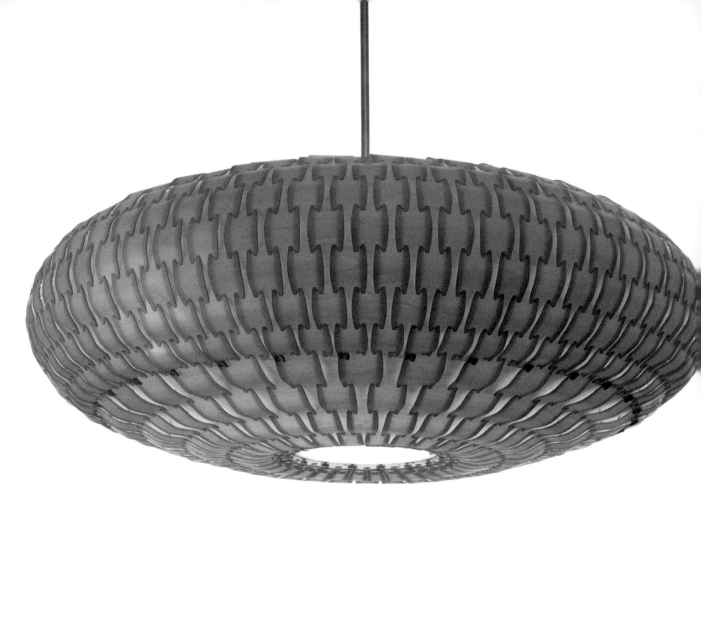

dform

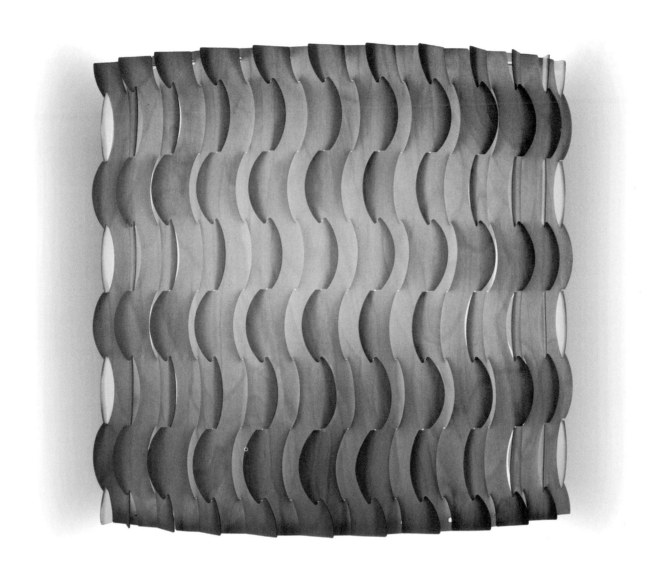

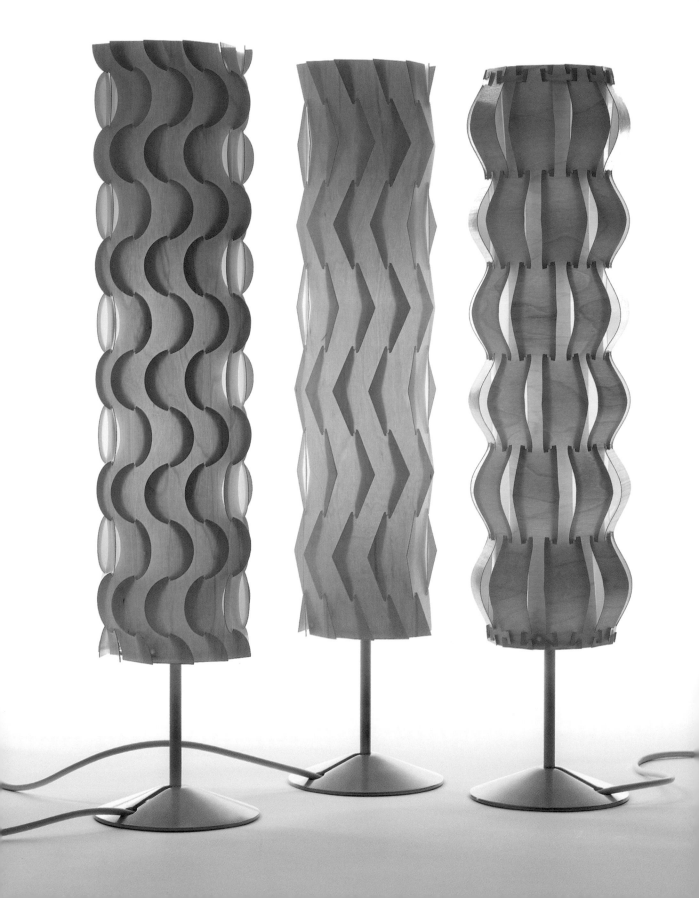

dform

63 Flushing Avenue, Unit 178, bny bldg 5 ste 317, Brooklyn, NY 11211, USA

+1 718 384 6887

+1 718 599 5931

www.dformdesign.com

info@dformdesign.com

James Dieter

1968
James Dieter born in New York, USA

1991
Rhode Island School of Design, BFA Industrial Design, Providence, Rhode Island, USA

1994–2000
Special effects rigging and models for film and advertising

2001
Foundation of dform, Brooklyn, New York, USA

2003
First Place, Home Design, Design 21 Competition New York/Paris

2004
Finalist, Designboom Folding Chair Competition

2005
Origami Masters Exhibition, Salzburg, Austria

After completing his industrial design studies at the Rhode Island School of Design, James Dieter first made models and special effects for the film industry. In 2001, he founded the dform studio. The idea came from a project in which he experimented with templates to which he wanted to give an optical structure and depth. This play with light and shadow gave him the idea to transform two-dimensional materials into three-dimensional lamps.

Nach seinem Industriedesign-Studium an der Rhode Island School of Design produzierte James Dieter zunächst Modelle und Spezialeffekte für die Filmbranche. 2001 gründete er das Studio dform. Die Idee dazu entstand aus einem Projekt, bei dem er mit Schablonen experimentierte, denen er eine optische Struktur und Tiefe geben wollte. Dieses Spiel mit Licht und Schatten brachte ihn auf die Idee, zweidimensionalen Materialien in dreidimensionale Lampen zu verwandeln.

Après ses études de design industriel à la Rhode Island School of Design, James Dieter se consacre d'abord à la production de modèles et d'effets spéciaux dans le secteur du cinéma. En 2001, il crée le studio dform, suite à un projet, où il fait des expériences à partir de pochoirs, afin d'essayer de les doter d'une structure visuelle, et de profondeur. Ce jeu d'ombres et de lumières lui donne l'idée de transformer du matériel en deux dimensions en lampes tridimensionnelles.

Tras sus estudios de diseño industrial en la Rhode Island School of Design, James Dieter empezó a producir maquetas y efectos especiales para la industria cinematográfica. En el año 2001 fundó el estudio dform. La idea surgió de un proyecto en el que experimentó con plantillas alas que deseaba dar una estructura y profundidad visual. Este juego con luces y sombras le llevó a convertir materiales de dos dimensiones en lámparas tridimensionales.

Dopo la laurea in design industriale alla Rhode Island School of Design James Dieter inizialmente costruiva plastici ed effetti speciali per il cinema. Nel 2001 fondò lo studio dform. L'idea nacque da un progetto nel corso del quale eseguiva degli esperimenti con sagome, alle quali voleva dare una struttura ed una profondità ottica. Questo gioco di luce e ombra gli diede l'idea di trasformare dei materiali bidimensionali in lampade tridimensionali.

Interview | dform

What do you consider the most important work of your career? I often think the best work is yet to be done. The initial conception of an idea usually feels more expansive than the resulting product. That said, the most intriguing projects I have tried to resolve have been folding structures.

In what ways does New York inspire your work? New York is inspiring in a motivational sense. With the large variety of cultural influences comes a compelling desire to involve oneself in some way.

Does a typical New York style exist, and if so, how does it show in your work? New York style runs the gamut but tends toward minimalism. I believe what I make feels a little warmer and more organic than what is typical of New York.

How do you imagine New York in the future? Hopefully, New York will continue to be a place where eight million people can live and work in harmony—but they'll also wear silver suits and have hover cars.

Was halten Sie für die wichtigste Arbeit in Ihrer Karriere? Oft denke Ich, dass die beste Arbeit noch geschaffen werden muss. Die anfängliche Konzeption einer Idee hat meistens einen umfassenderen Charakter als das endgültige Produkt. Daraus ergibt sich, dass zusammenfaltbare Strukturen für mich die faszinierendsten Projekte waren.

Auf welche Weise inspiriert New York Ihre Arbeit? New York inspiriert einen auf sehr motivierende Weise. Die große Vielfalt kultureller Einflüsse führt zu dem zwingenden Wunsch, sich selbst irgendwie einzubringen.

Gibt es einen typischen New Yorker Stil, und wenn ja, wie zeigt sich das in Ihrer Arbeit? Der New Yorker Stil durchläuft die ganze Skala, tendiert aber zum Minimalismus. Ich glaube, dass meine Arbeit ein wenig wärmer und organischer ist als das, was sonst typisch für New York ist.

Wie stellen Sie sich New York in der Zukunft vor? Hoffentlich wird New York weiterhin ein Ort sein, an dem acht Millionen Menschen harmonisch zusammen leben und arbeiten können –, aber sie werden auch silberne Anzüge tragen und in Schwebefahrzeugen durch die Luft gleiten.

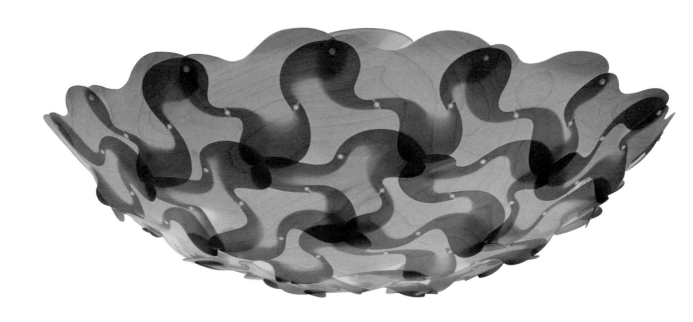

Quelle est l'œuvre la plus importante de votre carrière ? Vous savez, je pense souvent que la plus belle œuvre est encore à faire. La conception première d'une idée dépasse souvent le produit qui en résulte. Ceci dit, les projets les plus intrigants que j'ai eu à résoudre, ce sont certainement les structures pliantes.

Dans quelle mesure la ville de New York inspire-t-elle votre œuvre ? New York peut être source d'inspiration dans le sens de la motivation. De l'immense kaléidoscope d'influences culturelles, naît un désir irrésistible de s'engager d'une manière ou d'une autre.

Peut-on parler d'un style typiquement new-yorkais, et si oui, comment se manifeste-t-il dans votre œuvre ? New York passe par toute une gamme de styles, mais la tendance est au minimalisme. Je pense que ce que je fais est un peu plus chaleureux et davantage organique que ce qui est typiquement new-yorkais.

Comment imaginez-vous le New York de demain ? Il faut espérer que New York reste l'endroit où huit millions de personnes pourront vivre et travailler ensemble dans l'harmonie, mais qu'elles porteront aussi des costumes en argent et conduiront des voitures volantes.

¿Cuál es el trabajo que considera más importante en su carrera? Con frecuencia pienso que el mejor trabajo aún está por hacerse. La concepción inicial de una idea generalmente comunica más que el producto resultante. Dicho esto, los proyectos más enigmáticos que he intentado descifrar han sido las estructuras plegables.

¿De qué manera Nueva York supone una inspiración en su trabajo? Nueva York es inspiradora en un sentido motivador. Con la gran variedad de influencias culturales viene un deseo imperioso de involucrarse en cierto modo.

¿Existe un estilo típico neoyorquino y, si es así, cómo se revela en su obra? El estilo de Nueva York cubre todo el espectro pero domina el minimalismo. Pienso que creo ambientes algo más cálidos y más orgánicos de lo que es habitual en Nueva York.

¿Cómo se imagina Nueva York en el futuro? Con suerte, Nueva York seguirá siendo un lugar donde ocho millones de personas vivan y trabajen en armonía, pero seguro que llevarán trajes plateados y tendrán vehículos voladores.

Qual è secondo Lei il progetto più importante della Sua carriera? Mi trovo spesso a pensare che il progetto migliore sia quello che bisogna ancora fare. L'idea iniziale alla base di un progetto è sempre più ampia del risultato che poi si ottiene. Detto questo, credo che i progetti più ambiziosi di cui mi sono occupato siano quelli con strutture pieghevoli.

In che modo la città di New York ispira il Suo lavoro? New York è una fonte di ispirazione perché infonde motivazione e coraggio. L'enorme varietà di input culturali ti coinvolge, fa nascere in te un desiderio irresistibile di prendervi parte, in qualsiasi modo.

È possibile parlare di uno stile tipico per New York, e, se questo stile esiste, in che modo si manifesta nei Suoi lavori? Lo "stile New York" soddisfa tutti i gusti, ma tende al minimalismo. Credo che i miei progetti, rispetto allo stile tipico di New York, trasmettano una sensazione di maggiore calore, di maggiore organicità.

Come si immagina la New York del futuro? Mi auguro che New York continui a essere la città in cui otto milioni di persone possano vivere e lavorare in piena armonia – certo è che porteranno completi argentati e avranno macchine volanti.

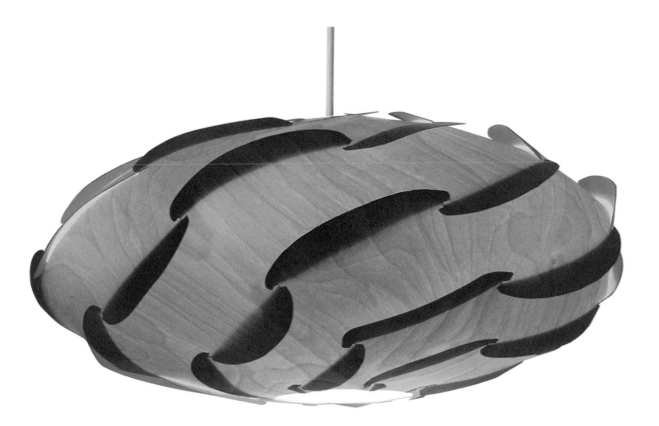

Collection

Basket Saucer 2004, Small Pucci Sconce 2004, Pucci, Marge and Flame Table Lamps 2001, Arabesque Bowl 2004, Meep Pendant 2004, Basket Wall Lamp 2001, Small Pucci Drum Pendant 2004, Pucci Drum Pendant 2004, Basket Drum Pendant 2004, Spade Drum Pendant 2004
Photographs: © Kent Rogowski

Dform lamps are the result of intense work with wood laminates, which are finished with the help of a laser. The subsequent templates are then placed upon one another as a pattern and, despite their flat shape, they create structures that reflect light with an interesting shadow effect. By means of this procedure, like in the Meep Saucer model, rigid materials can be shaped into round and oval forms.

Die Leuchten von dform sind das Ergebnis einer intensiven Arbeit mit Holzlaminaten, die mit Hilfe eines Lasers bearbeitet werden. Die daraus entstehenden Schablonen werden dann zu Mustern übereinander gelegt und schaffen trotz ihrer eigentlich flachen Form Strukturen, die das Licht mit einem interessanten Schatteneffekt reflektieren. Durch dieses Verfahren kann, wie bei dem Modell Meep Saucer, das an sich starre Material in runde und ovale Formen gebracht werden.

Les luminaires de dform sont le fruit d'un travail approfondi sur des lattes de bois, effectué à l'aide d'un laser. Les pochoirs ainsi obtenus sont superposés pour former des motifs qui, malgré leur faible relief, forment des structures réfléchissant la lumière avec des effets d'ombres intéressants. Ce procédé permet, à l'instar du modèle Meep Saucer, d'imprimer à des matières plutôt rigides des formes ovales ou rondes.

Las lámparas de dform son el resultado de un intenso trabajo con láminas de madera procesadas con ayuda de un láser. Las plantillas que se obtienen se superponen formando dibujos y, a pesar de ser planas, forman estructuras que reflejan la luz con interesantes efectos de sombras. Gracias a este procedimiento, se puede dar a un material en sí rígido formas redondas y ovaladas, como en el modelo Meep Saucer.

Le lampade di dform sono il frutto di un intenso lavoro con dei laminati di legno lavorati con il laser. Le sagome che ne risultano vengono sovrapposte formando dei pattern e creando così, nonostante la loro forma piatta, delle strutture che riflettono la luce con un interessante effetto di ombre. Grazie a questo procedimento il materiale di per sé rigido può essere trasformato in forme tonde ed ovali, come si può vedere nel modello Meep Saucer.

521 Design

521 Greencastle Ln., Virginia Beach, VA 23452, USA

+1 757 340 1568

+1 757 340 1568

www.fivetwentyonedesign.com

info@fivetwentyonedesign.com

Chris Ferebee

Chris Ferebee is a self-taught man. In the fields of photography, digital media and furniture design, he developed his abilities himself. Born in 1971 in Virginia Beach, he worked for companies such as IBM, Microsoft, Sony and Saatchi & Saatchi, before creating his studio 521 Design in 1999. By experimenting with different materials, he developed prize-winning designs such as, for example, the Hive Shelving Unit.

Chris Ferebee ist Autodidakt. In den Bereichen Fotografie, digitale Medien und Möbeldesign hat er seine Fähigkeiten selbst entwickelt. 1971 in Virginia Beach geboren, arbeitete er für Firmen wie IBM, Microsoft, Sony und Saatchi & Saatchi, bevor er 1999 das Studio 521 Design gründete. Durch das Experimentieren mit verschiedenen Werkstoffen entwickelt er preisgekrönte Designs wie beispielsweise das Regal Hive Shelving Unit.

Chris Ferebee est autodidacte. Dans les domaines de la photographie, de la communication digitale et du design de meubles, il s'est formé lui-même. Né en 1971 à Virginia Beach, il travaille pour des entreprises comme IBM, Microsoft, Sony et Saatchi & Saatchi, avant de fonder, en 1999, le studio 521 Design. En travaillant diverses matières, il conçoit des designs primés, à l'instar de l'étagère Hive Shelving Unit.

Chris Ferebee es autodidacta. En las áreas de la fotografía, los medios digitales y el diseño de muebles ha desarrollado sus habilidades por sí mismo. Nació en Virginia Beach el año 1971 y trabajó para empresas como IBM, Microsoft, Sony y Saatchi & Saatchi antes de fundar en 1999 el estudio 521 Design. A través de la experimentación con distintos materiales, desarrolla galardonados diseños como por ejemplo la estantería Hive Shelving Unit.

Chris Ferebee è autodidatta. Nelle discipline della fotografia, dei media digitali e del design di mobili sviluppò da sè le sue doti. Nato a Virginia Beach nel 1971 ha lavorato per ditte come IBM, Microsoft, Sony e Saatchi & Saatchi, e nel 1999 fondò lo studio 521 Design. Sperimentando vari materiali riuscì a sviluppare delle creazioni premiate, come ad esempio lo scaffale Hive Shelving Unit.

Chris Ferebee

1971
Born in Virginia Beach, Virginia, USA

1992
Collaboration with photo agencies Photonica, Getty Images, Graphistock
Published by clients as IBM, Microsoft, Sony, Saatchi & Saatchi, American Express

1998
Hollow Table

1999
Foundation of 521 Design with Laurice Parkin in New York, USA
One Cabinet

2000
Joseph Bench

2001
Design Distinction Award for furniture design from I.D. Magazine's Annual Design Review

2003
Hive H2 Shelving Unit

Which do you consider your most important work in your career? I'd have to say my most important work is the work I don't place too much importance on, not taking myself too seriously... yet connecting, through the process of the work, to those I work with in a way that is never superceded by the work itself.

In what ways does New York inspire your work? The limitless amount of visual information, diverse cultural references, the many different perspectives of design and architecture, art, graphic design, music... garbage even, all serve to play some part of overall inspiration.

Does a typical New York style exist, and if so, how does it show in your work? I think with the nature of technology today that "regional" styles are quickly ceasing to exist. I think there are simply trends on a global scale these days. Having said that, New York will always have an attitude that it is intrinsic to itself, no matter how you dress it up or design it.

How do you imagine New York in the future? Same animal, different skin.

Was halten Sie für die wichtigste Arbeit in Ihrer Karriere? Meine wichtigste Arbeit ist wohl die Arbeit, der ich nicht soviel Bedeutung beimesse. Ich nehme mich nicht so ernst ... allerdings stelle ich mit der Durchführung meiner Arbeit eine Verbindung zu denen her, mit denen ich arbeite, was aber niemals an die Stelle der Arbeit selbst tritt.

Auf welche Weise inspiriert New York Ihre Arbeit? Die unendliche Fülle visueller Informationen, unterschiedlicher kultureller Belange, die vielen verschiedenen Perspektiven von Design und Architektur, Kunst, Grafikdesign, Musik ... und selbst der Müll: Dies ist alles ist Teil einer allumfassenden Inspiration.

Gibt es einen typischen New Yorker Stil, und wenn ja, wie zeigt sich das in Ihrer Arbeit? Bei dem heutigen Stand der Technologie haben „regionale" Stile kaum eine Überlebenschance. Heutzutage haben Trends eher eine globale Größenordnung. New York wird aber immer seine ganz eigene Einstellung haben, egal was der aktuelle Trend oder Design vorgibt.

Wie stellen Sie sich New York in der Zukunft vor? Dasselbe Tier, nur mit einer anderen Haut.

Quelle est l'œuvre la plus importante de votre carrière ? L'œuvre la plus importante de ma carrière est justement celle à laquelle je n'accorde pas trop d'importance, où je ne me prends pas trop au sérieux... dans une étroite relation de travail avec mes collaborateurs, veillant à ne pas laisser l'œuvre nous dépasser.

Dans quelle mesure la ville de New York inspire-t-elle votre œuvre ? La quantité infinie d'information visuelle, les diverses références culturelles, les différentes perspectives de design et d'architecture, d'art, de graphique, de design, de musique... y compris les déchets, tout peut être source d'inspiration.

Peut-on parler d'un style typiquement new-yorkais, et si oui, comment se manifeste-t-il dans votre œuvre ? Je crois qu'en fonction de la technologie actuelle les styles « régionaux » finissent par disparaître. Je pense que de nos jours, on parle surtout de tendances à une échelle mondiale. Ceci dit, New York aura toujours une attitude personnelle, intrinsèque, indépendamment de la mode ou du design.

Comment imaginez-vous le New York de demain ? Le même animal, mais avec une peau différente.

¿Cuál es el trabajo que considera más importante en su carrera? Podría decir que el trabajo más importante es aquel al que no doy demasiada importancia, no tomándome muy en serio... pero conectando, mediante el proceso del trabajo, con aquellos con los que trabajo de una forma que nunca será superada por el trabajo propiamente dicho.

¿De qué manera Nueva York supone una inspiración en su trabajo? La cantidad ilimitada de información visual, las diversas referencias culturales, las numerosas distintas perspectivas de diseño y arquitectura, arte, diseño gráfico, música... incluso la basura, contribuyen a representar algún papel en la inspiración global.

¿Existe un estilo típico neoyorquino, y si es así, cómo se revela en su obra? Creo que con la naturaleza de la tecnología hoy en día los estilos "regionales" están dejando de existir a grandes pasos. En la actualidad simplemente hay tendencias a escala global. Dicho esto, Nueva York siempre tendrá una actitud que es intrínseca a ella misma, con independencia de cómo la vistas o la diseñes.

¿Cómo se imagina Nueva York en el futuro? El mismo animal, con una piel distinta.

Cosa pensa che sia la cosa più importante della Sua carriera? Devo dire che il mio lavoro più importante è quello al quale non do troppa importanza, in cui non mi prendo troppo sul serio... E in cui mi connetto comunque, attraverso il processo del lavoro, con coloro con cui collaboro, in un modo in cui questo non è mai soppiantato dal lavoro stesso.

In che modo New York influenza il Suo lavoro? La quantità infinita di informazione visiva, i riferimenti culturali differenti, le tante prospettive diverse di design e architettura, arte, grafica, musica... persino la spazzatura, tutto diventa parte di un'ispirazione generale.

Esiste uno stile tipico a New York? Se sì, come influenza il Suo lavoro? Credo che con la natura della tecnologia odierna gli stili "regionali" stanno cessando di esistere. Credo che oggigiorno ci siano semplicemente dei trend su scala globale. Detto questo, New York avrà sempre un'attitudine di essere intrinseca a se stessa, indifferentemente dalcome la vesti o la allestisci.

Come si immagina New York in futuro? Lo stesso animale, pelle diversa.

Collection

Hive H2 2003, One Cabinet 1999, Hive H2 2003, Joseph Bench 2000, 40 SQ- YRDS Bench 2002, Low Tek Table 1999
Photographs: © Nick Vaccaro Photography

Growing up In Virginia Beach as part of the skateboard and surf scene, his self-taught approach is unconventional and unencumbered. Inspired by artists such as Rauschenberg, Twombly and Beuys, he experiments with his eclectic designs, particular in terms of materials. By laying felt mats over one another or rolling them together, he completely redefined the idea of a stool with his Joseph Felt and 40 SQ Yrds Bench designs.

Aufgewachsen in Virginia Beach als Teil der Skateboard- und Surf-Szene ist auch sein autodidaktischer Ansatz unkonventionell und unbeschwert. Inspiriert von Künstlern wie Rauschenberg, Twombly und Beuys experimentiert er bei seinen eklektischen Entwürfen vor allem mit den Materialien. So hat er bei seinen Designs Joseph Felt und 40 SQ Yrds Bench das Konzept eines Hockers völlig neu definiert, indem er Filzmatten übereinander legt oder einrollt.

Ayant grandit à Virginia Beach, au milieu de la scène des planchistes et surfeurs, sa démarche autodidacte affiche la même originalité et insouciance. Dans la même veine d'artistes tels que Rauschenberg, Twombly et Beuys, il fait des recherches surtout sur les matières pour réaliser ses œuvres éclectiques. Dans ses designs, Joseph Felt et 40 SQ Yrds Bench, il redéfinit totalement le concept du tabouret, en superposant ou roulant des matelas de feutrine.

Como el ambiente del skateboard y el surf que lo rodeó en Virginia Beach, su enfoque autodidacta es desenfadado y alejado de los convencionalismos. Inspirado por artistas como Rauschenberg, Twombly y Beuys, en sus trabajos eclécticos experimenta sobre todo con los materiales. Por ejemplo, en sus diseños Joseph Felt y 40 SQ Yrds Bench, ha redefinido por completo el concepto de taburete, enrollando o superponiendo esterillas de fieltro.

Cresciuto a Virginia Beach nella scena dello skateboard e del surf, anche il suo approccio autodidatta è anticonvenzionale e spensierato. Traendo ispirazione da artisti quali Rauschenberg, Twombly e Beuys nei suoi progetti eclettici sperimenta soprattutto con i materiali. Nelle sue creazioni Joseph Felt e 40 SQ Yrds Bench ha dato una nuova definizione allo sgabello, sovrapponendo o arrotolando "pannelli" di feltro.

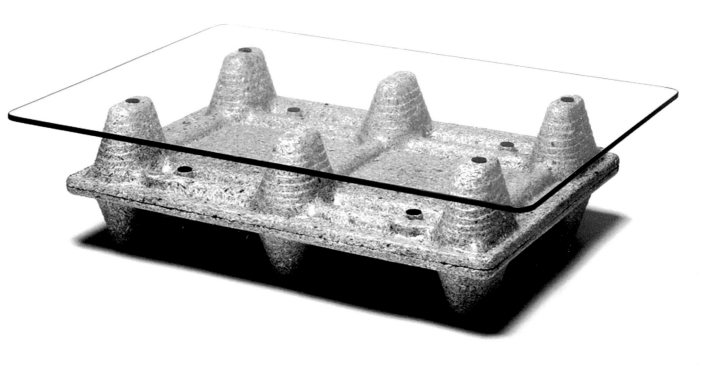

Designfenzider Studio

Designfenzider Studio

93 Reade Street, Tribeca, New York, NY 10013, USA

+1 212 791 2877

+1 212 343 8851

www.designfenzider.com

info@designfenzider.com

Ron Gilad

Ron Gilad was born in Israel and studied industrial design in Jerusalem. Before moving to New York in 2001 to open his studio, Designfenzider, he taught 3-D design at the Shenkar School of Engineering and Design in Israel. In his designs, Ron Gilad creates not only functional and aesthetically pleasing products but he plays upon their sensory effect and enriches them with a tongue-in-cheek quality.

Ron Gilad wurde in Israel geboren und studierte Industriedesign in Jerusalem. Bevor er 2001 nach New York umsiedelte und sein Studio Designfenzider eröffnete, unterrichtete er 3D-Design an der Shenkar School of Engineering and Design in Israel. Bei seinen Entwürfen schafft Ron Gilad nicht nur funktionale und ästhetisch ansprechende Produkte, sondern setzt sich vor allem mit deren sinnlicher Wirkung auseinander und bereichert sie um eine ironische Komponente.

Ron Gilad, né en Israël, fait des études de design industriel à Jérusalem. Avant de s'installer en 2001 à New York et d'ouvrir son studio Designfenzider, il enseigne le Design 3D à la Shenkar School of Engineering and Design d'Israël. Ron Gilad ne se limite pas à créer uniquement des produits fonctionnels et esthétiques mais recherche surtout leur impact sensuel en y ajoutant une composante ironique.

Ron Gilad nació en Israel y estudió diseño industrial en Jerusalem. Antes de trasladarse a Nueva York y abrir su estudio Designfenzider en el año 2001, fue profesor de diseño en 3D en la Shenkar School of Engineering and Design de Israel. En sus trabajos, Ron Gilad no solo crea productos funcionales y de gran atractivo estético, sino que ahonda sobre todo en su efecto sensorial y los enriquece con componentes irónicos.

Ron Gilad nacque in Israele e studiò design industriale a Gerusalemme. Prima di trasferirsi a New York nel 2001 ed aprirvi il suo studio Designfenzider, ha insegnato design 3D alla Shenkar School of Engineering and Design in Israele. Ron Gilad non solo crea prodotti funzionali e di elevato valore estetico, ma si confronta anche con il loro effetto "sensuale" e gli arricchisce con una componente ironica.

Ron Gilad

1972
Born in Israel

1995–1998
Industrial Design at the Bezalel Academy of Arts and Design in Jerusalem, Israel

2000
Vase Maker, part of the Tel Aviv Museum of Art Collection

2001
Foundation of Designfenzider with Lior Haramaty, New York, USA
Day Bed

2003
Dear Ingo Chandelier
A Void Stool and table
Run over by car

2004
Lamp no. 13

2005
Candlestick Maker
Fruit bowls no 4/5/6
Flower In
Lamp no. 14/15/16/17/18/19

Interview | Designfenzider Studio

Which do you consider the most important work of your career? My objects represent bits of information which when considered together tell a story. It is the accumulation of ideas, both extant and future, that has meaning.

In what way does New York inspire your work? All the conveniences of life are found on the street where I work and live: food, bank, cleaners and colleagues. When I do venture into the streets of New York, I find a comfort in the anonymity of the crowds. I like New York–and like it even better from within my studio.

Does a typical New York style exist, and if so, how does it show in your work? NY Design ingests the creative input of individuals from diverse cultures. As an Israeli by origin, I see myself contributing to this mosaic, nourishing its ever evolving Identity.

How do you imagine New York in the future? As a New Yorker, trying to live fully in the moment is all one can think about.

Was halten Sie für die wichtigste Arbeit in Ihrer Karriere? Jedes meiner Objekte stellt für sich ein Stück Information dar, zusammengesetzt erzählen die Objekte dann eine Geschichte. Erst in der Verbindung von momentanen und zukünftigen Ideen liegt eine Bedeutung.

Auf welche Weise inspiriert New York Ihre Arbeit? Wo ich arbeite und lebe habe ich die Annehmlichkeiten des Lebens direkt vor der Nase: Essen, Bank, Reinigungskräfte und Kollegen. Wenn ich mich auf die Straßen New Yorks wage, genieße ich im Gedränge die Vorzüge der Anonymität. Ich mag New York – und mag es noch mehr von meinem Studio aus.

Gibt es einen typischen New Yorker Stil, und wenn ja, wie zeigt sich das in Ihrer Arbeit? Im New Yorker Design fließt der kreative Input von Individuen unterschiedlicher kultureller Herkunft zusammen. Durch meine israelischen Wurzeln trage ich selbst zu diesem Mosaik bei und nähre die fortwährende Entwicklung seiner Identität.

Wie stellen Sie sich New York in der Zukunft vor? Als New Yorker denkt man nur daran, vollkommen im Moment zu leben.

Quelle est l'œuvre la plus importante de votre carrière ? Mes objets offrent des bribes d'informations qui, prisent dans leur ensemble, racontent une histoire. Le sens à tout cela, c'est l'accumulation d'idées, actuelles et futures.

Dans quelle mesure la ville de New York inspire-t-elle votre œuvre ? Je trouve toutes les facilités dans la rue où je vis et je travaille : alimentation, banque, nettoyage et collègues. Lorsque je m'aventure dans les rues de New York, je me sens bien dans l'anonymat de la foule. J'aime New York – et davantage encore au sein de mon studio.

Peut-on parler d'un style typiquement new-yorkais, et si oui, comment se manifeste-t-il dans votre œuvre ? A New York, le design absorbe le potentiel créatif d'individus de cultures diverses. D'origine israélienne, je pense contribuer à cette mosaïque, nourrissant son évolution constante.

Comment imaginez-vous le New York de demain ? En tant que new-yorkaise, je ne pense qu'à une chose, c'est vivre l'instant présent.

¿Cuál es el trabajo que considera más importante en su carrera? Mis objetos representan retazos de información que cuando se consideran en conjunto cuentan una historia. Es la acumulación de ideas, tanto existente como futura, lo que tiene sentido.

¿De qué manera Nueva York supone una inspiración en su trabajo? Todas las comodidades de la vida se encuentran en la calle donde trabajo y vivo: comida, banca, lavandería y compañeros. Cuando me aventuro en las calles de Nueva York, me encuentro cómodo en el anonimato de la multitud. Me gusta Nueva York, y me gusta casi más desde el interior de mi estudio.

¿Existe un estilo típico neoyorquino, y si es así, cómo se revela en su obra? El diseño de Nueva York engulle la información creativa de los individuos de diversas culturas. Como israelí de origen, considero que contribuyo a este mosaico, alimentando su identidad siempre en evolución.

¿Cómo se imagina Nueva York en el futuro? Como neoyorquino, intentar vivir plenamente el momento es todo en lo que uno puede pensar.

Cosa pensa che sia la cosa più importante della Sua carriera? I miei oggetti rappresentano dei bit di informazioni che, considerati tutti insieme, raccontano una storia. È l'accumulo delle idee, presente e futuro, che ha il suo significato.

In che modo New York influenza il Suo lavoro? Nella strada in cui lavoro e vivo, posso trovare tutte le comodità quotidiane: cibo, banca, lavanderie e colleghi. Quando mi addentro nelle strade di New York, mi sento al mio agio nell'anonimità della folla. Mi piace New York – e ancora più vista da dentro al mio studio.

Esiste uno stile tipico a New York? Se sì, come influenza il Suo lavoro? Il design di NY ingerisce l'input creativo di individui provenienti da diverse culture. Io che sono di origine israeliana, vedo me stesso contribuire a questo mosaico, nutrendo la sua identità eternamente in evoluzione.

Come si immagina New York in futuro? Per un newyorchese, tentare di vivere pienamente nel momento è tutto ciò che può pensare.

Collection

Run Over By A Car 2003, Anti Bouquet 1999, Void Stool 2003, Vase Maker 2000, Lamp No. 13 2004, Dear Ingo Lamp 2003, Negative Bench 1999
Photographs: © Designfenzider Studio, Srulik Haramaty

Ron Gilad calls himself a philosopher of everyday life items, for which not problem solving, but rather the reflection on the perception of products is the focus. His approach consists of discovering dimensions beyond the actual function of the article and to making them able to be experienced by the user. In this way, the Vasemaker vase is not a finished object, but rather it consists of individual parts, which one combines with one another.

Ron Gilad bezeichnet sich selbst als Philosoph der Alltagsgegenstände, bei dem nicht die Problemlösung, sondern die Reflexion über die Wahrnehmung von Produkten im Vordergrund steht. Sein Ansatz besteht darin, Dimensionen neben der eigentlichen Funktion des Gegenstandes zu entdecken und dem Benutzer erlebbar zu machen. So ist die Vase Vasemaker kein fertiges Objekt, sondern sie besteht aus einzelnen Teilen, die man miteinander kombiniert.

Ron Gilad se décrit lui-même comme philosophe des objets du quotidien, en mettant en avant la réflexion sur la perception du produit plutôt que la solution au problème. Son approche de l'objet consiste à en découvrir les dimensions en dehors de sa fonction intrinsèque, pour que l'utilisateur en fasse ensuite l'expérience. A titre d'exemple, le vase Vasemaker n'est pas en soi un objet fini : il est composé d'éléments que l'on peut assembler.

Ron Gilad se autodenomina filósofo de los objetos de uso diario, para el cual en primer término se halla la reflexión sobre la percepción de los productos, y no la solución de problemas. Su principio consiste en descubrir dimensiones junto a la función propia del objeto y hacer que el usuario las experimente. Por ejemplo, el jarrón Vasemaker no es un objeto acabado, sino que consta de varias piezas que se pueden combinar entre sí.

Ron Gilad si autodefinisce filosofo degli oggetti quotidiani, ove pone in primo piano, oltre alla risoluzione di problemi, anche la riflessione sulla percezione dei prodotti. Il suo approccio consiste nello scoprire nuove dimensioni oltre all'effettiva funzione dell'oggetto e di far vivere all'utente queste dimensioni. Il vaso Vasemaker per esempio non è un oggetto finito, bensì è composto da singole parti combinabili tra loro.

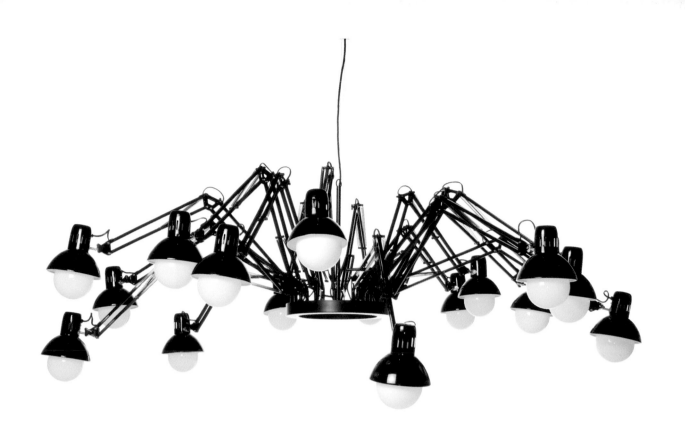

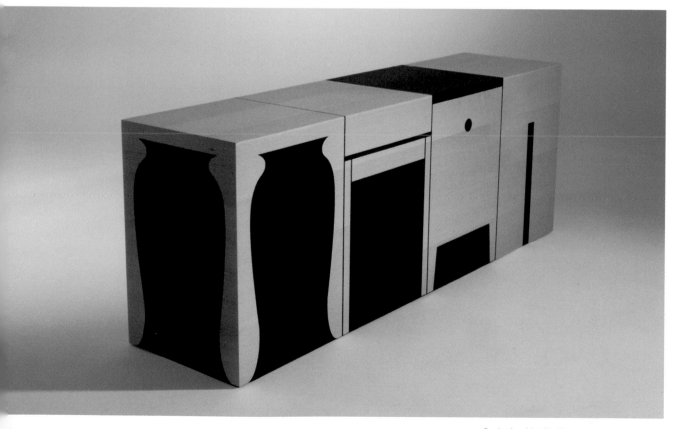

Designfenzider Studio

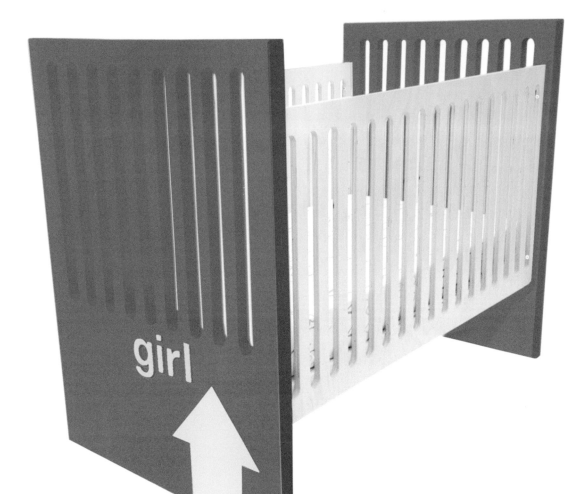

ducduc

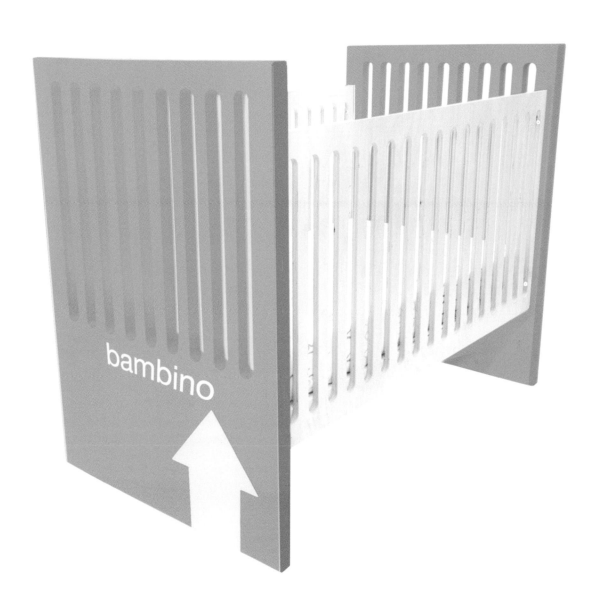

bambino

ducduc

524 Broadway No. 206, New York, NY 10012, USA

1 212 226 868

1 212 226 5504

www.ducducnyc.com

info@ducducnyc.com

ducduc

The idea for ducduc came out of Philip Erdoes' unsuccessful search for modern children's furniture, which can be used for a long time and in a flexible manner. After inspiring the other three founders, Brady Wilcox, David Harris and Rebby Gregg for the project, ducduc was brought to life in New York in 2004. The four founders are further supported in their playful and contemporary designs by a team with a strong educational background.

Entstanden ist die Idee zu ducduc aus der ergebnislosen Suche Philip Erdoes nach modernen Kindermöbeln, die man außerdem langfristig und flexibel verwenden kann. Nachdem er die drei weiteren Gründer Brady Wilcox, David Harris und Rebby Gregg für das Projekt begeistern konnte, wurde ducduc 2004 in New York ins Leben gerufen. Für ihre spielerischen und aktuellen Entwürfe lassen sich die vier Gründer zusätzlich von einem pädagogisch erfahrenen Team unterstützen.

Le concept du ducduc est né des vains efforts de Philip Erdoes à trouver des meubles d'enfant modernes, utilisable à long terme et modulables. Après avoir réussi à enthousiasmer les trois autres fondateurs Brady Wilcox, David Harris et Rebby Gregg pour le projet, ducduc a vu le jour en 2004, à New York. Dans la conception ludique et actuelle de leurs projets, les quatre créateurs sont secondés par une équipe pédagogique expérimentée.

La idea de ducduc surgió como respuesta a la infructuosa búsqueda por parte de Philip Erdoes de mobiliario infantil moderno, que además pudiera usarse de forma flexible durante varios años. Después de conseguir que los otros tres fundadores, Brady Wilcox, David Harris y Rebby Gregg, se entusiasmaran por el proyecto, en el año 2004 ducduc vio la luz en Nueva York. Para sus diseños actuales y desenfadados, los cuatro fundadores reciben el apoyo de un equipo de expertos pedagogos.

L'idea di ducduc nacque per Philip Erdoes dalla vana ricerca di mobili moderni per bambini, che permettessero anche di essere utilizzati in modo flessibile e per lungo tempo. Dopo essere riuscito a convincere del progetto i cofondatori Brady Wilcox, David Harris e Rebby Gregg, ducduc fu fondato a New York nel 2004. Nei loro progetti giocosi ed attualissimi i quattro si avvalgono dell'aiuto di un team di pedagoghi di grande esperienza.

2004
Foundation of ducduc by Philip Erdoes, Brady Wilcox, David Harris and Rebby Gregg, New York, USA

2005
Austin Collection
PJ Collection
Morgan Collection
Alex Collection
Dylan Collection
Sam Collection
Parker Collection

2006
Crosby Collection

Interview | ducduc

What do you consider the most important work of your career? Whatever we are working on.

In what ways does New York inspire your work? The most inspiring aspect of New York for ducduc right now is that so many young families have decided to stay and raise children in the city providing us with endless ideas, improvements, and encouragement.

Does a typical New York Style exist? No. That's the beauty of it!

How do you imagine New York in the future? Always evolving, always challenging, always dynamic.

Was halten Sie für die wichtigste Arbeit in Ihrer Karriere? Woran auch immer wir gerade arbeiten.

Auf welche Weise inspiriert New York Ihre Arbeit? Für ducduc ist es momentan das Inspirierendste an New York, dass so viele junge Familien sich entschlossen haben, in der Stadt zu bleiben und dort auch ihre Kinder aufziehen. Das gibt uns Mut und bedeutet für uns unbegrenzte Ideen und Verbesserungsmöglichkeiten.

Gibt es einen typischen New Yorker Stil? Nein. Und das ist genau das Schöne daran!

Wie stellen Sie sich New York in der Zukunft vor? Stetige Fortentwicklung, stetige Herausforderung und stetige Dynamik.

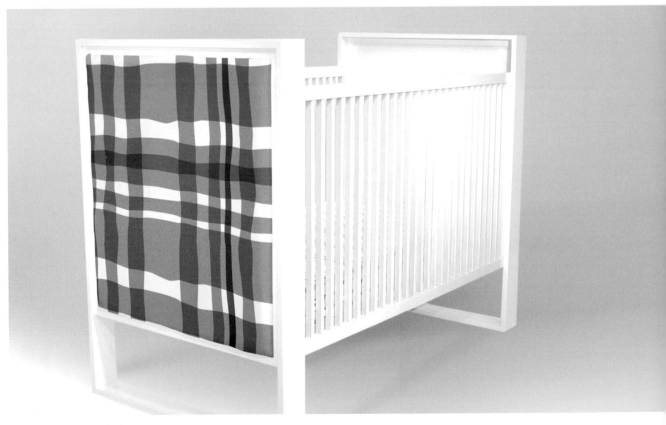

Quelle est l'œuvre la plus importante de votre carrière ? Tout ce qui fait l'objet de notre travail.

Dans quelle mesure la ville de New York inspire-t-elle votre œuvre ? Il y a un aspect de New York qui nous a particulièrement inspiré : c'est le fait que tant de jeunes familles aient décidé de rester dans cette ville pour y élever leurs enfants. Cela nous a donné un tas d'idées, nous a encouragé et permis d'avancer.

Peut-on parler d'un style typiquement new-yorkais ? Pas du tout. C'est ce qui en fait le charme et la beauté !

Comment imaginez-vous le New York de demain ? Toujours en mutation, toujours relevant des défis, toujours dynamique.

¿Cuál es el trabajo que considera más importante en su carrera? Cualquiera en el que estemos trabajando.

¿De qué manera Nueva York supone una inspiración en su trabajo? El aspecto más inspirador de Nueva York para ducduc ahora mismo es que tantas familias jóvenes hayan decidido quedarse y criar a sus hijos en la ciudad proporcionándonos infinitas ideas, mejoras y ánimo.

¿Existe un estilo típico neoyorquino? No. ¡Ahí radica su belleza!

¿Cómo se imagina Nueva York en el futuro? Siempre evolucionando, siempre desafiando, siempre dinámica.

Qual è secondo Lei il progetto più importante della Sua carriera? Tutto quello a cui stiamo lavorando.

In che modo la città di New York ispira il Suo lavoro? La cosa più interessante del momento è che moltissime giovani famiglie hanno deciso di vivere e crescere i loro figli nella città e questo, oltre a fornirci la forza per andare avanti, è per noi fonte di ispirazione per numerosissime idee e perfezionamenti.

È possibile parlare di uno "stile tipico" per New York, e, se questo stile esiste, in che modo si manifesta nei Suoi lavori? No, non c'è uno stile tipico. E proprio questo è il bello della città!

Come si immagina la New York del futuro? In continua evoluzione, eternamente stimolante, sempre dinamica.

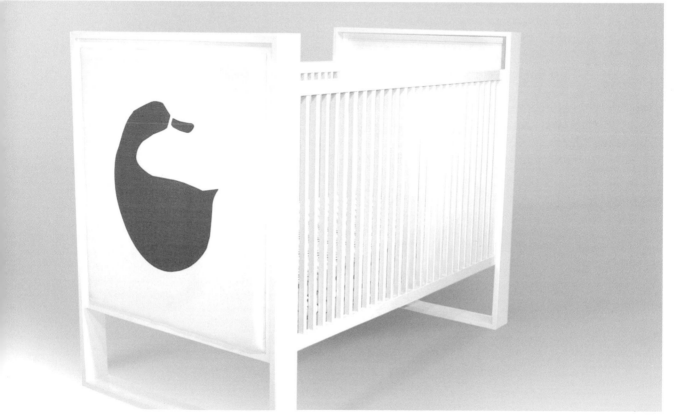

Collection

Alex Crib, PJ Armoire, PJ Fabric Panel Crib, Alex Crib
Year: 2004
Photographs: © Gregory

Ducduc's children's furniture can be defined both by its modern design and by its playful elements, such as for example, the slate cladding of the PJ armoire, which the children can paint based upon their whims. In addition, the furnishings are designed to grow with the child and be used over the long term. The designers use only re-forestable solid wood without harmful lacquer finishes.

Die Kindermöbel ducducs lassen sich sowohl durch ihr modernes Design als auch durch ihre spielerischen Elemente definieren, wie beispielsweise die Schieferverkleidung des Schranks PJ Armoire, den die Kinder nach Lust und Laune bemalen können. Zudem sind die Möbel so konzipiert, dass sie mit dem Kind mitwachsen und langfristig genutzt werden können. Die Designer verwenden nur wiederaufforstbares Vollholz, bei dem auf schädliche Lackierungen verzichtet wird.

Les meubles d'enfant ducduc se définissent autant par la modernité de leur design que par les éléments ludiques, à l'instar du revêtement en ardoise de l'armoire PJ Armoire, où les enfants peuvent dessiner à leur guise. Les meubles, conçus pour grandir avec les enfants, peuvent être utilisés longtemps. Les designers n'emploient que du bois massif en provenance de forêt de reboisement, dépourvu de vernis nocif pour la santé.

El mobiliario infantil de ducduc se puede definir tanto por su diseño moderno cuanto por sus elementos lúdicos, como por ejemplo el revestimiento de pizarra del armario PJ Armoire, que los niños pueden pintar a su gusto. Además, los muebles están concebidos de manera que crezcan con los niños y se puedan usar a largo plazo. Los diseñadores utilizan exclusivamente madera maciza de bosques reforestables y prescinden de pinturas y barnices nocivos.

I mobili per bambini di ducduc sono caratterizzati dal loro design moderno e dagli elementi giocosi come per esempio il rivestimento in ardesia dell'armadio PJ Armoire, che i bambini possono dipingere a piacimento. Inoltre i mobili sono concepiti in modo da crescere insieme al bambino e poter quindi essere utilizzati per molto tempo. I designer utilizzano esclusivamente legno grezzo da fonti rinnovabili, rinunciando completamente a dannose verniciature.

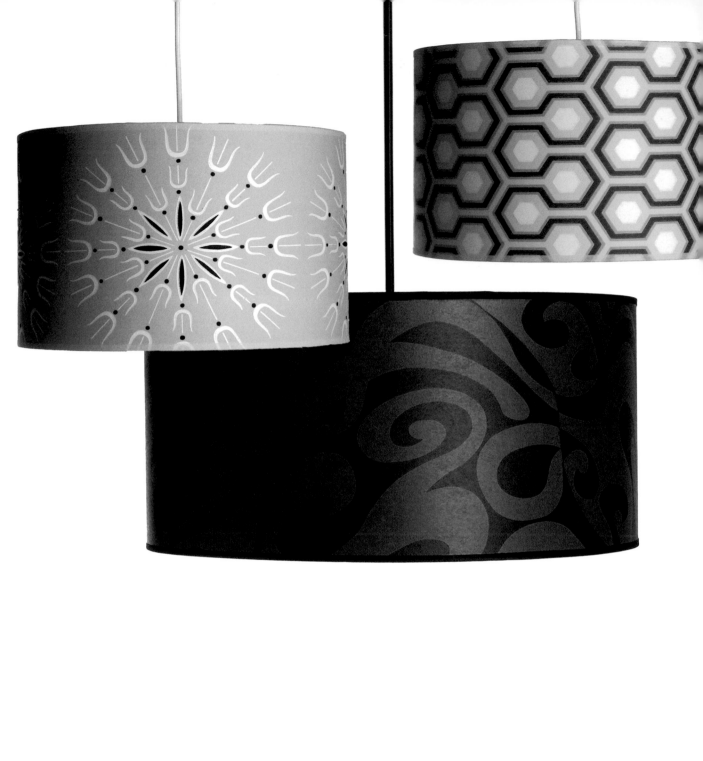

Zia-Priven Design

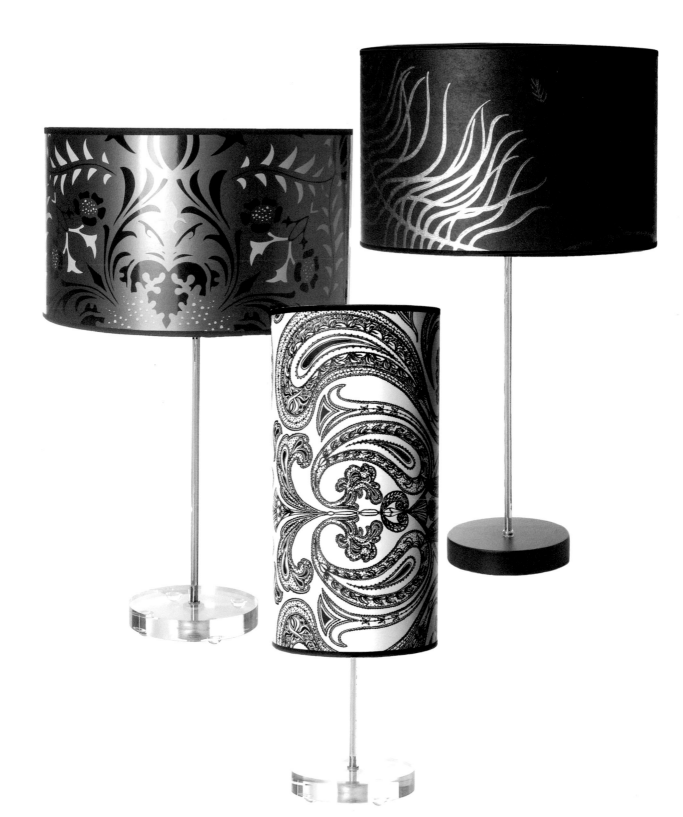

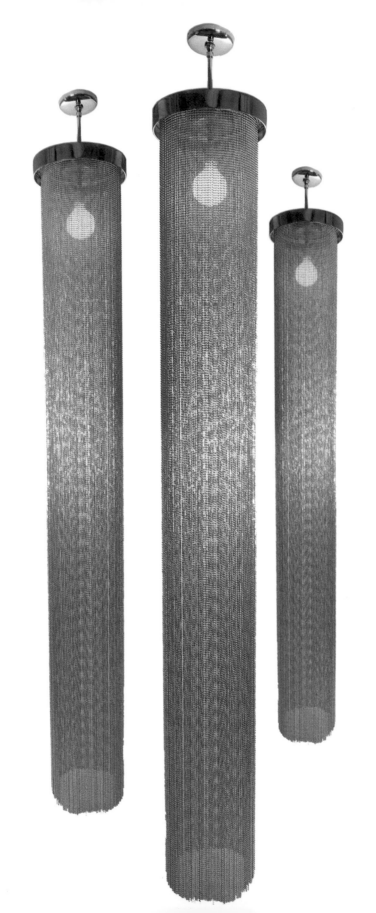

Zia-Priven Design

Brooklyn Navy Yard, Building 280, Suite 220, Brooklyn, NY 11205, USA

+1 718 398 6777

+1 718 398 0445

www.ziapriven.com

zia-priven@juno.com

Marcia Zia and Paul Priven

Marcia Zia and Paul Priven met in 1997 while filming in Los Angeles and decided to open a boutique and design studio in New York, after discovering their common interest in vintage lighting design. Their glamorous designs inspire not only private clients but they can also be found in hotels and bars. In addition to their collection for Stonegate Designs, they also created a line for Oscar de la Renta.

Marcia Zia und Paul Priven lernten sich 1997 bei Dreharbeiten in Los Angeles kennen und entschlossen sich, eine Boutique und ein Designstudio in New York zu eröffnen, nachdem sie ihr gemeinsames Interesse für Vintage-Lichtdesign entdeckt hatten. Ihre glamourösen Entwürfe begeistern dabei nicht nur private Käufer, sondern man findet sie auch in Hotels und Bars. Neben einer Kollektion für Stonegate Designs kreierten sie auch eine Linie für Oscar de la Renta.

Marcia Zia et Paul Priven se sont rencontrés en 1997 sur un tournage à Los Angeles. Ils décident ensuite d'ouvrir une boutique et un studio de design à New York, après avoir découvert leur intérêt commun pour le luminaires vintage. Si leurs projets emprunts de glamour soulèvent l'enthousiasme des acheteurs privés, ils font aussi la joie des hôtels et des bars. A côté d'une collection pour Stonegate Designs, ils ont créé aussi une ligne pour Oscar de la Renta.

Marcia Zia y Paul Priven se conocieron en 1997 durante un rodaje en Los Ángeles y decidieron abrir una boutique y un estudio de diseño en Nueva York después de descubrir su interés común por el diseño de iluminación vintage. Sus glamourosos diseños no solo fascinan a los particulares, sino que pueden encontrarse en hoteles y bares. Además de una colección para Stonegate Designs, también han creado una línea para Oscar de la Renta.

Marcia Zia e Paul Priven si conobbero nel 1997 sul set di un film a Los Angeles e decisero di aprire una boutique ed uno studio di design a New York, dopo aver scoperto il loro comune interesse per il design dell'illuminazione vintage. Le loro creazioni glamorose non entusiasmano solo gli acquirenti privati, ma si trovano anche in alberghi e bar. Oltre ad un progetto per Stonegate Designs hanno creato anche una linea per Oscar de la Renta.

1999
Foundation of Zia-Priven Design by Marcia Zia and Paul Priven, New York, USA

2000
Salon Collection

2004
Waterfall Pendant

2005
Contemporary Wallpaper Collection
Infinity Pendant
Studio 54 Pendant

Interview | Zia-Priven Design

Which do you consider the most important work of your career? The most important work of our career thus far, was a 10 foot tall modern interpretation of a classic French Empire chandelier made almost entirely of over 3000 luminous ping pong balls.

In what ways does New York inspire your work? New York has a passionate soul and rhythm. New York challenges us to be our personal best and inspires us to dream with her.

Does a typical New York style exist, and if so, how does it show in your work? The beauty of New York is that from hippies to socialites, the style is to do what you do best. We strive to make lighting that is unique and beautiful from concept to finish.

How do you imagine New York in the future? The future shines brightly for a city filled with people driven by passion and determination, who constantly reinvent themselves by reinventing design. It will always remain the City That Never Sleeps.

Was halten Sie für die wichtigste Arbeit in Ihrer Karriere? Die wichtigste Arbeit unserer Karriere war bisher eine drei Meter hohe, moderne Interpretation eines klassischen Kronleuchters aus der französischen Kaiserzeit, den wir aus über 3000 leuchtenden Pingpongbällen hergestellt haben.

Auf welche Weise inspiriert New York Ihre Arbeit? Die Stadt besitzt eine leidenschaftliche Seele und Rhythmus. New York fordert von jedem nur das Beste und inspiriert uns zum Mitträumen.

Gibt es einen typischen New Yorker Stil, und wenn ja, wie zeigt sich das in Ihrer Arbeit? Das Schöne an New York ist, dass sein Stil – von den Hippies bis zur Schickeria – darin besteht, dass jeder einfach das tut, was er am besten kann. Unser persönlicher Ehrgeiz liegt darin, Licht zu schaffen, das einzigartig und schön ist, von der Skizze bis zur Umsetzung.

Wie stellen Sie sich New York in der Zukunft vor? Die Zukunft einer Stadt, deren Menschen derart von Leidenschaft und Überzeugung angetrieben werden und die sich ständig ein neues Image geben und neues Design schaffen, steht unter einem guten Stern. Es wird immer die Stadt bleiben, die niemals schläft.

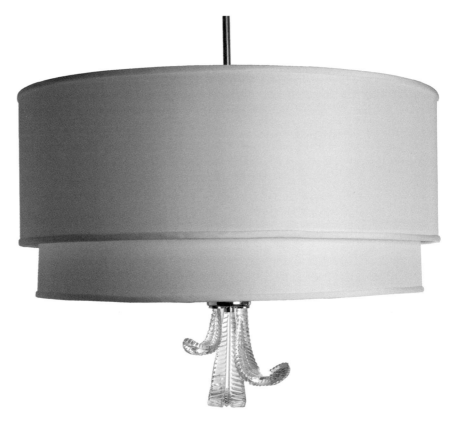

Quelle est l'œuvre la plus importante de votre carrière ? Pour l'instant, l'oeuvre la plus importante de notre carrière c'est l'interprétation d'un chandelier classique de l'Empire français, de dix pieds de haut, constitué presque entièrement de 3000 balles de ping-pong lumineuses.

Dans quelle mesure la ville de New York inspire-t-elle votre œuvre ? New York a une âme passionnée et vit selon un rythme effréné. New York nous met au défi de nous surpasser et nous inspirent pour rêver avec elle.

Peut-on parler d'un style typiquement new-yorkais, et si oui, comment se manifeste-t-il dans votre œuvre ? La beauté de New York est celle des hippies ou des personnalités mondaines, le style, c'est faire de votre mieux. Nous visons à créer des luminaires à la beauté unique du début à la fin.

Comment imaginez-vous le New York de demain ? L'avenir étincelle de mille feux pour une ville remplie de gens passionnés et déterminés qui se réinventent constamment en revisitant le design. New York restera toujours la Ville qui ne Dort Jamais…

¿Cuál es el trabajo que considera más importante en su carrera? El trabajo más importante de nuestra carrera, hasta la fecha, ha sido una interpretación moderna de unos 3 metros de altura de un chandelier clásico del imperio francés hecha casi en su totalidad de más de 3000 bolas de ping pong luminosas.

¿De qué manera Nueva York supone una inspiración en su trabajo? Nueva York tiene un alma y un ritmo apasionados. Nueva York nos desafía a sacar lo mejor de nosotros y nos inspira para soñar con ella.

¿Existe un estilo típico neoyorquino, y si es así, cómo se revela en su obra? La belleza de Nueva York va desde los hippies hasta las personalidades sociales, el estilo es hacer lo que mejor sabes hacer. Nos esforzamos por realizar una iluminación que sea única y bella desde su concepción hasta su finalización.

¿Cómo se imagina Nueva York en el futuro? El futuro se promete brillante para una ciudad llena de gente impulsada por la pasión y la determinación, que se reinventan a sí mismos constantemente mediante la reinvención del diseño. Siempre será la "ciudad que nunca duerme".

Cosa pensa che sia la cosa più importante della Sua carriera? Il lavoro più importante della nostra carriera finora è stata la reinterpretazione contemporanea di un candelabro francese stile impero, alto 30 centimetri e fabbricato praticamente per intero con più di 3000 palline da pingpong luminose.

In che modo New York influenza il Suo lavoro? New York possiede un'anima ed un ritmo appassionati. New York ti spinge a dare il tuo meglio e ti ispira a sognare con lei.

Esiste uno stile tipico a New York? Se sì, come influenza il Suo lavoro? La bellezza di New York appartiene agli hippies come alla società prominente, lo stile è di fare ciò che si sa fare meglio. Noi fornimao l'ispirazione per creare illuminazioni uniche e belle, dal loro concetto fino alla loro realizzazione.

Come si immagina New York in futuro? Il futuro è luminoso per una città piena di gente mossa da passione e determinazione, che si re-inventa continuamente re-inventando il design. Rimmarrà sempre la città che non dorme mai.

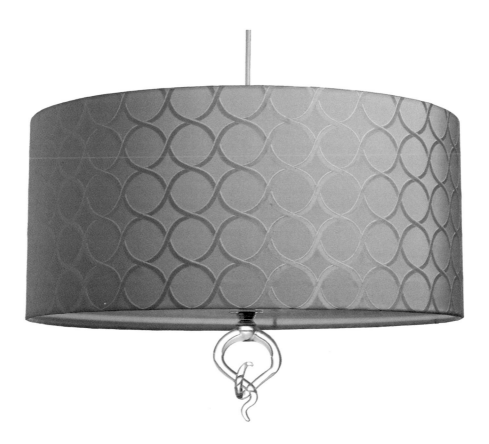

Collection

Contemporary Wallpaper Collection Hanging Pendants 2005, Contemporary Wallpaper Collection Table Lamps 2005, Infinity Pendant 2005, Marlene Two-Tier Pedant 2005, Madeline Pendant 2003, Waterfall Pendant Rectangular 2005
Photographs: © Brent Krause

Marcia Zia and Paul Priven's designs are born out of the love of classic materials from the 1940s. Disappointed with vintage lighting design, they decided to create their own designs and launched their first Salon Collection in 2000. They have not looked back since and do not cease to amaze the public with their six new collections, presenting contemporary models inspired by the classics, using precious materials such as Czech glass and Dupioni silk.

Die Designs von Marcia Zia und Paul Priven entstanden aus ihrer Liebe zu klassischen Leuchten der 40er Jahre. Unzufrieden mit modernen Vintage-Leuchten, entschlossen sie sich 2000, eine eigene Kollektion zu entwerfen und debütierten mit ihrer Salon Collection. Seitdem haben sie mit sechs neuen Kollektionen überrascht und überzeugt, bei denen sie klassische Modelle mit einem zeitgenössischen Design und edlen Materialien wie tschechischem Kristall und Dupioni-Seide verbinden.

Les designs de Marcia Zia et Paul Priven sont nés de leur amour pour les lustres classiques des années quarante. Peu satisfaits des nouveaux luminaires vintage, ils se décident en 2000, de créer leur propre collection et lance leur Salon Collection. Depuis lors, ils ont surpris et convaincu l'opinion avec six nouvelles collections qui proposent des modèles classiques dotés d'un design contemporain dans une alliance de matériaux précieux, à l'instar du cristal tchèque et de la soie Dupioni.

Los diseños de Marcia Zia y Paul Priven nacen de su amor por los materiales clásicos de los años cuarenta. Algo desengañados con el diseño vintage en iluminación, decidieron en el año 2000 crear su propia línea y lanzaron su primera colección Salon. Desde entonces no han dejado de sorprender, convenciendo a la opinión pública con seis nuevas colecciones, en las que proponen modelos contemporáneos inspirados en los clásicos, dentro de una alianza de materiales preciosos, como el cristal checo o la seda Dupioni.

I disegni di Marcia Zia e Paul Priven hanno origine nel loro amore per i luminari classici degli anni 40. Perchè insoddisfatti dai luminari Vintage moderni, nel 2000 decisero di disegnare una propria collezione e quindi debuttarono con la loro Salon Collection. Da allora hanno sorpreso e convinto con ben sei nuove collezioni, nelle quali uniscono i modelli classici con il disegno contemporaneo e i materiali pregiati come il cristallo ceco e la seta Dupioni.

J Schatz

J Schatz

5 South Chenango Street, New York, NY 13778, USA

+1 607 656 5634

+1 607 656 5642

www.jschatz.com

info@JSchatz.com

Jim Schatz

After completing his visual art studies at San Francisco State University, where he majored in photography and sculpture, Jim Schatz founded an art gallery in San Francisco in addition to his own artistic activities. In the year 2000, he moved to New York and designed the Egg Lamp. This design set the foundation for the J Schatz design studio in which Jim Schatz designs colorful, hand-finished ceramic lamps and vases.

Nach seinem Studium der Bildenden Künste an der San Francisco State University, bei dem er sich in den Bereichen Fotografie und Bildhauerei spezialisierte, gründete Jim Schatz neben seiner eigenen künstlerischen Tätigkeit eine Kunstgalerie in San Francisco. 2000 zog er nach New York und entwarf die Egg Lamp. Mit diesem Entwurf wurde der Grundstein für das Designstudio J Schatz gelegt, in dem Jim Schatz farbenfrohe und handgefertigte Lampen und Vasen aus Keramik entwirft.

Après ses études aux beaux-arts de la State University de San Francisco, où il se spécialise dans la photographie et la sculpture, Jim Schatz crée, parallèlement à son activité artistique, une galerie d'art à San Francisco. En 2000, il s'installe à New York et conçoit la Egg Lamp. Avec ce projet, Jim Schatz pose la première pierre de son studio de design J Schatz, où il réalise des lampes et vases en céramique aux couleurs gaies et faits à la main.

Tras finalizar sus estudios de artes plásticas en la San Francisco State University, en los que se especializó en fotografía y escultura, Jim Schatz, además de dedicarse a sus propias creaciones, abrió una galería de arte en San Francisco. En el año 2000 se trasladó a Nueva York y diseñó la Egg Lamp. Con este trabajo se sentaron las bases para su estudio de diseño J Schatz, en el que Jim Schatz crea lámparas y jarrones de rico colorido hechas a mano de cerámica.

Dopo aver studiato arti plastiche alla San Francisco State University, dove si è specializzato in fotografia e scultura, Jim Schatz parallelamente alla sua attività artistica fondò una galleria d'arte a San Francisco. Nel 2000 si trasferì a New York e disegnò la Egg Lamp. Questo progetto costituisce il fondamento dello lo studio di design J Schatz, dove Jim Schatz crea lampade e vasi di ceramica coloratissimi lavorati a mano.

1994
Bachelor of Fine Arts, San Francisco State University, San Francisco, California

2000
Foundation of J Schatz with Dan Llaurado, New York, USA

2003
Egg Lamps Collection

2005
Happening Curtains and Vases Collection

2004
Egg Bird Feeders Collection

2006
Cilindro Pendants Collection

Interview | J Schatz

Which do you consider the most important work of your career? The most important work happens everyday. I am a thread looped through a needle and everyday I make a stitch in my career.

In what ways does New York inspire your work? 8 million trees inspire me in the countryside, 8 million people inspire me in the city. A run down Laurel Road in the spring or a stroll down 14th Street after work.

Does a typical New York style exist, and if so, how does it show in your work? A typical New York style will not be found in the final product, but in the dynamics of the creation of style. A dynamic of people moving people to adopt, reject or consider the object being presented. All my work is created within this dynamic. It is the typical dynamic of New York style.

How do you imagine New York in the future? New York will continue to be a place where people dream and live in the support of each other's arms.

Was halten Sie für die wichtigste Arbeit in Ihrer Karriere? Die wichtigste Arbeit passiert jeden Tag. Ich bin wie der Faden an einer Nadel und jeden Tag nähe ich einen Stich weit an meiner Karriere.

Auf welche Weise inspiriert New York Ihre Arbeit? Acht Millionen Bäume inspirieren mich auf dem Land, acht Millionen Menschen inspirieren mich in der Stadt. Im Frühling die Laurel Road entlang zu joggen oder die 14. Straße nach der Arbeit entlang zu schlendern.

Gibt es einen typischen New Yorker Stil, und wenn ja, wie zeigt sich das in Ihrer Arbeit? Einen typischen New Yorker Stil wird man im Endprodukt nicht finden können, aber sehr wohl in der Dynamik der Erschaffung eines Stils. Die Dynamik von Menschen, die andere Menschen dazu bringen wollen, ein Objekt entweder anzunehmen, abzulehnen oder erst abzuwägen. Meine gesamte Arbeit spielt sich in dieser Dynamik ab. Das ist die typische Dynamik des New Yorker Stils.

Wie stellen Sie sich New York in der Zukunft vor? New York wird immer ein Ort sein, an dem die Menschen in gegenseitiger Unterstützung träumen und leben.

Quelle l'oeuvre la plus importante de votre carrière ? Celle de chaque jour. Je suis comme le fil au travers du chat d'une aiguille et je brode chaque jour un point de plus sur le canevas de ma carrière.

Dans quelle mesure la ville de New York inspire-t-elle votre œuvre ? A la campagne, 8 millions d'arbres m'inspirent et à la ville, 8 millions de gens m'inspirent aussi. Courir le long de la Laurel Road au printemps ou se promener le long de la 14éme rue, après le travail.

Peut-on parler d'un style typiquement new-yorkais, et si oui, comment se manifeste-t-il dans votre œuvre ? Ce n'est pas dans le produit final que vous trouverez un style typiquement new-yorkais, mais davantage dans les dynamiques de la création du style. L'élan des personnes qui bougent les autres pour adopter, rejeter ou prendre en considération l'objet présenté. Toute mon oeuvre est crée selon cette dynamique. C'est cette même dynamique qui définit le style de New York.

Comment imaginez-vous le New York de demain ? New York sera toujours un endroit ou les gens peuvent rêver et vivre en s'entraidant.

¿Cuál es el trabajo que considera más importante en su carrera? El trabajo más importante se realiza cada día. Soy un hilo enhebrado en una aguja y cada día doy una puntada en mi carrera.

¿De qué manera Nueva York supone una inspiración en su trabajo? 8 millones de árboles me inspiran en el campo, 8 millones de personas me inspiran en la ciudad. Un garbeo por Laurel Road en primavera o un paseo por la calle 14 después del trabajo.

¿Existe un estilo típico neoyorquino, y si es así, cómo se revela en su obra? No se puede encontrar un estilo típico neoyorquino en el producto final, sino en la dinámica de la creación de estilo. Una dinámica de gente que hace que otra gente adopte, rechace o considere el objeto que se presenta. Todo mi trabajo se crea en el seno de esta dinámica. Es la dinámica típica del estilo de Nueva York.

¿Cómo se imagina Nueva York en el futuro? Nueva York seguirá siendo un lugar donde la gente sueña y vive apoyándose en los brazos de los demás.

Cosa pensa che sia la cosa più importante della Sua carriera? Il lavoro più importante si svolge ogni giorno. Io sono un filo che passa attraverso la cruna di un ago e ogni giorno faccio un nuovo punto nella mia carriera.

In che modo New York influenza il Suo lavoro? 8 milioni di alberi mi ispirano in campagna, 8 milioni di persone mi ispirano in città. Passeggiare in Laurel Road in primavera oppure girellare per la 14esima strada dopo lavoro.

Esiste uno stile tipico a New York? Se sì, come influenza il Suo lavoro? Lo stile tipico di New York non si troverà mai in un prodotto finale ma piuttosto nelle dinamiche della sua creazione. Nella dinamica delle persone che spingono altre persone ad adottare, rifiutare oppure considerare un oggetto che viene presentato. Tutto il mio lavoro è creato all'interno di questa dinamica. Questa è la dinamica tipica dello stile New York.

Come si immagina New York in futuro? New York resterà un luogo in cui la gente sogna e vive sostenuta dall'abbraccio reciproco.

Collection

Dobo Vase 2004, Ono Vase 2004, Triple Egg Steam Lamp 2003, Happening Curtain 2005, Egg Floor Lamp 2003
Photographs: © J Schatz

Jim Schatz's designs show his long-time interest in sculpture. Despite the different colors and shapes, all J Schatz products share something in common: ceramic as a material and a love of detail. In this way, the products are custom-finished by hand and play with details, which one first notices upon closer inspection. The interior color of the Egg Lamp is only truly showcased when it is turned on.

Bei den Entwürfen von Jim Schatz zeigt sich sein langjähriges Interesse für die Bildhauerei. Trotz der unterschiedlichen Farben und Formen ist allen Produkten von J Schatz eines gemeinsam: das Material Keramik und die Liebe zum Detail. Dabei werden die Produkte individuell per Hand gefertigt und spielen mit Details, die man erst beim näheren Hinschauen entdeckt. So kommt die Innenfarbe des Lampenschirms der Egg Lamp erst beim Anschalten so richtig zur Geltung.

Les réalisations de Jim Schatz révèlent la longue passion de leur créateur pour la sculpture. De couleurs et de formes différentes, tous les produits J Schatz partagent un dénominateur commun : la matière, la céramique et l'amour du détail. Ses créations sont toutes fabriquées à la main et jouent avec les détails, uniquement visibles de près, à l'instar de la couleur intérieure de l'abat-jour de l'Egg Lamp qui ne se dévoile pleinement qu'une fois la lampe branchée.

En los diseños de Jim Schatz se muestra el interés que desde hace años siente su fundador por la escultura. A pesar de los distintos colores y formas, todos los productos de J Schatz tienen algo en común: la cerámica y el amor por el detalle. Los productos se elaboran a mano de forma individualizada y juegan con detalles que a menudo no se descubren hasta que no se observan de cerca. Por ejemplo, el color interior de la pantalla de la lámpara Egg Lamp realmente resalta al encenderla.

Le creazioni di Jim Schatz rispecchiano il suo interesse per la scultura. Nonostante la varietà di forme e colori, tutti i prodotti di J Schatz hanno in comune l'uso della ceramica e l'amore per il dettaglio. I prodotti sono lavorati a mano individualmente e giocano con dettagli che divengono visibili solo dopo un'osservazione più attenta. Il colore della superficie interna del paralume della Egg Lamp, ad esempio, risalta solo quando la lampada è accesa.

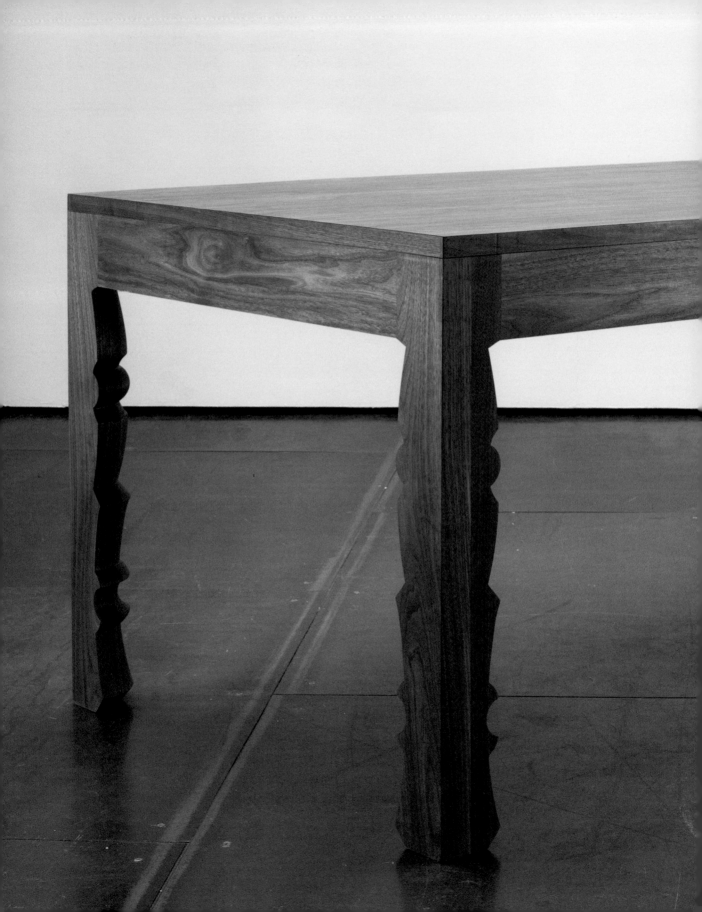

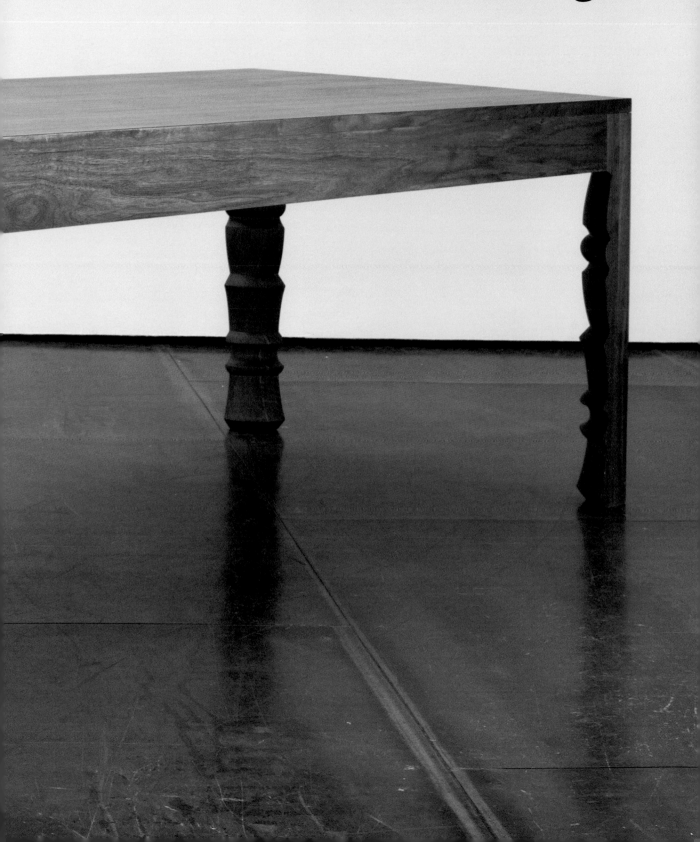

hivemindesign

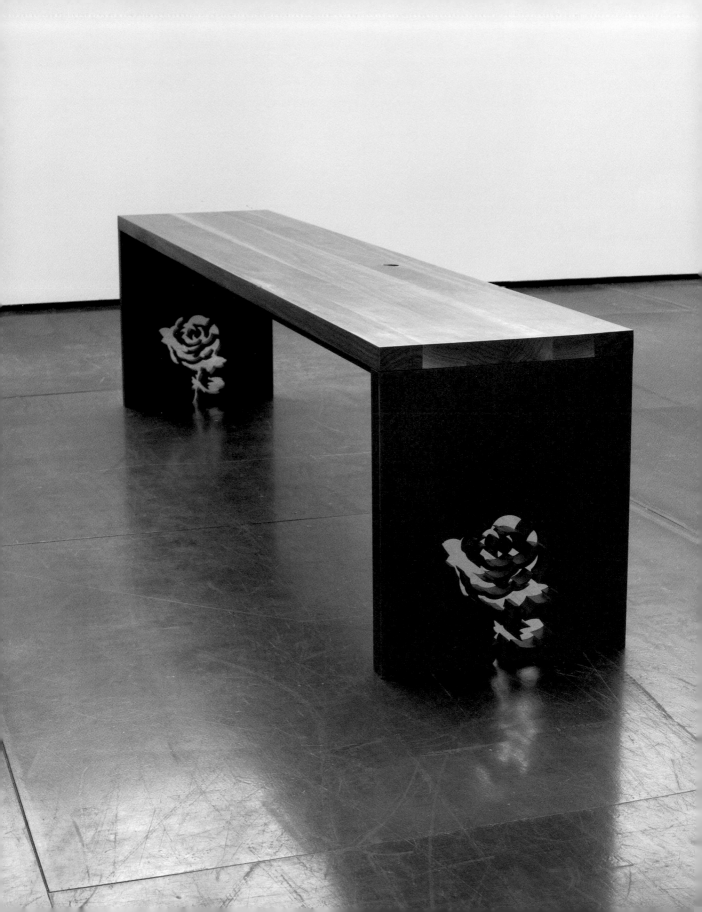

hivemindesign

27 Montrose Avenue, Brooklyn, NY 11206, USA

+1 718 782 3539

+1 718 782 7977

www.hiveminddesign.com

hivemind@hivemindesign.com

Hivemindesign was established in 2001 by Ruby Metzner and Sather Duke in Brooklyn. In their office they develop visually and tactilely responsive designs. The New York-born Ruby Metzner studied industrial design at the Rhode Island School of Design, while Sather Duke began his design career on another path: Before studying sculpture at the New York Studio School, he worked as a snowboard instructor.

Hivemindesign wurde 2001 von Ruby Metzner und Sather Duke in Brooklyn gegründet. In ihrem Büro entwickeln sie visuell und taktil ansprechende Designs. Die in New York geborene Ruby Metzner studierte Industriedesign an der Rhode Island School of Design, während Sather Duke seine Designkarriere auf Umwegen begann: Vor seinem Studium der Bildhauerei an der New York Studio School arbeitete er als Snowboardlehrer.

En 2001, Ruby Metzner et Sather Duke fondent à Brooklyn le studio hivemindesign. Ils y développent des designs visuels et tactiles. Ruby Metzner, né à New York, étudie le design industriel à la Rhode Island School of Design, alors que Sather Duke débute sa carrière de designer empruntant des chemins de traverse : avant d'entamer ses études de sculpture à la New York Studio School, il est professeur de snowboard.

Hivemindesign se fundó en Brooklyn en 2001 por Ruby Metzner y Sather Duke. En su estudio se desarrollan diseños que resultan atractivos tanto para la vista como para el tacto. Ruby Metzner, nacida en Nueva York, estudió diseño industrial en la Rhode Island School of Design, mientras que Sather Duke llegó a su carrera de diseño dando algunos rodeos: antes de estudiar escultura en la New York Studio School trabajó como profesor de snowboard.

Hivemindesign è stato fondato nel 2001 a Brooklyn da Ruby Metzner e Sather Duke. Nel loro atelier i due artisti sviluppano un design attraente per la vista e il tatto. Ruby Metzner è nata a New York e ha studiato Industrial design alla Rhode Island School of Design, Sather Duke invece ha iniziato la sua carriera da designer in modo singolare: prima di studiare scultura presso la New York Studio School ha lavorato come istruttore di snowboard.

Ruby Metzner

1995
BFA in Industrial Design, Rhode Island School of Design, Rhode Island, USA

Sather Duke

1998–2000
Studies of sculpture at New York Studio School, New York, USA

2001
Foundation of hivemindesign by Ruby Metzner and Sather Duke, New York, USA

2003
Honey room divider

2004
Tier Shelving

2005
Rune Table, Rune Bed
Rose Bench
Crux Wall Unit
Ruka Chair, Ruka Twin

Interview | hivemindesign

What do you consider the most important work of your career? Honey is our most significant: Just seeing it come to life was very important. The Tier Shelving is the most developed and refined, and is our strongest example of industrial design.

In what ways does New York inspire your work? New York is an industrial city, it allows for virtually any type of manufacturing. Anybody can make what they want. Great design can be found in the smallest coffee shop in the toughest neighborhood to a showroom on Madison Avenue.

Does a typical New York style exist, and if so, how does it show in your work? In a city where nearly every culture across the world is represented, there is room for all types of design Identifying a style is more of a curatorial process, where you become inspired by the best of what you see.

How do you imagine New York in the future? New York is changing. It is no longer only about Manhattan, it is about the outer boroughs. Those are the places to watch in the future for good design.

Was halten Sie für die wichtigste Arbeit in Ihrer Karriere? Honey ist unsere bedeutendste Arbeit: allein der Entstehungsprozess war sehr wichtig. Unsere Stufenregale Tier Shelving sind die am weitesten entwickelte und raffinierteste Arbeit und das stärkste Beispiel für Industriedesign.

Auf welche Weise inspiriert New York Ihre Arbeit? New York ist eine industriell geprägte Stadt, in der alles Erdenkliche hergestellt wird. Jeder kann machen was er will. Großartiges Design findet man im kleinsten Coffee Shop der rausten Viertel bis hin zum Showroom auf der Madison Avenue.

Gibt es einen typischen New Yorker Stil, und wenn ja, wie zeigt sich das in Ihrer Arbeit? In einer Stadt, in der nahezu jede Kultur dieser Welt vertreten ist, gibt es Raum für jegliche Art von Design. Einen bestimmten Stil zu identifizieren, ist eher ein heilsamer Prozess: da inspiriert einen nur das Beste, was man sieht.

Wie stellen Sie sich New York in der Zukunft vor? New York wandelt sich. Es dreht sich längst nicht mehr alles nur um Manhattan, sondern um die äußeren Bezirke. Dort wird in der Zukunft gutes Design zu finden sein.

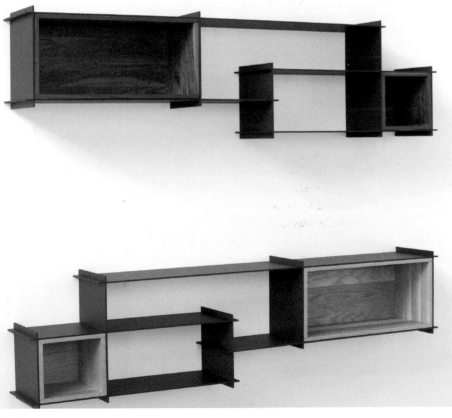

Quelle est l'œuvre la plus importante de votre carrière ? Honey est notre projet le plus significatif : rien que de le voir naître a été très important. Le Tier Shelving est le plus approfondi, le plus subtile, et c'est notre meilleur exemple de design industriel.

Dans quelle mesure la ville de New York inspire-t-elle votre œuvre ? New York est une ville industrielle, elle permet tous les styles. Chacun est libre de faire ce qu'il veut. On peut trouver du grand design dans le plus petit des cafés du quartier le plus dur, comme dans une salle d'exposition sur la Madison Avenue.

Peut-on parler d'un style typiquement new-yorkais, et si oui, comment se manifeste-t-il dans votre œuvre ? Dans une ville où presque toutes les cultures du monde entier sont représentées, il y a de la place pour toutes les sortes de design. Identifier un style fait davantage partie d'une démarche muséologique où l'on s'inspire de ce qu'il y a de mieux.

Comment imaginez-vous le New York de demain ? New York est en pleine mutation. Il ne s'agit pas uniquement de Manhattan, mais également des districts extérieurs. C'est là, où il faut à l'avenir, tourner ses regards pour trouver le bon design.

¿Cuál es el trabajo que considera más importante en su carrera? Honcy es el más significativo: sólo verlo cobrar vida fue muy importante. El Tier Shelving es el más desarrollado y refinado, así como nuestro ejemplo más marcado de diseño industrial.

¿De qué manera Nueva York supone una inspiración en su trabajo? Nueva York es una ciudad industrial, permite prácticamente cualquier tipo de industria. Cualquier puede hacer lo que quiera. Es posible encontrar un diseño excelente desde en la cafetería más pequeña del barrio más duro hasta en un escaparate en la avenida Madison.

¿Existe un estilo típico neoyorquino y, si es así, cómo se revela en su obra? En una ciudad donde casi tienen representación todas las culturas del mundo, hay sitio para todos los tipos de diseño. La identificación de un estilo es más un proceso propio del curador, donde te inspira lo mejor que ves.

¿Cómo se imagina Nueva York en el futuro? Nueva York está cambiando. Ya no se trata sólo de Manhattan, sino de los distritos exteriores. Allí es donde habrá que buscar el buen diseño en el futuro.

Qual è secondo Lei il progetto più importante della Sua carriera? Honey è certo il più importante. Già la sua nascita ha avuto per noi un'importanza straordinaria. The Tier Shelving è invece il progetto più sviluppato e rifinito, il nostro migliore esempio di design industriale.

In che modo la città di New York ispira il Suo lavoro? New York è una città industriale che permette la realizzazione teorica di qualsiasi prodotto. Ognuno può realizzare ciò che vuole. Si può trovare design fantastico ovunque, dal piccolo caffè nel quartiere più sperduto al più grande showroom di Madison Avenue.

È possibile parlare di uno stile tipico per New York, e, se questo stile esiste, in che modo si manifesta nei Suoi lavori? In una città in cui sono rappresentate quasi tutte le culture del mondo c'è spazio per tutti i tipi di design e in una città in cui è possibile farsi ispirare dal meglio di ciò che si vede, identificare uno stile significa piuttosto compiere una selezione.

Come si immagina la New York del futuro? New York sta cambiando. Ormai non è più solo Manhattan, ma anche i quartieri meno centrali. È qui che in futuro bisorrà cercare il design migliore.

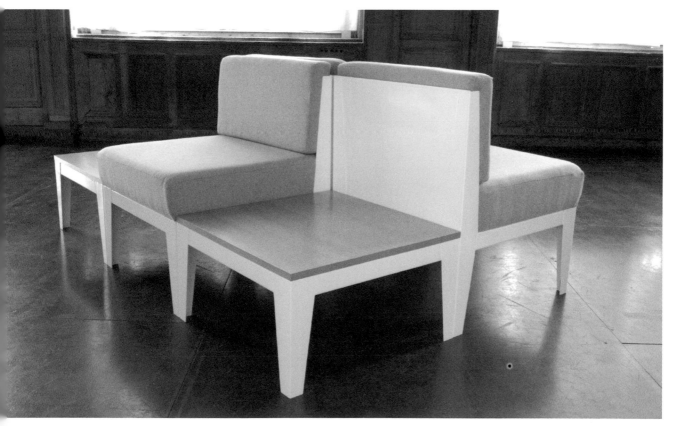

Collection

Rune Table, Rose Bench, Crux Wall Unit, Ruka Twin, Rune Bed
Year: 2005
Photographs: © Tom Cinko

Despite their brief existence, the hivemindesigners have already carried out a multitude of attractive designs such as the Rune Table or the Honey room divider. Ruby Metzner's experience from working with designers such as Karim Rashid, combined with the sculptural talent of Sather Duke, results in designs which have a sculptural character despite a two-dimensional surface, and which play upon patterns and structures.

Trotz ihres erst kurzen Bestehens haben die hivemindesigner bereits eine Vielzahl von reizvollen Entwürfen wie den Rune Table oder den Raumteiler Honey umgesetzt. Durch die Erfahrungen Ruby Metzners aus der Zusammenarbeit mit Designern wie Karim Rashid, kombiniert mit dem bildhauerischen Talent von Sather Duke, entstehen Designs, die trotz einer zweidimensionalen Oberfläche einen skulpturalen Charakter erhalten, indem mit ausgesägten Mustern und Strukturen gespielt wird.

Nouvellement créés, les « hivemindesigner » ont pourtant déjà réalisé bon nombre de charmants concepts comme la Rune Table ou la cloison Honey. De l'expérience acquise par Ruby Metzner en collaborant avec les designers comme Karim Rashid, conjuguée au talent de sculpteur de Sather Duke, naissent des designs, qui malgré une surface bidimensionnelle, affichent un caractère sculptural, dans un jeu de motifs et structures découpés à la scie.

A pesar de su corta existencia, los componentes de hivemindesign han puesto en práctica multitud de interesantes proyectos como la Rune Table o el separador de ambientes Honey. De la experiencia de Ruby Metzner surgida de su colaboración con diseñadores como Karim Rashid, combinada con el talento escultórico de Sather Duke, surgen diseños que a pesar de tener una superficie bidimensional poseen un carácter escultural que juega con modelos y esculturas moldeadas.

Nonostante la finora breve esistenza del loro atelier, gli stilisti di hivemindesign hanno già realizzato una serie di disegni piacevolissimi, come la Rune Table oppure il divisorio Honey. Grazie all'esperienza di Ruby Metzner che ha collaborato con stilisti come Karim Rashid, nascono, in combinazione con il talento scultoreo di Sather Duke, dei designs dalla superficie bidimensionale che comunque, in seguito al gioco di motivi e strutture seghettati, mostrano un carattere scultoreo.

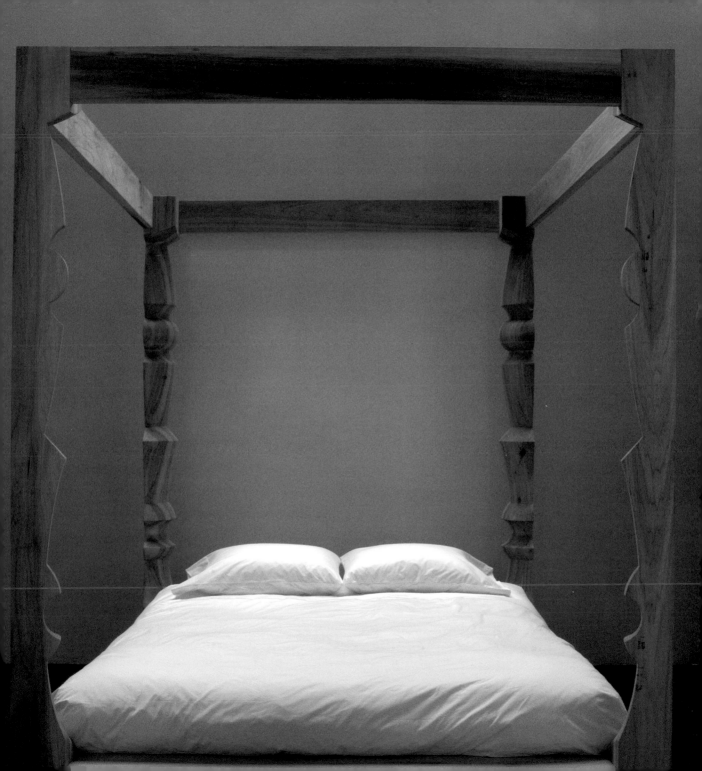

jGoodDesign

24 Fifth Avenue 1st Street 709, New York, NY10011, USA

+1 212 475 0479 x2

+1 212 254 2317

www.jgooddesign.com

info@jGoodDesign.com

Jeffrey Goodman

Jeffrey Goodman is the founder of jGoodDesign, a design studio in Greenwich Village, which designs handblown lamps as well as furniture made of bamboo. Before opening his studio in 1999, he worked as an economic advisor and professor at New York University. He uses his substantial interest in environmentally-friendly design not only in his work, but in his role as Vice President of the nonprofit organization, Furniture New York.

Jeffrey Goodman ist der Gründer von jGoodDesign, einem Designstudio in Greenwich Village, das mundgeblasene Leuchten sowie Mobiliar aus Bambus entwirft. Bevor er 1999 das Studio eröffnete, arbeitete er als Wirtschaftsberater und Professor an der New York University. Sein großes Interesse an umweltverträglichen Designs setzt er nicht nur bei seinen Entwürfen um, sondern er ist zugleich Vize-Präsident der gemeinnützigen Organisation Furniture New York.

Jeffrey Goodman est le fondateur de jGoodDesign, un studio de design de Greenwich Village, qui conçoit des luminaires en verre soufflé ainsi que des meubles en bambou. Avant de créer son studio en 1999, il est conseiller économique et professeur à la New York University. Le grand intérêt qu'il porte au design écologique se révèle dans ses projets mais également dans la fonction qu'il occupe en tant que vice-président de l'organisation d'utilité publique Furniture New York.

Jeffrey Goodman es el fundador de jGoodDesign, un estudio de diseño en Greenwich Village que crea lámparas sopladas artesanalmente y mobiliario de bambú. Antes de abrir su estudio en 1999, trabajó de consultor económico y de catedrático en la New York University. Su vivo interés por el diseño respetuoso con el medio ambiente no solo se refleja en sus creaciones, sino también en su labor de vicepresidente de la organización sin ánimo de lucro Furniture New York.

Jeffrey Goodman è il fondatore di jGoodDesign, uno studio di design nel Greenwich Village, che progetta lampade in vetro soffiato artigianalmente e mobili in bambù. Prima di aprire lo studio nel 1999, lavorò come commercialista e come docente alla New York University. Oltre a mettere in pratica il suo interesse per il design eco-compatibile nelle sue creazioni, egli è anche vicepresidente dell'organizzazione di interesse collettivo Furniture New York.

1986
Engineering Degree from University of Pennsylvania, USA

1992
Master Degree from New York University, New York, USA

1999
Foundation of jGoodDesign by Jeff Goodman, New York, USA

2002
Giraffe Pendant

2003
Oculus Pendant, Dome Accent, Dome Pendant, Stone Pendant, Stone Chandelier

2004
Aqua Pendant, Carillon Shaded table lamp, Carillon Pendant, Dome Sconce

2005
Helios Pendant, Carillon Sconce, Posted Stone Pendant

2006
Astral Chandelier, Helios Sconce, Aqua Sconce Bubbles Pendant

Interview | jGoodDesign

Which do you consider the most important work of your career? The Oculus refined my voice. It is individually handcrafted lighting that is sculptural, fluid, natural, and playfully alive, capturing the effects of hand-blown glass as it interacts with light.

In what ways does New York inspire your work? My work is inspired by the quality and diversity of New York City's designers, and by the city's excitement and sophistication.

Does a typical New York style exist, and if so, how does it show in your work? NY Style is driven by the desire for excellence and a melting pot of ideas from the diversity of the people. I combine the resulting urban aesthetic with the wonder and amusement of my childhood.

How do you imagine New York in the future? NY will lead in design, including the growing area of individually handcrafted and customizable products.

Was halten Sie für die wichtigste Arbeit in Ihrer Karriere? Oculus hat den Charakter meines Designs verfeinert. Es ist ein individuell und handwerklich hergestellter Leuchter, der das Plastische, Fließende und Natürliche verbindet und auf spielerische Art lebendig wirkt, indem er sich effektvoll das Zusammenspiel zwischen dem Licht und dem handgeblasenem Glas zu Eigen macht.

Auf welche Weise inspiriert New York Ihre Arbeit? In meiner Arbeit lasse ich mich einerseits an der Qualität und Vielfalt der New Yorker Designer inspirieren, andererseits an Begeisterung und Raffinesse der Stadt.

Gibt es einen typischen New Yorker Stil, und wenn ja, wie zeigt sich das in Ihrer Arbeit? Der New Yorker Stil ist gekennzeichnet vom Streben nach dem Überdurchschnittlichen und bildet einen Schmelztiegel der Ideen und der Vielfalt der Menschen. Die daraus resultierende urbane Ästhetik verbindet sich in meiner Arbeit mit den Wundern und Freuden meiner Kindheit.

Wie stellen Sie sich New York in der Zukunft vor? New York wird führende Kraft im Design werden, was den wachsenden Bereich des individuellen Handwerks und der flexiblen Herstellung mit einschließt.

Quelle est l'œuvre la plus importante de votre carrière ? L'Oculus est la quintessence de mon oeuvre. C'est un éclairage unique réalisé de façon artisanale. Il est sculptural, fluide, naturel, vivant et ludique, capturant les effets de l'interaction du verre soufflé ct de la lumière.

Dans quelle mesure la ville de New York inspire-t-elle votre œuvre ? Mon œuvre s'inspire à la fois de la qualité et de la diversité des designers de New York City, de l'effervescence et la complexité de la ville même.

Peut-on parler d'un style typiquement new-yorkais, et si oui, comment se manifeste-t-il dans votre œuvre ? Le style de New York, poussé par le désir d'excellence, est un creuset d'idées, fruit de la diversité de sa population. En découle une esthétique urbaine que je combine à l'étonnement et l'amusement de mon enfance.

Comment imaginez-vous le new York de demain ? New York sera leader dans le monde du design, y compris le domaine croissant de produits artisanaux et de consommation individuels.

¿Cuál es el trabajo que considera más importante en su carrera? El Oculus pulió mi estilo. Se trata de iluminación elaborada artesanalmente de forma individual que es escultural, fluida, natural y alegremente viva, que captura los efectos del vidrio soplado a mano a medida que interactúa con la luz.

¿De qué manera Nueva York supone una inspiración en su trabajo? Mi trabajo se inspira en la calidad y diversidad de diseñadores de la ciudad de Nueva York y en el entusiasmo y la sofisticación de la ciudad.

¿Existe un estilo típico neoyorquino, y si es así, cómo se revela en su obra? El estilo de Nueva York se ve impulsado por el deseo de excelencia y un crisol de ideas resultante de la diversidad de la gente. Combino la estética urbana resultante con la maravilla y la diversión de mi niñez.

¿Cómo se imagina Nueva York en el futuro? Nueva York será líder en diseño, también del sector en auge de productos personalizables hechos individualmente.

Cosa pensa che sia la cosa più importante della Sua carriera? L'Oculus ha affinato la mia reputazione. Si tratta di un oggetto di illuminazione fatto a mano singolarmente, è scultoreo, fluido, naturale e giocosamente vivo quando cattura gli effetti del vetro soffiato nella sua interazione con la luce.

In che modo New York influenza il Suo lavoro? Il mio lavoro si ispira alla qualità e alla diversità degli stilisti di New York, e all'eccitazione e alla raffinatezza della città.

Esiste uno stile tipico a New York? Se sì, come influenza il Suo lavoro? Lo stile New York è mosso dal desiderio di eminenza, è un crogiolo delle idee più disparate della gente. Io combino l'estetica urbana che ne risulta con il miracolo e la gioia della mia infanzia.

Come si immagina New York in futuro? NY sarà leader nel design, incluso il settore crescente dei prodotti lavorati a mano individualmente e su misura.

Collection

Posted Stone Pendant 2005, Helios Pendant 2005, Aqua Pendant 2004, Giraffe Pendant 2002, Dome Accent 2003, Carillon Pendant 2004
Photographs: © jGoodDesign

Jeffrey Goodman grew up in a small town on the New Jersey shore and this proximity to nature gave him a strong interest in environmentally-sensitive products. His mouthblown lamps not only have an innovative shape but they are made of environmentally friendly, partially recycled glass and re-usable aluminum and bamboo. In addition, the aluminum mounting fixtures are cleaned by hand without using anodized aluminum.

Jeffrey Goodman wuchs in einem kleinen Ort an der Küste von New Jersey auf und diese Nähe zur Natur erweckte bei ihm ein starkes Interesse an umweltverträglichen Produkten. Daher verfügen seine mundgeblasenen Leuchten nicht nur über eine innovative Form, sondern bestehen aus umweltfreundlichem, zum Teil recyceltem Glas und wieder verwendbarem Aluminium und Bambus. Zudem werden die Aluminiumhalterungen per Hand gereinigt und es wird auf anodisiertes Aluminium verzichtet.

Jeffrey Goodman grandit dans un petit village de la côte du New Jersey. Cette proximité de la nature éveille en lui un grand intérêt pour les produits non polluants. Cela le conduit à créer des luminaires en verre soufflé aux formes innovatrices, mais aussi à base de verre écologique ou recyclé et d'aluminium et bambou réutilisables. En outre, les supports en aluminium sont nettoyés manuellement et recouvert d'aluminium anodisé.

Jeffrey Goodman creció en una pequeña localidad costera de Nueva Jersey y esta cercanía con la naturaleza despertó su interés en los productos compatibles con el medio ambiente. Por tanto, sus lámparas sopladas artesanalmente no solo presentan una forma innovadora, sino que están fabricadas con cristal ecológico, a menudo reciclado, y con aluminio y bambú reciclables. Además, los soportes de aluminio se limpian a mano y se renuncia al aluminio anodizado.

Jeffrey Goodman è cresciuto in una piccola località sulla costa del New Jersey e la vicinanza alla natura risvegliò in lui l'interesse per i prodotti che rispettano l'ambiente. Quindi le sue lampade di vetro soffiato non hanno solo una forma innovativa, ma sono fatte di vetro ecologico e parzialmente riciclato e di alluminio e bambù riutilizzabili. Inoltre i supporti di alluminio vengono puliti a mano e si rinuncia all'alluminio anodizzato.

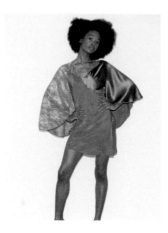 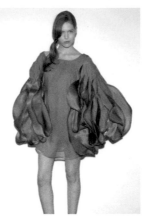 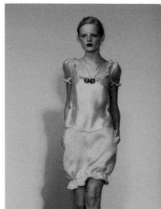

Fashion Design

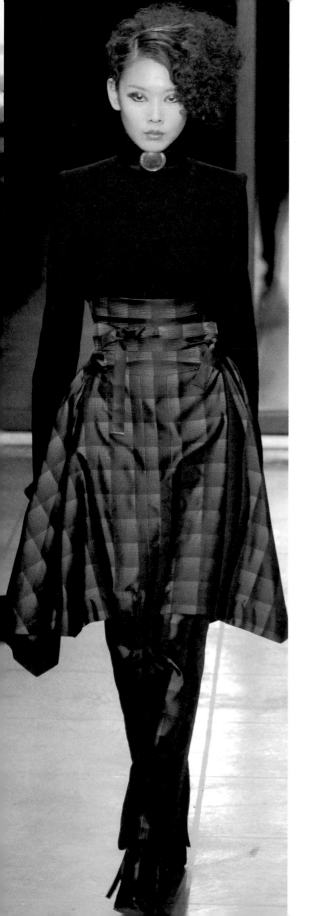

ThreeasFour

Doo Ri

Thakoon

Mary Ping

House of Diehl

Palmer Jones

Binetti

Ruffian

Boudicca

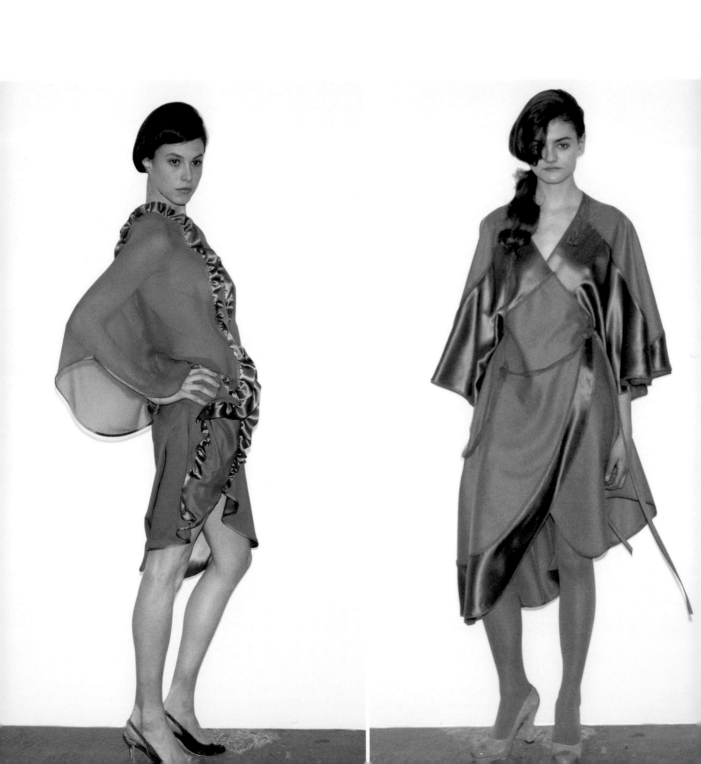

ThreeasFour

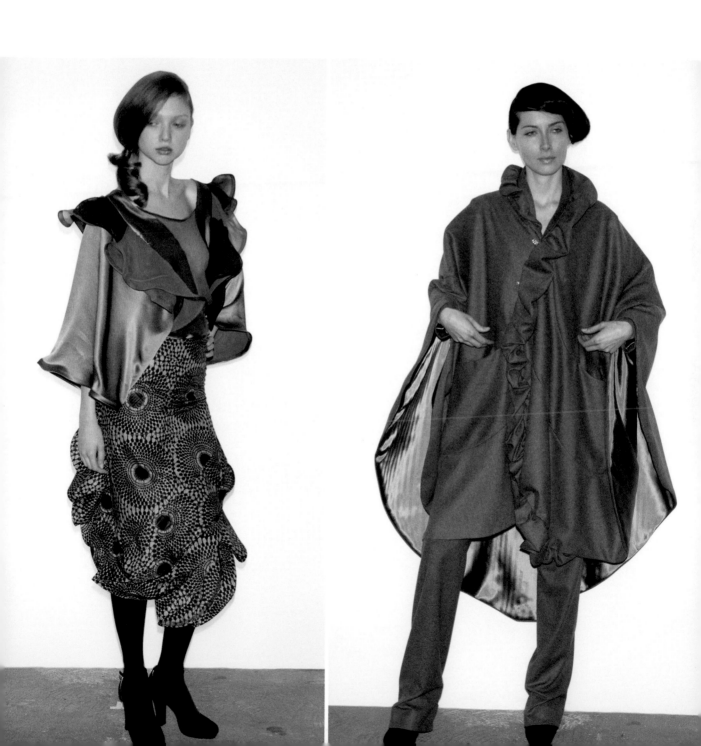

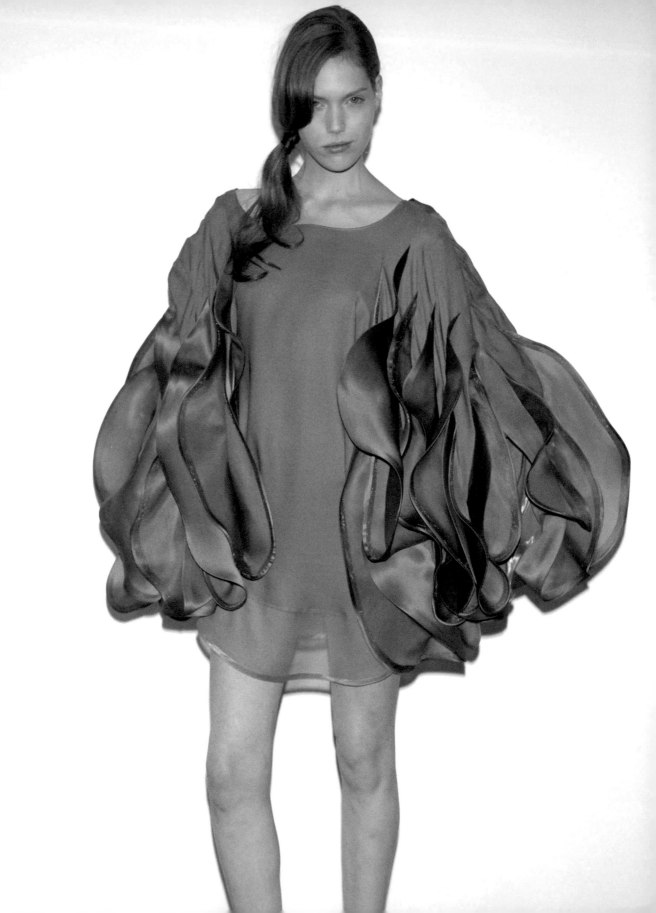

ThreeasFour

86 Foursyth Street, 4th Floor, New York, NY 10002, USA

+1 212 343 9777

+1 212 343 9860

www.threeasfour.com

threeasfour@threeasfour.com

ThreeasFour

2001
Foundation of AsFour by Adi, Ange, Kai and Gabi, New York, USA

2002
Ecco Domani Fashion Foundation Grant

2003
National Design Triennial, Inside Design Now, Cooper-Hewitt National Design Museum, New York, USA

2005
AsFour went to ThreeAsFour with the departure of Kai

ThreeasFour was founded in 1998 by Adi, Ange, Kai and Gabi as AsFour. After Kai left, the designers decided to keep working under another name with the same concept and spirit. Known for their dynamic designs and their unconventional presentations, they received substantial acclaim in the world of fashion and won the Ecco Domani Fashion Foundation prize in 2002.

ThreeasFour wurde 1998 von Adi, Ange, Kai und Gabi als AsFour gegründet. Nach dem Ausscheiden von Kai entschlossen sich die Designer dazu, unter anderem Namen, aber mit dem gleichen Konzept und Elan weiterzuarbeiten. Bekannt für ihre dynamischen Entwürfe und deren unkonventionelle Präsentationen erhielten sie viel Anerkennung in der Modewelt und gewannen 2002 den Ecco Domani Fashion Foundation Preis.

ThreeasFour, est fondé en 1998 par Adi, Ange, Kai et Gabi sous le nom de AsFour. Suite à la démission de Kai, les designers ont décidé de continuer à exploiter le même concept, fort de leur enthousiasme initial, mais sous un autre nom. Réputés pour leurs créations dynamiques et leurs présentations hors du commun, ils ont été récompensés à maintes reprises par le monde de la mode et se sont vus décerner en 2002 le prix de l'Ecco Domani Fashion Foundation.

ThreeasFour se fundó el año 1998 por Adi, Ange, Kai y Gabi con el nombre de AsFour. Después de la retirada de Kai, decidieron seguir trabajando bajo un nombre diferente aunque siguiendo el mismo concepto y con el mismo ímpetu inicial. Son conocidos por sus diseños dinámicos y presentaciones poco convencionales, han obtenido un gran reconocimiento dentro del mundo de la moda y el año 2002 ganaron el premio Ecco Domani Fashion Foundation.

ThreeasFour è stato fondato nel 1998 da Adi, Ange, Kai e Gabi come AsFour. Dopo che Kai abbandonò il progetto, gli stilisti rimasti decisero di continuare con un altro nome ma con lo stesso concetto e lo stesso entusiasmo. Noti per i loro disegni dinamici e le loro presentazioni non convenzionali, ricevettero molto riconoscimento nel mondo della moda e vinsero, nel 2002, il premio Ecco Domani Fashion Foundation.

Interview | ThreeasFour

Which do you consider the most important work of your career? There is no specific work that is the most important. Each stage of our development is important in its own right. We love the experience of every step in our evolution.

In what ways does New York inspire your work? New York is the place that allows us to be ourselves. We love the energy and the people here. It's the place where all cultures, religions, languages and styles merge.

Does a typical New York style exist, and if so, how does it show in your work? This city allows and supports individual style. Our work is an extension of ourselves.

How do you imagine New York in the future? We imagine New York to be more free.

Was halten Sie für die wichtigste Arbeit in Ihrer Karriere? Es gibt keine spezifische Arbeit die den wichtigsten Platz einnimmt. Jede unserer Entwicklungsphasen ist auf ihre Weise wichtig, jeder einzelne Schritt nach vorne liegt uns am Herzen.

Auf welche Weise inspiriert New York Ihre Arbeit? New York ist der Ort, der es uns erlaubt, so zu sein wie wir sind. Wir lieben die Energie und die Menschen hier. Es ist ein Ort, an dem alle Kulturen, Religionen, Sprachen und Stile zusammenfließen.

Gibt es einen typischen New Yorker Stil, und wenn ja, wie zeigt sich das in Ihrer Arbeit? Diese Stadt erlaubt und unterstützt jeden individuellen Stil. Unsere Arbeit ist eine Erweiterung unserer selbst.

Wie stellen Sie sich New York in der Zukunft vor? Wir stellen uns New York freier vor.

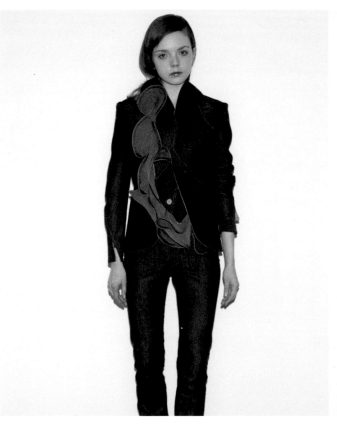

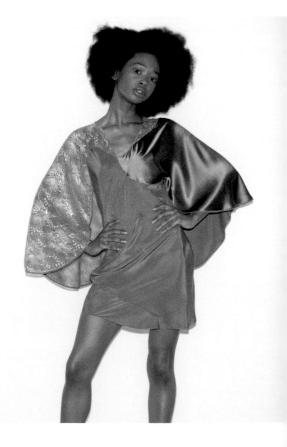

Quelle est l'œuvre la plus importante de votre carrière ? Il n'y a pas d'œuvre particulièrement importante. Chaque étape de notre évolution est importante et nous aimons l'expérience que chacune d'elle nous apporte.

Dans quelle mesure la ville de New York inspire-t-elle votre œuvre ? New York est l'endroit qui nous permet d'être nous-mêmes. Nous adorons l'énergie qui s'en dégage et les gens ici. C'est le point de rencontre de toutes les cultures, religions, langues et styles.

Peut-on parler d'un style typiquement new-yorkais, et si oui, comment se manifeste-t-il dans votre œuvre ? Cette ville permet et encourage le style individuel. Notre œuvre est le prolongement de nos êtres.

Comment imaginez-vous le New York de demain ? Nous imaginons une ville de New York plus libre.

¿Cuál es el trabajo que considera más importante en su carrera? No existe un trabajo específico que sea el más importante. Cada fase de nuestro desarrollo es importante por propio derecho. Nos encanta la experiencia de cada paso en nuestra evolución.

¿De qué manera Nueva York supone una inspiración en su trabajo? Nueva York es el lugar que nos permite ser nosotros mismos. Adoramos la energía y la gente de aquí. Es el lugar donde todas las culturas, religiones, idiomas y estilos se funden.

¿Existe un estilo típico neoyorquino, y si es así, cómo se revela en su obra? Esta ciudad permite y apoya el estilo individual. Nuestro trabajo es una extensión de nosotros mismos.

¿Cómo se imagina Nueva York en el futuro? Nos imaginamos una Nueva York más libre.

Cosa pensa che sia la cosa più importante della Sua carriera? Non esiste un' opera specifica più importante. Ogni fase del nostro sviluppo è importante per sè. Amiamo l'esperienza che comporta ciascuno dei passi della nostra evoluzione.

In che modo New York influenza il Suo lavoro? New York è un luogo che ci permette di essere noi stessi. È il luogo in cui tutte le culture, le religioni, le lingue e gli stili si mischiano.

Esiste uno stile tipico a New York? Se si, come influenza il Suo lavoro? La città permette di apprezza uno stile individuale. Il nostro lavoro è un'estensione di noi stessi.

Come si immagina New York in futuro? Ci immaginiamo una New York più libera.

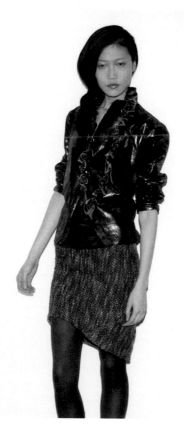

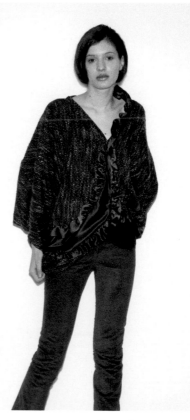

Spring/Summer

Year: 2006
Photographs: © Chris Moore

For their first ThreeasFour spring/summer collection, Adi, Ange and Gabi combined their own cultural–Israeli, Arab and Russian–roots and created an elegant mix of shapes, materials and colors. The three designers place substantial importance on the wearability of their elegant and dynamic designs.

Für ihre erste als ThreeasFour präsentierte Frühlings- und Sommerkollektion verbanden Adi, Ange und Gabi ihre eigenen kulturellen – israelischen, arabischen und russischen – Wurzeln miteinander und schufen einen eleganten Formen-, Material- und Farbmix. Dabei legen die drei Designer großen Wert auf die Tragbarkeit ihrer eleganten und zugleich schwingenden Entwürfe.

Pour la présentation de leur première collection de printemps et été sous la marque ThreeasFour, Adi, Ange et Gabi ont uni leurs propres racines culturelles – israélienne, arabe et russe – pour créer des combinaisons de formes, de matières et de couleurs élégantes. Pour les trois designers, il est primordial que leurs créations, à la fois élégantes et tout en mouvement, puissent être portées.

Para la primera colección de primavera-verano que presentaron como ThreeasFour, Adi, Ange y Gabi unieron sus propias raíces culturales -israelí, árabe y rusa- y crearon una mezcla elegante de formas, materiales y colores. Al mismo tiempo, los tres diseñadores consideran de gran importancia que sus elegantes y ondulados diseños sean llevables.

Per la prima collezione che presentarono come ThreeasFour, la collezione primavera-estate, Adi, Ange e Gabi riunirono le proprie radici culturali - israeliane, arabe e russe - creando un elegante miscuglio di forme, materiali e colori. In ciò i tre stilisti tengono molto alla portabilità delle loro creazioni eleganti e allo stesso tempo oscillanti.

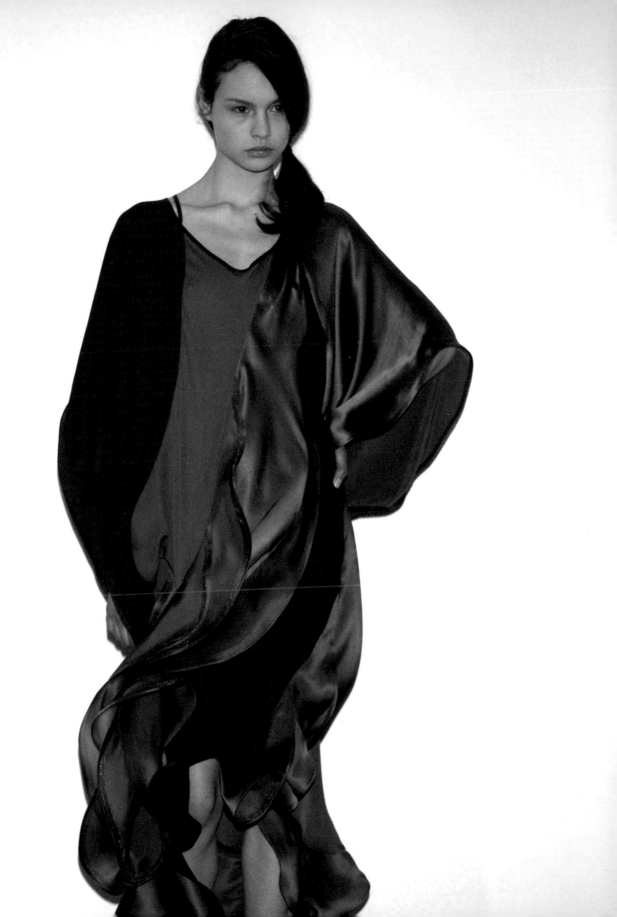

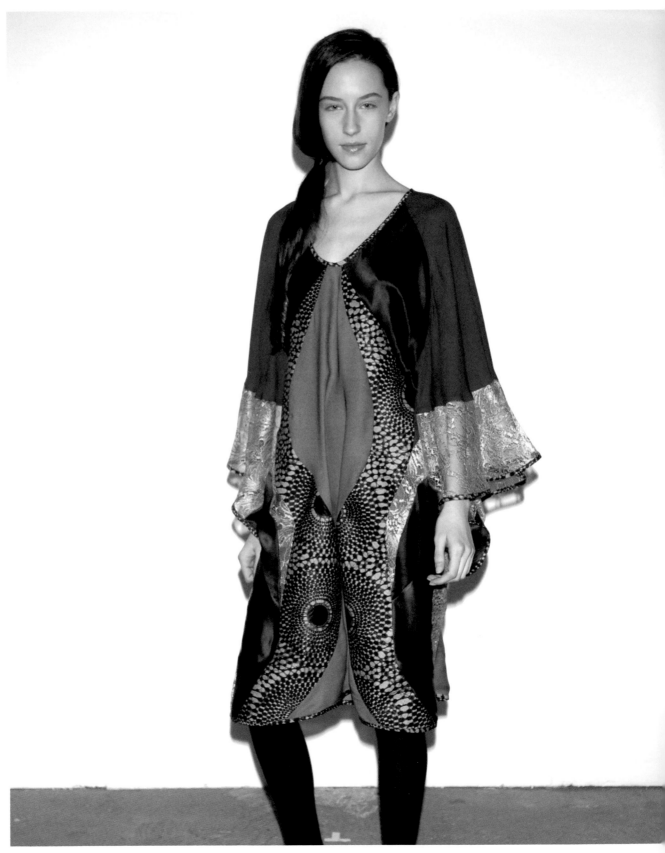

ThreeasFour

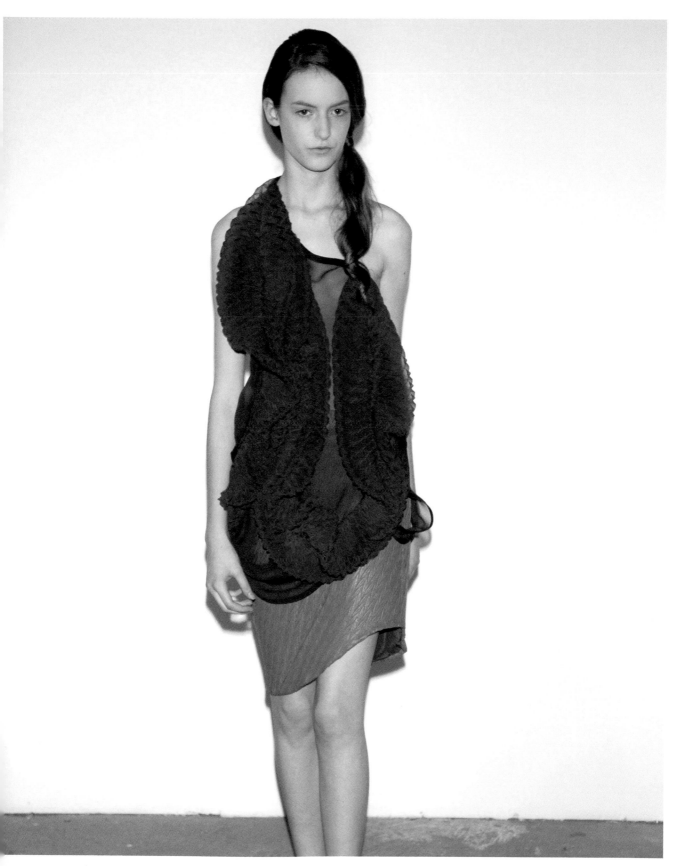

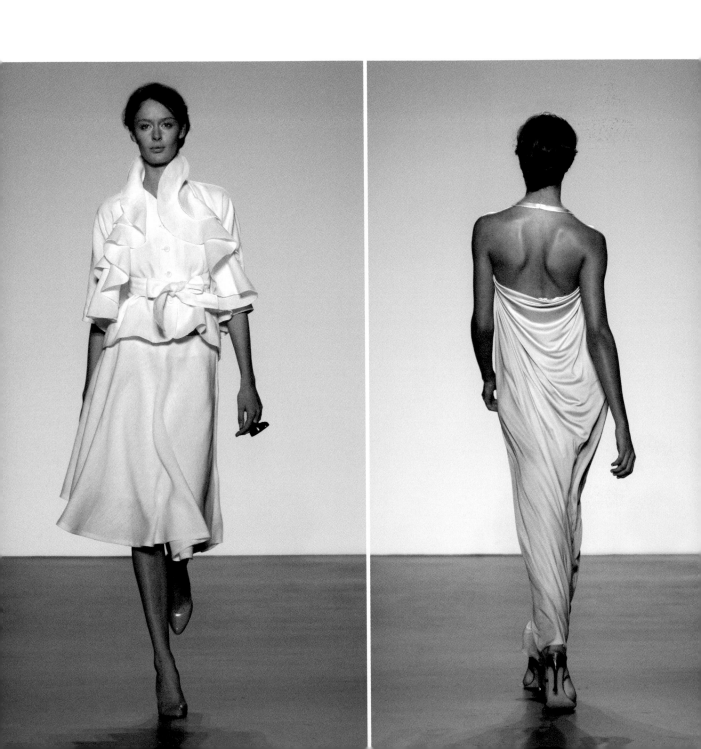

Doo Ri

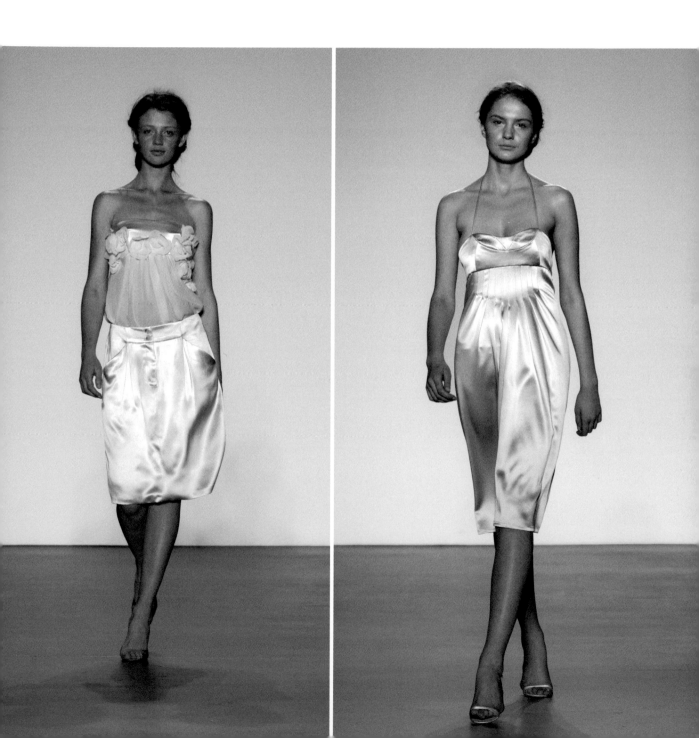

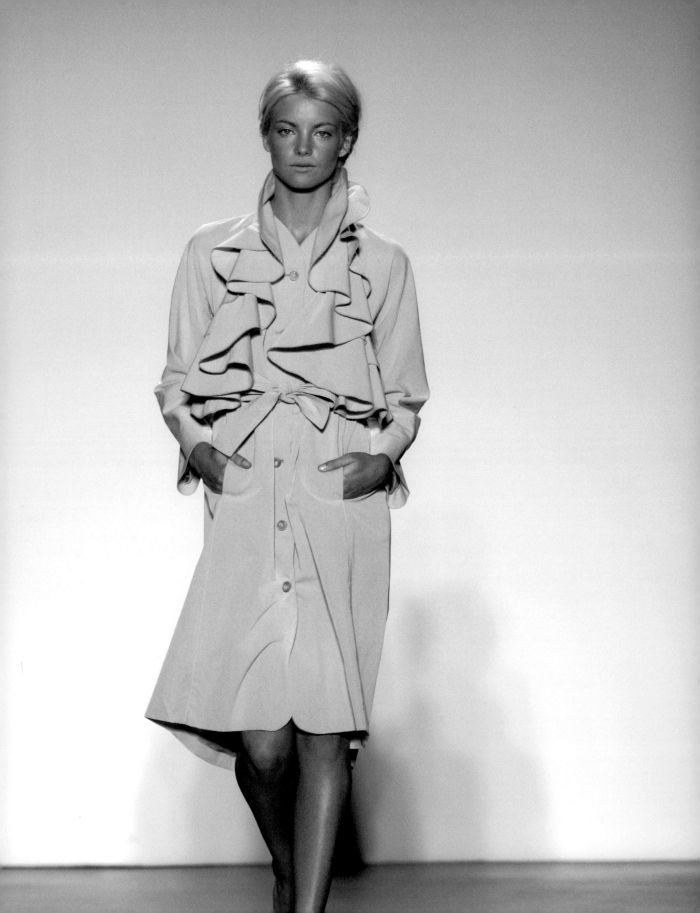

Doo Ri

36 West 38th Street, 5th Floor, New York, NY 10018, USA

+1 212 302 8725

+1 212 302 8724

www.doori-nyc.com

info@doori-nyc.com

Doo Ri

Before Doo Ri Chung presented her first own collection, she was already able to gather experience during her studies at New York's Parsons School of Design with designers such as Donna Karan and Stanley Herman. After receiving the Parsons Designer of the Year Award in 1995, the American designer Geoffrey Beene noticed her. Her light and elegant designs have since achieved great recognition and have won a number of prizes.

Bevor Doo Ri Chung ihre erste eigene Kollektion präsentierte, konnte sie bereits während ihres Studiums an der New Yorker Parsons School of Design Erfahrungen bei Designern wie Donna Karan und Stanley Herman sammeln. Nachdem sie 1995 den Parsons Designer of the Year Award erhielt, wurde der amerikanische Designer Geoffrey Beene auf sie aufmerksam. Ihre leichten und eleganten Entwürfe haben seitdem große Anerkennung gefunden und eine Vielzahl an Preisen gewonnen.

Avant de présenter sa première collection, Doo Ri Chung accumule une grande expérience à la Parsons School of Design à New York, auprès de designers comme Donna Karan et Stanley Herman. Après avoir reçu en 1995 la Parsons Designer of the Year Award, Doo Ri Chung se fait remarquer par le designer américain Geoffrey Beene. Ses créations toute en légèreté et élégance sont désormais reconnues et glanent tous les prix.

Antes de presentar su primera colección propia, Doo Ri Chung tuvo la oportunidad de recopilar experiencia, durante sus estudios en la neoyorquina Parsons School of Design, con diseñadores como Donna Karan y Stanley Herman. Tras obtener en 1995 el premio Parsons como diseñadora del año, el diseñador americano Geoffrey Beene fijó su atención en ella. Desde entonces, sus proyectos ligeros y elegantes han obtenido un gran reconocimiento y han ganado numerosos galardones.

Prima di presentare la sua prima collezione, Doo Ri Chung ha potuto cogliere esperienze presso stilisti come Donna Karan e Stanley Herman già durante gli studi alla Parsons School of Design di New York. Quando ricevette nel 1995 il Parsons Designer of the Year Award, lo stilista americano Geoffrey Beene si interessò a lei. I suoi disegni leggeri e eleganti da allora trovarono grande riconoscimento e vinsero una moltitudine di premi.

Doo Ri

1972
Doo Ri Chung born in Seoul, Korea

1995
Graduation from Parsons School of Design, New York, USA

1995
Parsons Designer of the Year Award

1995–2001
Lead designer for Geoffrey Beene, New York, USA

2003
Foundation of Doo Ri, New York, USA
Woolite Fashion Future Grant Award

2004
Ecco Domani Fashion Foundation Award
Selected for the first CFDA/Vogue Fashion Fund Award

2006
Winner of the Swarovski's Perry Ellis Award, Emerging Talent, Womenswear

Interview | Doo Ri

Which do you consider the most important work of your career? My most important piece is the one that launched my career. It is the piece I did as part of my senior thesis at Parsons—A Claire McCardel inspired "diaper" dress in cashmere jersey.

In what ways does New York inspire your work? When I imagine clothing it is always in reference to its movement or stride. New York is always kinetic, never static.

Does a typical New York style exist, and if so, how does it show in your work? New York has a style of its own, but its style is not easy to pinpoint like it might be in Paris or London. It's about versatility maybe because of the changing weather. I am a New Yorker and can't help but dress "New York."

How do you imagine New York in the future? Hopefully not too gentrified. New York's future is based on this "re-invention"; the buildings and style may change, but it will always be influenced by the creative people living here.

Was halten Sie für die wichtigste Arbeit in Ihrer Karriere? Meine wichtigste Arbeit ist die, mit der meine Karriere begonnen hat. Sie war Teil meiner Diplomarbeit an der Parsons School of Design: Ein „Windelkleid" aus Kaschmirwolle, im Stil von Claire McCardel.

Auf welche Weise inspiriert New York Ihre Arbeit? Beim Entwurf meiner Kleider spielen Gang und Bewegung eine große Rolle. New York ist stets dynamisch, niemals statisch.

Gibt es einen typischen New Yorker Stil, und wenn ja, wie zeigt sich das in Ihrer Arbeit? New York hat einen ganz eigenen Stil, aber der ist nicht so einfach festzunageln wie vielleicht in Paris oder London. Die Vielseitigkeit dieses Stils kommt vielleicht vom wechselhaften Wetter. Ich bin ein New Yorker und kann nicht umhin, „New York" einzukleiden.

Wie stellen Sie sich New York in der Zukunft vor? Hoffentlich nicht zu luxussaniert. New Yorks Zukunft hängt von seiner „Neufindung" ab. Die Gebäude und der Stil verändern sich zwar, aber die Stadt wird immer von den kreativen Menschen beeinflusst werden, die hier arbeiten.

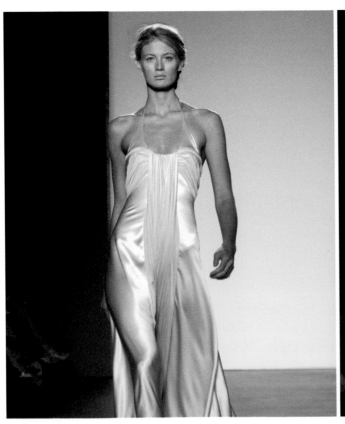
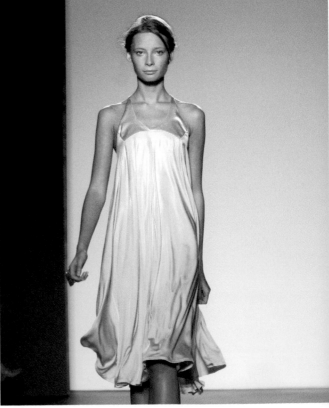

Quelle est l'œuvre la plus importante de votre carrière ? Mon oeuvre la plus importante, c'est celle qui a lancé ma carrière. C'est la création pour ma thèse chez Parsons – une robe « langes » en cachemire de jersey inspirée de A Claire McCardel.

Dans quelle mesure la ville de New York inspire-t-elle votre œuvre ? Quand j'imagine les vêtements que je vais créer c'est toujours par rapport au mouvement ou au pouls de la ville. New York est toujours cinétique, jamais statique.

Peut-on parler d'un style typiquement new-yorkais, et si oui, comment se manifeste-t-il dans votre œuvre ? New York a son propre style, mais il n'est pas facile à définir comme à Paris ou à Londres. C'est peut-être pour son aspect versatile, suite aux changements de temps. Je suis new-yorkaise et je ne peux m'empêcher d'habiller « New York ».

Comment imaginez-vous le New York de demain ? Pas trop embourgeoisé, j'espère. L'avenir de New York repose sur cette « réinvention ». Les édifices et les styles peuvent changer, mais ils seront toujours influencés par l'imagination des créateurs qui y habitent.

¿Cuál es el trabajo que considera más importante en su carrera? El trabajo más importante es el que lanzó mi carrera. Es la prenda que realicé como parte de mi tesis superior en Parsons: un vestido "pañal" inspirado en Claire McCardel en punto de cachemir.

¿De qué manera Nueva York supone una inspiración en su trabajo? Cuando me imagino la ropa es siempre en referencia a su movimiento o ritmo. Nueva York es siempre cinética, nunca estática.

¿Existe un estilo típico neoyorquino, y si es así, cómo se revela en su obra? Nueva York tiene estilo propio, pero este estilo no es fácil de determinar como es el caso de París o Londres. Tiene que ver con la versatilidad, quizá debido a la inconstancia meteorológica. Soy neoyorquino y no puedo sino vestir a lo "New York".

¿Cómo se imagina Nueva York en el futuro? Espero que no demasiado aburguesada. El futuro de Nueva York se basa en su reinvención; los edificios y el estilo pueden cambiar pero esto siempre se verá influenciado por los creativos que vivan aquí.

Cosa pensa che sia la cosa più importante della Sua carriera? La mia opera di design più importante è stata quella che ha lanciato la mia carriera. Faceva parte della mia tesi presso la Parsons: un abito "fasciato" ispirato a Claire McCardel in kashmir jersey.

In che modo New York influenza il Suo lavoro? Quando mi immagino un vestito è sempre in relazione al movimento, alla camminata. New York è sempre cinetica, mai statica.

Esiste uno stile tipico a New York? Se sì, come influenza il Suo lavoro? New York possiede uno stile proprio, ma il suo stile non è così facile da definire come può esserlo lo stile di Parigi o di Londra. Ha a che fare con la versatilità, forse per causa delle condizioni del tempo. Io sono newyorchese e non posso fare a meno di vestire "stile New York".

Come si immagina New York in futuro? Spero non troppo mondano. Il futuro di New York si basa su questa "re-invenzione"; gli edifici e lo stile possono cambiare, ma la città sarà sempre influenzata dalle persone creative che vivono qui.

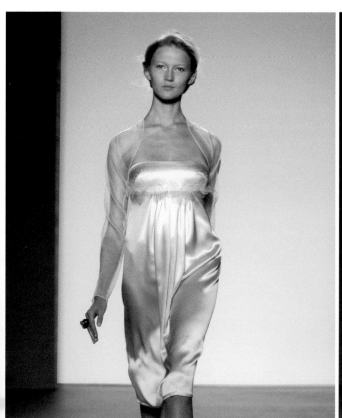 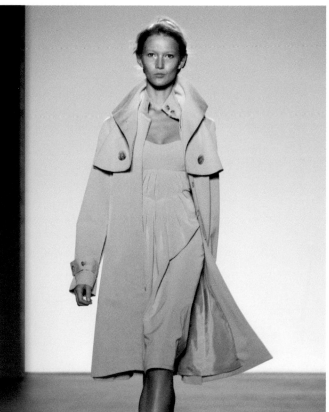

Spring/Summer Collection

Year: 2006
Photographs: © Francesco Lagnese, Luis Bañuelas Aréchiga (portrait)

For her spring/summer collection, Doo Ri Chung was inspired by photographs by Deborah Turbeville. She showed her preference for softly flowing and wonderfully draped designs and enriched models with beige-colored silk or satin with sparkling crystals and embroideries. An especially successful example of the implementation of cuts which are easy to wear are the trenchcoats with noticeable stand-up collars and sumptuous flounces.

Für ihre Frühjahrs- und Sommerkollektion ließ sich Doo Ri Chung von den Fotografien Deborah Turbevilles inspirieren. So setzte sie ihre Vorliebe für weich fließende und wundervoll drapierte Entwürfe fort und bereicherte die Modelle aus beigefarbener Seide oder Satin mit funkelnden Kristallen und Stickereien. Ein besonders gelungenes Beispiel für die Umsetzung von Schnitten, die die Figur lässig umspielen, sind die Trenchcoats mit auffälligen Stehkragen und üppigen Volants.

Pour sa collection de printemps et d'été, Doo Ri Chung s'est inspirée des photographies de Deborah Turbeville. Elle s'est donc adonnée à sa prédilection pour des créations aux merveilleux drapés blancs et fluides, agrémentant ses modèles de soie ou satin beiges, parés de paillettes ou de broderies. Un merveilleux exemple de coupe, qui enveloppe la silhouette avec désinvolture, se retrouve dans ses Trench-coats parés d'imposants mao et d'une abondance de volants.

Para su colección de primavera-verano, Doo Ri Chung se inspiró en las fotografías de Deborah Turbeville. Mantiene sus preferencias por los diseños suavemente difusos con maravillosos drapeados y adorna los modelos de satín o seda beige con brillantes cristales y bordados. Las gabardinas, de llamativo cuello alzado y voluptuosos volantes, son un ejemplo estupendo de modelos que dejan entrever la figura con desenfado.

Per la sua collezione primavera-estate Doo Ri Chung si è ispirata alle fotografie di Deborah Turbeville. In questo modo prosegue la sua preferenza per i disegni morbidamente fluenti e meravigliosamente drappeggiati e arricchisce i suoi modelli di seta o raso beige con cristalli e ricami scintillanti. Un esempio molto riuscito per i suoi tagli che avvolgono il corpo in modo quasi negligente sono i trenchcoat con colletto alla coreana e rigogliosi volants.

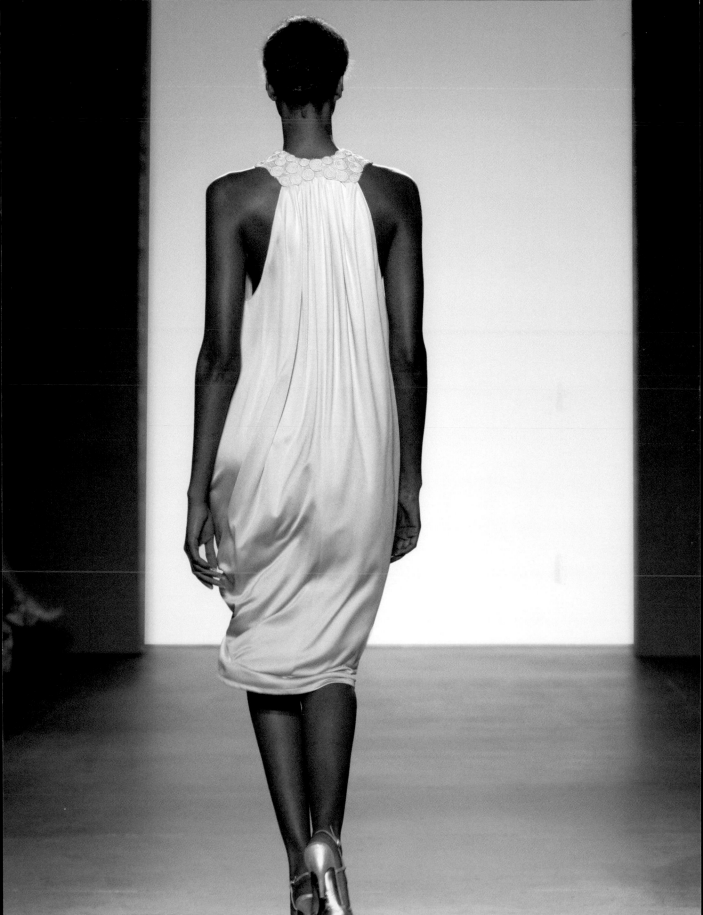

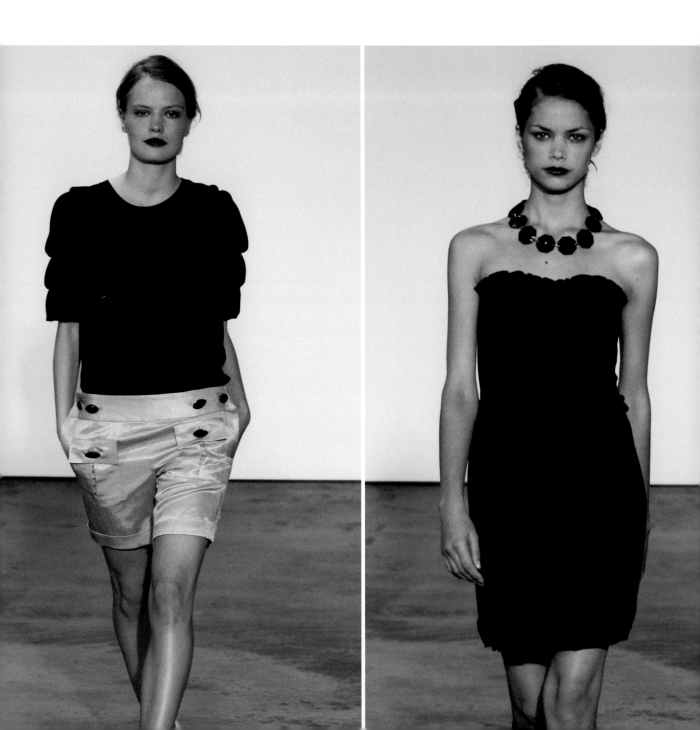

Thakoon

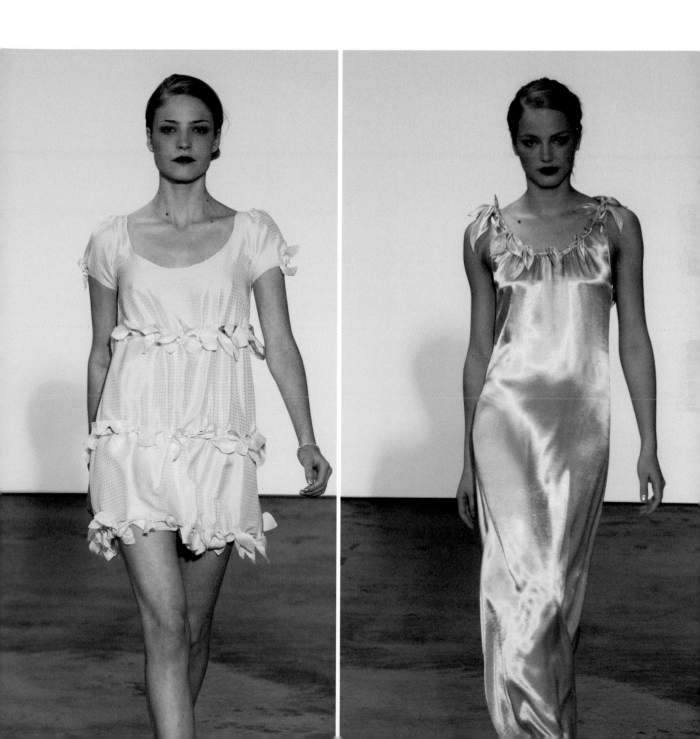

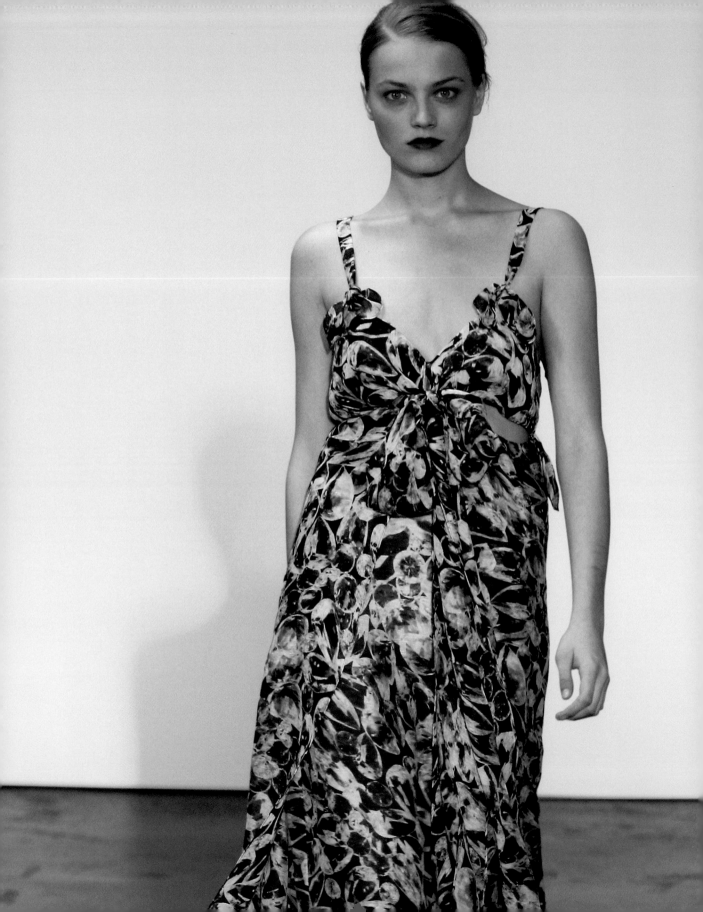

Thakoon

443 Greenwich Street, Suite 6K, New York, NY 10013, USA

+1 212 929 0700

+1 212 966 1627

www.thakoon.com

info@thakoon.com

Thakoon Panichgul

1974
Thakoon Panichgul born in Nakhon Phanom, Thailand

1997
Graduation, Business degree, Boston University, Boston, Massachusetts, USA

2000–2004
Writer and editor for Harper's Bazaar

2001–2003
Design studies at Parsons School of Design, New York, USA

2004
Foundation of Thakoon, New York, USA

The versatility of Thakoon Panichgul's designs represents the multilayered nature of his experiences in life. He grew up in Thailand before moving to the USA at age 11 with his parents. In his position as editor at Harper's Bazaar, he worked hard with the views of fashion designers and rounded out his knowledge with a design study at the Parsons School. In 2004, he presented his first collection with great success.

Die Vielseitigkeit der Entwürfe Thakoon Panichguls repräsentiert die Vielschichtigkeit seiner Lebenserfahrungen. Er wuchs in Thailand auf, bevor er mit elf Jahren mit seiner Familie in die USA umsiedelte. Während seiner Tätigkeit als Redakteur für Harper's Bazaar setzte er sich intensiv mit der Sichtweise der Modedesigner auseinander und ergänzte seine Kenntnisse durch ein Designstudium an der Parson School. 2004 präsentierte er mit großem Erfolg seine erste Kollektion.

La polyvalence des créations de Thakoon Panichgul est à l'image des multiples facettes de son expérience personnelle. Il grandit en Thaïlande, avant de s'installer à 11 ans avec sa famille aux Etats-Unis. Rédacteur chez Harper's Bazaar, il s'intéresse de près à la perception du designer de mode et complète ses connaissances en étudiant le design à la Parsons School. En 2004, sa première collection reçoit un succès retentissant.

La gran variedad de los diseños de Thakoon Panichgul refleja la heterogeneidad de las experiencias que ha vivido. Vivió en Tailandia hasta los 11 años y posteriormente se trasladó con su familia a los Estados Unidos. Durante su actividad como redactor en la revista de moda Harper's Bazaar analizó con profundidad la perspectiva de los diseñadores de moda y completó sus conocimientos con estudios de diseño en la Parsons School. El año 2004 presentó con gran éxito su primera colección.

La poliedricità dei disegni di Thakoon Panichgul rappresenta la complessità delle sue esperienze di vita. Cresciuto in Tailandia, all'età di undici si trasferì negli Stati Uniti. Durante la sua attività come redattore per Harper's Bazaar si occupò intensamente con la visione degli stilisti di moda, completando poi le sue nozioni con uno studio di stilismo di moda presso la Parsons School. Nel 2004 ha presentato con grande successo la sua prima collezione.

Interview | Thakoon

What do you consider the most important work of your career? The most important work so far in my career has been the initial drive to launch the collection. It was the biggest test for myself and something that I'm very proud of.

In what way does New York inspire your work? New York inspires modernity and change, which sets a good standard for fashion. In this city, creativity is conceived in the context of real, fast-paced life.

Does a typical New York style exist, and if so, how does it show in your work? Yes, in the perfect mixture of fashion and function. So much of the city is about the daily grind, that fashion has to be both elegant and all-terrain at the same time.

How do you imagine New York in the future? As neighborhoods change and gentrify, eventually every facet of the city will have an element of design.

Was halten Sie für die wichtigste Arbeit in Ihrer Karriere? Die bisher wichtigste Arbeit in meiner Karriere war der anfängliche Eifer, eine Kollektion herauszubringen. Das war für mich die größte Probe und darauf bin ich sehr stolz.

Auf welche Weise inspiriert New York Ihre Arbeit? New York inspiriert zu Modernität und Wandel und das setzt gute Maßstäbe für die Modewelt. In dieser Stadt steht Kreativität unweigerlich im Kontext einer schnelllebigen Realität.

Gibt es einen typischen New Yorker Stil, und wenn ja, wie zeigt sich das in Ihrer Arbeit? Ja, in der perfekten Mischung von Mode und Funktionalität. So vieles in dieser Stadt dreht sich um den alltäglichen Trott, dass Mode gleichzeitig elegant und multifunktional sein muss.

Wie stellen Sie sich New York in der Zukunft vor? Mit dem Wandel und der Aufwertung der Stadtviertel wird letzten Endes jeder Teil dieser Stadt ein eigenes Designelement haben.

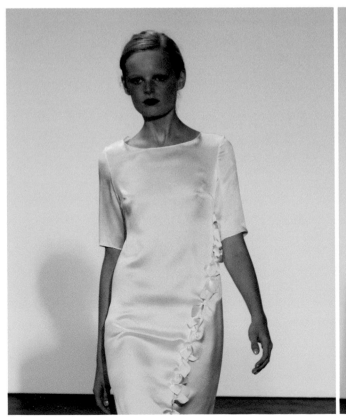 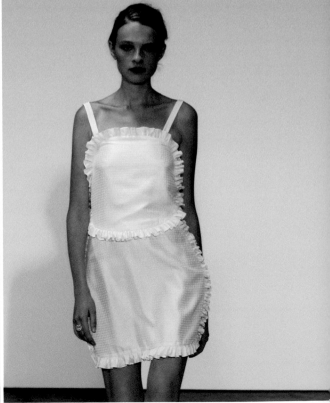

Quelle est l'œuvre la plus importante de votre carrière ? L'œuvre la plus importante de ma carrière c'est, jusqu'à présent, toute la préparation qui a précédé le lancement de la collection. C'était le plus grand test pour moi-même, quelque chose dont je suis très fier.

Dans quelle mesure la ville de New York inspire-t-elle votre œuvre ? New York inspire modernité et changement, excellents principes de base pour la mode. Dans cette ville, la créativité se conçoit dans le cadre de la vie réelle et de son rythme effréné.

Peut-on parler d'un style typiquement new-yorkais, et si oui, comment se manifeste-t-il dans votre œuvre ? Oui, dans l'association parfaite entre mode et fonction. La ville est tellement axée sur le travail quotidien monotone, que la mode doit allier élégance et commodité.

Comment imaginez-vous le New York de demain ? Comme les quartiers changent et se gentrifient, il se peut que chaque facette de la ville garde un élément de design.

¿Cuál es el trabajo que considera más importante en su carrera? El trabajo más importante de mi carrera, hasta ahora, ha sido el impulso inicial de lanzar la colección. Ha sido la mayor prueba para mi mismo y algo de lo que me siento muy orgulloso.

¿De qué manera Nueva York supone una inspiración en su trabajo? Nueva York inspira modernidad y cambio, lo cual establece un buen criterio para la moda. En esta ciudad, la creatividad se concibe en el contexto de la vida real, de ritmo acelerado.

¿Existe un estilo típico neoyorquino y, si es así, cómo se revela en su obra? Sí, en la perfecta mezcla de moda y función. Mucho de la ciudad está en el trabajo pesado diario, en que la moda debe ser al mismo tiempo elegante y todo terreno.

¿Cómo se imagina Nueva York en el futuro? A medida que los barrios cambien y se aburguesen, cada faceta de la ciudad llegará a tener un elemento de diseño.

Qual è secondo Lei il progetto più importante della Sua carriera? L'apice della mia carriera fino a ora è stata la spinta iniziale per il lancio della collezione. È stata la prova più grande che ho dovuto affrontare ed è qualcosa di cui vado molto fiero.

In che modo la città di New York ispira il Suo lavoro? New York è fonte di ispirazione per la modernità e il cambiamento, un buon punto di partenza per la moda. Il processo creativo in questa città è parte integrante della sua vita reale e della velocità che la caratterizza.

È possibile parlare di uno stile tipico per New York, e, se questo stile esiste, in che modo si manifesta nei Suoi lavori? Certo, si manifesta nella sintesi perfetta di bellezza e praticità. Molto in città rimane preso nell'ingranaggio del quotidiano: la moda deve quindi essere al contempo elegante e con piedi per terra.

Come si immagina la New York del futuro? Con il ricambio dei distretti e l'innalzamento degli standard abitativi, forse ogni aspetto della città finirà per avere elementi di design.

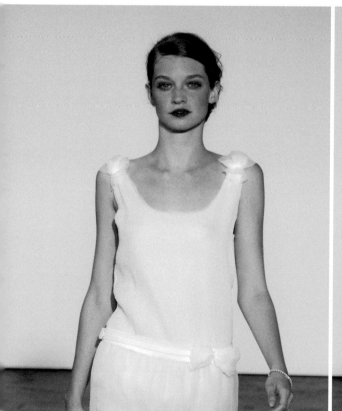

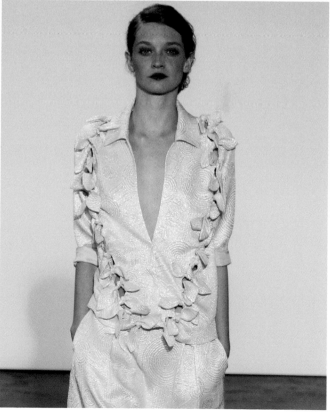

Spring Collection

Year: 2006

Photographs: © Monica Feudi

Thakoon Panichgul is fascinated by classical patterns, the details of which, however, he subjects to intensive analysis in order to create modernized designs, which respect tradition on the one hand and develop a new form vocabulary on the other hand. His minimalistic dresses are as feminine as they are innovative. For this year's spring collection, Thakoon Panichgul selected light materials, which he enriched by means of decorative knots and structures.

Thakoon Panichgul ist fasziniert von klassischen Schnitten, deren Details er jedoch einer intensiven Analyse unterwirft, um modernisierte Designs zu entwerfen, die einerseits der Tradition Respekt zollen und andererseits eine neue Formsprache entwickeln. Dabei sind seine minimalistischen Kleider ebenso feminin wie innovativ. Für diese Frühjahrskollektion wählte Thakoon Panichgul leichte Stoffe, die er durch dekorative Knoten und Strukturen bereicherte.

Thakoon Panichgul est fasciné par les modèles de coupe classiques. Il les étudie dans les moindres détails pour créer des designs revisités, respectueux de la tradition tout en développant un nouveau langage formel. Ses vêtements minimalistes sont aussi féminins qu'innovateurs. Pour sa dernière collection de printemps, Thakoon Panichgul a sélectionné des étoffes légères, agrémentées de noeuds et structures décoratives.

A Thakoon Panichgul le fascinan los patrones de corte clásico, cuyos detalles somete a un intenso análisis para esbozar modernos diseños que, por un lado, tributan un gran respeto a la tradición y, por el otro, desarrollan un nuevo lenguaje de formas. Por este motivo, sus trajes minimalistas resultan tan femeninos como innovadores. Para esta colección de primavera escogió tejidos ligeros adornados con nudos y estructuras decorativas.

Thakoon Panichgul è affascinato dai cartamodelli classici; se ne appropria attraverso un'analisi intensa per poi progettare disegni modernizzati che da un lato serbano il rispetto della tradizione e dall'altro mostrano un linguaggio di forme nuovo. I suoi abiti minimalisti sono tanto femminei quanto innovativi. Per la sua collezione primaverile Thakoon Panichgul ha scelto tessuti leggeri, impreziosendoli poi con nodi e strutture decorativi.

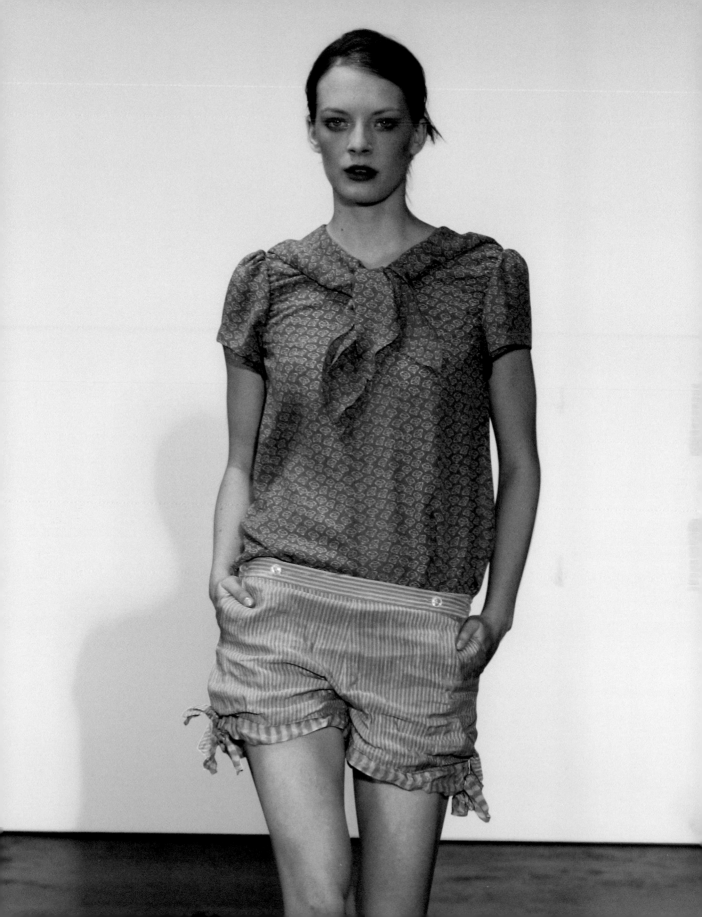

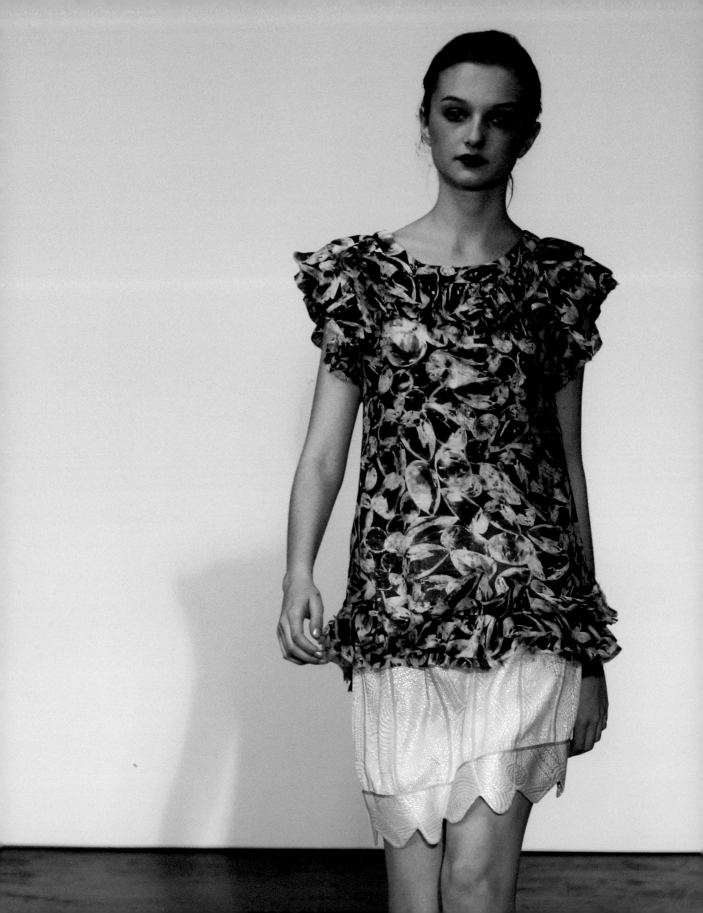

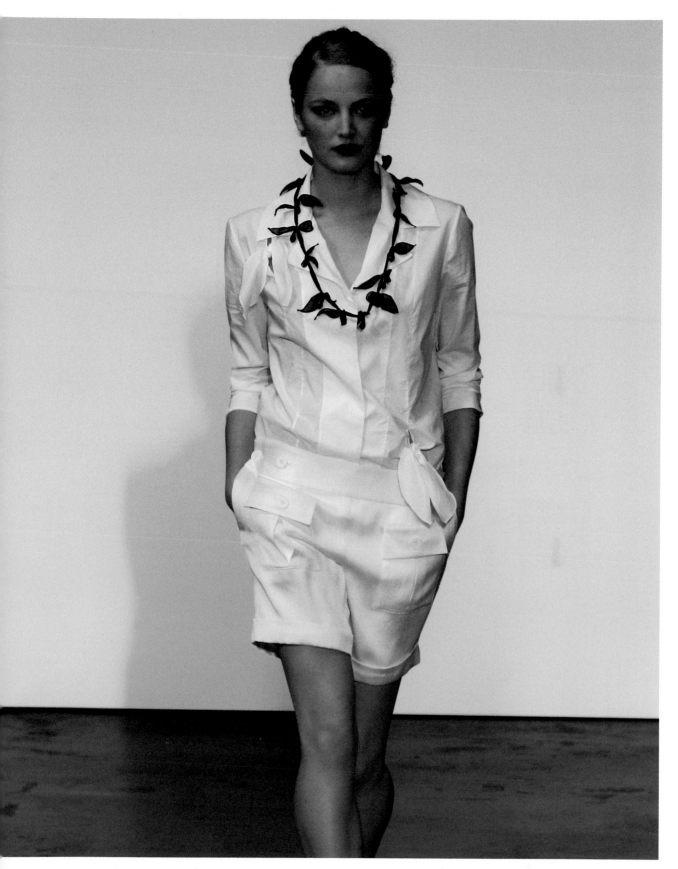

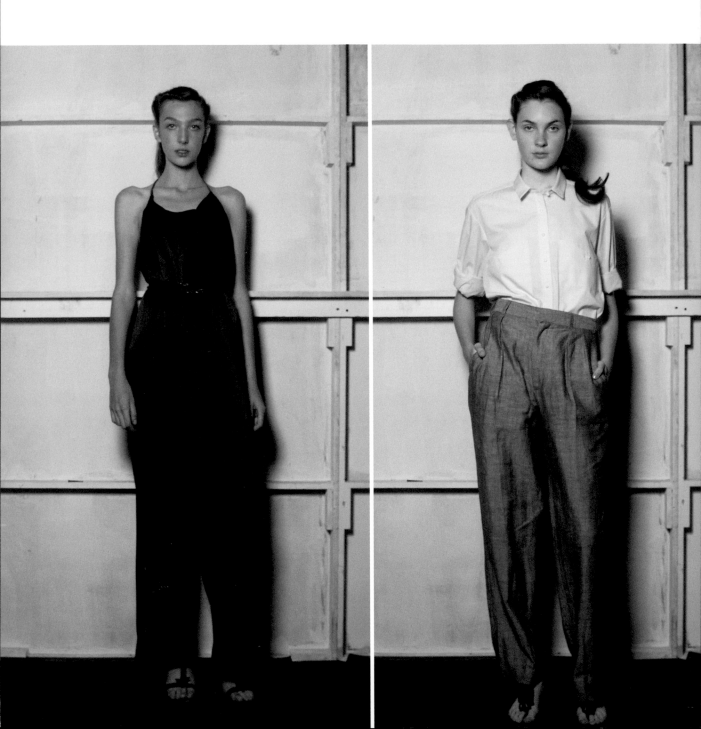

Mary Ping

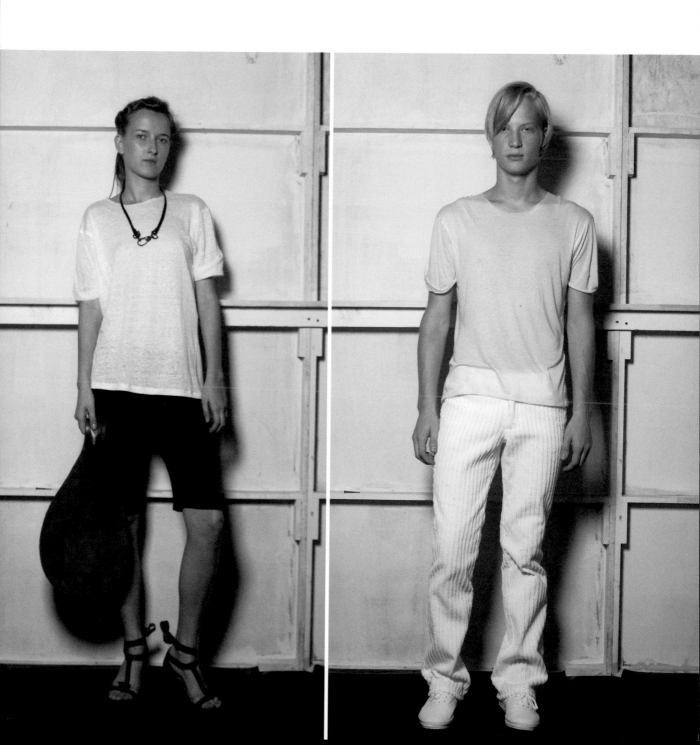

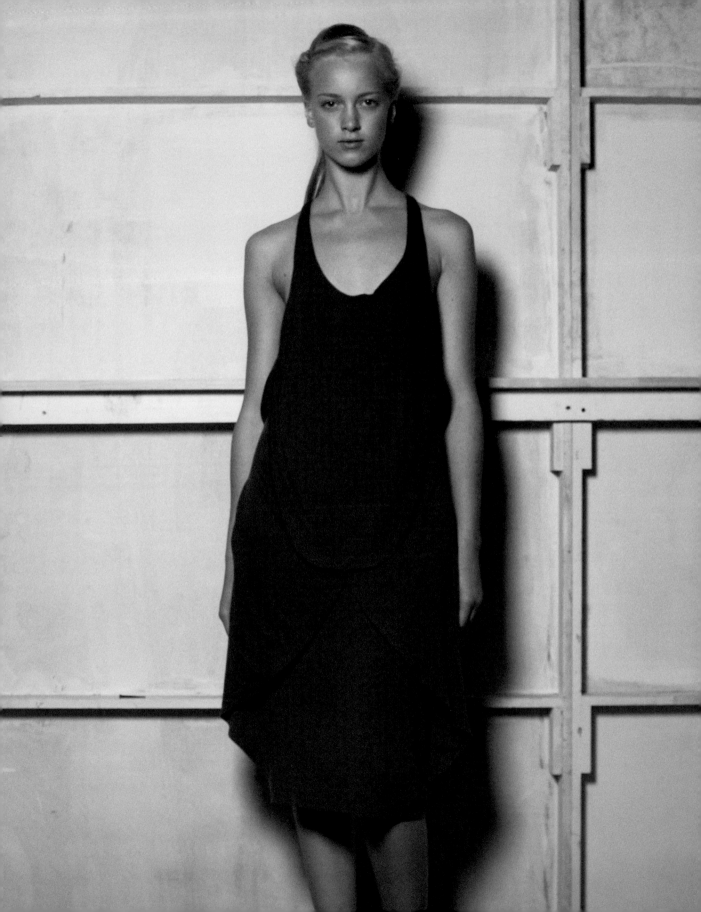

Mary Ping

331 E 65th Street, 4th Floor, New York, NY 10021, USA

+1 212 472 7753

+1 212 472 7754

www.maryping.com

info@maryping.com

Mary Ping

1978
Mary Ping born in New York, USA

2000
Bachelor of Arts, Vassar College, Poughkeepsie, New York, USA

2001
Launch of Mary Ping Label
Attended London College of Fashion, London, UK
Attended Central Saint Martins College of Art and Design, London, UK

2005
UPS Delivers Fashion Award
Ecco Domani Fashion Foundation Award

Already at age six, Mary Ping wanted to become a fashion designer and directly following her art studies at Vassar College and London's College of Fashion, she created her own label in 2001. With her malleable designs, she combines the experiences, which she was able to gather from designers such as Han Feng, Anna Sui and Robert Cary-Williams, with her artistic training.

Schon mit sechs Jahren wollte Mary Ping Modedesignerin werden und direkt nach ihrem Kunststudium am Vassar College und am London College of Fashion gründete sie 2001 ihre eigenes Label. Bei ihren plastischen Designs kombiniert sie die Erfahrungen, die sie bei Designern wie Han Feng, Anna Sui und Robert Cary-Williams sammeln konnte, mit ihrer künstlerischen Ausbildung.

Dès l'âge de six ans Mary Ping veut devenir designer de mode et directement après ses études d'art au Vassar College et au London College of Fashion, elle crée, en 2001, sa propre marque. Ses designs plastiques sont indissociables de sa formation artistique et de l'expérience accumulée auprès de designers comme Han Feng, Anna Sui et Robert Cary-Williams.

Cuando tenía seis años Mary Ping ya quería ser diseñadora de moda y, nada más finalizar sus estudios de arte en el Vassar College y en el London College of Fashion, fundó su propia marca el año 2001. En sus diseños plásticos combina la experiencia adquirida con diseñadores como Han Feng, Anna Sui y Robert Cary-Williams con su formación artística.

Già all'età di sei anni Mary Ping voleva diventare stilista di moda. Nel 2001 immediatamente dopo i suoi studi di arte presso il Vassar College e il London College of Fashion, fondò la propria firma. Nei sui disegni plastici combina le esperienze acquisite con stilisti come Han Feng, Anna Sui e Robert Cary-Williams, con la sua formazione artistica.

Interview | Mary Ping

What do you consider the most important work of your career? I consider the individual pieces rather than collections as certain milestones of my career. Notably, these are the same pieces which I feel I can revisit and are still fresh.

In what ways does New York inspire your work? My family and my friends in New York inspire my work.

Does a typical New York style exist, and if so, how does it show in your work? I think the heritage of New York style comes from a few different places, namely street and sportswear. There are traces of this in my work simply because I sometimes have a practical edge to my design.

How do you imagine New York in the future? Hard to say. New York can be unpredictable, but it has a soul which will always draw people to its core.

Was halten Sie für die wichtigste Arbeit in Ihrer Karriere? Es sind eher die Einzelstücke als ganze Kollektionen, die ich als Meilensteine meiner Karriere betrachte. Hauptsächlich sind das Stücke, von denen ich das Gefühl habe, ich kann sie immer wieder betrachten und sie haben immer wieder etwas Neues.

Auf welche Weise inspiriert New York Ihre Arbeit? Meine Familie und Freunde in New York inspirieren meine Arbeit.

Gibt es einen typischen New Yorker Stil, und wenn ja, wie zeigt sich das in Ihrer Arbeit? Ich denke, das Erbe des New Yorker Stils kommt aus verschiedenen Ecken, vor allem aus dem Bereich Street- und Sportswear. Spuren davon finden sich auch in meiner Arbeit, weil mein Design gelegentlich einen Hang zum Praktischen hat.

Wie stellen Sie sich New York in der Zukunft vor? Schwer zu sagen. New York kann sehr unberechenbar sein, aber es hat eine Seele, die stets die Menschen in ihren Bann ziehen wird.

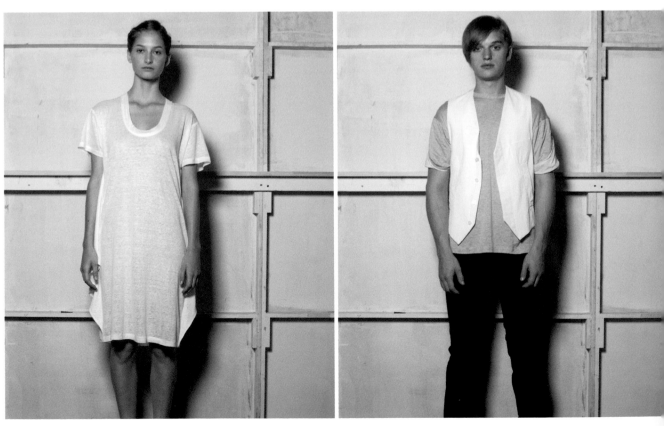

Quelle est l'œuvre la plus importante de votre carrière ? Je pense que ce sont des pièces uniques plutôt que des collections qui ont posé les jalons de ma carrière. Ce qui est intéressant, c'est que ce sont des œuvres que je peux revoir et qui ont gardé toute leur fraîcheur.

Dans quelle mesure la ville de New York inspire-t-elle votre œuvre ? Ma famille et mes amis à New York sont ceux qui inspirent mon œuvre.

Peut-on parler d'un style typiquement new-yorkais, et si oui, comment se manifeste-t-il dans votre œuvre ? Je crois que le style de New York tire son héritage de différentes sources, à savoir les rues et le sportswear. On en retrouve les traces dans mon travail, tout simplement parce que j'ai parfois une approche pratique du design.

Comment imaginez-vous le New York de demain ? Difficile à dire ! New York peut être imprévisible, mais elle a une âme qui ramènera toujours les gens vers elle.

¿Cuál es el trabajo que considera más importante en su carrera? Considero los trabajos individuales más que elementos de una colección como ciertos hitos en mi carrera. Estos trabajos son en particular los que siento que puedo volver a visitar y aún percibo como recientes.

¿De qué manera Nueva York supone una inspiración en su trabajo? Mi familia y mis amigos de Nueva York inspiran mi trabajo.

¿Existe un estilo típico neoyorquino y, si es así, cómo se revela en su obra? Creo que la herencia del estilo de Nueva York se deriva de unos cuantos sitios distintos, a saber, ropa de calle y de deporte. Hay rastro de esto en mi trabajo simplemente porque a veces aporto un tono práctico a mi diseño.

¿Cómo se imagina Nueva York en el futuro? Es difícil decir. Nueva York puede ser impredecible, pero tiene un alma que siempre atraerá a la gente hacia su corazón.

Qual è secondo Lei il progetto più importante della Sua carriera? Credo che, più che intere collezioni, alcune singole creazioni costituiscano delle pietre miliari nella mia carriera. Non a caso, si tratta di creazioni che possono essere ancora riviste e non perdono la loro freschezza.

In che modo la città di New York ispira il Suo lavoro? La fonte di ispirazione per il mio lavoro sono la mia famiglia e i miei amici di New York.

È possibile parlare di uno stile tipico per New York, e, se questo stile esiste, in che modo si manifesta nei Suoi lavori? Credo che l'eredità dello stile di New York passi attraverso pochi ambiti diversi tra loro, ovvero la strada e l'abbigliamento sportivo. Credo ve ne sia traccia anche nei miei lavori, semplicemente perché alle volte nel mio design non mancano tratti funzionali.

Come si immagina la New York del futuro? È difficile da dire. New York è imprevedibile, ma la sua anima sarà certo sempre in grado di attrarre le persone verso il proprio centro.

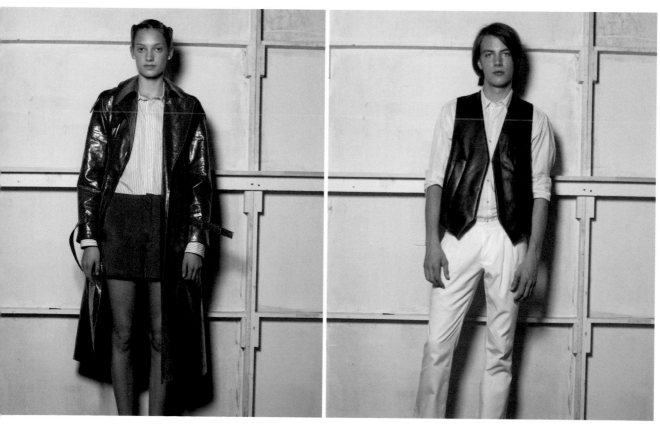

Mary Ping 481

Wide Set Eyes

Year: Spring 2006
Photographs: © Isabel Asha Penzlien

Despite her strong interest in fashion, Mary Ping first decided to study art in order to obtain a comprehensive artistic training. This schooled her sensitivity for the physical effect of fashion. She places a great deal of value on well-crafted precision as well as the elaboration of details. In her collection, Wide Set Eyes, the designer uses simple and defined forms, which are combined with soft edges and sophisticated colors.

Trotz ihres starken Interesses für Mode entschied sich Mary Ping zunächst einmal dazu Kunst zu studieren, um eine umfassende künstlerische Ausbildung zu erhalten. Dies schulte ihr Empfinden für die körperhafte Wirkung von Mode. Sie legt großen Wert auf handwerkliche Präzision sowie auf Ausarbeitung der Details. Bei ihrer Kollektion Wide Set Eyes setzt die Designerin auf schlichte und definierte Formen, die mit weichen Kanten und edlen Farbtönen kombiniert werden.

Malgré sa prédilection pour la mode, Mary Ping fait d'abord des études d'art, pour obtenir une formation artistique complète. Elle en reçoit un sens inné pour la relation entre la mode et le corps. Elle accorde une grande importance à la précision du travail ainsi qu'à l'exécution des détails. Dans sa collection Wide Set Eyes, la designer met l'accent sur des formes épurées et bien définies, associant douceur des angles et subtilité des nuances.

A pesar de su gran interés por la moda, Mary Ping decidió estudiar arte en primer lugar, para obtener una formación artística más completa. De esta manera adquirió un sexto sentido sobre el efecto de la moda en el cuerpo. Para ella es muy importante la precisión artesanal y la elaboración de los detalles. En su colección Wide Set Eyes la diseñadora apuesta por formas sencillas y definidas que se combinan con cantos suaves y tonos nobles.

Nonostante il suo grande interesse per la moda, Mary Ping decise inizialmente di studiare arte, per acquisire una formazione artistica completa. Durante gli studi sviluppò la sua sensibilità per l'effetto corporeo della moda. È molto attenta alla precisione artigianale e la lavorazione dei dettagli. Nella sua collezione Wide Set Eyes la stilista usa forme semplici e definite e le combina con bordi morbidi e colori eleganti.

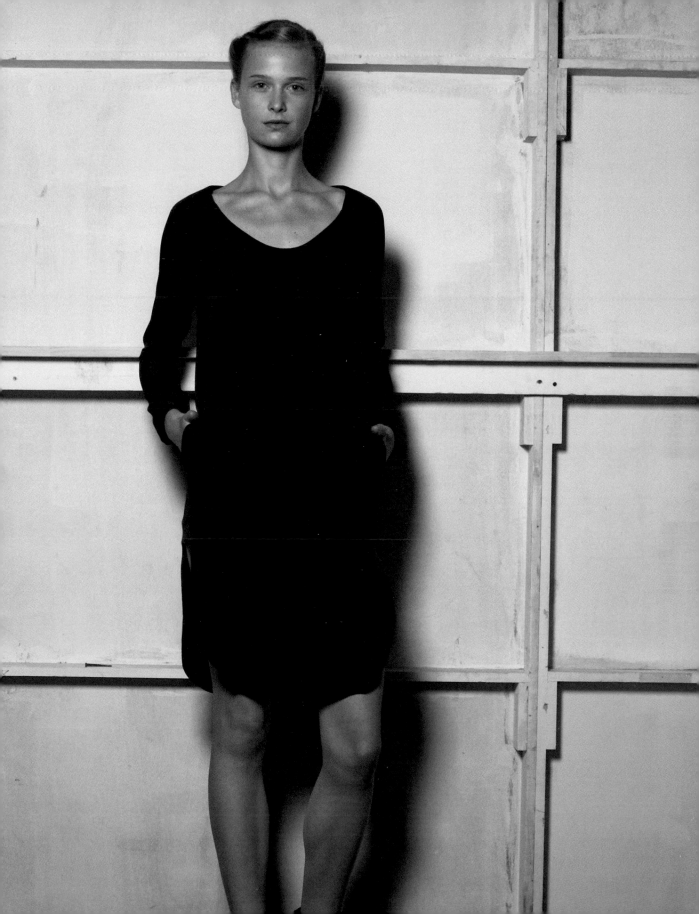

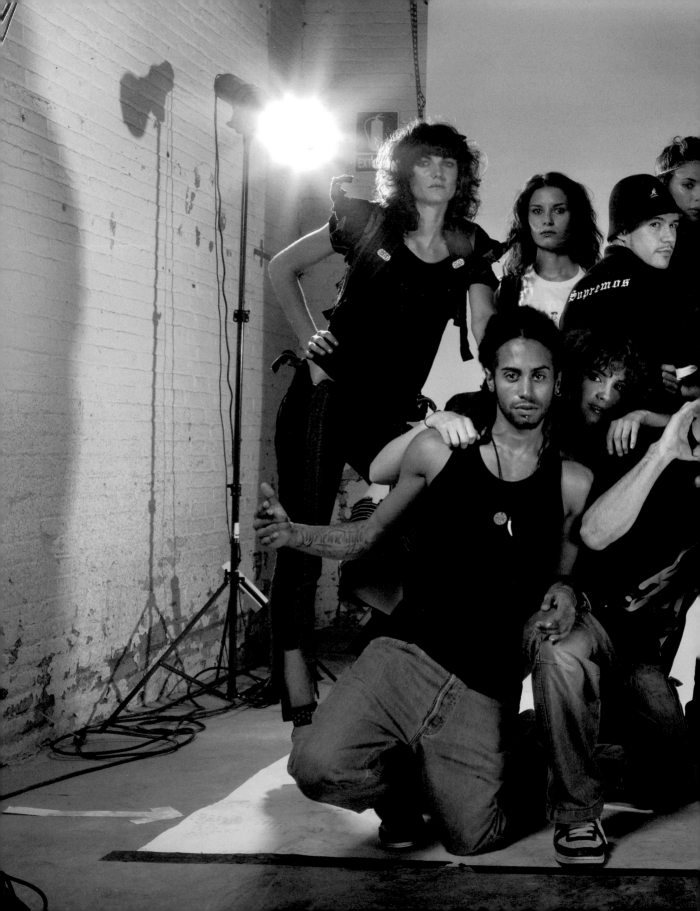

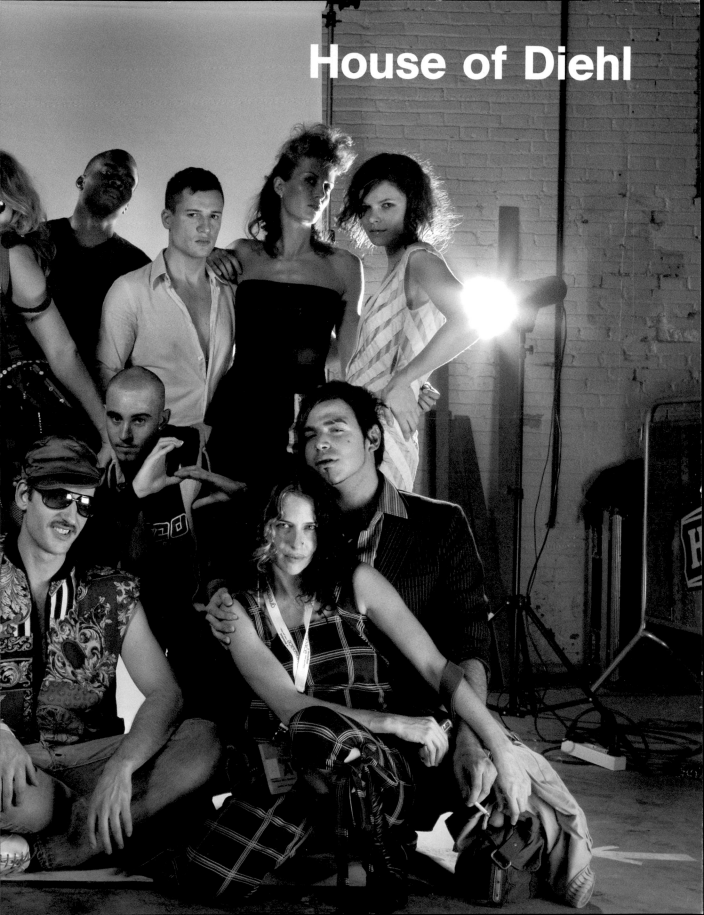

House of Diehl

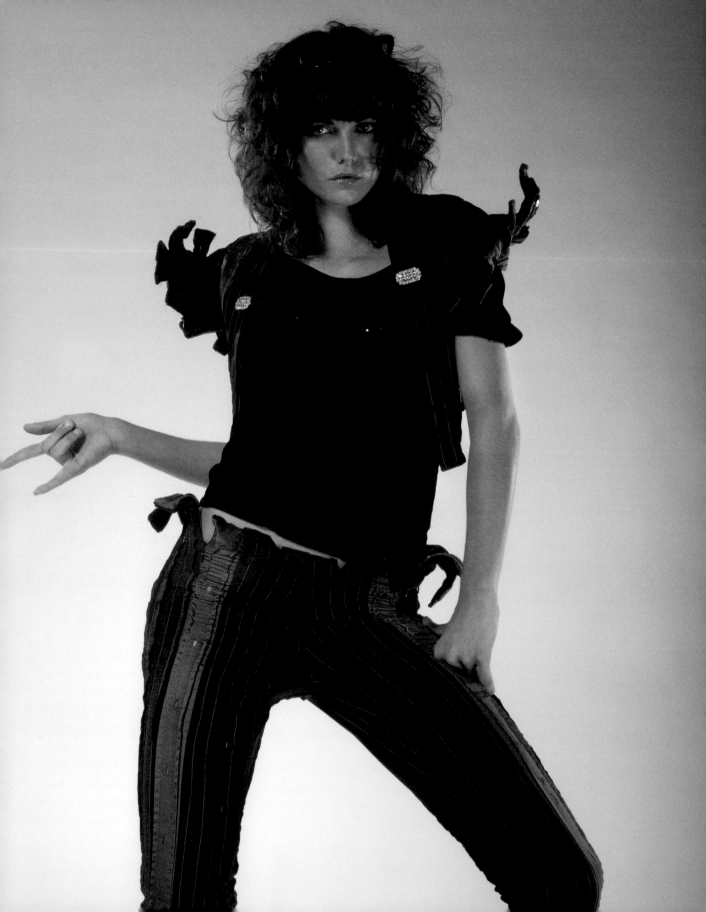

House of Diehl

279 Church Street New York, NY 10013, USA

+1 212 358 8915

+1 212 358 8915

www.houseofdiehl.com

hello@houseofdiehl.com

Mary Jo Diehl

After studying philosophy in Middletown, Mary Jo Diehl, born and raised in New York, first began her career as an artist. Her radical design, Instant Couture, was nominated for two of the most important American prizes, Gen Art Styles and the Ecco Domani Fashion Foundation Award. Encouraged by these successes, she created her own label, House of Diehl.

Nach ihrem Philosophie-Studium in Middletown begann die in New York geborene und auf-gewachsene Mary Jo Diehl ihre Karriere zunächst als Künstlerin. Ihr radikales Projekt Instant Couture wurde für zwei der wichtigsten amerikanischen Preise nominiert, den Gen Art Styles und den Ecco Domani Fashion Foundation Award. Bestärkt durch diese Erfolge gründete sie ihr eigenes Label House of Diehl.

Après ses études de philosophie à Middletown, Mary Jo Diehl, qui est originaire de New York, débute sa carrière d'artiste. Sa création insolite, Instant Couture, est nominée pour deux des plus importants prix américains, le Gen Art Styles et le Ecco Domani Fashion Foundation Award. Forte de ces succès, elle fonde alors sa propre marque, House of Diehl.

Después de cursar sus estudios de Filosofía en Middletown, Mary Jo Diehl, nacida y criada en Nueva York, inició su carrera como artista. Su radical proyecto de moda Instant Couture ha sido nominado para dos de los premios americanos más importantes, el Gen Art Styles y el Ecco Domani Fashion Foundation Award. Fortalecida por el éxito, fundó su propia firma House of Diehl.

Dopo gli studi di filosofia a Middletown Mary Jo Diehl, nata e cresciuta a New York, iniziò la sua carriera come artista visuale. Il suo progetto radicale Instant Couture venne nominato per due dei più importanti premi americani, il Gen Art Styles e l' Ecco Domani Fashion Foundation Award. Incoraggiata da questi successi, fondò la sua firma House of Diehl.

2001
Foundation of House of Diehl by Mary Jo Diehl and Roman Milisic, New York, USA
Instant Couture TM event

2002
Couture design collection nominated for Gen Art Styles and Ecco Domani Fashion Foundation Awards

2004
Winner of the Triumph International Fashion Award 2004/2005

Interview | House of Diehl

Which do you consider the most important work of your career? My first couture design: You Want A Piece Of Me? Without experience or training, idealism drove me to create this ultimate convergence of my aesthetic-social philosophy.

In what ways does New York inspire your work? The imagination to have great dreams, the courage to pursue them, is woven into the New York character. New York is my greatest inspiration.

Does a typical New York style exist, and if so, how does it show in your work? Proud of our differences, our style is as eclectic as our people. My work is culturally sensitive couture: designed to adapt to the individual who wears it—empowering personal expression.

How do you imagine New York in the future? A mecca of ideas-people, all jostling for attention; where personal identity and visual language merge, so that each of us becomes our own "brand" in a bid to carve out a niche in the cultural mindspace.

Was halten Sie für die wichtigste Arbeit in Ihrer Karriere? Meine erste Arbeit im Modedesign: You Want A Piece Of Me? Ich hatte weder Erfahrung noch Übung. Allein mein Idealismus hat mich dazu gebracht, diesen grundlegenden Ansatz meiner sozialästhetischen Weltanschauung umzusetzen.

Auf welche Weise inspiriert New York Ihre Arbeit? Große Träume zu haben und den Mut, sie zu verwirklichen: All dies ist fest im Charakter dieser Stadt verankert. New York ist meine größte Inspiration.

Gibt es einen typischen New Yorker Stil, und wenn ja, wie zeigt sich das in Ihrer Arbeit? Wir sind stolz auf unsere Verschiedenheit und unser Stil ist so eklektisch wie unsere Menschen. Meine Mode berücksichtigt kulturelle Elemente: Ihr Design ist auf das Individuum zugeschnitten, das sie trägt – und das ihr dabei die ganz persönliche Note verleiht.

Wie stellen Sie sich New York in der Zukunft vor? Ein Mekka der kreativen Menschen, die alle um Aufmerksamkeit buhlen. Ein Ort, an dem persönliche Identität und visuelle Sprache verschmelzen. In diesem Kampf um eine kulturelle Nische findet jeder Einzelne seinen ganz individuellen Stil.

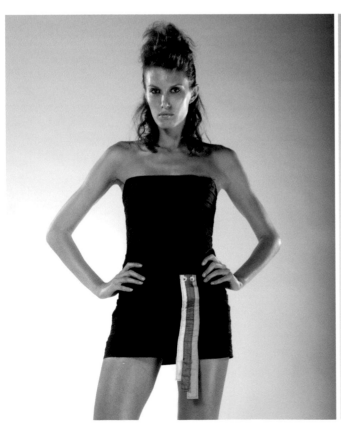
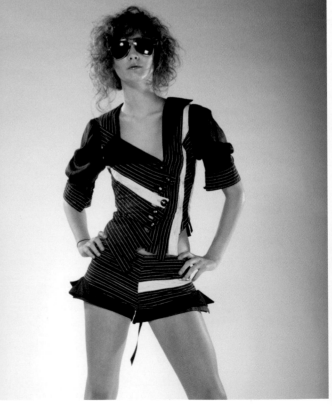

Quelle est l'œuvre la plus importante de votre carrière ? Mon premier design de couture : You Want A Piece Of Me? Dépourvue d'expérience ou de formation, l'idéalisme m'a poussée à créer cette dernière œuvre, aboutissement de ma philosophie esthétique et sociale.

Dans quelle mesure la ville de New York inspire-t-elle votre œuvre ? Le désir d'avoir de grands rêves et le courage de les réaliser sont tissés dans la trame urbaine de New York, qui est ma plus grande source d'inspiration.

Peut-on parler d'un style typiquement new-yorkais, et si oui, comment se manifeste-t-il dans votre œuvre ? Fiers de nos différences, notre style est aussi éclectique que les gens eux-mêmes. Mon oeuvre est une couture sensible à la culture: conçue pour s'adapter à l'individu qui la porte- exaltant l'expression personnelle.

Comment imaginez-vous le New York de demain ? Une Mecque de gens plein d'idées, tous désireux d'être remarqués, d'où émerge une identité et un langage pour que chacun de nous puisse avoir sa propre « marque », en quête de créer une niche dans l'espace culturel.

¿Cuál es el trabajo que considera más importante en su carrera? Mi primer diseño de alta costura: You Want A Piece Of Me? (¿Quieres un pedazo de mí?) Sin experiencia ni formación, el idealismo me llevó a crear esta suprema convergencia de mi filosofía estética-social.

¿De qué manera Nueva York supone una inspiración en su trabajo? La imaginación para tener grandes sueños y el valor para perseguirlos se entretejen en el carácter de Nueva York. Nueva York es mi mayor inspiración.

¿Existe un estilo típico neoyorquino y, si es así, cómo se revela en su obra? Orgulloso de nuestras diferencias, nuestro estilo es tan ecléctico como nuestra gente. Mi trabajo es alta costura con sensibilidad cultural: diseñada para adaptarse a la persona que la lleva, confiriendo una expresión personal.

¿Cómo se imagina Nueva York en el futuro? Una meca de ideas-gente, donde todos reclaman atención; donde la identidad personal y el lenguaje visual confluyen, de forma que cada uno de nosotros se convierte en nuestra "marca" en un intento de hacerse un hueco en el pensamiento cultural.

Cosa pensa che sia la cosa più importante della Sua carriera? Il mio primo disegno di moda: You Want A Piece Of Me? (vuoi una parte di me?) Senza esperienza o training: il mio idealismo mi a portato a creare quest'ultima convergenza della mia filosofia estetico-sociale.

In che modo New York influenza il Suo lavoro? L'idea di avere grandi sogni, e il coraggio di inseguirli sono ancorati nel carattere di New York. New York è la mia grande ispirazione.

Esiste uno stile tipico a New York? Se sì, come influenza il Suo lavoro? Siamo fieri delle nostre differenze; il nostro stile è tanto eclittico quanto lo è la nostra popolazione. Il mio lavoro si basa su una alta sartoria culturalmente sensibile: disegnata per adattarsi agli individui che la indossano: imponendo un'espressione personale.

Come si immagina New York in futuro? Una Mecca di persone e di idee, tutte alla ricerca di attenzione, dove l'identità personale e il linguaggio visivo si fondono, in modo tale che ognuno di noi ottenga la sua "marca", in una scommessa per trovare una nicchia nello spazio culturale comune.

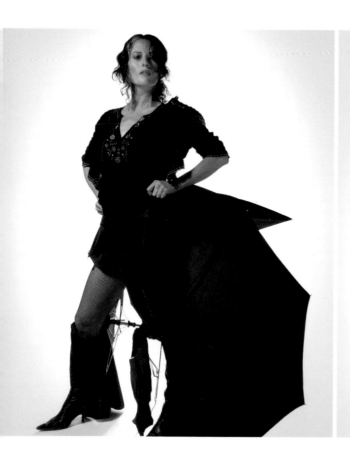
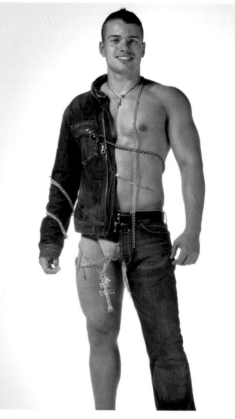

Instant Couture

Year: 2001–2006
Photographs: © House of Diehl, Perou

With their futuristic creations, the designers of House of Diehl create the unusual balancing act between art and fashion. Their approach is based on the idea that in today's visually-shaped culture, fashion is a form of self expression, which works beyond cultural borders. With her collections, Mary Jo Diehl creates designs which are expressly directed at real individuals and not at an idealized and abstract idea of people.

Die Designer von House of Diehl schaffen mit ihren futuristischen Entwürfen den ungewöhnlichen Spagat zwischen Kunst und Mode. Ihr Ansatz beruht auf der Idee, dass in der heutigen, visuell geprägten Kultur Mode eine Form des Selbstausdrucks ist, der über Kulturgrenzen hinweg wirkt. Mit ihren Kollektionen erschafft Mary Jo Diehl Designs, die ausdrücklich an realen Individuen ausgerichtet sind und nicht an einem idealisierten und abstrakten Menschenbild.

Les designers de House of Diehl réussissent avec leurs créations futuristes l'extraordinaire prouesse de réunir l'art et la mode. Leur démarche repose sur l'idée, que dans la société actuelle, l'expression culturelle de la mode, extrêmement visuelle, est une forme d'expression individuelle agissant au-delà des frontières. Dans ses collections, les designs de Mary Jo Diehl, s'adressent essentiellement à des individus réels, et non à une image idéalisée et abstraite de la personne.

A partir de sus proyectos futuristas, los diseñadores de House of Diehl consiguen un resultado poco común a caballo entre el arte y la moda. Su enfoque se basa en la idea de que en la cultura de hoy en día, característicamente visual, la moda es una forma de autoexpresión que actúa más allá de las fronteras culturales. Con sus colecciones, Mary Jo Diehl crea diseños dirigidos expresamente a individuos reales y no a una imagen idealizada y abstracta.

Gli stilisti di House of Diehl riescono con i loro progetti futuristici a costruire un insolito ponte tra arte e moda. Il loro concetto si basa sull'accezione che nell'odierna cultura, profondamente visiva, la moda è una forma di espressione dell'individuo che agisce oltre le frontiere culturali. Con le sue collezioni, Mary Jo Diehl crea disegni che si rivolgono esplicitamente a individui reali e non a un' immagine idealizzata e astratta dell'umanità.

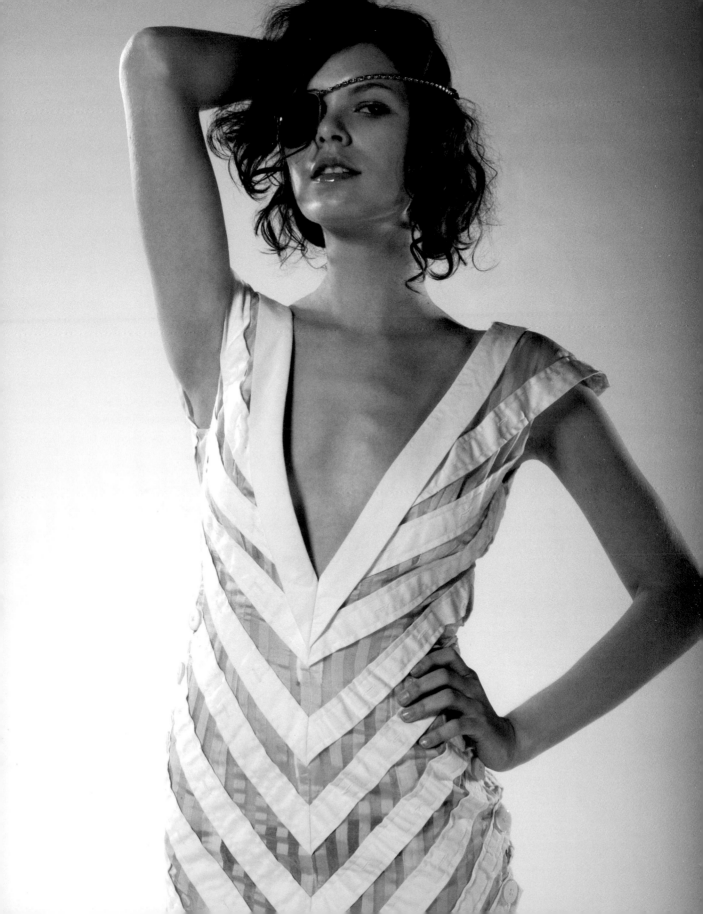

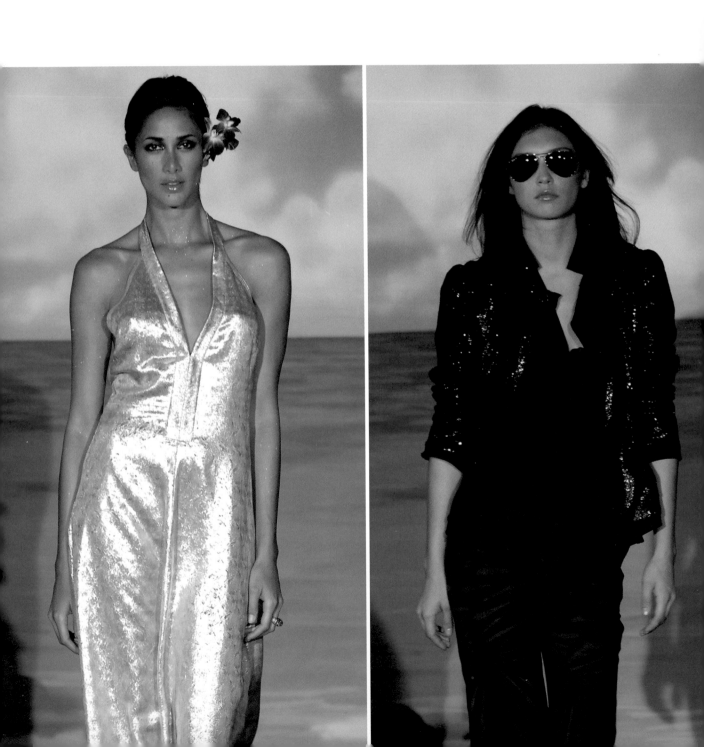

Palmer Jones

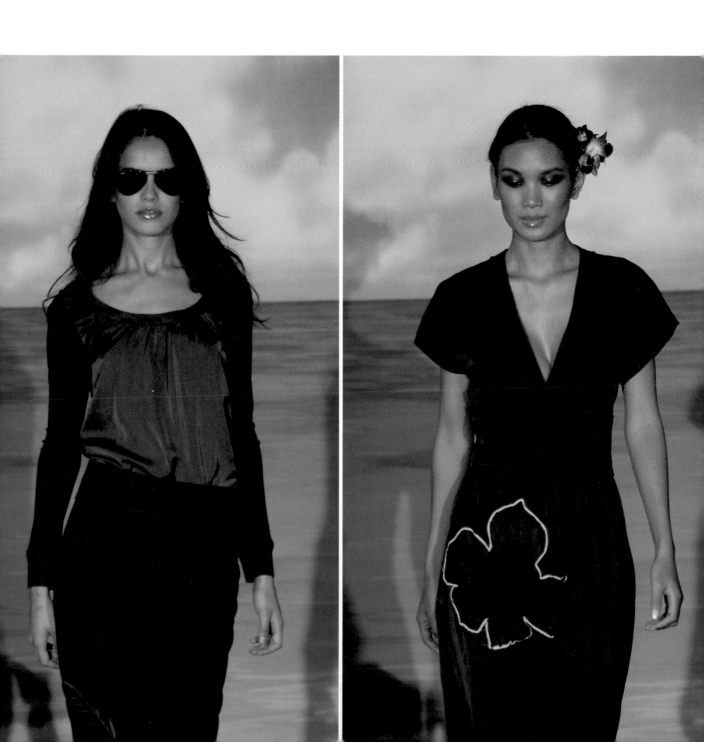

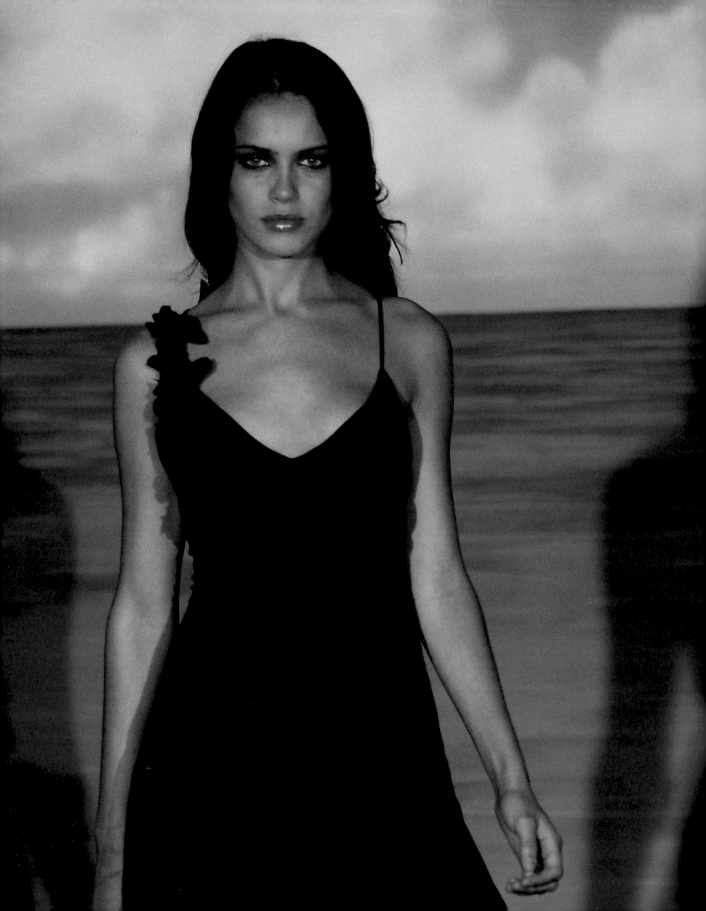

Palmer Jones

39 Wooster Street, 2nd Floor, New York, NY 10013, USA

+1 212 226 5321

+1 212 226 5325

www.palmer-jones.com

design@palmer-jones.com

Kathryn and Lindy Jones

1964
Kathryn and Lindy Jones born in Wales, UK
1986
Graduation Fashion School Kingston, London, UK

2000
Foundation of Palmer Jones, New York, USA

2003
Ecco Domani Fashion Foundation Award

2005
Fashion Group International Rising Star Award

The twin sisters Kathryn and Lindy Jones both studied fashion design at London's Kingston School. Afterwards they first went on separate paths and worked for 17 years in New York for fashion houses such as Ralph Lauren and Andrea Jovine. In the year 2000, they created their own label in order to design exquisite, feminine and dreamy designs. For their creations, they were honored with the Ecco Domani Fashion Foundation Award.

Die Zwillingsschwestern Kathryn und Lindy Jones studierten beide Modedesign an der Londoner Kingston School. Danach gingen sie erst einmal getrennte Wege und arbeiteten 17 Jahre lang in New York für Modehäuser wie Ralph Lauren und Andrea Jovine. 2000 gründeten sie ihr eigenes Label, um exquisite, feminine und verträumte Designs zu entwerfen. Für ihre Kreationen wurden sie mit dem Ecco Domani Fashion Foundation Award geehrt.

Les jumelles Kathryn und Lindy Jones font toutes les deux des études de stylistes à la Londoner Kingston School. Ensuite, leurs chemins se séparent et elles travaillent 17 ans à New York pour des maisons de couture, comme Ralph Lauren et Andrea Jovine. En 2000, elles créent leur propre marque, pour créer des designs de rêve, superbement féminins. Leurs créations sont récompensées par le Ecco Domani Fashion Foundation Award.

Las gemelas Kathryn y Lindy Jones estudiaron diseño de moda en la londinense Kingston School. Después sus caminos se separaron y trabajaron durante 17 años en Nueva York para casas de moda como Ralph Lauren y Andrea Jovine. En el año 2000 se juntaron y fundaron su primera marca para diseñar exquisitos modelos femeninos y románticos. Fueron galardonadas por sus creaciones con el Ecco Domani Fashion Foundation Award.

Le sorelle gemelle Kathryn e Lindy Jones studiarono entrambe stilismo di moda presso la Kingston School di Londra. Dopo lo studio ognuna prese la propria strada, lavorando per 17 anni a New York per le case di alta moda come Ralph Lauren e Andrea Jovine. Nel 2000 fondarono la loro firma, con lo scopo di disegnare uno stile squisito, femmineo e sognante. Per le loro creazioni hanno ricevuto il Ecco Domani Fashion Foundation Award.

Interview | Palmer Jones

Which do you consider the most important work of your career? The last collection for fall 2006 "Cinderella Labyrinth" by far. As we evolve as designers the integrity of our vision gets stronger and the clothes become more beautiful.

In what ways does New York inspire your work? New York is magical to us because of its contrasts. It is upbeat and endlessly positive, and infuses us with a sense of openness and power. You can walk out your door knowing anything can happen.

Does a typical NY style exist, and if so, how does it show in your work? New York is a melting pot as such there is no typical New York style. New York's upbeat sophistication permeates our collection, not a specific look.

How do you imagine New York in the future? It's fab the way it is. We feel New York is the best city in the world. As it gets older it will continue to diversify and be an inspirational city on so many levels. Perhaps maps of the world will be redrawn and all roads will lead to New York.

Was halten Sie für die wichtigste Arbeit in Ihrer Karriere? Mit Abstand die letzte Kollektion, für den Herbst 2006: „Cinderella Labyrinth". Je weiter wir uns als Designer entwickeln, desto ausgeprägter ist die Integrität unserer Visionen und die Kleider werden immer schöner.

Auf welche Weise inspiriert New York Ihre Arbeit? New York wirkt aufgrund seiner Unterschiede so magisch auf uns. Es hat etwas Zuversichtliches und unendlich Optimistisches und durchdringt uns mit einem Gefühl von Offenheit und Kraft. Wenn du aus dem Haus gehst, weißt du: Alles kann passieren.

Gibt es einen typischen New Yorker Stil, und wenn ja, wie zeigt sich das in Ihrer Arbeit? New York ist ein Schmelztiegel, da kann es per Definition keinen typischen New Yorker Stil geben. New Yorks positive Eleganz durchdringt unsere Kollektion, nicht etwa ein spezifischer Look.

Wie stellen Sie sich New York in der Zukunft vor? Es ist fantastisch genau so wie es ist. Wir haben das Gefühl, dass New York die beste Stadt der Welt ist. Je älter sie wird, desto größer werden ihre Vielfalt und Inspirationsquellen sein. Vielleicht werden die Weltkarten dann neu gezeichnet und alle Straßen führen nach New York.

Quelle est l'œuvre la plus importante de votre carrière ? C'est de loin « Cinderella Labyrinth », la dernière collection de l'automne 2006. Au fil de l'évolution de notre design, notre vision s'épure et les habits s'embellissent.

Dans quelle mesure la ville de New York inspire-t-elle votre œuvre ? A notre avis, la magie de New York réside dans ses contrastes. C'est une ville extrêmement positive qui dégage une sensation d'ouverture et de puissance. Dés que vous ouvrez la porte, vous savez que tout est possible.

Peut-on parler d'un style typiquement new-yorkais, et si oui, comment se manifeste-t-il dans votre œuvre ? New York est un véritable creuset culturel et pour cela on ne peut dire qu'il y a un style typiquement new-yorkais. L'élégance exaltée de New York imprègne notre collection, sans pour autant créer un look particulier.

Comment imaginez-vous le New York de demain ? Cette ville est fabuleuse telle qu'elle est. Pour nous, c'est la plus belle ville du monde. En vieillissant, elle va se diversifier encore plus et sera source d'inspiration sur divers plans. Peut-être que l'on redessinera les cartes du monde et alors toutes les routes mèneront à New York.

¿Cuál es el trabajo que considera más importante en su carrera? Hasta ahora, la última colección de otoño 2006 "Cinderella Labyrinth". A medida que evolucionamos como diseñadores, la integridad de nuestra visión se fortalece y la ropa es cada vez más bella.

¿De qué manera Nueva York supone una inspiración en su trabajo? Nueva York nos parece mágica por sus contrastes. Es optimista y constantemente positiva y nos infunde una sensación de apertura y poder. Puedes salir de casa sabiendo que puede pasar cualquier cosa.

¿Existe un estilo típico neoyorquino y, si es así, cómo se revela en su obra? Nueva York es un crisol y, como tal, no hay un estilo típico neoyorquino. La dinámica sofisticación de Nueva York impregna nuestra colección, no un look específico.

¿Cómo se imagina Nueva York en el futuro? Es fantástica tal y como es. Sentimos que Nueva York es la mejor ciudad del mundo. A medida que envejezca continuará diversificándose y siendo una ciudad de inspiración en tantos niveles. Quizá los mapas universales se volverán a trazar y todos los caminos conducirán a Nueva York.

Cosa pensa che sia la cosa più importante della Sua carriera? Certamente e di gran lunga l'ultima collezione autunnale 2006 "Cinderella Labyrinth". Continuando ad evolvere come designer, l'integrità della nostra visione accresce e i vestiti diventano sempre più belli.

In che modo New York influenza il Suo lavoro? Per noi New York è magica grazie ai suoi contrasti. La città è sempre all'avanguardia e infinitamente positiva, con un senso di apertura e di potere. Uscendo di casa si sa che potrebbe succedere di tutto.

Esiste uno stile tipico a New York? Se sì, come influenza il Suo lavoro? New York è un crogiolo di culture e come tale non esiste uno stile tipico newyorchese. La sofisticatezza all'avanguardia di New York lascia spazio alla nostra collezione, senza un look specifico.

Come si immagina New York in futuro? È fantastica come è adesso. Pensiamo che New York sia la migliore città al mondo. Col passare del tempo continuerà a differenziarsi e ad essere una città di ispirazione sotto molti punti di vista. Forse le carte topografiche del mondo saranno ridisegnate e tutte le strade porteranno a New York.

Cinderella Night & Day

Year: Spring 2006
Photographs: © Don Ashby

The contrast between the bright and sunny light play of a summer day and the dark shade of a clear summer night inspired Kathryn and Lindy Jones in this spring collection, in which metallic, glittering gold tones are combined with dark blue tones. Embroidered and narrowly cut suits from gossamer and light materials emphasize the summery and feminine character of the collection.

Der Kontrast zwischen dem hellen und sonnigen Lichtspiel eines Sommertages und den dunklen Schatten einer klaren Sommernacht inspirierte Kathryn und Lindy Jones zu dieser Frühjahrskollektion, bei der metallisch glitzernde Goldfarben mit dunkelblauen Tönen kombiniert werden. Bestickte und schmal geschnittene Anzüge aus hauchdünnen und leichten Materialien unterstreichen dabei den sommerlichen und femininen Charakter der Kollektion.

Pour leur collection de printemps, Kathryn et Lindy Jones s'inspirent du contraste entre les différents jeux de lumière d'un jour d'été et les ombres foncées d'une claire nuit d'été, en mariant des ors métalliques et scintillants à des tons bleu foncé. Costumes étroits et brodés en matières fines et légères exaltent le caractère estival et féminin de la collection.

El contraste que se crea en verano entre el juego de luces luminoso y soleado del día y las sombras oscuras de la noche serena inspiraron a Kathryn y Lindy Jones para esta colección de primavera, en la que se combinan los dorados centelleantes y metálicos con los tonos azul oscuro. Trajes bordados y de corte esbelto, de materiales sutiles y ligeros resaltan el carácter veraniego y femenino de la colección.

Il contrasto tra il gioco di luce brillante e solare del giorno e le ombre della chiara notte estiva ispirò Kathryn e Lindy Jones verso questa collezione primaverile, in cui si combinano colori d'oro metallici e scintillanti con tonalità blu scuro. Completi ricamati e tagliati stretti, confezionati in materiali sottilissimi e leggeri, sottolineano il carattere estivo e femmineo della collezione.

Binetti

501 Fifth Avenue, Suite 2001, New York, NY 10017, USA

+1 212 682 0419

+1 212 682 0419

www.ilovebinetti.com

binetti@playful.com

Diego Binetti

Diego Binetti was born to Italian immigrants in Buenos Aires. After completing his studies at the Fine Arts College in Miami, he went to Milan to continue his training. His next stop was New York. Here he worked as a stylist and fashion designer for Jill Stuart. At the same time, Diego Binetti began to work on his own collection and opened his studio in 2001 with the presentation of the 2002 spring collection.

Diego Binetti wurde als Kind italienischer Einwanderer in Buenos Aires geboren. Nach seiner Ausbildung am International Fine Arts College in Miami ging er nach Mailand, um dort seine Ausbildung fortzusetzen. Seine nächste Station war New York. Hier arbeitete er als Stylist und Modedesigner für Jill Stuart. Parallel begann Diego Binetti an seiner eigenen Kollektion zu arbeiten und eröffnete 2001 sein Studio mit der Präsentation der Frühjahrskollektion 2002.

Diego Binetti, enfant d'émigré italien, est né à Buenos Aires. Après une formation au International Fine Arts College de Miami il se rend à Milan, pour y peaufiner sa formation. Il se rend ensuite à New York où il travaille en tant que styliste et designer de mode pour Jill Stuart. En parallèle, Diego Binetti commence à travailler sur sa propre collection et crée son propre atelier en 2001 avec la présentation de sa collection printemps 2002.

Diego Binetti nació en Buenos Aires y es hijo de emigrantes italianos. Después de finalizar sus estudios en el International Fine Arts College de Miami se trasladó a Milán para proseguir allí con su formación. Su siguiente estación fue Nueva York, donde trabajó como estilista y diseñador de moda para Jill Stuart. Al mismo tiempo empezó a trabajar en su propia colección y en el año 2001 inauguró su estudio con la presentación de la colección de primavera 2002.

Diego Binetti nacque come figlio di immigranti italiani a Buenos Aires. Dopo la formazione presso l'International Fine Arts College di Miami si trasferì a Milano per proseguire il suo apprendistato. La sua prossima stazione fu New York, dove lavorò come stilista e designer di moda per Jill Stuart. Contemporaneamente, Diego Binetti iniziò a lavorare per la sua propria collezione. Nel 2001 aprì il suo studio con la presentazione della collezione primaverile 2002.

1971
Diego Binetti born in Buenos Aires, Argentina

1995
Graduation from the International Fine Arts College, Miami, Florida, USA

1997
Studies at the Istituto Marangoni dell'Abbigliamento, Milan, Italy

1996–2000
Fashion stylist for Antonio Bordonaro, Isabel Dupré, Beth Blake, Cathy Kasterine, Brana Wolf

1997–2001
Head designer for Jill Stuart, New York, USA

2001
Foundation of Binetti Design Studio

Which do you consider the most important work of your career? Every season I develop my collection and to me, the most recent one is the most important. With every collection I understand my consumer better and that in turn makes a better collection.

In what ways does New York inspire your work? Having lived here for over 10 years, the rhythm of the city is part of me. The tourists, the immigrants, the natives each bring something important to the city. NY is the melting pot of the world and all of the cultures here greatly influence it.

Does a typical New York style exist, and if so, how does it show in your work? Yes, the NY woman is a practical woman. She wears easy to wear clothing, comfortable and practical.

How do you imagine New York in the future? NY has a lot of visionaries. As we know, NY fashion week is one of the most important times in fashion and NY will continue to lead the world in the ready to wear department. NY will forecast trends, styles and attitudes.

Was halten Sie für die wichtigste Arbeit in Ihrer Karriere? Viermal im Jahr bringe ich eine neue Kollektion heraus und für mich persönlich ist immer die aktuellste die wichtigste. Mit jeder Kollektion verstehe ich meine Kunden besser und das wirkt sich wiederum positiv auf die neue Kollektion aus.

Auf welche Weise inspiriert New York Ihre Arbeit? Seit 10 Jahren lebe ich nun hier und der Rhythmus der Stadt ist Teil von mir geworden. Touristen, Immigranten, Einheimische, alle bereichern die Stadt. New York ist der Schmelztiegel der Welt und alle hier vertretenen Kulturen beeinflussen das auf großartige Weise.

Gibt es einen typischen New Yorker Stil, und wenn ja, wie zeigt sich das in Ihrer Arbeit? Ja, die New Yorker Frau ist eine sehr praktische Frau. Sie trägt Kleidung, die einfach zu tragen, bequem und praktisch ist.

Wie stellen Sie sich New York in der Zukunft vor? In New York gibt es viele Visionäre. Bekanntlich ist die New York Fashion Week ein Höhepunkt in der Modewelt und New York wird weiterhin weltweiter Marktführer im Bereich des Prêt-à-Porter sein. New York wird Trends, Stile und Moden voraussagen.

Quelle est l'œuvre la plus importante de votre carrière ? Je réalise à chaque saison une nouvelle collection et pour moi, la dernière est toujours la plus importante. A chacune d'elle, je comprends mieux le consommateur, et c'est ce qui l'améliore.

Dans quelle mesure la ville de New York inspire-t-elle votre œuvre ? Ayant vécu plus de dix ans ici, le rythme de la ville est ancré dans moi. Touristes, immigrants et autochtone, chacun apporte une note essentielle à la ville. NY est le creuset du monde, absorbant l'influence de toutes les cultures qui s'y trouvent.

Peut-on parler d'un style typiquement new-yorkais, et si oui, comment se manifeste-t-il dans votre œuvre ? Oui, la new-yorkaise est une femme pratique. Elle met des vêtements faciles à porter, confortables et pratiques.

Comment imaginez-vous le New York de Demain ? New York est rempli de visionnaires. Tout le monde le sait, la semaine de la mode de New York est l'évènement phare du monde de la mode et elle demeurera le leader dans le secteur du prêt-à-porter. Cette cité déterminera toujours tendances, styles et attitudes.

¿Cuál es el trabajo que considera más importante en su carrera? Cada temporada creo mi colección y para mí, la más reciente es la más importante. Con cada colección entiendo mejor a mis clientes lo que a su vez supondrá una mejor colección.

¿De qué manera Nueva York supone una inspiración en su trabajo? Habiendo vivido aquí más de 10 años, el ritmo de la ciudad forma parte de mi. Los turistas, los inmigrantes, los lugareños aportan algo importante a la ciudad. Nueva York es el crisol del mundo y todas las culturas que se mezclan aquí la influyen enormemente.

¿Existe un estilo típico neoyorquino, y si es así, cómo se revela en su obra? Sí, la mujer neoyorquina es una mujer práctica. Se pone ropa fácil de llevar, cómoda y práctica.

¿Cómo se imagina Nueva York en el futuro? Nueva York tiene muchos visionarios. Como sabemos, la semana de la moda de Nueva York es la cita más importante en el mundo de la moda y Nueva York continuará siendo líder mundial en el mundo de prêt-à-porter. Nueva York pronosticará tendencias, estilos y actitudes.

Cosa pensa che sia la cosa più importante della Sua carriera? Creo le mie collezioni ogni stagione e per me è sempre l'ultima la più importante. Con ogni nuova collezione capisco meglio i miei clienti e questo in cambio fa sì che la mia collezione sia migliore.

In che modo New York influenza il Suo lavoro? Vivo a New York da 10 anni, il ritmo della città è una parte di me. I turisti, gli immigranti, la gente del posto, tutti portano qualcosa alla città. NY è il crogiolo del mondo e tutte le culture qui presenti la influenzano fortemente.

Esiste uno stile tipico a New York? Se sì, come influenza il Suo lavoro? Sì, la donna newyorchese è una donna pratica. Porta abbigliamento facile da portare, comfortevole e pratico.

Come si immagina New York in futuro? NY ha molti visionari. Come sappiamo, la settimana della moda a New York è uno dei momenti più importanti della moda e New York resterà in testa nel settore della moda pronta. NY fornirà i trend, gli stili e le attitudini.

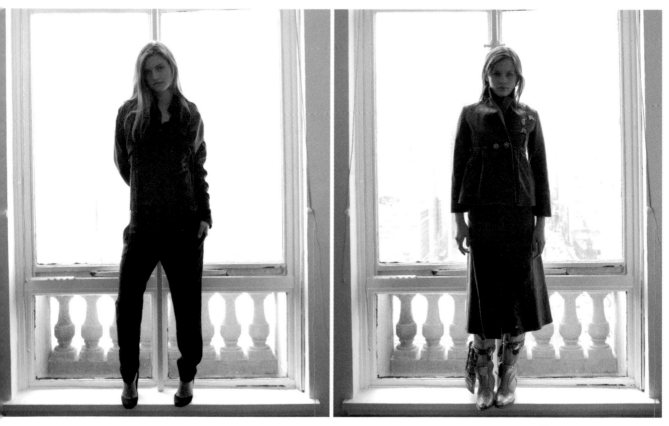

Binetti Tribe

Year: Fall/Winter 2006
Photographs: © Michael Harp, www.harpphotography.com

For his autumn and winter collection, Diego Binetti drew inspiration from the traditional colors and patterns of Indian tribes. Like the mountainous, American landscape colors such as terracotta and dark blue dominate. They are accented with the colors of the Indian feather jewelry, black, emerald-green and red. Details such as beads, feathers and embroideries supplement this elegant and, at the same time, informal interpretation of traditional patterns.

Für seine Herbst- und Winterkollektion ließ sich Diego Binetti von den traditionellen Farben und Mustern der Indianerstämme inspirieren. In Anlehnung an die bergige, amerikanische Landschaft dominieren Farben wie Terrakotta und Dunkelblau, die mit den Farben des indianischen Federschmucks, Schwarz, Smaragdgrün und Rot, akzentuiert werden. Details wie Perlen, Federn und Stickereien ergänzen diese elegante und zugleich zwanglose Interpretation traditioneller Muster.

Pour sa collection d'automne et d'hiver, Diego Binetti s'inspire des couleurs et motifs traditionnels des tribus indiennes. A l'image du paysage américain montagneux, les tons dominants se déclinent en terra cotte et bleu foncé, accentués par le nuancier de couleurs des plumes indiennes, noir, vert émeraude et rouge. Cette interprétation spontanée de motifs traditionnels se pare de ravissants détails, à l'instar de perles, plumes et broderies.

Para su colección de otoño-invierno, Diego Binetti se ha inspirado en colores y modelos tradicionales de las tribus indias. Siguiendo el paisaje montañoso americano, dominan colores como el terracota y el azul oscuro que acentúan los colores de los plumajes indios, negro, verde esmeralda y rojo. Perlas, plumas y bordados son los complementos de esta elegante a la par que desenvuelta interpretación de los modelos tradicionales.

Per la sua collezione autunno-inverno Diego Binetti si è ispirato ai colori e i disegni tradizionali delle tribù indiane, accostandosi al paesaggio montano americano. Dominano i colori come terracotta e blu scuro, con accenti del colore degli ornamenti di piume indiani, quali il nero, il verde smeraldo e il rosso. Dettagli come perle, piume e ricami completano questa interpretazione elegante e giocosa dei disegni

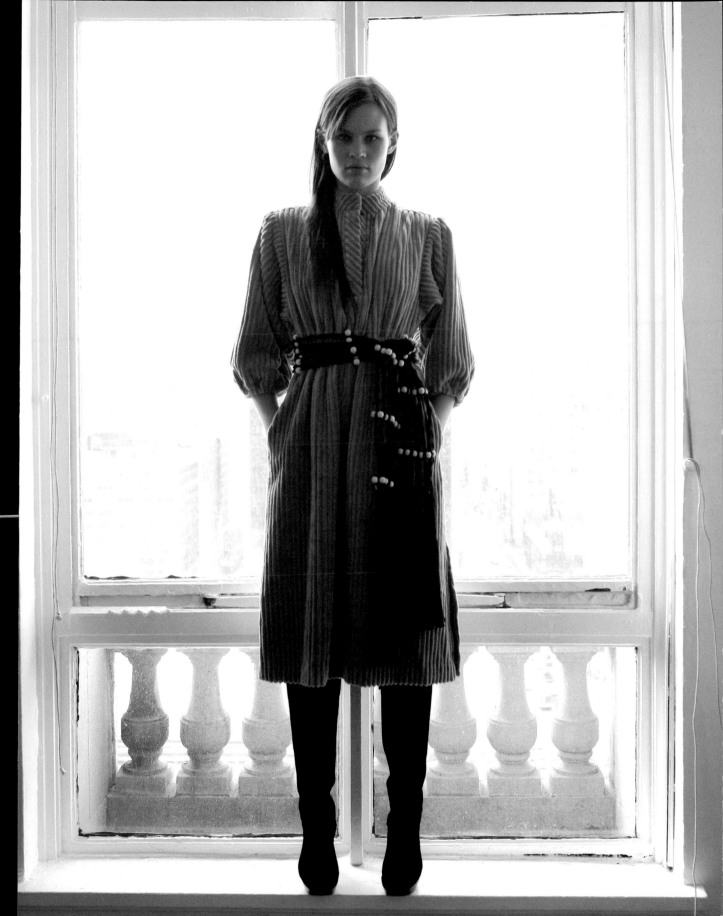

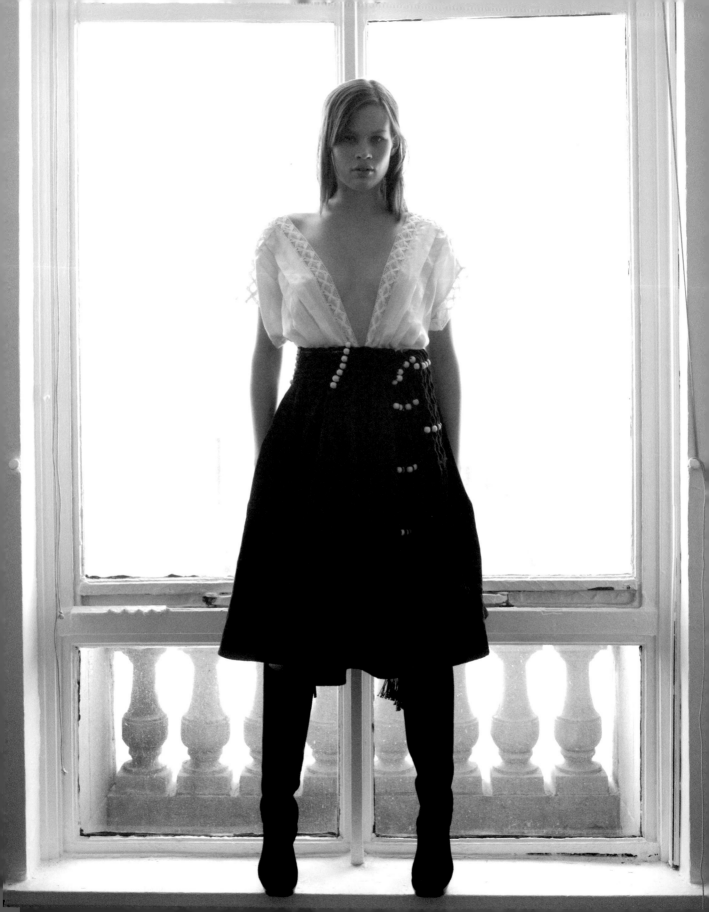

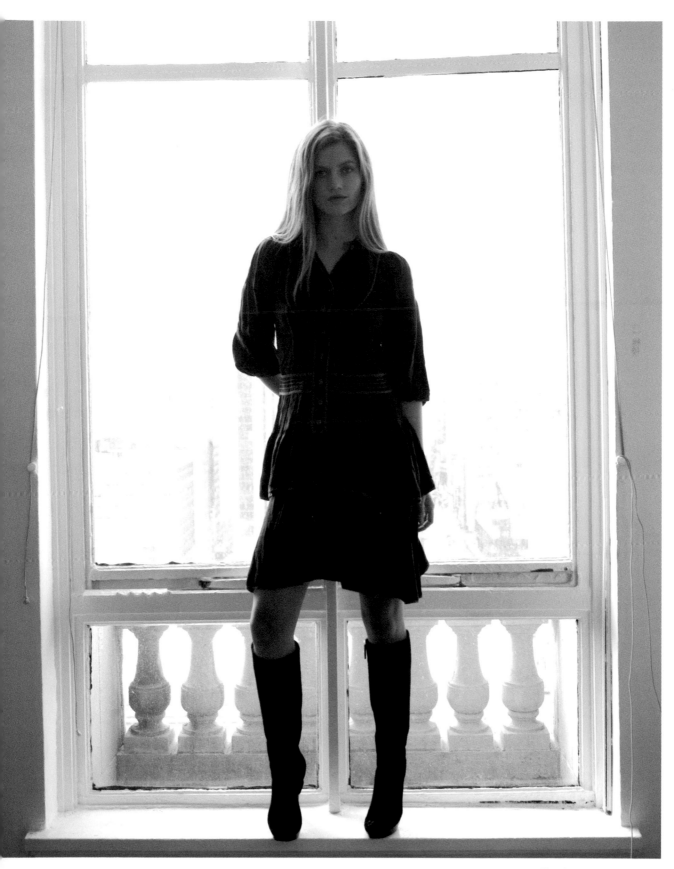

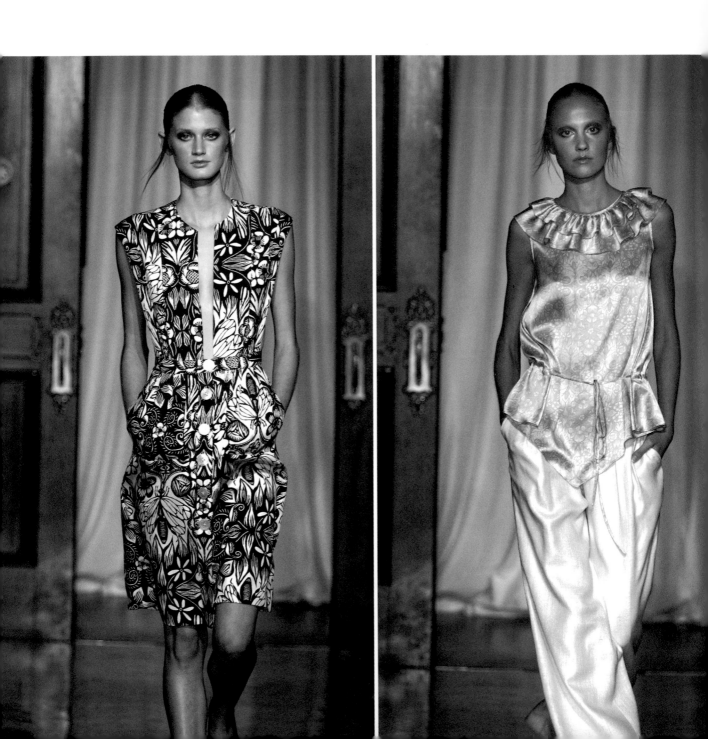

Ruffian

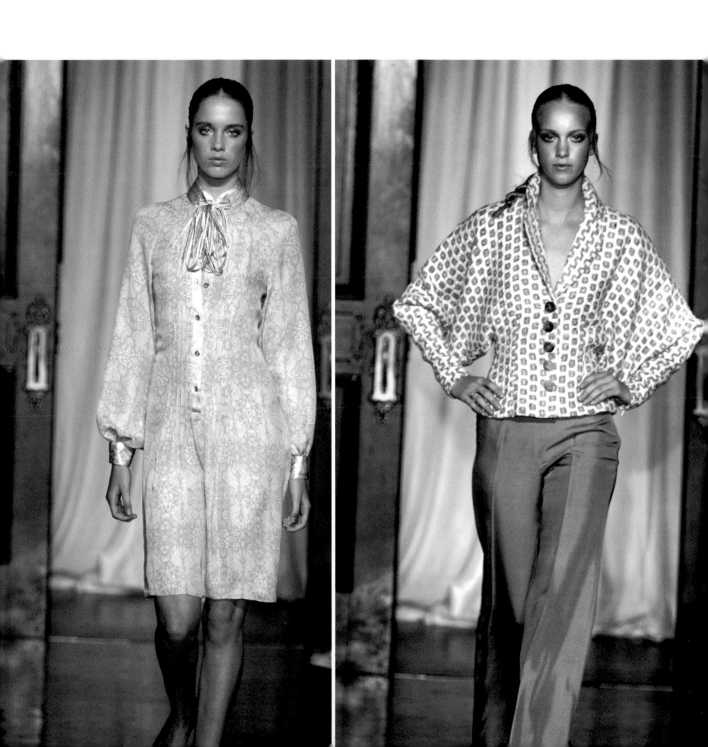

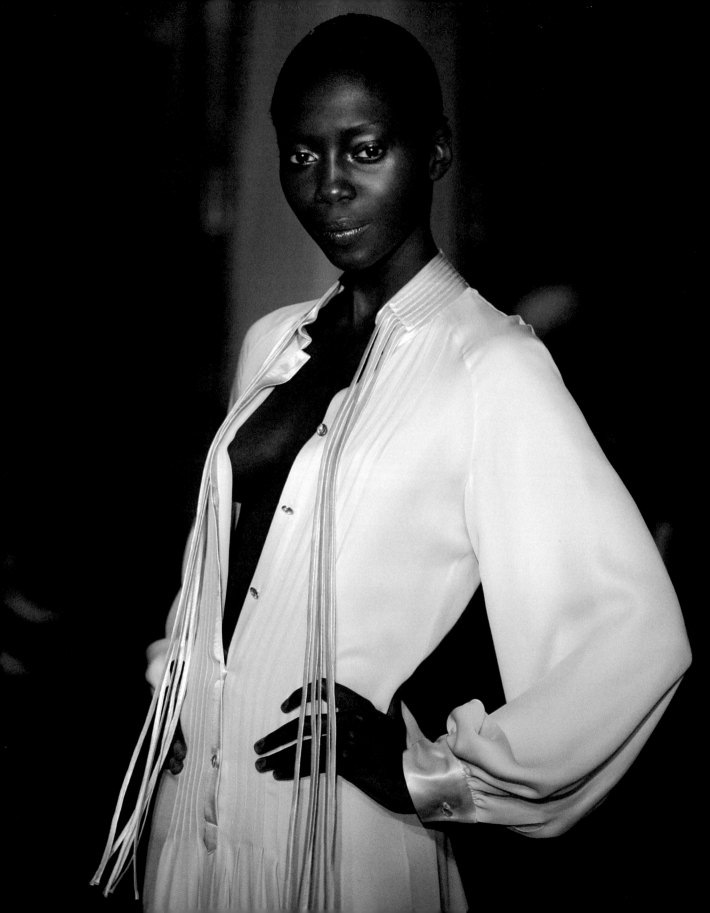

Ruffian

300 West 38th Street, 16th Floor, New York, NY 10018, USA

+1 212 279 4022

+1 212 279 4023

www.ruffian.com

mail@ruffian.com

Brian Wolk and Claude Morais, creative director and designer of the label Ruffian, share not only their common interest in fashion, but also the idea of understanding style as a mixture of the intensive analysis process and improvization. Before Brian Wolk designed for Ruffian, he worked as costume designer for the theater and opera. Claude Morais previously worked as a model stylist and designer.

Brian Wolk und Claude Morais, Kreativdirektor und Designer des Labels Ruffian, verbindet nicht nur ihr gemeinsames Interesse für Mode, sondern auch die Idee, Stil als eine Mischung aus intensivem Analyseprozess und Improvisation zu verstehen. Bevor Brian Wolk für Ruffian entwarf, arbeitete er als Kostümbildner für Theater und Oper. Claude Morais arbeitete zuvor als Model-Stylist und Designer.

Brian Wolk et Claude Morais, directeur de création et designer de la marque Ruffian, partagent le même intérêt pour la mode, et l'idée de comprendre le style comme un mélange d'intense analyse et d'improvisation. Avant de créer pour Ruffian, Brian Wolk travaille en tant que créateur de costumes pour le théâtre et l'opéra. Claude Morais travaillait auparavant comme styliste de mode et designer.

Brian Wolk y Claude Morais, director creativo y diseñador de la marca Ruffian, comparten no solo su interés común por la moda, sino también la idea de que el estilo debe entenderse como la mezcla de un proceso intenso de análisis e improvisación. Antes de que Brian Wolk diseñara para Ruffian, trabajó como encargado de vestuario para el teatro y la ópera. Claude Morais trabajó previamente como estilista y diseñador.

Brian Wolk e Claude Morais, il direttore creativo e lo stilista della firma Ruffian, sono uniti non solo dall'interesse comune per la moda, ma anche dall'idea di intendere lo stile come una combinazione tra un processo intenso di analisi e d'improvvisazione. Prima di diventare stilista per Ruffian, Brian Wolk lavorò come costumista per il teatro e l'opera. Claude Morais invece fu model stylist e designer.

Brian Wolk

Study of Fashion Design, Fashion Institute of Technology, New York, USA

Bachelor Degree in Costume Design, Purchase College, Westchester, New York, USA

Claude Morais

Graduation in painting and visual arts at the Ecole des Beaux Arts, Paris, France

2001
Foundation of Ruffian, New York, USA

Which do you consider the most important work of your career? The most important work of our career is making women feel smart, sophisticated, sexy, beautiful and relevant to the time we live in.

In what ways does New York inspire your work? New York clashes the old and the new. Its irreverence and sophistication make for a juxtaposition that forces the city to move forward and re-invent itself. This is evident in its fashion, architecture, and social mobility. Also its multiculturalism makes for an inspiring exchange of ideas and aesthetics.

Does a typical New York style exist, and if so, how does it show in your work? We don't believe anything in New York is typical. Perhaps there are classics, but these are come from longevity.

How do you imagine New York in the future? New York is constantly evolving and it is difficult to predict its future. The phenomena that will remain consistent are its diversity and international mix of people and its ability to amplify and celebrate individual style.

Was halten Sie für die wichtigste Arbeit in Ihrer Karriere? Die wichtigste Arbeit unserer Karriere liegt darin, dass wir es den Frauen ermöglichen, sich smart, raffiniert, sexy, schön und zeitgemäß fühlen zu können.

Auf welche Weise inspiriert New York Ihre Arbeit? In New York treffen alt und neu aufeinander. Das Nebeneinander von Respektlosigkeit und Raffinesse zwingen die Stadt dazu, sich weiter zu entwickeln und immer neu zu definieren. Dies geht eindeutig aus Modewelt, Architektur und sozialer Mobilität hervor. Auch die multikulturelle Wesensart trägt zu einem inspirierenden Austausch an Ideen und Ästethik bei.

Gibt es einen typischen New Yorker Stil, und wenn ja, wie zeigt sich das in Ihrer Arbeit? Wir glauben nicht, dass es irgendwas Typisches an New York gibt. Klassiker gibt es vielleicht, aber die haben ja eine lange Lebensdauer.

Wie stellen Sie sich New York in der Zukunft vor? New York entwickelt sich ständig weiter und es ist schwierig, seine Zukunft vorauszusagen. Es gibt Phänomene, die in dieser Stadt sicher Bestand haben werden, so die Vielfalt und der internationale Mix seiner Menschen sowie die Fähigkeit, individuellen Stil zu verbreiten und zu feiern.

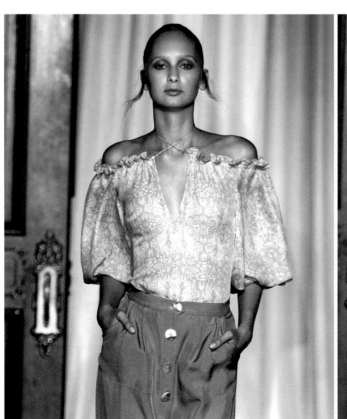 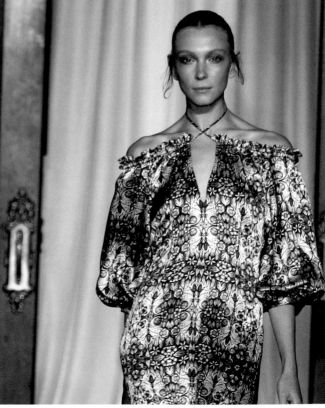

Quelle est l'œuvre la plus importante de votre carrière ? L'œuvre la plus importante de notre carrière est de faire en sorte que la femme se sente élégante, métamorphosée, sexy, belle et en osmose avec l'époque où nous vivons.

Dans quelle mesure la ville de New York inspire-t-elle votre œuvre ? New York confronte l'ancien et le nouveau. Son impertinence et complexité créent une juxtaposition qui force la ville à avancer et à se réinventer. Cela transparaît dans tous ses aspects: mode, architecture et mobilité sociale. Son multiculturalisme engendre des échanges d'idées et d'esthétiques, autant de sources d'inspiration.

Peut-on parler d'un style typiquement new-yorkais, et si oui, comment se manifeste-t-il dans votre œuvre ? Nous pensons qu'à New York, rien n'est typique. Il y a peut-être des classiques, fruits de la longévité.

Comment imaginez-vous le New York de demain ? New York étant en constante évolution, il est difficile de prédire l'avenir. Le phénomène qui perdurera, c'est sa diversité et l'internationalité de ses habitants et enfin sa capacité d'exalter et de célébrer le style individuel.

¿Cuál es el trabajo que considera más importante en su carrera? El trabajo más importante de nuestra carrera es hacer que las mujeres se sientan elegantes, sofisticadas, sensuales, bellas y contemporáneas al momento en que vivimos.

¿De qué manera Nueva York supone una inspiración en su trabajo? Nueva York enfrenta lo antiguo y lo nuevo. Su irreverencia y sofisticación forman una yuxtaposición que impulsa a la ciudad a moverse hacia delante y reinventarse a sí misma. Esto se hace evidente en su moda, arquitectura y movilidad social. Su multiculturalismo también supone un inspirador intercambio de ideas y estética.

¿Existe un estilo típico neoyorquino y, si es así, cómo se revela en su obra? No creemos que nada en Nueva York sea típico. Quizá haya clásicos, pero éstos vienen dados con el tiempo.

¿Cómo se imagina Nueva York en el futuro? Nueva York está en constante evolución y es difícil predecir su futuro. Los fenómenos que permanecerán constantes son su diversidad y la mezcla internacional de gente, así como su capacidad de amplificar y celebrar el estilo individual.

Cosa pensa che sia la cosa più importante della Sua carriera? Il lavoro più importante della nostra carriera è quello di fare sentire le donne scic, raffinate, sexy, belle e appropriate al tempo in cui viviamo.

In che modo New York influenza il Suo lavoro? A New York si scontra il vecchio con il nuovo. La sua irriverenza e la sua raffinatezza favoriscono una giustapposizione che costringe la città a muoversi in avanti e a reinventarsi. Questo è evidente nella sua moda, nell'architettura e nella mobilità sociale. In più, il suo multiculturalismo promuove lo scambio ispiratore di idee ed estetiche.

Esiste uno stile tipico a New York? Se sì, come influenza il Suo lavoro? Noi non crediamo che esiste qualcosa di tipico per New York. Probabilmente ci sono dei classici, ma più per causa di longevità.

Come si immagina New York in futuro? New York evolve continuamente ed è difficile predire il suo futuro. I fenomeni che rimaranno costanti sono la sua diversità e il miscuglio internazionale di gente, e la sua capacità nell'amplificare e celebrare lo stile individuale.

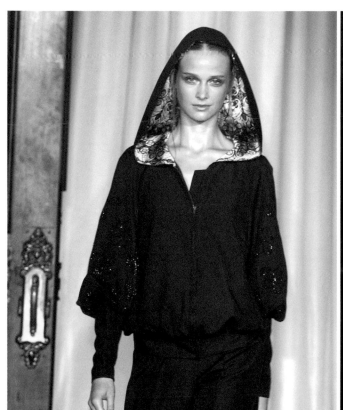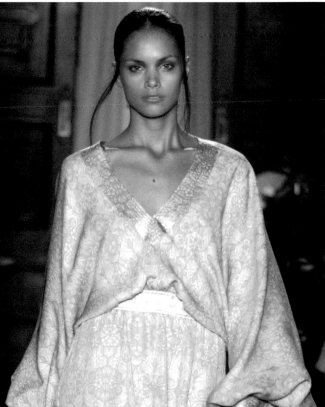

American Romantic

Year: Spring 2006

Photographs: © Ruffian, Margo Silver (portrait)

Ruffian's philosophy draws upon the tradition and materials of Haute Couture and adapts them to the needs of a modern woman. For their spring collection, American Romantic, they were inspired by the American Look as well as the aesthetic of the Swinging Sixties. The goal was to create an American aesthetic, which simultaneously gives life once again to the tradition of European fashion. They present contemporary designs, which are colorful and eccentric.

Ruffians Philosophie greift die Tradition und Materialien der Haute Couture auf und passt sie an die Bedürfnisse einer modernen Frau an. Für ihre Frühlingskollektion American Romantic ließ man sich vom American Look sowie der Ästhetik der Swinging Sixties inspirieren. Ziel war es, eine amerikanische Ästhetik zu schaffen, die gleichzeitig die Tradition europäischer Mode wieder belebt. Dabei stellen sie zeitgenössische Designs vor, die farbenfroh und exzentrisch sind.

La philosophie de Ruffian est de reprendre la tradition et les matières de la Haute Couture en les adaptant aux besoins de la femme moderne. Pour leur collection de printemps, American Romantic, ils se sont inspirés du look américain et de l'esthétique des Swinging Sixties. Le but est de créer une esthétique américaine tout en ravivant la tradition européenne de la mode. Ils offrent une gamme de designs contemporains, emprunts de couleurs gaies et d'excentricité.

La filosofía de Ruffian regresa a la tradición y a los materiales de la alta costura, que adapta a las necesidades de la mujer moderna. Para su colección de primavera American Romantic se han inspirado en el look americano y en la estética de los desinhibidos años sesenta. El objetivo: conseguir una estética americana que reviva al mismo tiempo la tradición de la moda europea. Presentan diseños contemporáneos, excéntricos y de gran colorido.

La filosofia di Ruffian si serve della tradizione e dei materiali della Haute Couture e si adatta alle esigenze della donna moderna. Per la loro collezione primaverile American Romantic si isono ispirati all'estetica degli Swinging Sixties. Mirano alla creazione di un'estetica americana che ravviva contemporaneamente la tradizione della moda europea. Presentano disegni contemporanei coloratissimi ed eccentrici.

Boudicca

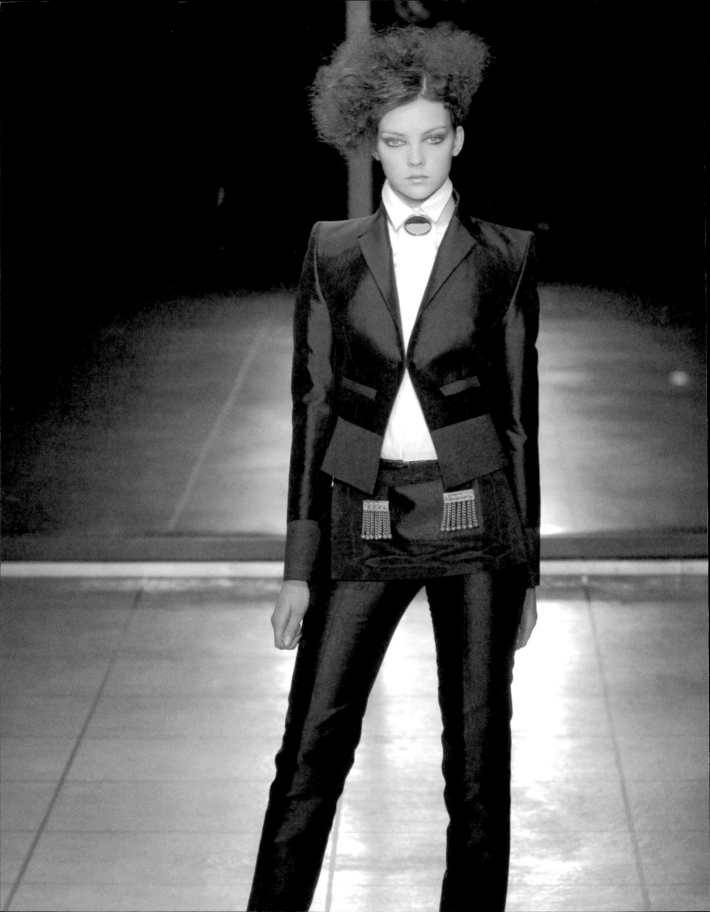

Boudicca

16D Kings Yard, Carpenters Road, Hackney Wick, London E15 2HD

+44 20 8 510 9868

+44 20 8 533 5183

www.platform13.com

boudicca@platform13.com

Life and business partners, Zowie Broach and Brian Kirkby named their label after the British Queen, who led an unsuccessful rebellion during the Roman occupation of Great Britain. This name choice does not surprise since Boudicca is well-known for its radical, avant-garde and at the same time feminine designs. Since 2005, they now also show their collections in Manhattan.

Lebens- und Geschäftspartner Zowie Broach und Brian Kirkby benannten ihr Label nach der britischen Königin, die in den Jahren der römischen Besetzung Britanniens einen erfolglosen Aufstand anführte. Diese Namenswahl erstaunt nicht, sind Boudicca doch für ihre radikalen, avantgardistischen und zugleich femininen Entwürfe bekannt. Seit 2005 präsentieren sie ihre Kollektionen nun auch in Manhattan.

Partenaires dans la vie intime et professionnelle, Zowie Broach et Brian Kirkby ont nommé leur marque d'après la reine d'Angleterre, qui lors de l'occupation de la Bretagne par les romains, tenta un soulèvement avorté. Le choix de ce nom n'est pas étonnant, les Boudicca étant connus pour le côté provocateur, avant-gardiste et à la fois très féminin, de leurs créations. Depuis 2005, ils présentent désormais leur collection à Manhattan.

Compañeros sentimentales y compañeros en los negocios, Zowie Broach y Brian Kirkby le pusieron a su marca el nombre de la reina británica que encabezó la última e infructuosa rebelión en Bretaña durante la época de la ocupación romana. La elección de este nombre no resulta sorprendente, pues Boudicca se ha dado a conocer por sus propuestas radicales, vanguardistas y al mismo tiempo femeninas. Desde 2005 también presentan sus colecciones en Manhattan.

Zowie Broach e Brian Kirkby sono compagni di vita e soci d'impresa. Intitolarono la loro ditta con il nome della regina britannica che durante gli anni dell'invasione romana in Gran Bretagna, fu in testa a una rivolta che non andò a buon fine. Questa scelta di nome non sorprende, tanto che i Boudicca sono famosi per i loro disegni radicali, avanguardistici ma anche femminini. Dal 2005 presentano le loro collezioni ora anche a Manhattan.

Zowie Broach

1966
Born in UK

1989
Graduation at Middlesex University, London, UK

Brian Kirkby

1965
Born in Bury, Manchester, UK

1992
Graduation at Middlesex University, London, UK

1995
Master at London's Royal College of Art, London, UK

1997
Foundation of Boudicca, London, UK

2005
Launch of the Fall/Winter collection 2005 at the New York Fashion Week, New York, USA

Which do you consider the most important work of your career? The Alpha and the Omega.

In what ways does New York inspire your work? Marcel Duchamp, Stieglitz, Joseph Cornel, Cindy Sherman, Inka Essenhigh, Charles Ray, and a million cellular references.

Does a typical New York style exist and if so, how does it show in your work? We live in a world where the digital language allows you to be everywhere and your influences are much closer and cerebral. It is not exactly what influences you but more the choice of what you want to influence you.

How do you imagine New York in the future? "Snake, I thought you were dead!!"

Was halten Sie für die wichtigste Arbeit in Ihrer Karriere? The Alpha and the Omega.

Auf welche Weise inspiriert New York Ihre Arbeit? Marcel Duchamp, Stieglitz, Joseph Cornel, Cindy Sherman, Inka Essenhigh, Charles Ray und eine Million weitere Bausteine.

Gibt es einen typischen New Yorker Stil, und wenn ja, wie zeigt sich das in Ihrer Arbeit? Wir leben in einer digitalen Welt, die es einem ermöglicht, überall zu sein. Die direkten Einflüsse liegen viel näher. Es geht nicht darum, was dich beeinflusst, sondern um die Wahl dessen, wovon man sich beeinflussen lassen möchte.

In what ways does New York inspire inspire your work? In etwa wie in Carpenters Film „Die Klapperschlange".

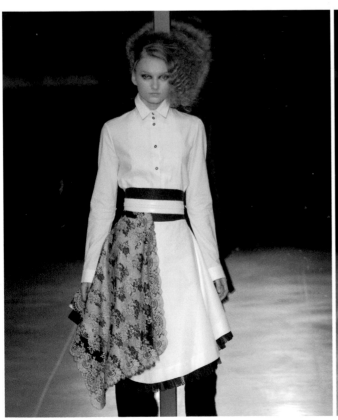
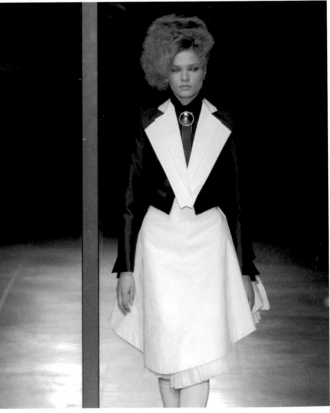

Quelle est l'œuvre la plus importante de votre carrière ? L'Alpha et l'Oméga.

Dans quelle mesure la ville de New York inspire-t-elle votre œuvre ? Marcel Duchamp, Stieglitz, Joseph Cornel, Cindy Sherman, Inka Essenhigh, Charles Ray, et des myriades d'autres minuscules références.

Peut-on parler d'un style typiquement new-yorkais, et si oui, comment se manifeste-t-il dans votre œuvre ? Nous vivons dans un monde où le langage digital vous permet d'être partout et vos influences sont plus rapprochées et davantage cérébrales. Ce qui compote ce n'est pas ce qui vous influence mais votre sélection personnelle de ce qui doit vous influencer ou non.

Comment imaginez-vous le New York de demain ? « Snake, I thought you were dead!! », comme dans le film de Carpenter.

¿Cuál es el trabajo que considera más importante en su carrera? El alfa y el omega.

¿De qué manera Nueva York supone una inspiración en su trabajo? Marcel Duchamp, Stieglitz, Joseph Cornel, Cindy Sherman, Inka Essenhigh, Charles Ray, y un millón de referencias celulares.

¿Existe un estilo típico neoyorquino y, si es así, cómo se revela en su obra? Vivimos en un mundo donde el lenguaje digital te permite estar en cualquier parte y tus influencias son mucho más cercanas y cerebrales. No es exactamente lo que te influye sino más bien la elección de lo que quieres que te influya.

¿Cómo se imagina Nueva York en el futuro? "Snake, I thought you were dead!!", como en la película de Carpenter.

Cosa pensa che sia la cosa più importante della Sua carriera? L'Alpha e l'Omega.

In che modo New York influenza il Suo lavoro? Marcel Duchamp, Stieglitz, Joseph Cornel, Cindy Sherman, Inka Essenhigh, Charles Ray, e un'infintà di riferimenti cellulari.

Esiste uno stile tipico a New York? Se sì, come influenza il Suo lavoro? Viviamo in un mondo in cui il linguaggio digitale ci permette di essere ovunque e l' influenza è molto più ravvicinata e cerebrale. La questione non è esattamente che cosa ti influenza, ma che cosa scegli per lasciarti influenzare.

Come si immagina New York in futuro? "Snake, I thought you were dead!!", come nella pellicola del Carpenter.

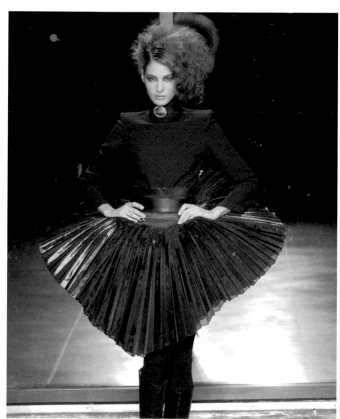
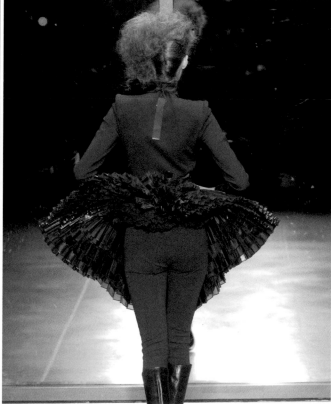

An Invisible City

Year: Autumn/Winter 2006
Photographs: © Chris Moore

For their radical and at the same time feminine designs, the well-known designer duo Boudicca decided upon the high-contrast combination of black and white for their autumn and winter collection, An Invisible City. This minimalistic color choice is stylized by the lively forms, whose lines were worked out using computerized precision. This gives the collection a futuristic and dramatic look.

Das für seine radikalen und zugleich femininen Entwürfe bekannte Designerduo Boudicca entschloss sich bei seiner Herbst- und Winterkollektion An Invisible City für die kontrastreiche Kombination der Farben Schwarz und Weiß. Diese minimalistische Farbwahl wird durch die lebendigen Formen stilisiert, deren Linien mit einer computertaften Präzision herausgearbeitet wurden, die der Kollektion einen futuristischen und dramatischen Eindruck verleihen.

Le duo de designers Boudicca, connu pour ses créations à la fois provocatrices et très féminines, a choisi pour sa collection d'automne et d'hiver, An Invisible City, un mélange de couleurs contrastées déclinant le blanc et le noir. Ce choix de couleurs minimalistes est stylisé par les formes vivantes aux lignes travaillées avec la précision d'un ordinateur, conférant à la collection une touche futuriste et théâtrale.

Para su colección de otoño-invierno An Invisible City, el dúo de diseñadores Boudicca, conocido por sus diseños radicales y femeninos, se ha decantado por una combinación llena de contrastes en blanco y negro. Esta selección de colores tan minimalista viene estilizada por las formas vivas de líneas elaboradas con precisión computerizada que confieren a la colección una sensación dramática y futurista.

Il duo di stilisti Boudicca, noto per i sui disegni radicali e allo stesso tempo femminini, per la collezione autunno-inverno dal nome An Invisible City ha optato per la combinazione contrastante di bianco e nero. Questa scelta cromatica minimalista è stata stilizzata in forme vivaci, le cui linee sono elaborate con una precisione computeristica, donando così all'intera collezione un'impressione futuristica e spettacolare.

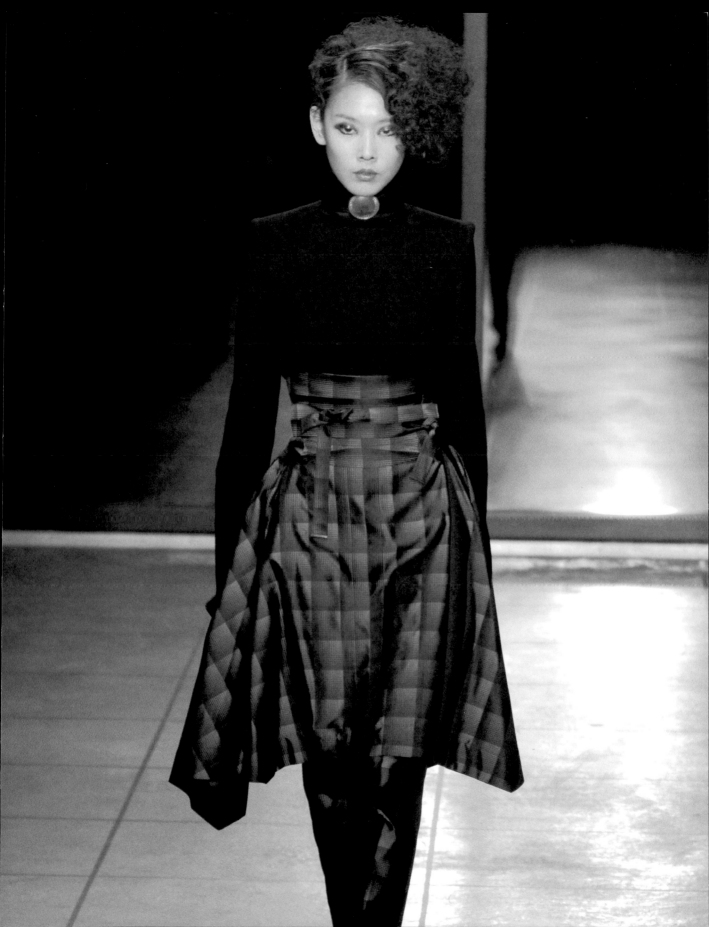

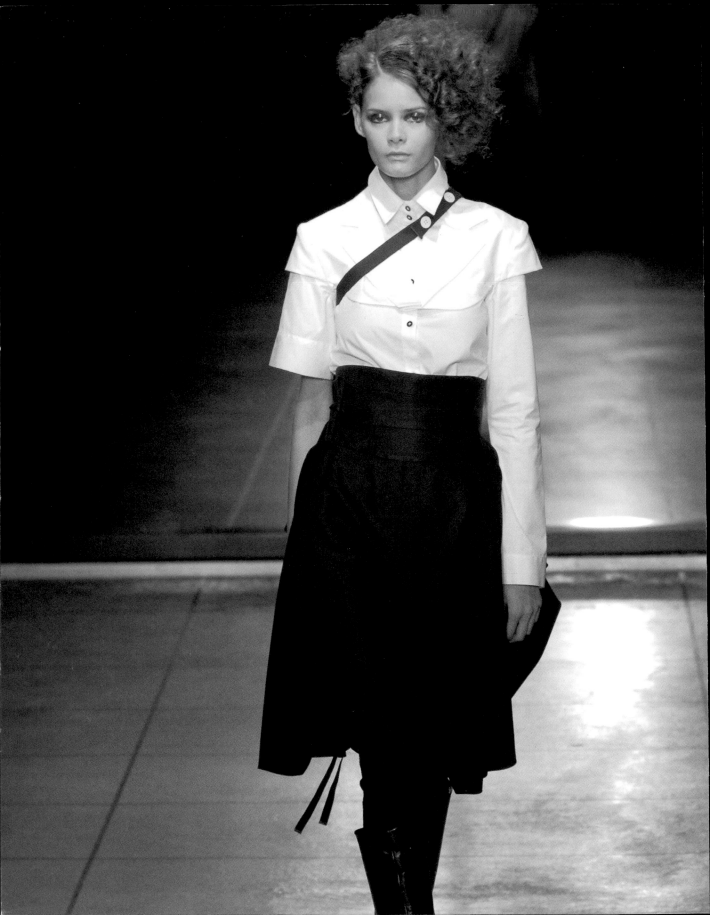

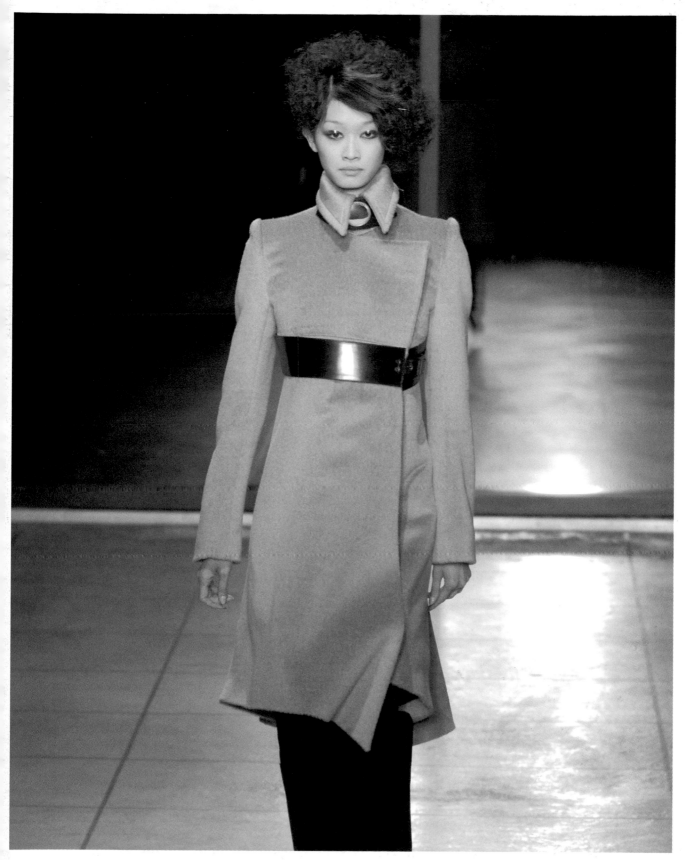